WITHDRAWN

City
Poet

The Life and Times of
Frank O'Hara

Also by Brad Gooch

Scary Kisses

Jailbait and Other Stories

The Daily News

City
Poet

The Life and Times of
Frank O'Hara

Brad Gooch

HARPER ● PERENNIAL

NEW YORK ● LONDON ● TORONTO ● SYDNEY ● NEW DELHI ● AUCKLAND

HARPER ● PERENNIAL

The publisher wishes to thank Maureen O'Hara Granville-Smith, Administratrix of the Estate of Frank O'Hara, for permission to quote from the unpublished letters, manuscripts, diaries and poetry of Frank O'Hara.

Owing to limitations of space, all other permissions to reprint previously published material will be found immediately following the index.

This book was originally published in 1993 by Alfred A. Knopf, Inc. It is here reprinted by arrangement with Alfred A. Knopf, Inc.

HarperCollins books may be purchased for educational, business, or sales promotional use. For information, please e-mail the Special Markets Department at SPsales@harpercollins.com.

FIRST HARPER PERENNIAL EDITION PUBLISHED 1994.

Reprinted 2014

Library of Congress Cataloging-in-Publication Data is available upon request.

ISBN 978-0-06-230341-7

14 15 16 17 18 OV/RRD 10 9 8 7 6 5 4 3 2 1

3183 8590

For my parents

I can't even enjoy a blade of grass unless I know
there's a subway handy, or a record store or some
other sign that people do not totally *regret* life.

—**Frank O'Hara**
"Meditations in an Emergency"

Contents

Photo inserts follow pages 142, 270, and 398.

Acknowledgments

Maureen O'Hara, the sister of Frank O'Hara, has been remarkably supportive of this biography from the beginning. I owe her my deepest thanks for allowing me access to all of her brother's unpublished letters, manuscripts, journals, and datebooks, as well as to family photographs. She opened difficult doors for me by encouraging other family members and friends to meet with me. Most helpful to me as well in O'Hara's immediate family circle: his brother, Philip O'Hara; first cousin Mary F. O'Hara; aunt Catherine F. O'Hara; uncle Thomas Broderick; sister-in-law, Ariel O'Hara; and niece, Alison O'Hara.

I also wish to thank those who piqued my interest in O'Hara's poetry and life—not just during the past five years of writing this biography but over the past twenty years. Foremost among these is Joseph LeSueur, the poet's roommate for nearly a decade, who was generous with his time, his talk, and even drafts of his own memoirs. It was at dinner parties at LeSueur's Manhattan apartment during the 1970s that I began to receive my unofficial education in Frank O'Hara. Missing these days is a constant guest at those dinners and a close friend of

O'Hara's near the end of his life, J. J. Mitchell. I regret more than I can say his death from AIDS in 1986, which prevented me from speaking with him about O'Hara—and so many other matters—as I wrote this biography. Among those who brought me closer to O'Hara's poetry early on, I think as well of Kenneth Koch, whose classes at Columbia College helped make the poems accessible and exciting to this undergraduate.

I owe much to my publisher at Knopf, Sonny Mehta, who not only commissioned this biography but offered illuminating advice at several crossroads along the way. My editor, Shelley Wanger, paid careful attention to the manuscript, which she read unusually closely. I feel grateful for her inspired combination of charm and precision. For support, excitement, and hard work, I must thank my agent, Joy Harris. This project at various times has required all of her various talents.

I would also like to thank The William Paterson College of New Jersey for time off from teaching to complete this manuscript. Many professionals at other libraries and resource centers were invaluable in helping with the labor of research. I am especially grateful to Joe Lane, St. John's High School; Reverend Paul J. Nelligan, S.J., college archivist, College of the Holy Cross; Mr. Pasquale Quidamo, retired principal, Dougherty Memorial High School; Robert Wilson, Grafton Historical Society; Ruth Emmanuel, New England Conservatory; William H. Morgan, executive director, USO of Northern California, San Francisco; Adrian Fisher, librarian, the Harvard Club; Rodney Dennis, Houghton Library, Harvard University, as well as his assistant, Elizabeth Falsey; Jeanne Newlin, Harvard Theatre Collections; Guy Sciacca, Harvard University Registrar's Office; Andrea Beauchamp, the Hopwood Room, University of Michigan at Ann Arbor; Kathy L. Beam, librarian, Department of Rare Books and Special Collections, University of Michigan at Ann Arbor; Rona Roobe, librarian, Museum of Modern Art, and her assistants Rachel Wild and Apphia Lod; Ron Maggliozi, Film Department, Museum of Modern Art; Cynthia Farar, research librarian, Harry Ransom Humanities Research Center, University of Texas at Austin.

Various people gave unusually of their time, hospitality, or creativity. Among the many of these to whom I feel especially indebted: John Ashbery, Kenneth Koch, and Cheri Fein for reading and commenting on the manuscript in its entirety. Bill Berkson, who regularly mailed me notes of memories or anecdotes; Kynaston McShine, for scrutinizing the pages on the Museum of Modern Art; Lawrence Osgood, for working closely with me on the chapters about Harvard and Ann Arbor; J. M.

Elledge, for sending me his *Frank O'Hara: To Be True to a City*; Jan Erik
Vold, for his album of O'Hara poems translated into Norwegian and
set to jazz, *Den Dagen Lady Dode*; Harold Snedcof, for a copy of his
unpublished 1970 Brown University dissertation—the first on O'Hara;
Jeffrey Julich, for his unpublished essay, "Locus Solus: The Magazine";
Nora Sayre, for an unpublished chapter on the Poets Theatre from her
book *Previous Convictions: A Journey Through the 1950s*; Vincent Warren,
for his hospitality as well as a lively tour of Montreal during my week-
end visit; Mary Guerin, housekeeper during O'Hara's childhood, for a
hand-crocheted potholder; Phil Charron, for finding his diary entry
from 1947 describing the funeral of Russell O'Hara; Jack Stuart, Sr., for
lending me his copy of the ninth reunion souvenir book of the U.S.S.
Nicholas; Rosemarie Hester and Stephen Darwall, for allowing me to
stay with them during a visit to Ann Arbor; the Harvard Faculty Club,
for their hospitality during an extended period of research on campus;
Elizabeth Delude-Dix and her son, Dermot, for their kindness on my
several trips to Boston and Grafton.

Most of O'Hara's friends were incredibly cooperative. His legend-
ary capacity for friendship is proved once again by the size of the list of
those who cooperated with his biography. To these, and to others who
helped, my warmest thanks: Edward Albee; Donald Allen; Amiri Ba-
raka; Mildred Bean; Thomas Benedek; Peter Bouthiette; Joe Brainard;
Jim Brodey; Harold Brodkey; Scott Burton; Wynn and Sally Chamber-
lain; Jules Cohen; William Cronin; Sharon DeLano; Tibor de Nagy;
Diane di Prima; Richard Door; Elsa Baldwin Ekblaw; Kenward Elms-
lie; Frederick English; Lawrence Ferlinghetti; Edward Field; Robert Fiz-
dale; Harold Fondren; Raymond Foye; Helen Franc; Helen Frankenthaler;
Jane Freilicher; Arthur Gartaganis; Allen Ginsberg; John Giorno; Mi-
chael Goldberg; Morris Golde; Edward Gorey; Maxine Groffsky; John
Gruen and Jane Wilson; Barbara Guest; Donald Hall; Grace Hartigan;
Stephen Holden; Molly Howe; Irma Hurley; Jasper Johns; Hettie Jones;
Howard Kanovitz; Alex Katz; Heidi Kleinmann; Ruth Kligman; Ken-
neth Jay Lane; Jack Larson; Roy Leaf; Leo Lerman; Alfred Leslie; Frank
Lima; Alison Lurie; Gerard Malanga; Sister Mary Barbara; Harry Mat-
thews; Luke Matthiessen; Porter McCray; Taylor Mead; James Merrill;
Michael Milan; George Montgomery; Renée Neu; Alvin Novak; Thomas
O'Brien; Genevieve Kennedy O'Connor; James O'Connor; Ron Padgett;
Spiros Paras; Waldo Rasmussen; George Rinehart; Clarice Rivers; Larry
Rivers; Steven Rivers; Burton Robie; Cervin Robinson; Gaby Rodgers;
Hans Rohwedder; Ned Rorem; Gordon Rosenlund; Jerome and Judy
Rubenstein; Kenneth Ruzicka; D. D. Ryan; Paul Schmidt; James Schuy-

ler; David Shapiro; Silas Simms; John Simon; D. W. Singleton; Vito Sinisi; Derrick Smit; Patsy Southgate; Douglas Starr; Virgil Thomson; Tony Towle; Chuck Turner; Dan Wagoner; Madeleine Warren; William Weaver; Arnold Weinstein; Chester Williams. My apologies as well to anyone whose name I may have inadvertently forgotten.

I also wish to thank the research assistants who helped: Amy Aronson, Eric Croszek, Caroline Payson, and Kim Cartright. Mostly, though, I wish to thank Sarah Lindemann, whose job defies any simple title or description. Over several years she worked with me closely, researching background; organizing a mass of interviews, secondary articles, and books; making the telephone calls required to find the odd sailor mentioned in a World War II letter of O'Hara's or an elusive Harvard classmate. Her time spent at the Harvard Club, the Museum of Modern Art, and the New York Public Library Reading Room added depth to both our understandings of O'Hara's milieu. Our discussions—often heated, often extended—contributed greatly to my arriving at conclusions that I felt were tested. Her challenging readings of my pages were an inspiration.

City
Poet
The Life and Times of
Frank O'Hara

Prologue

"Grace to Be Born and Live
as Variously as Possible"

The afternoon of July 28, 1966, was hot and sunny, with temperatures in the low nineties. Frank O'Hara's body was resting in a standard coffin from Yardley & Williams Funeral Home in Sag Harbor that was covered with white roses and ivy and supported above a four-plot grave on metal poles. One of the scrub oaks of Green River Cemetery in Springs, Long Island, cast its black shade nearby.

O'Hara never much liked funerals. When his Aunt Mary, a nun, had died in 1956 he did not attend her burial at a convent in Massachusetts. He commemorated it his way in "Poem" (And tomorrow morning at 8 o'clock in Springfield, Massachusetts):

> When I die, don't come, I wouldn't want a leaf
> to turn away from the sun—it loves it there.
> There's nothing so spiritual about being happy
> but you can't miss a day of it, because it doesn't last.

He had once told a friend, though, that he wished to be buried in Green River Cemetery, a small, acre-and-a-half, nondenominational

cemetery started in 1902. Not long after O'Hara's funeral, Ad Reinhardt noted, "Everyone wants to be buried in the Green River Cemetery," and over the next twenty-five years, Reinhardt, Lee Krasner, Elaine de Kooning, Stuart Davis, Jean Stafford, and A. J. Liebling would all be buried there. O'Hara had always been particularly affected by the grave of Jackson Pollock, who had been buried in the cemetery on a hot August day in 1956. In 1958 O'Hara had visited Pollock's grave with a neighbor's daughter who had said about the boulder marking the grave, "He isn't under there, he's out in the woods." Her remark, and the visit, inspired O'Hara to write a poem originally titled "Ode at the Grave of Jackson Pollock," in which he asked Pollock for inspiration as if the Abstract Expressionist artist were a classical muse:

> *and like that child at your grave make me be distant and*
>
> > *imaginative*
>
> *make my lines thin as ice, then swell like pythons*

When he mailed the poem off to fellow poet Kenneth Koch, he wrote, "It seems to have sprung from seeing Pollock's grave in the Springs, a subject which strikes me with considerable uneasiness, and I'm not joshing you. Grrrr." Now his own coffin was lying on the expanse of green grass just beneath the upslope to Pollock's grave. It was a juxtaposition that led Pollock's widow, Lee Krasner, to remark that day somewhat combatively, "Frank's head is at Jackson's feet."

O'Hara got his wish to be buried in Green River Cemetery, but not his wish that no one come. By 3:00 p.m. almost two hundred mourners had converged on the cemetery. The coffin was a reminder of the almost unbelievable facts. Frank O'Hara was dead at forty. He had been killed in a freak accident by a twenty-three-year-old summer worker taking a joyride with a young woman in a jeep on the Fire Island Pines beach at three in the morning. The fifteen years during which O'Hara had been so much a part of the creative life of New York as poet, Museum of Modern Art curator, *Art News* critic, and general catalyst were over. The subject of more portraits than any poet since Apollinaire—who as an art critic had championed the Cubists Picasso, Braque, Gris, Léger, Laurencin, and Picabia—was suddenly gone. O'Hara's excessiveness and sheer hubris had always seemed striking to some of his more concerned friends. As the illustrator of Gothic tales Edward Gorey says more particularly of the O'Hara who had been his roommate at Harvard, "I sometimes felt that he was resolutely ignoring the consequences of what he did. He was living on the edge."

To others, however, O'Hara's escapades—diving in the ocean during storms, falling asleep drunk at a construction site—were simply signs of his exceptionally high-spirited passion for life. Writing home to his parents from the Navy when he was eighteen, he had asked rhetorically, "Why prefer the shadow to the sunlight, water to land? Life with its trials has a zest that a Utopia would never have." One of his many updatings of the *carpe diem* theme of Latin poetry was the line in "Steps": "the Pittsburgh Pirates shout because they won / and in a sense we're all winning / we're alive." Another of O'Hara's classmates from Harvard, the poet Kenneth Koch, grieved quietly as the cemetery began to fill up for this funeral of a man who was hardly a celebrity outside his own charmed circle at the time of his death. "Why does it seem so impossible to believe that Frank is dead?" he asked his wife, Janice, a few weeks later. "Maybe because he was so full of life," she replied.

The mourners arrived from all points. Robert Motherwell and Helen Frankenthaler drove down from Provincetown (because small planes made Frankenthaler nervous). The poet Bill Berkson flew in from Newport. Alex and Ada Katz made the trip down from Maine. Allen Ginsberg and Peter Orlovsky chanted "Hare Krishna, Hare Rama" all the way from Manhattan in Larry Rivers's car. Barnett Newman had vowed never to return to the Hamptons after Pollock's funeral in 1956, but he and his wife, Annalee, reneged and rented a limousine and driver. The painter Howard Kanovitz flew from Provincetown in a chartered plane. Al Leslie heard the news on the beach and came straggling to the cemetery in his swimsuit with towel. Larry Rivers's wife, Clarice, walked in wearing a hat like a proper Welsh woman. Willem de Kooning wore splattered workclothes as did many of the other painters and sculptors. There were Adolf Gottlieb, Philip Guston, Alfonso Ossorio, Michael Goldberg, Norman Bluhm, Ibram Lassaw, Reuben Nakian. A yellow bus hired by the Museum of Modern Art made a sweltering three-hour trip from Manhattan filled with curators, directors, assistants, and secretaries. Waldo Rasmussen, having risen in the ranks with O'Hara, was annoyed when Elizabeth Shaw, the Museum's Director of Public Information, tried to enlist him to identify celebrities as they entered—information she then passed on to the reporter from the *New York Times,* who wrote a snide line in an early edition about the "many bearded, tieless friends of Mr. O'Hara."

The funeral began calmly enough. Expressions of grief were stifled. Many of those present wore sunglasses, as much to hide their tears as to block the glare of the relentless sun. As the young poet Lewis

MacAdams wrote in "Red River," "at the funeral friends stood in clumps / like people in galleries who know each other." The Reverend Alex Renton, a sixty-year-old Scottish pastor from the First Presbyterian Church in East Hampton, officiated in his clerical robes and collar. Those delivering eulogies stood near him informally on the grass in front of a simple wooden fence, with the potato fields of the Hamptons stretching out into the distance. The collector B. H. Friedman, who had carefully packed a black sports-coat before flying down from Provincetown, was startled at how casual Larry Rivers looked in his white dinner jacket with no tie. Shuffling uncomfortably next to Rivers were René d'Harnoncourt, Edwin Denby, Bill Berkson, and John Ashbery.

Suddenly Joe LeSueur, O'Hara's roommate of almost a decade, appeared weeping, supported on one side by the poet Barbara Guest and on the other by the painter Robert Dash. His loud sobbing as he came through the gate seemed to give others permission to let go. "I felt like I was on an LSD trip," says LeSueur of his emotional state. While LeSueur and O'Hara's relationship had been an ambiguous blur of friendship and love—a blur common in O'Hara's complicated life— LeSueur had definitely been his home base. It was of his seersucker jacket that O'Hara had written in "Joe's Jacket" in 1959: "it is all enormity and life it has protected me and kept me here." Yet it had only been eighteen months since the two had fought more fiercely than usual and LeSueur had moved out of their loft on lower Broadway. That their friendship was close again after that shaky time only magnified LeSueur's grief. He also found himself caught in cross fire. Typical was the comment a few weeks later by John Bernard Myers, the outrageous dealer at Tibor de Nagy Gallery who had published O'Hara's first book of poems, *A City Winter*: "Who do you think you are acting as if you're the only one griefstricken over Frank's death?" There had indeed been much discussion over who was to speak at the grave. According to the composer Virgil Thomson, "After his death a dozen of his lovers turned up looking for the glory of being the chief widow." Although he had finally been talked out of reading "Ode to Joy," LeSueur did come to rest with his two bolstering friends near the other eulogists.

The presence of the Reverend Renton made many of O'Hara's friends uncomfortable. O'Hara, after all, had once written, "It's well known that God and I don't get along together." But Renton was required to officiate if they wanted permission to use the Springs chapel down the road in case of rain. A worse offense, it was felt, would have been a Roman Catholic priest, as O'Hara, having attended a Xaverian Brothers parochial school as a boy, was a renegade Irish Catholic of the

most vehement sort. Renton opened with a few simple Presbyterian prayers and then went on to remark, "I never knew Frank, but from what I know of him he reminds me of the Scots' poet Robbie Burns." De Kooning later complained, "That minister seemed to think Frank needed some help to get to heaven."

René d'Harnoncourt, the towering Viennese-born Director of the Museum of Modern Art who had recently worked with O'Hara on the first large exhibition of American sculpture ever to be sent to Europe, spoke officially. He opened, though, by commenting that everyone knew that O'Hara—who began at the Museum in 1951 selling postcards in order to see Alfred Barr's Matisse retrospective more frequently—would soon have taken his own job. His comments were along the line of the letter he wrote to the *New York Times* a few days later to try to fill out their thin, slightly catty obituary: "Frank O'Hara was very much his own man; and precisely because of that, he belonged to us all." Absent from the service was Alfred Barr, Jr., now getting on in years, the pioneer spirit of the Modern, whom O'Hara had described as "a god" of the artworld and who was rumored to have twice tried to have O'Hara fired. That O'Hara, while curator, was appearing in galleries in nude paintings by Larry Rivers and Wynn Chamberlain had not improved relations between him and the rather puritanical Barr.

Dance critic and poet Edwin Denby spoke almost inaudibly, "standing Lincoln-like and low-voiced under the big elm at Springs" as Bill Berkson later described him. Almost twenty-five years older than O'Hara, Denby had often accompanied him to performances of Balanchine's New York City Ballet at City Center—both of them being committed and passionate balletomanes. Graced with a shock of white hair, Denby, who had ridden out on a Greyhound bus with the Katzes, opined fraily but surely that O'Hara had been "America's greatest living poet."

Bill Berkson, a strikingly handsome twenty-five-year-old poet and Kennedy look-alike, spoke for the younger protégés of Frank O'Hara. There was more controversy about his inclusion than anyone's. Some felt the son of fashion publicist Eleanor Lambert was too "Uptown." Others complained that he had teased and manipulated O'Hara, who wrote in "Biotherm (for Bill Berkson)"—quoting the remark of a friend—of "a year and a half of trying to make him." But Kenneth Koch, who had taught Berkson at the New School for Social Research and introduced him to O'Hara—according to Berkson—with the comic warning that O'Hara would become a "germ" in his life, nominated him. "Kenneth had a particular attitude about a lot of the gay people

around Frank," says Berkson. "It's what Frank called his 'H.D.'— 'homosexual dread.' He didn't want that to overwhelm the ceremony. Which may have been why he was being very strong for me to be the speaker." Actually, Berkson was a moving voice for the many young poets present, their faces set like voodoo masks while Allen Ginsberg went about propping them from behind and humming "Ommmmm" so they wouldn't buckle in the heat. Berkson said of O'Hara, "As a poet, a genius, just walking around, talking, he had that magic touch. He made things and people sacred."

John Ashbery broke down trying to read the last several lines of O'Hara's "To the Harbormaster":

> *I trust the sanity of my vessel; and*
> *if it sinks, it may well be in answer*
> *to the reasoning of the eternal voices,*
> *the waves which have kept me from reaching you.*

Ashbery had met O'Hara in 1949 at Harvard, and the two had been very close ever since—as deeply affectionate as they were competitive. O'Hara had once compared them to the two brothers in *East of Eden,* choosing the bad-boy James Dean role for himself while giving Ashbery and his poems the compliment of being "full of dreams and a kind of moral excellence and kind sentiments."

The painter Larry Rivers changed the tone by presenting a violent eulogy, full of raw fury. Rivers stormed forward with blazing eyes and a great shock of black hair, looking unkempt and wild. There was a tragic intensity to him. According to the curator Waldo Rasmussen, "Larry's Raskolnikovian entrance was out of a Russian novel." That afternoon Rivers remained true to O'Hara's description of him as having been, in the early fifties, "rather like a demented telephone. Nobody knew whether they wanted it in the library, the kitchen or the toilet, but it was electric."

Rivers had been as intimate with O'Hara as anyone. Although he was mainly involved with women, he had carried on a rocky stop-and-start love affair with the young poet when they were both in their late twenties. From their passion—based partly on bohemian fantasies of Rimbaud and Verlaine—came many paintings and poems. In 1954 Rivers had painted a well-known portrait of O'Hara nude in combat boots after Géricault's *Slave,* to which the *Times* in its obituary referred, discussing "the question of when exposure of human anatomy in paintings

is or is not offensive." O'Hara had written his epic "Second-Avenue" at Rivers's plaster garden studio on Second Avenue while posing for a sculpture. Many of O'Hara's early poems, filled with surrealistically coded images of pain and torment, of "yoyo-cartwheel-violences," were written during his frustrating and highly romanticized affair with Rivers.

"Larry's eulogy was searing, cauterizing," says Henry Geldzahler, then a young curator at the Metropolitan. "He took us out of our bodies, threw us first into the grave and then into the sky."

"Frank was my best friend," Rivers began, his eyes fixed on the closed casket, his posture akimbo, his saxophone of a voice even and steady. "I always thought he would be the first to die among my small happy group. But I day-dreamed a romantic death brought about by too much whiskey, by smoking three packs of Camels a day, by too much sex, by unhappy love affairs, by writing too many emotional poems, too many music and dance concerts, just too much living which would drain away his energy and his will to live. His death was on my mind all the sixteen years I knew him and I told him this. I was worried about him because he loved me."

Rivers then began describing O'Hara as he looked when he had visited him a few days earlier at Bayview General Hospital in Mastic Beach, Long Island, where O'Hara had survived for almost two days after his accident. The more Rivers went on, the more groans came from the mourners. Some yelled "Stop! Stop!" "He was purple wherever his skin showed through the white hospital gown," Rivers continued. "He was a quarter larger than usual. Every few inches there was some sewing composed of dark blue thread. Some stitching was straight and three or four inches long, others were longer and semicircular. The lids of both eyes were bluish black. It was hard to see his beautiful blue eyes which receded a little into his head. He breathed with quick gasps. His whole body quivered. There was a tube in one of his nostrils down to his stomach. On paper, he was improving. In the crib he looked like a shaped wound, an innocent victim of someone else's war. His leg bone was broken and splintered and pierced the skin. Every rib was cracked. A third of his liver was wiped out by the impact."

A gasp stopped Rivers short. It was O'Hara's mother. "People had acted as if Frank's mother wasn't there," remembers Elaine de Kooning's sister, Marjorie Luyckx. Suddenly they turned to take in the family scene. Katherine O'Hara, dressed in black and looking terribly frail, was standing by the grave. Curiously, she had been admitted that very week to a hospital in Westchester after a psychotic episode during which

she was found disoriented, deranged, and wandering the streets. Drinking was the primary problem. Her brother Tom Broderick, a second-generation Irish workman, had gone to Westchester to pick her up to take her to her son's funeral and return her immediately afterward. "What happened?" she had asked calmly when he told her the news. This afternoon she was standing next to her son Philip, who had fought to have O'Hara buried in his hometown of Grafton, Massachusetts. Nearby was her daughter, Maureen, and two cousins, Mary and Jane, who had crossed over on the ferry from Orient Point.

O'Hara had strained to escape his mother most of his adult life. Her alcoholism, following upon the sudden death of his father while O'Hara was a freshman at Harvard, had demoralized and infuriated him. He had not gone home for over ten years. Yet the habit of taking on others' dreams and cares, that had made him so popular among the New York School artists, had begun with his frail, seductive, ambitious, and eventually alcoholic mother many years earlier. Rivers's lashing out and her gasp constituted the jagged catharsis of the burial.

"Frank O'Hara was my best friend," Rivers said, subsiding. "There are at least sixty people in New York who thought Frank O'Hara was their best friend. Without a doubt he was the most impossible man I knew. He never let me off the hook. He never allowed me to be lazy. His talk, his interests, his poetry, his life was a theatre in which I saw what human beings are *really* like. He was a dream of contradictions. At one time or another, he was everyone's greatest and most loyal audience. His friendships were so strong he forced me to reassess men and women I would normally not have bothered to know. He was a professional hand-holder. His fee was love. It is easy to deify in the presence of death but Frank *was* an extraordinary man—everyone here knows it."

As the coffin was lowered into the ground, mourners filed by. Reuben Nakian, a white-haired sculptor, had attached to it a terra-cotta sculpture of his *Voyage to Crete* series, from a show then at the Museum of Modern Art, curated by O'Hara. Stephen Holden, a young poet, tossed in a laurel wreath. Allen Ginsberg and Peter Orlovsky intoned Indian sutras, while Jack Smith, the auteur-director of *Flaming Creatures,* snapped photographs. Many then dispersed to a wake at Patsy Southgate's house up the road, where she was forced for a few minutes to keep her two young children's eyes averted from Orlovsky's unbalanced brother, Lafcadio, recently released from a mental institution, who upset the tender occasion by masturbating between two slices of bread. The painter Jane Freilicher, an early muse of O'Hara's, went on with Ken-

neth Koch and John Ashbery to Fairfield Porter's house in Southampton where they reminisced quietly into the evening.

As Philip Guston and Joe LeSueur walked away from the grave, which would soon be marked by a slate stone inscribed with O'Hara's line "Grace to be born and live as variously as possible," Guston put his arm around LeSueur and whispered, "He was our Apollinaire."

Birth

Frank O'Hara never talked about his childhood. During the mid-fifties, when he and his roommate Joe LeSueur were in their twenties and living together in a coldwater flat on East Forty-ninth Street with a view of the new United Nations building, O'Hara often used to quiz him about his childhood and family. Many nights the young poet would sit rather mischievously at the kitchen table, a vodka in hand, unfiltered Camel burning in an ashtray, a French opera blaring on the radio, coaxing LeSueur, a Jack Mormon from Southern California, to read aloud just one more letter from his father, "a sort of W. C. Fields character" as LeSueur describes him, or to tell him one more funny story about the trials of growing up under the strictures of Mormonism.

"Frank always wanted to find out what I went through, all my childhood memories," says LeSueur. "But he would never reveal his. I don't know why I didn't pin him down, but I didn't."

"He did give the feeling of being very much on his own," confirms the painter Jane Freilicher. "My feeling towards him was that he was a grown-up, not a son. Other people would say, 'Oh I have to go see my

mother,' or 'My mother called,' or 'I wonder how my mother is.' With Frank, I somehow got the feeling of someone who had detached himself from his family."

In the bohemian artworld of 1950s Manhattan where O'Hara was such a leading player and a prime creative force, one of the unspoken rules was that people did not need to have come from anywhere special. It was considered "boring" to talk too much about family background. "I didn't want him to meet my parents either," explains the painter Grace Hartigan, one of O'Hara's closest friends during the fifties. "You leave that." Self-creating was part of the ethos of the times.

Yet Freilicher was quite accurate in sensing that perhaps there was something more to O'Hara's kind of detachment. It wasn't just that he didn't talk about family matters, he simply never went home again. His last trip to Grafton, Massachusetts, the sleepy semirural New England town with elm-lined streets where he had grown up, occurred on February 14, 1952, when he was twenty-six years old, for the funeral of his Aunt Grace, his father's sister. Around this time, O'Hara announced to his little sister, Maureen, who was then a teenager, "I'm leaving, and I'm not coming back, and I think you should do the same."

He laid it on the line to his brother, Philip, in different words. "As you know I don't give a fuck for families," he wrote to him in a letter. "I think that people should treat each other as they feel. I consider our mother to be one of the most mean, hypocritical, self-indulgent, selfish and avaricious persons I have ever known well. . . . I don't hate mother, but each individual (and why should she be excepted) runs into a pretty hard life, and their dealing with it, whether you came out of their womb or not, inspires either admiration, disinterest or dislike. In my case it's the latter."

Sentiments such as these were occasionally overheard by young poets when O'Hara would scream at his mother on the phone if she happened to call his Broadway loft in the 1960s. There was gossip about her having shown up drunk to visit him in the city. Many wrongly concluded that the poet's reticence in talking about his childhood must have been a response to having grown up in a sort of *Long Day's Journey into Night* psychodrama.

But they were mistaken. Whatever demons were later released in the O'Hara family were just night shadows in a boy's bedroom during most of the poet's childhood. When seventeen-year-old Francis O'Hara wrote home from the Navy in 1944 that the comic strip "Blondie will always be a symbol of our family life to me," he was quite sincere.

> *I hardly ever think of June 27, 1926*
> *when I came moaning into my mother's world*
> *and tried to make it mine immediately*
> *by screaming, sucking, urinating*
> *and carrying on generally*
> *it was quite a day*

That's how O'Hara teasingly describes his birth as Francis Russell O'Hara in Baltimore, Maryland. The poet, who could make much of little, muses elsewhere in the autobiographical "Ode to Michael Goldberg ('s Birth and Other Births)" on his infancy below the Mason-Dixon line. He begins in an appropriately Scarlett O'Hara-like honeyed tongue:

> *I don't remember anything of then, down there around the magnolias*
> .
> *and there's never been an opportunity to think of it as an idyll*
> *as if everyone'd been singing around me, or around a tulip tree*

He later fancies, "in Baltimore, you think of hats and shoes, like Daddy did."

But O'Hara's poetic license was even broader than he suspected. His birth certificate—found twenty-five years after his death—recorded his real birth as three months earlier, on March 27, 1926, at Maryland General Hospital. The presiding physician: Maurice Shamer, M.D. That O'Hara was misinformed about his own birth is particularly ironic for a poet of precise dates and times who wrote several occasional poems for friends' birthdays and had a bemused fascination with astrological signs. He wrote birthday poems for Michael Goldberg, John Button, and Bill Berkson. He began his long autobiographical "In Memory of My Feelings" on what he believed to be his own thirtieth birthday. In a prose fragment written in 1960 as part of a never-completed autobiographical fiction tentatively titled *A Short Unhappy Life*, O'Hara revealed that "Almost all data relating to my birth adds up to 6, which is curious, and I am an ardent horoscope reader, favoring particularly Constella, though I dislike her changing my zodiacal designation from Cancer to Moon Children." In "Poem" (Now it is the 27th) written in October 1959 to his lover Vincent Warren, he begins

Now it is the 27th
of this month
which would have been my birthday
if I'd been born in it
but I wasn't
would have made me a
Scorpion.

Actually his birth sign turns out to be Aries rather than Cancer.

The discrepancy is a mystery. But not a difficult one to solve. His parents had been married in Grafton, Massachusetts, on September 14, 1925—six months before the birth of their first son. As both were the offspring of morally conservative Irish-Catholic families, the shift of their baby's birthday three months later implied conception after marriage rather than before. The cover-up also solves the mystery of his parents' eighteen-month stay in Baltimore. They fled their thickly rooted families in New England to hide the progress of the pregnancy, then soon returned.

Katherine ("Kay") Broderick of Worcester, Massachusetts, had first met her husband-to-be, Russell Joseph O'Hara, a few years earlier when she had taken a trolley ride one town away to visit an uncle who lived near the O'Haras in Center Grafton. She and her future husband then became better acquainted when, aged seventeen, she had registered as a student in an English course taught by O'Hara, eight years her senior, at the Worcester Business Institute. They were married that same year.

At the time of his marriage, Russell O'Hara was moonlighting by managing a Stetson hat store in Worcester. Since he needed to get out of town, he arranged a transfer to a haberdashery in Baltimore. Though managership of the shoe and hat store was hardly an irresistible lure, it was necessary to escape prying eyes and wagging tongues. At the time of this trip, neither Russell, looking then remarkably like his future poet son with a widow's peak, angular face, and lucent eyes, nor Kay, her brown hair in twenties fashionable ringlets down around her pretty face, had ever strayed far from the protective perimeter of Worcester's seven hills—those hills, rather than any feverish cosmopolitanism, having earned the city its somewhat misleading nickname, "The Little Rome."

Their impulsive breakaway to Baltimore ended when the young parents were visited by Russell's mother, Mary Donahue O'Hara, and his brother, Leonard O'Hara. The relatives had come to see the new baby, who was usually dressed in outfits that Kay had cleverly sewn herself.

But their visit had an ulterior motive. They wanted to persuade Russell to return to Grafton to help run the farming business of their family patriarch, his uncle J. Frank Donahue, who had recently taken ill.

J. Frank Donahue was a brisk and authoritative presence. Usually dressed in an imposing overcoat with fur collar and peering sharply at everyone through his black-rimmed spectacles, he made his way about Grafton in a most self-confident way. He had his own picture engraved on his business envelopes and was a bit of a local legend: first Catholic selectman, Democratic state representative in a strong Republican district, nationally successful cattle dealer, trader in real estate, town undertaker, gentleman farmer. To some of his detractors in the town, though, he had the reputation of a "shyster," since during the early years of the Depression he had offered to help struggling neighbors with their mortgages only to soon own all of their property himself.

He was also a second father to Russell. Russell's own father, John P. O'Hara, a mail carrier who lived on Vernon Hill in Worcester, had died suddenly of coronary arrest in 1912 when Russell was thirteen. J. Frank Donahue, a confirmed bachelor, had invited his sister, Mary Donahue O'Hara, and her three children, Grace, Russell, and Leonard, to move into his Grafton household.

As dependents of J. Frank Donahue, the O'Hara children suddenly had heightened prospects, both educational and financial. Russell and Leonard graduated from Grafton High School in 1916, just as the German and French forces were battling each other at Verdun. They then attended the College of the Holy Cross, a Jesuit enclave of red brick buildings overlooking Worcester, where they both enlisted in the Student Army Training Corps and so earned their stripes as World War I vets. Leonard, though, dropped out early to help J. Frank Donahue with his burgeoning business. Russell, the more sensitive of the two, with interests in reading Russian novels and a talent for playing anything from "Ave Maria" to "Liebestraum" on the piano, decided to stay on and complete a liberal arts degree. The 1920 Holy Cross yearbook sketched him as "modest," a pool shark with "a steady hand and an eagle eye," "a baseball fan," "a favorite and friend to all," and "a gifted dancer."

In Baltimore, however, Russell wasn't feeling so footloose. He now had a young wife and baby to support, and, in a sense, his living debt to J. Frank Donahue was being called in. So he decided to cede to his mother's request. Kay, however, balked. Variously described as "dainty," "superior," "artistic," and "beautiful," Katherine O'Hara was a vivid young lady with an itch to get on with her life. Though the move to Baltimore had been expedient, she was beginning to enjoy the distance

from family and friends. She had recently even been wishing that the family could move on from Baltimore to balmier Florida where many young Americans were heading that year to cash in on a speculative land rush. Such fanciful longings were to become increasingly common as Kay developed over the years into more and more of a Tennessee Williams heroine—frail, seductive, ambitious, decorative. Her heels often seemed a few feet off the ground.

"My mother said they were very upset when my grandmother wanted my father to come back and run the family business," says Maureen O'Hara, recalling her mother's frequent retelling of the incident.

The Grafton to which the young family returned—Francis for his first time—was untouched. Ground zero was a grassy Common soon to be enlivened by a wooden bandstand built by MGM for the filming of *Ah, Wilderness!*—the film's director believing Grafton to be a perfect time capsule for the play's original 1906 typical New England setting. At the top of the Common stood an imposing bronze statue of Jerome Wheelock, a wealthy nineteenth-century industrialist involved in the invention of steam engines who had provided funds to build the Grafton Library across the street. On the circumference of the Common's surrounding traffic circle the same small stores continued in business throughout O'Hara's childhood: Mr. Webster's Grafton Pharmacy with long shiny marble counters where the young Francis always jockeyed to be waited on by a salesclerk named Daisy who concocted the most generous 5-cent ice cream cones; Ainsworth's Paper Store, featuring a chalkboard listing of bowling scores on which Russell O'Hara's name usually figured prominently; Town Hall; the Post Office; a Grocery Store & Spa stocked with penny candy; Joe's Barbershop, whose wall-calendar was to become forever tacked in Frank O'Hara's memory ("huge brilliants-encrusted metallic blue and gold and white hanging calendar depicting a foaming glass of beer, the date 1933, and the legend HAPPY DAYS ARE HERE AGAIN. . . . it is perhaps because of this experience that, no matter how much I may admire or dislike a pop art work, I can never find its image shocking or particularly unusual in motivation").

Central Square was also the site of three of the town's oldest and most-established churches—the Unitarian, Congregational, and Baptist. St. Philip's, the Roman Catholic church, with its attached brick tower and a stained-glass window dedicated by the Donahues, was located on a side street, a significant clue to the strength of Yankee institutions and genealogy in this socially striated small town; even the well-manicured state of the Protestant cemetery rising on Millbury Street

was in sharp contrast to the less amply funded St. Philip's Catholic Cemetery on the same side of the street.

Emanating from Central Square like spokes on a wagon wheel were the main residential streets of Grafton, including North Street, a sedate stretch of large nineteenth-century wooden houses shaded by ancient elm trees, where the young O'Haras soon settled. Their own white wooden house at 16 North Street, built in 1856, had two stories, with a full attic, black-shuttered colonial windows, and a screened-in front porch. On patriotic holidays an American flag hung from the flagpole out front. As gardening was a favorite hobby of Kay and Russell O'Hara and, later, of their son Francis, garden beds in the backyard and along the driveway were soon full of hollyhocks, pink and white peonies, azalea bushes, violets, irises, daffodils, jonquils, tulips, and roses.

This *Saturday Evening Post*-perfect house was situated four houses down from the more sprawling, imposing, and almost humorously jumbled headquarters of J. Frank Donahue. A long three-story converted shoe factory replete with iron elevator and mansard roof, it was located at the end of North Street catty-corner to Central Square, reflecting its hybrid function as office, farm, and home. At the front of the rambling structure J. Frank Donahue lived along with his two sisters, Mary Donahue O'Hara and Elizabeth ("Lizzie") Reid, his brother-in-law Jack Reid, and his niece, Grace O'Hara. Its facade was covered with a tracery of screened porches on different floors that allowed the women to discreetly observe this quite manageable town of fewer than six thousand people, panoptically watching all the goings-on.

As the Donahue building extended backward, it unfolded into offices, storage space for farm equipment, a hardware store, repair shop, and cattle barn. Outbuildings included chicken coops where chicken and turkeys were slaughtered, a horse barn, and pens for Iowa cattle unloaded directly from the train tracks. The arrival of the white-faced, red-bodied Herefords always drew a crowd and could incite a circuslike mood around town for a few days until the beef cattle were finally dispersed to local slaughterhouses around Worcester County. Out beyond the train depot, J. Frank Donahue owned many more acres of potato patches, apple orchards, pastures, and haying fields.

While the operation was large scale, and certainly J. Frank Donahue was one of the town's biggest landholders, though not its most liquid capitalist, there was a somewhat endearingly funky quality to his plantation, a quality epitomized by the large metal sleighs abandoned and

rusting in the storage barn, which the O'Hara children would often spend entire afternoons clambering over—with the exception of Francis, who tended to steer clear of playing in the barn. Epitomized too in Maureen O'Hara's childhood reminiscence: "I am amused when I think of the cows leaving the barn and crossing a major road and railroad tracks to get to pastureland across the road."

Russell O'Hara, "calm and cool-headed," as Frank O'Hara would later describe him, moved easily into the position of boss, along with his brother Leonard, as more of the business was placed in their hands in preparation for J. Frank Donahue's eventual death in 1931. Russell soon enough settled into comfortable patterns. During the winter months he could often be found in his office in overalls, a fire blazing in the fireplace, balancing ledger books beneath a painting of a Kentucky walking horse. In the midst of the Depression years, he was understanding of poverty in this small agricultural and textile town and would often file unpaid debts away with the legend "In Memory Of . . . ," written at the top. When spring came, Russell could more often be seen riding in sweater and tie on a satin brown horse near the stables, dapper in his early years, heavier and prematurely gray later on, as habits of chain-smoking Lucky Strikes and drinking black coffee, offset only by the weekly exercise of bowling, began to wear on him a bit.

While both of Russell O'Hara's sons occasionally came up against his forbidding temper—an underlying strictness perhaps strengthened by his years at Holy Cross with its compulsory Daily Masses and dry religious instruction stressing ethical certainties—he generally appeared relaxed and flexible, his social persona very much "hail fellow well met." Every day after lunch, neighbors heard his distinctive whistling as he returned to the office from home. Described in the local newspaper as "one of the best-known men in town," O'Hara was a team player who served variously as a member of the board of investment of the Grafton Savings Bank, vice president of the Kiwanis Club, member of the school board, parishioner of St. Philip's, and steady bowler for the Grafton Bowling League, which usually convened on Wednesday evenings at the Waskanut Bowling Alley in South Grafton. He also struck up friendships with the parish priest and curates, passing many evenings playing bridge in the rectory, smoking and having one or two drinks. He was not a big drinker.

If Russell O'Hara's move to Baltimore had been an attempt at a youthful breakaway, he certainly returned to Grafton fully, easing quite well into the role set for him. His trait of "modesty," cited in the Holy

Cross yearbook, shone through the crusty carapace he chose for himself and his family. As Philip O'Hara explains, demonstrating an innate sense of the heraldic significance of cars and houses in establishing class status in small towns: "My father drove Oldsmobiles. The other O'Haras drove Buicks. They simply weren't Cadillac people. That would be too showy and ostentatious for them."

While Russell gradually set about learning his family's patchwork of businesses, Katherine made 16 North Street into a smart home. Always high-strung with, as Frank O'Hara described her to herself once in a letter, "an astounding capacity for worry," this slight brunette tapped her percolating energies most successfully when absorbed in decorating, sewing, or entertaining. She was a perfectionist at the domestic arts. Whenever it was her turn in the regulated, slowly whirling social life of Center Grafton to throw a lawn party or covered-dish supper, attendance was always at its peak.

Her community efforts were on a par with Russell's. She was active in district nursing, volunteer work at the local school, and Girl and Boy Scouting. As a den mother and Girl Scout leader she led her charges on field trips to visit churches of all denominations so that they might learn the differences between religions—outings that chagrined many of her Catholic friends, who felt that such open-mindedness was vaguely impious.

The life Kay was fashioning for herself in Grafton was quite a bit more modern than the one she had grown up with in nearby Worcester. Her parents, Joseph Broderick and Margaret Tobin, were both first-generation Irish immigrants, born in 1874, who believed in mixing only with their own kind and maintaining the old-world life-style. To step into their maroon-stained shingled house at the corner of Delmont Avenue and Bedford Street on a hill adjacent to Vernon Hill—the hill where Russell O'Hara had passed his boyhood while his father was still alive—was to enter into the atmosphere of County Cork. Their friends were drawn exclusively from the local Irish-Catholic community; their walls were dotted with embroidered sayings praising home and God; a daily event was the radio broadcast of the rosary being recited by a priest with a slight brogue; their most proudly exhibited family treasure was a chest containing a silver chalice and silver monstrance for the use of visiting curates.

According to Kay's brother, Tom Broderick, in whose colorfully long-winded recountings can still be heard echoes of the pub poetry of the old country, Joseph Michael Broderick, their father, who hailed from a family of seven hulking brothers "with hands as big as clubs," left

Ireland because "His father sold either one or two of my dad's horses and kept the money. So my dad just washed his hands of the whole goddam thing and left for America."

In Boston, Joseph Broderick dropped the "Michael" from his name because its diminutive, "Mick," was a derogatory nickname for newly arrived Irish. Like many of his kinsmen, Broderick had to fight his way to a meal or a job. Many businesses in Boston advertised "Help Wanted," but underneath was printed "Irish Need Not Apply." He learned the housepainting trade, a skill he successfully parlayed into a respectable pile of cash. He then moved to Worcester, where he started a paint contracting company lucrative enough so that by 1919 he could be spotted in his buttoned shirt and suspendered trousers cruising about town in a brand-new four-door Oakland sedan.

In keeping with the times and little birth control, Joseph and Margaret Broderick raised a family of six children. Their first daughter, Mary, born in 1904, joined the Sisters of St. Joseph in Springfield, Massachusetts, and was allowed to visit home only when in the company of another habited nun. Margaret, born the following year, never married and became a librarian specializing in social sciences at the Worcester Public Library. Katherine Louise appeared in 1907. Joseph Broderick was quite disappointed at this string of girls, and Kay used to report that the night she was born her father was so distraught he walked the streets until dawn, upset that she had not been a boy. His first son, and namesake, Joe, born in 1910, died tragically twenty-five years later when he lost control of a truck he was driving. Carrying a case of strawberry tonic on his regular delivery run to local stores, he crashed into an elm tree at the intersection of North and Merriam streets, a mere 150 yards north of 16 North Street. (O'Hara, nine at the time of the accident, later recorded its darkening effects in "3 Requiems for a Young Uncle": "Brilliant uncle incarnadine / too, nuance posing dark van / nuance of roadster crash.") Tom, born in 1912, provoked his father's ire when he married an Italian girl, Tosca, who lived down the street. The youngest child, Rose, was born in 1914.

As the third daughter in the Broderick family, Katherine O'Hara seemed a rather ordinary girl. Her two older sisters were A students, with Mary proceeding on to teach high-school English in a parochial school, and Margaret eventually graduating with honors from Boston University, a notable feat for a woman at that time. Kay, however, who entered Commerce High School in 1920, had already transferred by 1922 because of disappointing grades to the less strenuous Worcester Hale-Fanning Trade School, where girls donned aprons to learn home

economics and cooking skills. It was the sister school to Worcester Vocational, where boys wielded soldering irons and repaired machinery. As the prettiest and least academically driven of the sisters, it was assumed that Kay would marry, or work as a secretary using the shorthand she eventually learned at the Worcester Business Institute while dating her husband-to-be. As her brother Tom describes Kay during her teenage years, she suffered from a middle child's "low self-esteem."

According to one Grafton neighbor, whose mother grew up near the Brodericks in Worcester, Kay was "wild" during her high-school years in the Roaring Twenties. "She was probably one to put on too much makeup, and one of the first girls to smoke. She was 'one of the crowd.' She didn't put on airs until she married Russell. And of course the O'Hara brothers were a good catch. They were handsome, had money, and there were more women than men anyway. After that marriage she developed a pretty good opinion of herself."

Any "low self-esteem" did seem thoroughly burned away by the time Kay was enchanting her new neighbors on North Street by dressing up in expensive salmon-colored sweaters and serving foie gras hors d'oeuvres. Indeed Kay's self-esteem often seemed quite the opposite of low to many members of both the O'Hara and Broderick clans, for whom a dour Christian humility was considered the most important social grace. To them Kay appeared haughty, to be putting on false airs.

"I remember Aunt Margaret as being quite rigid, very strict," says Maureen O'Hara of her librarian aunt from the Broderick side of the family. "My aunts were much more rigid than my mother. She was so lively that many members of the family were jealous of her."

Philip O'Hara remembers similar resentments on the O'Hara side: "My mother never really fit into the O'Hara family. She had a very superior way about her sometimes and could present herself in such a way that other people felt very uncomfortable."

"She had these euphemisms for everything," remembers Phil Charron, the son of close friends of the family. "She'd say, 'Would you boys like some chilled pears?' when she had some canned pears in the icebox. I'd ask my mother for 'chilled pears' and she'd say, 'You'll have to go over to the O'Haras for those.'"

Kay was perceived as "superior" partly because she had jumped class. Grafton was a very strictly class-divided town. Kay ignored these invisible, though closely guarded boundaries to strike up friendships with many of the wives of old-money WASP families living nearby. Some of the O'Haras' closest friends were the Kilmers, one of the lead-

ing landholding families in town, and the Andersons, a North Street family involved in a successful leather business. They maintained a friendship with one Catholic family, the Kennedys, with whom they attended Holy Cross football games, and Russell enjoyed his nights out with priests, a habit perhaps dating back to his days at Holy Cross, which was a clearinghouse for that profession. But otherwise, Kay's and Russell's social life, unlike that of either of their families, was hardly fenced in by their Irish Catholicism.

"I've often thought of my family as the only Irish-Catholic family that didn't behave like an Irish-Catholic family, socially," observes Philip O'Hara. "Their social life in Grafton really revolved around non-Catholic people. My mother in particular had cultivated quite a good group of friends who were not Catholic in persuasion. In those days you really were labeled."

"They were part of the cocktail circuit," specifies one friend of the family.

The linchpin in Kay's liberated new life was Russell. Eight years older, and her former teacher, he was always protective, even somewhat paternalistic. Russell paid the bills, hired the housekeeper, pruned the hedges. He was also an important diplomatic liaison with the rest of the O'Hara family, some of whose members, especially his brother Leonard's wife, Kitty, were irritated by Kay. Russell was usually able to smooth matters over so that whatever squalls arose hardly seemed to interfere with an all-American small-town existence that was as regular as the seasons. As Russell once remarked about the first day of spring, "You get the feeling that you ought to fix the driveway."

The spirit of these early days in the O'Hara family, quite removed from the tempests to come later, was captured by their son in a letter written home from Key West where he was temporarily stationed in the Navy. The eighteen-year-old O'Hara gave a child's point of view of his young parents shoving off to one Grafton cocktail party or another: "The other night I was over at the patio and they played 'Night and Day' and 'Smoke Gets In Your Eyes.' It made me think of you both. I can see you now going out to Ten Acres or the Horse Show and I remember one night in particular. It was Mary Charron's birthday party and you had your red dress and page boy, mum. . . . You all had cocktails before leaving—martinis I'm pretty sure. I wonder if you knew, either of you, what an impression you made on me—you made being grown-up so attractive and glamorous . . . so sophisticated and movie-ish to me."

He casts his parents there as forties movie versions of the perfect American family.

When childhood comes up in the poems of Frank O'Hara, it's always the childhood of a poet. These are rarely confessional poems. Rather, O'Hara seems bemused by how it all happened in his own rather ordinary American backyard. Sometimes his treatment of this metamorphosis is comic and parodistic, sometimes melancholy and tragic, but the theme is always that of the misfit.

O'Hara wrote the first of his poems about childhood and the vocation of poetry, "Autobiographia Literaria"—its title a spoof of Coleridge's *Biographia Literaria*—in 1949 or 1950, while still an undergraduate at Harvard:

Autobiographia Literaria

When I was a child
I played by myself in a
corner of the schoolyard
all alone.

I hated dolls and I
hated games, animals were
not friendly and birds
flew away.

If anyone was looking
for me I hid behind a
tree and cried out "I am
an orphan."

And here I am, the
center of all beauty!
writing these poems!
Imagine!

He sings the same song less hyperbolically about four years later in "Poem" (There I could never be a boy), tempered this time with darker hints of a difficult relationship with his mother, and a more tragic sense

of poetry as the gift that pulled him into a freer future and yet painfully prevented him from ever having had the childhood of an average boy:

> *There I could never be a boy,*
> *though I rode like a god when the horse reared.*
> *At a cry from mother I fell to my knees!*
>
> .
>
> *I knew her but I could not be a boy,*
> *for in the billowing air I was fleet and green*
> *riding blackly through the ethereal night*
> *towards men's words which I gracefully understood.*

And yet Francis ("Frannie") O'Hara could be a boy. Snapshots in the O'Hara family album show him looking very boyish indeed: squatting next to a girl cousin with her sand bucket on the beach; flanked by two little blond friends, grinning, a baseball bat wrapped too far around his back; or buttoned into a starched white First Communion shirt.

His bedroom was certainly a typical boy's room. A few steps up from his parents' bedroom in the back of the house on the second floor, his maplewood bed was centered in the room facing east-west, his walls were lined with orderly white bookcases and a desk. Through his three back windows, O'Hara would often look out on Pigeon Hill, an unspoiled hill rising up prepossessingly behind the house, overgrown with thick brush and oak trees, later to be evoked by the poet in "The Spoils of Grafton," written for his thirteen-year-old sister, Maureen:

> *The wind*
> *swoops down the hill without*
> *skis, driving mice into the cellar.*

His bookshelves during his earliest years were stocked with the classics, mostly gifts from relatives: *Uncle Tom's Cabin,* Hans Christian Andersen's *Fairy Tales, David Copperfield, Captains Courageous.* His passion, though, seemed to be dog books. Not only the standard *Dog Owner's Manual,* in the back of which he kept a list of kennels matched to breeds of dogs such as Afghan hounds, Yorkshire terriers, Pekinese, and standard schnauzers, but also a series of dog novels, including *My Friend the Dog* and *Bob, Son of Battle.* He owned Stevenson's *A Child's Garden of Verses,* a gift on his eighth birthday from his parents, but, as he admitted

later to the poet Bill Berkson, he was suspicious during most of his boyhood that there was something "sissy" about poetry.

Nights were the most difficult time for young Francis, an only child for the first seven years of his life until the birth of Philip in 1933. Often, when his parents were downstairs reading the newspaper or talking, he would, as he later wrote in his journal at Harvard, "cover myself with bedclothes, and underneath the white faintly lavendered sheets be protected from whatever horrible thing was in my room, waiting to plunge daggers into me." His worst fear was that of being orphaned, that his parents would slip out to one of their cocktail parties, an accident would occur, and he would be left to grow up alone. To allay this fear, he would insist that they always kiss him in his bed before departing and that they be careful to whisper "Good-night" rather than "Good-bye."

Francis was happiest in the daylight, especially when the sun was shining or, as in his favorite month of October, a strong wind was blowing. He would then whistle for one of his dogs, all of which show up in the catalogue of dogs in "Ode to Michael Goldberg":

> *Up on the mountainous hill*
> *behind the confusing house*
> *where I lived, I went each*
> *day after school and some nights*
> *with my various dogs, the*
> *terrier that bit people, Arno*
> *the shepherd (who used to*
> *be wild but had stopped), the*
> *wire-haired that took fits*
> *and finally the boring gentle*
> *cocker, spotted brown and white,*
> *named Freckles*

Or he might ride one of the horses, such as the "frightened black mare" of "Poem" (There I could never be a boy), which he began to borrow at a young age from the J. Frank Donahue stables, to ride along the local dirt paths. Or go swimming at Kitville, "the coffee lake," where he proved himself the best swimmer in town. Or, on hot summer days, help with the haying at one of the family farms, Tower Hill, the sweat pouring off his chest and back in sheets. An eighty-three-acre working

farm devoted to cattle and vegetable gardening, with its own yellow
barn, main house with seven fireplaces, and artesian well, Tower Hill
was one of Francis's favorite spots in Grafton. He claimed that when he
grew up he wanted to raise dogs and live in the house on Tower Hill,
which was often rented out to tenants during his childhood.

Francis, though, showed most interest in reading—a proclivity that
irked some members of the extended clan. His Uncle Tom Broderick
was a fan of his first nephew: "If you couldn't get along with Francis
you might as well go along and blow your brains out." But Tom dis-
trusted the avidity of Francis's steady reading: "Francis was withdrawn.
Francis was far happier reading a book than you or I would be playing
ball. He wasn't athletically inclined at all, but he loved to read. He just
wasn't paying attention to life as a balanced item." Gramp Broderick,
who had built up his painting business through hard work and deter-
mination, complained that his grandson needed to be "toughened up."

His Aunt Margaret, the librarian, encouraged his reading habit.
And consequently she perceived the most lasting of his character traits
early on. When she presented him with Dickens's *A Christmas Carol* for
his eighth Christmas, she inscribed the copy, "For Francis who charms
me with his thoughtfulness, amazes me with his intelligence, and
amuses me with his flashes of independence or of swift wrath! Love
from Mardie. Christmas 1934." Any of his future artist friends would
have recognized that description. In it are clues that the Frank O'Hara
to be was already ticking away, the poet who later claimed that "There
I could never be a boy," because, as he put it in the tones of lushest
romanticism,

> *it was given to me*
> *as the soul is given the hands*
> *to hold the ribbons of life.*

The house at 16 North Street was conducive, or at least not hostile,
to the growing pains of this boy who was intensely interested in things
cultural from an early age. A reproduction of a Tchelitcheff painting of
Stravinsky's Firebird hung in the living room. His parents regularly
bought *The New Yorker*, which he liked to read aloud on the train to
Boston. The family record collection included hundreds of classical al-
bums, as well as a selection of Bing Crosby and Gene Vincent.

Francis's developing artistic temperament, as well as a certain world-
liness, was definitely helped along by his father. Most Irish families in

those days owned a piano. The Broderick household boasted both a piano and a violin. But Russell O'Hara's playing of the tall wooden upright in the music room had advanced beyond the churning out of favorite sentimental tunes. With Francis perched on a chair nearby, he played every night before dinner for fifteen or twenty minutes—compositions by Gershwin, Tchaikovsky, Beethoven, and Rachmaninoff. Rachmaninoff was Russell's favorite composer, and the First Piano Concerto his favorite piece. Francis, influenced by his father, tried to get his parents to hang a portrait of the Russian composer in the den. He would later write seven poems, all in different years, all titled "On Rachmaninoff's Birthday," causing confusion among those who couldn't figure out how his love for this romantic composer fit in with O'Hara's more avant-garde interests such as Schoenberg or Cage. It's significant, too, given his father's emotional involvement with music, that O'Hara—even as late as his years at Harvard—was seriously preparing to be a concert pianist and composer.

"Russell could play 'Ave Maria' or any of those hymns and it would make you cry," testifies Tom Broderick. "You could always tell by the way he played how he felt."

Russell was also Francis's entree into the world of politics. It was his job to take his son to the barbershop, which doubled, as in so many small New England communities, as a town forum: "My earliest political memory is of being dragged by my father into a barbershop in a small New England inn for a haircut. . . . I was seven. . . . How happy I was then! politically speaking. Most of the adults I overheard in this mainly agricultural town were optimistic about Roosevelt. I was crazy about his campaign song. . . . There were a lot of Republican families around, of course, and not only had I been vindicated by history in my thought that there was something a little too piggish about Landon's face, but I had also won a lot of bets off friends who had written Anti-Roosevelt slogans on our windows that Hallowe'en." While O'Hara later wrote of politics that "the only truth is face to face," he seemed to have gained a keen sense in Grafton that politics is also a way in which social schisms are played out, where richer Protestants tended to be Republican, and Irish Catholics Democratic. Francis would often have "heated 'discussions'" on these matters with his father, who kept up on world affairs by sitting around in his striped robe reading the newspaper. As the thirties wore on, Francis became more sympathetic with the Communist movement and economic cooperatives, whereas his father's liberalism stopped at Roosevelt's White House. Their political debate

extended into music when Francis began to champion the Soviet composer Shostakovitch, against his father's wishes.

"I think my father brought a seriousness to Frank's focus that others didn't," deems Philip O'Hara. "He was very well read. He was knowledgeable about what was going on in national and international affairs. I remember he and Frank often having conversations about serious subjects."

Some of their talks were about more face-to-face concerns. Russell used to complain to Kay that she was spoiling Francis, and told his son that he let his emotions rule his mind. In a letter home from San Francisco, where he was briefly stationed in the Navy, Francis, responding to these private talks, conceded to his father: "Our differences lie in the present conflict of my intellect and emotions which, as you point out, will be cured by age and experience. . . . You are so right about my sentimentality. . . . In so many cases I let my emotions dwell on particular cases rather than my mind on the whole problem."

This was not to be the last mention of this matter. Russell's charge of "sentimentality" against his son was a constant source of conflict. By the time he was at Harvard, O'Hara would already be writing in his journal, "if it is true that Kassner's remark about Rilke that 'the conflict between judgment and feeling which is so masculine, so peculiar to men, did not exist for him,' applies to me also?"

Russell O'Hara did have a temper. It wasn't displayed often, but he was quite capable of taking a belt to his sons every now and then when they were still young. One such blow-up seems to have occurred in the backyard while he and Francis were gardening. The combat zone: the father's rose beds. In "Macaroni" O'Hara treats the primal conflict humorously:

> the old days when my father knocked me into the rose-bed
> thereby killing a half dozen of his prized rose plants

In "To My Dead Father" he is more plaintive about the thorns:

> I couldn't do what you
> say even if I could hear
> your roses no longer grow
> my heart's black as their

bed their dainty thorns
have become my face's
troublesome stubble

.

forgive the roses and me.

Russell believed in setting limits on his son, his favorite warning
being "Don't get in trouble now." He was absorbed most of the day in
the business of running a farm, a business that Francis found boring,
unlike his brother, Phil, who thrived on roping calves, milking cows,
and trying on his father's hip boots. In his poems O'Hara later tended
to flatten his father into a simple authority figure, a more two-dimen-
sional conformist than he actually was, perhaps as a way to leave his
childhood behind as simply as possible. Choosing largely to stay away
from the J. Frank Donahue farms and offices during the day, Francis
spent much more time at home with his mother. There is every sign
that he adored Kay in these formative years and that she was quite
pleased in return to find someone who understood and appreciated her.
Writing home during his Navy stint, he once expressed amazement that
she coincidentally had been playing recordings of the same two pieces
of music he had been humming all during his stay in Key West—
Brahms's Violin Concerto and Debussy's "La Mer." But he added,
"Then again, it isn't *so* odd because we know each other so well and
have so many tastes in common."

Francis appreciated the fastidiousness with which his mother pre-
pared family meals, "as if each piece of chicken in the a la king was
planned for the place it falls . . . neat, clean and, in a way, even scien-
tific." He was a fan of all her homemade dresses and wrote somewhat
seductively from the Navy of wanting to order her a dress he'd seen
advertised in *The New Yorker*: "It's a Bergdorf-Goodman—high neck,
no collar, puffed sleeves about one inch high but actually no sleeve at
all, slight bustle in back falling down to the hem line as a fold—in black
rayon satin-striped taffeta. Sound good? $70." He bought her delicate
presents with his allowance money: cloisonné cuff links, a brooch, a
little evening purse.

"He was in love with his mother, he was crazy about her," claims
painter Grace Hartigan. "When he was twelve he said he had saved all
his allowance to get his mother a pin for her birthday. As he walked in
the room she was with one of her women friends and wearing the pin.
The woman asked her, 'Where did you get that pin?' and she said, 'Oh

my son gave it to me.' Then they gave each other funny looks, and Frank knew the pin was tacky, that it was a terrible pin. It was agony that he picked up on that."

Kay took great interest in her son's appearance, always insisting that he be dressed stylishly. "She was a very hands-on mother," recalls Philip O'Hara. "I remember she was much fussier in making him get dressed the right way than she was with me. Everything had to be proper." When Francis was very small she used to dress him in the brown velvet suit that showed up later in "Ode to Michael Goldberg ('s Birth and Other Births)":

> being put into a brown velvet suit and kicked around
> perhaps that was my last real cry for myself

She remained enough involved in his wardrobe that he bothered to write her from the Navy about the pangs of missing his favorite red wool shirt, herringbone jacket, and camel-hair overcoat.

Her concern with Francis's clothes, from the viewpoint of one neighbor in Grafton, was oddly excessive. "Francis was definitely an oldest child," she recalled. "His mother would dress him like a sissy. If it were today and everybody wore blue jeans, Francis would be in trousers. And she would always be telling him, 'Your hands are soiled. I think you should go wash them.' Anyone else would have said, 'Your hands are filthy dirty. Go wash them.' But she was very much the lady."

It was partly through his obsession with his clothing that Francis revealed himself as his mother's boy, and any attacks on his wardrobe caused a reprisal charged with feeling. One autumn afternoon Jimmy and Chili Whitney, two middle-aged brothers employed by Russell O'Hara, were unloading a winter's supply of coal down the chute at their boss's home. Francis suddenly emerged dressed in a startlingly white suit. The two workers decided to play a practical joke, or enact a harmless bit of class warfare, by convincing the O'Haras' son to slide down the chute into the basement coal bin. Francis did as they suggested. When he returned upstairs in his blackened suit, his mother, furious at their prank, demanded that they be fired.

Kay's specialty was domestic arts—clothesmaking, cooking—but she also grew to share in her husband's and son's musical enthusiasms. She often took Francis to concerts at Mechanics Hall in Worcester, as well as by train to Boston for plays and art shows. She and Russell escorted Francis to his first concert: Koussevitzky conducting the Boston Symphony Orchestra in Tchaikovsky's Fifth Symphony and Pro-

kofiev's "Lieutenant Kije Suite." When Francis saw a black person for the first time on one of their excursions, his mother instructed him that he was not to be called "nigger" but "colored person," a memorable life lesson for the later poet of "Ode: Salute to the French Negro Poets."

In spite of this energy, Katherine was physically and emotionally frail. Francis was well aware of her weaknesses. He once had to save her life when the family was passing one of their traditional summer vacations at Dennisport on Cape Cod, by pulling her out of the water when she appeared to be going down in the gray waves of the Atlantic. "She was a goner," remembers Phil. "But he knew that she was out too far and he was there like that. He was a fabulous swimmer. He was good and he was fast." Her emotional crises were more difficult to ease. They are hinted at in "Poem" (There I could never be a boy):

> All things are tragic
> when a mother watches!
> and she wishes upon herself
> the random fears of a scarlet soul, as it breathes in and out
> and nothing chokes, or breaks from triumph to triumph!

As the years passed, these self-dramatizing tendencies would become increasingly suffocating for O'Hara, as they became increasingly random and uncontrollable in the mother. But during O'Hara's childhood, his mother's problems were still seemingly those of overexertion, which he dealt with by always encouraging her to go for checkups and to try vitamins, iron, and tonics, especially after the premature birth of his sister, Maureen, in 1937.

Francis also received an informal education from his various aunts. From the time he could speak, he was a bit of a settee star among the ladies of the O'Hara and Broderick families. His grandmother Mary E. Donahue, ensconced in the front of the long factory of the Donahue building until her death in 1941, doted on her grandson, who could read a book in a day and talk about it so cleverly on the phone the same evening. As Francis showed more cleverness, these older women, and widows, and spinsters, plied him with more books and more talk. None of the other children saw much of Francis because he spent most of his time reading and practicing piano or chatting with his aunts on the other side of the lace curtains.

"Francis just didn't come down to the barn to play," remembers his

cousin Mary O'Hara. "The rest of us were over there all the time. Certainly Phil was."

"I had no truck for those people," says Philip O'Hara, making his tastes quite clear. "I liked the animals and the farms. Not those old ladies sitting in rockers."

Probably the most influential of the older ladies in Francis's life was his Aunt Margaret ("Mardie"), his mother's sister. As soon as Francis was able to read she made it her business to supply him with any books he wanted, or that she felt he should read. Her presents to him were exclusively books: Samuel McCord Cruthers's *The Children of Dickens* (inscribed "8 years old today, may you learn to know and love these children as Mardie does, Francis, and they will always keep you company. Happy birthday, dear, June 1934"); Charles Dickens's *David Copperfield* (inscribed "For my valentine, Francis O'Hara, from Mardie"); Kipling's *Captains Courageous*; Hilda van Stocken's *The Cottage at Bantry Bay* (inscribed "To Francis on his birthday to remind you, dear, of Mardie's summer in Ireland, June 27, 1938"); Washington Irving's *Rip Van Winkle*; *The Animal Book: American Mammals North of Mexico*; *A Treasury of Russian Literature*; Jawaharlal Nehru's *Autobiography*. She also used him as a reader for the Worcester Public Library, allowing him to advise her on which new novels to purchase.

"Margaret and Francis had a language all their own," says Tom Broderick. "They had an affinity for one another. They were both going in the same direction. I would say that Francis without any problems at all had as high an IQ as anyone I ever met. And it wasn't just something on paper, he had it upstairs. And Margaret was the same way."

O'Hara's personal favorite was probably his Great-Aunt Elizabeth Donahue Reid, older sister to J. Frank Donahue, wife of realtor Jack Reid, affectionately known as Lizzie. Although she burned all her letters from relatives in Ireland before her death in 1944 because she was embarrassed by her modest beginnings, Lizzie was a positive, upbeat lady. For his entire life Francis kept an emotional candle burning for her. Writing home from the Navy he vividly remembered spotting a crab with Lizzie one summer in Provincetown: "To this day nothing has ever seemed more green than that green crab in the green water." He channeled his grief over her death into a somewhat dissonant elegy in 4/4 time, composed while stationed as a shore patrolman in San Francisco, titled "Elegy for My Great-Aunt Elizabeth." He mentioned her in his poem "In Memory of My Feelings," written over four days during the summer of 1956:

My
grand-aunt dying for me, like a talisman, in the war,
before I had even gone to Borneo
her blood vessels rushed to the surface
and burst like rockets over the wrinkled
invasion of the Australians, her eyes aslant
like the invaded, but blue like mine.

In his Broadway loft, where he lived in the 1960s, he kept a tiny picture of her in an old-fashioned frame near his typewriter. Hers was the first of many deaths he would mourn intensely throughout his life.

Aunt Lizzie had been the one to introduce him to the world of the movies. She often took him to Loew's or Warner's, the large movie palaces in Worcester, with their red velvet seats, organ-pipe pillars, and filigreed arches. To his great delight and titillation, she even allowed him to see movies that had been banned by the Catholic Legion of Decency: Greta Garbo movies, Marlene Dietrich movies, B movies.

I went to my first movie
and the hero got his legs
cut off by a steam engine
in a freightyard, in my second

Karen Morley got shot
in the back by an arrow
I think she was an heiress
it came through her bathroom door

The silver screen was a revelation to this young boy who was so prone to romanticizing reality. Hollywood's vamping and stalking silhouettes were a welcome alternative to the mores and morals of Grafton. In an unpublished novel he was writing in 1950 titled *The 4th of July*, his rendition of a young boy, Billy, taking in an afternoon movie gives a sense of O'Hara's juvenile thrill at those first outings: "He loved movies. The screen was really silver to him, and he was fond of going to the first show in the afternoon. That way you could sit and eat popcorn for awhile before the lights darkened. Then he would always stop munching and get excited. The light that was gradually seeping out of the bulbs and fixtures around the theatre gradually flooded the screen like moon-

light, behind the heavy gauze curtains. . . . His spine would stiffen and
Billy would lean forward against the back of the seat in front of him,
even if he knew what the picture was going to be about, even if he'd
seen it already."

At the age of twelve, Francis was still diffident about poetry. When
he sent his brother a copy of William Blake's poems for his twelfth
birthday, he wrote to his parents, "I hope he'll like the poetry—al-
though I never did at his age." Much of the excitement, contemporary
color, and emotional beauty that he later came to put in his own poetry,
he first found as a child at the movies. This theme of childhood awak-
ening at the cinema appears several times in his later poems. In "Ave
Maria":

> *Mothers of America*
> > *let your kids go to the movies!*
> *get them out of the house so they won't know what you're up to*
> *it's true that fresh air is good for the body*
> > > *but what about the soul*
> *that grows in darkness, embossed by silvery images*

And in "To the Film Industry in Crisis":

> *In times of crisis, we must all decide again and again whom we love.*
> *And give credit where it's due: not to my starched nurse, who taught me*
> *how to be bad and not bad rather than good (and has lately availed*
> *herself of this information), not to the Catholic Church*
> *which is at best an oversolemn introduction to cosmic entertainment,*
> *not to the American Legion, which hates everybody, but to you,*
> *glorious Silver Screen, tragic Technicolor, amorous Cinemascope,*
> *stretching Vistavision and startling Stereophonic Sound, with all*
> *your heavenly dimensions and reverberations and iconoclasms!*

Most of the actors and actresses O'Hara included in his personal
pantheon in "To the Film Industry in Crisis" were at the height of their
careers during those dark afternoons in the thirties when Aunt Lizzie
would treat her enthusiastic nephew to the 35-cent admission to the
movies. "Jeanette MacDonald of the flaming hair and lips and long,
long neck" was starring with Nelson Eddy in *Naughty Marietta* and with
Clark Gable in *San Francisco*. "Ginger Rogers with her pageboy bob like

a sausage / on her shuffling shoulders" danced with "peach-melba-voiced Fred Astaire of the feet" in *Flying Down to Rio, The Gay Divorcee, Top Hat,* and *Swing Time.* Mae West with "her bordello radiance and bland remarks" drew the second highest salary in America (after William Randolph Hearst) when she made *Goin' to Town* in 1935. The "gentle Norma Shearer" played in *Marie Antoinette* and *The Women. Libeled Lady* featured Myrna Loy, "being calm and wise," opposite William Powell, "in his stunning urbanity." Johnny Weissmuller was the Tarzan of *Tarzan the Ape Man*: "I cannot bring myself to prefer / Johnny Weissmuller to Lex Barker, I cannot!" Jean Harlow was "reclining and wiggling" in *Public Enemy, Platinum Blonde,* and *Dinner at Eight,* while Alice Faye was "reclining / and wiggling and singing" in *Poor Little Rich Girl.*

O'Hara never shrugged off his early infatuation with the movies. It contributed to a pop component of his sensibility and gave him another standard by which to judge the poetry of his time. As he wrote in "Personism," a mock poetry manifesto published in *Evergreen Review* in 1959, "And after all, only Whitman and Crane and Williams, of the American poets, are better than the movies."

The third of his aunts to take Francis under her wing was Aunt Grace, his father's unmarried older sister, who lived with her mother in the front quarters of the Donahue house and taught school her entire life at Rice Square Grammar School in Worcester. Grace kept a piano in her apartment and was a faithful reader of *The Catholic Mirror.* A very withdrawn woman, she rarely smiled and tended to put off some of the younger members of the family. "Lizzie had three times as much positive power in her life as Grace had negative," says Philip O'Hara. And yet Francis and his well-read spinster aunt got along famously. They tended to do most of their chatting in the mornings, when she would drive him into Worcester on her way to work and drop him off at parochial school, which he attended rather reluctantly for the entire twelve years of his education. Those lifts in Grace's car saved Francis the trouble of catching the bus from Grafton Square every morning at around seven for the long forty-five-minute ride into Worcester, though he would often take the bus back late in the afternoon.

A series of "Autobiographical Fragments" written in the early 1960s reveals O'Hara's anger at those years of parochial school. It was anger not only at the rigors of the strictly regimented schools but also at the Catholic Church that devised them: "I was sent against my will to Catholic schools, but fortunately I also began at the age of seven to study music. . . . I had rather summarily deduced that my whole family

were liars and, since our 'community' consisted of a by and large very mixed national descendency it couldn't be they were Irish liars, they must be Catholic liars. Had I been a French child I probably would have simply become an anti-cleric; as it was, I blamed almost everything onto the Catholic Church, which they all talked about in the most revoltingly smarmy way (a priest once later said, trying to win me over, that I had been overparochialized!). I left the Truth to Music." Such clear opinions, though, came later. As a seven-year-old, O'Hara was still reacting to the rituals, sayings, and classroom scenarios that later made him a renegade Irish Catholic and led him to write such lines as those in "Now That I Am in Madrid and Can Think": "it's well known that God and I don't get along together."

Francis's grade school, St. Paul's, on Chatham Street across from St. Paul's Cathedral, which he attended from 1932 to 1940, was a large brick building with sturdy enough walls to have been designated a Worcester bomb shelter during World War II. Originally an eight-room school, with eight grades, one in each room, during the Depression years when O'Hara attended, the school had many lower-middle-class and middle-class boys and girls, as well as orphans looked after by its teaching order, the Sisters of Mercy. The school was a study in the parochial style, with nuns in black habits clicking across terrazzo marble hallways on their way to large wooden classrooms whose vanishing points were crucifixes hung straight and center. Each morning began with the Sign of the Cross, followed by a recital of prayers, the Pledge of Allegiance, and the singing of a hymn. Religion was always taught during the first half-hour, and visiting priests were often brought in to explain points of the catechism or to lead a session of bible study.

Francis grew irritated with the disciplinarian fervor of some of the sisters, whose order was famous for strictness. He was particularly angry one afternoon when his Aunt Lizzie and Cousin Mary were left sitting out in the parking lot waiting to take him to the movies while his entire class was forced to stay an extra hour as punishment for an infraction by one student. He often squirmed in the mornings over the rote prayers the children were forced to pray, and later on thought back on those supplications with little pleasure: "My next political memory was that of revulsion at having been made to pray for Franco's success during the Spanish Civil War when I was in grade school and didn't know which side was which. By the time I read *For Whom the Bell Tolls* (which introduced me to the most attractive aspect of John Donne) this made me furious, and still irritates me in a metaphysical way."

O'Hara's consolation was the piano. On the first floor of the St.

Joseph's Home for Working Girls, the sisters ran a rather elegant music school called St. Gabriel's Music Studio. The teaching of piano was actually done by three biological sisters from the Galvan family—Sister Mary Barbara, Sister Mary Cecelia, and Sister Mary Virginia—all of whom had joined the Sisters of Mercy and were considered quite talented musicians. Francis used to take a half-hour lesson once a week, either at noon or after school, when he learned to play elementary classical pieces from a standard colored music book sold in a nearby music store. Playing his basic Mozart scales was an exhilarating escape for Francis. "A lot of my aversions to Catholicism dumped themselves into my musical enthusiasms," he later explained. When his playing became more sophisticated he began taking lessons with J. Fred Donnelly, an organist at St. John's Church, whose wife helped Francis learn a concerto for a recital. The Donnellys appear, appropriately enough, in one of O'Hara's Rachmaninoff birthday poems:

> *where is J.F. Donnelly and his Russian wolfhounds?*
> *where is his wife, Helen? where is the cigar-smell*
> *and the hootings in the studio while I practice?*

Francis switched piano teachers at about the same time he entered St. John's High School, an all-boys' school run by the Xaverian Brothers on Temple Street in Worcester. The school, housed in a typical turn-of-the-century rectangular brick building, with long and dismal hallways, was next to an asphalt playground. As the Worcester train station was located nearby, the brothers' lectures would be constantly interrupted by the whistles of passing trains, after which grit settled on the students' pages as they wrote, and the air was filled with the nostril-tingling scent of coal dust.

Academic standards were rigorously upheld by the brothers, an off-shoot of the Jesuit order, who always wore white collars and black cossacks except when, as in some Hollywood movie, coaching in the playground they would hike their skirts up and tie them at the waist. As at St. Paul's, there were weekly vocational talks in which priests or brothers would try to persuade the young students to enlist in orders for the good of Mother Church. The first Friday of every month was devoted to Mass and Communion at St. John's Church across the street, where one could always hear "the orderly scuffing of feet after the 'Domine, non sum dignus.'" The essence of St. John's, from the viewpoint of the brothers, was spelled out in a school magazine, *Golden Con-*

quest: "These students have not climbed a ladder whose rungs are merely Latin, English, Algebra, and the like; but there has been a guiding light at the top of this ladder to show them the way to true success—that light being Religion, the true knowledge and worship of God, the primary purpose of Catholic education."

The rungs on that ladder, light at the top notwithstanding, were quite sturdy, as St. John's maintained a rather demanding classical college preparatory curriculum. Francis O'Hara, nicknamed "Frannie" along with at least a half-dozen other Francises in his class, carried a steady load: four years of Religion, four years of English, three years of Latin, one year of Greek, two years of French, two years of Algebra, two years of History, one year of Physics, and one year of Biology. His grades tended to be highest in Religion and English, lowest in Math and Science. Graduating seventh in a class of fifty-two students, he evidently became distracted by other interests such as piano and editing the school newspaper during senior year, when his grades, formerly in the 80s and 90s, dipped listlessly into the 70s. His French 2 grade that year was 79.

Francis was a noticeable presence in the classroom, with his prominent brow, strikingly aquiline look, light blue eyes, and nose already broken in some childhood scuffle by, as he later remembered him, "the bully who broke my nose / and so I had to break his wristwatch." He tended to sit off to one side of the classroom by the windows where he would joke with one or two friends. His barbed comments were entertaining, as was the spunky style with which he ran the school newspaper, *The Red and the White*. The 1944 yearbook captioned his personality as "snappy," his ambition as "to live in a big city," and his favorite expression as "Bull!"

O'Hara could be quite "spikey" when he wanted. But he was also a bit of a loner who kept his own counsel or who could be thinking circles around a companion without ever letting on. His intelligence was subtle, revealed in lucid or simply "smart-ass" remarks in class, but never used in a public debating team manner to slam an opponent analytically against a wall of Reason. "Frannie was an intellectual kid with a clipped, articulate way of talking," remembers classmate Richard Dorr. "He always seemed to have something going on in his head he wasn't telling you about. I had this feeling, even back then, that he had had a very vivid kind of created companionship. Not extraterrestrial beings. But that he had once peopled a world around him with his own kind of creatures, or friends."

"Frannie wasn't gregarious, exactly," says Bill Cronin, nicknamed

Porky by O'Hara when he served under him as sports editor of the school newspaper. "But he had an infectious smile. He wasn't that interested in athletics, but if we were having a discussion about something, he would be likely to dominate, well dominate might not be the right word, but he could easily be the center of it, and lead it. Otherwise the two things that stood out about Frannie were his love of classical music and his love for his mother."

Francis's favorite teacher was Brother Elias, a rather unorthodox choice actually as many of the students found him the most unnerving of all the teaching brothers. Elias, who taught O'Hara English for four years, as well as a year each of Latin and Algebra, was pudgy, wore glasses, had a mealy-mouthed way of speaking, and had a perpetual pout. When he became upset with one of the boys he would turn an apoplectic red. He was known to fling chalk or, corporal punishment being an acceptable discipline among the Xaverian Brothers, to drag the offending boy into the locker room. These incidents, though, would always be followed by the most abject displays of friendliness on Brother Elias's part.

Francis never tangled with the extremes of Elias's temper. Rather, he picked up on Elias's eccentricities and lightly teased him for them. Describing Elias as "well-read, good-humored, very dry & witty," O'Hara enjoyed relating stories at his expense, as in one wartime letter home from San Francisco: "My favorite memory of him [Elias] concerns a rather prurient conversation we were having on the sexual exploits of Sheba, the Negress in 'The Sun Was My Undoing,' which he happened upon one day. To cover confusion, and out of curiosity to know what his reaction to both the conversation and Sheba would be, I asked him what he thought of her. He reflected a moment and then replied blandly, 'She was pretty black, wasn't she?'"

While Brother Elias was obviously Francis's choice for discussing books, perhaps his only one in the entire school, those conversations must have been somewhat limited given the sorts of works Elias assigned in his classes. He taught literature from a thick volume blandly titled *Prose and Poetry* and filled with such classic English and American works as Coleridge's "Rime of the Ancient Mariner" and the short stories of Nathaniel Hawthorne. Sophomore year they read *Silas Marner,* and contemporary novelists with a theological edge such as G. K. Chesterton and C. S. Lewis were favored.

O'Hara found it difficult to escape from the long shadow cast by Catholicism in his early life. After an entire week of readings and studies intellectually tinged with Catholic theology, Sundays were the day

his family devoted to the Church. Their own Sunday routine was every bit as ritualized as that of St. John's, evident in O'Hara's description of them in a 1944 letter from Norfolk, Virginia: "Now (10:26) you are either getting out of church at St. Philip's or just taking the car out of garage for the 11:00 Mass. If the latter, Dad, you are tooting the horn, Maureen is in the back seat, Phil is waiting for you, Mother, to close the garage door, trying to lock it, hurry to the car, get your gloves on, hold your purse, and straighten your hat—all at the same time!" As Francis attended parochial school, unlike his brother and sister who somehow escaped—possibly due to his own plea-bargaining—he didn't need to attend catechism classes with the rest of the children. But the family routine of Sunday School annoyed him anyway. The only thought that could help Francis unravel himself from his Sunday morning bed-sheets early enough was knowing that one of his favorite pianists, Egon Petri, broadcast a half-hour radio program that he could catch only if he went to early Mass. "The first time I saw Francis was at St. Philip's," recalls Phil Charron. "I noticed how fastidiously dressed he was. He was really dressed to the nines. But actually the whole O'Hara family was immaculately dressed."

Then the rest of the day was more pleasant. The family sat around and read the Sunday papers, Francis always turning first to "Blondie," the comic strip that had become such a staple in middle-class American family life since its first appearance in 1930. One such Sunday afternoon a lunch of fried boneless chicken was served followed by a blackberry liqueur sipped while listening to Witold Malcuzynski playing one of Chopin's two piano concerti.

During his teens, Sundays were the one day Francis could stay home with Phil and Maureen, playing the big brother, a role he found quite natural and pleasant. When Phil was a baby he used to feed him his bottle and, later, chase him down when he tried to escape at bedtime. When Phil entered the sixth grade, O'Hara tried to interest him in playing the piano and attending dance classes. Phil was much more interested in tasting fresh calves' blood at a slaughterhouse, but he did apply himself briefly to the piano, mostly for his brother's sake. Francis would ply him with books of Handel and Bach and be convincingly seductive in his encouragements, as when he wrote from the Navy that Phil would be a natural at playing Beethoven, "with all the fire, humaneness, simplicity, and honesty that is the main charm of them both." Francis also took it upon himself to inform Phil about the birds and bees, a job traditionally taken on by a father.

"One of the fondest memories I have of him is when he got an

album, and I can see the album right now," recalls Philip O'Hara. "It was 'Songs of the Red Army,' with a maroon cover. Sitting in the front living room listening to the Russian music, the marches and the voices, was terrific. There was something very mysterious about that."

Phil never became the musical aficionado that his brother seemed to be hoping he would, but he did appreciate his brother's push to share his enthusiasms and had, from an early age, a sense of its uniqueness. "I think Frank was an esoteric, sophisticated, erudite person from the time he left grammar school," says his brother. "I knew that he had a lot of genius in him. From the time I was able to discern the differences in people I knew that Frank was a very special kind of person. But he was always trying to interest me in a more classical orientation than I was really interested in. We simply lived in two very different worlds."

O'Hara's sister, who was eleven years younger, was much more susceptible to her brother's charms and guiding protectiveness. She remained quite affectionately his "little sister" for the rest of his life. He took her to the movies, or swimming at Kitville, brushed her hair, gave her charm bracelets and nighties and bubble bath, fought with his parents to let her go roller-skating one Easter when she wished, lavished her with books on artists such as Chagall and Seurat, instigated painting lessons with girlfriends of his in town, suggested that she do sketches after Picasso, requested Yehudi Menuhin's autograph after a concert to send to her, wrote a play for all the students in her fifth-grade class. "Whenever he had friends over, and had parties, he would always wake me up and bring me downstairs and make a big fuss," Maureen recalls.

Writing home from the Navy he took a keen interest in her clothes: "Sweaters and skirts are best for girls—I know that's the kind of girl that's most attractive to a fellow and looks the nicest." And planning for her future became one of his steady exercises, as when he chose her college though she was still only seven years old: "I have decided that Smith is the college for Maureen, unless it changes for the worse in the interval between now and attendance. Period. But where is she to go to high school?"

O'Hara's tone with both Philip and Maureen was always quite parental, and much more responsible than that of the usual teenage son. It was as if between his father's generally vague response and his mother's nervous overprotectiveness, he sensed there might be a need in his siblings for another voice of authority. So during the time he was in the Navy, he sometimes stepped in with advice for Phil and Maureen, a continuation of talks he had with them at home: "And always remem-

ber (I'm nobody to say this but anyway—) that you are alone always as far as what you yourself are going to be. You can be clean or dirty inside, and mum & dad will never know it; but you'll know it and be disgusted with yourself. It's perfectly normal to swear once in a while or to laugh at a story you wouldn't tell mother; but don't get to thinking that way."

O'Hara's circle of friends his own age was rather small until he was about sixteen years old. During the school year he usually spent most of his time in Worcester, or practicing piano. During the summer months, his playmates were two blond boys, the children of a Marine officer, who visited their grandmother next door to the O'Haras. Like Francis, the DeWitt boys, Birchard and Randy, were removed from the clique of boys who attended school together all year in Grafton. They used to swim a few days a week at Kitville with its tower, raft, and "bath house / sweet as a wash basin," as O'Hara later described it in a poem named after the spot. "Fran loved to swim and could never get enough of it," remembers Birchard DeWitt. Or they took showers in summer rainstorms or toasted marshmallows in a fireplace under the old covered-over well by the trunk of a dead tree on Chestnut Hill.

But mostly Francis entertained by playing the piano or by checking out books from the Grafton library—two activities the DeWitt brothers went along with because of Francis's persuasiveness rather than because of any inner promptings. In those days Francis was very fond of popular songs, especially Frank Sinatra's newly recorded "All of Me" and Harry James's "I've Heard That Song Before." He also liked to sit and play Gershwin's Preludes and then ask for opinions on the pieces played. As Birchard DeWitt now admits, "I knew and know nothing about music and was really bored but I pretended I liked it."

To read, the boys sat on one of their front porches, the DeWitts reading adventure stories and Francis reading *Ulysses,* since Joyce was a great favorite all during high school. "The main reason Randy and I were spending part of our summers reading was simply because Fran did it and enjoyed it," says DeWitt. "We didn't read much at home [in Alexandria, Virginia] but spent most of our time playing sandlot baseball and football and outdoor games like kick-the-can. Fran on the other hand was not interested in sports. Other kids in Grafton were but we were not involved." Somehow Francis's "enthusiastic" and "exuberant" approach to his own pastimes was infectious enough to enlist the DeWitts.

Another of O'Hara's summertime friends was Phil Charron. During summers in the early 1940s the O'Haras and the Charrons would

often rent houses near each other on Cape Cod near Dennis, Craigsville, or Yarmouth. They would drive fifteen miles to shop in Hyannis. One summer the two families rented places near Wareham on the mainland by Buzzard's Bay. "Fran's mother really enjoyed drinking," recalls Charron of the dynamics between the two couples. "And my father enjoyed drinking. Fran's father and my mother drank less." Kay was more of an intent listener than Russell, who tended to talk a lot. But she was capable of some sharp comments, too. Almost ten years younger than either her husband or the Charrons, Kay used to complain, "We've got to start doing things. Ten years from now you people are going to be in your fifties and I'll still be in my forties. We have to get going."

"Kay could be very outspoken," says Charron. "Once my father bought an Indian rug. Kay was walking over it on her way upstairs and she said, 'How much did you pay for that rug?' My father told her eighty bucks. 'Well, you got gypped,' she said. My father found Kay charming. My mother found her interesting. She used to quote Kay and say, 'Well, if it's good enough for Kay O'Hara it's good enough for us.'"

Although their relationship was never overly warm, the families' two boys shared an interest in music and books. They used to sing together the songs from the latest hit musical, *Oklahoma!*. O'Hara persuaded Charron to read the novels of James Hilton and Somerset Maugham. When O'Hara was sixteen, Charron recalls his stating to him after a vigorous two-mile swim in Wareham Bay that "Everybody's a genius in some way." Charron, angry at his father at the time for throwing so many drinking parties, shot back, "Oh yeah? How's my father a genius?" O'Hara replied evenly, "Your father's a genius at giving parties and making people feel at home." On another such reflective occasion, Charron expressed his adolescent fears of dying but O'Hara quickly brushed them off. "I'll die and they'll stick me in St. Philip's Cemetery and that'll be the end of that," he said stoically.

"He liked to please the hearer," says Charron. "I felt that sometimes he would say things just because he knew I would become excited or interested. Once he played me a recording of Chopin's 'Polonaise Militaire.' Then he told me that he had heard a symphony recording of the piece transcribed for orchestra. He said, 'In the middle there's a part with big trumpets.' He knew that I would be thrilled by that. But I sought for that orchestral version of 'Polonaise Militaire,' and I never found it."

During O'Hara's last year or so at Grafton, and then during summers home while attending Harvard, he cultivated a different group of

friends, affectionately dubbed "the Bloomsbury Circle" by at least one of them and "the Left Bank crowd" by another, that was much more attuned to his interests. He struck up an artistic friendship with Burton Robie, a boy from South Grafton, who was adept at the mandolin, and was able to team up with him on four-handed Beethoven symphonies for one piano. The boys exchanged books of poetry: O'Hara gave Robie *The Collected Poems of T. S. Eliot,* and Robie reciprocated with Robert Frost's *Masque of Reason.* Another of O'Hara's friends, Elsa Ekblaw, the daughter of a Clark University professor—dressed all in black, her lips lined with purple lipstick—looked as bohemian as any Greenwich Village poet of the time. She was unusual, attractive, and artistic, and O'Hara kept up their friendship even after she went to Wellesley to study psychology while he was attending nearby Harvard. Sally Warren was perhaps O'Hara's oldest friend, as he had known her since he was a little boy when he used to jump rope with her after supper at her house across the street. While she was peripherally involved in his adolescent circle, her appearances in his later poems are always as a young girl, as in "Poem" (That's not a cross look it's a sign of life), where her last name associates her with the dancer Vincent Warren:

> *I was thinking*
> *of President Warren G. Harding and Horace S.*
> *Warren, father of the little blonde girl*
> *across the street*

and in "Galanta":

> *where are you Sally with your practicality*
> *and bottles of fireflies.*

O'Hara went on horseback riding dates with Jean Kilmer, a sort of "poor little rich girl," daughter of a large landholding family in Grafton, who used to explain to some rather resentful girls in her high-school class that Europe is best seen on a tour the first time so that the second solo trip will be more enjoyable. Also in the group were Andy Dilts, son of a career military officer who lived in Grafton Center; Genevieve Kennedy, an aspiring painter; Caroline Brown, with whom O'Hara went on ice-skating dates; her brother Willard; Burton Robie's brother Curtis; and Joy Anderson, in front of whose house on North Street O'Hara's Uncle Joe had been killed in his crash.

These friends used to gather most often in the O'Haras' front living room where they drank, talked, read poetry, and listened, prior to the dawn of the LP era, to the O'Haras' impressive collection of ten-inch disks. A wind-up Victrola with hood in the music room was a special amusement. During the summers, when the Red Barn Theatre at Westboro opened, O'Hara and his companions—who had cultivated friendships with many of the summer stock actors and actresses—often stayed on after a performance for bull sessions on drama and the arts.

O'Hara was very much the center of this circle of friends. While he dated some of the girls occasionally, most of his energy was directed into larger get-togethers at his house where he led discussions, poured drinks, and changed the records, but where he remained curiously ineluctable, this time by the very fact of his chosen position as general animator.

"Frank never had a best friend in Grafton," corroborates Burton Robie. "He was gregarious, frank, and a person of tremendous energy. Definitely the life of the party."

The adolescent O'Hara needed a room of his own. The one he found was in the attic, up a flight of stairs from the landing near his bedroom on the second floor. That he had commandeered his own studio reveals a lot about his favored position as a first-born son, but his decorating of it is also revealing of his life plan. For O'Hara's attic room, with very few available props, was as close to a bohemian loft as he could devise in the middle of Grafton.

Under the eaves, this hideaway's slanted ceilings and louvered windows gave it the expressionistic off-kilter look of *The Cabinet of Dr. Caligari*. Across the walls, which Francis had painted beige and pink and then trimmed in black, he made free and simple black-brush drawings of nude women, one draped voluptuously over a line drawing of a bed, which he captioned in his sweeping script with one-word exclamations: "Oblivion!" "Ecstasy!" "Rapture!" "Rupture!" He painted a closet door and wrote in black next to the door: "Mme. Récamier's laundry" and "Monte Carlo." He tacked up huge colored maps of the world, later alluded to in the poem "The Poet in the Attic": "He slides warmly o'er the world / on nationally geographic carpets." And he papered the walls with box-office posters of movie stars.

"He had pictures of all the stars on the walls," remembers Philip O'Hara. "He was a very, very rabid fan of Marlene Dietrich. He had

posters of Rita Hayworth and all those exotic gals of the thirties, and some of the men."

By 1944, when O'Hara left behind this attic room to enlist in the Navy, he had fittingly become something of an expert on the latest developments in twentieth-century avant-garde music, art, and literature. This precocious boy may have been helped along by his Aunt Margaret or Brother Elias or his parents, but mostly he had educated himself on his own by reading books, poring over sheet music, and studying reproductions of modern paintings. His drive for knowing about all the arts was as tireless as it was unfocused, and he showed a genius, early on, for being in the know.

"Fran idealized the flaming Toscanini," recalls Phil Charron. "He also had me listening to Marguerite's song from Gounod's *Faust* in 78s. I think maybe his Aunt Margaret had introduced him to opera. He also liked Tchaikovsky's Sixth Symphony, the *Pathétique*. I remember him explaining to me that it wasn't like a normal symphony but that it ended rather in a big sob."

By listening assiduously to the phonograph in his attic room he had already decided quite firmly by the age of eighteen on his favorite performers: Horowitz, piano; Szigeti, violin; Lily Pons, coloratura soprano. Stravinsky was his favorite composer, and he listened to *The Firebird* exhaustively; one of his first clashes in the Navy was with a violinist in the next bunk over the relative merits of Beethoven and Stravinsky, O'Hara arguing that "Beethoven improved and brought innovations but not the radical changes Stravinsky has." He subscribed to *Musical America*. In 1943 he was reading *Toward a New Music* by Carlos Chávez, a Mexican composer being championed then by Aaron Copland. And he compulsively ordered the sheet music of such newer composers as Schoenberg, Cowell, Bernstein, and Hindemith from Associated Music Publishers. The sixteen-year-old O'Hara was quite proud that he had bought the music for Hindemith's *Ludus Tonalis* in April 1943, when its first performance wasn't given until the fall of that year in New York.

Among painters, the young O'Hara favored Picasso over Braque, thought of Kandinsky as "my favorite," and Rufino Tamayo as "my pet." He knew the work of Rouault, Chagall, Matisse, Klee, Calder, Dalí, and Siqueiros. His reactions to art, though, were usually critical and highly personal. When he visited the San Francisco Art Museum, while stationed there in 1945, his love of Picasso didn't stop him from finding nuances of quality in his works nor from expressing his disdain

for the critics. Writing to his parents, he fumed, "There were a number of good ones, but a couple of lousy Picassos which the critics liked, evidently because they could tell what it was a painting of. . . . Phooie to critics!"

His reading of literature could be just as contentious. He loved Gertrude Stein, but he felt contempt for Hemingway for "all the tripe he wrote about the Spanish Civil War." Somerset Maugham's *Of Human Bondage* and *The Moon and Sixpence* were among his favorite novels, but with the appearance of *The Razor's Edge* in 1944 he felt that the best-selling English novelist had disappeared "along the road to riches." He could casually dismiss such classics as Milton's *Paradise Lost* as "too pompous," while hotly defending Virginia Woolf's controversial stream-of-consciousness method: "For when can we separate ourselves from our past life?"

The one writer whose modernist fiction would never be criticized by O'Hara was James Joyce. In his attic room, or on the front porch, he had gradually read all of his works. When he went on board the destroyer U.S.S. *Nicholas,* he couldn't fit *Dubliners* in his duffel bag so wrote asking his father to type out and send the last paragraph from "The Dead," its ultimate story, in which snow falls "faintly through the universe and faintly falling, like the descent of their last end, upon all the living and the dead." He also left behind *Portrait* and, regretting his decision while on the high seas, wrote to his Aunt Margaret requesting her to send a new copy.

During his high-school years, *A Portrait of the Artist as a Young Man* was O'Hara's favorite work by Joyce. He identified with Joyce as the Irish-Catholic renegade who had deserted his Jesuit training to become a writer, who had decided not to pursue the religion of Mary Mother of Jesus but rather to pursue the religion of High Art. O'Hara often felt he was in the position of Joyce's protagonist in *Portrait,* Stephen Dedalus, a parochial student who sat through an endless fire-and-brimstone sermon much as O'Hara had sat through so many lectures at St. John's, where a Father Gallagher had relayed, according to the school magazine, *Golden Conquest,* "most interestingly how he had been a one-time athlete, stevedore, lumberjack, and goldminer before becoming a missionary priest laboring for the salvation of souls." And he felt some tug, too, with all the earnestness of adolescence, to pledge himself, as had Dedalus, "to forge in the smithy of my soul the uncreated conscience of my race." O'Hara's favorite scene in *Portrait* was the pivotal one in which, as he paraphrased it in a letter to his parents, "Stephen is out on

the beach watching a girl wading, and realizes his vocation is to be an artist."

O'Hara had his own vocational epiphany, or perhaps a number of them, which he condensed into one in "Ode to Michael Goldberg ('s Birth and Other Births)." Stephen's walk on the beach was either the inspiration for, or a romantic reflection of, his own climb up an attached metal ladder to the rim of a cylindrical open-topped water tower on Pigeon Hill behind his house, a water tower that afforded him a 360-degree view of Mount Watchusett to the north, Rhode Island to the south, and the Grafton Airport toward Worcester in the west:

> there,
> the wind sounded exactly like
> Stravinsky
> I first recognized art
> as wildness, and it seemed right,
> I mean rite, to me
>
> climbing the water tower I'd
> look out for hours in wind
> and the world seemed rounder
> and fiercer and I was happier
> because I wasn't scared of falling off

This apparently wasn't the last of his recognitions, though, since he later told the poet James Schuyler that he had decided to be an artist when he saw a show of Assyrian sculpture in Boston.

O'Hara divided his solitary time between his attic room and the woods and fields near his home. As he wrote his parents from the Navy, "How lucky I was not to be so popular that our beautiful surroundings would go unnoticed." He then tried his hand at a somewhat purple parody of Marcel Proust's description of the landscape around Combray in *Swann's Way*: "The general scene of rolling hills, nearer, the outline of evergreens, stunted crab trees and elms, nearer still, tiny white clumps of flowers, little roses, small seedling evergreens; the extreme quiet, made more noticeable by the sighing wind, and the faint sound of tooting horns from the highway, children's cries from the schoolyard, and Jimmy and Chilly calling the mooing cows, all as if heard from a great distance or through a glass bell."

The young O'Hara's solitary "straining struts," like Stephen Dedalus's walk on the beach, were less appreciations of natural beauty than they were moments of awareness of an artificial beauty stirring inside. It wouldn't be that long until O'Hara would be claiming, in "Meditations in an Emergency," "I can't even enjoy a blade of grass unless I know there's a subway handy, or a record store or some other sign that people do not totally *regret* life."

And yet the solitary times that O'Hara spent in his attic, or in the hay bins at Tower Hill farm, were not only artistic epiphanies in the footsteps of Stephen Dedalus. They were also sexual epiphanies, seeking the truth of his sexual identity, in his case a homosexual identity, which was becoming quite obvious to this sensitive adolescent while he was still living at home in Grafton, and which could only have been circumspectly expressed in a small American town in the 1940s, especially within the restrictive rulings of the Catholic Church. One critic has described O'Hara's poems of childhood as suggesting a "strange sense of isolation and of buried life." Part of that buried life would have been an inkling of himself as an artist rather than a priest, doctor, or lawyer—the professions chosen by most of his St. John's classmates—and a sophisticated knowledge of cubism and stream-of-consciousness literature that was well beyond that of any of his peers. But a large part of O'Hara's buried life was erotic.

In "Poet in the Attic," written on a visit home in 1951, O'Hara remembers himself as a boy masturbating in his faux-bohemian loft:

> *The most ancient of boards creaks*
> *beneath Frank's mammoth back*
> *and lava bursts o'er the flesh! that*
> *childishly thrusts for lost Pompeii*

In "Galanta" he sets the same scene, apparently, in the music room downstairs:

> *A strange den or music room*
> > *childhood*
> *dream of Persian grass configured distilled*
> *first hardon milky mess*

O'Hara writes in "Kitville" of a sensual kiss behind the bathhouse from a little girl who had been reading a book:

Once I was humbled
amidst the flowers
and her crushed books
were like bloomers!

.

and garish her lips
as they parted! a piano
of grassy incidents
twined with the liana

of her wet arms!

Phil Charron recalls many boyhood conversations with O'Hara concerning masturbation and sexual awakenings. "We talked about masturbation and about fears that our sexual drives would become so strong that we might rape someone," recalls Charron. At age thirteen, Charron asked O'Hara how he broached the subject of masturbation with his priest in the confessional and O'Hara smartly replied, "I just tell the guy I jerked off." Dismayed, Charron asked how the priest reacted and O'Hara calmly answered, "He usually gives me good advice. He tells me to think of the Blessed Virgin Mary. And to avoid the occasions of temptation." O'Hara was both fascinated and annoyed that he shared his first name with St. Francis of Assisi. "St. Francis of Assisi was such a clown," he once complained to Charron of the medieval saint. "He threw himself onto a bramble bush because of sex. I can't see myself doing that." Although O'Hara never discussed homosexuality with Charron, he treated the topic of sexuality rather openly and whimsically, as when the two boys walking toward the Donahue stables came across a huge bull lying on his side, his giant testicles hanging out, and O'Hara quipped, "We call him Ballsy."

O'Hara's first homosexual experience seems to have occurred with "the stable boy who gave me the diamonds" mentioned in "Commercial Variations," written in 1952. The painter Larry Rivers claims that "Frank told me that his first homosexual experience was with a stable guy, a guy who took care of the horses, when he was sixteen." The childhood poems point in that same direction.

O'Hara's full-scale poem of childhood, "Ode to Michael Goldberg ('s Birth and Other Births)"—his "Out of the Cradle Endlessly Rocking"—hints at such a risky assignation in an old barn, even at a series of such assignations:

It's odd to have secrets at an early age, trysts
whose thoughtfulness and sweetness are those of a very aggressive person
carried beneath your shirt like an amulet against your sire
what one must do is done in a red twilight
on colossally old and dirty furniture with knobs,
and on Sunday afternoons you meet in a high place
watching the Sunday drivers and the symphonic sadness
stopped, a man in a convertible put his hand up a girl's skirt
and again the twitching odor of hay, like a minor irritation
that gives you a hardon, and again the roundness of horse noises

The same confluence of hay, horses, and erotic surrender flashes almost subliminally in a line in "For Bob Rauschenberg": "and an adolescence taken in hay / above horses—."

The libidinous landscape of "Ode to Michael Goldberg" with its soft stables and vaguely pornographic pastures is reminiscent of Cocteau's *Le Livre Blanc*. O'Hara's stable boy story is a juvenile and homoerotic recasting of D. H. Lawrence's *Lady Chatterley's Lover*. And yet in the world of young Francis O'Hara such elements weren't merely literary. They were features of the social pecking order and semirural terrain where O'Hara found himself when his father decided to return to Grafton to run J. Frank Donahue's farming business. Curiously, Francis had shrugged off the daily round of the farm and the farmhands, the world of his father, the traditional world of men, to pursue the world of his more educated aunts, of music and poetry. And yet in his erotic life, he seemed to have been drawn back to the very hay bins and farm animals he was so bored by in the workaday world. Even if he hadn't lost his virginity to a stable boy, in "Ode to Michael Goldberg" he eroticizes that very working-class turf, and even Jimmy and Bailey Whitney, one of whom, with another of his farmhand brothers, had persuaded Francis to take the slide down the coal chute, are recollected mowing in a field that is overgrown with sexual innuendoes, and are overheard making remarks that cause the poet as a young boy to prick up his ears:

Yellow morning
 silent, wet
 blackness under the trees over stone walls
hay, smelling faintly of semen

a few sheltered flowers nodding and smiling
at the clattering cutter-bar

> *of the mower ridden by Jimmy Whitney*
"I'd like to put my rolling pin to her" *his brother Bailey*
leaning on his pitchfork, watching

> *"you shove it in and nine months later*
it comes out a kid"

> *Ha ha*

Grace Hartigan claims that O'Hara told her that the chiding from his father in "Second Avenue" was a direct quotation:

> *My father said, "Do what you want but don't get hurt,*
> *I'm warning you. Leave the men alone, they'll only tease you."*

Either Russell O'Hara was shrewd enough to pick up on his son's activities, or proclivities, and characteristically warn him of consequences and trouble, or he was making a comment on an incident such as the coal chute pratfall, which his poet son comically later caused to be misunderstood.

Whatever teasing O'Hara was susceptible to must have registered. And no matter how brazen he might have been in acting on his desires, he must have felt the uneasiness that comes from overstepping taboos. Following on the heels of the twilit barn scene in "Ode to Michael Goldberg" is a shrieking section of horror either at the "trysts," and the life they will bind him to, or at "invisible bonds" of family and birthplace that were making life difficult for a poet who ostensibly came to want nothing more than to be rootless:

> *"Je suis las de vivre au pays natal"*
> *but unhappiness, like Mercury, transfixed me*
> *there, un repaire de vipères*
> *and had I known the strength and durability*
> *of those invisible bonds I would have leaped from rafters onto prongs*
> *then*
> *and been carried shining and intact*
> *to the Indian Cemetery near the lake*

O'Hara probably played his cards close to his chest by remaining quite secretive about any "trysts," not so much from simple discretion but because to be an openly homosexual teenager would have been quite dangerous. His literary treatments of teenage boys tingling for homosexual meetings always transmit a sense of furtive danger shot through with a contradictory, or perhaps contingent, ecstasy. In "Ave Maria" he associates juvenile homosexual sex with pickups in the back rows of movie theatres, the poem a sort of Swiftian "A Modest Proposal" on the advantages of pederasty. Pleading with the mothers of America to give their kids quarters for the movies, he confides:

> they may even be grateful to you
> > for their first sexual experience
> which only cost you a quarter
> > and didn't upset the peaceful home
> they will know where candy bars come from
> > and gratuitous bags of popcorn
> as gratuitous as leaving the movie before it's over
> with a pleasant stranger whose apartment is in the Heaven on Earth Bldg

In O'Hara's unpublished novel, *The 4th of July,* Bud, a Boston youth carrying on an affair with a sailor stationed at the Charleston Navy Yard, writes to his boyfriend about his first sexual experience. The facts of the case could certainly fit in with some boyhood experience of O'Hara's:

I used to come to Boston and go down to Scolley Square, or go to New London. Only a few times, but my! the effect on me (about fourteen, I suppose)—the first time was really funny. I must have stood on one street corner just about all day when finally a huge salesman (a beginner in automobiles if I remember) walked by a couple of times. How funny it was. I was seething with curiosity. Something had been 'in the air' all day. I had run away and knew something would happen to me, I would force it to, if necessary. Then he walked up to me and said, "You look hungry, kid, how about coming up to my room for a sandwich." I said instantly, "Okay." We walked about a block, in silence. I felt nervous. He acted thoughtful. He turned sideways to me and said, "Listen, kid, have you ever done this before?" "No." He sighed. I was embarrassed at my lack of experience. I felt like nothing, like two cents. Finally he said, looking at me carefully (I smiled), "Well. It may hurt." I

shrugged elaborately, "I won't mind." Well, to make a long story short—it did, and I didn't.

O'Hara didn't display the bravado in his teenage life he did in his poems. He was pragmatic, and if he was adventurous in his exploits in Boston or at the horse barn, he kept it hidden. The price he paid, though, was that he concealed some of the substance of that famous personality that he later called "my mess."

"His sexuality was never flaunted in any way," says St. John's class-mate Richard Dorr. "He had a furtive, secretive aspect. When he al-lowed himself to come out more fully later on he probably allowed himself to express the more sparkling side of his personality. You couldn't be in a strict Catholic environment and give vent to those feel-ings."

"He did stay 'in the closet' in Grafton," concurs Burton Robie. "I think probably that he repressed a lot when he came home for the sum-mers with his family and the various mise-en-scènes around here. That would have been a problem for them. I don't think that any in our group would have cared one way or the other, to tell the truth. It would have been the older generation that cared."

It was through music that O'Hara often chose to express himself, par-ticularly the romantic swoonings of his suppressed self, at the keyboard in the family's music room or occasionally at recitals sponsored by his teacher, J. Fred Donnelly, at St. John's Church in Worcester. His favorite show pieces in those days were such accessible works as Gershwin's First Prelude, Rachmaninoff's Second Piano Concerto, Bach's *Well-Tempered Clavier*, Debussy's "Rêverie," and Dvořák's "Humoresque." But he also worked up several pieces that were perhaps less popular but satisfied his own serious interest in contemporary music: "Seven Anni-versaries" by Leonard Bernstein, "10 Preludios" by Carlos Chávez, the piano part of "Konzertmusik" for piano, brass, and harps by Paul Hin-demith, "Prélude, choral et fugue" by César Franck, "Méditation sur un motif de Claude Debussy" by Zoltán Kodály, and "Saudades do Bra-zil" by Darius Milhaud. O'Hara's hands were slightly small and his fingers surprisingly pudgy, but he practiced steadily and showed true musical flair in his interpretations.

By 1943 O'Hara felt that he had outgrown the local piano teaching of J. Fred Donnelly. So he proposed to his parents that he matriculate as a "special student" at the New England Conservatory in Boston,

taking lessons on Saturdays. At first, as O'Hara records in "Autobiographical Fragments," his parents balked:

"So you think you're going to be a great pianist," my father said to me in 1943, "say, like Rachmaninoff?"

"Yep," I said, "and a composer, too."

"Hmmmm," my father said. My mother was eating an apple.

"What's the matter, don't you think I can?"

"Well, I think it's more difficult than you do, apparently."

My mother put down her apple and sighed. "I may as well tell you, Russell," she said, "that he's already told me about his great plans. I think it's depressing. The other day when I was in Worcester I stopped in at a bookshop and read some of Mozart's letters. Really, that poor man had *such* a miserable life! I'd just die if I thought he was going to be a composer. They have such terrible lives. I can't begin to tell you."

"So what?" I said. "And anyway, all of them didn't. Just a few."

"Now wait a minute," my father said, glad to have the opportunity to be more permissive than my mother, for once. "If we don't let him, he'll always think we stopped him. And it isn't so very much money after all."

My mother sighed again. "I'm not going to argue with *both* of you. But when it all began, remember, we just wanted him to have some general culture. I didn't want him to become an addict!"

I pulled my trump. "Then why have you made me practice every day since I was seven years old?"

"I don't know," my mother said. "I can honestly say I don't know."

"Maybe she liked having you around the house," my father said.

"Really! I liked to hear him play, that's all."

"You see?" I said joyfully. "So will everyone else!"

"All right," my father said. "You can't say in the afterlife that we stood in the way. Go ahead. Learn the hard way."

"Okay," I said.

And so I began studying piano at the New England Conservatory. It was a very funny life. I lived in Grafton, took a ride or a bus into Worcester every day to high school, and on Saturdays took a bus and a train to Boston to study piano. On Sundays I stayed in my room and listened to the Sunday symphony programs.

The New England Conservatory, where O'Hara took one course a week for one semester during 1944, was the foremost musical institution in the Northeast at the time, with half of its approximately 250 students drawn from Massachusetts. Founded in 1867 and patterned on the flourishing European conservatories of the nineteenth century, the

New England Conservatory, by the time O'Hara attended, had moved to Huntington Avenue, a block away from Symphony Hall, up the street from the Opera House where the Metropolitan Opera performed on tour, and across the street from the Putnam Hotel where visiting baseball teams used to stay before the Red Sox moved to Fenway Park. The prime meeting spot of Conservatory students was the large bronze statue of Ludwig van Beethoven, cape thrust aside, score grasped in heavy hands, prominently located inside the entrance of the Main Building.

In *The 4th of July,* Ethel Amanti, the novel's alcoholic mother, walking past the Conservatory, registers some of the sights and sounds that O'Hara must have remembered from his Saturday afternoon theory lessons:

She walked past the Conservatory and paused for a minute to listen to the sounds melting together inside and then seeping out into the street. Vague notes falling in a faint hodge-podge of violins, pianos, flutes, male and female voices, an occasional sharp trumpet call, talking, chattering, scolding; students bustled and idled in and out of doors, late for lessons or finished with them, bright faces and dull faces, neat-looking girls, scrubby looking boys who hadn't thought to get haircuts, all rather visionary, vacant faces behind which some thought more important than what they saw before them claimed complete attention. . . . They were not alert or strong, they were relaxed and waiting for something worthy of their emotion and their energy.

As O'Hara was a "special student," he wasn't working toward a B.A. degree. Yet his teacher, Margaret Mason, was one of the best-respected teachers of theory in the history of the Conservatory. That she refused to teach Solfège, an elementary course in such basics of theory as tonality, tempo, and rhythm, implies that O'Hara was already at a rather advanced level. Mason, a brilliant harpsichordist and fine pianist, was a bit of a character, with her white hair in a bob, unfashionable flat sandals, and long dresses to the floor. She was a favorite target for take-off skits of faculty members by students each spring.

O'Hara, though, was quite fond of Mason, and excitedly planned with her a college career at the Conservatory that would include classes his freshman year in harmony, counterpoint, theory, musical criticism, English, German, French, and physics. O'Hara's plan, in which Margaret Mason supported him, was to prepare for a career in either music reviewing or teaching, to support his own composing. As he wrote to

his parents at the time, "Only the good and the really bad can support themselves at composition."

By 1944 Grafton was affected by World War II. Russell O'Hara was serving as a blackout warden for part of North Street, alerting residents if he spotted any cracks of light escaping under doors or through venetian blinds. A lookout station at the top of Potter Hill, two miles from Grafton Center, was staffed with Grafton residents on five-hour shifts to scan the empty skies for enemy warplanes. Women gathered in each other's homes to knit V-neck sweaters for soldiers overseas, or to roll bandages, or to cut flowers, which the Grafton Garden Club then distributed at a military hospital ward in nearby Framingham. Shoes, butter, cream, and gasoline were all rationed by stamps. And a weekly newspaper, *The Grafton Link,* went into print with items about local boys in the service, always noting when a V-mail letter (a photostat-type copy of a GI's original letter) was received by a local family. Many families with children in the service—828 from Grafton altogether, 19 of whom lost their lives—hung flags with stars in their front windows.

(When Phil O'Hara wanted to hang a star in the second-story window above their front door on North Street, his older brother grudgingly agreed, "Phil is doing without a brother—so if he feels he wants a star I guess it's up to him." But he warned, with the practical humanism characteristic of his wartime political thinking, "I hope he and Maureen are not believing that all Japs or Germans are bad. The Nazis are only less than 1/3 of the German population, and the Japs we are fighting are the top ones, at most only 1/10th of the people.")

The St. John's from which O'Hara graduated on June 18, 1944, had also been touched by the wartime climate. At commencement, the boys in caps and gowns mingled with others already in uniform. During the next few months, twenty graduating seniors enlisted in the armed services, while two others enlisted in what was always then referred to as "the Army of Christ," one going off to a seminary in Baltimore, the other joining a Xaverian novitiate.

O'Hara enlisted immediately upon graduation. It was handled locally at the Grafton Town Hall, and he was probably included in one of the groups of Grafton boys given flag-waving sendoffs as they boarded a bus at Central Square, sendoffs diligently organized by George Jordan, owner of the only gas station and garage in Grafton Center as well as a Chevrolet dealership behind the Town Hall, whose son had been one of

the first local boys killed on foreign soil. The war that O'Hara's group was being sent off to fight seemed to be tilting decisively in the Allies' favor in Europe but was continuing to be fought as an island-by-island conflict in the Pacific.

The newly recruited O'Hara, who rode off on a bus that connected to a sleeper train on its way to upstate New York, had passed his boyhood protected by an overly fussy mother, three intellectually helpful aunts, and a long line of strict nuns and priests. His experiences over the next two years would do much to counteract that. O'Hara was entering a confusing world where men from different cities and classes were forced into close quarters in intimate barracks, where black soldiers were segregated from white soldiers, where largely unsuccessful attempts were made at induction centers to screen out homosexuals by the observation of feminine mannerisms or the asking of such leading questions as "Do you like girls?"

O'Hara became increasingly sophisticated as he spent time in large cities such as San Francisco or on the destroyer U.S.S. *Nicholas* cruising through the Pacific from the Philippines to Japan. Inwardly, his steady interest in Whitman, Joyce, and Schoenberg in foreign surroundings did much to speed his maturing. Soon any real return home became less and less possible.

> So I left, the stars were shining
> like the lights around a swimming pool.

Navy

Seaman Francis O'Hara's take on World War II was always slightly askew.

Watching a propaganda film screened during the first month of Basic Training, he seemed less impressed by the movie's message than by its score. His letters home, over two hundred in the next two years, were decidedly artistic rather than patriotic. "Daddy will be amused to hear that in one of the 'Why We Fight' movies we've had, they added pathos to a scene showing the misery of the Poles who had been tortured by the Germans using Beethoven as background. As a matter of fact we have a record of the music they used—the 2nd movement from Beethoven's 7th Symphony. It was the best part of the film—I always loved that particular part."

His reports on the daily grind, or the weather, were usually keyed up with a boyishly naive excitement: "Today has really been swell. The air is cool and clear, the sky bright blue with clouds that remind you of 'Supersuds.'"

Sitting in classrooms for lectures on antiaircraft guns or ship rec-

ognition, O'Hara only half-listened to the drone of technical informa-
tion, which he called "the usual stuff." "It's restricted but I can't
remember the figures anyhow so that removes any danger of me spill-
ing the beans," he wrote home rather fuzzily about a lecture one after-
noon on the Allied armament. "In destroyers or something like that (it
might be battleships or cruisers, I'm not sure) we have 11 times as many
as Japan."

Somehow O'Hara managed to move through an obstacle course of
barracks, destroyer sonar rooms, and Philippine islands exploding in
fireworks of artillery, as well as pass from boyhood to manhood, with-
out losing his own uncorrected point of view. O'Hara seemed oblivious
to the horror of the war into which he had been thrust along with about
16 million other young Americans, and it was his own private enthu-
siasms and interests that helped sustain him. He kept an attic room in
his mind filled with books, musical compositions, and paintings. Such
self-reliance made life a bit lonely at first for this young sailor who was
more interested in listening to Sunday symphony broadcasts than ma-
rauding in local towns with his bunkmates. But it gave him time to
dwell on the flourishing of what he would later call "my rococo self."

O'Hara left Grafton full of sadness and anticipation. "My father
crying as I left, sure of my failure," as he wrote later in his unpublished
novel. While there is no record of Kay's reaction, one can imagine what
it must have been, given her tendency to worry. It was June 23, 1944,
and for weeks the newspapers had been full of articles on Operation
Overlord, the Allied invasion of Normandy launched on June 6 that
resulted in a shocking daily tally of casualties. O'Hara, though, having
enlisted in the Navy in the face of a certain draft, was partially excited
about entering the service. As he later wrote in "Lament and Chastise-
ment," a short story for which he earned a B+ in Albert Guerard's
creative writing class at Harvard, "And after all I was a fairly rational
person who had voluntarily enlisted in the navy and that must mean
that I had subconsciously wanted to go to sea. Think of how much I
liked Cape Cod in the summer. For one reason: the sea. Well, then, it
would all be great fun."

During a long wait that afternoon in Springfield, Massachusetts,
O'Hara slipped happily into a movie theatre to catch Danny Kaye's
movie debut as a hypochondriac who joins the Army in *Up In Arms*.
He then boarded a sleeper train, arriving the following day at Sampson
Naval Training Center in upstate New York on the shores of Lake Sen-
eca. The base, opened in 1942 expressly to handle the influx of new
recruits, was a busy complex of four hundred buildings served by 9

miles of railroad tracks and 53 miles of roadways on a few thousand acres of low-grade Finger Lakes farmland. Equipped with its own fresh water, telephone exchanges, sewerage and power systems, and an efficient network of streets named after war heroes born in the state of New York, Sampson was fit to handle up to forty thousand men and women.

O'Hara's first duty was to walk "the naked mile," a rite of passage in which recruits were stripped of their civilian clothes and examined by a Navy doctor before donning their Navy uniforms. O'Hara's statistics: height, 5 feet 7½ inches; weight, 130; eyes, blue; complexion, ruddy; hair, dark brown; blood type, A. In *The 4th of July*, O'Hara transposes his experiences that day into those of the novel's Navy veteran, Lewis: "Coming away from home, shedding my garments in the station in the midst of thousands of gleaming buttocks and ugly faces. The light came through the windows, pale and ashamed then. I stood there and to order." O'Hara was well aware of "the subtle looks, ashamed and furtive peeks of naked eyes," while "my pants fell like a punishment, and that day, as a rite, my father died, could never again touch me in disapproval or, even, reward." His hair cut, fingerprinted, administered a military oath, and assigned a serial number, rank, training unit, and barracks, O'Hara felt strongly the sense of having been inducted into a tightly supervised group where conformity was encouraged and enforced. It was a sensation he was well attuned to after years in parochial school. In *The 4th of July*, Lewis reacts by turning inward: "And I alone, hidden, walked like a disguised emperor among them, knowing alone what was lasting and eternal, what would happen and what would work. Yes, knowing what beauty was, or at least knowing that there was such a thing." At the time, though, O'Hara was not quite so sure. Those feelings were still inklings, not convictions. And his first impulse was to draw back. "No one had said anything to me for months and I had said nothing in return," he exaggerated in "Lament and Chastisement."

O'Hara was assigned for his twelve weeks of Basic Training to bottom bunk 76, near a window, its desirability proved by his upper bunkmate who tumbled onto the floor during their first night on the "topside" (second floor) of C-unit barracks. His unit was confined for the duration to these barracks surrounding an oval athletic field nicknamed "The Grinder" where they ran laps in shorts every morning at five. O'Hara's life in boot camp quickly became a regulated routine of four-hour watches, mess duty, and educational movies on everything from aircraft recognition to venereal disease. Recreation in the camp,

which he described as looking "more or less like a prison camp," consisted of boxing matches, rowing contests on Lake Seneca, and "smokers," which the young connoisseur of Camels, Chesterfields, and Philip Morrises dismissed because "you can't even smoke at them."

O'Hara was still very much living at home, at least in his mind. His link to 16 North Street was music, and his strongest cases of homesickness were brought on by listening to familiar pieces from the base library's record collection, a collection of which he mostly approved: "The records here are pretty good. You don't hear much Hindemith though. None at all in fact. Dad'd like it." Although one Sunday he couldn't attend the radio broadcast of the Sunday symphony at the library because his company's white uniforms weren't back yet from the tailors, he assured his parents, "You may be sure at three I'll be mentally drying dishes and listening with you." On the way to eat one evening he found himself humming Mendelssohn's Piano Concerto in G Minor, the only Mendelssohn piece in the O'Haras' record collection, and so felt moved to call home.

The young recruit tried to continue to run his family from a distance. He was mostly adamant that his younger brother and sister help their mother—"Don't let her do all the work, either of you—remember, I'm not home and she has nobody to help her at all now." He instructed his parents on how to listen to their recording of Brahms's Violin Concerto: "Be sure & notice in the Finale how the theme (main) begins (start of the 8th record I think) and then recurs about twice as fast, or perhaps just with a different emphasis (about 1/2 way thru the 9th record I think)." He suggested that his mother try to go to bed before eleven, strongly recommended Mr. Farmer as a piano teacher for Phil, encouraged Maureen to practice her swimming, and his father to read *War and Peace*.

Eventually O'Hara did make friends with a few of his barracks mates. There was Everett Pillsbury, a tall blond from Maine who used to enjoy reading O'Hara's letters from his mother because he deemed them "the height of gentility." Lucky Frementel, a 5-foot 3-inch bunkmate of O'Hara's from East Boston was "the nearest thing to Jimmy Durante you ever saw." Particularly irksome was a fellow musician with "periwinkle eyes" from Vermont whom O'Hara could never forgive for claiming that he "hated Stravinsky for being so brutal one should write like Schubert." "This boy is a violinist and so takes his music sentimentally," O'Hara explained sharply in a letter to his parents. "I'm more interested in structure, etc., than he is."

But O'Hara gave many the impression of being shy and standoffish.

"He was soft-spoken and he kept to himself a lot," remembers Jim O'Connor, a barracks mate from Maine. "He didn't volunteer a lot of information, or say a great deal about his family background. You had to ask him questions. He was quiet as opposed to being a loudmouth. He didn't care anything about athletics, but he had a good command of the English language and always expressed himself well when he did speak. When we were kids, we would have said that he was a sissy type. Some of the men were always telling about their conquests. But I never heard him mention dating or going to a prom or anything like that."

The shower room was the scene of some of O'Hara's loosening up. He described it as a boyish playground in a letter to his sister, Maureen: "I was waiting for a boy to get off watch so we could take a shower. About four of us take them together each night and have lots of fun. Our chief amusement is throwing each other into an all-cold, icy shower. Last night someone had left part of a dungaree rag in there so we threw that at each other." But the showers weren't all simply horseplay. O'Hara was particularly struck by the fate of one of his shower mates, a "very nervous" Greek boy whom he recalled years later in run-on sentences in "Lament and Chastisement": "And from up North there was a Greek boy who looked ten years old and could move his hip in and out of joint when he felt like showing off in the showers and began to have nervous seizures and sweat and tremble and go to the hospital but the people who knew all about queers said he was queer and just trying to get out of it all because he had no guts they never do." This shower room shows up briefly in *The 4th of July*, "from the one who masturbated in the showers every night to the one who blew me under the covers with secret and night-delirious pleasures." Such desires could usually be coped with successfully if kept under wraps. Although O'Hara had acted on some of his impulses as a teenager, his sexuality was still largely as undefined as that of many of the young men drawn democratically from all over the country, some of whom were becoming aware of homosexual impulses for the first time in their lives. Whatever activities O'Hara may have engaged in while at Sampson were surely as surreptitious and fleeting as the confessed blow job under his sheets.

Off-color activities, though, were occasionally dangerous. O'Hara was personally involved in the case of the Greek boy who was eventually transferred to L-16 for psychiatric observation and then discharged. The Sunday before his confinement, the two had eaten supper together. O'Hara concluded, "Without exaggerating at all the discharge will ruin

him—from what conversation I've had with him, and it was intimate on his part because he wanted a listener, it will cause a permanent inferiority complex and possibly a nervous breakdown." A few weeks earlier he had written home quite openly about a "lieutenant in one of the nearby units" who was "kicked out recently for having homosexual relations with an A.S." O'Hara was partly relaying this story as a way of coyly tipping his hand to his family about some of his own sexual leanings, and partly because of the discomfort its proximity caused him, a discomfort that was contributing to his increasingly fiery sense of outrage at any injustice.

O'Hara was introduced at Sampson Naval Station to other prejudices, especially racial, which were far more serious than the subtler tensions between Catholics and Protestants, or Irish and Italians, in Grafton. As blacks were segregated during World War II into their own units, racial slurs against them could be easily voiced. But O'Hara never swayed in his condemnation of such remarks. His model in this open-mindedness was his father. As Philip O'Hara remembers, "My father was very open about other people's ethnic basis. His brother, Leonard, was very prejudiced in my view. He would say that Frenchmen were cheats and sneaks, and so on. I never could understand why, but Russell certainly wasn't like that. He didn't talk like that. He didn't behave like that. He had good friends who were Jewish." In the barracks, O'Hara found racist comments particularly common among a few Southerners, "who are so darn anti-Negro," a tendency that surprised him as his summer friends from Virginia, Birchard and Randy DeWitt, were not at all prone to "condemn the whole race as not worthy of education, etc., as these boys do." Anti-Semitism was also apparent, especially in the case of one agriculture teacher, a graduate of Cornell, who balked when a Jewish boy was assigned to their unit, a boy whom O'Hara later described as "the lonely Jewish boy who thought I was kind." When the ex-teacher growled, loud enough for everyone to hear, that he "wouldn't march beside him and he knew it!" O'Hara was irate. "I don't know why," he fumed. "The guy just came in so he couldn't have done much to offend him—evidently Cornell didn't do him much good."

From Sampson, the recruits were shipped to other naval centers for more specialized training. O'Hara was considering trying out for the post of musician, even learning a second instrument such as the trumpet, until he discovered that he would have to attend the National Music School and enlist for six years. "The 6 yrs. stopped me deader than a door nail," he confessed. When he filled out his request form, O'Hara

listed "pharmacist's mate" or "hospital assistant" as his first choice, "radioman," his second. The position of radioman had been suggested by his selection officer who felt that "with my years of musical training I would have good pitch and be able to operate a machine which sends out sound waves and can determine what objects are around it by the pitch of the returning sound." O'Hara seemed convinced by the officer's rationale. "The training should improve my pitch and teach me about the physics of sound and therefore music," he wrote, a bit wistfully, to his parents on the day he learned that he would soon be transferred to the fleet sonar school at Key West, Florida.

O'Hara was emotionally ambivalent about his departure from Sampson. Although he had been anxious for his parents to understand that his homesickness was not excessive ("Don't think I'm a sissy as all the kids here are worse"), O'Hara was enmeshed enough within his family that every separation was difficult. When his parents paid a Sunday visit to Sampson, his response, after he waved good-bye to their car even though he thought they could no longer see him, was, "It feels so much better here since you've been here & seen it. . . . I guess I'm pretty sentimental or something." Like a good Catholic boy, he continued to attend Mass, evidenced by the Mass cards the chaplain would mail home, as "it's the only thing we do here that you people do at home." Yet O'Hara couldn't help but feel a buzz at the prospect of going South, south to Florida where his mother had so much wanted to set up house after he was born. To the young O'Hara, now Seaman second class, Key West was an exotic, distant spot on the map—"not too far from Miami and is near Cuba!"—from which he could send his siblings "a shawl or a pair of maracas."

"Phil, you certainly must agree that I'm going places now!" he spiritedly wrote.

During the last week in September, O'Hara boarded a bus to Geneva where he was transferred to a plusher pink-and-white Lehigh Valley coach pulled by a streamlined engine, the "Black Diamond," to make the trip to the Thirtieth Street Station in Philadelphia. After being served a meal of lobster cutlet in the railway station's main dining room, he and the other sailors caught a Pullman that transported them nonstop to Miami. O'Hara was quite alert during the trip, avidly registering the faces and voices of all his fellow passengers—the several Marines, the elderly lady who disembarked at West Palm Beach and spoke with an accent that made roast beef "roz biff," and the lively Puerto Rican girl straight from convent school in Cleveland with a "Dolores Del Rio

mouth" who enticed the boys with invitations to a dance with lots of beautiful girls.

When he arrived in Key West on September 28, all of its streets lined with "palm trees that look like hat pins tipped with monkey fur," O'Hara was assigned to a wooden barracks with a corrugated metal roof where he laid eyes on "the largest cockroach in the world . . . sixteen inches long and you couldn't help but respect it for it." At this time about thirteen thousand servicemen were stationed on the island, its skies having burned red for many nights in 1942 when a fleet of nine Nazi submarines had steadily torpedoed oil and gasoline tankers in the Straits of Florida. The naval base now consisted of a naval hospital, naval air station with two landing fields, naval submarine base equipped with extensive repair facilities, and, O'Hara's assignment, one of the nation's two fleet sonar schools.

But O'Hara was oblivious to the military logistics. He was more fascinated with the October hurricane that blew through Hurricane Alley, the only region vulnerable to those storms born in the Atlantic, Gulf, or West Caribbean, disrupting military activities while the enlisted men helped clean up the base and town. "It was nice to think that something could be destructive and not mean it," he later wrote in "Lament and Chastisement." He was positively entranced by the swimming pool, the movie theatre, and the baseball diamond where films were projected at night. "I've gone to the movies almost every night this week," he wrote home at the end of his first week. "I suppose that means I'm returning to normal or something." His favorite movie during his stay in Key West was the Technicolor epic *Kismet,* starring Ronald Colman and Marlene Dietrich ("was she exotic").

Key West had a reputation as a wild town. As one Navy report put it: "The City of Key West continually posed numerous problems. Its main street, Duval Street, was a wide-open honky-tonk area, studded with bars and so-called night clubs of fairly tawdry character. Side streets had their proportionate share of such establishments. . . . A policy of firmness in dealing with proprietors of local resorts whose places had to be put out-of-bounds for a night soon began to show results." Occasionally the naval commander felt the need to declare the entire city out-of-bounds, a sternness reflected in O'Hara's observation that "There are also a lot of lovely night sounds but the military police are mean."

If O'Hara fit at all into the stereotypical profile of the sailor at war it was in his drinking. "I can understand why men drink away from at home," he had warned his family near the end of his stay at Sampson.

By the time he was finding his way around the bars on Duval Street, the habit, which was to become legendary in later life, was definitely established. "At Key West there is Duval Street," he later wrote. "Except for a small side street where there's a small book store with nothing but best sellers and Modern Library editions, I've never been on any street but Duval. There are bars all up and down and you drink rum or vodka, sometimes brandy-and-vodka, but the scotch is watered. . . . It was in Key West that I realized I couldn't tell Haig and Haig pinch from Cutty Sark, and believe me, even though both had been watered down in Miami, it was a blow. I also realized in Key West that if you went without lunch and dinner and drank fifteen bottles of beer the world seemed a great deal worse than it had. There is nothing like a good crying jag to make you want to hear the Brahms Concerto for Violin and Orchestra in D major, opus 77. Or is it 72."

Sonar school was less like the New England Conservatory than he had hoped. "Sonar" is an acronym that stands for SOund Navigation And Range. The five-week training course consisted mostly of learning to detect underwater objects, especially submarines, using high-frequency waves sent out from an oscillator stuck on the bottom of a destroyer or destroyer escort. By the time O'Hara was mimicking his sonar instructor's voice in "Lament and Chastisement," the irony of confusing ear training with honing in on torpedo targets was fixed in his mind: "When you see the button you press it. You must determine the target by sighting along this line and squeezing like on an orange. There are several million Germans in the world and more Japanese who are utter horrors: we shall plant them not like dragon's teeth but like Parma violets. You get right about center by listening for the mean tone, that's right sweep back and forth across the target and determine its center by your hearing, you've had musical training haven't you? I just love the Symphonie Espagnole. Milstein, of course. That's right fire."

The training also entailed riding out to sea in yachts consigned by the Navy to search for an antique French submarine that had escaped after the Nazi invasion and was now used as a decoy. O'Hara, again, seemed drawn more to the surface of these practice raids, imbuing the sea with a thirties movie glamour: "the sea was very rough and looked like silver lamé." He liked to spend as much time as possible on deck, leaning over the rails, staring out to sea, communing with the schools of dolphins, which, to the annoyance of many of his fellow sailors, were mischievously bouncing back the oscillator's high-frequency waves. "They seem to feel the same delight in swimming that I do," he wrote to his parents. "They glide as if they enjoyed the feeling of the water,

the constant movement, and the immensity and cleanness, as much as I do. If I were a Hindu I would believe that my soul was in the body of a porpoise in my last life. As it is they make me think I'm in the water with them."

O'Hara's social life in Key West was mostly confined to the few musicians he happened across. He met two violinists who played at his request the Brahms Violin Concerto, which his drinking bouts had so made him want to hear, and who bolstered his opinion that Szigeti was the world's finest violinist. One of the instructors on base, a violinist named Johnson, inspired O'Hara's affection because he had been present at Heifetz's recording of the Walton Violin Concerto—the last album O'Hara had listened to before leaving home. O'Hara later recorded their talk impressionistically in "Lament and Chastisement": "Why yes, I rather liked the Walton. Yes, Heifetz did it. Why yes, I suppose we are the only two people in the world who remember what it sounds like. No, I don't think Schoenberg is being perverse."

He also struck up a friendship with Tom Benedek, a graduate of the University of Chicago, who could share his enthusiasm for piano music. "For an eighteen-year-old Fran was rather refined," recalls Benedek. "He was always talking about classical music and classical pianists. As I remember, our conversations were pretty much focused, at least by him, on the piano rather than on symphony orchestras in general. At that time he was fantasizing about becoming a concert pianist. He was obviously more intelligent than most of the people I encountered. He was friendly and talkative. I wouldn't have selected him out as far as peculiarity of behavior from anybody else. Any homosexuality certainly wasn't evident to me, but maybe I was just too naive. Or maybe he wasn't that sure about it at that time either." When Benedek later visited O'Hara in Grafton for an afternoon after the war, the two of them, along with Burton Robie and a woman friend, sat in the O'Haras' home reading aloud from Ibsen's *Ghosts,* an activity that Benedek found "a slightly bizarre thing to do under the circumstances."

As at St. John's and Sampson, O'Hara remained a bit of a loner. In a Navy barracks, as Benedek explains, "There wasn't an opportunity to meet very many bright people." As O'Hara's friendships from an early age had always been based on some sort of intellectual stimulation, this lack was particularly difficult. Although he would later develop a style of artistic gregariousness that was quite distinctive, in this early period he fit more fully the mold of the introverted and sensitive young artist. "Wherever I'm sent don't worry about me," he wrote to his parents as the date approached for an assignment, which would almost

certainly be overseas. "One of my main deficiencies was always my moreorless detachment but at last it is an asset. Except for swimming, most of my real pleasures are in my mind. So are always at my fingertips."

The absence of a close circle of friends made Key West more unpleasant to O'Hara than it might otherwise have been. He found it "depressing" and, referring to Maureen and Phil, to whom he had recently mailed a machete, claimed that "I think I'd die rather than have either of our kids live in this town. Excuse me for being maudlin." This maudlin mood was later magnified in "Lament and Chastisement": "I've been in the navy three thousand years without ever seeing my mother. I haven't cried so hard since 1929." His schoolwork did little to lift his mood. After cursorily completing two more weeks of advanced sonar training on the U.S.S. *Sylph,* docked in Fort Lauderdale, O'Hara graduated eighth in his class of twenty-four and was promoted to the unexceptional rank of Sonarman third class.

"Except for the sky being so near, the dewy stars and the sea, I loathed Key West," he later exploded. "Its only excuse for being there is that Wallace Stevens wrote a poem about it."

At the end of November, O'Hara was transferred to a training center for those about to be shipped to sea, in Norfolk, Virginia. He waited there a month for an assignment to a destroyer, passing through one of his "periodic spells of dejection," wandering around in a heavy peacoat, eating devil dogs, in a city that proved to be even less hospitable than Key West. "For Norfolk is a cold cold city, the ass-hole of the universe, even if I did hear Grace Moore there," he complained in "Lament and Chastisement." "I'm sure she was the only good thing that had happened in Norfolk in years. . . . My life is a journey; whatever may happen I know that I shall never go to Norfolk again." The singer Grace Moore's USO concert at Norfolk Auditorium thrilled O'Hara enough to enclose the program in a letter home, as well as his own drawing of her gown, replete with penciled shading, which he labeled "pink beading."

O'Hara's Norfolk stay was largely taken up with worrying. It was now clear to him and his family that he would soon be sent into one of the world's battle areas. At that very moment, his friend Burton Robie was lost somewhere behind the lines in Belgium where fierce fighting was taking place. O'Hara became particularly solicitous during these uncertain weeks about his mother's health, which was so often a barometer of her fragile emotional disposition, and was insistent that she visit the family doctor for a checkup. He thought of her whenever he

tuned in to "Ma Perkins," one of the most popular daytime radio pro-
grams of 1944. She was equally solicitous about her son's rather solitary
social life during the Christmas season. "I'm glad to be a lone wolf,"
he wrote home. But his conviction that he would rather walk the foggy
streets of Norfolk than be dragged along with some buddies in activities
he didn't enjoy was unconvincing to her. So O'Hara resolved at first
not to mention that he had spent his Christmas Day alone except for
dinner with a "perfect stranger" at a Navy social club in Norfolk.

Concerned that their son not spend his New Year's Day alone, his
parents made a long car-and-ferry trip to Norfolk to be with him. "I
waited at the ferry for hours and ate four apples which were sold at a
candy stand by an emaciated woman," O'Hara recalled lightly in "La-
ment and Chastisement." "The ferry came in and people streamed
around the station. My mother and father were on it; I barely recog-
nized them and they thought I was suffering from malnutrition; all
through the weekend they were not sure it was me and I was not sure
it was me, but I was sure it was *them* after a few minutes, and that
made it a very nice weekend. . . . we did not talk about the war but
about what had happened in the family and how immense my brother
and sister now were, they did not come out to see the base and I did
not offer to have them; it was very nice and the first thing I knew they
had gone. . . . I now had a picture of my grand-aunt Elizabeth, who
had died shortly after I left for the navy."

O'Hara's reaction at the time, though, was not quite as breezy as
his Harvard short story implies. His parents' visit, and their imminent
departure, brought up uneasy feelings reminiscent of those he had en-
dured on evenings in Grafton when they had left him to go off to a
cocktail party. "I hated to have either of you leave the room I was in,"
he admitted of their stay in Norfolk. He was reassured, though, to see
his mother "looking well, dressed so nicely, so humorous and pleasant,
as keen and interested as ever before and more fun to be with, if that's
possible." His discussions with his father never became "heated" be-
cause he seemed eager this time to soak up his advice: "My mind has
been almost seven months without flushing and was filled, I'm afraid,
with you-know-what."

The following week O'Hara boarded a train bound for San Fran-
cisco, the port from which he would eventually sail to the Pacific. Before
departing, he mailed home three books for safekeeping: *Harmony, Six-
teenth-Century Polyphony,* and his favorite, *A Portrait of the Artist as a Young
Man,* of which he wrote, "In some places Joyce's character is uncannily
like me—remarkably so in the passage where he goes down to the beach

and 'finds himself.' His (the character's) way of thinking of his child-
hood school was also similar to my own."

A new theme, too, began to be sounded in his letters during this
transitional time. "Lately I've been getting better adjusted, I think," he
tentatively wrote to his parents. "One can't stay at home all his life, I
guess."

It was a theme that was to recur more forcefully over the course of
the unusual year to come.

For the boy whose yearbook wish had been "to live in a big city,"
wartime San Francisco was a tumultuous relief from the tedium and
loneliness of the East Coast boot camps. A revolving door of a city,
militarily speaking, San Francisco in January 1945 was teeming with
sailors either waiting to be shipped to the Pacific theater or just returned
to land, raring for a drink, a free ticket to a show, a hamburger and
"cup of Joe" (coffee). Thanks partly to USO backing, the city's sym-
phony, opera, and ballet were packed nightly with audiences colorfully
divided between civilians and uniformed men and women. Not since
the Gold Rush a century before had this port city been so energized.

"There was the symphony and there was the ballet," O'Hara re-
called in "Lament and Chastisement," "and there was the fresh old city,
gauche and precious, wide avenues, tiny streets, hills and troughs for
cable cars, there was wind blowing, the scent of lavender, and snow in
the air."

O'Hara's train trip along the "southern route" from Norfolk to San
Francisco had been pleasant. He had started reading Thomas Mann's
The Magic Mountain, a Christmas gift from his parents. When his upper
bunkmate shared a pint of rye with him on their first night out, O'Hara
insisted on returning the favor by presenting him with a copy of André
Gide's homosexual novel *The Counterfeiters,* which he had bought in
Norfolk and read through "practically without stopping for breath." It
was an exchange he recorded in "Ode to Michael Goldberg ('s Birth
and Other Births)," his autobiographical poem, which significantly picks
up his Navy experiences on the train to San Francisco and, more fully,
in the Pacific. These were experiences that were obviously more seeded
with poetry for O'Hara than his six months in the training barracks:

> *kept moving in berths*
> *where I trade someone* The Counterfeiters *(I thought it was about personal*
> *freedom then!) for a pint of whiskey,*

He jotted down notes along the way for a piano piece, a variation on a Beethoven sonata, to be titled "Conversation on a Beethoven Theme." Two or three times, passing through Texas and Arizona, he mentioned sending a card to "my kids" or "the kids," referring to Phil and Maureen, much to the amusement of his companions. "I don't want to be overpaternal," he apologized to them by letter.

O'Hara's first stop was Treasure Island, a man-made island built in the center of San Francisco Bay as the site of the 1939–1940 Golden Gate International Exposition, which was now being used to process up to twelve thousand men a day for Pacific area assignments. Within days he was transferred to a centrally located Market Street barracks— "I think Market Street is the best street in the world of the streets in the world which I have seen"—where he served as a Shore Patrolman for the next month. His job, for which he was outfitted with boots, belt, an armband, and club, was to guard the entrances to hotels and bars designated out-of-bounds for military personnel, or to act as a sort of extra policeman on wagons sent to pick up drunks and accident cases, an uncharacteristic task that he recalled in "Ode to Michael Goldberg":

> and I stared with my strained SP stare
> wearing a gun

During 1943 and 1944 the Navy's Shore Patrol had been particularly active in a crackdown on many of the city's gay nightclubs—including Finocchio's, the Black Cat Cafe, and the Top of the Mark at the Mark Hopkins Hotel. One newspaper claimed the toughened regulations were a reaction to a return of the "devil-may-care spirit of Barbary Coast days," which was again turning San Francisco into a "hell-raising town" with "Uncle Sam's fighting men" weaving drunkenly through its streets. By 1945, though, many of these bans had been lifted, as evidenced by O'Hara's several meals at the Silver Rail, a tavern attracting a gay clientele that had earlier been declared off-limits.

O'Hara was a benign Shore Patrolman who felt his duty was to keep sailors out of trouble, at times even to intercede with his superiors on their behalf. He was simply not disciplinary, and enjoyed the post only because it gave him the opportunity to see more of the city as he stood guard at the Lido Club, the Continental Hotel and Bar, and a dormitory run by the Harbor Club. Of his street patrols he wrote home, "The more I am on SP the more it is born in on me that drunks and I are just naturally attracted."

To allay his parents' concern, he later filled in: "Now don't worry. I don't like cheap liquor and anything else is out of my wage bracket, so I am in the same position as the repulsive spinster who prided herself on her virginity. Lately I've been too busy anyway."

To the extent that O'Hara was casual, even self-deprecatory, about his assumed authority—"Pretty soon I'll be one of those fat Irish cops!"—he was horrified at other Shore Patrolmen who became overly zealous. Particularly repulsive was the Baptist ex-minister who headed the main lockup room of the Shore Patrol headquarters, "a gloomy efficient place with innumerable cages and rooms and ramps." O'Hara once observed this "pear-shaped fish-faced southerner" who spent hours reading a book titled *The Power of Prayer* inappropriately relishing a punishment. "He was doing a beautiful job of beating up a young Negro steward's mate who not only had done nothing (I was watching) but also was slighter, thinner, and shorter than I am, and couldn't have been over 17 yrs. or 130 lbs.," O'Hara wrote home. "As I said before, this 'man of God' has an original way of expressing his convictions. The jackass! I'd like to see him get his head knocked off."

Luckily O'Hara's stints were brief. Shore Patrol consisted only of eight-hour shifts on alternate nights, so that he was free every forty-eight hours to walk the streets of the city, eagerly noticing stray details, such as the prevalence of dungarees among boys aged ten to seventeen, or taking in concerts and museums. On his first night of liberty he was thrilled to attend a performance of the symphony at the War Memorial Opera House with its gold and cream hangings and red plush chairs. His ticket, purchased from an ensign, allowed him to sit close enough to the stage to see the guest conductor, Efrem Kurtz, "squint his eyes at the violins and count under his breath" during a Corelli suite, and to watch "the drops of perspiration on Jan Smeterlin's forehead in the heated passages" of Rachmaninoff's Second Piano Concerto. O'Hara's favorite piece was "Metamorphosis on Themes by C. M. Weber" by his contemporary favorite, Hindemith. "Pardon me for saying so," he gloated to his parents, always playing up his ability to scout talent, "but I guess I can tell a genius when I come across one!!!"

Two weeks later he went to the Civic Auditorium to hear Yehudi Menuhin play a Bach violin concerto with the San Francisco Symphony Orchestra. After the performance O'Hara, along with another sailor he had met in the ticket line, filed backstage where he asked Menuhin to autograph a program to send to his sister. Menuhin was about thirty years old at the time, and O'Hara was particularly struck by his blond

hair, which was as light, he thought, "as Sally Warren's used to be when she had braids."

In San Francisco O'Hara first established the hectic urban pace that was to become his trademark later in New York, attending a breathtaking number of exhibits, concerts, movies, and shows in a crowded six weeks, crossing lines effortlessly from one art form to another. The future aficionado of Balanchine's New York City Ballet saw his first ballet in San Francisco, a production of *Princess Aurora* with Tamara Toumanova that inspired him to write home decisively, "From now on your son is a member of that part of the public known as ballet enthusiasts or, as the N.Y.er calls them, balletomanes." He visited the San Francisco Art Museum, where he thought enough of the Calder mobiles to draw them for Maureen in a letter, as well as to offer short critiques of paintings he had seen by Braque ("I never liked his so much before"), Matisse ("loads of rhythm"), Chagall ("touching, sentimental, humorous") and Klee ("a simplified face, done in an embarrassed pink"). He took in as well a show of "sculptured orotund animals" at the Civic Center, deciding "I don't like sculpture." He enjoyed Duke Ellington at the Golden State Theatre more than the San Carlo Opera Company's production of *Lucia di Lammermoor.* And he still managed to keep up with many current movies, including *Dark Waters* and *A Song to Remember,* both with Merle Oberon—of whom he gushingly wrote, "Wish I'd meet someone like her!"—and *To Have or Have Not* with Lauren Bacall—whom he summed up less attractively: "She moves like a horse and has a voice like a bass drum."

Missing were the almost equally energetic friends who would be accompanying O'Hara in the crush of artworld events a decade later in New York. Yet in his last two weeks in San Francisco he finally began to meet some friends who were able to share at least partly in his interests, friends his mother was rather quick to brand as "bohemians." One Sunday afternoon O'Hara went searching for an arts center in Chinatown that he had seen advertised in a brochure at an art museum. Making his way through the neighborhood of buildings "similar to pagodas" he found, on a second floor, the Servicemen's Arts Center, comprising the home of its founder, the composer and pianist Charles Cooper, plus three studios for painting, sculpture, and piano. As Cooper and his wife were friendly with a number of contemporary composers, including William Schuman, he and O'Hara found much to discuss. After their talk, Cooper led his astonishingly learned young friend into the piano studio where, while a fire crackled in the fireplace,

O'Hara played for him two pieces he had bought in Norfolk—Leonard Bernstein's "Seven Anniversaries" and Jacques Ibert's "Little White Donkey." O'Hara then stayed on from two until five in the afternoon playing Bach's *Well-Tempered Clavier* without stopping while Cooper practiced next door on the baby grand in his living room.

Cooper invited O'Hara to come back at eight as he was having some friends in to play string quartets. This invitation led to a number of musical soirees. That evening there were two other sailors, one in the audience with O'Hara and one playing cello. Mrs. Brown, a musician who had done concert work in New York, played first violin, supported by a Mr. Foy. Along with Mr. Cooper, they played a movement from a Schubert quartet and two movements from the César Franck piano quintet. Afterward, Cooper invited O'Hara to play two of the "Seven Anniversaries" he had practiced that afternoon. O'Hara did, to the displeasure of "a young lady who wore her black glossy hair in a large bun at the base of her skull," as O'Hara remembered her in "Lament and Chastisement," "and knew but did not care for Leonard Bernstein which I thought very snotty indeed." O'Hara stayed on until midnight listening to Cooper play some of his own romantic and very pianistic compositions.

"Mrs. Brown, the Coopers and the people I've met in that connection have done me a world a good," O'Hara wrote to his parents, relieved to have finally found someplace away from home where he felt he belonged. "Proving what I've always held to be true, that musicians are not the weak, effeminate, or neurotic people who hide under music's skirts for solace, emotional release, and the like. . . . they have shown me how normal my love of it is, and what a bond exists between music lovers."

O'Hara soon became enamored of Mrs. Brown's daughter, Carolyn, in the sort of theatrically flattering fashion that would become characteristic of his passions for certain women artists throughout his life, their appeal to him being more dramatic than sexual. Nicknamed Natasha, she was, as O'Hara described her in "Lament and Chastisement," "a beautiful art student from Stanford . . . who wore black always and tortoise-shell combs; there was beer and Natasha loved Russian rye with anchovy paste." He described her to his parents as "a very attractive girl with brown eyes, brown hair, medium complexion, oh lovely!" He was a bit suspicious, partly because of his susceptibility to his mother's judgment, of an unproductive artiness in some members of the group, vowing "I shall never get to the point where a cocktail table will be

more attractive than a piano or desk." He was impressed with Natasha not only because she was "nice-looking" but because she could sketch and play piano. O'Hara met her only a week before his draft notice arrived with orders to ship out to the South Pacific, but they spent his last night in town together playing duets, building a fire in the fireplace, and seeing *The Canterville Ghost,* with Charles Laughton playing the part of a ghost who haunts an English castle where a group of American GIs are billeted. The young O'Hara, already enamored with the freedoms of San Francisco, whipped his brief acquaintance with Natasha up into a sort of movie romance. "We're going to write," he assured his parents.

Although O'Hara's stay in the booming harbor city had been brief, he was decisively changed by his encounters there. His resolution in Norfolk to be more self-reliant had not greatly enhanced his life, leading him at best to a local performance of a "turgid" Brahms First. But in San Francisco, he was able to attend truly stimulating concerts and exhibits. He followed a trail of tickets and leaflets that eventually led him to the more cultivated Charles Cooper and Natasha Brown, musicians who could share some of his excitement at his recent purchases of sheet music for Hindemith's "Konzertmusik" for piano, brass, and harps and César Franck's "Prélude, choral et fugue." He managed, too, to shake his spells of dejection and homesickness, claiming that he now felt "on the whole more independent, freer, more confident, happier, and more at ease—because I've found I can rely on myself, not only to amuse myself, but to attract new friends." This sensitive boy who had so relied on his family for his emotional sustenance was beginning to realize, though, that as he solved his problems in finding happiness on his own, he was also rendering any true return home impossible. "The trouble is that I may have trouble readjusting myself when I *do* get home," he warned gently, "but I imagine our mutual affection will take care of most of the obstacles."

On February 9, O'Hara arrived at a fenced and guarded pre-embarkation barracks on Treasure Island where he was issued his mess kit, high work shoes, mosquito netting, and a new seabag, while awaiting orders to board ship. His transport was scheduled to make its trip across the Pacific Ocean in twenty-eight days, docking eventually at Manus, a volcanic island of New Guinea that had been occupied by the Japanese from 1942 until 1944 and was now being used as a holding base for sailors about to be deployed in General MacArthur's campaign to conquer the Philippine Islands, and push on to Japan.

"I'll remain in constant communication with you all via telepathy anyhow so we'll never lose touch," O'Hara wrote in his last letter from San Francisco.

Although O'Hara would often think back nostalgically on San Francisco, and joke while stationed in the Philippine Islands that the popular song lyric "carry me back to San Francisco" captured his sentiments exactly, he did not share in the general lamenting on February 28 as the Golden Gate Bridge disappeared off the ship's stern in a morning mist. O'Hara was moved at the sight of Fort Mason, where Colonel Brown, Natasha's father, was stationed. As they sailed past the district of apartments where the Browns lived he soothed himself with the thought that "It isn't as if I were going away forever." All of his usual anguish at separation was evoked this time by Natasha and his friends at the Arts Center rather than by thoughts of his family.

After waiting on the beach for hours until finally being shuttled aboard "like cattle," as one of his fellow sailors described it, O'Hara boarded the U.S.S. *Lurline,* a converted ocean liner. Steaming to the South Pacific at a brisk twenty-eight knots, the *Lurline* traveled without escort, jammed with an overload of sailors and a segregated corps of five hundred WACS waiting to be dropped off in Hawaii. All of the liner's staterooms were packed with bunks stacked four high, and queues for meals looped endlessly through the cafeteria. It was a rough crossing and the long swells of the Pacific Ocean caused a lot of seasickness, with a few sailors always draped over the rails vomiting.

The main attraction of the boat to many of the enlisted men, especially O'Hara, was the sea. Its deck was filled each day with boys escaping their crowded cabins to stare out at it. One friend's comment as he leaned over the rails stuck in O'Hara's memory for years: "I'm a chemist; this is just the blue I used to make things with indigo." O'Hara particularly enjoyed walking the more solitary decks at night, careful not to light up a cigarette—a punishable offense as its flicker might alert an enemy plane. As he described one of these trysts to his parents: "The other night up on deck in the moonlight, with the stars unbelievably bright, and clouds incredibly low, and the boom of the waves and rustle of the foam, very lovely, I thought as usual of you all. It was very pleasant—I felt so very serene and calm and detached. I love the sea now more than I ever did. I hope it doesn't get to wearing off or become boring."

O'Hara's stateroom, with only nine men assigned to it, was less

crowded than most. While four of his companions didn't have much to say, O'Hara claimed that he and the other four often engaged in "heated discussions" about "law, music, Negroes (inevitably?), social problems, socialism, liberalism, government, politics, current events, personal beliefs, morals, sex, industry, labor, Franco, and even Sacco & Vanzetti!" One of his bunkmates enraged O'Hara by arguing that Stravinsky's *Le Sacre du printemps* was "a work of ignorance," but then redeemed himself by reciting almost perfectly a part of one of O'Hara's favorite works, "The Communist Manifesto." These were the sorts of debates O'Hara had been primed for by his living room discussions with his father. He now felt particularly justified in voicing opinions, even if they sounded reckless, because he had been reading an essay by Emerson (included in his 1944 Christmas gift from his Aunt Margaret, *Selected Essays of Ralph Waldo Emerson*), in which, wrote O'Hara, "Emerson says something to the effect that 'I have no patience with consistency. Only a stupid man is consistent!'"

The trip to the South Pacific seemed long, and many of O'Hara's shipmates grew restless. But he managed to keep himself quite busy and absorbed. He read a number of best-selling novels, including W. Somerset Maugham's *The Razor's Edge* and Lillian Smith's *Strange Fruit*, the story of a love affair between a white man and black woman, which had been banned in Boston. He composed two pieces: "Little Dances for Piano" (made up of a waltz, march, sarabande, and polka) and "Rere Regardant," a string quartet based on four passages from Joyce's *Ulysses* in which he was absorbed at the time. He even tried his hand at poetry, although he later told the poet Bill Berkson that his efforts were such failures that he tossed them overboard.

Confined on the U.S.S. *Lurline* in the middle of an immense "great gray tarpaulin" of ocean, cut off from his family, O'Hara arrived at a stronger sense of his own identity and of the importance of the pieces of music and poetry, his own and others, that he had studied and composed. This realization during his sea crossing was powerful enough that he would later describe it with unusual drama as "a second birth." "At this time I reread *Ulysses,* needing to throw up my sensibility and Joyce's art into the face of my surroundings," he wrote in "Lament and Chastisement." "I found that Joyce was more than a match, I was reassured that what was important to me would always be important to me; deprived of music I wrote pieces which turned out to sound something like early Bartok, and I wrote awful poetry compounded of Donne, Whitman and Cummings, which I later destroyed. I found that I myself was my life: it had not occurred to me before; now I knew that

the counters with which I dealt with my life were as valid in unsympathetic surroundings as they had been in sympathetic ones. . . . I had subconsciously felt this, and now I knew it. From that monstrous womb: a second birth."

By the time the U.S.S. *Lurline* arrived at Manus, though, even O'Hara was ready to jump. The remainder of the voyage had been smooth enough, except for a few squalls. The sights had become increasingly tropical and picturesque. Blue-and-white flying fish would "taxi off just like an airplane," sometimes leaping so high they would land on deck. Swirling winds stirred up hundred-feet-high liquid tornadoes called "water devils." But as the weather grew hotter, the ship became smelly, the beds stank, and the men, including O'Hara, who enjoyed clomping around deck in "noisy as heck" wooden sandals he had bought in Norfolk, were forced to bathe only with salt water and special soap.

Manus was an extremely hot jungle island in the Admiralties, which because of its location a mere three degrees south of the equator had neither dusk nor dawn, but rather passed from day to night as quickly as if someone had flipped a light switch. The *Lurline* arrived two weeks ahead of schedule on a March night, and the sailors took notice at the first sighting of the Southern Cross constellation. They were also surprised by the busyness they could see on shore. "When we were on the West Coast everything was blacked out," recalls a radioman who sailed over with O'Hara. "So it was funny when we arrived at Manus, which was lit up like New York City with beacons and searchlights and yardlights. It was a twenty-four-hour operation. Munitions were being transferred to ships on the beach all night long."

O'Hara was assigned to a Quonset hut through which the rains blew during almost daily downpours. All of the sailors were issued doses of a malaria preventative, Atabrine, which O'Hara felt caused him to look "very oriental," and his shaved head, he felt, resembled "a coconut" or "a football with fungus growing on it." If the routine on Manus was round-the-clock, it was still tedious in its repetitiveness, with each day consisting of a predictable cycle, which O'Hara reduced to "watch; chow; shower; nap; chow." He was involved mostly in stockpiling cases in ammunition dumps, which he described in "Lament and Chastisement" as "situated in clearings along a broad dusty highway. Working parties went there for eight hours at a time in the hot sun; everyone blistered ached burnt and was unhappy." This task resulted in the accident recorded in "Ode to Michael Goldberg ('s Birth and Other Births)":

> *warm as we never wanted to be warm, in an ammunition*
> *dump, my foot again crushed (this time by a case of 40 millimeters)*
> *"the*
> *only thing you ever gave New Guinea was your toenail and now*
> *the Australians are taking over"*

As usual, O'Hara seemed more enchanted by the colorful topography of the South Pacific "where the beaches flower with cat-eyes and ear fungus" than he was concerned with the dangers of its tactical significance in the war with Japan. He was particularly alert to tropical animals he had never encountered in New England: scorpions, monkeys, green lizards, plumed birds. The bats he described in a letter home as "wheeling in the air" appeared four years later in "Lament and Chastisement": "bats swooped from flopping trees, knocked coconuts and bumped everything with a squeal of surprise like a mouse's as the sky oozed into the gray bay each night quickly when the sun went out and the flag went down."

O'Hara escaped the card-playing tedium of the hut, which his mates had nicknamed Stumble Inn, by composing music. "He was composing music every free minute he had," recalls O'Hara's bottom bunkmate, Gordon ("Rosey") Rosenlund, a metalworker from Minneapolis to whom he eventually gave his only copy of *Ulysses*. "He was continuously busy writing symphonies up there, in that upper bunk, with these big sheets of music paper around him. I was twenty-four when I joined the Navy so I already had some sand in my boots. Francis appealed to me because he had a quieter and more mature nature than many of these other guys. There were some real characters around. They were noisy and they would get more than their share of beer and wind up tipsy. Some of the younger guys were really filthy in their language, the filthier the language the more they gloried in it. Francis had a clean mouth. He was well-mannered and reserved. He wasn't one of those macho boisterous types."

O'Hara and Rosenlund took in many movies at the base's USO shell up the road from St. John's by the Sea Chapel, "a chapel made of brown wood which smelled almost as bad as the bodies." They saw *Experiment Perilous* with Hedy Lamarr, a Disney cartoon titled *Three Caballeros,* and a film life of Chopin, *A Song to Remember,* which O'Hara was seeing for the third time. These Hollywood features were mixed in with captured Japanese movies and endless newsreels, one of which included a sequence of a GI spitting on a dead enemy's body that only

incensed O'Hara. On Sundays symphonic transcriptions were played for sailors and natives sunning on the benches in front of the shell. In "Lament and Chastisement," O'Hara, quoting Villa-Lobos's description of Bach as "the folk music of the universe," recalled a broadcast of Bach's fourth *Brandenburg* concerto as particularly liberating: "the fourth *Brandenburg* Concerto established a meaning and a synthesis akin to the Elizabethan chain of being; a finger touched a button and lit up the world there all aglare with death suffering struggle defeat in motion and in blinding coherence."

There were savage times, too. One Sunday morning the body of a murdered black mess-cook was discovered slumped in front of his hut. As Gordon Rosenlund recalls, "One of the cooks did try to fool around with one of the Melanesian women and they didn't like that. They dropped off his body one morning, killed, mangled, with his testicles sewn in his mouth." O'Hara never related this incident to his parents, only hinting at such disturbing events when he wrote to his mother that "situations arise that you and dad and your friends, sophisticated as you and they undoubtedly are, cannot imagine." He did eventually express the strange horror of the incident twelve years later in "Ode to Michael Goldberg":

> *in New Guinea a Sunday morning figure*
> *reclining outside his hut in Lamourish languor*
> *and an atabrine-dyed hat like a sick sun*
> *over his ebony land on your way to breakfast*
>
> *he has had his balls sewed into his mouth*
> *by the natives who bleach their hair in urine*
> *and their will; a basketball game and a concert*
> *later if you live to write, it's not all advancing*
> *towards you, he had a killing desire for their women*

O'Hara was growing increasingly bold at expressing new ideas to his parents. These notions, which were stimulated by his demanding reading list as well as by his wartime experiences, were often at odds with the Catholic dogmas he had been taught at St. John's. His reading of *The Magic Mountain* led him to dispute Hans Castorp's preoccupation with death, a preoccupation of Catholicism: "Our religion rather encourages us to picture death as a relief and a refuge, it seems to me as I think of it; and I can't help but think that that is not healthy and

wholesome. . . . why prefer the shadow to the sunlight, water to land? Life with its trials has a zest that a Utopia would never have. I would prefer to believe a little less that this is just a preparation, to lose a little of the attitude Hans Castorp has in the book. . . . It is good not to fear death but I know darn well it is unhealthy to look forward to it as an interesting and enlightening (does information always bring the cat back?) experience." He recommended to his parents an Isak Dinesen story from *Seven Gothic Tales* about a devout churchgoer, Miss Malin, who dies "virga intacta" but spends her last years in delightful reminiscences of her past amorous indiscretions. "And doesn't the church say the thought is sinful?" O'Hara asks rhetorically. To his brother and sister he recommended "This Moment Yearning and Thoughtful," a poem from the Calamus section of Whitman's *Leaves of Grass*, which his parents had sent him as an eighteenth birthday present the previous year: "It's most appropriate for Sunday, and more Christian than many things you'll hear in church. But there I go again." These percolating notions gradually resulted in new behavior. The boy who had been so assiduous about attending Mass and having the priest send home Mass cards suddenly grew lax. "I hope you don't expect such church attendance of me when I get back," he wrote to his parents about their recent "pious" bout of churchgoing.

Such comments sent Katherine O'Hara into a panic. She sensed that she was beginning to lose her oldest son. She blamed the books he was reading—particularly such racy pieces as *Strange Fruit*, and *Seven Gothic Tales*—and seemed to sense that his excitement about them was somehow related to the company he was keeping with those "bohemians" in San Francisco. Her son's rather sarcastic response: "You seem to think that what I believe comes from outside influences, although considering my schooling and contacts I don't see how you could." She was also concerned with what she called his "taste in liquor" and used the well-worn parable of one apple spoiling the barrel to shift the responsibility for his drinking onto his bunkmates. "Because one comes in contact with thieves one is not going to become one is he?" O'Hara countered. "After all, people are not exactly apples. And because a person likes food he does not become a glutton does he? Or liquor a drunkard? Really, now."

Her alarm was not entirely unfounded. The more she tried to control her son from a distance, the more O'Hara realized that he would never be able to satisfy her expectations again. He began to spell out his warnings quite clearly. "I hope you won't be disappointed when I get home again," he wrote, preparing them for his break from childhood.

"You both always think of me as a baby, I know, but you must expect a different person from the one that left. Not essentially, but in detail; more complete or extended, perhaps, if that explains it. . . . there are a few opinions which have been strengthened or corroborated which are not new but which I didn't express; but because of my conclusions I am now ready to express them. You may or may not agree. I don't mean that I may not be wrong, but I hope you'll be able to respect them and to accept the slight changes in me, without loss of affection. You cannot expect me to be a carbon copy of yourselves."

O'Hara was increasingly comfortable with his hutmates. No longer looking forward to a return home as an antidote for his "cycle of moods," he was freer to find some fun in "horseplay, jokes, kidding, arguments." He pursued a government-sponsored correspondence course in English literature, "From Beowulf to Thomas Hardy," and worked absorbedly in his upper bunk on his latest piece, which was titled "Tribute to Afro-Americans." O'Hara didn't seem to mind the claustrophobic quarters filled with the smoke of five-cents-a-pack cigarettes, its walls covered with pin-ups of Vargas girls in bathing suits. One hutmate's decorative contribution, which O'Hara slyly judged as "more realistic" than the pin-up girls, was "a large photograph of a steak, with butter melting over the top as mother serves it."

His newfound ease with a few of these sailors only caused O'Hara redoubled pain when they were eventually transferred out a few weeks before him. At that time his anguish at separating was cued in powerfully. "I know every one of my immediate circle of friends is going to be transferred and I'm not!" he wrote home. "It is so rare to meet *several* people of above ordinary intelligence with common interests and ideas similar to my own. Oh, hell, I don't give a tinker's damn anyway. Every time I leave myself open I get stung and I'll be damned if I'll do it again. Damn this sentimentality of mine." By the next day, however, O'Hara, although passionately declaring that "I can no more resist people than music," had cooled enough to realize that his friendships with these sailors weren't actually so intimate. He tended to magnify—to himself and in his letters home—the importance of casual conversations or shared recreation time in a way that might have surprised some of his buddies had they known. He often mitigated his loneliness by exaggerating gestures of friendship from men to whom he was attracted. "I'm not so friendly with all those fellows as I inferred," he wrote. "My talent, or fault, of dramatization (to substitute from Porgy and Bess—'Sincerity is a sometime thing') can be blamed for it appearing so tragic."

Two weeks later, following news of the death of Franklin Roosevelt, which was met with a hush throughout the camps, O'Hara received his own assignment. On April 22, 1945, he boarded the U.S.S. *Nicholas*, a Seventh Fleet destroyer, which had been built as the first of the Navy's smaller-class fighting ships. Unaffectionately known as "tin cans," they were equipped with torpedo tubes, forty-millimeter guns, radar for shooting down planes at night, and carried about three hundred sailors at a time. Within five days, O'Hara's ship was situated strategically at the Bay of Tarakan, a heart-shaped island off the Dutch, eastern coast of Borneo valued for its oilfields and Japanese airfield sites. On the morning of May 1, the *Nicholas* was part of a covering force for Australian land forces that fired a prelanding bombardment starting at 5:30 a.m.

As O'Hara described the day in "Lament and Chastisement": "Borneo loomed nearby then gaped blue under the spatter of what there is a midget submarine blocking the bay if you're thinking of leaving but the ship ahead just struck a mine and the fiss-fiss-fiss-fiss-fiss-fiss-fiss spewed feathered fans of earth trees bones skyward in the most abstract of designs you wouldn't get me to go ashore thank god for the Australians everything that comes up goes down hoho right on some Australian's head."

The U.S.S. *Nicholas* engaged in a series of such limited bombardments and sweep-up operations. From June 17 until June 25, the destroyer served as part of a covering force in the closing phase of the Okinawa campaign, an assault that, in early May, at the time of the announcement of V-E Day, had been one of the most severe in the war. "When we again went to sea there was Okinawa flashing red," O'Hara recalled in "Lament and Chastisement." From July 3 until August 22, the *Nicholas* operated in a task group replenishing the Third Fleet off Japan, an assignment that seemed to imply eventual combat in an invasion of Japan. All such contingency plans were quickly dropped, however, when an atomic bomb was dropped on Hiroshima on August 6, and another on Nagasaki on August 9, a maneuver from which O'Hara was still recoiling in "Lament and Chastisement": "we killed the great Japanese architect the great German scientist the great Italian musician dropped death on Hiroshima killed killed killed and yes I hate us for it killedkilledkilled."

In its circuitous course through trouble spots from Tarakan to Tokyo Bay, the U.S.S. *Nicholas* had spent many weeks stopping at various liberated ports to help evacuate prisoners of war. These stopovers, including Sendai Bay about five hundred miles north of Tokyo, visited

after the formal surrender, were charted impressionistically by O'Hara
in "Ode to Michael Goldberg":

> *banana brandy in Manila, spidery*
> *steps trailing down onto the rocks of the harbor*
> *and up in the black fir, the*
> *pyramidal whiteness, Genji on the Ginza,*
> *a lavender-kimono-sized*
> *loneliness,*
> *and drifting into my ears off Sendai in the snow Carl*
> *T. Fischer's* Recollections of an Indian Boy

Between ports, O'Hara preferred to sleep on deck rather than in the
hot and humid "racks" below, enjoying the sensation so much that he
joked to his parents that "I probably won't be able to sleep in my bed
when I get back." He recorded the essential poetry of this experience
later in "Lament and Chastisement": "sleeping on the open deck under
the teetering mast which stirred the stars like a finger in a porridge bowl
under showers of soot under the warm wind as the slouching like ghosts
in mist in the straits the islands like slow hippopotami passed until there
was fragrant and fruitful in doe-eyed women and gazelle-legged men
the yellow slush the Philippine rain had slobbered."

While O'Hara didn't tend to tell war stories later in life, any more
than he revealed details about his childhood, he did mention the de-
stroyer *Nicholas* to a few friends, usually dwelling teasingly on its shad-
owed homoeroticism. He confided to Larry Rivers that his nickname
on board had been "Butch," obviously a humorous misnomer as it im-
plies a tough maleness, contrary to the impression made on his Navy
acquaintances or, obversely, was used in slang to refer to women
thought to behave in a masculine manner.

A letter O'Hara received in 1950 from one of his shipmates began
"Dear Butch." "Don't suppose anyone ever calls you Butch anymore,"
O'Hara's buddy from the U.S.S. *Nicholas* continued. "Well it's been a
long time since I've written or heard from you. . . . Now comes the
big question. 'Are you married yet?' Sure hope so for it is a wonderful
life. If you haven't you don't know what you're missing. Butch please
write and tell me about you."

Most of the friends who remember O'Hara discussing his warship
experiences were with him at Harvard in the late forties when the war
was still a fresh topic. "Frank had wonderful memories of life at sea,"

recalls his friend George Montgomery. "He told us that he sat all night in the lap of the gunner." Larry Osgood remembers O'Hara telling of a shore leave where "he and another sailor in uniform got drunk and fell down in the gutter and started kissing and hugging until a Shore Patrolman tapped them and told them to get back to the base." This may be the same story he later told Joe LeSueur. "He said he went around whoring with this guy one night in the Navy but that they couldn't make out," says LeSueur. "Frank stuck with this guy and finally got to do something with him after the whole night was over." According to his Eliot House roommate, Hal Fondren, who had served as a gunner in the Army Air Forces, "Frank talked about having been buddies with someone on his battleship. It was sort of like going steady. It never got sexual, but it was sweet and loving. He didn't talk about it very often. He implied that if there was the slightest hint of homosexuality among the men it was really thought to be quite disgusting. Obviously the relations were basically homosexual but they could never be admitted as such. Frank and I shared stories about war romances where it was never admitted as such by either party." These adventures of O'Hara's tended to be adolescent and romantic and mostly imaginary, closer to the sporadic and furtive liaisons of boys at summer camp than to sexually or emotionally committed affairs.

When he did tell war stories, O'Hara preferred waxing on about his Valentine's Day cards of romantic friendships rather than describing any brushes with battle or death. Not until he wrote about the events of the summer of 1945 in "Ode to Michael Goldberg" was the mixture of the military with the erotic, the constant threat of sudden death with the romantic, expressed:

> *a tangerinelike sullenness in the face of sunrise*
> > *or a dark sinking in the wind on the forecastle*
> *when someone you love hits your head and says "I'd sail with you any*
> > *where, war or no war"*
> *who was about*
> > *to die a tough blond death*
> > > *like a slender blighted palm*
> *in the hurricane's curious hail*
> > > *and the maelstrom of bulldozers*
> > *and metal sinkings,*
> > > *churning the earth*

even under the fathomless death
 below, beneath
 where the one special
 went to be hidden, never to disappear
 not spatial in that way

Standing on deck, observing "huge and ungainly" albatrosses trail-
ing the ship, O'Hara had plenty of spare time to pursue his reading. He
skimmed another best-selling novel banned in Boston, *Forever Amber* by
Kathleen Winsor, but was disappointed: "Does it stink!" More to his
taste was *Lost Weekend* by Charles Jackson, a novel about four days in
the life of an alcoholic that had been released as a movie in 1944 and
had recently won Academy Awards for Best Picture, Best Director
(Billy Wilder), and Best Actor (Ray Milland). O'Hara identified with
the main character and used his discussion of the novel in a letter to his
parents as a means to hint again at the existence of darker possibilities
in his own personality: "It really is interesting and gripping—and be-
cause some facts of the man's character remind us of ourselves (or did
me, anyway) practically terrifying. . . . but still it is a novel of a partic-
ular man with distinct characteristics—artistic leanings (dreams of
being a great pianist—but never took a lesson!), mother complex, ho-
mosexual tendencies, etc. His mind deteriorates right before your eyes.
And what a fine contempt he has for the 'amateur' who can't stand the
smell or sight of liquor the next morning!"

On August 27 the U.S.S. *Nicholas* entered Tokyo Bay. Its assign-
ment was to transfer Japanese emissaries from the destroyer *Hatuzakura*
to the U.S.S. *Missouri* for the formal surrender on September 2. "When
we pulled up alongside the Japanese ship to pick up their officers we
couldn't see anyone aboard," remembers Pete Bouthiette, a shipmate of
O'Hara's. "It looked completely empty. So we manned our loaded guns.
We got almost alongside of it before we finally saw some heads pop
up." The *Nicholas* also shuttled Russian, French, British, and American
officials to the ceremony, including most of General MacArthur's staff.
According to Bouthiette, "The only officer we weren't carrying was
MacArthur. He didn't want to associate with the rest of his officers.
You could overhear the officers complaining about his not coming
aboard with them." It was perhaps this tension surrounding Mac-
Arthur's entrance, as well as O'Hara's own mixed feelings about his
war experiences, that later inspired his 1964 satiric play about the return

of "The General" to the scene of his Pacific triumphs, *The General Returns from One Place to Another.* (As General MacArthur was gravely ill at the time of the play's production—he died a month later—there was a comment in one newspaper about the tastelessness of satirizing the former supreme commander of the Allied powers.)

O'Hara wasn't particularly moved by the ceremony on the "Old Mo," where the same American flag that had flown over the Capitol on the day of the bombing of Pearl Harbor was hoisted over the heads of American generals in khaki uniforms with open-necked shirts, civilians in formal dress with top hats, and a frozen-faced Japanese delegation. Rather than dwelling on the historical resonances of the day, as did the radio announcer with an "emotion-filled voice" whom O'Hara slyly dismissed by remarking, "Well I suppose that life would be very dull if we didn't dramatize it a little," he tended to concentrate on the more theatrical details of the French officers' "gold-braided hat boxes" or the Russian generals so grandly decked out in swords and gold epaulets that he cast them as "musical comedy veterans." He was also aware of the comic touches, such as the *Nicholas* anchorman who nervously heaved a line around a general's neck rather than onto an adjoining ship.

Far more inspiring to O'Hara, though, gazing off across the bay, were the aesthetic reverberations of "a segment of landscape that would be perfect on a vase or parchment." "Looking at the hills and mountains, the foliage, the sloping lines and milky mists, it is easy to see where the Japanese get inspiration for their much-admired paintings," he wrote to his parents from the destroyer *Nicholas,* docked until October 1 in Sagami-wan under the shadow of a cratered Mount Fuji, which he described as having an "unfinished look."

The remainder of O'Hara's term in the Navy was a waiting game.

Having earned the right to wear the Philippine Liberation Campaign ribbon, American Area Campaign medal, Asiatic-Pacific Area Campaign medal with one operation and engagement star, and a World War II Victory medal, O'Hara was shipped in October to Seattle Bay and then to the San Pedro shipyard twenty-five miles south of Los Angeles. There he waited, along with millions of other soldiers, as the military bureaucracy slowly processed the papers that would shrink the American forces over the year from 11 million to 1 million. During this interlude he visited the orange groves "(ripe too!)" of the San Bernardino Valley and took shore leaves in Los Angeles, where he attended a

range of concerts from the opening night of Johnny Grier's band at the Biltmore Bowl to the Pro Arte Quartet's performance of three quartets by Schubert, Schoenberg, and Beethoven.

> *to the orange covered*
> *slopes where a big hill was moving in*
> *on LA and other stars were strolling*
> *in shorts down palm-stacked horse-walks*

O'Hara and his roommate in later years, Joe LeSueur, discovered that they had probably attended the same concert during a shore leave of O'Hara's in 1946. "One night Frank was saying he loved every piano concerto ever written," recalls LeSueur of a conversation in 1959 after having watched *A Woman's Face* on the Late Late Show at a friend's. "He was mimicking Joan Crawford when she announces to Conrad Veidt that she likes 'some symphonies and all piano concertos.' So I said, 'I bet there's one concerto you've never heard, the Pan-American Piano Concerto by Roy Harris.' 'I have too,' he said. 'I heard his wife, Joanna Harris, play it at the Wilshire-Ebell in Los Angeles in 1946.' Well I had been there that night. I went with a girl, and I did remember looking up and seeing a sailor sitting in the balcony!"

On June 2, 1946, O'Hara received his separation papers at the Personnel Intake Station in San Pedro, California. He then boarded a train at Long Beach, California, for the cross-country trip. This train trip—or a collage of this trip with previous trips to and from Boston on a brief Christmas leave in 1945—is evoked in "Ode to Michael Goldberg":

> *eight o'clock in the dining car*
> > *of the*
> *20th Century Limited (express)*
> > *and its noisy blast passing buttes to be*
> *Atchison-Topeka-Santa Fé, Baltimore and Ohio (Cumberland),*
> > *leaving*
> *beds in Long Beach for beds in Boston, via C- (D,B,) 47 (6)*

On the surface O'Hara's homecoming was smooth as he settled again into his rear bedroom with its red rug. As he had written to his parents from the Admiralties, "What could be more satisfying than a

red rug??" The only immediate evidence of any stress from having served on a warship was his insistence that his mother give away her yellow canary to friends on Worcester Street who had other canaries because its chirping was so close in pitch to the sounds emitted by sonar equipment. "It was a great concession for my mother," remembers Philip O'Hara. "But that canary was gone the next day."

O'Hara was struggling privately, however, with his attempt to adjust at home after achieving a measure of adult independence. "It's independence I want," he had written to his parents from Los Angeles in January. "There are things I must learn for myself and undoubtedly they will hurt—but not forever. I'd rather be hurt than stunted anyhow. And besides—perhaps the worst has already happened! It hasn't killed me yet. Very few things will shock me, I'm afraid."

O'Hara described the disorienting experience of returning home more trenchantly in a letter written to a classmate from Harvard in 1950. "This finality is actually better than when I left the Navy," he wrote of his graduation, "because I am going to a place of my choice, whereas then I had to go home, and it upset me terribly because I first in the Navy managed to establish my identity with real people and situations, rather than depend on the context of a piano or a vide papier to enable me to manage it, and upon discharge I had to return home like a prodigal who has done many evil things only to find that his parents didn't even hear about them!"

O'Hara again expressed this feeling of displacement on returning to Grafton in "Ode to Michael Goldberg":

> to "return" safe who will never feel safe

Harvard

One afternoon in the spring of 1946, O'Hara was lounging in his company barracks in San Pedro with a fellow sonarman, Douglas ("Dippy") Starr. Their conversation turned, as it often had that season, to the G.I. Bill of Rights, passed by Congress in 1944, providing four years of college education for veterans. O'Hara, unlike most of his fellow sailors, who were singularly pleased with the windfall, was wary. He had been impressed with an article he had read in the *Saturday Evening Post* by President Hutchins of the University of Chicago claiming that the bill would turn some colleges into "educational hobo jungles." He also was suspicious of a bandwagon mood in the country that assumed "education is the solution to all problems." After mulling over the list of schools each was considering, O'Hara shot off a piece of characteristic advice that was to lodge in Starr's memory for years to come. "It's not the education that's important," asserted O'Hara, with the mature self-confidence that had earned him a reputation on ship as someone to come to with one's problems. "It's what you do with it that counts."

O'Hara's own plan was to study music, hoping later to teach or compose. His first idea was simply to live at home in Grafton and commute to the New England Conservatory to continue his studies with Margaret Mason. He claimed, quite earnestly, that "For now I like the idea of a small school and few social interruptions." But as the empty weeks on Terminal Island added up, he had many free hours to begin to consider various music schools connected to larger universities, such as the Eastman School at Rochester (where he feared he might flunk entrance exams in counterpoint, harmony, and theory), Juilliard in New York City, and the Curtis Institute in Philadelphia. He even toyed with the notion of apprenticeships with the Koussevitzky Summer School at Tanglewood or the Casadesus group in Connecticut.

Deciding on a school forced O'Hara, briefly liberated by the war from daily family pressures, to deal once again with his parents' and various aunts' plans for his future. His father, who had cast the deciding vote in allowing his son to study at the New England Conservatory during his high school years, was adamantly opposed to his pursuit of a degree at such a specialized school. He argued, instead, for colleges with more general liberal arts programs. Russell O'Hara's first choice for his son was his own alma mater, Holy Cross, a choice that during one telephone discussion caused an outburst between them. O'Hara cleverly pointed out that "Naturally it is out of the question for me because it doesn't have a music department." Even more out of the question was the suggestion of his Aunt Mary, sequestered in her convent in Springfield, Massachusetts, who sent her nephew a booklet about vocations and expressed her opinion that he was destined for the priesthood. O'Hara, increasingly unsympathetic with Catholic piety, sarcastically wrote to his parents that "If so, it looks like this is one occasion where destiny loses out. Eh?" The influence of his Aunt Margaret, whom Phil Charron described as "his authority, he quoted her often," was the strongest. At her nephew's request she had mailed him catalogues for Rochester, Cornell, Chicago, and Columbia universities, but she had slipped in as well a catalogue for Harvard, her own first choice for Francis's matriculation. Kay O'Hara, too, liked the notion of Harvard, as much, perhaps, for its social aura as for the sophisticated academics that had attracted her sister Margaret. So she began to lobby at home for her son to attend, if accepted. "I think my father would have preferred that he go to a Catholic school for college," remembers Philip O'Hara. "My mother did yeoman's work to get Francis to go to Harvard over my father's wishes."

O'Hara was skeptical at first about his chances of acceptance at Har-

vard as he had been notified by mail that the college was accepting only
10 percent of all applicants that year. "Not much hope there, I suppose,"
he wrote home. He did, however, fill out the school's questionnaires.
Harvard's music department satisfied his own needs, and its more gen-
eral classical courses, his father's. While still on board the *Nicholas,*
O'Hara had read and heavily annotated *On Harmony,* a basic textbook
written by Walter Piston, the chairman of Harvard's music department,
who would receive a Pulitzer Prize in 1948 for his Third Symphony.

But O'Hara did not fix on Harvard. He preferred to use his free
hours, perhaps because there were so many, to make sometimes fickle
calculations on the pluses and minuses of different schools. While in Los
Angeles he had also read Paul Hindemith's *The Craft of Musical Com-
position* and *A Concentrated Course in Traditional Harmony.* He was tempted
to apply to Yale, where Hindemith was teaching, but felt put off by its
quota system: "Their policies as an institution are odious to me." Even-
tually he also "mentally" crossed Cornell "off the list" as it cost three
hundred dollars in expenses above government aid; dismissed Teachers
College at Columbia as "too specialized"; and even grew suspicious of
the Eastman School of Music, which had been "nip and tuck" with
Harvard College, when he discovered that "some of the composers on
its faculty are practically chauvinistic in their negation of all European
influences." The New England Conservatory fared better in his opinion
because of its more "international," less "emphatically American," mu-
sical allegiances.

Upon his return to Grafton in June, O'Hara did finally apply to
Harvard, taking the requisite aptitude tests in early July in which he
scored a somewhat dichotomous 700 in Verbal and 483 in Math. He
attended a personal interview on July 8 in which his interviewer rated
him *A,* described him as "a very likeable fellow as well as a musician,"
and noted that the applicant "was attracted to Harvard always because
of Walter Piston in Music." The only exceptional piece in O'Hara's oth-
erwise standard application package was his required essay on "Service
Experience." In it he detailed his progress from boot camp, "probably
the most depressing months of my life," through the "'do as little as
possible' attitude the Receiving Stations I had been stationed on had led
me to believe was the Navy viewpoint," to the U.S.S. *Nicholas* where
he found himself assigned duties he felt he could "get his teeth into" as
part of a unit involved in the formal surrender, which "instilled a keen
feeling about the peace in every member of the crew." The punch of
the essay, though, was its fiery and quite self-assured denouncement of
militarism, which gives a sense of the sorts of unorthodox remarks that

were making his father increasingly exasperated with his son during this homecoming phase: "Watching the botching of Military Governments, the crippling of the U.N., the ineffectual expediency of our national policies, and the mishandling of the Atomic Bomb, has been a bitter experience for all of us, and almost to a man we all waited for discharge. . . . The months of waiting for discharge in a state of near-inertia served to clarify issues, consolidate standards. It is often necessary to experience to realize fully: my disillusionment with militarism is no longer instinctual, or a matter of principle only, and is a strong spur to achievement in civilian life."

On July 24, the Committee on Admissions invited O'Hara to matriculate in September, and he accepted. While his attitude toward the G.I. Bill had been idiosyncratic and his bitterness toward militarism more extreme than that of many of his shipmates, O'Hara's compulsion to seize the day was shared by most returning veterans. He wasn't interested in acquiring "polish" or "school spirit," but rather in exhausting the facilities at his disposal to pursue his musical composition and writing: "I must specialize and fast." It was this unleashed ambition, so evident in O'Hara, that was to galvanize Harvard and many other college campuses across America during the postwar era.

"It is very well to emphasize liberality for seventeeners who can develop a social philosophy and appreciate the classics in a leisurely way," he wrote to his parents. "But I have a social philosophy of parts and 'I think I'd better hurry or I'll be too late!'"

In 1946, you might as well have been living in an American Legion post as in one of the houses."

Such was the characterization in the 1950 *Harvard Yearbook* of the hectic and disorienting situation on campus when Francis O'Hara joined almost four thousand returning veterans filing three-a-minute through a registration checkpoint at Memorial Hall. This sizable influx of veterans, constituting 71 percent of all students and pushing the total enrollment of Harvard College up to a record 5,435, radically changed the appearance of the Ivy League campus that third week in September. The traditional prewar Harvard ceremony of seventeen-year-old beardless youths arriving in the Yard from select preparatory high schools in the Northeast, dressed in white bucks, unloading Vuitton bags from the backs of their convertibles, was lost in a surge of new, and often older, faces searching for their assigned rooms in squat red brick dormitories toward the north end that were reserved for veterans. (Veterans were

soon given priority to be moved as soon as possible to rooms in the posher upperclassmen houses located mostly along the Charles River, while nonveteran freshmen were sometimes required to spend two years, rather than one, in the Yard.) Double-deckers were moved into dorms to accommodate extra roommates, although even then a certain number of latecomers were forced to sleep on cots, shipboard fashion, in the Indoor Athletic Building basketball court. Lines formed everywhere—to eat, to cash checks, to receive Veterans' Administration book authorizations. As the term began, seats on windowsills or in aisles were at a premium at choice lectures. The school newspaper, the Harvard *Crimson,* predictably kept referring to this turbulence as a "siege" or "invasion."

The transition from prewar to postwar Harvard was hardly abrupt, however. As so many of its students' lives had been disrupted by World War II, so the university had been gradually yet indelibly transformed. During the war Harvard had been nicknamed "Annapolis on the Charles" as it played host to thirteen Army-Navy service schools training over sixty thousand officers and enlisted men. Eighty of the university's science laboratories, policed by solemn guards, were turned over for military research to the Office of Scientific Research and Development of which Harvard's President Conant was a member. The university converted to a trimester to comply more smoothly with military scheduling, while its civilian students, dwindling in number, were confined to two houses: Lowell and Adams. V-12, a Naval officers' training program, bivouacked a number of its officers-in-training in Eliot House, including the young Robert Kennedy. Besides moving washers and dryers into the grill, draping P.A. speakers from the courtyard lights, and pruning back a mascot of a willow tree for marching purposes, the Navy transformed Eliot's formal dining room, formerly staffed by waitresses and purveying the atmosphere of a fairly decent restaurant, into a self-service cafeteria with gray metal trays. This alteration was allowed to stand after the war, much to the displeasure of certain returning students nostalgic for earlier, more gentlemanly dining habits.

The dress of the freshmen arriving that fall was a constant reminder of the transition under way. Jackets and ties were required in the Union, the freshman dining hall across Quincy Street, and so tended to be worn to classes. Yet as white shirts and blazers had been discontinued by most manufacturers during the war, many veterans had to concoct suitable attire by wearing their military-issue khaki trousers, service coats cut down to hip length, and old service shirts with the rank re-

moved. O'Hara blended in with his blue Navy workshirts. By the spring term most veterans had acquired proper Brooks Brothers–style clothing, although one classmate recalls seeing O'Hara often walking about campus in later years in his blue workshirt and tan chinos, by then a statement of nonconformity.

While some returning veterans were disgruntled by what they felt to be a "conveyor-belt diploma-mill" mentality at Harvard, with its new policies of compulsory attendance, roll call, even limited-access cards to Widener Library, these concessions to the postwar crunch seemed more than balanced by the intensity and decisiveness of its added students. "They knew what they wanted as had no other generation in the recent past," judged the 1950 *Harvard Yearbook,* an assessment corroborated by Frederick English (Class of '51), who claimed that "a great exuberance disappeared when the Class of '50 departed." Postwar Harvard proved itself to be a seeding ground for important leaders in the next few decades of American political life. Henry Kissinger was a classmate of O'Hara's. As was Daniel Ellsberg, later involved in the Pentagon Papers scandal, who, while an editor of the literary magazine, the *Harvard Advocate,* reviewed the first production of O'Hara's play *Try! Try!* at the Poets Theatre in 1951. Both Arthur Schlesinger, Sr., and Arthur Schlesinger, Jr. (Class of '38), were teaching in the History Department. A highlight of that first fall was a campaign speech by congressional hopeful John F. Kennedy (Class of '40) delivered in Central Square, Cambridge, from the roof of a beat-up black Ford by the Navy veteran still yellowed with an Atabrine tan and discomforted by a back injury suffered on PT-109. His candidacy was treated a bit flippantly by the *Crimson,* which headlined its article on the event: "Earnest, Issue-sly, Joe Kennedy's Boy Glad-Hands Way to Congress."

Equally charged was the Cambridge literary scene, enough so that O'Hara's creative writing instructor, the poet John Ciardi, could write a "Letter from Harvard" for *Poetry* magazine. Among the poets studying at Harvard in the late forties were Robert Bly, Robert Creeley, Donald Hall, John Ashbery, Kenneth Koch, and Adrienne Rich. Fiction writers included John Hawkes, Harold Brodkey, John Updike, and Alison Lurie. Richard Wilbur, then a Junior Fellow, and Richard Eberhart were both living in Cambridge, as was Robert Frost (Class of '01), who tended to make his home there in the spring and fall. Crucial to the sense of poetry as a living concern on campus was the university's Morris Gray Readings series, which sponsored poetry readings during O'Hara's four years by Wallace Stevens, Marianne Moore, Dylan Thomas, Edith Sitwell, Robert Frost, Archibald MacLeish, and Stephen

Spender. Perhaps the best-attended of these events was a reading by T. S. Eliot during O'Hara's freshman year to an audience in Sanders Theatre so overflowing that most students had to listen to his words as they were piped into other parts of Memorial Hall. Eliot (Class of '10) felt moved to comment that evening on the postwar mood on campus. "Nobody ever seems to stop working. It was certainly not like that in my day," he said, suggesting that the students were part of a new "worried generation." "I don't mean to suggest," he added, smilingly, "that there isn't plenty to worry about."

O'Hara made his way through this charged atmosphere at first rather quietly and independently, exhibiting the self-reliance he had learned in the Navy. His initial room assignment was Room B-21 in Mower Hall, a three-story red brick dormitory in the north end of Harvard Yard filled mostly with veterans. When asked in his application to specify any qualities he might prefer in a roommate, O'Hara, after filling in the requisite blank as to whether he was "white or colored," had written in "I have no preference as to religion, race, or section but would prefer a roommate whose interests were somewhat similar to mine." Given the crowding and chaos at Harvard that semester, not too much attention was paid to careful roommate matching, although O'Hara and one of his roommates, Jim McGovern, were somewhat compatible. McGovern, an aspiring writer from New York City, tended to sit at his typewriter with a cigarette hanging from his mouth knocking out short stories in the style of John O'Hara. Although McGovern never loomed largely in O'Hara's life, the two did share enough musical interests to sit together on at least one Saturday evening listening to Hindemith, Berg, and Stravinsky on a record player borrowed from a mutual friend, Dalbin Bindra, a teaching fellow in psychology from India. The other bedrooms of the quadruple suite, kept clean by one of Harvard's maids, were occupied by two other first-year returning veterans—Spiros Paras, a science major, and Arthur Gartaganis, a math major. The four roommates did not mix very often during this intense first semester, described by Paras as "all work and no play."

O'Hara still found it amazing that he was at Harvard at all. A mere three months before he had been an enlisted man on the U.S.S. *Nicholas* who, without the G.I. Bill, would never have been able to afford Harvard's steep fees. Yet not all of the nuances of the school pleased him. O'Hara couldn't help but feel the pressure of the elitism of Harvard. It was the one drawback he indicated to his parents when he complained, "as if merely going to a place means anything to anyone except *snobs*." In his case his Irish-Catholic background pigeonholed him. Although

Irish Catholics had been the first minority admitted to Harvard in the 1870s there had always been a subtle rivalry between Protestants and Catholics of which a strong residue remained if only in the form of drinking contests. While the number of veterans on campus clouded some of these distinctions, O'Hara, as a new arrival from a small Massachusetts farm town and the graduate of a parochial high school, would have been considered a bit of an ethnic. One acquaintance described the young O'Hara, on first glance, as having looked "potato Irish, lower class, with pasty skin." Another, who observed him in a class they took together, recalls him as "this small, thin, angry, sentimental Irish boy from a hick town." O'Hara was kidded often enough at dinner for coming from "Asshole." That he saw his Irish Catholicism as somehow antonymous with Harvard is evident in a joking remark he made in Grafton to his childhood friend, Phil Charron. "Oh I'm going to Harvard," he announced. "They say it's the death knell of all Catholics." O'Hara coped with any social fencing he felt to be beneath him by going his own way, as he had in the Navy. In the course of his four years at Harvard, however, he would gradually develop a personal style, using certain arch Angloisms, which became simultaneously an achievement of the WASP culture implicit in some of these traditional attitudes and its send-up.

During his first semester O'Hara's schedule was filled with the standard introductory courses: English A, the English composition course taught from a basic textbook, *Five Kinds of Writing,* which he enlivened by writing a two-thousand-word essay on Gertrude Stein, whose *Autobiography of Alice B. Toklas* he had described to his parents as "one of the most interesting things I've ever read by anyone"; Elementary German, a required language course in which a fellow student recalls O'Hara as having "practically died in the struggle, as did everyone who took German as their language requirement"; Elementary Psychology, taught by Professor Boring, who had written servicemen's psychology manuals for the War Department and had served as Director of the Psychology Laboratories for twenty-five years; Elementary Harmony with Assistant Professor Irving Fine, whom Stravinsky once referred to as "my son" and who had studied with Nadia Boulanger in New York and Paris in 1938 and 1939, showing an internationalism that appealed to O'Hara.

O'Hara worked quite intensively on these courses his first term. This was his chance, after all, to carry through finally on all the ambitious resolutions he had made while lying restlessly on his bunk in San Pedro. As he had written then so decisively to his parents: "No more

late nights, postponed studies, disregarded opportunities, or interrupting school with social stuff. Anything that interferes with my work goes *out* once I get started." After spending a fall weekend at Wellesley with his attractive, rather eccentric friend from Grafton, Elsa Ekblaw, he had worried to his parents, "I was a little afraid that I should have stayed here and studied."

Yet O'Hara's interests—as he listed them in his application, "music, philosophy, literature, psychology, art"—soon led him beyond the guidelines of his own course list. In the Navy O'Hara had been known as a "refined" talker on matters he cared about, especially music, but few of his shipmates could keep up with his pronouncements on the superiority of piano concertos to symphonies. At Harvard O'Hara began to meet friends who could catch his clever references and liked him for making them. One evening he walked over to Mower to discuss music with another student in his harmony class, Marvin Minsky, later to be dubbed "the father of artificial intelligence" for his work with computers. During their talk he noticed that Minsky's roommate, Jerome Rubenstein of St. Louis, owned a volume of the poems of Federico García Lorca. O'Hara excitedly launched into a quite knowledgeable discussion of the works of the Spanish poet and so earned the casual friendship of an impressed Rubenstein for the next four years.

During fall term, O'Hara's pent-up curiosity was always propelling him to sit in on courses for which he never officially registered. "This was the age of the bravura lecture," writes Alison Lurie of Harvard at the time, "and we went to our classes as if to a combination of theatrical performance, sermon and political oration—to be entertained and inspired as well as informed." The most obvious draw for O'Hara was Harry Levin's course Joyce, Mann and Proust, considered daringly, even shockingly, modern by some. The young Levin, cultivating a fashionable mustache and dressed inevitably in a three-piece suit, taught, as Lurie put it, with "scholarly brilliance and elegant flair." O'Hara had already read the three titular authors—he had bought Proust's *Remembrance of Things Past* in Key West at his Aunt Margaret's suggestion—but his prime interest remained Joyce so that he confined his book purchases for the course to Levin's *James Joyce, A Critical Introduction* as well as an ancillary *Skeleton Key to Finnegans Wake*. He had read through Joyce's *Exiles* during the summer in Grafton and his Aunt Margaret had recently presented him with *Stephen Hero*. Levin's animated lectures, along with the blur of his own readings of Joyce and teenage musical compositions based on *Ulysses,* were crystallized by O'Hara into one of the three slight poems he wrote that semester, "A Portrait of James

Joyce," which begins as a sort of parody of the style of *Finnegans Wake*: "riverrun, said jute, oh why the enterrential / faggus?" (The other two poems, "Dialogue for Man, Woman & Chorus of Frogs" and "The Highway" also played with aural surfaces of words from various periods and dialects in a Joycean manner.)

Not since San Francisco had O'Hara been as stimulated as he was during these first few months. Cambridge in the heady postwar days, its lilac-shaded, cobbled streets lined with gray eighteenth-century or Victorian Gothic houses, was indeed filled with some of the same warmth and confusion, the air of suddenly having been benignly invaded, as the wartime San Francisco through which O'Hara had made his way as a Shore Patrolman. There were clubby bookstores such as Grolier's on Plympton Street where he purchased *The Complete Poems of William Carlos Williams* and Eliot's *Four Quartets*; art movie theatres such as the Exeter in Boston, which that fall screened Noël Coward's *Brief Encounter* with Rachmaninoff's Second Piano Concerto as its theme music; and the Fogg Art Museum across from the Yard with an impressive gallery of European paintings and renowned series of lectures, including Professor Post's art history course on Venetian painting, which O'Hara was to faithfully attend—again not registered—three years later. Clipping his way through the busy neon bustle of Harvard Square with its glaring street-lamps, sizzle of overhead wires, and billboards advertising Royal Crown Par-T-Pak Beverages, O'Hara was always alertly taking note of flyers tacked to bulletin boards or posters glued on the dark brick walls up and down Massachusetts Avenue, searching for leads, as he had in San Francisco when he discovered a folder for the Servicemen's Arts Center at an art museum he happened to be visiting.

O'Hara's attention was usually caught first by announcements of musical performances, both in Cambridge and in Boston just across the Charles River. As a music major, he kept up assiduously with concerts given by the Music Club. In letters to his parents prior to his Christmas vacation he informed them that he had attended a performance of Darius Milhaud's Sonata for Violin and Harpsichord at Jordan Hall, was planning to go to the Music Building to hear two different sonatas for two pianos, one by Stravinsky and another by Alexei Haieff, as well as a new composition by a junior in the department, and that he would be staying on campus an extra few days at the end of term because "Sat. nite I plan to go to the Symphony by hook or crook. Darius Milhaud is here to conduct his *Suite Français* and *Symphony No.2!*" (The Boston Symphony's importance in current musical affairs was evident from its

premiere that October of Copland's Third Symphony conducted by Koussevitzky.) He followed the Harvard-Radcliffe Choral Society, which had performed at Sanders Theatre and Wellesley in November, and he was planning to return to campus from Grafton in time for an all-Hindemith concert to be given by the Music Club on January 9. The freshman O'Hara, with his boyish, percolating energy, away from home again after a few summer months of trying unsuccessfully to squeeze back into his family's mold, had finally found a place with enough artistic brio to sustain his high-spiritedness.

This much-anticipated time of expanding his horizons was abruptly cut short, however, never to be resumed with quite the same innocence, by a phone call O'Hara received on the evening of January 22 in Mower Hall where he had returned to study for his final exam in Psychology. His father had died suddenly and unexpectedly at the age of forty-eight of a heart attack at the Waskanut Bowling Alley in South Grafton. His Uncle Leonard would be driving up to Harvard Yard to pick him up in the morning and return him to Grafton for the two days of waking to come. O'Hara began to take in bits of the story from his mother, from Mary Guerin, the housekeeper, and from his Uncle Leonard as he drove with him on a cold winter morning over the familiar highway home.

O'Hara heard that his father had gone the previous day to the doctor who had told him he was in good health but added, "Tell Mary to put your food on a plate. Not all out on the table. You're eating too much." Russell O'Hara had joked a few hours later at supper, "I'll have my banana cream pie tonight but then I guess I won't be having any more for a while." That night at the bowling alley he had turned, falteringly, to one of his partners, and said, "You take my turn. I feel kind of funny. I'll get a Coke or something." On his way to the soda concession he had keeled over, dead. A policeman and a priest had knocked on Kay's door. She knew something was wrong the instant she saw their grim faces. "When you see the priest you always know," said the housekeeper with her folkish wisdom. Kay had walked into the bathroom, slammed the door shut, and screamed, "I loved him so much and they took him away from me!" She was taking it all very badly and carrying on terribly. She had called up Madeleine Warren, Sally's mother, across the street, and cried, "I don't know what I'm going to tell the children." Phil, thirteen—the same age his father had been when his grandfather died of a heart attack—discovered what had happened when he walked downstairs at dawn to feed his pets only to find the front room filled with cigarette smoke and adults murmuring in hushed tones around his mother. Phil's reaction was to race down to the barn where he pulled

on his father's boots and overalls and sat at his father's desk beneath the painting of the Kentucky walking horse while the farm hands Jimmy and Chili Whitney cried in chorus on two milking stools.

By the time O'Hara walked up the front steps to 16 North Street he could already feel the heavy atmosphere of family tragedy and Irish-Catholic mourning which he would experience for the next three days. The body had arrived at the house at noon, brought by undertakers Thomas Reilly & Sons of Westboro, and was laid out in an open casket on a bier in the front room with a number of tall floor candles burning nearby. The room was perfumed with the sweet smell of the elaborate bouquets of sympathy flowers that had already begun arriving. The music room, where Russell had played piano every evening, had been converted into a smoking room with folding chairs for guests, and the dining room table was kept fully stocked by neighbors with food and liquor. As was the custom, family members took turns sitting with the body, or praying at the tiny altar set up near the bier, through the empty hours of the night. Because of Russell O'Hara's popularity at Holy Cross and St. Philip's Church, there were plenty of visiting priests to give a religious cast to the rituals of mourning. "I don't think there was an hour when there wasn't a priest there," remembers Philip O'Hara. "There'd be prayers every so often during the day. I spent a lot of time down there kneeling, or standing and looking at him, not understanding any part of it."

O'Hara's own involvement in these ceremonies was odd and unexpected. He broke the news of their father's death to his little sister with his usual love and big-brotherly compassion. He was there at quiet times to bolster his mother. But given the tendency in his letters home from the Navy to usurp his father's role in trying to shape and support his family from afar, O'Hara shied away on this occasion from being the strong figure around whom everyone could gather. He showed no interest in sharing his grief with the neighbors, relatives, and priests who were milling about at all hours on the first floor. It seemed he had taken to heart his own observation to his father a year earlier, "It's odd how soon one can outgrow a place and with it the people one knew there. . . . How do you explain that, Dad?" O'Hara dealt with his mesh of contradictory feelings in a dramatically private manner. "Frank went directly to his room, which was in the back of the house, and nobody really saw him," recalls his brother. "He went up there and he didn't come out. I don't remember seeing him until the next day. Everybody was saying, 'Where's Francis? What happened to Francis?' We would check on him and he was always in his room. Then he just broke

out crying. You could hear him from downstairs. He just sobbed uncontrollably."

The bedroom to which O'Hara withdrew had remained largely untouched since his high school days, its walls covered with posters of paintings by Gauguin and Rousseau, its bookcases neatly crammed with books. The bathroom, used by Russell O'Hara for shaving in the mornings, still contained his father's long leather strop for sharpening razors. The room, the house, the view of the pine tree through the window, the sounds of adults talking downstairs, all were familiar cues that brought back memories. Certainly, for all his contrariness, O'Hara had been very close to his father. As Genevieve Kennedy, a friend of O'Hara's from Grafton, explained, "His father was a very kind man. I think that Frank got his kindness and gentleness from his father. And he got his creativity from his mother who was a very high-strung woman." Russell O'Hara's death unfortunately came at a moment of high-pitched tension. O'Hara's decision to go to Harvard, his dismissal of the teachings of the Catholic Church, his flirtations with Communist thinking, and his youthful urge to strike out on his own, an urge made more pressing by his experiences in the Navy and by his unspoken awareness of an even more threatening homosexuality, only exacerbated the traditional father-son conflict. The vociferous tone of O'Hara's protests can be heard in a letter from San Pedro beginning, "Dear Dad, You and I have a slightly different attitude toward a rather basic thing: the world. . . . As the nuns used to remark, quoting Wordsworth, 'The world is too much with us.' But it is our natural habitat and is not rejection of it cowardice or laziness of one kind or another?" His father did not take kindly to such remarks, or perhaps merely to the strident tone in which they were delivered, as O'Hara's letter home after his Christmas leave of 1945 makes clear: "I sensed while I was at home that my suremindedness on some subjects annoyed you. I hope you have gotten over it by now. I had a feeling that you would prefer my being hesitantly agreeable, rather than sure and disagreeing. Am I right?" That their differences had not been resolved only made O'Hara's grief more inconsolable.

The drone of prayers and the clicking of rosary beads from the downstairs parlor, which had been transformed into a ghostly antechamber to the world beyond, held little solace for O'Hara. Although he had recently described himself as Roman Catholic in the appropriate blank on his Harvard admission application, he had over the previous year been consistently striking a renegade stance toward the Church, based in large part on the attitudes toward death, life, and the afterlife

implicit in these funeral ceremonies. Soon after his Great-Aunt Elizabeth's death in 1944 he had written disapprovingly to his mother, "You're not going to stay in black, are you, Mum?" The prayers being recited by the priests in the front room to welcome his father's soul into heaven seemed irritating rather than comforting to O'Hara, caught by this untimely death thinking thoughts about life and death quite different from those taught to him by another group of men in black cassocks at St. John's.

On Saturday morning, O'Hara, with the rest of his family, rose early and gathered downstairs in the front room for a private ceremony at the side of the casket. They then made their way on the sunny but cold morning, as they had every Sunday morning with Russell O'Hara always at the wheel, to St. Philip's Church. "Kay looked in another world as she came in supported by Fran," nineteen-year-old Phil Charron wrote in his diary that day. "Very pitiful and poignant." Following High Mass, its loveliest moments the boy's voice of Billy Cahill rendering "Ave Maria" and "Panis Angelicus," the mourners moved on to St. Philip's Cemetery for the interment, where prayers were read in Latin beside Russell O'Hara's grave. Near his freshly shoveled plot on a knoll overlooking Millbury Street rose the gravestones of other members of the O'Hara and Donahue families, including his father, John P. O'Hara (1857–1912), his mother, Mary E. Donahue O'Hara (1858–1940), his Uncle J. Frank Donahue (1869–1931), and his Aunt Elizabeth J. Donahue Reid (1867–1944). With the exception of his brief stay in Baltimore, Russell O'Hara had never wandered far from this clannish fold.

After a buffet luncheon at North Street, prepared by Mary Guerin, Francis made his excuses and departed again for Harvard. It was an awkward moment, but as his mother was supported by such a close group of family members, including Aunt Grace who offered to move in temporarily to ease the transition, O'Hara's leavetaking did not register harshly. He was diffidently polite to the guests, but the focus of his feelings was obviously elsewhere. A few hours later, having reacclimated himself to the campus, O'Hara was moved by the inner pressure of his loss, as well as by the wintriness of Harvard Yard, its leafless trees like so many tall scarecrows through which only more cold brick buildings were visible, to write "Solstice," a melancholy poem in which the true subject, his father's death, was cloaked in a Renaissance conceit trimmed with square quatrains and regular end-rhymes:

> *The waning star*
> *falls wanly to*

> *the planets are*
> *no vivid hue.*

(When O'Hara came to write "To My Dead Father" six years later he again used quatrains, a conservative form he perhaps associated with his relatively conservative father.) O'Hara was more comfortable pouring his grief into this little poem than he had been fielding condolences. As he had once written of his privateness to his parents, "It always amuses me when someone remarks how well they know me; throughout my life my most cherished wishes have been my most secret (simply because to share is to spoil in many cases) ones." As the following year progressed, O'Hara would start expressing these secret feelings more at his typewriter and less at the piano, so that while he had written only three poems in 1946, he was to write thirty in 1947. Significantly, piano-playing and political discussions, activities so much associated by O'Hara with childhood and his father, began to wane in importance after his father's death to be gradually replaced by poetry and his new identity as a poet.

The most immediate change for O'Hara as he entered his second term was his reassignment as a veteran, along with three roommates, to Eliot House. O'Hara was pleased to be moved to this great five-story pink brick Georgian building constructed around a hexagonal courtyard, its Greek dome supported by tall white Corinthian columns, its most coveted suites affording slanted views of the airy, if often chilly, Charles River on which they fronted. O'Hara's room that spring semester was J-21, a corner triple suite cramped by the presence of one extra roommate. Every evening he would join his peers filing past a steam table in their somewhat feudal dining hall with its dark oak paneling and tall windows that looked out on the sawed-off weeping willow in the court, or perusing the volumes in a house library still strong in history and literature after three years of Navy borrowing, or listening to classical LPs on the new LP attachment to the phonograph in the music room in C entry. On rare spring days, the lock on the gate to Memorial Drive was open and O'Hara was able to walk directly down to the river for sunbathing, one of his favorite activities. With the crew practicing their plashing strokes on the river, white clouds passing overhead, and grassy meadows that seemed to stretch endlessly on the far side of Memorial Bridge, the broad expanse between Eliot House and the river on warm days was the most desirable on campus. Indoors, O'Hara's hideaway was the dusty but magical attic piano room. Located in the tower and reachable only with difficulty by a staggered

series of staircases, this room, with its round windows affording views of river, sky, and trees, was where O'Hara practiced and composed for hours on a black grand piano.

During O'Hara's day Eliot House was a peculiarly lively mix of jocks, aesthetes, scholars, and snobs. The man responsible for picking and choosing was its house master, John H. Finley, Jr., the Eliot Professor of Greek, who had a reputation for being a bit stuffy. As one of his students put it, Finley flaunted a "keen sense of professorial majesty." He had a predilection for throwing tea parties with exquisite cookies and fruitcakes to which he invited "Eliot gentlemen" he was cultivating with surnames such as Cabot and Lodge belonging to the exclusive "final clubs" along the river. This elitism irked the increasingly sarcastic O'Hara who made many smart comments to his friends at Finley's expense. But in all fairness it was Finley's shrewd search for men he felt would be prominent in any field that made Eliot House just the sort of heterogeneous setting where O'Hara could flourish. Finley found accomplished athletes who brought home seven of the eight intramural sports awards. He invited poet Archibald MacLeish to speak at the annual house dinner that spring and kept on Harry Levin, F. O. Matthiessen, and Theodore Spencer as house tutors. When Donald Hall became editor of the *Harvard Advocate,* Finley rewarded him with a plum single suite outside the doors, which allowed him to invite girls in at any hour. Finley also encouraged the presence of the actors of the Veterans Theatre Workshop. Their student director, Jerome Kilty, staged *Bartholomew's Fair* as the 1946 Eliot House Christmas play and, in 1947, *The Merry Wives of Windsor* in which Finley played the part of a Latin scholar of dubious merits. Eliot House wasn't particularly scholarly—that distinction belonged to Lowell—but it was intellectually and artistically strong enough that its residents pulled in the most fellowships abroad every year, while its frequent and noisy cocktail parties and all-night bridge games were the envy of the more muted houses such as Adams and Winthrop.

That spring as the elm trees in the Yard turned pale green, O'Hara sat busily in his unprepossessing corner of Suite J-21 transforming himself from a composer into a poet. It was the sea change of his second semester. "I asked him one day why he decided to become a poet instead of staying in music," recalls his brother, "and he talked about James Joyce's *Portrait of the Artist as a Young Man.*" Joyce had been O'Hara's boyhood hero pointing a way out of the dank crucifix-lined halls of St. John's toward a more exhilarating world where Stephen Dedalus could be called to his vocation as an avant-garde poet while standing on a

beach, O'Hara's favorite landscape. More recently Joyce's works had come to present more fully to him the possibility of a coalescence of music and literature. From a first book of poems revealingly titled *Chamber Music* through to *Finnegans Wake,* Joyce had used language with as much attention to sound and rhythm as to sense. O'Hara knew this tendency intimately, having written a string quartet inspired by *Ulysses* and a poem inspired by *Finnegans Wake.* (O'Hara must not have thought his string quartet a success, for he later wrote to his Navy friend, Tom Benedeck, "I believe *Ulysses* is too intensely and perfectly a novel, as is *Portrait of the Artist,* to lend itself to another's music.") During freshman year, Joyce the polyphonic poet, as well as Joyce the renegade Irish Catholic, was playing on O'Hara's mind.

Meanwhile O'Hara's earliest wish to become a composer and concert pianist was fading. His growing desire to be a poet was accompanying an increasing dissatisfaction with the practical hurdles of a career in music. The more academic side of music had always perplexed him, and he had shied away from prestigious music schools such as Juilliard and Eastman because he felt he lacked basics. "I've studied and loved some things while passing over the simple bases leading toward them," he had admitted to his parents. "In too many places I have information but no knowledge." Irving Fine's Elementary Harmony course, which he was routinely continuing along with the second halves of his other first semester courses, did little to dispel his misgivings. By its conclusion, O'Hara had sworn off all music courses at Harvard. At the same time he came to accept his limitations as a pianist, a difficult reckoning for a young man who had tackled such complex pieces as Rachmaninoff's Prelude in C Sharp Minor (not the modified version in C minor) in search of ever more impeccable finesse and polish. "Remember to make hammers out of your fingers," he had advised his brother Philip about his piano practicing. During O'Hara's senior year a story circulated at Harvard that he had played once for Rachmaninoff at the New England Conservatory and that the Russian pianist and composer had advised him that his hands were too small for ultimate success. O'Hara drew on this story years later when he wrote one of his "On Rachmaninoff's Birthday" poems:

> Good
> *fortune, you would have been*
> *my teacher and I your only pupil*
>

Only my eyes would be blue as I played
and you rapped my knuckles,
dearest father of all the Russias.

While such a session may never have taken place, the conclusion that he was physically unsuited to excel at a concert hall career helped to dissuade O'Hara from a career in music.

As a freshman O'Hara was already displaying an ability to dash off poems in longhand, or at a typewriter. "I was never sure how good I thought anything could be that was just tossed off," observed one neighbor. O'Hara approached poetry much as he had approached the keyboard. His pose was not the lovelorn, anguished, or confessional one adopted by so many young poets. Rather, having already achieved a sophistication in music, he exhibited a relish for virtuosity. O'Hara's freshman poems tended to be games, tests, exercises, or parodies. Learning about the history and techniques of poetry as he went along, he challenged himself by imitating the styles of Wyatt, Coleridge, or Stein. On February 15, three days after Wallace Stevens read from *Harmonium* to a crowd of five hundred in Fogg Large Room, O'Hara wrote "The Militarists" in a ballad style similar to Stevens's "Anecdote of the Prince of Peacocks." (O'Hara mixed Stevens's sensuous high style, though, with the rougher stuff of politics, putting forward the theme of antimilitarism so close to the heart of this fledgling poet who was still as interested in the address to be given by five-time Socialist presidential candidate Norman Thomas in March at New Lecture Hall as he was in Stevens.) Although he was having trouble with its grammar in German Ab, O'Hara dared himself to write a rhyming poem in the German language, "Das Lied für Der Erwachend." He wrote three poems in French, the high school foreign language in which he had earned a C+: "Merde," "L'Ennui," and "Le Coeur Sur Le Main." (Interested in translating Verlaine, O'Hara prodded Jerome Rubenstein's linguist girlfriend, "You just tell me what it says and I'll put it into poetry.") In April O'Hara wrote a number of poems based directly on musical models: "Blues Song," "Nachtstück," "Quintet for Quasimodo," "Song." These poems relied on musical constructions and on such musical values as the alternation of fast and slow tempi for their effect. Like the Renaissance poets he was mimicking that semester in "Homage to John Webster" and "Virtu," O'Hara was inclined to think of songs as poems. He even kept a separate notebook in which he diligently copied down lyrics of some of his favorite art songs, including

"Blues Tempo" from Kurt Weill's *Mahagonny* and "Mimi" from *La Bohème*.

While O'Hara was disillusioned with the Music Department by late spring, he was certainly no less eager to hear new music. On May 1 he stood eagerly in line with hundreds of other college students outside Sanders Theater for the opening of a three-day "Symposium Musicales" sponsored by the Music Department. The hall was filled that first afternoon with everyone from a seemingly lonely Robert Frost to a highly gregarious redheaded young woman from Wellesley, all listening along with O'Hara to E. M. Forster speak on "The Raison d'Être of Criticism in the Arts" followed by Roger Sessions on "The Scope of Music Criticism." O'Hara whispered condescendingly to a friend that Sessions composed "sewing machine music." The draw for O'Hara that evening was the premiere of a newly commissioned string trio by Arnold Schoenberg played by the Walden String Quartet. Friends from the Music Department made fun of him for attending a premiere of atonal music, which O'Hara would describe four years later in "The Tomb of Arnold Schoenberg" as a "loud windless blizzard, / pianoforte of celestial hazard." Composer and *Herald Tribune* music critic Virgil Thomson (Class of '23), who was to become a friend of O'Hara's in New York, spoke the following afternoon on "The Art of Judging Music." On Saturday night O'Hara attended the festival's finale, a world premiere of Martha Graham's "Night Journey" with music by Juilliard's president, William Schuman. There he was, wrapped along with the rest of the intent audience in the shadows of a modernist piece based on the incestuous union in Greek legend of Jocasta and Oedipus. That this uncompromisingly avant-garde performance, designed as were most of Graham's dances to reveal "the inner man," premiered at the Cambridge High and Latin School gives a sense of the sophistication evident in much of the cultural calendar at Harvard in the late forties, as far from the usual college-circuit fare as its more mature veterans were from the usual freshmen.

On June 1 the spring semester officially ended. O'Hara packed his bags and vacated J-21 to return to Grafton for the summer. This was a difficult transition, as he was moving at once backward to the confines of the scene of his childhood and forward to contending with the fallout from his father's death. The main casualty, of course, was his mother. Eight years younger than her husband, Kay had always remained somewhat the girlish pupil who had fallen in love with her English teacher. Russell had balanced her unstable charms by assuming a paternalistic role in their marriage and handling all of the practical household re-

sponsibilities. Kay was now suddenly lost. Her first impulse was to try to draw her oldest son back into the family as a surrogate husband. "She sure did try to depend on Frank," recalls Maureen O'Hara. "She wanted him to be there. She wanted him to go to dinner parties with her. When he was at Harvard she would always want him to come home. But he was very clear about what he would do and what he wouldn't do."

O'Hara, feeling the uncomfortable tug of duty, did step in occasionally to help his mother through a difficult situation. Immediately following Russell's death his Aunt Grace had moved into the music room with the ostensible motive of helping Kay. Her disapproving presence, however, only cast a further pall over the family. Grace strictly supervised Kay and tried to keep her within the proper bonds of widowly behavior by dressing her in black and discouraging her from going out to parties. Such enforced gloom enraged O'Hara who marched downstairs during one visit home and ordered his startled Aunt Grace to vacate the premises because she was upsetting his mother. "Frank was sticking up for my mother more than she was sticking up for herself," says Maureen O'Hara. One legacy of Grace's short stay, however, was Kay's burgeoning drinking problem. As an antidote to Kay's sleeplessness, Grace had plied her with hot toddies every evening at bedtime. Soon Kay didn't need any coaxing. She would sit up nights grieving alone in the front room, playing classical records on the phonograph and drinking sherry. At dawn, as a gray light washed across the room, it took on the look of *The Lost Weekend*: glass ashtrays filled with squashed cigarette butts and little cups of half-eaten shrimp cocktail scattered across tabletops. An all-consuming alcoholism was beginning to take hold.

O'Hara found himself in a bind. The freedom that he had glorified in his letters from the West Coast and that he had just begun to achieve at Harvard was suddenly at risk. Phil Charron recalls that "Fran became heroic after his father's death and tried to step in to save the family." While O'Hara truly did make efforts to hold his disintegrating family together, he also made equal efforts to keep at a distance from matters that were either outside his ken or that he was too busy at school to address. His brother claims that when a family lawyer, Francis X. Reilly, representing at once Leonard O'Hara, Grace O'Hara, and Kay O'Hara, decided on the terms by which his mother was bought out of the Donahue business—a payment of $40,000 with an amount deducted for the worth of their collectively owned house—O'Hara paid no attention to the proceedings. The eventual result of the minimal legal

settlement was that Kay would have to work for the rest of her life at odd jobs in bookkeeping, bank auditing, and billing. "I really got very angry at Frank at this time," admits Philip O'Hara, who was then fourteen. "Even as a kid I knew that something was wrong there, one lawyer representing three families. Frank was too busy at Harvard. From my point of view he'd really taken a walk on the family."

Making his way anxiously through this labyrinth of family emotions, O'Hara felt his Navy resolutions severely tested, especially his Emersonian resolve to protect his personal freedom. "I should not find it difficult to justify cutting anyone from my life I was convinced thoroughly had no place there," he had written to his parents from the Pacific. "It might give me pangs for a while but time heals everything and it would still be the lesser of two evils." This determination, easy enough to express by letter, was to be refined and given weight by his wrestling with the question of his responsibility toward his mother over the next few years. In the acting out of its implications, O'Hara defined a complexity of his character that friends in New York would later either praise as living in the moment or denigrate as emotional ruthlessness.

O'Hara significantly concluded his autobiographical poem about growing up, "Ode to Michael Goldberg," with a grand paean to the virtues of this liberty, as light and evanescent as a fleece, so tantalizing and yet unattainable during his three summers in Grafton:

> for flowing
> as it must throughout the miserable, clear and willful
> life we live beneath the blue,
> a fleece of pure intention sailing like
> a pinto in a barque of slaves
> who soon will turn upon their captors
> lower anchor, found a city riding there
> of poverty and sweetness paralleled
> among the races without time,
> and one alone will speak of being
> born in pain
> and he will be the wings of an extraordinary liberty

O'Hara dealt with his caged summers in Grafton by staying busy. He worked part-time at the Wuskanut Worsted Corporation in nearby Farnumsville as a millworker, payroll assistant, weaverroom clerk, and

warehouse overseer. This textile mill shows up in the novel O'Hara was writing in 1950: "the whole room banging and clacking as frame slammed into frame and bobbins flashed through metal tubes and wooden casings, like so many pistols being fired at your dancing feet." At night O'Hara would gather with his local friends to play out their group fancies of living on the Quai d'Orsay in twenties Paris or in Virginia Woolf's Bloomsbury, entertaining each other by playing charades or throwing dress-up parties with offbeat themes such as "Worms Eating an Apple." These parties often turned into serious discussions on art and politics, usually instigated by O'Hara who was adamantly avant-garde and pro-labor. An important magnet for the group was the Red Barn Theatre in Westboro where their objective was to lure one of the leading summer stock actors or actresses, often nationally prominent, back to O'Hara's home for a late-night bull session. All of these self-consciously madcap parties were fueled by drinking, and many a moonlit evening O'Hara would wind up in a car driving recklessly around the curving back roads of Grafton at fifty miles an hour. Almost every teenage boy in Grafton Center lucky enough to be able to use his parents' car sped wildly on those dirt back roads. As one of the gang, Genevieve Kennedy recalls the essence of those summer soirees, "It was beer, beer, beer, beer, beer." Kay O'Hara complained in vain about the noise and excessive drinking at her son's parties, while he in turn was given to slamming doors in annoyance at her own drinking, their trading of accusations a clue to the hidden dynamic of much of the anger simmering between mother and son. For as his mother's drinking was escalating, so was O'Hara's, and much of their criticism of each other was made only more emotionally grating by their denial of their own excesses.

O'Hara also gingerly avoided any admissions or displays of his homosexuality. His friends complied tacitly in this discretion although they all felt inklings of O'Hara's as yet largely unacted upon proclivities. "All the girls in our circle in Grafton were vying for his attentions," claims Genevieve Kennedy. "But you didn't get his attention by being sexy but by being interesting. You had to touch his intellect. I sensed that early on. Frank and I did kiss once. But I knew then that there was something different about him from other boys. He didn't try to make moves. I think he knew that I sensed that and that I still liked him and didn't judge him and I think he appreciated me for that." Phil Charron, too, recalls that O'Hara hinted at new desires without ever directly revealing them. One night Charron made a comment about a handsome young man named Billy whom they both had befriended separately.

O'Hara looked surprised, then exclaimed, "It's too bad Billy isn't here. With his looks and my music we could conquer the world!" "I felt a real attraction there of Frank for Billy," says Charron. O'Hara also complained to Charron, "Nothing passionate ever happens in Grafton." Sensing the dangers of any flamboyant admissions in Grafton, but quite adept by now at secrecy, O'Hara remained simultaneously gregarious and private.

A typical party, which had taken place at Elsa Ekblaw's, was described by O'Hara in a letter to his Navy buddy Tom Benedek. Benedek had recently mailed him a musical setting of part of Joyce's *Finnegans Wake,* which O'Hara and Burton Robie planned to sing at Ekblaw's "entertain-each-other party." These plans collapsed, however, as Ekblaw couldn't persuade her guests to cooperate. When his free-thinking hostess tried to promote further intimacy, "even to giving the female guests orders about 'whom to work on,'" O'Hara characteristically, as he said, "detached myself to serious drinking and conversation." He spent most of the party in the kitchen arguing the superiority of James Joyce to Thomas Hardy. "I drank entirely too much," he confessed, "and didn't get home until five." Most revealing was O'Hara's attitude toward a guest at the party whom he suspected to be homosexual. "One of the girls accused one of the men of homosexuality because he wouldn't accompany her upstairs," O'Hara wrote to his Navy friend. "He really is odd—I shouldn't be surprised if she had unwittingly hit the nail on the head." Not betraying his own sexuality at the party, and choosing the pejorative word *odd* in his descriptive account, O'Hara gives a sense here of the sort of fancy footwork he was capable of in Grafton—and, earlier, in the Navy—to deflect attention from his own hidden sexual identity.

Evidence of the underlying drain of these stressful summers, and proof of the strength of their undertow to pull him back to an earlier existence, is the dearth of Grafton poems. The graph of O'Hara's poetry production during his Harvard years shows a series of radical peaks and valleys as he frantically composed more and more poems each school year only to dutifully pass the summer months at 16 North Street without completing more than two or three.

As his life in Grafton became more weighted and conflicted, O'Hara compensated by growing increasingly flamboyant at Harvard. His main accomplice in this flowering was Edward St. John Gorey. The son of a Catholic Chicago newspaperman and his Episcopal wife, Gorey had

shuffled off his initial religious instructions as a Roman Catholic quickly enough to manage to escape his own confirmation and First Communion. Having passed through the "progressive" Frances Parker School in Chicago, and a crash course in Japanese sponsored by the Army at the University of Chicago, Gorey arrived at Harvard at twenty as a precociously full-blown eccentric. Standing over six feet tall, thin and gaunt, Gorey accentuated the towering effect of his presence by dressing in long sheepskin-lined canvas coats and sneakers. Looking like a Victorian curiosity, Gorey invited inevitable characterizations from fellow students who perceived him as "tall and spooky looking" or as a "specter." The costuming and gesturing, including, as one Eliot House neighbor recalls, "all the flapping around he did," decidedly cast him as a campus aesthete. "I remember the first day Ted Gorey came into the dining hall I thought he was the oddest person I'd ever seen," recalls the photographer George Montgomery, an Eliot House resident. "He seemed very very tall, with his hair plastered down across the front like bangs, like a Roman emperor. He was wearing rings on his fingers. It was very very faggoty."

O'Hara was quite taken with Gorey whom he had met early in their first semester in Mower Hall. Their proximity—Gorey on the first floor, O'Hara on the second—was due to their shared status as veterans. But O'Hara's attraction was hardly based on exchanging war stories. Gorey represented his first serious brush with a high style and an off-beat elegance to which he quickly succumbed. Gorey dressed, after all, in the same sorts of long fur coats trailing behind him as the Boston Brahmin poet John Wheelwright (Class of '20), a local legend, who was struck down by a drunken driver in 1940. Gorey was appropriately vague in his pronouncements, especially about his own emotional states, but always spoke in such a way that clichés or commonplaces were given a twist, almost as if he were placing invisible quotation marks around them as he spoke. There was a lilting music in his quiet remarks that somehow implied humor in even the most serious of situations. He made whimsical drawings of endearingly ghoulish Edwardian figures in ruffled collars, smoking jackets, and floor-length frocks, using India ink on scratch paper, figures O'Hara would describe in a student poem, "For Edward Gorey," as "elegant indifferent" and "busy leisured."

O'Hara and Gorey soon became a noticeable odd couple on campus. Tall and short, these friends, not lovers, stalked the Yard together, rummaged through dusty book bins, traveled into Boston to catch a ballet at the old Opera House on Huntington Avenue or a foreign film at the Kenmore near Boston University. As an inveterate bookworm who had

quickly run up tabs for hundreds of dollars at three local bookstores, Gorey was impressed by O'Hara's extensive discourses on obscure writers whose works never showed up on the syllabi of any of their classes. "I was reading Ronald Firbank but never had any notion of what was going on," says Gorey, referring to the eccentric English author of *The Flower Beneath the Foot* and *Prancing Nigger.* "But Frank always knew that so-and-so was doing such-and-such. He was great on plot synopses." O'Hara, in turn, found Gorey's personal style liberating, especially given his own repressed early years in parochial classrooms and Naval barracks. "I remember thinking that Frank kept himself under wraps the first year at Harvard," says Gorey. "He was very much involved in the whole lapsed Catholic bit, which obviously disturbed him." By teaming up with Gorey, however, O'Hara gave his first visible signs of unwrapping, causing some of his earlier friends on campus, friends of convenience rather than soul mates, to grow irritated. "He had friends in the Music Department who actually accused me of having *corrupted* Frank," reports Gorey, "like in some turn-of-the-century novel."

At the start of his sophomore year, twenty-one-year-old O'Hara became Gorey's roommate in Suite F-13, an Eliot House triple. O'Hara's room was a small bedroom down a hallway and up a few steps from the suite's bathroom. The second bedroom was occupied by Vito Sinisi, an Army acquaintance of Gorey's whom he had bumped into in a History of Religion class freshman year. "He either called himself 'Vito' when he was feeling very Italian or 'Victor' when he was feeling less Italian," reports Gorey of the philosophy major whose dealings with O'Hara were cursory. Gorey slept in the suite's living room where he often sat laboriously designing wallpaper or drawing his humorous Edwardian figures whose "eyes glow gas jets" in O'Hara's poem, on a largish table near a window looking out on dusty Boyleston Street. With a broad range of furniture styles available for rent on Harvard Square, O'Hara and Gorey eccentrically chose white modern garden furniture for their rooms, including several chaise longues. "It was all very sturdy stuff because Ted was quite weighty at that time," claims one Eliot House neighbor. A slate tombstone taken from Mount Auburn Cemetery served, at one time, as a coffee table. This was only fitting for Gorey, who became well known as an author and illustrator of wistfully macabre drawings in such books as *The Doubtful Guest* and *The Haunted Looking Glass,* as well as for his Tony-award-winning set designs for *Dracula.*

At first Gorey—an authority on bohemian eccentricity—had a

more distinctive personal style than O'Hara. Yet O'Hara was always the more talkative and animated. Gorey was shy, if funny, while O'Hara, at ease for once in his new surroundings, displayed an Irish garrulousness expressed either in deeply absorbing personal conversations or in expansively entertaining routines. "Frank talked a lot and Ted never opened his mouth," remembers poet Donald Hall. "You'd go into the room to talk with Frank and there would be Ted sitting at the desk drawing one of his Christmas cards." Genevieve Kennedy, who came down from Grafton to act as O'Hara's date at a few Harvard football games, remembers more occasions of shared animation. "That was where Frank really came into his own," says Kennedy of the suite where she visited O'Hara and Gorey. "The idea was to lie down on a chaise longue, get mellow with a few drinks, and listen to Marlene Dietrich records. They just loved her whisky voice. At that time Frank got me started on Gertrude Stein, James Joyce, and Zoltán Kodály. He was very much a modernist. I would then get these funny funny letters from him written in this tone of Oscar Wilde. That's what happens to young people in college. They decide on their mentor and they go all the way in trying to be like him."

O'Hara and Gorey were not lovers, but their adopted style was full of the mannerisms of upper-class English homosexual society. The wit, the slightly nasal British intonation, the eccentricity and coolness were borrowed in part from such aesthetes of the 1890s as Oscar Wilde, as well as from the post–World War I generation at Oxford that Evelyn Waugh wrote about in *Brideshead Revisited*. (Gorey insists that their mimicking of the Oxford generation was carried off only "in a tacky sort of way.") O'Hara's readings during 1947 and 1948 of such particularly stylized English novelists as C. Day Lewis, E. M. Forster, Cyril Connolly, Christopher Isherwood, Virginia Woolf, Henry Green, and Ivy Compton-Burnett made him a perfect game-player for the rather precious world into which he had recently stepped. He aped style and tone with the same ease and speed with which he was able, through imitation, to write heroic couplets or French chansons. That O'Hara was quite adept at such chameleonlike transformations is evident in a letter he wrote to Gorey from Grafton in the summer of 1949, at the end of their two years together as roommates:

Mon ange,

I am feverishly upset and hostile to god to know I shan't see you yet awhile. Do let me know when you arrive East soon by way of encouragement. I have had it, by now, believe me; my heart from the depths of

fatigue can only murmur 'l'angoisse d'été' and 'ces souvenirs, va-t-il fal-loir les retuer?' Not so much as a stipend of *love* to allay the pangs!

The contrast between this swooning and quite theatrical note and the more open-faced letters O'Hara wrote home from the Navy is striking. It is a modulation partly explained by his playing to his audience, and partly by the truly radical changes in voice and personality he had man-aged in the prior three years. Yet Gorey's style was never entirely ap-propriate for O'Hara. As one observer at Harvard felt, "It was cool, English. Nothing could get to you. But then Frank was someone who everything got to."

O'Hara and Gorey soon found that the old wooden classrooms of Harvard's Sever Hall, where many English classes were taught, paled next to their own ground floor salon. Gone was the earnest studiousness of O'Hara's first semester. "We had a very frivolous attitude about the courses we were taking," remembers Gorey, a French major. "Vito was always trapping us into courses. I remember he trapped me into one philosophy course and then dropped out, leaving me behind. I think it was Symbolic Language." At about this time O'Hara complained to his little sister, probably with some exaggeration, that he had read all the books they were teaching at Harvard. His coursework during this sec-ond year did reflect, however, a new resolve to concentrate in English rather than Music, and he officially registered for such survey courses in the English and History departments as Professor Munn's History and Development of English Literature, Dr. Elliot Perkins's History of England from 1688 to 1815, and Dr. Salvemini's The Italian Risorgi-mento: 1748–1870. He also continued with an intermediate Reading and Composition class in the German Department, in which he worked at translating Schiller's poetry, including "Wilhelm Tell," and Hermann Hesse's "Knulp."

The only professor able to draw O'Hara and Gorey out of their studied lassitude was the young poet John Ciardi whose English Com-position course they both registered for, O'Hara submitting a sheaf of new poems, Gorey a few limericks. Ciardi, still in his early thirties, was a recent firebrand on campus. A Boston-born Italian, he had spent his undergraduate years at Bates and Tufts before moving out to the University of Michigan where he earned an M.A. in English and com-posed a manuscript of verse, *Homeward to America,* that won a 1939 Avery Hopwood Major Award in Poetry, the same prize O'Hara was to win in 1951. Ciardi then spent his war years flying B-29s out of Saipan

and turning those experiences into a series of war poems, which were published as *Other Skies* in the fall of 1947. When he read from these poems in a Morris Gray lecture, Professor Theodore Spencer praised him as "one of the younger poets . . . honest and straightforward . . . whose war poetry gives a good psychological account, and physical description." As the Briggs-Copeland Assistant Professor in English Composition, Ciardi was soon pleading on a soapbox for some of his favorite leftist causes, especially countering the growing pressure to bar teachers with Communist Party affiliations, a movement given some impetus by the Nixon-Mundt Bill before Congress in the spring of 1948.

The mood in Ciardi's composition course—taught as a writing workshop—was livelier and less formal than in O'Hara's other classes. Shaggy-browed with slicked-back hair and a black mustache, Ciardi, pipe in hand, criticized his students' work with the sensitivity of someone having vague misgivings rather than as a dogmatic lecturer about standards and opinions. "The purpose of writing is to be read," he was fond of saying. While Ciardi's push for communicative clarity was not particularly exciting to O'Hara, who was more drawn to wordplay and musicality for their own sake, he found the professor's openness to student comments agreeable. Habitually seated with Gorey in the front row on the left side near the window, O'Hara was not at all reticent about making authoritative remarks. "He was kind of scary because he was elderly, having already been in the Navy," recalls Donald Hall, a nonveteran freshman in the class. "He was also very funny, very smart, and very effeminate. And that was scary too. Ciardi admired him a lot." Ciardi was near enough in age, and in war experience, to carry on outside friendships with his favorite students, in this case Gorey and O'Hara, whom he described as having "a lovely sardonic sense of fun," and George Rinehart, son of the New York publisher. After class these four would often gather at a coffee shop. "It was always one hour of class followed by two hours of coffee," recalls Rinehart. When Ciardi and his wife needed wallpaper steamed from their attic apartment in Medford, they hired Gorey, O'Hara, and Rinehart as a crew. "They were at it for days as they played a game of killing insults," Ciardi remembered years later in a letter to editor Donald Allen. "They were beautiful and bright and I have never come on three students as a group who seemed to have such unlimited prospects."

O'Hara, assured of close readings, was now more industrious than

ever. "He really did just toss these poems off," recounts Gorey. Always
endowed with inordinate energy, as evidenced by his many letters home
from the Navy, O'Hara was now furiously impelled to create rather
than to dwell on his familial conflicts. His impulse was centrifugal
rather than centripetal as he used his writing to push out to feelings of
nonsense, fun, parody, or beauty, rather than down to confessional ut-
terances. Ciardi occasionally caught some of his excesses in such mar-
ginal notes as "word-bog" (at the line "the Count assayed gavotte" in
"La Poussière d'une Fleur Précieuse"; "strictly for Tin Pan Alley" (at
the rhyming of "arms" and "her charms" in "Poem" (Speeding autos
chasing garters), and "Auden does it, but it still seems precious to me"
(at the elimination of the article in the line "she wailed at bier" in "The
Fattening Nymph"). (A few years later in New York when O'Hara
showed his verse to Auden, the older poet said, "You've got to be an
Auden to get away with lines like that.") O'Hara paid scant attention
to Ciardi's warnings, typing up many of the poems a few years later
without incorporating the professor's suggestions except in minute
cases, as in changing "Tiny autos" to "Speeding autos." His unwill-
ingness to rework poems according to Ciardi's reactions revealed his
strong desire to push swiftly on to the next poem without looking back,
as well as his early confidence in his own work.

During the spring term of the year-long English C, O'Hara con-
centrated almost entirely on writing rather achingly sophisticated stories
in which he attempted to imitate the English novelists whose work he
was reading. The opening phrases of a story he read in class—"five
mauve clouds like negro fingernails above the horizon"—created enough
stir to lodge permanently in Donald Hall's memory. In "The Detected
Shop-lifter" a wrongly imprisoned Mrs. Mildred Holmstead is crawled
upon by a talking cockroach, a swipe at Kafka's "Metamorphosis."
The versatile O'Hara even tried his hand at a play, *Dig My Grave
with a Golden Spoon,* concerning the death of a grandfather, which
was meant to be performed in front of a giant gilt scallop shell.
Ciardi, however, quibbled with the term *play* to describe the unortho-
dox scenario. Impressed with his student's sparking talent and abun-
dant productivity, Ciardi was said to have remarked at the time that
O'Hara was writing "like a young Mozart." Yet he also characteristi-
cally expressed reservations about the depth of emotional response avail-
able in such blithe Mozartian études. "He showed his brilliance rather
than his feelings," Ciardi observed almost thirty years later, suggesting
the drift of his earlier criticism. "That was a point I often made in

talking about his writing. I think, in fact, it was when he learned to use his brilliance to *convey* rather than *hide behind* that he found his power."

Tucked away in a tiny block of Plympton Street just off the noisy main drag of Massachusetts Avenue was another favorite hangout of Gorey and O'Hara: the Grolier Bookshop. Founded in 1927 by Gordon C. Cairnie when he and a friend decided to merge private library collections, the bookshop was faltering until Cairnie's decision in 1933 to stock the first copies of *Ulysses* in Cambridge while other bookstores were still busily consulting with the Legion of Decency. A small, claustrophobic brown shop, its tall wooden shelves crammed with volumes of poetry and literary novels, Grolier's in O'Hara's day was still watched over by the shy and reclusive Cairnie, who kindly allowed his customers to squeeze in at one solid wooden table to read, creating a sort of clubby atmosphere. O'Hara and Gorey passed many afternoons at Grolier's, where yellowish sunlight filtered through the dust that filled the air of the high-ceilinged but confining space. O'Hara was collecting all the novels of C. Day Lewis. "They were thin," as Gorey describes them. "I mean they were full-length novels, but they were sort of elegant, a little dull, concerning sensitive young English men in the early thirties." Gorey, meanwhile, was collecting all the Penguin editions of Ivy Compton-Burnett, whose entire ouevre had yet to be purchased by the Widener Library. "Frank and I couldn't afford to buy complete editions," explains Gorey. "So we'd start buying one at a time. Well Gordon would catch on, if we were starting to become interested in one author, and would mark up the prices slowly for that author. By the time we arrived at the last book on the list, the price would be about ten times higher than it was when we started. I always said, 'If only we had covered our tracks better.'" Although O'Hara's tastes were decidedly British that year, he continued to keep up with alternate trends in modern poetry by purchasing Hart Crane's *Collected Poems,* Ezra Pound's *Homage to Sextus Propertius* and *Make It New,* and, by Dylan Thomas, who was to give a popular reading at Harvard in O'Hara's senior year, *18 Poems, 25 Poems, Deaths and Entrances,* and *Portrait of the Artist as a Young Dog.*

In the spring, O'Hara's metamorphosis from composer to writer was marked by the publication of two of his stories in the college literary magazine, the *Harvard Advocate.* Like Gorey, who claimed that he "always felt a bit removed from Harvard," O'Hara was not a joiner. His history as editor of his high school newspaper never propelled him to-

ward an editorship on the *Crimson, Lampoon,* or *Advocate.* "We looked down on the whole thing," says Gorey of such extracurricular activities. Yet Gorey's diffident attitude was not entirely characteristic of O'Hara. Gorey's own temperament was leading him toward a reclusive eccentricity. O'Hara's natural gregariousness eventually led him instead to a small circle of poets and writers he knew well. He preferred charmed circles. They were more personal, familial, and manageable than the staffs of college literary magazines. Indeed, throughout his life O'Hara would avoid the traditional literary pecking order, protecting himself from the ups and downs of its cool rejection slips and overheated acclaim. A certain shyness about his writing remained with him always, as did a definite antiauthoritarianism.

Yet if O'Hara had been at all inclined, the *Advocate* was closest in spirit to his interests as it drew within its somewhat small circle most of the other poets on campus. Bly, Creeley, Ashbery, Koch, Hall, and Ellsberg were among the editors during O'Hara's years, who sat in the magazine's offices on Bow Street—the offices from which they had thrown a cocktail party in the fall of 1947 to introduce the actress Elizabeth Taylor to the freshman class—battling heatedly in a gray haze of cigarette smoke over the merits of a single line of poetry. "We used to stay up late arguing whether a poet should get in the magazine or not," says Hall. "When I went to Oxford right afterwards I was amazed that everybody printed everything. There were about 450 poems printed every year in student periodicals, while the *Advocate* printed maybe twenty. We took ourselves very seriously. We were sort of pompous."

By cultivating their own defensive cult, Gorey and O'Hara managed to blind themselves to much of the moral conservatism at Harvard. *Advocate* editors, for example, had direct dealings with the school's straitlaced Boston legacy. Having been funded by a group of Old Guard trustees, the magazine had actually been disbanded in the early 1940s because of indications that its editorial board had turned into an exclusively homosexual club. When it was started up again in 1947 with funds from a Boston businessman, an unofficial guideline had supposedly been agreed upon banning homosexuals from the board. While this stricture was hardly taken seriously by its current group of self-consciously sophisticated editors, the threat was always present, if also scoffed at. "This actually almost kept me from getting on myself," recalls John Ashbery, an *Advocate* editor who helped to choose O'Hara's first stories without having met him. "But Kenneth Koch, who was

perhaps a bit naive about such things, swore up and down that this was not the case with me, and that if it turned out to be true he would resign from the board. After I got on, I found out that several of the editors *were* that way."

When O'Hara's stories were published in two spring issues of the *Advocate,* a Contributor's Note in the back of the April issue described his fiction as "controversial" although the cause of this controversy is unclear. "O the dangers of daily living," which appeared in March, was a slice of a story, which used script dialogue to tell of a group of shrill people descending a flight of stairs, concluding when its narrator finally "fled into what was soon to be the night." Ashbery deems that "It's quite possible there may have been some gay overtones in this," although such a judgment would have been based on the story's telltale tone rather than on plot or action. Its title a nod at a Cyril Connolly book owned by O'Hara, his second story, "The Unquiet Grave," which came out in the April issue, was a horror tale about a buried blond Viking boy named Ho whose suicidal mother arranged to have her lusty blacksmith lover murder her husband. Reviewing this story, the student critic for the *Crimson* vacillated: "It is good, but not especially so, and certainly not controversial. The idea of the story, which seems to me exaggeratedly picturesque, is generally hidden behind a style which is floridly poetic. Perhaps this concealment is a good thing for the style is definitely the strong part of the piece." O'Hara was indifferent to such criticism, especially of style at the expense of substance. His current apprenticeship was to Ronald Firbank, who had once boasted that "My writing must bring discomfort to fools since it is aggressive, witty and unrelenting."

Appearing with O'Hara in his debut in the March issue were Robert Crichton reviewing Frank O'Connor's *The Common Chord,* John Snow reviewing Gore Vidal's *The City and the Pillar,* and Denis Fodor writing a story about a band of Greek guerrillas. In the April issue O'Hara kept more likely company; his fiction was included with poems by Ashbery and Koch, though he still had not met either of them. Yet the exigencies of magazine editing often led to some weird juxtapositions—most notably the printing of an essay called "Athletics Problems" by Harvard football coach William J. Bingham, '16, in the September 1950 issue of the *Advocate* on the page following a story by O'Hara. Both Gorey and O'Hara felt lucky to be free of the need for any such politicking.

"We were giddy and aimless and wanting to have a good time and to be artists," sums up Gorey of his and O'Hara's condition at the end

of their sophomore year together. "We were just terribly intellectual and avant-garde and all that jazz."

For O'Hara, the summer of 1948, during which he turned twenty-two, was the blankest of all. No poems survive from those months. His home life became more governed by his mother's moods. No new friends entered his circle. When he returned to campus in September, though, he serendipitously happened upon an interesting tea party. Suddenly it seemed as if the summer had thankfully never transpired and as if the fall were to be an only slightly restaged production of the giddiness of the spring.

For most returning students, the election was foremost in their minds. The race between Truman and Dewey was being made more interesting by the third-party candidacy of Henry Wallace. (Heat on the third-party issue was intense enough that the *Advocate* felt it necessary to qualify a story by literary board member George Bluestone titled "The Harvard Political Scene: 1948" by editorializing in his contributor's bio that "Although purportedly a Third Party man we feel he has maintained a surprisingly objective view in his discussion of Harvard political organizations.") The buzz on campus subsumed other sorts of political issues as well. That September, for the first time in Harvard Stadium history, women were legally allowed to sit in the College's traditionally all-male cheering section between the 50th and 28th yardlines. And the taking of attendance was finally made optional in a majority of upperclass courses.

None of these matters was much discussed, however, at the humorously elegant tea party at which O'Hara found himself on his return to campus on an early September afternoon. It was being thrown by Hal Fondren in an Eliot House suite where he had been temporarily housed for the summer semester while making up a course he had failed. A graduate of McKinley High School in Canton, Ohio, Fondren was a veteran who had served as an Air Force gunner stationed in England, an assignment from which he had profited by purchasing T. S. Eliot's *Four Quartets* in separate pamphlets as they were published during the war. He loved displaying these treasures to his guests. His excuse for the party that afternoon was the visit of an English friend of a friend whose background inspired Fondren to playfully plead continual nervousness that his guest would be making "all sorts of invidious comparisons to life at Oxford."

As Fondren had never met O'Hara, his invitation was to Gorey who

then mentioned that his two roommates had recently returned to campus. "Well bring them too," said Fondren in a melodious stage voice that communicated at once both ebullience and unknown possibility. His was a contrived-sounding, slightly English voice of the sort that would have appealed to the Gorey contingent. And so the residents of F-13 arrived, walking into the usual swirl of a coterie of Eliot House gentlemen rushing back and forth to their rooms to fetch extra cups while Fondren poured hot water from his electric kettle into a constantly emptying tea pot. "It was a great big tea party which degenerated into a cocktail party and then into dinner," tells Fondren. But amidst all the smoking and chattering O'Hara and Fondren settled into a talk and found much to respond to in each other. O'Hara, who would be registering that semester for Professor Rollins's English Literature from 1500 to 1603, engaged Fondren in a conversation about Elizabethan literature and was quite struck by the éclat with which Fondren replied, "Really, all I know of Elizabethan poetry is by Herrick and all I can remember of that is, 'Now the mirth comes / With a cake full of plums,'" at which line he produced from hiding a fruitcake he had transported all the way from Ohio. "Frank seemed to find that sufficient basis for a lasting friendship," says Fondren, "and I was quite grateful." Over the course of the coming school year O'Hara and Fondren gradually built up their friendship so that by spring O'Hara had largely abandoned F-13 to spend most of his time in O-22, the suite of rooms overlooking the master's garden into which Fondren moved with an assigned roommate, Tony Smith.

While O'Hara loved using bits of his learning to carry on conversations such as that with Fondren on Renaissance poetry, his attitude toward his classes erred toward negligence. His paper-writing ability alone saved him. In the second survey course he elected in the fall semester, English Literature from 1603 to the Restoration, followed in the spring with English Literature from the Restoration to 1700, taught by Professor Kenneth Murdock, he earned an A. ("What is English 130?" he wrote indifferently of the course to a friend two years later. "I found on my transcript that it lasted a year and I got two A's in it but can't remember the subject.") In Chaucer, however, taught by the extremely popular Professor B. J. Whiting, dressed in the celebrated three-piece suit and smoking a pipe, he did not fare so easily or so well. Although O'Hara felt strongly enough about the poetry of the *Canterbury Tales* to copy two lines from the "The Knyghtes Tale" in Middle English into his personal notebook—"Infinite harmes been in this mateere" and "This world nys but a thurghfare ful of wo, / And we been pilgrymes,

passynge to and fro"—he was not assiduous about Chaucerian scholarship. "Frank wasn't doing any of the work at all," recalls Jerome Rubenstein who was also taking the course that semester. "He said to someone, 'Jerry is working hard and I'm not but we'll both get the same grade.' When I got a B and he got a D I was very pleased to say, 'Aha Frank! Virtue does pay.'"

O'Hara also registered that fall semester for English J, an advanced two-semester English composition course taught by Albert Guerard. An attractive, natty dresser who slicked back his dark hair, wore oval wire-rim glasses, and smoked cigarettes as he taught, Guerard was himself a fiction writer who published his novel, *Night Journey,* in 1950. Guerard instituted what his student Alison Lurie has described as "one of the best fiction seminars in the country," and his first students included future novelists Alice Adams, Stephen Becker, Robert Crichton, and John Hawkes. Guerard also served as faculty advisor to *Wake,* which was named by Hawkes and edited for a while by Creeley, published e. e. cummings, and served briefly as a substitute for the *Advocate.* O'Hara appreciated Guerard enough that he would register senior year for his course on European literature titled Forms of the Modern Novel, which included intensive readings of André Gide. Gorey took the course, too, but was less enthusiastic, claiming that "Guerard was very tiresome as I recollect because every work turned out to be about latent homosexuality." O'Hara, though, was remiss about keeping up with the thousand-words-a-week requirement for English J. As the finishing line of the semester neared, he had fallen behind sufficiently in his word count to need to write an extended piece of fiction. Jerome Rubenstein was similarly behind and again had the opportunity to observe O'Hara attempt to play hare to his tortoise. "With three weeks and about nine thousand words to go, I was writing night and day," remembers Rubenstein of the week in which O'Hara wrote his memoir of Navy life, "Lament and Chastisement." "Frank was in a similar bind. His solution was to sit down at his typewriter off and on for about a week and bang out a long unstructured piece. Probably with a record playing. And perhaps sipping wine and talking to friends when they came into the suite where he had set up his desk in the living room. I stayed up all night finishing the last of three stories and submitted them the following morning and Frank was there submitting his. I remember he received a written comment from Guerard stating, roughly, 'You're obviously talented but you don't work at your writing. Henry Miller suffers from the same problem.'"

More challenging and absorbing to O'Hara were the cocktail parties

in F-13. Sometime during his sophomore and junior years, O'Hara had learned how to inject his naturally fresh intelligence with hidden fury to create a kind of talk that was at once stinging and entertaining. Cocktail parties were a forum for such displays of probing. They were competitions whose laurels O'Hara was much more interested in capturing than the races being run for grades in his classrooms. Having survived kamikaze attacks on a perimeter ship in Okinawa, and the swift and absurd death of his father, he had developed a taste for games of life. At one such party O'Hara and Donald Hall started exchanging quips, trying to be clever at each other's expense. The fighting, which continued all night, was memorialized by Ciardi the following year as "psychoanalysis by bourbon" in a poem in *The New Yorker.* "His was a biting, waspish wit but not deeply cruel," explains Donald Hall. "You'd feel the flick but your head didn't come off." Yet Hall continued to be a whipping boy for O'Hara, who was once heard to chant in sing-song fashion, "Mirror mirror on the wall / Who is Donald Andrews Hall?"

Hall and O'Hara fought partly because they felt they belonged in separate camps. Full of highly competitive young men who could be rude and tendentious, Harvard was always being subdivided into rival groups. Among the young poets a civil war had developed between those who favored Yeats and those who favored Auden. Hall was to write his senior thesis on Yeats, while Ashbery in the spring of 1949 was writing his on W. H. Auden. A banner poet for the more traditional Yeatsians was the young Robert Lowell, whose *Lord Weary's Castle* had won a Pulitzer Prize for its twenty-nine-year-old author in 1947. Auden made his presence felt by reading at Harvard in December 1947, after which a party was thrown for him by George Montgomery at Eliot House, and by earning a Pulitzer Prize in 1948 for *The Age of Anxiety.* "Koch and Ashbery and O'Hara loved Auden," claims Hall, "while Bly and I loved Yeats and Robert Lowell." As O'Hara was to write in his self-dating "Memorial Day 1950": "And those of us who thought poetry / was crap were throttled by Auden or Rimbaud." That these early wars of sensibility continued to matter would be shown years later in an uncomfortable reading given by O'Hara with Lowell at Wagner College in 1962, as well as by his characterization of Lowell to an English interviewer in 1965 as having "a confessional manner that lets him get away with things that are really just plain bad but you're supposed to be interested because he's supposed to be so upset."

As a practitioner of the art of bright conversation and a self-reliant figure on campus, O'Hara managed to conceal his own anxieties. But in October of junior year he suddenly dipped into a strong depression.

Rubenstein was one of those who detected signs of O'Hara's inner bout, a bout that was to last through the winter, although he was confused about its source. "I suspected he was having some sort of crisis before the Chaucer midterm," says Rubenstein. "Something happened to him. I saw him in the exam room and he'd been up all night and was depressed." At this time O'Hara began keeping a journal, an uncharacteristic genre for a young man who usually expressed himself in more public forms such as letters or stories and poems. That such confessional turning inward from art and social life felt compromising to him is clear from his own appraisal: "In a journal are the things which would intrude upon the purity of the work." After January 1949, he never again returned to any sort of diary-keeping or self-analysis, but was poised to burn furiously as a writer. In spite of a guess from a friend that his depression came from realizing he was a homosexual, O'Hara's crisis was more truly a confrontation with questions of meaning and vocation. Though his homosexuality and his struggles with his mother were undoubtedly darkening this depression, its permanent solution was a decision to commit as a writer who would draw on his own idiosyncratic experience rather than emulate any outside pattern.

Depression shadowed O'Hara for months. Sitting in Eliot House on the evening of October 11 he recorded a spell of "utter depression" as he listened over and over again to Schumann's Piano Concerto, Piano Quintet, and Second Symphony. A week later he wrote, with black humor, "I often wish I had the strength to commit suicide, but on the other hand, if I had, I probably wouldn't feel the need. God! Can't you let us win once in a while?" Sitting in the Waldorf Cafeteria on the morning of October 29 between Sixteenth Century and Chaucer classes he drank coffee, read *The Daily Worker,* and thought of failure. He dreaded returning to Grafton for the holidays, with its memories of sudden death and the bruise left on surrounding lives: "Holidays coming. Will it happen this year? Will I die capriciously? Or will it be something unexpected." And yet when he returned in January to Eliot House, taking a chair amid the din and high spirits of the dining hall, his mood was not lifted. Familiarity had bred contempt. "Back at school the same old depression reestablished itself, settling over me like the brown stain of the dining hall's walls," he wrote with disdain. "That hall full of people worrying about what anyone else is saying or thinking about them!"

During the fall and winter months, relief for O'Hara always seemed to be accompanied by inclement weather, the rain and snow allowing him to share his melancholy with the impersonal skies, to more fully

indulge the pleasing pain of separation. As he walked down Huntington Avenue on October 10 after buying the Scott-Moncrieff translation of Stendhal's *The Red and the Black* from a dusty bookstore, he reveled in the residue of the smell of disintegrating books and the damp of a falling rain "lit by store windows." After finishing reading *In Our Time* two weeks later, O'Hara went for a walk in the "good and cold and raw" rain along the Charles River while arguing in his head with Hemingway, whom he dismissed as a writer of "short stories which clack along like a sewing machine. . . . I'd rather read someone's last will and testament." Returning in January he took an afternoon off to perform silly entrechats and pirouettes in a "dense and comforting" snow on the banks of the river until a strong wind forced him back through the black iron gates toward the lit windows of Eliot House whose residents he stereotyped angrily to himself as "people who are embarrassed by enthusiasm." Arrogance, solitude, and anger were often his consolations during this night journey phase.

Off-campus, big changes were taking place politically. In Columbia, South Carolina, the previous year Bernard Baruch had announced, "Today we are in the midst of a cold war," a phrase then picked up and popularized by Walter Lippmann. On November 2 O'Hara cast his ballot. "I voted for the first time today and I've been waiting to vote for so many years that I was quite excited," he wrote. "Maybe I'll become a social novelist, except that I probably couldn't think of anything to say, and would never be sure it was right, at that. And I'm not irresponsible enough to be successful at it, really." He was part of that small minority of Harvard students for the third-party Progressive candidate, Henry Wallace, whose outspoken criticism of the U.S. "gettough" policy toward Russia had caused President Truman to ask him to resign as Secretary of Commerce in 1946. (In a straw poll in Eliot House, Dewey received 105 votes, Truman 54, Wallace 6.) Wallace's major campus supporter F. O. Matthiessen, who had compared his candidate to Thomas Jefferson in a speech at Harvard Hall, had received a letter of support from O'Hara the previous spring. "Your letter came at a time when I happened to need that kind of heartening," replied Matthiessen. No matter how O'Hara cast his vote that fall, he could not help but feel the shifting political winds. When he had arrived at Harvard, liberal students were tending to join cells, and at least one freshman English course offered readings in John Reed. By the spring of 1949, however, Harvard's President Conant, in alliance with Columbia's President Eisenhower, was calling for a ban on Communist professors, while the House Un-American Activities Committee was ex-

amining, in the glare of television lights, microfilm allegedly discovered in a hollow pumpkin on a Maryland farm, as evidence that Alger Hiss was a Russian spy. At Harvard the bitter climax of the purging of Communist "fellow travelers" came with Professor Matthiessen's jump to death from the twelfth story of the Hotel Manger in Boston on April 1, 1950, after his name had been included in *Life* magazine in a spread that pinpointed Communist "dupes" in the manner of Senator Joseph McCarthy. In a suicide note left behind, Matthiessen had written: "How much the state of the world has to do with my state of mind I do not know. But as a Christian and a socialist believing in international peace, I find myself terribly oppressed by the present tensions."

The core of O'Hara's own depression was a more private fear of inconsequentiality. Pushed by his father's death and cut loose from Catholic certainties, he had developed a craving to fill the void. Yet wherever he looked that fall he saw only signs of decay. It was an early inkling of his obsessive theme, the theme of death, which so lightly touches many of his poems. "I historically / belong to the enormous bliss of American death," he wrote in 1959 in "Rhapsody." Though he seemed very aware of death, he carefully kept himself from falling into the clichés of self-important morbidness he so detested in Mann's Castorp. Sitting in F-13 before the holidays he wondered, "Who killed the ivy on the mantle [*sic*] while we were away last Christmas vacation? Is there a god? Or was it the biddy?"

In January he dove deeper into the discomfort: "The fragility of things terrifies me! However belligerent the cactus, ash from a casual cigarette withers its bloom; the blackest puddle greys at the first drop of rain; everything fades fades changes dies when it's meddled with; if only things weren't so vulnerable!" A spiritual heaven was no consolation to O'Hara who rebelliously began to cast himself as a devil or, later, as "the serpent in their midst" of "In Memory of My Feelings." "I am reading, slowly, St. Jerome," he recorded in his journal in October, "and I know now that Satan lives, and I have not yet made up my mind which side I am on." Deciding that "against death art is the only barrier," he chose a pagan, or Renaissance, solution, making art his bid for fame and immortality, his wing and a prayer against death. "I am romantic or sentimental enough to wish to contribute something to life's fabric," O'Hara wrote earnestly at a table in the tile-floored Waldorf Cafeteria on Harvard Square. "Simply to live does not justify existence, for life is a mere gesture on the surface of the earth, and death a return to that from which we had never been wholly separated; but oh to leave a trace, no matter how faint, of that brief gesture! For someone, some

day, may find it beautiful!" As Harold Brodkey, whom O'Hara befriended senior year, put it: "Frank was ferocious about his life having some kind of meaning."

While worrying about making his contribution to art, O'Hara was also making decisions about how to focus. He was deciding which kind of writer he wanted to be. He knew that he didn't want to be a Hemingway, the sort of popular writer who reduced the complexities of felt life to an "elegant machinery" while his characters pretended to a deceptive lifelikeness. O'Hara wanted rather "to move towards a complexity which makes life within the work and which does not (necessarily, although it may) resemble life as most people think it is lived," he wrote. "This makes my models *Between the Acts, Nightwood, The Tragic Comedians* (in a special way), *The Waves* (most of all, perhaps), *Ulysses,* and *Prothalamium*; also in a special way Ronald Firbank's perfect light tragedies *The Flower Beneath The Foot, Sorrow In Sunlight* and the less perfect because less light *Eccentricities of Cardinal Pirelli.*" O'Hara was still thinking of himself primarily as a fiction writer, a path he would not entirely abandon until receiving the Hopwood Poetry Award in 1951. Yet the predilection he felt for works emphasizing language, style, and complex surfaces, rather than stories built on traditional plot and character development, hint already at his eventual turning to poetry rather than prose. He was coming to poetry by way of poetic prose.

In his final journal entry of January 28, 1949, he wrestled with a comment of Mary McCarthy's that "the most harrowing experience of man" was "the failure to feel steadily, to be able to compose a continuous pattern." The notion of steadying one's feelings was particularly irritating to O'Hara whose father, like Proust's, had accused him of an inability to assert any willpower over his sentimentality, the supposed weakness later alluded to in "Meditations in an Emergency": "I will my will, though I may become famous for a mysterious vacancy in that department, that greenhouse." O'Hara opposed amorphous "being" to McCarthy's imposed "pattern." "I feel steadily but there is no pattern, there can be no pattern, there is only being," he argued. "The artist *is* and always loves and always creates and cannot help but love and create; I do not mean that only the artist achieves being; I am not metaphysical, quite vulgarly I mean realization of personality." In working through his objections, O'Hara not only granted himself implicit permission to perform pirouettes on the banks of the Charles and to behave as abnormally in love as he wished, but also to eventually write poems that depended on aleatory happenings and a jumble of feelings for their inspiration.

O'Hara's school journal is a tapestry of loose threads. The threads were being tied together elsewhere. In November he wrote "How Roses Get Black," which was the first poem included in Donald Allen's post-humous edition of O'Hara's *Collected Poems,* an appropriate beginning as the poet's distinctive voice is heard in its lines clearly for the first time, the poem a knot of an announcement of his poetic beginnings. The tone of the poem is adversarial, witty, engagingly perverse. The adversary is a childish troublemaker who dashes a porcelain pony against a radiator, sets pink roses on fire, and laughs maniacally from the bath-room. The opposing voice is that of the poet: "I / who can cut with a word, was quite / amused." The poet identifies with the burnt roses as his voice rises up against his alter-ego in mock-prophetic tones from the conflagration:

> *You are no myth unless I choose to*
> *speak. I breathed those ashes secretly.*
> *Heroes alone destroy, as I destroy*
>
> *you. Know that I am the roses*
> *and it is of them I choose to speak.*

Roses, especially roses damaged in a rebellious and slightly guilt-tinged scenario, were evocations for O'Hara of his father and of a primal scene based on the backyard incident evoked later in "Macaroni": "when my father knocked me into the rose-bed / thereby killing a half dozen of his prized rose plants." "How Roses Get Black" was enfolded in the materials from which O'Hara's poetry was first bred—childhood trauma, a broken relationship with his father, the cry of personal freedom heard in the exclamatory line "Talk about burning bushes!" By mixing this stuff of his own autobiography with a confident diction full of excla-mation points, enjambed lines, and a rapid display of surreal and amus-ing images the young poet had, by late 1948, hit on a voice that was unmistakably his own.

O'Hara's poetic breakthrough coincided—as such breakthroughs often later would—with the end of his funk. He began "moving on-ward and upward," as Gorey somewhat ironically describes his behavior during the spring term of 1949. Having clicked into his own poetic voice, he was also more assured of his social voice. He began spending much of his spare time in Hal Fondren's suite, impressed enough by Fondren's witty remarks, sounding so much like his own in tone and sentiment, to copy some of them into his commonplace book along

with quotations from Firbank, Baudelaire, and Marcus Aurelius. He records Fondren as quipping on one occasion, "Some people don't understand about life. That we're just passing through. These people don't love you." And on another occasion, "I'm so well equipped for living that I've never learned how to do anything." Conveniently, Fondren's roommate, Tony Smith, the tall offspring of a Republican textile mill family in Fall River, began at the same time hanging around more regularly with Gorey so that the four of them performed an unofficial dos-à-dos. "Tony and Ted would go shopping every week at Filene's Basement," says Fondren, referring to the Boston department store. "They were always buying things. It was just at the time when those long canvas coats with sheepskin collars became very fashionable and they both wore them. Tony was always embarrassed when Ted wore his sneakers so when they went to Filene's he always wore shoes. Frank and I could hardly suppress our giggles." This shifting arrangement was resolved at the end of the term when O'Hara announced to Gorey that he would be moving in with Fondren senior year. "I have to admit I did feel mildly abandoned," recalls Gorey. Suffering from pressures from his mother on the home front and committed to notions of personal freedom and the importance of personality, O'Hara was reacting increasingly by pursuing his own wishes with a single-minded resolve. This was the trait that would later allow him to abandon himself with a sometimes frightening passion to the openings and closings of human relationships, counseling as he would in "Poem" (Hate is only one of many responses), "you don't have to fight off getting in too deep / you can always get out if you're not too scared."

O'Hara began to flirt during the spring term with some of the homosexual implications of the high style he had so cleverly absorbed. "I felt that after we stopped rooming together that he sort of expanded," says Gorey. "There was some carrying on towards the end. He would occasionally come back bombed out of his wits." Such early activities on O'Hara's part, though, were extremely circumspect and seemed as much involved with flirtation and seduction as with any serious coupling. As in later life, his attractions seemed more wrapped up with the poetry of sex than with any uncontrollable physical drive. At this time he carried on two discreet friendships with actors who lived in Eliot House and were involved with the Veterans Theatre Workshop, which had taken over the Brattle Street Theatre off Harvard Square that year to stage *Troilus and Cressida* and *The Tempest*. "It all happened on a Midsummer's Eve, or so Jerry Kilty described it," reports Fondren of O'Hara's theatrical romances.

O'Hara preserved an air of mystery and innocence in his liaisons by often being attracted to young men whose primary orientation was heterosexual. Such tentative romances enabled him to preserve some of the spirit, if not the letter, of the Roman Catholic purity and pining virginity in which he had been incompletely indoctrinated. "Frank made a lot of these instant conquests," says Fondren. "A lot of them turned out to be in a way sexual. And most of them were with people who were straight, or decided they were straight later on." O'Hara managed such relationships in part by maintaining a somewhat ambiguous pose. Given the chameleonlike quality of his personality, some observers were struck by his obvious effeminate gestures, while others failed to observe any such signs at all. "He was quiet, not aggressive," says Arthur Gartaganis, his assigned roommate freshman year. "I know he knocked around with Gorey who flaunted himself much more. Not the sexual part, that would not have happened then. But today Gorey might be the sort who would flaunt it whereas Frank I don't think would." Such indecipherability sometimes led to problems. Having double-dated with O'Hara and Elsa Ekblaw at Harvard football games, Jerome Rubenstein was caught by surprise. "I wasn't aware of his homosexuality and he never acknowledged it to me," explains Rubenstein. "But once I repeated to him a comment I heard from a mutual friend of ours about someone else we knew. The mutual friend dismissed this other person as 'that dreary fag.' Although Frank didn't say anything, I think I could see immediately I was wrong. I didn't see as much of Frank senior year and just before we graduated he came up to my room, slightly drunk, and told me I had hurt his feelings with that remark. He said something like, 'Just because you're from the Midwest doesn't give you the right to be insensitive.' But he forgave me." The forgiveness was marked by his presenting Rubenstein before graduation with a sheaf of ten poems titled "Anthology," including a poem dedicated to him, "Morgenmusik," which ironically concluded with lines sounding a rhythmic battle cry for homosexuality:

> practice a falsetto lilt
> that's only partly keen,
> appreciate a different kind
> of drums and fifes made out of shins,
> confess things to each other,
> dance the Männerdämmerung un-
> prejudiced, with discipline and taste.

O'Hara's discretion at Harvard was as practical as it was temperamental. In some ways Harvard after the war practiced an enlightened tolerance so that Donald Hall was nonplussed to see O'Hara brazenly walking hand-in-hand with Fondren, who was not a lover of his, down a path winding among the houses. But there were also occasions, during and shortly after O'Hara's time, of authentically threatening repression. A black acquaintance of Hall's had been expelled when discovered by a maid necking with a white man in one of the nooks of the Eliot House library. Another rather wealthy Eliot House resident was expelled for illicit activities with a student in his NROTC program. "Two very good friends were thrown out of Eliot House for a scandal that deserved nothing more than a yawn if you could find the energy to yawn over it," corroborates Frederick English, a writer friend of O'Hara's. "But it was a horrible tragedy because one of them eventually killed himself. To me it left a cloud over Harvard that I never really recovered from."

Spring term, much of O'Hara's public social life began to center on the Mandrake Bookstore at 89 Mount Auburn Street. Opened by the wives of two English A instructors in December 1948, the Mandrake was a cozy bookstore with a large front window, which O'Hara had taken upon himself to decorate quite effectively with fishnet, a green ball, a few shells, and a handful of sand to advertise the Brattle's production of *The Tempest* in May. The store's interior was arranged like a sitting room, and each afternoon Mrs. McCormick and Mrs. Parrish would serve a light tea to customers reading in chairs among the comfortably arranged books. "It became a salon," says Fondren. "I had an account there because I wanted every Henry Green novel. It was at the time they were bringing out all of the novels of Evelyn Waugh and Elizabeth Bowen as well. Ivy Compton-Burnett, of course, was the patron saint of that group with Ted Gorey as her chief acolyte. We were all dying over the latest Ivy Compton-Burnett. You can't imagine the excitement it created." Given the tendency of Harvard's young literary types to accentuate their differences, the Mandrake quickly took on a cliquish cast that distinguished it from nearby Grolier's. "The Mandrake was more homosexual," explains Donald Hall. "The theatrical people from the Brattle went to the Mandrake. There were probably more copies of Firbank there. I don't mean anything heavy, though. I was at the two stores about equally. I remember turning around in the Mandrake one time and seeing Richard Wilbur walking in followed by Howard Nemerov and Howard Moss. This was 1949. They were the young poets in their thirties. Everybody had published one book. We were the kids who wanted to publish books of poetry."

At the Mandrake a few weeks before the end of term O'Hara finally met the poet John Ashbery. The occasion was a party celebrating an exhibition of watercolors by Edward Gorey, and the tiny store was overflowing with an animated crowd of young students smoking, drinking, and, above all, uttering sharp, fast comments. In the din, Ashbery heard a flat, nasal voice, sounding much like his own, making an offhand pronouncement that he could imagine himself making in one of his more tendentious moments. "Let's face it, *Les Sécheresses* is greater than *Tristan*," O'Hara was exclaiming, referring to a vocal work by Poulenc recently performed at Harvard. "I knew instinctively that Frank didn't really believe that *Les Sécheresses* was greater than *Tristan*," Ashbery later wrote in a reminiscence, "and that he wanted people to understand this, but at the same time he felt it important to make that statement, possibly because he felt that art is already serious enough; there is no point in making it seem even more serious by taking it too seriously." Pleasantly provoked by hearing O'Hara voicing an aesthetic attitude so close to his own, Ashbery pushed his way through the crowd. "Hi, I'm John Ashbery," he said by way of introduction. "I'm interested in what you said." O'Hara was immediately drawn in by his invitation to discuss twentieth-century music, a difficult topic at the dawn of the LP era with so few pieces recorded, and made more difficult by the snobbish attitude he had come up against in Harvard's Music Department, which refused to take Poulenc or any other modern composer except Hindemith, Piston, and Stravinsky seriously.

Neither was a total stranger to the other. Ashbery, an editor on the *Advocate,* who had clear blue eyes, brown hair, and hawkish features and dressed in the proper Ivy League uniform accessorized on occasion with a vest or umbrella, was already known to O'Hara. Donald Hall had often urged them to meet. But Ashbery was much further along in his involvement with poetry and Harvard's literary community than O'Hara. He had grown up as an only child on a fruit farm in Sodus, New York, and studied painting as a boy at a museum school near the University of Rochester where his grandfather taught physics. He had already turned to poetry seriously enough by his high-school days at Deerfield Academy to publish in *Poetry* magazine. It was Theodore Spencer who, upon his arrival at Harvard in 1945, had encouraged him by singling out one of his poems for praise in a freshman creative writing class. Sophomore year Ashbery published a poem in the first issue of the newly revived *Advocate,* titled "A Sermon: Amos 8: 11–14," in which hints of his own meditative voice can already be detected in an uncharacteristic sort of T. S. Eliot format:

Let the cool martyr, whose distant head
Now seems a swimming dog's, explore,
Sustained in a vast disinterest.

Dedicated to Auden, whom he considered to be the consummately
modern poet, Ashbery became enchanted as well at Harvard by Wallace
Stevens. He began to read Stevens seriously in F. O. Matthiessen's
Twentieth-Century American Poetry course for which he wrote a paper
on Stevens's "Chocurua to Its Neighbor." Supported in his candidacy
for an *Advocate* editorship by Kenneth Koch, Ashbery was soon actively
engaged in the heated undergraduate politics of poetry board meetings,
though like O'Hara, he felt somewhat distant from most of the tradi-
tional poems being written around him.

O'Hara remained a more inveterate outsider, a mysterious figure on
the fringes of the scene. "I seem to remember Kenneth Koch once say-
ing, 'I wonder what it would be like to know O'Hara,'" says Ashbery.
While O'Hara's considerable energies had been absorbed in finding his
way from music to poetry and coping with death and depression, his
following of a path diverging from that of the *Advocate* poets had acci-
dentally endowed him with an aura of mystery. "There was a sort of
legend about Frank," says Ashbery. "That he was this brilliant young
writer who talked sassy. Someone who looked like he was going to be
famous someday." Yet from a distance Ashbery found O'Hara's "punk
angel" demeanor a bit intimidating: "He didn't look like a very friendly
person. He had this pugnacious look with a broken nose. He wasn't
someone one thought one could just go up to and say 'Hi' and start
chatting with. In fact that was completely misleading as it turned out.
He was exactly that type of person." Robert Bly, too, felt that O'Hara
was somehow exotically different. "Frank had an air of fate around him,
as if he had come into the world to be an earl or a count," says Bly,
remarking as well on O'Hara's seeming "willingness to be joyfully
walking around in the forest rather than sitting in the castle at the
center."

Surprised by O'Hara's friendliness, Ashbery determined to spend
as much time as possible with him during the few weeks remaining
before his own graduation in June. Shortly after their first meeting, he
ran into him in Widener Library carrying a stack of books by various
unknown writers including Samuel Beckett, Jean Rhys, and Flann
O'Brien. An insatiable reader, O'Hara introduced him soon afterward
to the novels of Ronald Firbank. "I had known about Firbank but

thought he was too silly to bother with," says Ashbery. "Frank taught me that (A) nothing is too silly to bother with, and (B) it was just a completely erroneous opinion." The first novel of Firbank's that Ashbery read that summer was *Vainglory*, which he described as "obviously greater than *Tom Jones*" in a letter to O'Hara in the excited and precious tone they tended to adopt with each other in those days. In their discussions of poetry that month they both agreed on the importance of Wallace Stevens, whose *The Auroras of Autumn* would be published in 1950, while mutually downplaying T. S. Eliot. "One day I ran into John and Frank on Massachusetts Avenue and they started saying that Stevens was a more important poet to them than Eliot, who was a huge influence on half the professors at Harvard," recalls Harold Brodkey. "They wanted to abandon Eliot for Stevens and they wanted me to go along with them. They were very superior about being over Eliot's kind of exaltation and incantation and upper-level meaning. It made me feel very stodgy." Anxious to share some of his more obscure musical discoveries, O'Hara soon led Ashbery up to the music room in Eliot House, where he played for him pieces by Satie, Krenek, Sessions, and Schoenberg in the percussive style that was then in fashion. "It sounds like 'There's a long long trail awinding' with a sort of a foxtrot," explained O'Hara as he played a short suite by Krenek. He also performed one of his own compositions, which he described as "a sonatina that lasts three seconds." Both O'Hara and Ashbery mixed their interests in avant-garde poetry and music with a love of popular American culture, particularly film—an interest first aroused for O'Hara in the movie theatres of Worcester—and so they didn't hesitate to travel into Boston to catch a double bill of Howard Duff and Ida Lupino movies. O'Hara claimed a great fondness for Duff, who was typically cast as a tough hero or cop in grade B action films such as *Brute Force* and *Johnny Stool Pigeon*. The new friends then spent hours discussing all of their enthusiasms while sunbathing on the banks of the Charles.

While the tone of these talks was flawlessly casual and hilariously witty, the range of their content was actually quite new and important. O'Hara's and Ashbery's innovation was to be able to pass with each other from the high to the low, to gather in their net such disparate fascinations as French Surrealist poetry, Hollywood's "guilty pleasures," Japanese Kabuki and Noh, Schoenberg's twelve-tone compositions, Leger's geometric paintings, Looney Tunes cartoons, and Samuel Beckett's spare prose. Ashbery credits O'Hara with having been the leader in instilling such an original, and almost impossibly inclusive, esthetic into his group at Harvard. While such pluralism became a striking trait

of American culture in later decades, at the time such a dynamically eclectic approach to art—at once casual and profound—was unheard of, especially at Harvard. But it was in the air. And soon enough, thanks in part to the range of tones in Ashbery's and O'Hara's poems, and to their ceaseless championing of both popular and difficult music, art, literature, dance, and film, such an attitude would become pervasive rather than strange. Their springtime chats on the bank of the Charles, especially as they inspired the two poets to continue their accumulating and collaging of voices, contributed to what later became thought of as the "postmodern" attitude.

The immediate effect on Ashbery of their meeting was a relief similar to what he had felt when he first met Kenneth Koch in the fall of 1947 after submitting poems to the board of the *Advocate*. "This was the first time I knew a real poet who had read my things and liked them and with whom I could discuss poetry," says Ashbery. "So Kenneth and I became very good friends." In Ashbery, O'Hara, too, had found a poetic accomplice. Given to casting his friends in romantic settings drawn from the history of art, he was soon well on his way to the tender characterization of his friendship with Ashbery in his 1954 poem "To John Ashbery":

> *I can't believe there's not*
> *another world where we will sit*
> *and read new poems to each other*
> *high on a mountain in the wind.*
> *You can be Tu Fu, I'll be Po Chu-i*
> *and the Monkey Lady'll be in the moon,*
> *smiling at our ill-fitting heads*
> *as we watch snow settle on a twig.*

That summer, Ashbery moved to New York City to work at the Brooklyn Public Library. He kept up a correspondence with O'Hara, continuing a friendship, always lightly tinged with rivalry, that would have been platonically described as like "sisters" in the homosexual slang of the 1940s. It was kept alive by a constant exchange of hot tips on music and books (Ashbery recommending Jane Bowles's novel *Two Serious Ladies* and Prokofiev's ballet *Cinderella*) as well as the crucial swapping of their latest poems for critical response.

O'Hara's final summer in Grafton was more productive than usual as he spent much more time writing in his garret room. He continued

to work at the textile mill, his shift commented on in a letter from Lyon
Phelps, an Eliot House writer who wore his hair long in the style of the
nineties poets and founded the Poets Theatre the following year. "As
for the mill, I am glad to hear it is not so bad as might be expected,"
wrote Phelps. "Blake has a few appropriate words about mills of an-
other kind—this one may be a valuable contrast." O'Hara read and
loved Henry Green's newest novel, *Concluding,* as well as two plays of
Seneca's (*Thyestes* and *Phaedra*) and George Meredith's *Diana of the
Crossways.* He also viewed, and thought excessively about, a Warner
Brothers cartoon, *Dough for the Dodo,* alternately titled *Porky in Wacky-
land.* "Some people can't seem to get it through their heads that a sur-
prise is funny *if* it's funny not *because* it's a surprise," he delineated in a
letter to Gorey. "Porky Pig next to limp watches à la Dali and bodyless
pedestrians à la Artzybasheff is not funny in the same way D. Duck
among bathing beauties is not funny." He concluded that the cartoon,
"an attempt at being surrealistically comical," was "terrifyingly inept."

Surrealism, as well as most other qualities of French poetry from
Baudelaire through Prévert, was very much on O'Hara's mind that
summer. His readings in French poetry were beginning to keep pace
with those in experimental English fiction, so that between 1948 and
1950 he purchased *Les Fleurs du mal* and *Le Spleen de Paris* by Charles
Baudelaire, *Poésies* and *Un Coup de dés* by Stéphane Mallarmé, *Choix de
Poésies* by Paul Verlaine, *Illuminations* and *Oeuvres* by Arthur Rimbaud,
Anabases by St.-John Perse, *Poèmes & Paroles* and *Figures et Paraboles* by
Paul Claudel, *Paroles* by Jacques Prévert, and, in English, *Selected Writings*
by Paul Valéry. O'Hara was increasingly discovering in French poetry
much of the same attention to beautiful surface, witty wordplay, and
playful nonsense that had attracted him to his favorite English novelists,
as well as an openness to darker and lusher methods and themes that
was to greatly increase his own poetic range. O'Hara was soon to out-
grow certain of the preciosities of his Anglophile phase, a turn signaled
in a letter he wrote the following summer to a friend who had sent him
a prose poem for his appraisal. "I can see certain tendencies in you
which we all have to get rid of," he wrote. "With me it was Ronald
Firbank, with you it looks a bit like the divine Oscar (have you read
that PRETTY poetry!). We americans are all more lonely for glamour
than for each other, and until we learn to find it in each other and
around us, that is to say in something which we can comprehend, relax
with, and *use,* glamour is just an elder brother's cast off exoticism."
French poetry, though, was an influence that O'Hara was never to
outgrow.

O'Hara's chief fascination during the summer of 1949 was Arthur Rimbaud, the nineteenth-century French poet who at the age of sixteen had claimed that a poet transforms himself into a seer only through a long and prodigious "dérèglement de *tous les sens*." O'Hara copied into his commonplace book a positive assessment by Henry Miller from *The Time of the Assassins*, his study of Rimbaud's visionary poetics: "Of what use the poet unless he attains to a new vision of life, unless he is willing to sacrifice his life in attesting the truth and splendor of his vision?" He copied as well his favorite lines from two of Rimbaud's poems, "Mauvais Sang" and "Vies," and parodied the first line of Rimbaud's "Voyelles":

> *A black, E white, I red, O blue, U green*
> *(Rimbaud)*
> *A red, E blue, I yellow, O white, U green*
> *(me, 49)*

From June until August O'Hara worked on eighteen pastorals titled "Oranges," which were his attempts to write in the style of Rimbaud's *Illuminations*, a series of prose poems that Rimbaud had originally titled simply *Poèmes en prose*. (The following summer O'Hara would write to a friend that the prose poem was "perhaps the most difficult prosodic form.") O'Hara's resulting poems are often antipastorals, emphasizing the excrement as much as the beauty of the farm landscape of central Massachusetts in which he had grown up, a tactic suggested as well by Rimbaud in his own antipastoral poem, "Ce qu'on dit au poète à propos de fleurs." Obviously working at digesting this French poetry, O'Hara disorders his senses from the first line of "Oranges" on: "Black crows in the burnt mauve grass, as intimate as rotting rice, snot on a white linen field." Caught at the crossroads of poetry and prose, and always prone to flirting in his poems with the flat rhythms and long lines of straight prose, O'Hara had found in Rimbaud's prose poetry a naturally appealing model.

On the weekend of September 17, the final weekend before O'Hara's return to Harvard for his senior year, he visited John Ashbery in New York City. It was their first reunion since Ashbery's graduation in June. Ashbery had been turned down by Harvard's graduate English department and was preparing to study for a master's degree in literature at Columbia University instead. (The irony of Harvard's decision was to become obvious forty years later when Ashbery, as one of America's

most celebrated poets, was invited to deliver the university's prestigious 1989–90 Charles Eliot Norton lecture in poetry.) At the time he was living with a fellow library worker at 21 Jones Street in a sort of *My Sister Eileen* Greenwich Village basement apartment, the legs of passers-by always visible through its living room window. In honor of O'Hara's brief visit Ashbery threw a party in the spirit of the crowded late-night alcoholic fetes filled with young men and women passionately discussing art, as well as the proper ratio of gin to vermouth that had become O'Hara's element both in Cambridge and Grafton. Many of those attending were regulars at the Phoenix Bookshop on nearby Cornelia Street, a literary store along the lines of the Mandrake, where Ashbery had befriended John Lynch, an expert on the construction of mobiles. Late in the evening O'Hara caused a stir among the smashed party-goers by appearing wrapped in a lavender feather boa he had discovered somewhere in the apartment. "I dimly remember some story where during the party John Lynch wanted to show Frank the Phoenix Book-shop," says Ashbery. "I'm not at all sure this is an actual memory of mine and if it is it undoubtedly couldn't have happened, but something somehow sticks in my mind. They walked around the corner and Frank was, I think, wearing his feather boa. He said a woman with a little boy came up to him and said, 'This is my son. Please take him and teach him your ways.'"

O'Hara's first taste of life in New York City was tantalizing enough for him to think about living there someday. His excitement from this first visit inspired a whimsical poem titled "Song" written on a return visit a year and a half later that opened "I'm going to New York! / (what a lark! what a song!)." O'Hara's dreamy description of Manhattan in the poem's closing stanza as "hung with flashlights" marks the beginning of his poetic fascination with the city that was soon to become his muse.

The last week in September 1949, Hal Fondren took a train from his mother's home in Canton, Ohio, to New York and then to Springfield, Massachusetts, where O'Hara met him. They had decided to room together, and Fondren was planning to spend a night in Grafton before traveling with O'Hara to Cambridge. The visit, however, turned out to be more unsettling than the pleasant detour he had anticipated.

When O'Hara met Fondren at the Springfield train station he nervously cautioned his guest, "Whatever you do, don't ask for a drink at home. We'll go out and have a drink." O'Hara had never informed

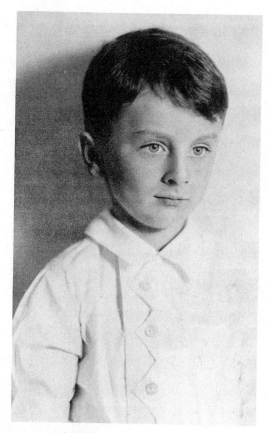

Childhood photograph of O'Hara, 1931

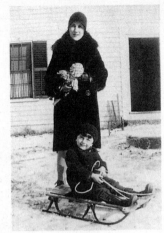

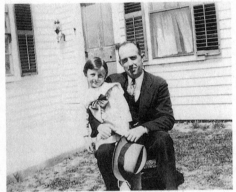

ABOVE: Young Francis O'Hara
with his mother outside their
house at 16 North Street, Grafton,
Massachusetts
LEFT: With his father
BELOW: On horseback at Tower
Hill, the family farm on the out-
skirts of Grafton where O'Hara
hoped to raise dogs when he
grew up

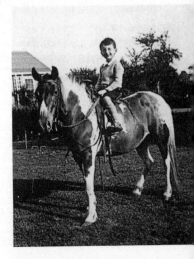

ABOVE: O'Hara's father on horseback by the J. Frank Donahue offices and barn
RIGHT: Holding Freckles, "the boring gentle cocker, spotted brown and white," in Grafton, ca. 1944
BELOW: With his parents in West Dennis, Massachusetts, August 1943

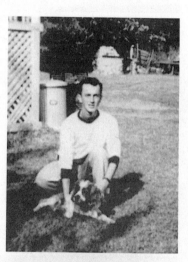

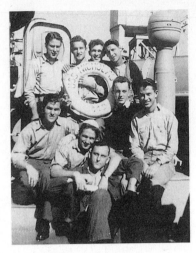

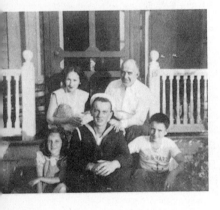

ABOVE: O'Hara and shipmates who manned the bridge aboard the destroyer USS *Nicholas*, South Pacific, 1945
LEFT: In Grafton, home on leave from the Navy, with his parents, brother, Philip and sister, Maureen, 1944
BELOW: Reading the leftist magazine *Politics* in his bunk on the USS *Nicholas*.

At Harvard, wearing his trademark corduroy jacket

O'Hara in what became his uniform of navy sweater, blue jeans, and sneakers,
Boston, ca. 1950

LEFT: Poet V. R. Lang ("Bunny")—a close friend during his Harvard years
BELOW: Posing in an outrageous headdress during his Firbankian period at Harvard

LEFT: Joe LeSueur (left) and Tibor de Nagy at Tibor de Nagy Gallery, 1954
BELOW: O'Hara with John Ashbery at a taping for Daisy Aldan's poetry magazine, *Folder 1*, November 1953

With Helen Frankenthaler, ca. 1953

Posing for Grace Hartigan's painting *Masquerade* (with Ashbery, seated center; and Jane Freilicher and O'Hara standing, right)

RIGHT: Sketch class
at Hartigan's studio,
1954, with (front to
back) Wolf Kahn,
Larry Rivers, O'Hara,
Allen Kaprow
BELOW: O'Hara and
Grace Hartigan on a
picnic, 1954

ABOVE: O'Hara in the rumble seat of
Franz Kline's old Buick acquired by Larry
Rivers, who is in the driver's seat. Standing
(left to right) Kenward Elmslie, John
Button, and Joe Rivers, 1955

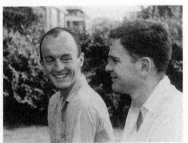

ABOVE: O'Hara and James Schuyler after
lunch at Fairfield Porter's home in
Southampton, summer 1956
BELOW: O'Hara, Hartigan, Allan Kaprow,
Joe Hazan, and Jane Freilicher at George
Segal's house in New Jersey, ca. 1955

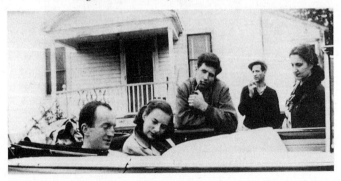

Fondren of his mother's alcoholism, and Fondren was a bit puzzled by the warning. "That was a big stumbling block for him," says Fondren. "I certainly would have been understanding if he'd said 'Mother is an alcoholic.'" Instead of explaining, O'Hara mysteriously proceeded to take him on a whirlwind tour of local bars and friends' houses, where they drank Indian Pale Ale, described by Fondren as "the local champagne," on the pretext that a guest required lots of drinks. "I think it was probably more his problem than mine," says Fondren. At dinner Mrs. O'Hara nagged them in a very dramatic voice, "Aren't you boys drinking a great deal too much?" Afterward O'Hara took Fondren to a summer production at the Red Barn Theatre in Westboro from which he left at curtain call to drive the leading lady back to her motel while Fondren went off with someone he had met at the theatre's bar. They agreed to meet in the town square of Grafton at midnight.

Fondren arrived at the Common with its empty bandstand and silhouette of the statue of Jerome Wheelock, but O'Hara never showed up. After waiting in the deserted square until 1:30 a.m. with no sign of his friend, Fondren set off in the dark to try to recognize the vaguely Victorian outline of the O'Haras' home. After quite a while, he arrived at 16 North Street, where he was greeted by a worried Mrs. O'Hara who explained that her son had arrived home earlier, badly injured, after wrecking his Aunt Grace's car. He was upstairs sleeping. At about six in the morning, O'Hara came downstairs looking very battered, with a black eye and blue bruises, asking Fondren if he remembered what had happened. O'Hara, it turned out, had drunk so much that he had entirely blacked out the evening and the events surrounding the accident. "That morning his mother was making it quite difficult," recalls Fondren. "She turned on the radio. She was listening to the local news, expecting unidentified bodies to be turned up all over, news of a hit-and-run driver. By this time we were thoroughly alarmed. We tried to retrace the route he must have taken. There weren't any houses knocked down, or hedges. We couldn't see any place where there was any damage." Toward noon they dropped the car at a garage in Worcester and took a bus back to Cambridge. Fondren was now privy to a view of some of the darker landscape his discreet roommate had been concealing—especially the specter of alcoholism as it was moving down from mother to son with its obviously destructive potential. The accident O'Hara couldn't remember must have brought up haunting memories for his mother of the death of his Uncle Joe in his soda van over twenty years before.

Back at Harvard, the incident was characteristically left undiscussed

as O'Hara and Fondren set their undergraduate lives in motion again, their sense of freedom heightened by their status as seniors. The best accommodations of O'Hara's student career were in Eliot House's O-22—a two-bedroom suite with a living room and fireplace overlooking the master's garden, with its own private entrance outside the courtyard. Nicknaming their quarters Fall River Suite in deference to the Fall River furniture left behind by Fondren's previous roommate, O'Hara and Fondren added a decidedly bohemian air to the rooms by constructing bookcases out of lumber and bricks on which Fondren displayed his original editions of Gertrude Stein and Evelyn Waugh near living room windows hung with heavy dark red curtains. O'Hara, who had so admired Calder's mobiles while stationed in San Francisco, contributed a mobile of stones and chains of his own design, which he hung in front of the fireplace, as well as a large reproduction of Picasso's *Harlequin*. In these rooms they often carried on all-night discussions in which they fancied themselves offspring of plantation society from their respective birthplaces of Maryland and Kentucky, a fanciful game alluded to by O'Hara in "A Note to Harold Fondren" written that year:

> *The sky flows over Kentucky and Maryland*
> *like a river of riches and nobility*
> *free as grass. Our thoughts move*
> *steadily over the land of our birth.*

A record player that O'Hara had brought from home figured importantly in entertainments they would occasionally devise for each other while having drinks before going down to dinner. O'Hara's specialties were singalongs to an old recording of Marlene Dietrich's cabaret performances, during which he sometimes applied blue lipstick to his full lips for effect. Fondren matched these excesses by performing a Charleston to the accompaniment of a recording of Cole Porter's "Why Shouldn't I?" Theirs was a form of cross-dressing burlesque more prevalent as acceptable entertainment in their World War II days than at Harvard. "Anyone passing by would have thought we were balmy," says Fondren.

O'Hara and Fondren fed each other's exaggerated lack of concern for schoolwork. Both headed out excitedly for the first lecture of Associate Professor H. C. Baker's Drama of the Restoration and Eighteenth Century, to which they never again returned, mostly due to the course's scheduling at 9:00 on Monday mornings. For the final hour

exam, they overslept and arrived a half hour late. "I swear that everyone gasped," remembers Fondren. "We walked in silently and picked up our blue books and sat down and started writing. I think Frank got a C — and I got a D +. They were general questions which, if you'd ever been to the theatre or read a play you could extrapolate in the way that Frank did. He needn't ever have seen one of the plays or even heard of them." Undoubtedly similar was O'Hara's treatment of Professor Sherburn's English Literature from 1700 to 1798.

While shirking the required courses for which they were being graded, O'Hara and Fondren were busily attending various courses in the Art History Department that caught their fancy. O'Hara had assimilated most of the offerings of the Music and English Literature departments and was growing increasingly interested in art, evident in his readings that year of Max Ernst's *Beyond Painting* and Paul Klee's *On Modern Art*. They attended an entire series of lectures on Venetian painting at the Fogg Museum. They audited as well an introductory art appreciation course, which consisted mostly of the slide projection of a thousand university prints of masterpieces of painting and sculpture, which students were required to commit to memory. "There were some hilarious moments in that course," says Fondren in the cool and detached tone he and O'Hara and Gorey had perfected. "The very idea of being able to snap off the titles of these masterpieces as they flash by! We were afraid to take any courses for credit in that department because all the people were eager beaver future museum directors and they were really serious." Such an attitude was ironic for Fondren who became a director of the Poindexter Gallery, and O'Hara who would make his mark as a curator at the Museum of Modern Art.

The course to which O'Hara was devoting his full energy was the year-long upper-level English G, Composition: Poetry workshop taught by Ciardi during which O'Hara composed about two dozen poems. One of Ciardi's favorites, which he graded *A,* was a formal rhymed poem in quatrains, "[White and casual, how the breath]." But most of O'Hara's poems were more surreal, humorous, exotic, and derivatively French than this traditional and more immediately comprehensible play of variations on the simple theme of breathing. More numerous were such richly and purposefully dazzling efforts as "The Muse Considered as a Demon Lover," a Baudelaire-like vision in heavily exclamation-pointed couplets about the visit of an angel muse who "burned all over the sheets"; "Poem" (At night Chinamen jump), which opened jauntily with the aggressively rhymed couplet "At night Chinamen jump / on Asia with a thump"; and "Poem" (The eager note on my door said,

"Call me"), a Surrealistic black comedy published in the *Advocate* the following September in which the poet rushes over to discover his note writer "there in the hall, flat on a sheet of blood that / ran down the stairs." While the pejorative sense of the term *French* sums up most of these willfully clever poems, even the most precious, such as "Today," which opens, "Oh! kangaroos, sequins, chocolate sodas!," mixes what Ashbery has described as its "Parisian artiness" with a pragmatic American feeling for the solidity of objects, concluding "These things are with us every day / even on beachheads and biers. They / do have meaning. They're strong as rocks." "I never thought that I was a Surrealist and I doubt that Frank would have either," says Ashbery, qualifying Octavio Paz's reductive assertion in his 1971 Norton Lectures that Ashbery and O'Hara were the first American Surrealists. "But we were certainly very much influenced and were 'fellow travelers' of Surrealism. There were people like Charles Henri Ford and Parker Tyler in the thirties and forties who wrote rather heavy-handed approximations of French Surrealism. And there were undoubtedly others who I think actually wanted to be thought of as Surrealists." For O'Hara, French Surrealism, described by André Breton in his first Surrealist manifesto in 1924 as "pure psychic automatism," was mostly a foreign discovery that helped him to write unusual poems that remained contentiously outside the bounds of the traditional academic poetry of the 1940s. "Much of the poetry we both wrote as undergraduates now seems marred by a certain nervous preciosity," Ashbery wrote years later, "in part a reaction to the cultivated blandness around us which also impelled us to callow aesthetic pronouncements."

By senior year O'Hara had met Violet R. Lang, nicknamed Bunny, the other poet whose friendship was as important to his development as Ashbery's. "I first saw Bunny Lang . . . at a cocktail party in a book store in Cambridge, Massachusetts," O'Hara wrote in a memoir in the *Village Voice* in 1957, most likely referring to the Mandrake. "She was sitting in a corner sulking and biting her lower-lip—long blonde hair, brown eyes, Roman-striped skirt. As if it were a movie, she was glamorous and aloof." The young lady O'Hara was talking to only increased his curiosity by remarking, "That's Bunny Lang. I'd like to give her a good slap." Many of the literati of Cambridge knew who Lang was and had strong opinions about her. Like O'Hara, she had been endowed with an aura of mystery and idiosyncrasy. The last of seven daughters born to a Social Register family, Lang lived with her father, Malcolm Lang, a King's Chapel organist for many years, in a four-story brownstone at 209 Bay State Road overlooking the Charles River. The house

was largely deserted since the death of her mother, Ethel Ranney, in 1949, and the marriages of her other sisters. Lang had graduated from the Hannah More Academy, came out in 1941, and spent her life restlessly shimmying out of the constrictions of her Boston Brahmin upbringing. Bored after two years at the University of Chicago and too young at age eighteen for any of the American women's organizations, Lang had enlisted in the Canadian WACS during World War II. After the war she returned to the University of Chicago and edited the *Chicago Review* in 1948 before returning to Boston, where she worked on an uncompleted historical novel with Jack Rogers, a friend who became one of the actors of the Poets Theatre, Roger Jackson. Lang was a serious writer with a mania for constant rewriting. During 1949 and 1950 she published four poems in the most prominent of the little poetry magazines at the time, *Poetry* of Chicago: "The Suicide," and "Philosopher King" (both in May 1949), "At the Meeting of Two Families" (November 1949), and "The Pitch" (February 1950). She was an unwavering disciple of Auden, and most of her poems emulate at least faintly the elliptical Anglo-Saxon–derived Audenesque diction of the opening triplet of "The Pitch": "Spring you came marvelous with possibles / Marvels sparked everywhere burning from bracken / Lichen leapt crackling, and long grass."

Much of Lang's magnetism, like O'Hara's, was ascribable to her presence—her larger-than-life personality and her sharp and uncommonly witty tongue. She had a plump, pretty face set off by bleached blond hair and underlined by a full sensual mouth and was known for extremely quick-shifting moods. In addition to being a poet, she wrote, directed, and acted in plays. "She had a mournful clown's face," says Ashbery who was later introduced to her by O'Hara. "Her sort of Walter Keene expression would constantly be interrupted by a giggle or a joke." Lang satisfied some of her desire for role-playing by filling her drawers and closets with various exaggerated clothes, almost costumes, which she would wear in constantly shifting arrangements: huge fur coats, black cocktail dresses, men's navy cotton jerseys, torn blue sneakers, white strapless piqué dresses, an old brown trenchcoat, a long white nightgown, bulky sweatshirts. Though Lang was always bankrolled by her father's money, she further added to her mystique by taking up an inconsistent string of odd jobs, from bridal consultant for Fabian Bachrach to commission saleswoman for a Your Child's Lifetime Photograph plan, to cover short-term debts. Her most famous gig was as a chorus girl barely covered by red sequins and wearing spiked heels and a tall feather headdress at Boston's Old Howard burlesque theatre—the

experience served as raw material for her 1952 verse drama, *Fire Exit,* a retelling of the Orpheus myth set in a burlesque house in Union City, New Jersey. These excesses, and the confusions and insecurities behind them, could place heavy demands on her friends. "You meet Bunny and you love her so much you want to carry all her packages for her," commented George Montgomery at the time. "So she puts them into your arms and as you go along you find that they get heavier and heavier until you are ready to drop with fatigue." "Bunny was definitely one of the great sacred monsters," says Gorey. "I always felt she gave short shrift to the likes of Sylvia Plath and Anne Sexton. Like, 'Oh you haven't been through anything, honey.'" John Simon, the theatre critic who was serving as Harry Levin's reader while a teaching fellow at Harvard, put it another way: "Bunny Lang was a fag hag. She was an exaggerated, overdone parody of femininity who cultivated around her a retinue of homosexual men who liked her for her outrageousness and outspokenness."

While O'Hara's friendship with Lang was often played out in public, a significant sector was private and intimate. Given to vague romances with arty women, such as Natasha whom he had met at the Servicemen's Arts Center in San Francisco, O'Hara and Lang defused any sexual tension by casting themselves imaginatively as brother and sister, often claiming that they traded identities. The love they felt for each other was focused on their kinship as lovers of poetry and art. A few weeks after their meeting at the bookstore, they met again for a fencing period during which they sounded each other out for hours over beers. They both loved Rimbaud and Auden, although Lang felt O'Hara loved Rimbaud too much and he felt the same about her obsession with Auden. As strongly opinionated as O'Hara, Lang claimed that she simply couldn't like Cocteau and couldn't bear *Ivan the Terrible.* "It's so black," she argued. "I don't believe a minute of it!" "And we then began our 'coffee talks' which were to go on for years, sometimes long distance," O'Hara wrote in his memoir. "At 11 each morning we called each other and discussed everything we had thought of since we had parted the night before, including any dreams we may have had in the meantime. And once we were going to write a modern Coffee Cantata together, but never did."

Their usual meeting place was Jim Cronin's, a popular quick beer stop-off in Cambridge, which the 1948 *Harvard Yearbook* described as a "somewhat incongruous combination of the intimate booth system with a square footage ample enough for an airplane hangar." Students taking late-night study breaks squeezed into straight-backed wooden booths,

seating four to six persons, for eighty-cent hot roast beef sandwiches and Ballantine on tap. O'Hara and Lang were always crowded in a booth as their fast dialogue attracted a regular group of friends who, it seemed to Robert Bly, were part of "an astonishing collection of intense maniacs." One of these nightly companions was George Montgomery, a quietly enigmatic poet and photographer who was often compared to the harlequin of Picasso's blue period hanging over O'Hara's fireplace. Ashbery described him as "a glamour boy. He worked out a lot which you didn't see much of at the time." Lyon Phelps was also a regular. The aspiring Yeatsian playwright was sure enough of his own ascendent fame that he had balked at addressing invitations for his sister's wedding, afraid his handwriting would later be identified as having executed an unartistic task. O'Hara's and Lang's socializing sometimes spilled over to other Cambridge locales, though without much variation in its decidedly crazy spirit. "I once saw Frank and Bunny dance on the tables of the Hayes-Bickford Cafeteria," says Harold Brodkey. "They did a Fred and Ginger routine. It was marvelous. But they did it as a form of incest. It wasn't romantic." With the help of Lang, O'Hara had begun to indulge senior year in this sort of communal café nightlife, the kind he would later thrive on at the San Remo and Cedar Tavern in downtown New York.

O'Hara liked to write in public and often scribbled poems at Cronin's, including a collaboration one night with Montgomery, who contributed the leading line, "Oh for a faithful sailor!" Lang, however, was a more solitary poet. She hid away in her big room at the top of her Boston house, staring out at the Charles River and ignoring her two noisy Siamese cats who always seemed to be in heat, while she typed up her poems over and over, sometimes as many as forty times, in contrast to O'Hara who revised quickly and sparingly. Here Lang and O'Hara sat together writing joke poems, collaborating on alternate lines, or correcting each other's work so that it was difficult to tell whose was whose. The inclusion of a poem actually written by Lang in O'Hara's *Collected Poems*—"Words to Frank O'Hara's Angel," which concludes "Protect his tongue"—was an understandable editorial error, especially given its similarity to O'Hara's own poem written at the same time and dedicated to V. R. Lang, "An 18th Century Letter," which begins "To you who's friend to my angels (all quarrelling)." (When a *Poetry* editor rejected "Words to Frank O'Hara's Angel" in the fall of 1950, Lang's reaction in a letter to O'Hara was "The NERVE of him sending back your Angel.") O'Hara's poems to Lang were always personal communications filled with inside jokes, a familiar tack for the

poet whose poems, as he would describe them half-seriously in his 1959 manifesto "Personism," were simply unmade telephone calls. O'Hara used his Cambridge poems to Lang to poke teasingly at weak spots in her character, especially what he regarded as her self-important seriousness. As he wrote impishly in "V. R. Lang":

> *You are so serious, as if*
> *a glacier spoke in your ear*
> *or you had to walk through*
> *the great gate of Kiev*
> *to get to the living room.*

Theirs was a complex and symbiotic friendship that would stimulate both of them enough to put up with its fluctuations over the next several years.

As he became more involved with the extracurricular scene at Cronin's, O'Hara was even less inclined to sit through classroom lectures. The only new offering that inspired his regular attendance second semester senior year was The Symbolist Movement, taught by Renato Poggioli. Its effect on O'Hara far outstripped that of his two other electives: Edwin Honig's Allegory and Associate Professor Walter Jackson Bate's English Critics. An Associate Professor in Slavic and Comparative Literature, Poggioli was recognized as an authority on Russian writers and thinkers of the nineteenth and twentieth centuries and had recently written an article on "Theory of the Advance-Guard Art." For O'Hara, the appeal was Poggioli's syllabus, which included extensive readings in the French Symbolist poets—Baudelaire, Rimbaud, Valéry and Mallarmé. The work of these poets overlapped almost perfectly with O'Hara's own interests of the moment. O'Hara was charmed, too, by Poggioli's easy European manner, so distinct from the predominating stern and proper Anglo-American sensibility of the English Department. Whenever Poggioli was lecturing his face always moved, as he paused, into a smile. As he explicated a problem he would often announce, "Eet's a seem-bol."

O'Hara met a fellow student in this course, Lawrence Osgood, with whom he had one of his first romantic affairs in which the feelings were somewhat reciprocal. A nineteen-year-old nonveteran member of the Class of '50 from Buffalo, New York, Osgood had served as a sophomore on the board of the *Advocate,* dropped out of school for a

year of self-examination, then returned in the spring of 1950 during which he roomed with Lyon Phelps in Eliot House. During his year off, Osgood had spent a year in psychoanalysis in Philadelphia because of fears of his homosexuality. At Harvard that spring Osgood continued his analysis by seeing a university psychiatrist. While O'Hara was still in the Navy, he had been briefly fascinated with the writings of Freud, but by senior year at Harvard he had grown mostly uninterested in undergoing any of the forms of psychoanalysis that were to become increasingly fashionable among his fellow artists and intellectuals in the fifties.

One evening Osgood joined O'Hara's circle at Cronin's for a night of the usual drinking. Osgood, O'Hara, Phelps, and Fondren then returned to O-22 to continue the party with a bottle of Southern Comfort. Fondren went off to bed, while Phelps stayed on playing O'Hara's favorite Marlene Dietrich records on his phonograph. When O'Hara and Osgood began dancing together, Phelps finally tottered off to his own room. "As soon as I started to dance with Frank, I knew exactly what I wanted to do," says Osgood, "which was to go to bed together." Knowing that Osgood had never been to bed with a man before, O'Hara sweetly kept asking, "Are you sure you want to do this? Are you sure you know what it means?" "I may have appeared to him as a one-night stand," says Osgood. "It wasn't like that for me at all. I really had no experience in that kind of thing. But afterwards I instinctively pulled every kind of trick to keep Frank interested in me that one can pull under those circumstances, being the person who wants to continue an affair when the other person may or may not want to."

O'Hara's affair with Osgood, who later became a playwright and Arctic adventurer, fit a pattern that he would follow in many of his future romantic involvements. The seduction of younger, inexperienced young men, with the special interplay of power, initiation, adolescence, innocence, and corruption involved in such scenarios, held a powerful attraction for O'Hara. He felt exceedingly comfortable in the role of the big brother that extended in these relationships well beyond the bedroom, often their least significant aspect. "From some distance I've come to realize that he was in fact very fond of me," judges Osgood. "As a lover, physically. But also as a more innocent person than he was. It was sort of a younger brother–older brother relationship. I think he found that charming. He guided me into a world of certain attitudes towards literature and music. Frank formed quite a bit of my thinking in those respects, or helped significantly." That this sort of seduction

continued on apace later in New York, especially in its most blatant form in the seduction of heterosexual men with little or no homosexual experience, is attested to by the poet Richard Howard. "Frank was always convincing straight people that they could sleep with him," says Howard. "That was an interest of his. But a lot of us felt that that wasn't an interest of ours. To colonize in that way."

Because of his intimacy with O'Hara, Osgood witnessed some behavior that was hidden from his other friends. He was especially aware of the toll of the crisis at home, which was peaking for O'Hara during this year. "There were times at Harvard when Frank would go into absolutely black black black depressions," recalls Osgood. "Not many. But I can remember when he would lie down on the couch in the room he and Hal Fondren had, draw the shades, and stay in darkness for several hours. My feeling about those times was that they had a lot to do with his mother, and that he was really working out of feeling responsible for her. I can remember him saying things which were hostile and unfeeling about his mother in order to distance himself from the hold that she had been trying to exert on him. That's when she was beginning to drink and he could see himself being drawn into having to spend his life coping with that. During the spring of 1950 he did talk about her some, mostly in terms of how ill-equipped she was, how he was just going to have to get away from her, and how he was not going to let her tie him down."

Typically O'Hara worked out his conflicts between mother and art, Grafton and bohemia, in a poem, "Memorial Day 1950," written at the end of his last semester at Harvard and later judged by Ashbery "one of his most beautiful early poems." As O'Hara was famously careless about keeping copies of his work, the poem exists only because it was copied out by Ashbery in a letter to Kenneth Koch. Most of its irregular stanzas, similar to indented paragraphs of prose, are filled with quick references to the poets and artists who were inspiring him. Beginning "Picasso made me tough and quick, and the world," the poem constitutes a catalogue of his enthusiasms while at Harvard: "I had a lot to say, and named several last things / Gertrude Stein hadn't had time for"; "even when you're scared art is no dictionary. / Max Ernst told us that"; "we were all busy hoping our eyes were talking / to Paul Klee"; "Fathers of Dada! You carried shining erector sets / in your rough bony pockets"; "O Boris Pasternak, it may be silly / to call to you, so tall in the Urals, but your voice / cleans our world."

O'Hara challenges authority figures from his past, especially his

mother and father, with these new, thoroughly avant-garde poems. Like Rimbaud in "Les Poètes de sept ans" his tone is one of adolescent rebelliousness, his images bright, dirty, and provocative. O'Hara's attitude toward his parents is strident and contrary:

> My mother and father asked me and
> I told them from my tight blue pants we should
> love only the stones, the sea, and heroic figures.
> Wasted child! I'll club you on the shins! I
> wasn't surprised when the older people entered
> my cheap blue hotel room and broke my guitar and my can
> of blue paint.

These "tight blue pants" held special resonance for O'Hara who had been asked recently by a patron of the Silver Dollar, a gay bar in Boston that O'Hara frequented, about his tight-fitting blue jeans, "How'd you get into those? With a shoe horn?" At the end of the poem O'Hara opts, not surprisingly, for the artist's life in his garret, a fanciful reproduction of his attic room in Grafton:

> Look at my room.
> Guitar strings hold up pictures. I don't need
> a piano to sing, and naming things is only the intention
> to make things. A locomotive is more melodious
> than a cello. I dress in oil cloth and read music
> by Guillaume Apollinaire's clay candelabra. Now
> my father is dead and has found out you must look things
> in the belly, not the eye. If only he had listened
> to the men who made us, hollering like stuck pigs!

As the poet who wrote two poems that year revolving around the fantasy of orphanhood—"Gamin" and "Autobiographia Literaria"—O'Hara created for himself in "Memorial Day 1950" a lineage of artists rather than of O'Haras and Brodericks. It is the Rimbauds and Apollinaires who made him, he claims, and not he himself. Like the cubist Picasso of whom he writes

Once he got his axe going everyone was upset
enough to fight for the last ditch and heap
of rubbish

O'Hara was creating by destructively rearranging.

Commencement Day finally arrived on Thursday, June 23. O'Hara and Fondren got up that morning with terrible hangovers just in time for the arrival of both their mothers: O'Hara's drove in from Grafton, Fondren's was staying at the Ritz-Carlton. Putting on their rented black and white caps and gowns, they both took generous slugs from a bottle of scotch they had set on their coffee table, fashioned from an old sewing machine. "I waved the bottle at my mother, knowing full well that she wouldn't dream of having a drink of scotch whisky, let alone at ten o'clock in the morning, without ice, on a hot day," recalls Fondren. O'Hara's mother, however, replied with surprising alacrity, "Yes, I'd like a drink too." "That was the beginning of the end of that day," says Fondren, whom O'Hara had still not informed of his mother's alcoholism. "I thought nothing of it. But it was too late. I mean Frank should have warned me, which he never did."

At 9:30 a.m. O'Hara and Fondren joined the rest of Harvard's seniors in front of Holworthy Hall where, preceded by the band, they passed in front of the statue of John Harvard to form a double line along the path leading to the grassy space between Memorial Church and Widener Library, filled with rows of wooden chairs and transformed yearly into the "Tercentenary Theatre." The opening of Harvard's 299th Commencement for the conferring of 3,021 degrees, including those of the doctoral candidates in their bright pink gowns, was marked by the appearance on horseback of the Sheriff of Middlesex County dressed in eighteenth-century garb. Governor Dever arrived escorted by the scarlet-coated National Lancers of Massachusetts. After the seating of President Conant in a historic Tudor chair, a student began solemnities almost three centuries old with an oration in Latin. Soon the graduating seniors were called by President Conant to rise to their feet as their representatives ascended the steps of Memorial Hall to join "the fellowship of educated men." Honorary degrees were awarded to Secretary of State Dean Acheson, whose resignation had recently been requested by Senator Joseph McCarthy, and to General Carlos P. Romulo, president of the fourth session of the U.N. General Assembly. It was O'Hara's first brush with such pomp and ceremony since his witnessing of the formal surrender in Tokyo in 1945, and it marked the passing

of the last of Harvard's classes predominantly made up of veterans, the gradually mythologized Class of 1950.

Following the ceremonies, the O'Haras and Fondrens returned to O-22 where the two graduated seniors braced themselves with a little jigger of whiskey each. Mrs. O'Hara also continued to drink, enough so that when they arrived at Hopewell Farm in Concord for lunch she momentarily lost her equilibrium. "Frank noticed it and was very concerned and embarrassed about it," recalls Fondren. "He never talked about his mother. You had to worm any information out of him. But that day he then admitted to me that his mother was an alcoholic and that it was a terrible problem." The problem for O'Hara was not simply concern for his mother's well-being, but concern that she would use her sickness, as she had used her weaknesses and hypochondriacal illnesses in his boyhood, as a means of trying to control those around her. That summer he reported on his conversation with Fondren in a letter to Larry Osgood who was working as a stage manager with a musical theatre troupe in San Francisco: "I was telling Hal the other day that I have the awful premonition that my Mother will do something foolish and terrible which will involve me and destroy my liberty. Dear god I hope I'm not right. People always try to make their attempted tyrannies seem like reminders of your responsibility."

O'Hara began vacating O-22 the following afternoon, moving to a rented room in Cervin Robinson's family house on Beacon Hill where George Montgomery was also residing. As he left Eliot House, his mood was decidedly different from that of most of his peers, with whom he had been so synchronized four years earlier when he had written to his parents, "I think I'd better hurry or I'll be too late!" He as yet had no specific future plans and was certainly not anxious to join the ranks of the majority of Harvard seniors moving ambitiously on to graduate and professional schools or to positions waiting for them in the job market. O'Hara had unconsciously echoed his earlier freshman sentiments in his pivotal student journal of 1948, though shifting his meaning at that time more aggressively into the context of art: "One must live in a way; we must channel, there is not time nor space, one must hurry, one must avoid impediments, snares, detours; one must not be stifled in a closed social or artistic railway station waiting for the train; I've a long way to go, and I'm late already." By the time he graduated, his energy and anxieties had become centered solely on writing, and on living his life as if it were art. He was the same but different.

This development can be felt in his attitude toward his name. Before O'Hara arrived at Harvard he was accustomed to being called Francis,

a name shortened by students at St. John's and by Navy buddies to Fran or Frannie. During his first semester at Harvard, when he met Edward Gorey and coped with the death of his father, whose name he carried as his middle name, he began to prefer to be called Frank, known to him most intimately as the preferred name of his bachelor uncle and the family czar, J. Frank Donahue. During his four years at Harvard, O'Hara was split, being called Frank in person while continuing to sign papers and published poems and stories as Francis. This split was reflected in the issues of the *Advocate* in which he was published. In the April 1948 issue in which "The Unquiet Grave" appeared, the story was credited to Francis O'Hara while the Contributor's Note referred to him more personally as Frank O'Hara. In the September 1950 *Advocate* in which the "The Drummer" and "Poem" (The eager note on my door said, "Call me,"), as well as a story, "Late Adventure," were published, he finally signed his stories Frank O'Hara, though he was listed by the editors in the Table of Contents as Francis O'Hara. In all future publications, beginning with the February 1951 *Advocate* in which "A Prayer to Prospero" was published, he would always appear on the page as Frank O'Hara. Frank, with its direct, flat, smacking sound, appealed to O'Hara's poetic ear, and he loved using it in his poems, either directly and self-dramatizingly as in "And if / some aficionado of my mess says 'That's / not like Frank!', all to the good!" in "My Heart," or punningly when the Sun announces, "Frankly I wanted to tell you / I like your poetry" in "A True Account of Talking to the Sun at Fire Island." At Harvard, O'Hara had accomplished the transition privately and publicly from the Francis of his childhood to the Frank of his future poetry.

Ann Arbor Variations

Beacon Hill was the dirtiest place in the world and the best," O'Hara characterized his new neighborhood in the novel he was working on during the summer of 1950.

Certainly the once fashionable residential area running up alongside the Public Gardens and the Common to the gold-domed State House had seen better times, its status as the preferred home of Boston Brahmins having given way since the nineteenth century to its present more colorful and bohemian mood. But much of its past was still intact, including 72 Myrtle Street, O'Hara's new address, a four-story red brick townhouse with shuttered colonial windows set on a gaslit, cobble-stoned street. Its owners, the parents of his photographer classmate Cervin Robinson, conformed to an older generation of Beacon Hill residents. Judy Rubenstein recalls attending a small dinner at 72 Myrtle Street where Robinson's mother descended the staircase wearing a hat with veil and carrying a purse. Many of the Robinsons' peers, however, had permanently abandoned their central city homes, leaving behind them a picturesque jumble of cast-iron fences, stair rails, balconies,

waxed windowpanes, footscrapers, rose-red brick Georgian facades, and giant elm trees. The neighborhood's resulting haunted state was first evoked by O'Hara in a whimsical student poem, "Beacon Hill":

> *The houses are ghettoes of ghouls*
> *and out in the stagnant pools*
> *the heads of maidens*
> *deflowered on whim*
> *decompose*
> *and rise to the rim.*

O'Hara began his first summer away from Grafton as a stage apprentice at the Brattle Street Theatre. While his gofer's job consisted almost entirely of hunting down stage props and painting sets, the theatre was imbued with enough residual magic to keep him entranced for a few weeks. The Brattle had been founded after the war by a group of Harvard students as the Veterans Theatre Workshop. It had evolved into its present incarnation as a professional company housed in a tiny theatre off Harvard Square from its cradle at Sanders Theatre, where a 1947 production of Shaw's *Saint Joan* had felicitously transformed the lecture hall's transept into a vast Reims Cathedral. A showcase for the virtues of mixing more mature veterans with younger student actors versed only in prep school skits, the VTW's activities had been front-page news in the *Crimson* from its inception as the group ambitiously imported name actresses such as Luise Rainer and Hermione Gingold (in her American debut in a musical revue), corresponded with George Bernard Shaw on his suggestions for a male actor for *Saint Joan,* and earned the enthusiastic championing of F. O. Matthiessen as well as the praise of W. H. Auden (for Jerome Kilty's Falstaff). Their performances of classics during O'Hara's four years included Pirandello's *Henry IV,* Chekhov's *The Seagull,* Sartre's *No Exit,* and Shakespeare's *Henry IV, Part I, Richard II, Troilus and Cressida, King Lear,* and *The Tempest* with a new score by Lukas Foss. All the excitement and debate stirred up by the Brattle was given a more worldly context by Boston's function as an out-of-town testing ground for big Broadway shows. Harvard's students were able to get a jump on New York critics, arguing among themselves later at the Window Shop, a Viennese pastry and coffee shop on Brattle Street, the merits of such new plays as Tennessee Williams's *A Streetcar Named Desire* and Rodgers and Hammerstein's *South Pacific.* O'Hara's own tastes in theatre during his college years veered between

verse plays and more popular mainstream dramas and musical come-
dies, and would for the rest of his life.

O'Hara had spent several summers loitering at the stage door of the
Red Barn Theatre, since actors and actresses held a great fascination for
him. He loved their shuttlings between reality and fantasy, personality
and stardom. Sympathy for an actor had led him to write "A Prayer to
Prospero," which he dedicated "to David Hersey who created him for
me," removing some of the sting of the *Crimson* reviewer who had
panned Hersey's performance in the Brattle production in the spring of
1949 as "disappointing." (Critics were lifelong enemies of O'Hara who
described one as "the assassin / of my orchards" in his poem of the
following January, "The Critic," and whose own later art reviews tended
to be appreciations rather than critiques.) O'Hara's closest brush with
acting came during his apprenticeship on the Brattle's production of
Julius Caesar, which opened on July 4 and starred John Carradine. He
performed a brief walk-on as a Roman soldier, a record of which re-
mains in a publicity photo that captures O'Hara dressed in a tunic,
holding a long pointed spear, looking out with a panicked expression
from his shiny helmet. Five years later, O'Hara recalled this experience
when he was writing one of his many elegies to James Dean, whose
tragic death had set him up as one of the most romantic of the actors
O'Hara had so admired on the screens of the Worcester movie theatres
as well as at the Red Barn and the Brattle. By a sort of method poetry,
O'Hara located himself, in "Thinking of James Dean," at the same age
as Dean when he died, twenty-four, acting on the stage of the Brattle,
trying to enter into the screen idol's death by empathic identification:

> had I died at twenty-four as he, but
> in Boston, robbed of these suns and knowledges, a corpse more whole,
>
> less deeply torn, less bruised and less alive, perhaps backstage
> at the Brattle Theatre amidst the cold cream and the familiar lice
> in my red-gold costume for a bit in Julius Caesar, would I be
> smaller now in the vastness of light?

While this fragment of O'Hara's apprenticeship was later incorporated
into poetry, he mostly found his job interfering with writing and so
decided at the beginning of August to quit. "I am looking for a job for
the fall and so do not spend so much time at the Brattle as I did," he
wrote to Osgood on August 2. "It was really very taxing, at least 12

hours a day (through performances) and weekends were much worse. For the first five weeks I had only one evening to myself (I saw *The Scarlet Empress* and was entranced with Dietrich, von Sternberg's direction, and the wonderful eclectic decors) and had not written a line, naturally."

While O'Hara looked fitfully for a job, Ciardi was setting in motion a plan that would determine a different future for him. At a spaghetti dinner at the Ciardis' one evening attended by O'Hara, Edward Gorey, and Donald Hall, Ciardi suddenly announced to O'Hara, "You go out to Michigan and get a Hopwood!" and then and there wrote a letter to Roy Cowden, the university's creative writing professor, who had been his own teacher when he had won a Hopwood eleven years earlier. "He is inquiring whether I can get into Michigan U. graduate school but it is so late now that I rather doubt that I will," O'Hara wrote a bit self-protectingly to Osgood of Ciardi's campaign, its last-minute timing similar to that of his application to Harvard four years earlier. O'Hara's backup was simply to share an apartment with John Ashbery in either Boston or New York. When Ashbery heard of the Hopwood plan, though, he found it so "hotsy-totsy" that he too decided to apply to the University of Michigan, which at the time offered one of the few master's degree programs in creative writing outside of the Iowa Writers Community and Stanford. Ashbery, who had recently earned an M.A. in English Literature at Columbia, writing his thesis on Henry Green, asked O'Hara whether he thought Ciardi might write a recommendation for him too, diffusing the competition he must have felt could have been provoked by such a suggestion by adding, "Of course we both can't win the Hopwood, but I feel we'll write so well we'll be glad we didn't."

When Ashbery came up to Cambridge to stay for a week at the Robinsons', he and O'Hara took in Olivier's *Hamlet* and *Panic in the Streets,* a film about a cholera epidemic in New Orleans starring Richard Widmark. But most of their volleying took place that summer by letter. Ashbery, for instance, sent O'Hara a "mad madrigal" he had written. O'Hara, inspired by its elaborate stanzaic form, quickly dashed off his own "Madrigal for a Dead Cat Named Julia" written on the occasion of George Montgomery's rushing his typhus-infected cat to the Animal Rescue League. Ashbery informed him in turn that the form "which you used so well" had been borrowed from Hopkins's "Wreck of the Deutschland" and suggested that O'Hara "would do well to take a half hour out to read this." Their pedagogy was mutual. Ashbery was reading *Melmoth the Wanderer,* the Reverend Charles Maturin's nineteenth-

century Gothic novel about a satanic hero, partly because O'Hara had bothered to write his own "Melmoth the Wanderer" the previous December. The novel appealed to O'Hara who was increasingly glamorizing himself as devilish, as it had appealed before him to Scott, Balzac, Baudelaire, and Oscar Wilde (who had adopted Melmoth briefly as his own nickname). When O'Hara mailed Ashbery two recent poems ("Quiet Poem" and "Today"), Ashbery replied—enclosing a copy of John Wheelwright's "Why Must You Know?"—that O'Hara had been reminding him recently of that idiosyncratic 1930s Anglican Socialist Boston poet: "he is somewhat like you, though not too much." This appraisal was to stick in Ashbery's mind so that he would write in *Book Week* in 1966 that O'Hara's death was "the biggest secret loss to American poetry since John Wheelwright was killed by a car in Boston in 1940."

O'Hara was spending many of his free afternoons with George Montgomery, as they were both holed up in the empty Beacon Hill house. They had always had a rather private friendship, befitting Montgomery's quietly elusive personality. "We weren't lovers ever," claims Montgomery. "Many people thought we were, but we never were." A student of medieval philosophy from Berlin, Connecticut, who never finished at Harvard, Montgomery was a bit of an enigma on campus. His cryptic nonverbal manner and mastery of such arcane arts as mobile making and the Zen arrangement of stones and tiny objects allowed him to serve as a still center about whom a group of much more verbal and frenetic people moved. He was also good-looking in a very refined way—as one Radcliffe graduate put it, "George Montgomery was the most beautiful creature then who ever walked the earth."

Montgomery persuaded O'Hara to pose for photographs in the Robinsons' garden as all the animals in a medieval bestiary, including a snake crouched up in a tree, a fitting allegory for O'Hara, "the serpent in their midst" from his 1956 poem "In Memory of My Feelings." O'Hara, reciprocating, captured Montgomery for posterity in his poems, not only indirectly in "Madrigal for a Dead Cat Named Julia," but also in "A Walk on Sunday Afternoon," which records a relaxed stroll with Montgomery around Beacon Hill, the Common, and the Navy Yard during which Montgomery remarks tersely and inexplicably, in one of O'Hara's earliest uses of direct quotation in poetry, "Rio de Janeiro / is just another fishing / village." Both were entranced with all things avant-garde, though Montgomery's interest was more stubbornly purist than O'Hara's. This difference in emphasis created strains on their friendship as late as the 1960s when Montgomery, living in a loft above

O'Hara's on lower Broadway, often criticized him for not spending enough time at his typewriter.

O'Hara passed most of his August evenings drinking and talking with his Cronin's circle, a more accomplished version of the Bloomsbury Circle of his previous summers in Grafton. "And you think you've got patterns!" he wrote to Osgood of his regular beer-drinking sessions. The Circe of that circle, of course, was Bunny Lang whom he described as "my constant companion solace and inspiration this summer." Ever adamant and opinionated, Bunny Lang was constantly praising or criticizing everyone's poems. Ashbery became piqued during his July visit when she disliked a poem titled "Mencius on Mill Street" and told him he took his art too seriously. "You and I are much better than Violet whose high-hatted attitude somewhat nettled me," Ashbery wrote O'Hara voicing an opinion he later retracted. When O'Hara showed her his "Madrigal for a Dead Cat Named Julia" she backhandedly praised its "neatness." ("The shit," he wrote to Osgood.) Writing "A Letter to Bunny" in October, O'Hara thought back wistfully on their 1950 Cambridge summer, which had included the Brattle ("All day long at the theatre"); so many controversial first drafts of poems ("I wrote, 'it's grey and monstrous' which / is false"); a compulsive reliance on one another ("When anyone reads this but you it begins / to be lost"); an artistic intimacy bordering on romance ("Be always my heroine and flower. Love, Frank"). Adversarial and sure of himself, O'Hara had found his match in Lang and so allowed himself, as if trumped, to worry insecurely in front of her; "my / nerves thank you for not always laughing," he wrote.

Missing from Cronin's was Osgood, a favorite not only of O'Hara's but also of Bunny Lang's. Writing to Osgood he voiced an exaggerated jealousy of his relationship with Lang: "She is looking very beautiful and I adore her even though I used to get annoyed when she used to cart you away for whole days at a time. (I didn't mention it because I was afraid you'd become difficult and skittish)." When he showed one of Osgood's letters to Ashbery, O'Hara, who liked to flatter his boyfriends by stressing their importance to his other friends, reported to Osgood that Ashbery moaned, "Oh Frank! do you suppose someone will write letters like this to me someday?" O'Hara invited Osgood to travel from San Francisco to meet him in Cambridge, "knowing that you enjoy assuming the masculine role in such matters as transportation and pursuit." Cast fully adrift by now into the world of homosexuality where roles could not be assumed as the natural consequence of biology or society, O'Hara was quite comfortable with a theatrical attitude to-

ward romance, adopting with Osgood, as with most of his lovers, a complicated pose at once passive and powerful.

By the end of the summer O'Hara had plunged into the ambitious project of writing a novel titled *The 4th of July*. He spent many hours typing in his Spartanly furnished room at the Robinsons' where he slept on an Army cot and used a large frying pan as an ashtray, perhaps the frying pan of "Memorial Day 1950": "How many trees and frying pans / I loved and lost!" On the surface the unpublished novel gives a sense of O'Hara's daily routine and impressions through Bud, a twenty-four-year-old writer and composer, who lives in his mother's house on Beacon Hill situated almost precisely on the same spot as the Robinsons'. One chapter follows Bud on the day before the "4th" of the title as he abandons his small room, walks past his favorite Louisburg Square, its statues of Aristides and Columbus "standing with their backs staunchly to each other all through the years," and down to the seedier Scollay Square, the site of the Old Howard where Bunny Lang would soon be performing her bump-and-grind dances. From there he caught the Orient Avenue express subway to the beach, a favorite destination of O'Hara's, "ankle deep in the glassy water, feeling it suck away from his feet and then flood back in, watching the patterns appear and change and disappear and change, like abstract and instantaneous photographs."

The novel offers glimpses, through O'Hara's eyes, of the Charles River "thick with boats and canoes tied by buoys," the "huge copper and black trees" of the Public Gardens, the State House's "flashing gold dome" behind which run "the smooth black ribbons of streets," and, by night, a sawdust bar called The Gulch, its red-haired torch singer named Lotte helping link the club to the Silver Dollar, a mixed bar with heavy gay overtones in Boston's Combat Zone. There a woman in a crazy gown played the organ nightly above a din of drunken soldiers and sailors and their girlfriends, sleazy drifters, homosexual hustlers, and Harvard boys. "Everyone looked heroic and beautiful," O'Hara wrote of the thinly disguised Silver Dollar in an inebriated prose. "Powerful in their evil or cheapness, atypical, stoic in hidden suffering, knowing their own meaning and not denying it, not licked yet."

The novel also reveals those conflicts with which he was struggling at the time, especially that between his mother and her alcoholism. Thematically the novel is a prose version of "Memorial Day 1950." These conflicts buzz about the head of Billy, the novel's twelve-year-old boy hero, whose father, Lewis Amanti, works in a textile mill, while his stepmother, Ethel Amanti, stays home sneaking swigs from a hidden bottle of sherry. Billy is forever running away to the home of Mrs. Helen

Jarvis, a piano teacher who lives on Beacon Hill with her son, Bud, and daughter, Sarah. Mrs. Jarvis, described in Joycean terms as an "artificer," enjoys mostly playing the works of Schoenberg and Scriabin while carrying on an affair with the town's Mayor Humphrey Ide. Obviously the setup is between O'Hara's increasingly undesirable Grafton family home and the more scintillating, avant-garde Beacon Hill townhouse filled with the atonal strains of twelve-tone music. O'Hara's special passion that summer was Schoenberg's Third Quartet.

The picture drawn of Billy's stepmother, blatantly based on Katherine O'Hara, is harrowing. "Billy! Come help your mother!" she sobs as he peers in the kitchen window at her "lying on the kitchen floor" having "gotten the bottle from under the sink and . . . pulling the cork out with her teeth." When Lewis comes home to find his wife's kitchen a mess and "the ash trays . . . all filled," he also discovers the telltale "nose of the sherry bottle peering out from under the bed" and gives it "a vicious kick." After pouring herself a tumbler of cooking sherry one evening, Ethel takes her bull terrier named Boy for a walk to the local bar where she picks up an overweight salesman with a loud tie and goes back to his apartment to make love, his huge body lying "like a hillside in the moonlight."

If O'Hara's characterization of his mother in the novel is extreme, so was her life. During the time when O'Hara was writing *The 4th of July,* and in the upcoming years, his mother was to become more like Ethel, the mirror in which she was reflected so darkly. According to Maureen O'Hara, her mother once ran into the cement traffic light post in Grafton Square in broad daylight while drunk, she often called Maureen on the phone when she was away at high school and threatened that she was "going to walk in front of a bus" if Maureen did not return home; and in the mid-1950s she underwent a brief marriage with a gas meter repairman whom O'Hara never met that quickly disintegrated. Philip poured alcohol out of bottles to prevent his mother from drinking and picked her up from a local bar to force her to return home. "Frank saw his mother fall apart and have a nervous breakdown and become an alcoholic," says Maureen O'Hara. "She was someone who I'm sure he loved very much. But she became a monstrous person." O'Hara achieved some distance in the novel by making the mother a stand-in and by idealizing Billy's real mother, the woman dead in childbirth whom Lewis describes to himself as "Shaking her head like a bright young horse bitted only by my tongue in her grinning way, the boy's true and only mother."

Billy's father was O'Hara's dream come true, a solution to the prob-

lem of Russell O'Hara. He is a blue-collar worker, sometime farmer ("my father works in a stable"), and sometime garment worker. A Navy veteran whose World War II experiences duplicate O'Hara's, Lewis Amanti is also a fantasy of masculine sexuality. Working off his anger at Ethel by lifting weights in a gym, "His flesh smelled, stank, and the hair on his body was flattened in little rivulets against his skin; his genitals were cool and wet with sweat." Lewis also exhibits some of Russell's submerged violence, he directs it toward Ethel whom he hits on one occasion. He also begins to frequent The Gulch where he befriends a young black homosexual named Bucky (although O'Hara in the manuscript keeps indecisively shifting Bucky from "he" to "she"). Lewis is a depository of O'Hara's warmer feelings toward his father, the incident of the rose bushes and the conflict over homosexuality deleted. These were feelings he expressed at the time in his conversations with Ashbery. "He always seemed passionately fond of his father and disliked his mother," recalls Ashbery. "He once told me, to give an example of how awful his mother was, that he happened to walk into their bedroom while his parents were making love and his mother was smoking a cigarette. I guess he, like anybody, had problems with both parents, but my feeling was that he was on his father's side, but not on his mother's."

There are no traditionally balanced families in *The 4th of July*. Instead there is the bizarre and black wit he showed in a "little bagatelle," which was praised by Gorey a bit archly as his best work: "Dearie dearie me / mother is out to tea / father's the lover / of mother's brother / what is there left for me?" The happiest relations in the novel are homosexual, especially that of Bud and Mike, a sailor stationed at the Charleston Navy Yard, whose white uniform, looking "fresh and odd in the light of the streets, the heavy bells slapping against his ankles as he walked," is always catching the narrator's eye. Bud explains the joys of his situation to his sister, Sarah, with whom he has a playful friendship similar to O'Hara's with Bunny Lang, based on dancing fanciful waltzes together while whistling Arensky or discussing the poems of Rimbaud. He exclaims, "Poor dear, you haven't the faintest concept of the intensity of homosexual love, how it fosters itself amidst the alien corn, triumphant in its own found identity, this magnificent facade thrust in the face of hostile society!" after which he and Sarah collapse in laughter. The permissive blessing on this intense love is of course the bisexual father figure, Lewis, who enjoys hanging out at the beach with the boys, including Bud and Mike.

Unfortunately O'Hara had trouble making his novel work. Al-

though Bud remarks to Sarah when she enters his room, "My god you look like something out of *Vainglory*," the novel's Firbankian nonsense dialogue and lines of pure poetry are always at odds with a more sentimental, even confessional, American domestic tale. Early on, twelve-year-old Billy recites to Mrs. Jarvis a long Surrealist tale supposedly told to him by his loom-operator father, beginning, unconvincingly, "I looked no longer inward toward that grace which transforms existence into life." O'Hara complicated such jolts by inserting much of his earlier Harvard prose writing, including his 1948–49 journal, a few short stories, and his Navy memoir "Lament and Chastisement." The shiny objects in this unsifted soil are predictably its bright imagistic descriptions of avenues "hung with pale light tulips, like amber on a wet string," a policeman whose "bare head looked like an airplane in the rain, lit by his eyes," or Mayor Ide's pajamas "sprinkled and looped with arabesques and dots like Persian musical instruments."

Frustrated, O'Hara continued on the novel until the middle of September, when he was finally notified of his acceptance to the University of Michigan's graduate program in creative writing. He decided to take the novel along to finish as his submission for the Hopwood contest the following April. Required to arrive at the Ann Arbor campus by September 20, O'Hara was left with only a few days to pack. His Cambridge friends, feeling a bit abandoned, found the move perplexing, inspiring, threatening, and sad. Their mood was summed up by Bunny Lang when she soon wrote to O'Hara, referring to money given by his Aunt Grace to help pay tuition costs, "You are not going to have this invaluable year (which I know it will be) at your Aunt's expense, you are to have it at *ours*." As Ashbery had not been accepted, O'Hara's prospects seemed solitary. Self-reliant, but afraid of the loneliness ahead, he set off for the Midwest carrying a suitcase full of his favorite books, including Joyce and Rimbaud.

Surely Ann Arbor is the only place in the western hemisphere where cafeterias frankly put out a neon sign saying simply and clearly: FOOD."

Such was the tenor of O'Hara's first reports from the Midwest, a mixture of humor and surprise, but not the solitary pain he had anticipated. "So far this is not at all a bad place," he wrote to Osgood a few days after his arrival. "I do not mind being alone as much as I thought except for odd moments of really intense lonesomeness for you all and Jim's and the roto-rooter ads in the MTA." O'Hara had chosen to rent

a small room in an oversized Victorian house at 1513 South University Avenue, one of many old family homes converted into student apartments serving as alternatives to the standard campus dorms and to the formidable row of fraternities and sororities, known as the Greeks, just down the street. Falling back on reserves of independence uncovered in the Navy, O'Hara decided to hunker down in this epitome of a college town to work on his writing, a resolution that was to result in a burst of almost ninety new poems and two new plays over the next ten months. This productive spree was all the more surprising from a poet who supposedly required a crush of close friends for his inspiration.

The University of Michigan was as American as Harvard was European. Its scale alone was a reminder of the campus's location in the middle of the vast expanse of the American continent, a sensation of coastlessness that made O'Hara a bit nervous, as was evident in his poem of the following July, "Ann Arbor Variations": "We are sick of living and afraid / that death will not be by water, o sea." Divided by a long and much-traveled stretch called the Diagonal, the main campus was a collection of stone and brick buildings such as the Union, a men's drinking and socializing hall that resembled a railroad station, its Taproom tables carved with decades of alumni initials; the League, the women's counterpart until escorted co-eds were finally allowed to join the men in the Union after December 1950; Angell Hall, its pillars and countless steps leading up to floors of classrooms as well as to the Hopwood Room, an old-fashioned sitting room with round wooden tables covered with poetry magazines and shelves crowded with books, where O'Hara's writing professor, Roy Cowden, held his weekly conferences with students. Unlike Harvard's Yard, hemmed in by the traffic and bustle of Massachusetts Avenue and Harvard Square, Ann Arbor's campus was given over to the relentless strolling of its students. In the winter, this strolling was slowed down by heavy snowdrifts; in spring, when the air was heavy with the fragrant scent of lilacs, its main drag, South State Street, served more in the early 1950s as a boulevard than as a busy thoroughfare.

The so-called police action of the United Nations forces headed by General MacArthur in South Korea dominated the front page of the student paper, *The Michigan Daily*, during O'Hara's entire year, and the conflict took the blame for the state university's decline in enrollment to 21,000. Many of the students felt personally threatened by the draft, but the Ann Arbor campus remained a showplace for a certain buoyant Joe College spirit evident in autumn "football madness," pep rallies, and enthusiastic fraternity pledging. More casual in its dress code than Har-

vard, Michigan was a school where male students tended to walk about in sweaters, shirt sleeves, saddle shoes, and argyle socks, while the women wore turtlenecks, pearls, and peasant blouses, with their hair cut short and conservatively brushed back. The social exchanges between these students were quite a bit more low-key and friendly than at Harvard where intense factionalism and sharp repartee were the norm. "At Michigan everybody was kind to each other, or pretended to be," says Donald Hall who taught at the campus in the late 1950s. "There was a kind of convention where people spoke softly to each other."

O'Hara, too, modified his manner at Ann Arbor, concealing the sharpened wit from all but a few. "He was very warm and very empathic and you just sort of loved Frank," says Susan Wexler (then Siris), editor of the campus literary magazine, *Generation,* which first published "Homage to Rrose Selavy" and "Women" in 1951 as well as a selection of five poems from O'Hara's Hopwood manuscript in 1952. Jascha Kessler, a poet in the graduate writing program who often watched O'Hara walking alone in denims and sneakers or moccasins with a kind of gliding gait down the corridors of Rackham Hall, the graduate studies building, was aware of his intense private air. "He struck me as faunlike," recalls Kessler. "He had a hurried walk and a sidelong glance. He didn't meet one's eyes. His gaze was half-lidded. 'Cool' was the word in those days. Or 'laid back' we'd say nowadays. You could see that this was a self-possessed person." O'Hara's distance was compounded by his age difference as a veteran from all the undergraduates as well as most of the graduate students.

Roy Cowden, the writing teacher who administered the Hopwood awards and with whom O'Hara had come to Ann Arbor to study, was a grand old man on campus, a sort of urbane Mr. Chips who had graduated from the University of Michigan in 1908. He had received a master's degree at Harvard in 1909 and then returned to devote his life to the cultivation of young poets, playwrights, and novelists, the Hopwood having already been awarded by the time O'Hara arrived to such future successes as Arthur Miller, John Malcolm Brinnin, and Howard Moss. A large, white-haired man with a benevolent mien, Cowden met weekly with his students in a light pearl gray seminar room where he guided them in the study of the original manuscripts of Keats and Hardy that he had retrieved from the British Museum. He prodded them to discover why these writers had changed a word here or shifted a sentence there, setting up a lofty historical context for their own early efforts. A break in the poring over of mimeographed paragraphs was

provided each session by a chosen student reading from a work in progress. Cowden's method was to gently help his charges find their own way, to nudge them from the nest. "Remember you're doing this to get answers to questions you may have," Cowden constantly reminded them. "Not to answer questions that others may have about what you write." As O'Hara wrote to Osgood of Cowden's suggestion that he write whatever he wanted at whatever speed, "Professor Cowden is surely the only person in the world who would dare to say to such a class 'I am interested in quality, not quantity.'" Averse to most critical editing from professors, O'Hara enjoyed Cowden's laissez-faire approach enough to dedicate to him a sonnet titled "In Gratitude to Masters," concluding:

> he leads us to the light,
> there where it so naturally
> falls upon the unknown sea.

In addition to a writing seminar, O'Hara was required to take two other courses autumn term, one in the English Department, for which he chose Shakespeare, and another in an outside department, for which he chose Plato. O'Hara subjected these Titans to some witty reevaluations. Uncowed, even provoked, by their reputation and canonization, O'Hara found himself annoyed with the sweep of Shakespeare's historical dramas, which he compared for sheer tediousness to a play of Dryden's: "I must say I think that *Henry 6—Richard 3* vaudeville ensemble is loathsome in the extreme. I'd rather read *The Conquest of Granada* over three times than go through it all again." The course picked up for him, though, with *Two Gentlemen of Verona, Titus Andronicus,* and *Love's Labour's Lost,* all of which he felt to be "SUPERB." Paying Shakespeare what for O'Hara was a high compliment he discovered in the plot and dialogue of *Cymbeline* qualities reminiscent of Gorey's favorite, Ivy Compton-Burnett. "Do you think Ivy will ever replace the Wall?" he asked in a letter the following spring. In the same play he had uncovered a couplet, "Briefly die their joys / That place them on the truth of girls and boys," which for him was "just like that other master of the English language, P[aul] Goodman." O'Hara needed to make Shakespeare part of his own private world of in-group references in order to appreciate him. This was consistent with his intelligence, characterized by Osgood as carrying "some kind of feeling or emotion behind every thought he might express. There was very little detached, analytical thinking in Frank's character."

Plato received the same treatment. "I had never read any Plato and really adore him so far, these dialogues are the best thing since Mutt and Jeff!" he campily informed Osgood. "Really that Socrates is such a bitch! I'm sure it's piles that makes him try to spoil everyone's game, and nothing more abstract. You can see where Ivy Compton-Burnett got her style of writing conversation." O'Hara's strange enjoyment of Plato resulted in his trying to use some of his ideas, or irresponsible versions of them, in *The 4th of July.* Following along with required reading assignments in Plato's *Republic,* O'Hara coyly turned his Mayor Humphrey Ide into a bumptious version of a modern-day philosopher king. The Ann Arbor passages of his novel can be dated by the unlikely appearance of such Platonisms as the mayor's admission that "I thought about Plato's city, and I thought about my duties and how best I could execute them," and his heady exclamation, "I'm the city. You already know me. It's not that I'm good, it's that people are good and love me."

O'Hara was not entirely incognito at Ann Arbor. He made one friend, Kenneth Jay Lane, with whom he allowed himself to carry on in the fashion he had become accustomed to in Cambridge and whom he immersed in Firbankian aesthetics. Lane, who went on to become a well-known jewelry designer, was then a seventeen-year-old freshman from Bloomfield Hills, a suburb of Detroit. Though younger and less sophisticated, like Osgood before him, Lane was fascinated by O'Hara and entered into a sort of younger brother–older brother relationship with him. "Frank changed all my interests so that I never saw another old friend again," says Lane. "All of a sudden I had so much to read. Lots of Firbank. The whole thing was very Firbankian. I became so precious. I had left my middle-class environment, my middle-class family, my middle-class values, and I met total nonsense, which I hadn't really known until then. He gave me the sense of nonsense for the rest of my life." Lane's mother was so furious at the Svengalian hold she felt the older poet had over her son that she burned a George Montgomery photograph of him that Lane had brought home from school. "My mother loathed the very idea of Frank O'Hara," admits Lane.

The two went to dinner together several nights each week at the Old German, which served wonderful hasenpfeffer and spätzle, or to the Pretzel, a jock hangout famous for its green beers on St. Patrick's Day. Under the influence of O'Hara's profligacy, Lane began writing his own poems so that they could read each other new lines on the phone every day, a distant re-creation of O'Hara's working phone friendship with Bunny Lang. Lane even published a few poems under the pseudo-

nym Robert Meadle in *Generation*. They both owned rose geranium plants and took great pleasure in putting the pungent leaves in their underpants to soak up the body's perspiration. "To go out without a rose geranium was heresy," recalls Lane. Taking Lane with him on long winding walks down through the Arboretum, a huge nature preserve in Ann Arbor cut through by the Huron River, O'Hara created for Lane "the closest thing to Brideshead in Ann Arbor." One of the park's many trees was captured by O'Hara in "The Arboretum":

> *This tree is black with dry feathers*
> *sprawled as if the sun had smashed it*
> *cluttered with broken bicycles*
> *the river flops on the grassy roots.*

(Bicycles were a ubiquitous form of transportation around Ann Arbor.) Lane, in turn, earned points with O'Hara by possessing the first Mabel Mercer LP. There was much mouthing of "Remind me not to find you too attractive" between them in the style of O'Hara's earlier Eliot House sing-alongs to Beatrice Lillie with Hal Fondren.

Lane sustained O'Hara by his freshness and availability. "Part of the reason Frank liked me was that I was so much younger than he was," Lane assumes. "I made him feel younger." However, the youthfulness that attracted O'Hara was primarily mental and psychological rather than physical. Their one attempt to go to bed together collapsed in comedy. "Frank and I were never lovers," says Lane. "We got very drunk on his last night and very giggly and Frank told me he was madly in love with me, and he put on more Marlene Dietrich, and we had to consummate it. So we started to, but we giggled so there was no way. I don't think we could even kiss because you can't kiss and laugh at the same time, and it was more fun laughing."

When O'Hara was alone in his simple room on South University Avenue, minimally outfitted with a bed, a typewriter, a few plants and books, he was writing poems that went well beyond his Firbankian nonsense mode. It seemed almost as if the openness and cleanness of the tree-lined streets and regular lawns of Ann Arbor, its fresh air and wide open spaces, were giving his poems a new clarity of language and concreteness of detail, their self-conscious preciosity being tempered by American pragmatism and imagism. The first poem O'Hara wrote on arriving in Ann Arbor, "Les Etiquettes Jaunes," is the account of picking up a fallen yellow leaf from the sidewalk:

> *Leaf! you are so big!*
> *How can you change your*
> *color, then just fall!*

The poem is clear, colloquial and brief. The quietly haunting images in
"Morning" in which "the buses glow like / clouds," "I stand / rattling
my keys the car / is empty as a bicycle," "Last night the stars / were
numerous and today / snow is their calling / card" moved Ashbery, to
whom O'Hara had enclosed the poem in a letter, to write back that "it
makes me think how wonderful the midwest must be and want to come
there." In "Ann Arbor Variations," written the following summer, he
draws his most sustained picture of the town and campus:

> *Wet heat drifts through the afternoon*
> *like a campus dog, a fraternity ghost*
> *waiting to stay home from football games.*
> *The arches are empty clear to the sky.*

The poem is filled with images of ordinary people done in very acces-
sible language: "Along the walks and shaded ways / pregnant women
look snidely at children."

Of course O'Hara's more direct new poems were not just the result
of his moving to Ann Arbor. Equally important, though quite appro-
priate to his stay in Middle America, was the growing influence of the
poems of William Carlos Williams. O'Hara had been reading Williams
for a few years, attracted to the New Jersey poet's resolve to shake off
what he felt to be the overly cosmopolitan and intellectualized poetry of
the expatriate T. S. Eliot in favor of an indigenous American poetry
grounded in colloquial speech rhythms and filled with such locally ob-
served objects as wheelbarrows, ambulances, locomotives, and locust
trees. Freshman year O'Hara had purchased *The Complete Collected
Poems of William Carlos Williams* (first published in 1938 by New Direc-
tions) and in 1950 he had bought Williams's *Kora in Hell: Improvisations*
(1920), an early work with which he connected strongly because of
Williams's attempt to write prose poems in the manner of Rimbaud's
Illuminations, as O'Hara had tried to do in his own Grafton pastorals.
But it was *Paterson,* Williams's epic poem about a city, the first four
books of which appeared between 1946 and 1951, that he found most
energizing. After reading *Paterson* 4, he wrote to a friend that he found
the work "so incomparably lucid and beautiful, my frontal lobes are

awhirl." According to editor Donald Allen, "In conversations with me in 1958 and 1959 Frank spoke several times of WCW as being the only poet around that he could read in the late forties (when *Paterson* was appearing)." By 1951 O'Hara was well on his way to ranking Williams, along with Whitman and Crane, as the only American poets better than the movies—the claim he would make for them in "Personism" eight years later.

As early as August 1950, O'Hara had been writing to Ashbery of his enthusiasm for Williams, to which Ashbery replied, "I'm glad W. C. Williams has made a hit with you. By a strange and no doubt explainable coincidence, I've been reading tons of Wallace Stevens. . . . Please open *Parts of a World* this instant and read a poem called 'Yellow Afternoon.' That poem has completely floored me with its greatness—every time I read it I am ready to turn in my chips and become an osteopath." Ashbery's poems were to increasingly become a record of whatever thoughts, memories, or words were in his mind at a given moment, while O'Hara's poems, especially his "I do this, I do that" works of the later fifties, were more often kaleidoscopic pictures of events in time. In early December 1950, Ashbery mailed O'Hara a new poem titled "Illustration," filled with melancholy statements such as "Much that is beautiful must be discarded / So that we may resemble a taller / Impression of ourselves." It sounded in its musings on life as art similar to his favorite "Yellow Afternoon," in which Stevens writes, "This is the mute, the final sculpture / Around which silence lies on silence," but using the couplet form of other poems in *Parts of a World*. Intimately informed of Ashbery's fine-tuning of his craft, O'Hara was able to write in a review in *Poetry* magazine in 1957, using the hyperbolic style with which he was most comfortable as a critic, that Ashbery's *Some Trees*, just published by Wesleyan University Press, was "the most beautiful first book to appear in America since Wallace Stevens's *Harmonium*."

O'Hara always liked to keep some irritating distinction operating in his friendships with his aesthetic soul mates, as in his squabbles with Bunny Lang over Auden and Rimbaud. With Ashbery the need to define his own voice and stance was even more crucial as the poets' voices actually sounded alike. As Ashbery wrote in "A Reminiscence," "Though we grew up in widely separate regions of the east, he in Massachusetts and I in western New York state, we both inherited the same flat, nasal twang, a hick accent so out of keeping with the roles we were trying to play that it seems to me we probably exaggerated it, later on, in hopes of making it seem intentional." Early in December 1950, Ash-

bery rebuked O'Hara for his constant contrariness. "You always disagree with everything I say," he wrote accusingly. "Such as when I liked Lyon [Phelps] you didn't and now vice versa, and the similar business with Stevens and Williams, and you liking Shelley and Shostakovitch, while I preferred Keats and Prokofiev, etcetera." The prose was a bit of a ruse, though, for Ashbery's confidence was ticking strongly enough for him to continue writing poems that were picking up on, and furthering, Wallace Stevens's lofty experiments in imagination and poetry. As Ashbery had written in "Some Trees," a Harvard poem that is still perhaps his most popular, "Our days put on such reticence / Those accents seem their own defense."

In December O'Hara and Ashbery were briefly able to resume their subtle games of art and friendship in person. The occasion was O'Hara's Christmas recess, which began on December 22. "You can stay in the repulsion of my room as long as you wish," invited Ashbery. "I do hope the Soutine won't close before you arrive. I can't decide *which* kind of party to give." The reference was to an exhibition of the Expressionist painter Soutine at the Museum of Modern Art, a shrine at the time to all the young painters whom Ashbery had recently befriended. O'Hara's excitement at the prospect was more than conveyed in "Song," written that season: "I'm going to New York! / (quel voyage! jamais plus!) / far from Ypsilanti and Flint!" While his visit required spending the holidays in Grafton, an increasingly thankless obligation, O'Hara's true destination was the promised welcoming party in a furnished room Ashbery had moved into on West Twelfth Street between Fifth and Sixth Avenues. It would prove to be a crucial party in a life soon to be filled with parties.

Ashbery had decided to throw a literary party, with many members of the *Partisan Review* crowd present, including Delmore Schwartz, and lots of other Uptown types in suits and black cocktail dresses all crowded, drinking like crazy, into one large, high-ceilinged room. O'Hara, the guest of honor, arrived dressed down in Army pants and sneakers, smoking cigarettes heavily in his soigné manner, and producing the fast comments and instantly intimate responses for which he had already earned a reputation among many of those present. O'Hara's energies, pent up for months in Ann Arbor, were rapidly disseminated. The guest he was most anxious to meet, though, was the painter Larry Rivers, whom he had missed on his last trip down from Harvard when Rivers had been away in Europe. Rivers, to whom Ashbery had already shown "Morning," was primed to meet O'Hara, too, assured by friends that the young poet would certainly be attracted to him.

At twenty-seven, Rivers was easily O'Hara's equal in sheer cha-
risma, a charmed, romantic, and unpredictably volatile figure, described
later by O'Hara as a "demented telephone," whose presence invited al-
most involuntary speculation and interest. Yizroch Loiza Grossberg,
who had been born in the Bronx to Ukrainian immigrants, changed
his name to Rivers in 1942 after the jazz band in which he played sax-
ophone was introduced one night at a nightclub as Larry Rivers and His
Mudcats. He had been discharged from the U.S. Army Air Forces in
1943 for a disease diagnosed as multiple sclerosis, which never pro-
gressed, and returned to studying music at Juilliard in 1944, as well as
taking up painting; he took drawing classes with his neighbor Nell
Blaine, studied abstract painting techniques with Hans Hofmann for
two years in Provincetown and New York, and with William Baziotes
at New York University. By the time of Ashbery's party Rivers had the
aura about him of someone certain to be a famous artist someday. His
one-man exhibition in 1949 at the cooperative Jane Street Gallery had
already earned him the praise of Clement Greenberg in *The Nation* as
"a better composer of pictures than was Bonnard himself in many in-
stances." (Rivers had been inspired in his paintings filled with golden
nudes and sunny studios by the impact of the Bonnard retrospective at
the Museum of Modern Art in 1948.) Rivers's messy life further em-
bellished the bohemian myth. He had married Augusta Berger in 1946,
divorced her a year later, and continued to live with his easygoing
mother-in-law Berdie Berger; Steven, his baby by the marriage; and
Augusta's first child, Joseph, all crowded into Rivers's lively and noisy
studio, the mood of which he would later document in "The Studio,"
his 1956 version of Courbet's *The Painter's Studio* of 1855. Rivers had
recently returned from a long trip to Paris and Italy where he had writ-
ten poetry by day and walked the streets by night. "I probably was
acting out some nineteenth-century idea of the artist searching for ex-
perience," he said later. The restlessness and romance of the trip were
still driving him upon his return to New York.

Both Rivers and O'Hara were big talkers so that their eventual con-
versation that night was as voluble as it was inevitable. The two even
resembled each other a bit—wiry, trim, electric. Rivers's prominent
forehead matched O'Hara's widow's peak. His hawkish nose was as
noticeable a vanishing point as O'Hara's broken one. But the accents in
which they carried on—art and gossip being the favorite topics—were
quite different, as different in sound and effect as their two instruments
of choice, concert piano and jazz sax. O'Hara's nuanced voice insinuated
itself tirelessly and ironically, while Rivers's exploded in more disorderly

loud blarings, just as the excitement O'Hara generated was largely mental and disguised by a body seemingly languid and in repose, while Rivers acted out his passions more physically, often seeming to be larger than any room he happened to inhabit. This was the difference in tone conveyed in Kenneth Koch's poem "Fate," a memory of an evening a year later in which "Frank said Uh hun. . . . and Larry if he / Was there said Boobledyboop so always / Said Larry or almost."

O'Hara was unreservedly impressed with his new acquaintance. "I thought he was crazy and he thought I was even crazier," wrote O'Hara in a 1965 memoir of their first meeting. "I was very shy, which he thought was intelligence; he was garrulous, which I assumed was brilliance—and on such misinterpretations, thank heavens, many a friendship is based. On the other hand, perhaps it was not a misinterpretation: certain of my literary 'heroes' of the *Partisan Review* variety present at that party paled in significance when I met Larry, and through these years have remained pale while Larry has been something of a hero to me, which would seem to make me intelligent and Larry brilliant. Who knows?"

There was a sexual teasing and testing going on between the two as well. It was the case of a charmer being charmed by a charmer. Rivers in those days was toying with at least the notion of homosexuality, feeling drawn by the spirit of fun that seemed to characterize what he called "queerdom," as well as being narcissistically flattered by the attention paid him by certain homosexual men. "I as usual was on the make for anything," Rivers later said of the evening at Ashbery's. "I liked—you know, boys, girls, animals, dogs, houses—anything." Rivers's heterosexual credentials endowed him for O'Hara with the sort of ambiguous masculine sexuality of Lewis Amanti in his novel, while his avid passion for matters artistic and literary made him romantically Left Bank. So O'Hara felt compelled to exercise his considerable powers of seduction and camouflaged pursuit. "As the party was going on I sort of glanced at one of the windows of my furnished room and I saw two pairs of shoes protruding from the drape," says Ashbery, "one of them being Frank's usual white sneakers and the other being Larry Rivers' shoes." Hidden behind those drapes, O'Hara whispered to Rivers, "Let's see what a kiss feels like." As the two kissed, Rivers claims to have felt as if they were experiencing a kiss for the first time, as if they were reinventing the kiss. For O'Hara this first surreptitious kiss would eventually seem like the insight granted by the poet's muse in his 1957 poem "A Young Poet," which "comes as a kiss / and follows as a

curse." O'Hara's future love and friendship with Rivers were to prove as complex as they were tempestuous.

The painter Jane Freilicher was also present at this pivotal party. O'Hara had been introduced to Freilicher by Ashbery during his previous trip to the city when the three had gone out to supper at the Five Oaks, a restaurant in the Village. This was the trip that had included a jaunt up to Times Square to view a King Kong spinoff called *Mighty Joe Young* after which, while they were strolling beneath the Bond's sign with its waterfall seemingly dropping eighteen stories, Freilicher had successfully captured the attention of both poets by wittily remarking, "I'm going to go to the Bond's sign on my honeymoon." But it was during O'Hara's 1950 Christmas visit that his friendship with Freilicher was sealed.

A pretty twenty-six-year-old painter, with dark hair and a misleadingly serious and preoccupied demeanor, Freilicher had a campy wit and a brainy zest for literature in the vein of Ivy Compton-Burnett that made her a natural focus of O'Hara's enthusiasm. She had been born Jane Niederhoffer in Brooklyn, New York, and eloped after high school with Jack Freilicher, a jazz pianist, though their marriage was later annulled. It was through her first husband, who was then playing with Larry Rivers's band, that Freilicher had met Rivers in 1945. The meeting had led to his interest in painting, and to an on-again off-again romance between the two that continued rockily into the early fifties. Freilicher and Rivers together had absorbed many of the stronger and often contradictory artistic influences of the late forties—including the Bonnard show and Hans Hofmann's classes—as she painted slightly Expressionist landscapes with figures in which certain patches were left filled with arbitrary geometrical patterns. "It seems against her will because she professes to admire the Apollonian calm of Matisse," Ashbery had written to O'Hara of some of her more wildly Expressionist recent canvases. Living in a little apartment on West Tenth Street, Freilicher made money by teaching art history in a grammar school, a task for which she was eligible because of her B.A. in art from Brooklyn College and M.A. in art education from Columbia Teachers College where she had taken a course with the art historian Meyer Schapiro. (Schapiro, one of the few academics with a connection to Downtown artists, had chosen that year to mount, along with Clement Greenberg, a show of rising painters, called "Talent 50," which included such artists as Larry Rivers, Elaine de Kooning, Grace Hartigan, and Alfred Leslie.)

"He became your friend in about six seconds," recalls Freilicher of

her friendship with O'Hara. "It was a bond such as I never had with anyone else. It was instant intimacy." They quickly developed a rapid banter, feeding each other's penchant for references to Hollywood films and ability to deliver bons mots. O'Hara flattered Freilicher with the sort of theatrical love and admiration he displayed in his intense infatuations with certain key women throughout his life. "It was very flattering to have somebody who would sit and look at you in wonderment," says Freilicher. "Every word that you said he would think was sort of a profound utterance. And he meant it." O'Hara, for example, endlessly praised the line of Freilicher's shoulder to her and others, danced the Lindy with her at parties, and, beginning with "Interior (With Jane)," written in Ann Arbor in February, turned out a number of poems dedicated to her. She was to become the muse of his poetry in 1951 and for some time after, as Bunny Lang had been the chief muse of his poems of 1950.

O'Hara's Christmas visit to New York had permanently changed his sense of his life. He now had little doubt where he would head after completing his M.A. He had also significantly altered the lives of those he had so quickly befriended and was now leaving behind, especially Rivers and Freilicher, with whom, because of their ambivalent feelings for one another and his confusing passion for both of them at once, he had entered into a complicated three-way affair. O'Hara, in a very brief time, had managed to reshuffle the cards in the social life of this still small circle.

"All my friends, so it seemed to me, liked him better than they did me," recalls Ashbery wistfully of the effect of O'Hara's whirlwind visit. "So I went through a period of being very depressed that he was more popular than I was and that my friends were only too happy to trade me in for him."

For the duration of O'Hara's stay at the University of Michigan he attempted with some success to be in three places at once: Ann Arbor, Cambridge, and New York. Consequently his poems over the following nine months are filled with different means of public conveyance. In "Boston" he describes flying in March into the airport, "the blinding grin / of clouds, the altitude's deafening sigh," to meet friends he imagines running "fast on fences / towards me!" In "Lines Across the United States," written sitting on a night train from New York to Ann Arbor while the "wheels slice quickly," he registers some of the side effects of his frenetic pace: "I've done too much / I've loved too little / And I'm

tired of running." In "Ann Arbor Variations" he records as well a foray on "the express train to / Detroit's damp bars," bars that he had described in "February" as suffused with "blue light." Such restless documentary images are filled out in the poems of the period with more fantastic voyages, such as the one he takes in "A Terrestrial Cuckoo" with Jane Freilicher down the Essequibo "in our canoe of war-surplus gondola parts." O'Hara was obviously less content now to sit in Ann Arbor than he had been the previous September.

Classes resumed on January 8, and in his second semester O'Hara continued his writing seminar and Shakespeare course, and took Aristotle, a course in which he had even less success than Plato, for which he had received a B-minus. (O'Hara received an A for all three semesters of writing and an A-minus for both semesters of Shakespeare.) For a boy educated by Xaverian Brothers, O'Hara showed remarkably little aptitude for interpreting the Church's favorite philosopher. The failing grade he received almost prevented him from graduating until he managed to persuade a professor to upgrade him to C-minus. "Today I was perusing Aristotle after finding out how far behind I am in a class this morning," he wrote to Freilicher in March. "I found the following Ronaldish sentence, sho, lil lambbbb o' mime: 'For obviously they do not think these to be open questions; no one, at least, if when he is in Libya he has fancied one night that he is in Athens, starts for the concert hall.—' To this my heart could only murmur, that's what you think. . . ."

The brightest event in O'Hara's life that winter—a severe Midwestern winter that caused him to feel "the going into winter and the never coming out" of "An Audenesque Poem"—took place not in Ann Arbor but in Cambridge. This was the production at the newly formed Poets Theatre of his just-completed *Try! Try!*, a parody of a Noh play in verse for three players. Interest in the Japanese form among American poets had been fanned by Ezra Pound's extensive 1916 translations of Noh plays with commentary by Ernest Fenellosa. O'Hara's version was a rhythmic mix of triplets, couplets, quatrains, blank verse stanzas, and poetic prose stage directions, all used to tell an arch tale of a love affair between Violet and John interrupted by the annoying reappearance of Violet's husband, Jack, home from World War II after encountering "a sniper in a tree / on the edge of the Pacific's / exciting waters." A send-up of such popular Hollywood postwar melodramas as *The Best Years of Our Lives, Try! Try!* shifts from the high Surrealist poetry of speeches such as Violet's "Since you left I've had / to sell the flute and the / bathtub" to the flat deflations of John's "For god's sake, Jack! this / is no

way to talk." In *Try! Try!* O'Hara replaced his usual off-kilter family triangle, the primal scene of *The 4th of July*, with a French movie complication in which three adults are romantically entangled, a harbinger of future complications in O'Hara's own life.

Confined to Ann Arbor by a demanding curriculum, O'Hara was unable to attend this first production of the Poets Theatre—a Yeatsian project he had often dreamed about at his table at Cronin's but which was not turned into a rolling enterprise until the exhaustive work of fund-raising and managing was undertaken in the fall of 1950 by Lyon Phelps. Phelps, a manic and driven acquaintance of O'Hara's, was an eager poet for whom the actual writing of a poem was a mythological event. Describing the group's aspirations to stage contemporary verse plays rather than more popular naturalistic prose dramas, Phelps had zealously suggested in a recent interview with the *Crimson* that "this Poets Theatre could be the nucleus of a permanent adjunct to the American stage." On the evening of February 26 *Try! Try!* shared the tiny stage in the basement of Christ Church Parish House with three other productions: *Everyman*, a masque by John Ashbery with incidental piano and flute music composed by O'Hara; *The Apparition* by Richard Eberhart starring Donald Hall; and *Three Words in No Time* by Lyon Phelps performed by Brattle actors Thayer David and Jerome Kilty. O'Hara's play, directed by Bunny Lang, self-reflexively featured the director as Violet, John Ashbery as John, and Jack Rogers, a friend of Lang's, as Jack. In his absence, O'Hara mailed his actors a supportive poem titled "An Epilogue: to the Players of *Try! Try!*" in which he clarified to Lang that "you are my Bunny and other / people's Violet."

The basement theatre, seating over two hundred, was packed that first night with a charged and sympathetic audience standing four deep in the rear, including Thornton Wilder, Archibald MacLeish, Renato Poggioli, Robert Bly, John Malcolm Brinnin, Richard Wilbur, and much of the rest of Harvard's literary community. In the first row were the most excited of O'Hara's friends, including George Montgomery, his Rolleiflex ready for snapping pictures. The whole production was crackling with animation as the curtain rose—after two measures of an Offenbach waltz—on Edward Gorey's stage set, which was starkly confined to an ironing board illuminated by a circle of light, a window painted on a shade hanging at the back with a February calendar and a spider sketched on its panes, and a wind-up Victrola. Dressed in her rattiest white sneakers and a faded red and white apron, Violet delivered her opening speech—altered by her a bit from the script—which she phonetically reproduced for O'Hara in a letter as "My name is Vi-o-let.

/ It's not a name I ever WANTED / It's not a name that any beauty / ever / HAD." Ashbery, as he delivered his lines, tossed the used pages of his script onto the stage one by one. His job included placing, at a critical moment, the Victrola's needle down on a record of John Cage's "Amores I-II." When Jack took off his olive drab jacket and cap he hung them on Violet's hands stretched over the ironing board where she had frozen at his entrance like a wooden marionette with her arms out in odd positions. At the play's conclusion, the audience, which had been erupting in shrieks throughout, responded enthusiastically, calling for an extra curtain call. "The play earned the most appreciative reception of the evening," reported Daniel Ellsberg in his positive review in the *Crimson*. The only blot on the event was Thornton Wilder who, having been requested by Phelps to pass the hat after *Try! Try!* to help defray $39 in production costs, used the opportunity to berate the audience— especially those gigglers in the front row seated beneath his raised fist— for a "bad performance" in not recognizing the seriousness of the work they had just witnessed. "Thornton Wilder went off his head that night," recalls Molly Howe, the director of Eberhart's *Apparition*. "He started talking as if it were a sacred occasion, a holy night. While the play was actually very funny." As Richard Wilbur recalls, "Archie MacLeish, who was seated next to me and had given a number of guffaws, muttered to me, 'I think Thornton's gone a little off his trolley.'" More in keeping with the general spirit of the audience were comments passed among them as they shuffled out for intermission, only slightly put off by Wilder's anger. "Frank's play has the makings of Epic Theatre!" gushed one audience member. "But it's *The Cocktail Party* as a Noh!" another replied. Anxious for a repeat performance, Lang wrote to him immediately, "Please write more plays. MUST you write a novel? I don't think you *should*."

O'Hara lacked such exhilarating events in Ann Arbor. He had discussed *Try! Try!* the day of the performance in his writing seminar but the reaction wasn't satisfying. He did, however, attend a screening of Cocteau's *Orphée* at the Hill Auditorium on March 9 and made the most of the event, starved as he was for some sense of the avant-garde. Cocteau's 1950 art film, which recast Orpheus (Jean Marais) as a French café poet and the classical Fates as a motorcycle gang, had just completed a long run in New York. "Cocteau was *the* artistic experience of that time," says Freilicher. After viewing the film, O'Hara stood on a table in a rowdy college hangout as Kenny Lane was about to depart. Hands on hips, legs spread wide apart, he shouted the last line of the film as it had been vampishly delivered by Death (Maria Casares) to

Orpheus's poetic rival, Jacques Cégeste (François Perier): "Adieu, Cé-geste!" Friends at Ann Arbor were so well informed of O'Hara's passion for the film's rare combination of poetry and cinema that they filled his room afterward with leftover posters so that it looked, according to O'Hara, "like a forest." He mailed one to Freilicher, writing on its drawing of Jean Marais and Maria Casares, "you and I à la recherche du temps perdu."

The month of March was taken up for O'Hara with preparing his manuscript for the Hopwood award. *The 4th of July*, unfortunately, did not seem to be shaping up well. "In addition to woes of a general physical blahness I am almost flat broke temporarily, and also pushing headlong towards the finish of that god damned novel," he wrote in a depressed letter to Freilicher. "I want it done by April 1 and how can I get all my willful creatures to agree on this deadline without pushing their ill-temper too severely is beyond me. You notice how long it took Dostoevsky to arrange this—and I'm just little weak-writer me, without a muscle in my head! I have taken to treating them all with abandon, and hope they will like whatever happens to them the way I would if Ronald Firbank had treated me this way." O'Hara soon abandoned the novel, a form he would never again attempt, and any idea of applying for a Hopwood in prose.

The manuscript he eventually submitted in April was called "A Byzantine Place" and consisted of fifty poems in addition to *Try! Try!* As the entries were to be judged anonymously, he chose as his pseudonym Pablo Pasternak, a strong hybrid of a Spanish painter and a Russian poet. He dispensed with his original plan to divide the manuscript into serious poems, light poems, and plays, finding, as he wrote to Freilicher, that "The serious poems are all irrelevant to any concern but my own for myself, and the light poems are the most truthful, so there you are." The poetry judges invited in 1951 by Cowden were Peter Viereck, whose *Strike Through the Mask* was to be published by Scribner's in the spring; Louis Untermeyer, poet, critic, and anthologist; and Karl Shapiro, the editor of *Poetry* magazine. Their job was to rank and comment on the seven manuscripts submitted. Viereck tied O'Hara for first place, praising his "lyrical talent" and "fantastic metaphor" but warning of his "risk of ruining it through showy cleverness and preciosity." Untermeyer ranked O'Hara third, praising his poems as "intensely interesting" technically although he was bothered by their "disintegrating" quality: "There are pieces, splinters and memories of Cummings, Auden, W. C. Williams, Wallace Stevens, and others, but

only occasional glimpses of the 'onlie true begetter.'" O'Hara's strongest supporter was Shapiro who ranked him first and wrote, "The collection of this poet is far and away the best. This man is unquestionably a poet, even in his failures. . . . In spite of his parodistic leanings, he seems to be on his own; his affectations and frequently youthful lapses into games are perhaps too dangerous for him, but he seems to have courage and a full awareness of what he is doing. And he is prolific and versatile." When the rankings were completed, O'Hara won the Avery Hopwood Major Award in Poetry and was awarded its honorarium that year of eight hundred dollars.

By the time O'Hara had gathered together the poems for "A Byzantine Place" his poetic direction was set. He was no longer trying on different voices and styles merely to learn the craft of poetry, a process described by Ashbery in his introduction to O'Hara's Collected Poems as "trying on various pairs of brass knuckles until he finds the one which fits comfortably." His personal puzzle was somehow to combine the dissociations of language practiced by his favorite post-Symbolist French poets with the free verse and local voice of the American poets descended from Walt Whitman, the poet whom William Carlos Williams claimed had "broken the dominance of the iambic pentameter in English prosody." O'Hara was trying to bring the live wires of these two traditions together. While Untermeyer, as an academic poet of the 1940s, would naturally have noticed the borrowings in O'Hara's manuscript from the English and American poets, there were at least as many echoes and parodies of the French—Rimbaud in "A Prose Poem," Mallarmé in "Yet Another Fan," Apollinaire in "A Calligram." His models were definitely not the elegantly crafted and intellectually supple poems currently being written to much acclaim on American campuses by such sons of T. S. Eliot as Robert Lowell, Delmore Schwartz, Karl Shapiro, and Richard Wilbur—the sorts of poems Kenneth Koch would dismiss as those "of the baleful influence" in his 1955 manifesto of a poem, "Fresh Air." By exhibiting a taste for French poetry, and for such nonliterary models as Schoenberg's "Serenade" or the early paintings of Mondrian—with a natural temperamental inclination toward openness and spontaneity and away from serious meaning—O'Hara was largely ignoring the Berryman-Lowell-Shapiro generation. What remained for him was to infuse his poems during the fifties even more fully with the voice that seemed most personally and colloquially his own. This was the intimate voice already audible in his Hopwood manuscript in "Poem" (Although I am a half hour):

> *I put on my black shirt*
> *and my sneakers, whistle*
> *Glazunoff and try to*
> *pick up the dirty room.*

The awarding of the 1951 Hopwoods was marked by a few special events. Mark Van Doren arrived on campus at the end of May to deliver the Hopwood Lecture on "The Possible Importance of Poetry." That same week Herbert Weinstock of Alfred A. Knopf visited Ann Arbor looking for fiction manuscripts. "Weinstock is looking over both Hopwood and non-Hopwood manuscripts and is particularly interested in novels," the *Michigan Daily* reported. "Although he personally likes poetry and short stories, he explained that they just do not sell." This assessment was not lost on a disgruntled, though not unamused, O'Hara, who relayed the news to Freilicher: "No publication goes with the Hopwood award, alas, and both Alfred Knopf and Herbert Weinstock of the same 'firm' told me it was next to impossible to publish poetry in our time. I think of this with absolute delight when I think how embarrassing my letters will be for my relatives when I have to dig my poems out of them if I ever do get published. Anyway you could fit the people I write for into your john, all at the same time without raising an eyebrow."

To complete the requirements for his degree, O'Hara needed to spend the summer term in Ann Arbor taking Writing for Grads, Modern English Grammar, and Chaucer, a fragment of which was embedded in "Ann Arbor Variations":

> *The spherical radiance,*
> *the Old English*
> *look, the sum of our being, "hath perced*
> *to the roote."*

"I am writing a paper on Chaucer whom I now love with a burning devotion," he wrote to Freilicher. For those sweltering few months—the high temperatures causing cases of heat exhaustion and sunstroke on campus—he moved to a small apartment in Alpine House at 1022 Forest Street. It was the summer of "Ann Arbor Variations," of "The fainting into skies / from a diving board." His room was outfitted with a compact kitchen, closet, commode, chair, and a single Hollywood bed, which inspired him to ask his shocked landlady, "What's so Hol-

lywood about a single bed?" It was to this apartment that O'Hara invited Freilicher. He assured her, given his landlady's prudery about men and women being alone unchaperoned in her rooms, that "she doesn't live in this apt house but in another several blocks away so you could sit on the grass outside until she was out of the way if you didn't want to be brazen." O'Hara continued to press Freilicher to visit him for a summer of painting, with a hint of a plea in his voice, "It would be out of NY and although it is not very attractive here in any way there are lots of trees, flowers and squirrels, an arboretum with a river running through, and some incredibly ugly midwestern gothic which you might be able to make into a bouquet."

To his delight Freilicher finally accepted his invitation. She arrived at the beginning of July in Ann Arbor, a town she recalls as having looked, with its lawned houses and lots of trees, "a little like South Hampton." Freilicher painted various "Rubens-like landscapes," as O'Hara described them in a postcard to Rivers, including an expressionistic blur of two figures embracing in front of a television set, which he insisted on buying with sixty dollars of his Hopwood money, and a charcoal sketch he extravagantly retitled *Portrait of Frank O'Hara Thinking about the Genius of Arnold Schoenberg*. (The death of the twelve-tone composer on July 13, 1951, inspired O'Hara to write "The Tomb of Arnold Schoenberg" later in the year.) He and Freilicher drank beers at the Union, where O'Hara was surrounded by a few of the university's more precious and literary students and hangers-on. "He was the beloved romantic figure for all of these people," recalls Freilicher.

The highlight of that summer was a trip to Chicago where they stayed overnight on separate floors of the YMCA. Freilicher, who stayed up late reading *The Naked and the Dead*, had the extremely unpleasant experience of hearing a man make a suicide jump from his window. O'Hara recalled the trip in July 1956, in "In Memory of my Feelings":

> *Five years ago, enamored of fire-escapes, I went to Chicago,*
> *an eventful trip: the fountains! the Art Institute, the Y*
> *for both sexes, absent Christianity.*
> 　　　　　　　　　　　*At 7, before Jane*
> *was up, the copper lake stirred against the sides*
> *of a Norwegian freighter*

During the day they visited the Art Institute where they were particularly struck by Seurat's *La Grande Jatte*, the inspiration for O'Hara's

"On Looking at *La Grande Jatte,* the Czar Wept Anew," written that July and accepted for publication by Delmore Schwartz in *Partisan Review* the following March. This painting was to reenter O'Hara's life in 1958 when he was working at the Museum of Modern Art. He claimed to have personally helped rescue the canvas, on loan for an exhibition of "Seurat Drawings and Paintings," from the museum fire.

O'Hara had been very happy during Freilicher's visit, only to feel an enormous loss after her departure ("I have been so lonely since you left that I haven't even made any oatmeal," he wrote her). This served to confirm her ascendance to the pedestal as O'Hara's current muse. He already had poetic designs on her, evident from the letter in June in which he had enclosed "A Sonnet for Jane Freilicher." "Here 'tis;" he announced, "my very first that bears the name and escapes the wastebasket." Soon afterward a series of poems appeared, written during and upon the heels of her visit, bearing her name either in the title ("Jane Awake") or in scattered references ("The Arboretum," "A Terrestrial Cuckoo," and "A Mexican Guitar"). In "Cuckoo," O'Hara confronts the tricky issue of the decrease in poems to Bunny Lang and the increase of those to Freilicher. His betrayal would be quite blatant over the next two years as he wrote about fifteen "Jane" poems, including "Jane at Twelve," "Jane Bathing," and "Chez Jane." The shift made Freilicher feel a bit queasy, especially as Bunny Lang had begun to come down to New York after O'Hara's arrival, and the two women had grown friendly enough to exchange winter overcoats for one season. While discretion precluded their ever discussing the matter, Bunny Lang's constant assertion during the early fifties back in Cambridge that "New York has brutalized Frank!" might well have been a reaction to her feeling spurned in print by the poet she had called her "Object Attachment" and "Dethroned Sibling" while he was in Ann Arbor. But Freilicher need not have worried, as she would soon discover that she was hardly at the end of the line of O'Hara's poetic infatuations.

One of the stronger influences on O'Hara's thinking at the end of the summer was the writing of Paul Goodman, three of whose books he had purchased in New York: *The Dead of Spring, The Facts of Life,* and *Stop Light.* Goodman, a therapist who favored Gestalt psychology, became well known in the sixties as the author of *Growing Up Absurd.* Goodman's poetry was often overlooked, but O'Hara was drawn to his plain speech, his tendency to write occasional poems, and his love of New York City. The city's taxis, El trains, hustlers, and Hudson River often appear in his poems, as do the proper names of friends—"Mrs. Kraus," "Troy," "Dr. Davidson"—as well as his own name, Paul, in

such self-dating poems as "Ballad of the Great Books, 1935" or "1934: A Train Wreck at Sixty-Sixth Street." This was the summer in which O'Hara, besides writing his "Jane" poems, was beginning to use familiar references more. In "A Party Full of Friends" he brings in "dizzy Violet," "Jane, her eyeballs like the crystal of a seer," Larry who "paced the floor," Hal, John who "yawked onto the ottoman," and Lyon, and the poem ends, "Someone's going / to stay until the cows / come home. Or my name isn't / Frank O'Hara." Encouraging O'Hara to try to publish "A Party Full of Friends" Ashbery argued, contradicting some of his other comments on the matter, "the fact that no one would know who the people are would add rather than decrease charm."

O'Hara did not particularly need encouragement in writing about his friends. But Goodman, in an article titled "Advance-Guard Writing, 1900–1950" in *The Kenyon Review* of Summer 1951, argued that the wisest move for the avant-garde in the present "shell-shocked" society was to reestablish a community of friends through art. "In literary terms this means: *to write for them about them personally,*" as Goodman put it. "But such personal writing about the audience itself can occur only in a small community of acquaintances. . . . As soon as the intimate community does exist—whether geographically or not is relevant but not essential—and the artist writes about it for its members, the advance-guard at once becomes a genre of the highest integrated art, namely occasional poetry—the poetry celebrating weddings, festivals, and so forth. 'Occasional poetry,' said Goethe, 'is the highest kind.'" A perfect example of such occasional poetry was O'Hara's 1957 epithalamion, "Poem Read at Joan Mitchell's," a form, according to Goodman, that "heightened the everyday."

"The only pleasant thing that's happened to me since you left gal is that I read Paul Goodman's current manifesto in *Kenyon Review* and if you haven't devoured its delicious message, rush to your nearest newsstand!" O'Hara exulted in a letter to Freilicher. "It is really lucid about what's bothering us both besides sex, and it is so heartening to know that someone understands these things. . . . he is really the only one we have to look to now that Gide is dead, and just knowing that he is in the same city may give me the power to hurt myself into poetry." While O'Hara's contact with Goodman once he moved to the city was less a revelation than an example of the disappointment that sometimes follows upon meeting a cultural hero in person, his sense of the essay's message, or its voicing of what he already felt, animated O'Hara over the next decade and a half. In addition to his friendships with Ashbery, Rivers, and Freilicher O'Hara soon developed friendships with many

other artists in all fields. Aside from his increasingly apparent need for many friends, there was always the sense, too, of zealously undertaking some crucial avant-garde mission. He never spelled out the essence of that mission as fully as Goodman had in this essay he so admired in the *Kenyon Review*.

Although O'Hara later became too busy, and too disillusioned with established poetry magazines, to submit unsolicited poems, he was still interested enough during his last term in Ann Arbor to contact poetry editors. "The Three-Penny Opera," along with Ellsberg's review of *Try! Try!*, appeared that summer in Kerker Quinn's well-respected *Accent* published at the University of Illinois. He received word in August that Karl Shapiro, his champion on the Hopwoods, had accepted "Ann Arbor Variations" for publication in December in *Poetry,* as "*A POEM!*" as O'Hara put it, but *The New Yorker* sent a penciled rejection note during the same season for a poem he had mailed to Howard Moss, a former winner of the Hopwood, who was unfortunately away on vacation.

By the last week in August O'Hara had completed his coursework and was ready to move to Manhattan. Larry Rivers, who had invited him to a twenty-eighth birthday party O'Hara was "feverish" to attend, had suggested that they share an apartment. Freilicher, though, advised against such an arrangement. "I do think it would make a smorgasbord out of all of your personal relationships and become extremely confusing to everybody," she counseled, referring perhaps most specifically to what such a ménage might make out of her own life. O'Hara finally decided to take up the offer of his former Eliot House roommate Hal Fondren, now living in a tenement apartment on East Forty-ninth Street, who had graciously written, "I will surely be glad to have you stay as long as you like." His apartment, Fondren had luringly pointed out, was "only a hop-skip from the B.P.," referring to the Blue Parrot, a popular gay bar on Manhattan's Upper East Side.

O'Hara's friends in New York eagerly awaited his arrival. They sensed, as did he, that there was to be nothing casual about his presence in their midst. As Ashbery wrote later in an essay on Jane Freilicher: "The one thing lacking in our privileged little world (privileged because it was a kind of balcony overlooking the interestingly chaotic events happening in the bigger worlds outside) was the arrival of Frank O'Hara to kind of cobble everything together and tell us what we and they were doing. This happened in 1951."

Second Avenue

To celebrate O'Hara's much anticipated arrival in New York, on a hot day during the last week of August 1951, Hal Fondren, John Ashbery, Jane Freilicher, and O'Hara piled into a car and headed uptown on a mock tourist junket. Although the tour was designed for his edification, it was O'Hara who was at the wheel. They drove up Eighth Avenue from the Village, passing by the main post office and Pennsylvania Station, complementary McKim, Mead & White buildings designed in 1910 so that the post office's two-block row of tall Corinthian columns was mutely mirrored by the stubbier row of Doric columns of the railway station across the street. His friends breezily captioned Penn Station as "a Baths of Caracalla." At Thirty-fourth and Eighth Fondren, paraphrasing an ad of the time, pointed to the Hotel New Yorker and announced, "On the left is the famous Hotel New Yorker, which has eight thousand rooms, each with an inside view."

Enormously pleased with themselves, the group decided to push on as far as Palisades Amusement Park on the cliffs of New Jersey, a destination that allowed them to take O'Hara across the elegant and stately

sweep of the George Washington Bridge. They spent the rest of the day and night on rides, including the merry-go-round, Ferris wheel, and roller coaster. "I feel so at home," O'Hara quipped sarcastically to Fondren. "These buildings remind me of the University of Michigan."

Of course that night O'Hara was far from nostalgic about Michigan. His interest lay with the skyline beckoning from across the Hudson River, a skyline he would one day describe as "ozone stalagmites / deposits of light." O'Hara could hardly realize, as he drove the group back across the George Washington Bridge, that the car contained those friends from his immediate past who were to have the greatest impact on his immediate future in New York. Hal Fondren, his Harvard roommate and a gourmet cook, exerted a steadying and domestic influence on O'Hara, something the poet always needed from others but rarely provided for himself. "Hal was sort of like his aunt," explains Larry Osgood. John Ashbery, whom O'Hara fancied playing Tu Fu to his Po Chü-i, would eventually be grouped with O'Hara, Koch, Schuyler, and Barbara Guest under the label The New York School poets. Jane Freilicher was their moll; her name, after O'Hara's lead, began to appear in many of their poems. "We did a lot of driving around in the course of our friendship," says Freilicher, putting their ride that day into a context. Indeed it was as if once O'Hara got into his friends' car that day, he never stopped moving again—away from Grafton and toward his own version of bohemia.

The raucous mood of the small band was hardly a barometer of the times, which had largely come under the influence of McCarthyism. In the early 1950s the zeitgeist was more grim than ebullient. Ethel and Julius Rosenberg were found guilty of treason as Russian spies and sentenced to death; Korea marked the beginning of U.S. involvement in difficult Asian wars; an endemic conformity in the nation was analyzed by David Riesman in his acclaimed sociological study *The Lonely Crowd*.

"I couldn't write anything from about the summer of 1950 to the end of 1951," admits Ashbery. "It was a terribly depressing period both in the world and in my life. I had no income or prospects. The Korean War was on and I was afraid I might be drafted. There were anti-homosexual campaigns. I was called up for the draft and I pleaded that as a reason not to be drafted. Of course this was recorded and I was afraid that we'd all be sent to concentration camps if McCarthy had his own way. It was a very dangerous and scary period."

Their consolation was Downtown—the busy grid of coldwater lofts, storefront galleries, and artists' clubs and cafeterias along an axis

of Second Avenue and Tenth Street—where, unknown even to most New Yorkers, the so-called "heroic age" of the new abstract American painting was cresting and a second generation of New York painters was already waiting for recognition. The only remotely famous figure among them was Jackson Pollock, who had been photographed by *Life* magazine in 1949 moodily smoking a cigarette next to his eighteen-foot-long canvas *Number 9* (which was priced at that time at $1,800). The rest of the group's personal heroes were still working largely in the dark—Willem de Kooning, Mark Rothko, Franz Kline. The suicide of Arshile Gorky in 1948 proved that such marginal struggling had a high price. But artistic suffering in the interest of beauty and truth was part of the romantic ethos of the times. As de Kooning later warned O'Hara after they became friends: "If fame ever comes your way, give it the back of your hand." These painters felt that New York City, especially with the influx of European painters during World War II, had replaced Paris as the art capital of the world. Their belief was that expressed by O'Hara in "A Terrestrial Cuckoo": "New York is everywhere like Paris!"

"Everyone felt this kind of energy," recalls Freilicher. "The new art of younger people was being done here. French art seemed extraneous, except Picasso was going great guns, but then he was from another period. The action was here. One knew all these people. It was a kind of community."

The younger painters were particularly enamored with New York. The titles of their canvases often gave away their infatuation with the light and silhouettes of the urban landscape. During the fifties Freilicher painted *Early New York Evening*; Rivers, *Second Avenue with THE*; Hartigan, *Grand Street Brides*; Kaprow, *George Washington Bridge (with Cars)*; Kline, *Third Avenue*. De Kooning even joked that he thought of the fiercely totemic *Woman* of his 1950–52 series as "living" on Fourteenth Street. O'Hara matched the spirit of his new artist friends by trying to create a poetic city of New York. Other poets had certainly written about Manhattan—Whitman, Crane, Lorca, Auden. But over the next fifteen years O'Hara composed a fragmented epic of the city, focusing particularly on the humor and chaos of the growing metropolis and using his experiences as a trail through an ever-changing urban labyrinth rather on the scale of Joyce's Dublin or William Carlos Williams's Paterson. From the moment he arrived, the twenty-five-year-old poet began absorbing the images, smells, and sounds that appeared in his work—newspaper headlines, subway bathrooms, yellow construction helmets, taxi honkings, funeral home signs, painters' lofts, instant coffee, negronis, abandoned storefronts, lunchroom tables, smoke-filled

bars, liquor stores, and tobacconists. "A scent of garbage, patchouli and carbon monoxide drifts across it," wrote Ashbery in his introduction to O'Hara's *Collected Poems,* of the authentic urban flavor of the poetry O'Hara was to begin writing.

While O'Hara's plunge into the life of his downtown painter friends was sudden, the move was not out of character. As a boy, O'Hara had been inspired enough by his father's piano playing to want to become a concert pianist. But when he arrived at Harvard, the Music Department seemed relatively conservative and stodgy. His most interesting friends were reading Firbank and Compton-Burnett, and O'Hara switched to literature. In New York, however, the acquaintances who most fascinated him were in the artworld, not at the *Partisan Review.* He began writing poems influenced by the aesthetic experiments of the painters and frequenting painters' bars such as the Cedar. As O'Hara's poems were always influenced by the company he was keeping, so was the direction of his life.

After the Palisades drive, O'Hara returned with Fondren to the apartment they were to share at 326 East Forty-ninth Street between First and Second avenues. The East Side of midtown, with its rows of cheap tenement houses and rents well in line with the thirty-one dollars a month split between O'Hara and Fondren, was a neighborhood that was then attracting plenty of other young arrivals to the city. O'Hara and Fondren lived on the sixth floor of a walk-up filled mostly with Italian trucking families, and they were subjected daily to shouting matches quite different in tenor from the exchanges they had overheard in the hallways of Eliot House. There were two landings between each floor, and they often felt as if they lived on the eighteenth, rather than the sixth, floor. "This was not the kind of apartment you would have stayed in if you could have found anything better," says Fondren. "Walking up the steps at five o'clock in the morning to try to get some sleep before you had to go to work was really an ordeal. Both of us would come in blind."

Their coldwater flat had a good-sized living room, one large corner bedroom occupied by Fondren, and two smaller rooms, one of which O'Hara used as his bedroom. The sink in the apartment's big kitchen doubled as a bathroom basin; the bathroom itself had only a soiled, grayish bathtub and toilet. The place was furnished with fairly "pedestrian-looking" furniture, including two beds, an armchair, and a dinette set left behind by the German count from whom Fondren was subletting. According to Fondren, "It looked like a German slum." In an attempt to counteract the look of the apartment, O'Hara set up his

cheap record player in the living room to play his limited collection of three or four albums—including works by Poulenc and Milhaud as well as Rachmaninoff's Second Symphony—and an antiquated little radio, which he kept tuned to one of two classical radio stations, WQXR or WNYC.

On bright days, however, the apartment was flooded with so much sunlight that sleeping was impossible. A decent amount of blue sky, flocks of gray pigeons on the next-door roof, the River House uptown, and, most impressively, the United Nations building under construction a block away on the East River were all a part of the dramatic view. O'Hara commemorated the newly finished aquamarine slab of the United Nations Secretariat in several poems; in "Shelter" he writes of "the UN Building's / enigmatic mirror" and in "Nocturne" he identifies with the architectural prism conceived by Le Corbusier:

> *A tiny airliner drops its*
> *specks over the UN building.*
> *My eyes like millions of*
> *glass squares, merely reflect.*

Unfortunately for Fondren, who was very tidy, O'Hara had lapsed from the orderliness instilled by his mother, who had helped keep his upstairs bedroom in Grafton neat and clean. At Harvard the two undergraduates had had an industrious cleaning lady to whom they were so grateful they had presented her with all of their Fall River furniture upon graduation. Now, oblivious to dirt and chaos, O'Hara focused his attention on his Royal portable typewriter or whomever he was speaking with on the phone. "It was sort of a disaster scene, and it seemed to come very naturally to Frank who never did very much about it," complains Fondren. The sink, filled with dirty dishes, was often crawling with cockroaches, but O'Hara was able to dismiss, or glamorize, the bugs: "The cockroach and the ginkgo tree are the oldest things on earth!" he shrugged. William Weaver, a friend of O'Hara's who lived nearby on East Fifty-first Street and who went on to become a well-known translator of Italian, nicknamed the apartment Squalid Manor.

In those first few months in New York O'Hara did not seem particularly worried by practical matters. He was living on the last few dollars of his Hopwood and he had yet to find work. But then most of his friends were either working at odd jobs—like Fondren who was unhappily employed at a paper company on Park Avenue—or they were

unemployed, like Ashbery who eventually found a job in October in the publicity department of Oxford University Press. There seemed to be vast amounts of free time for wandering to museums, bookstores, the ballet, movie theatres, restaurants, and bars. O'Hara was capable of cooking quite a good pot-au-feu but preferred neighborhood restaurants to cooking. His favorites, in the East Forties and Fifties on Lexington and Third avenues, were Original Joe's, an Italian restaurant that served ziti and manicotti; the Russian Bear, which had terrific Slavic meatballs; and a nearby Chinese restaurant that featured family dinners with many choices from Column A and Column B. "Whichever restaurant we agreed on, John Ashbery invariably disagreed and said, 'Oh the last time I went there I got ptomaine,'" recalls Weaver of the slyly humorous games Ashbery played with his friends. "Usually it ended up being John's choice, and then when we got there he would always complain about it and say, 'How did we come to this awful place?'"

Cruising was a big part of all their lives, as much an excuse for drinking whiskey and exchanging witty remarks as for picking up partners for sex. O'Hara's new neighborhood was bursting with gay bars, all named for different birds, that together were known as "the Bird Circuit." They included the Blue Parrot on Fifty-third Street between Third Avenue and Lexington (about which Rivers had warned O'Hara in a letter to Ann Arbor, "The cops are making arrests at the Blue P every night these days"), the Golden Pheasant on Forty-eighth Street, and the nearby Swan—all in the neighborhood of the Third Avenue El. The East Side bars tended to be dressy, and their customers were conservatively dressed in bow ties, blazers, or fluffy sweaters. The "bird bars" usually started coming to life between eleven-thirty and midnight when the plays let out. Often the men in the bar could be found shoulder to shoulder, singing tunes from such Broadway musicals as *South Pacific* or *Kiss Me, Kate* in unison with the jukebox.

Plainclothes policemen were stationed in the bars, however, and could usually be spotted in their black-tie shoes nursing a single drink the entire night. The Oak Room of the Plaza Hotel was a popular gay meeting spot until the mid-fifties when the management became nervous about the clientele. The appearance after an Easter Parade of Walter Florel, a well-known milliner, with his pink-dyed poodles, persuaded the owners to ban men unescorted by ladies at the bar. The same was true at P. J. Clarke's on Third Avenue.

O'Hara preferred the bars downtown on Eighth Street. "A Harvard friend who had preceded us by one year taught us the ropes," says Fondren. "He said, 'There's a special train. After you've done the Third

Avenue bars, you take it at Fifty-third and Third and it goes right to
West Eighth Street. And then you have all of Eighth Street.'" O'Hara
and Fondren often followed their friend's map, riding the E train to
Eighth Street to have dinner at the Alice Foote MacDougal Restaurant,
one of a chain of tearoom-like restaurants, which served food until
9:00 p.m. Afterwards, they pushed on to Mary's, a lively blue-neon-lit
gay bar. "Mary's was very much a make-out bar," says the poet James
Schuyler. The composer Ned Rorem wrote in his *New York Diary* in
1958: "Mary's Bar on Eighth Street. It is already eleven summers ago
that John Myers and Frank Etherton worked there, whining the tunes
Paul Goodman and I composed for them: Bawling Blues. Jail-Bait
Blues. Near Closing Time. Occasionally, for comic relief, Eugene
Istomin would play Ondine on the tuneless piano and the drunks would
actually stop talking. . . . John Myers was trying to make it into a
Boeuf sur le Toit, Cocteau hangout, which it wasn't." Along the same
street were Main Street, the Eighth Street Bar, and the Old Colony.
"Main Street was sort of uptight, pretty," recalls Edward Albee. By
1952 Albee and his lover Will Flanagan were hanging out at the popular
bar of the Old Colony, so absorbed in each other's conversation that
they came to be nicknamed "the Grimm Sisters" by some of their
friends.

While O'Hara enjoyed the ritual of seduction by talking at the rail
of a gay bar, his true interests lay elsewhere. His taste for men whom
he thought were straight, especially straight black men, often led him
outside the perimeter of the established gay bars. Soon after his arrival
in the city he set up a pattern of episodic promiscuity that characterized
his sexual life over the next five years, and these episodes fed his con-
versation and poetry as much as, if not more than, his sexuality. While
he chose to break this pattern around 1957, for about five years he was
prone to the kind of assignations he wrote about in November in "After
Wyatt," a Petrarchan sonnet originally titled "Blowing Somebody,"
which begins, "The night paints inhaling smoke and semen." He often
told the tale of the security guard he used to make out with regularly
in his guard house after midnight at the United Nations, a tale he hinted
at in "October":

> *this lavender sky*
> *beside the UN Building*
> *where I am so little*
> *and have dallied with love.*

He once invited in the overweight black postman, whom he and Fondren had nicknamed Aunt Jemima, for sexual favors in thanks for climbing six flights of stairs. One evening when he was quite smashed he missed his E train stop and wound up in a change booth in Queens performing fellatio on a black token clerk.

His poems at this time winked at these adventures. In "Grand Central," "He unzipped the messenger's trousers / and relieved him of his missile" and "Homosexuality" tallied the merits of cruising different subway latrines:

> *14th Street is drunken and credulous,*
> *53rd tries to tremble but is too at rest. The good*
> *love a park and the inept a railway station.*

He enjoyed the shock value of these escapades when he confessed them drunkenly in public, especially in mixed company. "I used to get bug-eyed at Frank's sex adventure stories," recalls the poet Kenward Elmslie of O'Hara in the Hamptons in the summer of 1952. "He'd tell these stories in front of Janice, Kenneth Koch's wife, and other women and straights, spelling out everything so it wasn't just shocking, it was hilarious."

One November evening O'Hara's Harvard friend Freddy English threw a cocktail party on East Sixty-seventh Street at which O'Hara, Fondren, Freilicher, and a crush of other friends were present. At midnight they all headed off to eat something at Regent's Row, a "piss-elegant" gay restaurant nearby. One friend floated off to the Blue Parrot where he picked up two surly young men, classic examples of "rough trade." Freilicher went home, but a small band returned, including the two pickups. A few hours later, as heavy drinking continued in the living room, O'Hara's screams were heard from the bedroom. English rushed in to find one of the young men on top of O'Hara, pounding him. He yanked him off. The assailant prevented English from using the phone, so he crawled out the window into the bedroom of two women next door to call the police, who had already been alerted by others in the building upon hearing the loud shrieks. The two young men fled, and English rushed O'Hara to Bellevue where a bloody gash in the side of his head was stitched. The incident, or one similar, is behind the lines in "October":

> *My glasses*
> *are broken on the coffee table.*

And at night a truce
with Iran or Korea seems certain
while I am beaten to death
by a thug in a back bedroom.

O'Hara discovered a giddy liberation in acting out and regaling others with less dangerous incidents, especially after keeping quiet during all his years in parochial school and the Navy. "It's wonderful to admire oneself / with complete candor," he wrote in "Homosexuality." The shadowy parks, subway stations, and ship docks of the city were a libidinal landscape for the young poet, their furtiveness part of a mischievous midsummer night's game. O'Hara felt he could exorcise some of the secrets of his past with the group of artists and intellectuals who were his friends. He could safely shock them with stories of falling asleep drunk in a construction site. As his audience was willfully liberal, he did not suffer from the grimmer repression experienced by many homosexuals in small towns across America during the conservative Eisenhower years.

Yet O'Hara, with his attraction to straight men and what was called "rough trade," was setting himself up for disappointments and frustration in love. His peregrinations late at night were part of a romantic bad-boy identification with the stalkings of Melmoth the Wanderer, that villainous Gothic fugitive from God's light. O'Hara combined sexual and Catholic imagery in his renegade poems of the early fifties. In one of his Hopwood poems, "The Young Christ," the narrator, Jesus, declares, "I must be a pansy" and cries, "I'll thrust my skull between king's purple thighs / a burning child, adoring and my Father's pyre." In another Hopwood poem, "A Proud Poem," O'Hara, who once told Harold Brodkey that "Hellfire must be fun," writes, "black my heart is," "no god turns me / inside out," and "I'll go down / grinning into clever flames." One of his favorite castings of himself, ever since his interest in Sacher-Masoch's *The Serpent in Paradise* in college, was as a snake. His weaving together of sexuality and apostasy resulted in a curious blend of exhibitionistic liberation and more hidden pessimism.

The center of O'Hara's more public social life was conveniently located near his apartment. This was the Tibor de Nagy Gallery at 219 East Fifty-third Street, about five doors up from the Third Avenue El station. The gallery was in a converted coldwater flat on the stoop level a few steps up from the street and advertised itself with a sign beneath which an old man usually stood selling chips off a block of ice. In an

attempt to give an air of some sort of chic to the rather poverty-stricken and desperate gallery, a young Milanese architect named Robert Mango —in exchange for being allowed to mount a show of photographs—had stripped the long narrow showroom's white walls of molding, painted its ceiling blue, hung a web of black wire to which he attached spotlights, and covered the floor in black linoleum. Although it had only opened the previous November, the upstart gallery had already been identified as the home of the group of younger painters known as the Second Generation—the successors to the First Generation of Pollock, de Kooning, Gorky, Kline, Motherwell, Rothko. The gallery's exhibitions in 1951 and 1952 included Larry Rivers, Grace Hartigan, Al Leslie, Helen Frankenthaler, Jane Freilicher, Fairfield Porter, and Robert Goodnough.

The impresario behind the gallery was the irrepressible, and sometimes equally irresponsible, John Bernard Myers. Myers was a former managing editor of *View,* Charles Henri Ford's avant-garde magazine in which many of the French Surrealists, such as Tanguy and Breton, who moved to America in the 1940s, had published. Since the magazine's closing in 1949 Myers had been moving from one artistic project to the next, ever enthusiastic about meeting interesting artists and introducing them to one another. He had organized a marionette theatre for a while with the help of his partner, Tibor de Nagy, a Hungarian refugee from a feudal family, whom he had persuaded to back his project because of the great popularity of "Howdy Doody," the children's puppet show on television. Some of his artworld friends, including Pollock, Greenberg, and de Kooning, then encouraged Myers and de Nagy to start a gallery to show some of the painters of the next generation, just as the galleries of Peggy Guggenheim, Charles Egan, Sidney Janis, Betty Parsons, and Sam Kootz had shown the previous generation. While his eye for painting was criticized by some of the painters in his own stable, Myers's knowledge of who was who was impeccable. It was this sixth sense, as well as his flamboyance and pushy energy, that made his gallery a landmark in the fifties artworld, if not always a solid business enterprise. "John Myers was always a hollow tree," says the poet James Merrill. "You could get in touch with anyone through him, or hear about what people were up to."

O'Hara had visited Myers's gallery on a trip from Ann Arbor, but the first opening he attended after his arrival in 1951 was Larry Rivers's October exhibition, which kicked off the gallery's fall season. No show could have pleased O'Hara more, including as it did *The Burial,* Rivers's Expressionist painting of his grandmother's funeral, praised by *Art*

News in its review as "heroic" and remembered later by O'Hara: "His early painting, 'The Burial,' is really, in a less arrogant manner than Hemingway's, 'getting into the ring' with Courbet ('A Burial at Ornans')." Other paintings in the show reflected the influence of the Chaim Soutine retrospective held the previous year at the Museum of Modern Art.

O'Hara was already a presence around Rivers and around Myers's gallery, where he would often show up dressed, as Freilicher described him, in "his dark fuzzy shetland sweater, no shirt, chino pants & tennis shoes—Ivy League but rather exotic & chic in the N.Y. artworld in those days." Myers's first impression of him, as of many of his favorites, is colored by rather outrageous and literary imagery. "The long neck, the high cheek bones, the bridged nose and flaring nostrils reminded me of an over-bred polo pony," Myers later wrote in a memoir. "Or did he bring to mind Robert de Saint-Loup, that reddish-golden aristocrat leaping over the tabletops in Proust's novel?" Always a saver of souls, Myers immediately made O'Hara's precarious joblessness his business. He found him work to carry him through until December, typing up a libretto written by John LaTouche for his musical, *The Golden Apple,* an Americanized retelling of some Homeric tales, which was to be published by Random House. (LaTouche had recently been blacklisted in *Red Channels,* a list of names of supposed Communist sympathizers printed by American Business Consultants.) Myers had a crush on LaTouche, so persuading him to hire one of Myers's protégés furthered Myers's designs as well.

The great crush for Myers, however, was Larry Rivers, whom he had first arranged to meet at Louis', through the suggestion of Clement Greenberg. Louis' was an early bohemian haven on Sheridan Square in Greenwich Village, and Myers was sitting, as Rivers has remembered him, in a "hanky-panky cross-legged position at the bar, with a sort of Oscar Wilde smile on his face." No matter how large Myers's stable of artists became, Rivers was from then on always its showpiece. When buyers came to see an artist's exhibition, Myers often hustled them into the back room to look at a new canvas by Rivers. As Rivers had written to O'Hara in August, "John M. has been so nice to me as to make me think he loves me (something he repeats ohvah and ohvah agahyne)." Myers expressed this infatuation by calling Rivers three or four times a day, telling him whom he had lined up to buy his work or which magazine he had persuaded to write an article. Rivers basked in the attention, using the opportunity to exchange sexual favors to hustle his own career advancement as well as to indulge in the thrill of breaking the

homosexual taboo. "John Myers was quite a number," admits Rivers. "He loved me and I actually made it with him quite a bit. It's as if I were some kind of woman who is with some man she's not attracted to, but she knows that after about five seconds it's going to all be over. So why make a fuss? The whole life was about men and sweethearts and homosexuality and the meaning of it, if one could really get an idea. It's amazing that that was that much the subject matter of my life at a certain point. I felt as if I were some stranger looking in on it. Because obviously I had the other experience." Myers's obsessive passion for Rivers meant that he and O'Hara had a topic for frivolous banter, though there was also rivalry, and Myers's jealousies were famously vindictive. Some of the gallery wits observed that Myers could only have been played by George Sanders, the English actor who had become famous the previous year for portraying a venomous drama critic in *All About Eve*.

At a party held at Myers's apartment on East Ninth Street after Rivers's opening, during which Willem de Kooning and Nell Blaine stood arguing about whether it was deleterious for an artist to do commercial work, O'Hara walked up to introduce himself to the poet James Schuyler. Schuyler, who had been born in Chicago in 1923, had spent several years in Italy as well as a summer at Auden's house on Ischia typing up most of the poems in Auden's *Nones,* a fact not lost on O'Hara, as *Nones* was one of Bunny Lang's favorite books. Schuyler was already aware of O'Hara's poetry since his own stories had been published in the same issue of *Accent* as O'Hara's "The Three-Penny Opera." The day Schuyler received his issue Myers called him up to compliment him while Schuyler raved about O'Hara's poem. "Why my dear, he's here in the room!" replied Myers, of the poet visiting on break from Ann Arbor. The evening of the party O'Hara began their conversation almost in midsentence by debating with Schuyler Janet Flanner's article that week in *The New Yorker,* which had disclosed the scandal of Gide's wife burning all his letters to her. "I never liked Gide," O'Hara announced, "but I didn't realize he was a *complete* shit." "This was rich stuff, and we talked a long time; or rather, as was often the case, he talked and I listened," Schuyler later recalled in a memoir in *Art News*. "His conversation was self-propelling and one idea, or anecdote, or *bon mot* was fuel to his own fire, inspiring him verbally to blaze ahead, that curious voice rising and falling, full of invisible italics, the strong pianist's hands gesturing with the invariable cigarette." Schuyler, who was included with O'Hara as a member of what John Bernard Myers decided to call the New York School of Poetry in an article in

Nomad magazine ten years later, was struck enough by his first meeting to begin writing imitative poems.

O'Hara was quickly beginning to make his presence felt all over town, at least in those spots frequented by the poets and painters for whom the Tibor de Nagy was an Uptown outpost. One of their prime gathering places was the San Remo at the corner of MacDougal and Bleecker streets in the middle of an Italian section of Greenwich Village. A weathered bar with white-and-black tiled floors, a pressed tin ceiling, wooden booths, great big urinals, hanging chandeliers, and a clamorous backroom restaurant, the San Remo was owned by Joe Santini, born across the street at 190 Bleecker, and presided over by a bartender with a club to whack patrons if they misbehaved. Hence the line in O'Hara's "For Janice and Kenneth to Voyage": "The penalty of the Big Town / is the Big Stick." Although Thursdays were purported to be gay night at the San Remo, the bar, a fictional version of which looms in Jack Kerouac's *The Subterraneans,* was simply a mixed, talky bar to which all genres of poets, writers, intellectuals, and bohemians were drawn. It was a sort of café, its existence depending, like that of so many Parisian cafés, on the discomfort of the tiny apartments in which many of its patrons were living. Among those who could regularly be found drinking its fifteen-cent beers, or martinis, were Tennessee Williams, John Cage, Paul Goodman, Dylan Thomas, Allen Ginsberg, William Burroughs, Judith Malina and Julian Beck, Miles Davis, Merce Cunningham, Dorothy Day, and James Agee. More a hangout for writers than painters, the San Remo was the site of O'Hara's meeting with Paul Goodman, one that proved disappointing to the irreverent O'Hara, who discovered that Goodman insisted on holding court and on being surrounded by young writers as disciples. Goodman in turn was a bit dismissive of O'Hara's seeming absence of seriousness. He found his pluck irritating, as well as his fondness for Prokofiev. "Paul Goodman would be smoking his pipe and there'd be a few of his disciples," recalls Kenneth Koch. "I remember he asked John Ashbery what he did and John said, 'I'm a poet,' and Paul said, 'You can't be *just* a poet.' I never stopped thinking about that, mainly because it didn't make any sense." Such exchanges were fast and furious in the dim, crowded bar, which was rapidly becoming a curiosity to some of the sullen neighborhood hoods lounging on their stoops, as well as to out-of-towners. "Even then there was a certain touristic fringe who would stare in the window and point at us," recalls James Merrill.

O'Hara found himself more often at the Cedar, the artists' tavern across town on University Place and Eighth Street. The Cedar was

more straight and macho than gay, more art-oriented than literary, but O'Hara enjoyed playing poet to the painters, and he had always been drawn to straight men. Although he was only in his middle twenties, he was able to talk about art with such eminences as de Kooning and Kline, who treated him with respect and interest. This was the pleasure he had missed with Goodman. As O'Hara later wrote in "Larry Rivers: A Memoir": "In the San Remo we argued and gossiped: in the Cedar we often wrote poems while listening to the painters argue and gossip. So far as I know nobody painted in the San Remo while they listened to the writers argue. An interesting sidelight to these social activities was that for most of us non-academic, and indeed non-literary poets in the sense of the American scene at the time, the painters were the only generous audience for our poetry. . . . The literary establishment cared about as much for our work as the Frick cared for Pollock and De-Kooning."

O'Hara treated the Cedar as if it were his college hangout, Cronin's, often arriving with a fresh poem in his back pocket, jotting down overheard phrases he liked the sound of while squeezed into a noisy booth. Freilicher recalls saying something about "ducal days," kidding around one evening at the Cedar, which O'Hara then used as the title for a poem he scribbled down on a napkin. When de Kooning remarked in a late-night blur, "maybe they're wounds, but maybe they are rubies," the comment found its way, unexplained, into "Ode to Willem de Kooning." The Cedar, a landmark of his New York poems, appears throughout the fifties as a convenient spot to meet an increasing list of friends—Mike Goldberg in "Poem" (I live above a dyke bar and I'm happy.): "I meet Mike for a beer in the Cedar as / the wind flops up the Place, pushing the leaves / against the streetlights"; Gregory Corso in "The 'Unfinished'": "Gregory is back in New York and we are still missing / each other in the Cedar"; Grace Hartigan in "L'Amour avait passé par la": "to get to the Cedar to meet Grace / I must tighten my moccasins." As a poet of the New York School of Poetry, O'Hara also lived aesthetically under the umbrella of the Cedar painters, who had coined the phrase "New York School" to cover their own painting as a sort of joke-cum-power-play on the "École de Paris."

The Cedar, which Rivers described as a "verbal news shop," was nondescript, with flaking green plaster walls bare except for a few Hogarth prints, glaring white ceiling lamps dangling overhead, a long bar in the front and a honeycomb of brass-studded leatherette booths in the rear. Looming from its back wall was a round industrial clock whose hands sometimes turned backward like a prop in a Cocteau movie. The

bar was kept purposely drab, colorless, and ordinary by its faithful artist patrons who persuaded the owners not to renovate and pressured them to ban all jukeboxes and TV sets. (An exception was a television rented for the World Series.) Here they felt free to indulge in what Rivers has described as the "ich-schmerz" existentialist jargon of the times, filled with talk about "risk" and "living on the edge," the cultivation of which was greatly nurtured by a long string of shots of straight alcohol. "The drinking in those days was a killer," says Helen Frankenthaler, who was reportedly involved in having a sign posted, "No Beatniks," when she snitched on Jack Kerouac for urinating in a sink outside the men's room. "The amount of liquor consumed in the artworld between 1950 and 1960 seemed like a flood."

At the Cedar, O'Hara stepped into a world to which he was perfectly suited. The excessiveness of the period matched his own penchant for excesses, for trying to shake the mundane in favor of daily, or nightly, liberations. It was a time in which everyone, in public at least, seemed to be drinking too much, smoking too much, staying up too late talking. Certainly during the day the painters were spending many hard hours experimenting with paint and light, trying to "make it new." Certainly O'Hara spent many hours hunting and pecking at his typewriter. There were also countless quiet days involved with talking on the phone, seeing friends, going to the movies, or simply staying home reading. But as a public personality, O'Hara's nervy energy, infectious excitement, love of drinking, and total dedication to a life lived for art's sake made him increasingly a mascot of an era in which wild parties seemed as creatively indispensable as they were fun. Judgments about alcoholism or acting-out came later, after the party was over.

Among the regulars whom O'Hara found himself packed in with over the coming years in what had become simply known as "the bar" were David Smith, Philip Guston, Mark Rothko, Isamu Noguchi, Barnett Newman, Norman Bluhm, Howard Kanovitz, Aristodemis Kaldis, Michael Goldberg, Herman Cherry, Jack Tworkov, John Cage, Edwin Denby, John Gruen, Morton Feldman, Harold Rosenberg, Clement Greenberg (who complained that "At the Cedar, *everybody* looked unattractive"), Alfred Leslie, Arnold Weinstein, Robert Rauschenberg, Jasper Johns, Irving Sandler, and Milton Resnick; among the few women in the classic "men's bar" were Helen Frankenthaler, Grace Hartigan, Joan Mitchell, Jane Wilson, Barbara Guest, Elaine de Kooning, Mercedes Matter, and Ruth Kligman. "The attitude of the tough guys in the Cedar Bar toward Frank was they sort of wanted to have it both ways," recalls Kenneth Koch. "I said something about Frank to one of them

and he said, 'What do I care about those Nances?' But everybody was perfectly willing to profit from Frank's electrifying enthusiasm and perception."

The atmosphere of the Cedar was very much that of a saloon, its Wild West rowdiness only increased by the presence of Jackson Pollock, who usually appeared on Tuesday nights after coming in from the Hamptons for his weekly psychiatric session. Pollock tried to overcome his extreme shyness by drinking inordinate amounts of whiskey, which then allowed him to release his Cody, Wyoming, cowboy persona. Pollock's two-fisted swagger set the bar's somewhat paradoxical tone, filled as it was mostly with macho men who were in truth hypersensitive artists who sometimes had trouble relating to the women in the bar with their black stockings, black eyeliner, and very long hair. "Most of those guys you couldn't even sit and have a cup of coffee with because they could barely socialize with anyone, men or women," recalls Al Leslie.

The din of the Cedar regularly hit a high note with Pollock's explosions of fist-fighting or shouting. Once when he and Kline had a brawl he tore the door off the men's room and smashed a few chairs. Pollock thrived on such angry confrontations. To a black man he said, "How do you like your skin color?" To a lady painter, "You may be a great lay, but you can't paint worth a damn." He made licking motions with his tongue at John Myers whom he leeringly asked, "Sucked any good cock lately?" To Larry Rivers, who was then in a phase of using heroin, he pantomimed shooting-up. On at least one occasion he called O'Hara a "fag" to his face and was enough of a menace that O'Hara fled the Cedar one night when he heard that Pollock was on a drunken rampage. But this unpleasantness was always forgiven in the name of genius and art. As O'Hara later wrote, "If Jackson Pollock tore the door off the men's room in the Cedar it was something he just did and was interesting, not an annoyance. You couldn't see into it anyway, and besides there was then a sense of genius. Or what Kline used to call 'the dream.'"

The Cedar seen through the eyes of its regulars made up a historic Dutch Masters sort of grouping of Downtown painters. O'Hara's favorite was Willem de Kooning, the blond housepainter from Rotterdam who he decided was the world's greatest painter after Picasso and Miró. When Rivers introduced them, O'Hara claimed he became almost sick with fear. (According to O'Hara, the single most important event in Rivers's own artistic career was when de Kooning praised his painting for being "like pressing your face in wet grass.") De Kooning in turn

was taken with O'Hara's confidence and free-floating poetic conversation. "I liked him immediately, he was so bright," de Kooning later recalled. "Right away he was at the center of things, and he did not bulldoze. It was his manner and his way. There was a good-omen feeling about him." Evidently free of Pollock's homophobia, de Kooning often greeted O'Hara at the Cedar with a big juicy kiss.

Franz Kline, another great presence of the bar, used to arrive early at 5:00 p.m. and often closed the place ten hours later. Famous for his monologues—a rendition of which survives in O'Hara's 1958 piece "Franz Kline Talking"—Kline moved from discussing dissections of Géricault's horses to imitations of Mae West and W. C. Fields to the trading of baseball statistics. Given to equally grand gestures in life as on his canvases, one night at "last call" Kline ordered sixteen scotch and sodas for himself and de Kooning's wife, Elaine. This caused much consternation until O'Hara and Joan Mitchell entered unexpectedly from a party and sat down to absorb some of the burden by drinking four scotches each. (Mitchell and Willem de Kooning used to poke fun at Kline for the broad swathes of his black-and-white paintings, such as *Wotan,* by pointing to tape on the windows of a newly built house and saying, "Oh look, there's a Franz Kline.")

The Cedar was O'Hara's entrée not simply into the contemporary artworld but into a livelier history of art as well. As the interests of his friends became his own, he began to work his way back to find their common references in the canvases of the past. His curiosity was aroused in a way that it had never been in the art history lectures at Harvard. "It is interesting to think of 1950–52, and the styles of a whole group of young artists whom I knew rather intimately," he wrote in "Larry Rivers: A Memoir" in 1965.

It was a liberal education on top of an academic one. Larry was chiefly involved with Bonnard and Renoir at first, later Manet and Soutine; Joan Mitchell—Duchamp; Mike Goldberg—Cézanne-Villon-de Kooning; Helen Frankenthaler—Pollock-Miro; Al Leslie—Motherwell; DeNiro—Matisse; Nell Blaine—Helion; Hartigan—Pollock-Guston; Harry Jackson—a lot of Matisse with a little German Expressionism; Jane Freilicher—a more subtle combination of Soutine with some Monticelli and Moreau appearing through the paint. The impact of THE NEW AMERICAN PAINTING on this group was being avoided rather self-consciously rather than exploited. If you live in the studio next to Brancusi, you try to think about Poussin. If you drink with Kline you tend to do your black-and-whites in pencil on paper. The artists I knew at that time knew perfectly well who was Great and they weren't going to begin to

imitate their works, only their spirit. When someone did a fake Clyfford Still or Rothko, it was talked about for weeks. They hadn't read Sartre's *Being and Nothingness* for nothing.

O'Hara educated himself during the day in the artists' studios. "He used to just love to be around the studio and he would come and help me stretch my canvases, which was like a great privilege to him," says Freilicher. His presence led to his appearance in more and more artists' works, beginning with Freilicher's portrait of O'Hara done from memory in 1951. He is standing in the doorway by the kitchen where the drinks were kept in her apartment on West Tenth Street, and according to John Ashbery, it is a portrait in which "Abstract Expressionism certainly inspired the wild brushwork rolling around like so many loose cannon, but which never loses sight of the fact that it is a portrait, and an eerily exact one at that." During his first year in New York O'Hara's enthusiastic loitering led to two nude sketches done in charcoal on paper as well as an abstract portrait in oil on canvas by Nell Blaine; Larry Rivers's *Portrait of Frank O'Hara* in oil on canvas; and Grace Hartigan's *Frank O'Hara and the Demons* in oil on canvas. "When he posed for you it was about the drawing," says Rivers of O'Hara's way of flatteringly deflecting attention onto his partner, even when in the spotlight of posing. "It was about you and your art. He was available. He was a professional fan."

O'Hara soon discovered that all of Downtown's roads led Uptown to the Museum of Modern Art, which was known among the young painters simply as "the Museum." Located at 11 West Fifty-third Street between Fifth and Sixth avenues, the Museum of Modern Art was housed in a stark, sleek International Style building designed by Philip Goodwin and Edward Durell Stone, which by its functional facade announced its commitment to modernism. The museum was the brainchild of a group of three wealthy ladies: Abby Aldrich Rockefeller, Miss Lillie P. Bliss, and Miss Mary Sullivan. It had opened five days after the stock market crash of 1929 to show cutting-edge European art of the sort first seen in New York in the controversial 1913 Armory Show. These women had wisely brought in as their director Alfred H. Barr, Jr., a young, bespectacled art history instructor at Wellesley who had been a prize pupil of Paul Sachs at Harvard's Fogg Art Museum. Barr was the son of a Presbyterian minister—thin-lipped, stiff, and rather intense—and he devoted himself with an almost ascetic intellectuality to modern music, poetry, painting, sculpture, dance, and industrial design. It was these eclectic tacks that helped him give the Museum its

ability to shock and outrage. That Barr had succeeded at his avant-garde mission is obvious from O'Hara's memoir of the Cedar days in which he deemed, "Meyer Shapiro a god and Alfred Barr right up there alongside him but more distant."

In 1951 the Museum was an unpredictable showplace. Barr had emerged in 1948 after a series of Machiavellian power struggles as Advisory Director rather than Director, and the Museum's exhibits three years later included such wide-ranging subjects as "Abstract Painting and Sculpture in America," "Korea—The Impact of War in Photographs," "New Lamps (Design Competition)," "Modigliani," "James Ensor," and "Eight Automobiles." The previous year a series of "Five Evenings with Modern Poets" had presented W. H. Auden, Marianne Moore, e. e. cummings, William Carlos Williams, and Robert Frost. Such constant updating on the state of the arts was underpinned by the Museum's permanent collection, described by Jane Freilicher as "a dictionary of art," in which the funding of Mrs. Simon Guggenheim alone had allowed the purchase of such modern masterpieces as Picasso's *Girl Before a Mirror*, Rousseau's *Sleeping Gypsy*, and Léger's *Three Women*. But the special events that made an enormous impression on the Downtown artworld were Barr's monumental retrospectives of Bonnard, Munch, Soutine, and, in 1951, Matisse. "It seems now that those surveys at the Modern always had immediate repercussions among painters, perhaps because they had seen less art than young painters today," says Ashbery. "Travel to Europe wasn't all that common yet, and the media hadn't filled in the gaps."

When Barr's Matisse retrospective opened on November 14, O'Hara was so intent on viewing and reviewing the paintings that he applied for a job selling postcards, publications, and tickets at the Museum's front desk. "Frank had idols (many) and if Matisse was one, so was Alfred Barr, and remained so during all Frank's years of association with the museum," Schuyler later wrote in *Art News* of O'Hara's attempt to situate himself in a context he considered heroic. O'Hara's job application, with recommendations from the poet Delmore Schwartz and the editor Jason Epstein, was accepted and on Monday, December 3, with the Christmas rush threatening, he began his clerkish duties at the Museum's long sales counter. O'Hara was quite content to bask in the light flooding through the building's large waxed front windows and then refracted along its hard-edge angled surfaces, the modernist texture of the lobby much like that pictured in Schlemmer's *Bauhaus Stairway* then hanging in a stairwell of the Museum. Stationed at one end of the counter, O'Hara continuously ran over to the other side to

chat with friends or painters who had stopped by to see the show, or simply to visit him, a ritual that continued in later years when his friends needed to take the extra step of riding an elevator up to his office. Freilicher recalls O'Hara's walking over to a typewriter at the counter to type up a poem. "He had this sort of instant creativity," she says. When Schuyler dropped by the first time he came across O'Hara selling admissions tickets to visitors while writing on a yellow lined pad a poem, since lost, titled "It's the blue!" Resting beside him was a translation of André Breton's *Young Cherry Trees Secured Against Hares*. That month, transfixed more than ever by the riddles of a vocation in art, O'Hara wrote "Poet," its theme the plight of the artist who, like Cocteau's Orpheus, "escapes always and's forever blinded."

Within three months of his arrival, O'Hara had figured out a clever way to combine his need for art, money, friendship, and poetry. He needed a job, and he found one that exposed him to painting and painters while still allowing him time to write poems. These days would seem particularly halcyon and innocent by the end of the decade when O'Hara found himself, for better and worse, immersed more professionally in the Museum's mission of promoting the New American Painting internationally, as well as in its Byzantine office politics.

On New Year's Eve John Ashbery gave a party at his new one-room apartment at 44 Morton Street. His frequent changes of residence were typical and even desirable among this young crowd living experimentally in a city of cheap rents. Present was an attractive twenty-seven-year-old blond from Los Angeles named Joe LeSueur who was credited at the time with "Tab Hunter looks." LeSueur was a graduate student in English at Columbia University who had a decided taste for poets and intellectuals. He was being introduced around by Paul Goodman, whom he had first met at Maxwell's, a gay bar in Los Angeles. Goodman said to his protégé, "There's a poet named Frank O'Hara I think you'll like," and led him across the room. O'Hara quickly took in the stranger, whom Larry Rivers has described at the time as "a blond beauty, sought after by everybody." As Tchaikovsky's Third Piano Concerto was playing full volume on Ashbery's portable phonograph, O'Hara and LeSueur set to dreaming up a frivolous accompanying ballet scenario.

The two, who went on to share a series of apartments as roommates from 1955 to 1965, had actually been introduced cursorily by Ashbery at a concert of contemporary American music earlier in the fall at Town

Hall, but the introduction had led nowhere. On this evening, though, O'Hara and LeSueur discovered much that was complementary. O'Hara, with his dazzling and confident intellect, satisfied LeSueur's need for a knowledgeable guiding hand: at the time, LeSueur felt himself to have been "an intellectual climber with vague, pretentious notions about becoming a writer." Although he was two years older than O'Hara, LeSueur immediately felt drawn to O'Hara's big-brother quality and friends usually assumed that LeSueur was the younger of the two. O'Hara in turn was struck by LeSueur's appearance. Blonds were mythologized in his private world: in a poem written three years later beginning, "All of a sudden all the world / is blonde," as well as in the rhetorical question opening "Meditations in an Emergency," "Am I to become profligate as if I were a blonde?" LeSueur was also able to talk knowledgeably about movies, literature, and gossip. "He was a different type," says Rivers. "He wasn't that aggressive. So he didn't have to express every minute every single idea he had on his brain. But he had a lot of ideas." Before parting that night O'Hara and LeSueur happily discovered that they lived only a block away from each other in the East Forties. At the time, LeSueur was living with his boyfriend Gianni Bates, a photographer who worked as an assistant to Francesco Scavullo.

The next day O'Hara and Ashbery attended a concert of John Cage's *Music for Changes* performed by David Tudor at the home of Judith Malina and Julian Beck's migratory Living Theatre, the Cherry Lane Theatre on Commerce Street. (In March, Ashbery and O'Hara appeared at the same theatre as the two curtains and two bow-wows in Picasso's *Desire Caught by the Tail*.) "When John Cage had his first concerts," O'Hara later told a television interviewer, "or not his first but, you know, there was a limited audience, and it was bored and so forth, a lot of it. But everybody went because they had to know about it, whether they were bored or they weren't bored, they felt it was important to know what John Cage thought, or did, or sounded like." The piece was a piano work lasting over an hour and consisting almost entirely of tone clusters struck randomly up and down the keyboard according to a coin-tossing method adapted from the *I Ching*. As Ashbery later told John Gruen, "It had very little rhythm and it just went on and on until you sort of went not *out* of your mind but *into* your mind. I really felt that it was a kind of renewal. And the fact that it happened on New Year's Day seemed to have a certain significance. So the cloud that had been hanging over me gradually lifted." (Ashbery and O'Hara's rhapsodizing that day was no different from their rhap-

sodizing earlier in the fall when they saw *A Place in the Sun* with Eliz-
abeth Taylor and Montgomery Clift in Times Square and, according to
Ashbery, "had to be almost carried out of the theatre.") Although Ash-
bery dates the end of his writer's block to the New Year's Day concert,
its aftereffects apparently carried over into February, when O'Hara
wrote "Ashes on Saturday Afternoon," prodding Ashbery to verse by
reminding him of his poem "The Picture of Little J.A. in a Prospect
of Flowers" published the previous summer in *Partisan Review*:

> You, dear poet
> who addressed yourself to flowers, Electra,
> and photographs on less painful occasions,
> must save me from the void's external noise.

In the middle of February O'Hara was wrenched back home and
away from his successful exploration of New York life. The occasion
was the death from breast cancer of his father's sister, his Aunt Grace
O'Hara, on February 12; her funeral was held on Thursday, February
14 at 8:15 a.m. at his Uncle Leonard's home. In spite of O'Hara's ar-
guments with his Aunt Grace at the time of his father's death—her
spinsterish schoolmarm censoriousness creating rather than solving
problems for his mother—O'Hara was genuinely indebted to her for
having driven him to parochial school in Worcester every morning, as
well as for giving him money to help pay his expenses at Harvard and
Michigan. He was also to be a beneficiary in her will. The visit, how-
ever, was fraught with memories of his father's funeral at the same time
of year, and further deepened his sense of outrage at his mother's dete-
riorating condition and his frustration at being unable to get through to
her. This painful trip to Grafton, where he had been dutifully returning
every year for Easter, Thanksgiving, and Christmas holidays, was his
last.

Over the past five years O'Hara had put a tremendous amount of
energy into trying to help his mother when he did go home. Although
alcoholism was barely recognized as a disease, he used to accompany
her to meetings of a local chapter of Alcoholics Anonymous in Worces-
ter. Usually she resisted, however, claiming a distinction between herself
and "those drunks." Similarly, he eschewed any such help when his
own drinking became more and more out of control in later years, but
now O'Hara spent a lot of time trying to find a psychiatrist who spe-
cialized in treating alcoholism. "Frank said he owed a psychiatrist a

great deal," says Grace Hartigan, "because he had gone to one a few times about his mother and the psychiatrist had said, 'Save yourself. You can't do anything about your mother.'" It was at this time that O'Hara counseled his sister, Maureen, "I'm leaving and I'm not coming back, and I think you should do the same"—advice she was grateful for and acted on.

When O'Hara returned to New York, his friendship with the painter Grace Hartigan began to intensify. O'Hara was, in fact, very upset by the break with his mother, and Hartigan, who had never felt his mother was exactly a good influence, tried to comfort him during this crucial time. "I never met Frank's mother," says Hartigan. "I didn't want to because I was so loyal to Frank and I thought she caused him so much pain." Hartigan was going through a transition of her own— one of many. She had a son from a first marriage in Elizabeth, New Jersey. She then briefly married ex-Marine and painter Harry Jackson, though their marriage was annulled soon after a honeymoon in Mexico. As Jackson was a friend of the Pollocks, who had hosted the party for their marriage in the Hamptons, Hartigan managed to see Jackson Pollock's drip canvases early on and to learn from him about the Downtown painters. "They're all shit but de Kooning and me," Pollock advised her.

Hartigan was attractive, with clean-cut American looks, which Cecil Beaton captured in a portrait taken in 1952. "Hefty, big-boned, nicely proportioned, with expressive eyes and skin all aglow, she seemed to me to be in the Ann Sheridan mold," recalls Joe LeSueur. She was then living in a top-floor loft over a pickle store on Essex and Hester streets. She shared the studio—which was full of the smell of vinegar, dill, and spices, as well as the noise of trucks, pushcarts, and merchants crying from the streets below—with Al Leslie, a young bodybuilder painter six years her junior always referred to by John Myers as "Mr. Bronx." Leslie had started out on the scene as an artists' model, something Hartigan had done as well, modeling nude for classes of the Hans Hofmann school on West Eighth Street. Although the couple seemingly thrived on their love of painting and struggling—sometimes dining on Wheatina three times a day—Leslie and Hartigan split up about the time of their 1952 shows at the Tibor de Nagy Gallery, his in February, hers in March. "Grace always seemed to be having an unhappy love affair about which she could be very funny," recalls William Weaver.

Hartigan first met O'Hara at one of John Myers's regular Thursday night gatherings. She didn't appear in his poetry, however, until the time

of her March show, for which she assumed the name of George Harti-
gan, a pseudonym chosen by Myers supposedly to help her overcome
the stigma against women painters. Hartigan's version of her *nom de
brosse* is slightly different: "When I first met John Myers I was taken
with the idea that homosexuals had camp names. I wanted another
name too. So we decided on George since other famous women had
chosen it and it began with G like Grace." O'Hara satirized this ruse
in his play of late February, *Grace and George, an eclogue*—one of his
unplayable plays with abstract dialogue and impossible stage directions
such as "a breath of snow crumbles across southern Italy towards the
pair who, hand in hand, think only of sunsets." Hartigan's show was
praised by an *Art News* critic for going "directly and boldly to painting
problems," her *Portrait of W* (an Expressionist portrait of a photographer
boyfriend, Walt Silver) showing her resolve to break out from the all-
over abstractions that had won her the approval of the first-generation
painters. This show was picked up on by the Museum of Modern Art
curator Dorothy Miller, who began to select work for Museum shows.
O'Hara's admiring review was "Poem for a Painter":

> *Grace,*
> *you are the flowergirl on the candled plain*
> *with fingers smelled of turpentine.*

If Hartigan dressed like George while painting—in overalls, Army
tans, and men's shirts—at night she dressed like Grace, in skirts and
sweaters that showed off her big-boned and robust figure. O'Hara re-
sponded to both sides. He and Hartigan became pals—often talking on
the phone about parties, art, boyfriends. They shared an enthusiasm for
movies, as well as for fanzines. (Seated in a big Fourteenth Street movie
theatre in 1952 to see Marilyn Monroe's *Niagara,* with Elaine and Wil-
lem de Kooning a few rows up, they overheard, to their unbridled
amusement, a woman behind whisper to her friend, "I told you this
was an arty movie. See. The de Koonings are here.") O'Hara and Har-
tigan also shared an amorousness of the sort that O'Hara tended toward
with the special women in his life. "We fell in love," claims Hartigan.
"If a homosexual and a heterosexual could be in love, it was a falling in
love. . . . I think Frank as a homosexual was really unusual in his amount
of love for a few women. I have many homosexual friends and that's
something I've never encountered." As an expression of that love,
O'Hara, as he did with many painters, male and female, helped artic-

ulate Hartigan to herself. "Grace brought a kind of gutsiness and tough-
ness, and Frank was like her wings of language," says Kenneth Koch.
"He did that for a lot of people, painters especially. They'd have all these
wonderful ideas and feelings about themselves, and they'd say, 'Duh,'
and Frank would say, 'Yes, you put that green there. That's the first
interesting thing that's been done since Matisse's **"Number 267."** '"
O'Hara made his and Hartigan's mutual absorption practical by posing,
his likeness appearing in her *Frank O'Hara and the Demons,* which, in
turn, was evoked in "In Memory of My Feelings": "I am naked with
a plate of devils at my hip." *Ocean Bathers* (after Matisse's *Bathers by a
River,* seen in Barr's retrospective) is mentioned in the same poem:
"One of me is standing in the waves, an ocean bather." In *The Masker,*
O'Hara posed barefoot in Hartigan's Persian jacket looking, according
to her, "like Hamlet." In *Masquerade,* a harlequinade, he posed in tights
along with Ashbery, Freilicher, and Daisy Aldan.

Following Hartigan's exhibition, O'Hara managed to make his own
appearance at Tibor de Nagy. At the end of March John Myers pub-
lished a limited edition of a thirteen-page chapbook of O'Hara's titled
A City Winter and Other Poems, which the poet dedicated "To George
Montgomery," although the two had not recently been in touch. Myers
printed 280 folded paper copies of the glorified pamphlet at one dollar
each and twenty hardbound copies at twenty dollars, both versions in-
cluding two drawings by Larry Rivers and thirteen poems. "It is to be
remembered that in 1952, poetry like Frank's was considered bizarre,
a bit cuckoo," Myers admitted later. "It was hard for me to decide
which ones were better than others; I knew that I liked the work and
thought it extremely original and fresh. My friends at *Partisan Review,
Poetry, The New Republic* and other high brow publications thought I was
getting soft in the head to admire such stuff. . . . The best supporters
of Frank's poetry were always artists who liked to purchase a poetry
pamphlet while visiting my gallery." O'Hara's was the first in a Tibor
de Nagy series of books by poets with artists' drawings, which in-
cluded, the following year, *Poems* by Kenneth Koch with Nell Blaine
prints, and *Turandot and Other Poems* by John Ashbery with four Jane
Freilicher drawings.

Although Myers did neglect some of the striking poems of O'Hara's
past, including "Autobiographia Literaria," "Memorial Day 1950," and
"Les Etiquettes Jaunes," his choices in *A City Winter* were actually an
accurate reflection of the mixed poetics O'Hara was practicing during
his first season in New York. The second part of the chapbook's five-
sonnet title sequence—a parody of Wyatt's "The Lover Compareth His

State to a Ship in Perilous Storm at Sea" that begins "My ship is flung upon the gutter's wrist"—is a perfect example of his experiments at the time in using traditional forms—couplets, quatrains, sonnets, rhymes—to carry quite untraditional Surrealist dream imagery and disjunctive language such as "garter tongue" and "waveless bosom's mist." *A City Winter*—the first book of a poet experiencing life in New York City—is a collection of poems experimentally trying to match the rhymed schemes of Wyatt and Skelton with the language of Joyce, Mallarmé, and Breton. While O'Hara's recent immersion in action painting and aleatory music explained his freer uses of words, he had yet to tamper with the underpinnings of verse itself. His attitude toward its traditional forms was still playful and parodistic rather than confrontational and rebellious.

Spring of 1952 was a heady time for O'Hara. His first book was published. "On Looking at *La Grande Jatte,* the Czar Wept Anew" appeared in *Partisan Review,* an event Kenneth Koch said was "like seeing somebody in his first tuxedo." And, perhaps most exhilarating for O'Hara, he was invited to appear on a series of panels at the Club, the artists' forum at 39 East Eighth Street where the Downtown painters met to haggle about serious topics before heading on to the Cedar to drink vociferously—both hangouts an antidote to the loneliness of the days in their studios.

Always a bit desperate for the café life of Paris, for their own version of Picasso's Au Lapin Agile, the painters had gathered during most of the 1940s at the Waldorf Cafeteria at Sixth Avenue and Eighth Street where they drank coffee and talked leftist politics and modern art. The cafeteria, though, became dangerous because of longshoremen who started rowdy fights; the owners also began to discourage the painters from lingering for hours over one cup of lukewarm coffee. (When Gorky was not allowed in with his dogs his painter friends had to go outside to speak with him.) In the fall of 1949 de Kooning, inspired by the social clubs of the Greeks and Italians along Eighth Street, said, "Let's have discussion among the old-timers," a wish that eventually led to the founding of the Club. While the Club changed locations often—only its large coffeepot remained a constant—its steadiest address was the Eighth Street location first used by Robert Motherwell for his short-lived "School of the Artists," then replaced by Studio 35, a prototype of the Club, where Joseph Cornell showed his early films. Founding charter members of the Club, some jealous of their power to approve

and disapprove later members, included Willem de Kooning, Philip Pavia, Franz Kline, Landes Lewitin, Ad Reinhardt, Charles Egan, Giorgio Cavallon, Milton Resnick, and Jack Tworkov. By 1951 the list included Robert Rauschenberg and Helen Frankenthaler (then Clement Greenberg's girlfriend) and, in 1952, Alfred Leslie, Larry Rivers, Joan Mitchell, Grace Hartigan, Nell Blaine, Michael Goldberg, Leo Castelli, Herman Cherry, Philip Guston, Elaine de Kooning, and Harold Rosenberg. Friday night panels included Sir Harold Acton holding forth on Vasari, Max Ernst introduced by Robert Motherwell, Buckminster Fuller explaining his geodesic domes using egg containers and Ping-Pong balls, Suzuki on Zen, and Pierre Boulez performing the piano music of John Cage. Liquor was introduced on the scene by one of the Club's rituals—passing a hat to buy it. It was then drunk greedily out of tiny paper cups by the artists scamming for second portions. When money began to filter in through early painting sales, a bottle of whiskey started to appear on the front table to loosen the tongues of some of the artists on that night's symposium, only fanning the intensity of the debates. On most weekends the folding wooden chairs were temporarily cleared out to fashion a serviceable dance floor on which the artists attempted anything from the two-step to the tarantella, Pavia bringing in his own records of Italian folk music and jazz to help calm down the group fired up with drink and sexual excitement.

When O'Hara made his way to the Club that winter, the ongoing debate had been sparked by the appearance of Tom Hess's *Abstract Painting: Background and American Phase,* which O'Hara described as "the important book." The discussion concerned the nature of the new American painting and, though Hess had not used the term, increasingly the label "Abstract Expressionism," which seemed to be gaining credence among critics much to the frustration of many of the purist first-generation painters. At the opening discussion of Hess's *Abstract Painting* on January 18, Pollock sat angrily clutching the book, frontispiece and endpapers all featuring Gorkey's *The Betrothal II,* its illustration plates placing his own work last, out of alphabetical order, until he finally flung the offending volume at de Kooning and shouted, "It's a rotten book. He treats you better than me." Pollock's instincts were not mistaken. Hess, an independently wealthy and urbane Yale graduate who had recently taken over the editing of *Art News* and was trying to turn the magazine into as prescient a recorder of contemporary art as *Cahiers d'Art* in twenties and thirties Paris, clearly favored de Kooning over Pollock. (The other "starmaker," Clement Greenberg at *Partisan Review,* was championing Pollock.) The debate that spun from this en-

counter was an angry and continuing shouting match about the impossibility of the term Abstract Expressionism, Abstract having been associated with the geometry of Mondrian and Expressionism with the more dramatic figurative paintings of Munch, Bonnard, and Soutine. "When anybody was called an Abstract Expressionist you thought they were joking," recalled Club organizer Philip Pavia. "It's like saying you're black and blue. For about six months the artworld was in an upheaval over those words." This was the maelstrom into which O'Hara stepped when he appeared on Friday, March 7, on a fourth and final panel on "Abstract Expressionism" titled "A Group of Younger Artists" with Jane Freilicher, Grace Hartigan, Larry Rivers, Al Leslie, and Joan Mitchell, moderated by John Myers. Although O'Hara had plenty to say on any subject, his delight that evening had to do simply with having been taken up as an equal by the painters, confirmed as he was in the self-deprecating belief of "John Button Birthday": "You know how / I feel about painters. I sometimes think poetry / only describes." His presence as a poet was less threatening than that of the art writers whom Pavia tried to blackball. De Kooning was particularly enthusiastic about talks linking poetry and painting—the most recent had been on the relationship of Cézanne to Baudelaire and Mallarmé.

O'Hara's chance to show off his quick wit and intellect and to air his views on contemporary poetry came the following month on Friday, April 11, when he appeared on a panel on "The Image in Poetry and Painting" with Edwin Denby, David Gascoyne, and Ruthven Todd, moderated by Nicholas Calas. O'Hara was invited onto the panel by Elaine de Kooning, his only peer in combining interests in writing and painting, talking and drinking, and in sharply appraising people. (Described at the time as a female O'Hara for her plunges—often rescue missions—into other people's lives, de Kooning was characterized by O'Hara in his memoir of the early fifties as "the White Goddess: she knew everything, told little of it though she talked a lot.") O'Hara used this opportunity to trace the tradition of contemporary poetry, from Pound, whom he called "the father of modern poets," through Auden, Stevens, Crane, and early Dylan Thomas, though he blamed the later Thomas for peddling "an image of the poet as a storm-battered heather-kicking bard from the wilds." The villain in his talk was T. S. Eliot for his "deadening and obscuring and precious effect." Reading selections from these poets, O'Hara apologized for his "flat voice," which did tend to disappoint listeners when poetry readings began to occur more frequently during the sixties. "I don't read poetry well, this is just an expedience," he said. That evening O'Hara arrived at a vision of

poetry that sounded remarkably like the abstract painting Hess had been praising and tracing: "Poetry which liberates certain forces in language, permits them to emerge upon the void of silence, not poetry which seeks merely to express most effectively or most beautifully or most musically some preconceived idea or perception."

O'Hara returned the following month on Wednesday, May 14, to a panel of "New Poets" moderated by Larry Rivers with James Schuyler, John Ashbery, and Barbara Guest (the only woman member of the so-called New York School). "It was a poetry reading in which Frank did most of the reading," recalls Schuyler. Reading his own poems as well as poems by the others on the panel to illustrate his declarations, O'Hara used this occasion to slyly distance his group from their immediate predecessors. In a humorously catty tone not unknown to him, O'Hara classified Delmore Schwartz as playing the "clown. . . . the brave young poet who is willing to take up any challenge, but one defeats him if encountered," Karl Shapiro as a "machine poet" who "like a nickelodeon writes on every subject," and Richard Wilbur and James Merrill as part of "the school of elegance" whose aesthetic "is based on the memory of adolescent reading of Tennyson's *Idylls*." In closing, O'Hara took a more dignified approach to the various personae of contemporary poets to talk about the attempts of his own group to use translation to explore "the varieties of technique" rather than slumping confessionally into "the mythology of the Ur-self" and of their striving, like the painters, for "the ideal of High Art," for poems that would be "honest, tough, hard, beautiful."

In 1952 O'Hara left his job at the Museum every evening in the spring to consider several options for the night's entertainment. His life was still uncomplicated enough that he could simply return home to sit around with friends, including his current roommate, James Schuyler. ("I couldn't stand it after Frank had been there a bit," says Fondren of his decision to flee the apartment a few months earlier. "I could see that for my peace of mind, probably, as well as his, it would be better if I lived somewhere else. I really couldn't stand the disorder.") Or O'Hara could just get on the E train and see what happened.

Walking about the city was particularly stimulating to the peripatetic O'Hara, and those who accompanied him were often treated to a checkered blend of observation and intimacy that obviously suited him. "If you were out with him you were with him," says Rivers. "It was the most extraordinary thing, a simple walk. It's like everybody who wants to define the word 'love.' I think a corny description of 'love' would say, 'If you're in love you can go into a soda fountain and enjoy

yourself with a person.' Well Frank was just a joy to be with. He was smart on any subject. Anything you said he had like five responses and you were throwing the ideas against a fantastic wall and it would come back more brilliant than you had ever intended it." This was the sort of experience recorded from O'Hara's side in his March poem "Walking with Larry Rivers," with its rumble of Rivers's New York Jewish accent, so appealing to O'Hara's poetic ear: "oi! prayer, prayer, be mine your lazy latenesses." (The critic Peter Schjeldahl later wrote of Rivers's style of speaking that its "giddy mixture of tones, from guttural-laconic to high-parodic," was "his great natural gift to the poetry of Frank O'Hara.")

"For Frank, New York was the New Jerusalem," says Weaver of similar walks. "I remember just going down the street with him when they were tearing down some brownstones. I said, in the usual clichéd way, 'Oh what a pity they're tearing down those brownstones.' Frank said, 'Oh no, that's the way New York is. You have to just keep tearing it down and building it up. Whatever they're building they'll tear that down in a few years." O'Hara used the cityscape constantly in his wishful need to transmute life into game or art. "Once we were walking down Fifty-seventh Street," recalls Weaver. "There were all these very grand antique shops, but small, each one with a window that would be arranged as a little Louis Quinze salon or a Victorian fumoir. One night Frank and I stopped and looked and a game began spontaneously where this was our living room and we were inviting all our idols in. He would say, 'Tab, how nice to see you,' and I would say, 'Sugar Ray, I'm so glad you could come.' We played the game the length of Fifty-seventh Street. This sort of thing happened every time you were with him."

O'Hara spent many evenings as well at City Center on West Fifty-fifth Street, the converted mosquelike Shriners Temple, with its inlaid scimitars and crescents, which was serving at the time as the home of the New York City Ballet and the New York City Opera. The City Ballet in the early fifties was a popular underdog compared to Ballet Theater which was in its twelfth year presenting dramatic ballets. But among the artists and intellectuals in O'Hara's circle the only serious ballet was the City Ballet, and their attendance made up a true cult following. Under the direction of George Balanchine—the Russian choreographer who had been influenced by the experimentalists Lopukhov and Goleizovsky before leaving Petrograd in 1924, and who had then practiced his musically rather than theatrically biased choreography for Diaghilev's Ballets Russes in Paris in the late twenties—the company seemed a direct link to the finest in the avant-garde tradition. "The City

Ballet had a kind of poetic mystique," recalls the painter Howard Ka-
novitz. "It seemed as though here was this living legend. Balanchine
had contacts with Stravinsky and Stravinsky with Picasso. It was almost
like a metaphoric laying on of hands." The program during the com-
pany's busy 1951–52 season included premieres of such Balanchine
works as *Till Eulenspiegel,* music by Richard Strauss, its title role danced
by Jerome Robbins; Tchaikovsky's *Swan Lake* with sets by Cecil Bea-
ton, danced by Maria Tallchief (in "John Button Birthday" O'Hara re-
calls "watching Maria Tallchief in the Public / Gardens while the swan-
boats slumbered"); *Caracole* to Mozart's Divertimento no. 15 in B Flat
Major with principal dancers Diana Adams, Melissa Hayden, Tanaquil
LeClercq (later the subject of O'Hara's "Ode to Tanaquil LeClercq"),
Maria Tallchief, Patricia Wilde, André Eglevsky, Nicholas Magallanes,
and Jerome Robbins; *Bayou,* choreographed to the music of Virgil
Thomson's *Acadian Songs and Dances.*

The pitch of enthusiasm among O'Hara's friends for the City Ballet
was first sounded by Jane Freilicher in a letter she wrote to Ann Arbor
after she had attended with John Ashbery *La Valse*—Balanchine's ballet
set to Ravel's score, which premiered in February 1951. "It is the great-
est ballet either of us has ever seen or anyone else I'm sure, if not the
greatest work of art in history," Freilicher insisted. Of course O'Hara
had no trouble in matching, even somehow surpassing, their Balanchi-
nomania. He began at once to see almost all the performances, the price
for balcony seats at the time being a merciful $1.75, and sneaking in
with a friend's ticket stub during intermission was made even easier as
performances were usually only half sold out. Sight lines were excellent
from all vantage points. The prices, and absence of a yearly subscription
policy, made it possible for O'Hara to treat City Center as casually as
if it were a movie theatre. As an audience member he was every per-
former's dream: rapt and expressive. "At the ballet he would just get
up and cheer," recalls Morris Golde, who had recently met O'Hara at
the San Remo. "It just knocked him out." O'Hara was also easily given
to tears, a reaction he alluded to in "Notes from Row L," written on
request for a 1961 New York City Ballet program after a decade of his
serving as one of the company's more dedicated and visible fans: "It all
depends on whether you want your heart to beat, your blood to pound
through your veins and your mind to go blank with joy, until you are
brought back to self-consciousness by an embarrassing tear your neigh-
bor might see (we are still Americans, aren't we?)" In the same essay
O'Hara describes Balanchine's genius in the establishment of dance as
the true subject of dance, much as he would claim in his notes to his

own poem "Second Avenue," "I hope the poem to *be* the subject, not just about it": "One of Balanchine's greatest achievements is in making the dancers be the dance, be human and yet have the theatrical grandeur of the specific occasion of the dance." Actually O'Hara found Balanchine's choreography as aesthetically satisfying as he did Balanchine's corps of dancers, many of whom appear for short spins in his poems. As he went on in the program notes, "Ballet lovers have the knack of turning away at the right time during a wrong move; they are always enchanted."

O'Hara's constant companion at "the Ballet" was Edwin Denby whom he had first met at the Cedar. Denby was about twenty-five years older than O'Hara, tall and bony with pale blue eyes and a startling shock of white hair. He had been educated at Harvard and the University of Vienna and was a poet who had served as the dance critic for the *New York Herald Tribune* between 1942 and 1945 and continued to write for various dance magazines. Soft-spoken, reserved, and gentlemanly, Denby—another of O'Hara's totemic figures and somewhat of a guru on the art scene—always deferred to his junior friend as the greater poet. "Frank O'Hara was a catalyst for me, although I was much older," Denby later told John Gruen. "But then, he was everybody's catalyst. My entrée was that I was an old friend of Bill de Kooning's, who was a great hero of Frank's. I liked to go to the ballet with Frank and John and Jimmy. We were all mad about George Balanchine. We all thought he was a genius. He was like de Kooning—going through difficult periods, defending what he wanted to do, seeing what else was possible." Denby and O'Hara spent many hours at Carnegie Tavern, the bar across the street from City Center, discussing the ballets they had just seen. Denby made the sorts of idiosyncratic observations O'Hara mentally collected, such as the one that slipped into "A Step Away from Them":

> Neon in daylight is a
> great pleasure, As Edwin Denby would
> write, as are light bulbs in daylight.

For O'Hara, sitting next to Denby at the ballet felt like sitting next to a lightning rod.

Other evenings O'Hara went to the City Opera, or the movies, or both. "One night we took Larry Rivers to *Madame Butterfly*," recalls Weaver:

It was the first time he had ever been to an opera. He didn't run all the way to get there but he sort of enjoyed it, was sort of bemused actually. Afterwards we said goodnight to Larry at the subway at Lexington Avenue and Fifty-first Street. Across the street was a big Loew's Cinema with a double feature of *Island of Desire* with Tab Hunter and Linda Darnell and another movie with Gene Tierney and Clark Gable in which she played a Soviet ballet dancer. We saw the sign and without a word to each other went straight to the box office, bought our tickets, and went in. We didn't even have to communicate. When we came out, kind of silent, it was almost four o'clock in the morning. Frank said, "Two more lousy movies under our belt." Tab Hunter, though, was actually a great favorite of ours and we then talked very enthusiastically about the movie until we separated at the corner of Second Avenue and Fifty-first Street.

The summer of 1952 was the first of O'Hara's yearly summers in the Hamptons. In the summer he tended to write more poems, to struggle through the beginnings or endings of more love affairs, to generally be more active. O'Hara came to see the sun as a personal poetic symbol, most obviously in "A True Account of Talking to the Sun on Fire Island," in which the Sun, a descendant of Mayakovsky's talking Sun, encourages him,

> *Frankly, I wanted to tell you*
> *I like your poetry. I see a lot*
> *on my rounds and you're okay.*

The landscape of beach, sun, sky, and water was his favorite. He had spent his childhood summers on Cape Cod, later, on Navy destroyers, identified with the leaping porpoises he watched from the deck and was, for his entire life, a tireless swimmer who seemed unnaturally invigorated by proximity to the sea. Not only had he, on more than one occasion, baked on the beach until his body blistered, but he had also been known to dive nude into the ocean at night during an electrical storm.

The Hamptons was where the luckier of the Cedar crowd spent their summers, or at least as many weekends as possible. A thirty-mile strip of hills, dunes, woods, potato fields, and beaches on the South Fork of eastern Long Island's split fin, the Hamptons coastland had light, landscapes, and sky that appealed to the painters, especially to the painters of the fifties who were still enamored with the romantic notion

of leaving the city to escape to the country. By the time O'Hara made
his appearance, the barns, bungalows, and saltbox houses of the coun-
tryside were already being colonized by a small force of painters and
wealthy Manhattanites. Indeed the process of transforming the Hamp-
tons—its year-round local residents still making their living mostly by
farming and fishing—into an artists' colony and eventually a fashionably
chic resort had been under way for almost a hundred years. Most amen-
able to this trend was the village of East Hampton. Its Guild Hall had
been built in 1931 to exhibit oil paintings by local artists, and its in-
volvement in the more recreational side of art history dated back to the
nineteenth-century American painters Augustus Saint-Gaudens and Wins-
low Homer and continued with the 1940s French Surrealists Max Ernst,
Fernand Léger, and André Breton, who had strolled its blue-and-white-
striped awninged streets and breathed its salty air reminiscent of Deau-
ville. Most of these artists had arrived, as had most visitors since the
1870s, by means of the somewhat unpredictable Long Island Rail Road.
O'Hara immortalized his trips into the old Penn Station's vast iron and
glass train shed to catch the 4:19 to East Hampton in "The Day Lady
Died," and "Joe's Jacket" begins "Entraining to Southampton in the
parlor car with Jap and Vincent."

During the summer of 1952 Jackson Pollock was living with his
wife, Lee Krasner, in his small clapboard house in the Springs as he had
been year-round since 1945. ("Below the bridge" from East Hampton,
the Springs was muggier and hotter. Patsy Southgate had described a
Springs house where O'Hara visited her in the early sixties as "a hot
house, with cedar trees pressing against the windows like big women
in fur coats, blocking out the air.") Elaine and Willem de Kooning were
spending the summer as guests in art dealer Leo Castelli's sprawling
house in East Hampton, where de Kooning worked on his *Woman* series
in an enclosed porch. Robert Motherwell lived for a while in a Quonset
hut, an architectural oddity designed by the famous French architect of
the Maison de Verre in Paris, Pierre Charreau. Motherwell revealed his
patrician roots that summer by joining the stuffy Maidstone Club, the
exclusive East Hampton country club with tennis, swimming, and golf
founded a hundred years earlier by the painter Thomas Moran. Larry
Rivers had yet to move to the house on Toylsome Lane in Southampton
that he rented the following year. Rivers's presence was felt, however,
in his cement and plaster sculpture of a nude woman, which was
mounted near Castelli's driveway, where Pollock tried to run it down
one night because he found it too realistic.

O'Hara was staying at a house rented by John LaTouche (nick-

named Touche) on Georgica Pond in East Hampton. The occasion was the making of a sixteen-millimeter black-and-white silent film, "Presenting Jane," produced by LaTouche's Aries Productions, based on a screenplay by Schuyler, and starring Jane Freilicher, John Ashbery, Frank O'Hara, and John Bernard Myers. The entire cast, along with Kenward Elmslie, LaTouche's friend at the time, lived in the big "swell-elegant, very Middle America" residence with a large living room on its first floor and eight bedrooms on the second, which was located in a wooded area next to the pond. Most of the hand-held filming by Harrison Starr took place in and around the water so that Freilicher, to whose ineffable qualities this film was purported to be an homage, spent much time mucking around in wet sand. Its most memorable scene showed Freilicher walking on water by means of the special effect of a dock located, invisibly, slightly below the surface. This tongue-in-cheek Helen of Troy treatment inspired O'Hara to write even more of his Jane poems, the poems that had started the mock-troubadour cult in the first place. He wrote "Jane at Twelve," "Jane Bathing," and "Chez Jane" that summer, assuring her, "I don't want to give the impression that you are a fille de joie in our gloomy society and thus a misfit." As theatrical as the filming itself was the day-to-day life unfolding in LaTouche's house, where John Myers did all the cooking in his role as film commissary. Elmslie, still in a rather innocent phase of his life, was startled one morning to find the door to an upstairs bedroom wide open and Freilicher in bed sandwiched between O'Hara and Ashbery and on yet another morning to find her in the same bed with Larry Rivers. He was puzzled as to what was going on. "I was goggle-eyed," says Elmslie, who did not realize the innocence of her frolicking with O'Hara and Ashbery.

This was the summer in which the poet Kenneth Koch began to figure more fully in O'Hara's life. Until then they had been playing an at least partly unintentional game of cat-and-mouse. Koch was at Harvard serving on the *Advocate* and studying poetry with Delmore Schwartz during O'Hara's first two years but graduated in 1948 without meeting him. In the summer of 1950 Koch was in his hometown of Cincinnati about to leave for Aix-en-Provence on a Fulbright grant when he read some poems of O'Hara's, including "Memorial Day 1950," which had been mailed to him by Ashbery. Unimpressed with the new contender, he wrote back that he didn't believe O'Hara was as good as they were. Koch packed the letter in one of his suitcases, however, and a year later he read the poems again and felt differently. "I read them on my way to Vienna and all of a sudden my poems got full of pennies, raisins,

raspberries, banana splits, exclamations," says Koch. "It was great. It was like love. I really loved Frank's poetry." O'Hara, then at school in Ann Arbor, heard of this geopolitical shift in their tiny world. "Alack aday, who has changed Kenneth Koch's mind about my poetry," he wrote to Freilicher upon hearing the news. "Is it you, Tabby? I pinch *your* paws. Anyhow, I was thinking perhaps I shouldn't like him if he didn't because Paul G said there was no line between the artist and his work, do you think this is true? what is art? what is life? who is Koch? I hear he writes his lyrics on human skin, is this correct?" O'Hara later inscribed a book of his poems: "To Kenneth, in honor of the conversion in Vienna." Koch recorded one of their first post-"conversion" brushes, in New York in June 1951, in "Fate": "Frank so sure of his / Talent but didn't say it that way, I / Didn't know it till after he was / Dead just how sure he had been." Koch was then off again to California where he worked as a teaching assistant for a year and met his future wife, Janice Elwood.

If the poets of the New York School could be grouped together because they wrote in language that was illogical and often meaningless, O'Hara's particular tone was Surrealist, Ashbery's was philosophical, and Koch's was comic. Koch's nickname was Dr. Fun. When Ashbery first came down from Harvard in 1949 to stay at Koch's loft in the undistinguished three-story building on Third Avenue and Sixteenth Street, Koch once donned a rubber ape's mask to entertain the passengers on the El train rushing by. (This was also the summer of the ape movie *Mighty Joe Young*.) Koch lived up to his nickname by indefatigably assuming accents, such as a hillbilly accent, or speaking in flawless and uninterruptible blank verse. As O'Hara once commented, "I don't know why Kenneth is so fond of John's poetry, because he thinks everything should be funny and John's poetry is about as funny as a wrecked train." Yet in spite of his somewhat feckless veneer, Koch was actually deliberately pursuing an academic career, juggling teaching jobs at Columbia, Rutgers, and Brooklyn College. This often drew him away, keeping him a bit off to the side, a trait picked up on by O'Hara in his gossipy prose poem written in East Hampton that summer, "Day and Night in 1952": "Kenneth continually goes away and by this device is able to remain intensely friendly if not actually intimate." Koch's heterosexuality also led to some reverse kidding. "When Frank first brought Kenneth around I started carrying on in a sort of campy way, in an including-him-in way," remembers LeSueur. "Kenneth took Frank aside and said, 'Would you tell him I'm not queer?' I said to Frank, 'I don't believe it. He's a big swish. What are you talking about?'" Be-

cause of Koch's skittishness, O'Hara began to tease him for what he called his "H.D."—"homosexual dread."

The benefits of his friendship with O'Hara were worth the price to Koch of some occasionally heavy teasing. That summer O'Hara encouraged him in the joys of collaboration, particularly suited to O'Hara's preferred style of creating with people around rather than in solitude—a condition he strenuously avoided. Together they composed a sestina for the sixteenth birthday of Leo Castelli's daughter, Nina. "Something about Frank that impressed me during the composition of the sestina," Koch later wrote, "was his feeling that the silliest idea actually in his head was better than the most profound idea actually in somebody else's head—which seems obvious once you know it, but how many poets have lived how many total years without ever finding it out?"

The most famous of O'Hara's creations during the summer of 1952 was "Hatred," a poem of twenty-seven five-line stanzas he had typed out on a long roll of office-machine paper such as court stenographers used. The poem revealed O'Hara's growing desire for an epic length, for a poem that would go on and on as Cage's aleatory piano music had gone on and on. Its scale was an important step in the blossoming of his style. The poem's Surrealist images ("held like a cleft palate in a bus of silver") are kept moving by a grinding revelation of underlying pain, the pain of being compulsively pursued as in a nightmare. No matter how playful and witty O'Hara could be at the cocktail hour, his poems were often glimpses into other, unrevealed moods and thoughts, the glimpses given and taken as quickly as an opening and shutting door, their brevity part of their pathos. As in "In Memory of My Feelings" written four summers later, in which the autobiographical theme is that of "The dead hunting / and the alive, ahunted," so "Hatred" is filled with the same feeling of being hunted and haunted: "I hounded and hounded into being born / my own death," or "I have been hunted in the purple arms of a lover." Whether the sources are family ghosts, alcohol, frustrated sexuality, or death, there is evidence of a high anxiety, which he felt throughout his adult years, his burgeoning social life a double symptom of love and anxiousness.

In "Easter," which, according to Koch, "burst on us all like a bomb" that summer, O'Hara finally managed an "action poem" in which his form was as free as the canvases of the "action painters," a term coined by Harold Rosenberg in Art News in 1952 to describe the effort of the Abstract Expressionists to turn the action of painting into its own end. His language was unabashedly surreal and Joycean, espe-

cially in its reveling like Joyce in body parts and bodily functions: "when the world booms its seven cunts" or "to be pelted by the shit of the stars at last in flood / like a breath." As the critic Marjorie Perloff has pointed out in *Frank O'Hara: Poet Among Painters,* the poem recalls the long catalogue poems of the French Surrealists and Dadaists, especially Tristan Tzara's "Droguerie-conscience" and Benjamin Peret's "Nebuleuse." Its conversion of melodic pastoral imagery into angry scatological shoutings is in the mood of Rimbaud's "Ce qu'on dit au poète" as well as O'Hara's own Grafton "Pastorals," the long lines of both prose poems making way for the open verse of "Easter."

Although some of the obscenity of "Easter" was shocking in the early fifties, more startling and unusual was the use of the coded language of homosexuality. "Camp," the sort of theatrical double-talking and double-acting by which homosexuals tended to both reveal themselves to each other and conceal themselves from a potentially dangerous larger society, had never been discussed in print until Christopher Isherwood devoted two pages to a discussion in his 1952 novel *The World in the Evening.* The term was then picked up by Eric Bentley, when he described Ruth Gordon as "camping all over the stage" in a review of *The Matchmaker* in 1956, and Susan Sontag, in her "Notes on 'Camp'" in *Partisan Review* in 1964. Yet O'Hara had already written earlier in "Easter" of "swish" and "camp": "a self-coral serpent wrapped round an arm with no jujubes / without swish / without camp." Using the gay argot of the time he exclaimed, "it's the night like I love it all cruisy and nelly." Providing a glimpse of the furtive urban landscape of homosexual cruising, he wrote "Giving and getting the pubic foliage of precarious hazard / sailors." He revealed personal tastes with "the big nigger of noon" and "Black bastard black prick black pirate." While O'Hara's expression of his own homosexuality was not as direct as in the love poems he wrote to Vincent Warren in the late fifties and early sixties, he was already obliquely identifying himself in the coded style of the times by including gay dialect in his art. It was the method he had used a few weeks earlier in "Locarno," in which the lines "I had overheard you telling / Dorabella and Jo" refer to Schuyler, whose "gay name" was Dorabella, and to Joe LeSueur. The adoption by men of women's names is part of the gender-switching sort of role-playing common to camp.

That fall John LaTouche arranged a reading of "Easter" at his penthouse on the sixth floor of an apartment building opposite a fire station on East Sixty-seventh Street. About forty people attended the informal reading at which LaTouche played the piano in the living room followed

by O'Hara's reading along with John Ashbery and Barbara Guest. (Guest's "New York Remembering Nights Awake" had just been published in *Partisan Review.*) O'Hara's effect on the understatedly elegant audience was a bit strong. "I hated it—the violence of the language scared me to death," recalled Elmslie. "Ashbery read a witty poem called 'He' which could have evolved out of a Cole Porter 'list' lyric, so I could understand *him.*" One of the most shocked was Jackson Pollock's dealer, Betty Parsons. "Afterward Betty Parson was saying, 'I don't know why I've been invited to hear this, I don't know why I have to hear this,'" recalls Schuyler. "You wouldn't have expected this reaction from her, not because she was a lesbian, but because everything in her gallery was the furthest out there was." Particular exception was possibly taken by Parsons to a line about "women who use cigars."

The fall also brought about a crisis in the increasingly complicated three-way relationship between O'Hara, Rivers, and Freilicher. Ever since moving to New York O'Hara had nurtured a crush on Rivers while being much more publicly demonstrative about his infatuation with Freilicher; his feelings for her were less troublesome and so more easily flaunted. "Working at my relationship with Frank and behind all these enthusiasms was I felt his real passion for Larry," says Freilicher. "He obviously had this great passion for Larry but somehow he repressed it and sort of turned it on me. There seemed to be some sort of ambivalence." Rivers concurs that "Most people cynically would probably have thought that since he wanted to sleep with me he was keeping on the best side of Jane." The only solid emotional truth at the bottom of the puzzle O'Hara was creating was his passion for Rivers. "He tended to develop crushes on people who were straight, or almost straight," recalls Ashbery. "I don't remember his really being in love with anybody, though, until Larry Rivers."

Although Rivers and Freilicher had been fitfully involved for many years, their relationship had been rocky and uneven. "I think she decided that I was impossible," says Rivers of Freilicher's stance by 1952. "There was drugs. I could go with men, I could go with women. Even though I imagined myself to be in love with her I would sleep with anybody who came along. But as soon as she did something I got rather upset." The "something" was Freilicher's growing romantic involvement with Joe Hazan, a young painter she eventually married in 1957. Rivers, already capable of exhibiting extreme behavior, went on a rampage of obsessed espionage, spying on Freilicher and Hazan from shadowy doorways, climbing onto a roof across the street to observe them through a window. "Larry had this thing of using jealousy as a moti-

vator in his sex life," complains Freilicher. "We had been friends for a long time. The whole thing was burnt-out. Then when I started going out with Joe, he suddenly brought this old ember back to life and acted like some kind of spurned lover and completely went insane. It had no basis in reality."

Rivers decided one November night to act out his tortured feelings by slashing his wrists. "I probably thought I was in either a Russian or a French novel," figures Rivers. "I would think of characters in novels. It all seemed to be literature. There wasn't anything that was happening that wasn't literature." Rivers was canny enough about the difference between literature and life, however, to cut the skin of his wrists with a razor but no arteries. He then called up O'Hara who came rushing over to bandage them. (Hartigan claims that Rivers checked first to make sure the phone was working before doing the deed.) O'Hara took it upon himself to nurse Rivers through this difficult period, allowing him to stay for a few days at East Forty-ninth Street during which time they slept together in the same bed. Rivers then went to stay briefly with the painter Fairfield Porter in Southampton, writing to O'Hara on November 18, "My wound seems to be healing. Both of them. I have eaten and even had a glass of beer. If I tear now it is because of how sweet everybody has been to me. Self-indulgence on dark Saturday was revenge. . . . I'm glad I was unsuccessful. I knew I would be. If you weren't someplace I could get you I'd probably never have attempted it." Larry Osgood recalls that O'Hara brought Rivers to a Thanksgiving Day dinner of roast turkey later that month at Hal Fondren's new apartment on Lexington and Ninety-third Street, and that Rivers was wearing a long-sleeved undershirt to conceal his wrists still showing signs of the abortive suicide attempt.

O'Hara not only bolstered Rivers in the wake of the accident, he also took it upon himself to make sure that Freilicher was kept away. According to Freilicher, "Frank said that Larry doesn't want to see you and don't prolong the agony by trying to contact him because that will only make it harder for him to get over this great thing that he's going through." O'Hara's sympathy, though, was a bit self-serving, even "a little nasty," as Freilicher characterizes it: "He took the opportunity to sort of get rid of me." Rivers, too, later felt manipulated by the manner in which O'Hara played the role of go-between to his own advantage. "For a guy who had fifty insights per minute into human behavior and human reasoning, for him to make a statement I might have made that I don't want to see her because she hurt my feelings, to take that as a final statement worked very much into his plan," says Rivers. "Once

that gap was established between myself and Jane he wasn't going to do anything about reestablishing the old thing." Feeling doubly slighted, Rivers began a campaign of not speaking to Freilicher at parties and of walking out of any room she happened to be in.

Insofar as O'Hara was interested in pushing his relationship with Rivers ahead, the melodrama of the wrist-slashing did lead to a period of working, sleeping, living, and spending hours of each day and night together, an acceleration that O'Hara could construe as the beginning of a love affair. Some of his friends, though, cast a cold eye on the goings on. "It seemed doomed," says William Weaver. "I have a much sort of simpler mind and I couldn't understand all the complications of it." "I think Frank was more aggressive sexually," recalls Rivers. "I was in a rather conventional tradition of men who are mainly heterosexual, or have had mostly heterosexual experience, who when they get with men who are homosexual act as if they are allowing themselves to be had. So he would get me aroused enough by a blow-job for me to get a hard-on and then screw him in the ass. That was what it was about. And then I'd sort of play with him I think as I was doing that and he would come off. One night I'd be with him and the next night I'd be with a woman. It got to be funny."

As a switch-hitting figure, Rivers had a particular allure for certain homosexual men in the fifties for whom a heterosexual or married male was often the most desirable sexual partner. In *Drawings and Digressions,* Rivers gave a fair sense of O'Hara's tendencies: "He usually picks on guys who also like women—the classic case of the homosexual who likes 'men': by definition a 'man' is someone who likes women." As O'Hara deferred to painters, giving them precedence over poets, so he deferred to straight men, preferring them as sexual partners and romantic interests to gay men. His ultimate dream lover was clearly a straight painter. This attitude, of course, was self-deception. It showed a lack of self-acceptance. Yet the glorification of the straight male in the homosexual scene—later called the "eroticization of the oppressor" in the radical gay political language that came into use after O'Hara's death—was so endemic as to be almost invisible. In this sense, O'Hara was a type, although in other predilections and impulses he definitely transcended his genre.

More upset than Jane Freilicher by this turn of events was John Bernard Myers. Like a jealous character in one of Proust's novels, to which he was so fond of comparing life, Myers one night began banging at Rivers's door when he was in bed with O'Hara shouting "Let me in, I know you're there." Rivers finally got up to let in a sobbing Myers.

After all, Myers had been investing both money and time in Rivers, his amorousness leading, like O'Hara's, to hours of posing: as all twelve disciples for the painting *The Agony in the Garden,* as what Rivers has described as a "depressed schizophrenic" for a series of drawings, "The Disturbed" and, in October, as Balzac in Rivers's parody of Rodin's famous sculpture. One evening at the City Center toward the end of 1952 Myers raged jealously when he saw Rivers and O'Hara descending the stairs from the cheap seats to the mezzanine together, "There they are, all covered with blood and semen!" This spiteful remark having originally been uttered by Madame Verlaine upon seeing her husband with his lover, Rimbaud, at the Opéra amused O'Hara, but was a bit lost on Rivers, and recurred by virtue of its excellence as a bon mot when O'Hara and Rivers collaborated in the late fifties on a series of lithographs, *Stones,* in which Rivers sketched himself and O'Hara as Rimbaud and Verlaine surrounded by several bullets shaped like penises.

"Luckily, just as my high feelings were about to turn into a first class obsession," Myers later wrote, "I met the theatre director, Herbert Machiz, who seemed to me to be far more thrilling than Larry Rivers, perhaps even a greater artist." Machiz directed many poets' plays, off-Broadway plays, and, in the summer of 1955, ran the Lakeside Summer Theatre at Lake Hopatcong, New Jersey. "John Myers was like the brood hen trying to find something for Herbert to do," recalls Kenward Elmslie. "He really had no talent for poetry theatre. Actually what he did best was meat and potatoes kind of theatre. Every so often he'd really come through—with *Suddenly Last Summer* off-Broadway, as well as with a production of *A Streetcar Named Desire,* starring Tallulah Bankhead." Myers's appraisal of Machiz's directing talent was always open to debate, and Bunny Lang wrote to Alison Lurie after Machiz directed her play *Fire Exit* at the Amato Opera in 1954, "Herbert Machiz is about the worst director in NY or anywhere."

The increased intimacy between O'Hara and Rivers led to a productive, if emotionally hectic, period in both their lives. It was a boon to the art scene as well, which was enlivened by the presence of its two most electric figures as a couple. According to the painter Jane Wilson, "Larry and Frank had a very unique . . . timing is much too trivial . . . but they were connected to some kind of energy . . . As they were both talkers, the threat of silence when they were around was impossible." "They talked endlessly when they were together," remembers Kenneth Koch. "They were always challenging each other. Sometimes they'd make me a little bored because they were so abstract and profound. Of course Frank's conversation was more sophisticated in the ordinary

sense of the word than Larry's was. But Frank admired Larry's intelligence enormously. He thought Larry was really brilliant, with which I agree." The painter Howard Kanovitz, who briefly shared Rivers's fifty-dollar-a-month loft on Second Avenue, remembers, "One aspect of their being together was in a funny kind of way argumentative. It had a sort of competitive ring to it. There was high tension. It seemed as if Frank wanted to get Larry down to earth a little bit, or level him up in life. Larry seemed to want to soar on certain levels of fancy while Frank took pleasure in bringing him back to something that seemed more communicable. He could remind him that he'd gone off someplace." According to the painter Mike Goldberg, "Larry alone always got to be a pain in the ass because he was always involved with the dance he was doing. I think with Frank it became a minuet. He was a partner."

Wise and opinionated, O'Hara quickly settled into the role of Rivers's artistic and ethical director, constantly giving him advice on his career. "He talked a lot of artists into thinking that they were terrific," says Rivers. "That's why he was so popular and so sought after. He had you on his mind. And if 20 percent of it was horseshit, so what? With most people 90 percent of it is horseshit, about thinking about you." This dynamic, however, led to a Pygmalion myth among their friends that, if true, did not take into consideration Rivers's success before or after his involvement with O'Hara. "Larry has never been as good a person, or an artist, or a mind as he was when Frank was running herd on him, keeping him in order, checking him, making sure he did the best and insulting him when he didn't," says Hartigan, on whose life and art O'Hara had had a similar effect. As one observer noted: "It seemed to me as if the electrodes had been planted in Larry's mind. It was like the college girl sleeping with the professor."

While Rivers was content with the flirting friendship with O'Hara, O'Hara sometimes wanted more. The frustrations of his love affair with Rivers resulted in a series of powerful poems beginning in the summer of 1952, many of them dark and tortured. The emotional insecurity shook him. "A lot of those very unhappy, wretched, miserable poems about unsatisfied love I think were about Larry," says Kenneth Koch. "His feelings about Larry seemed to correspond to a big change in his poetry from the happiness of the early poems, the sort of excitement." The poems of the period that reflect this new anxiety about Rivers begin with "Invincibility" (original titles: "Razors at Twilight," "The Tears of Invincibility"), "Savoy," "Round Robin," "Sonnet for Larry Rivers & His Sister," and "River," its title an obvious pun, in which he laments "that brutal tenderness" that held him "like a slave / in its liquid

distances of eyes, and one day, / though weeping for my caresses, would abandon me."

In February 1953, O'Hara and Rivers's collaboration on a new production of *Try! Try!* was presented as part of the opening program of the Artists' Theatre at the Theatre De Lys, which had recently been converted from a movie theatre on Christopher Street in Greenwich Village. As the original *Try! Try!* had opened the Poets Theater in Cambridge, so this new production helped launch a New York attempt at a similar theatrical Yeatsian dream, this time conceived by John Bernard Myers and under the direction of his new boyfriend, Herbert Machiz. *Try! Try!* shared the bill with *Red Riding Hood* by Kenneth Koch, decor by Grace Hartigan, and *Presenting Jane* by James Schuyler, decor by Elaine de Kooning, including a showing of a three-minute version of the summer movie. The collaborating artists were given thirty dollars for set materials. Rivers spent his money on metal pipes from which he made a weird sculpture, which doubled as a coat rack. He also painted a large suspended mural, which consisted, according to Myers, of "strange, large-eyed figures placed in a cityscape that suggested Istanbul." At rehearsal, however, O'Hara was unhappy with his original play. "At the first run-through I realized it was all wrong and withdrew it," he later wrote in his memoir of Rivers. "He, however, insisted that if he had done the work for the set I should be willing to rewrite to my own satisfaction, and so I rewrote the play for Anne Meacham, J. D. Cannon, Louis Edmonds and Larry's set." O'Hara's new version dispensed with the clever shifting of poetic forms that had marked his first version in favor of a looser bebop style of verse more in keeping with his current work. "Up until rehearsal I didn't think there were going to be any plays the way everyone screamed at each other," recalls Hartigan, who spent her thirty dollars on brown paper and gouache for an inside-outside backdrop and then filled the stage with chairs and a drawing table from her studio. "It was such an idealistic thing to do, for poets to write plays and for artists to do the sets." Their sense of success among themselves, however, was intimate and unsustained by public acclaim—the theatre had been only half-filled with the usual crew of friends and artworld supporters. As O'Hara later told a television interviewer, "John . . . when he was producing us, he would look at the audience and say, 'Well, Harold Rosenberg is here; Tom Hess is here, Mark Rothko just came in. It must be a hit.' Only it'd be a one-night hit."

A few months later, O'Hara, fed up by now with Myers after their rivalry over Rivers and his experience working with him on a book and

a play, lit into him in a letter to Rivers. "John's chief characteristic in every area, emotional, financial, sexual, social, every single characteristic one can remark is based on the greed which is gradually eating up whatever distinction of personality one used to find traces of in the elaborating camouflage which is his manner." O'Hara, eminently capable of bitchery, complained too of the nonexistent "royalties" from *Try! Try!* that he claimed had been "intended to raise money for his and Herbert's shirts, ties and silver sets." In the same letter, O'Hara revealed his sense of the crucial importance of the artist's (in this case opposed to the dealer's) life. "I think of other occupations as related to life in almost the same inconsequential and peripheral way that a lay person is related to the church," he wrote, slipping in his Thomistic training. "I realize how biased this is, but I do believe that the artist is near the mysteries that govern us or that we govern subconsciously, and that other people are only aware of them in some sketchy way."

In spite of O'Hara's annoyance with Myers and Machiz, however, the productions at the Artists' Theatre, when finally mounted, inspired him again with the possibilities for poets in theatre, for rekindling the successes of Yeats and Lorca. In this spirit he encouraged Kenneth Koch later in February to keep up the good work of *Red Riding Hood*: "One day I told Frank I wanted to write a play, and he suggested that I, like no other writer living, could write a great drama about the conquest of Mexico," Koch has recalled. "I thought about this, but not for too long, since within three or four days Frank had written his play *Awake in Spain,* which seemed to me to cover the subject rather thoroughly." A short five-act play written for over eighty characters including Church Steeple and Marlene Dietrich, *Awake in Spain* was another of O'Hara's conceptual closet plays best read, as it was at the Living Theatre in 1960 by ten seated players wearing different hats. "Frank called me up one day and said, 'I've just written a five-act play,'" recalls William Weaver, who in 1953 was working at *Collier's* magazine. "I said, 'Oh that's wonderful, Frank.' He said, 'Shall I read it to you?' It was *Awake in Spain* so an act was very short and he did read it, too."

During March and April O'Hara wrote his longest poem, the eleven-part 478-line "Second Avenue," the culmination of his accelerating desire to use a kind of automatic writing to match the epic scale and grandeur built up by accident and subconscious connections in Abstract Expressionist painting, aleatory music, and French Surrealist catalogue poems. O'Hara worked on "Second Avenue" mostly in Larry Rivers's plaster garden studio overlooking Second Avenue between Seventh and Eighth streets. Rivers at the time was making a sculpture of

O'Hara who, between poses, would sit down to add more and more lines. Rivers has recalled the night when "Three fat cops saw the light and made their way up to make the 'you call this art and what are you doing here' scene that every N.Y. artist must have experienced." During this phase, Hartigan stopped by occasionally on missions of mercy. "They were lovers," she recalls, "and I'd come by and bring them choc-olate éclairs because Frank had hangovers and Larry was coming down from drugs. Sweets are always good for both those cases."

O'Hara was encouraged to keep pressing forward by the pressure he was putting on Kenneth Koch to work on his long poem, "When the Sun Tries to Go On." (Ashbery was working on a similarly long and deranged work at the time titled "Petroleum Lima Beans.") O'Hara and Koch used to call each other up every day to read their daily results, or sometimes they met for a sandwich with pages in hand. One such meeting was recorded in "Second Avenue":

> *of umbrella satrap square-carts with hotdogs*
> *and onions of red syrup blended, of sand bejewelling the prepuce*
> *in tank suits, of Majestic Camera Stores and Schuster's,*
> *of Kenneth in an abandoned storeway on Sunday cutting ever more*
> *insinuating lobotomies of a yet-to-be-more-yielding world*
> *of ears.*

As Koch has said, "I had no clear intention of writing a 2400-line poem (which it turned out to be) before Frank said to me, on seeing the first 72 lines—which I regarded as a poem by itself—'Why don't you go on with it as long as you can?' Frank at this time decided to write a long poem too; I can't remember how much his decision to write such a poem had to do with his suggestion to me to write mine." Koch feels there was a sense of racing to the finish line, adding that O'Hara "was very polite and also very competitive." Following the publication of "Second Avenue" by Totem Press in 1960, Koch later wrote about the work in *Partisan Review* that "To speak historically, I think 'Second Ave-nue' is evidence that the avant-garde style of French poetry from Bau-delaire to Reverdy has now infiltrated the American consciousness to such an extent that it is possible for an American poet to write lyrically in it with perfect ease." Hartigan, also perhaps influenced by her per-sonal involvement in its making, told an interviewer that she felt "Sec-ond Avenue" to be "Frank's greatest poem, one of the great epic poems of our time. . . . Name it, name anything, and it's got it." Ashbery

distanced himself a bit in his introduction to the *Collected Poems* by describing the extremely experimental poem as a "difficult pleasure" and relegating it to what he somewhat mystifyingly labeled as O'Hara's "French Zen" period.

The original dedication of "Second Avenue," "To Willem de Kooning," was scratched and replaced with an epigraph from the Russian revolutionary poet Mayakovsky's "The Cloud in Trousers"—"In the church of my heart the choir is on fire"—and then simply to "In memory of Vladimir Mayakovsky." The example of both de Kooning and Mayakovsky figured in the voice and feel and scale of the poem. In "Notes on *Second Avenue,*" a collection of stray observations written that year by O'Hara at the request of Time/Life cultural editor Rosalind Constable for her in-house memorandum on the arts, O'Hara explains that "Where Mayakovsky and de Kooning come in, is that they both have done works as big as cities where the life in the work is autonomous (not about actual city life) and yet similar: Mayakovsky: 'Lenin,' '150,000,000,' 'Eiffel Tower,' etc.; de Kooning: 'Asheville,' 'Excavation,' 'Gansevoort Street,' etc." The de Kooning painting that found its way into his poem was the *Woman* he had seen the summer previously in the Hamptons, its demonic Mona Lisa female landscape built up from viscous grinds, halts, and erasures executed violently about the focal point of the pasted-on ruby smile of a Lucky Strike lady from an ad. The canvas's flirtation with a figure, no matter how distorted, was extremely upsetting to those painters who believed that the hegemony of pure abstraction was already a closed case. Even more upset was Elaine de Kooning who, frustrated with rumors that the fierce woman was modeled on her, had asked a friend to take a snapshot of her in front of the canvas only to discover in the photograph that the painted arm of the *Woman* seemed to rest maternally on her shoulder. O'Hara claimed that his own woman in "Second Avenue" began as a description of a woman leaning out a window on Second Avenue with her arms on a pillow but was soon permeated with de Kooning's fractured icon:

> *how like a yellow pillow on a sill*
> *in the many-windowed dusk where the air is compartmented!*
> *her red lips of Hollywood, soft as a Titian and as tender,*
> *her grey face which refrains from thrusting aside the mane*
> *of your languorous black smells, the hand crushed by her chin,*

According to Koch, who like the rest of O'Hara's gang had witnessed the pile of slashed and discarded *Woman* canvases mounting out back at

Castelli's during the summer of 1952, "The Women were obviously wonderful. They had that double vision of things which we were so interested in in poetry. Those sorts of double-exposure effects. You'd see a woman, and her lips would also look like a seascape."

While O'Hara was finishing "Second Avenue," another of his collaborations with a painter was exhibited in Grace Hartigan's show opening on April 7 at Tibor de Nagy. As O'Hara had been writing poems to Hartigan, including "Portrait of Grace," based, he said, on "Rivers' drawing of Grace as a girl monk," she wanted to make paintings with his poems. So he gave her twelve of his original nineteen "Pastorals" and called them "Oranges," saying as he handed them over to her, "How about a dozen oranges?" These led to the twelve oil paintings on paper—Hartigan couldn't afford canvas that month—that were displayed on cardboard nailed to the gallery's wall. "It coincided with a time when I was moving out of completely abstract work into imagery," says Hartigan. "So he was handing me image after image after image in these things." A few days before the show Myers decided to mimeograph O'Hara's poems and bind them in gray three-hole paper binders of the style used by schoolchildren on which Hartigan painted about twenty original covers. These were sold for one dollar each. O'Hara was quite sentimental about the show. He kept one of Hartigan's *Oranges* paintings over his bed all through the sixties, and in 1956 wrote to her from Boston, "I often think of your paintings for the *Oranges*—where are the snows of yesteryear?"

During the spring and early summer of 1953 O'Hara, who had been promoted in March to Front Desk Manager at the Museum, was spending as much of his free time as possible at the house Larry Rivers had begun renting in May on Toylsome Lane in Southampton. Although his mother had become by then an enormous burden, O'Hara kept enough warm memories of his own early family life that he enjoyed becoming part of the families of certain of his heterosexual friends. Other people's families were a curious comfort to him. As Rivers was living with his two sons and his mother-in-law, O'Hara not only had the benefit of their own complicated romantic and artistic collaboration, but also of a family scene. O'Hara became close to Rivers's two boys, including them in poems such as "Steven" and "Two Shepherds: A Novel" while they referred to him as Uncle Frank, a development that allowed him to express those obliquely paternal impulses that sounded so strongly in his Navy letters to his little brother and sister. Tibor de Nagy recalls that whenever he saw O'Hara during the day in the Hamptons he was with Rivers's two boys, especially at the beach. Rivers never

had any tolerance for the beach and was always impatient to return to the barn that Fairfield Porter, a Southampton resident since 1949, was allowing him to use as a studio. As O'Hara once remarked to a friend, his humor thinly disguising his subliminal desire, "I'm Larry Rivers' sons' stepmother." (The incestuousness threatening this surreal family surfaced in the sixties when a drunken O'Hara made a pass one night at the teenage Steven Rivers, who was "bugged" because, he says, "for all these years I thought I was sort of more like some kind of relative.")

It was Mrs. Bertha Burger who acted like the mother of them all. Known as Berdie, Rivers's mother-in-law, a widow from the Bronx, was the perfect Jewish grandmother; her kindness and unquestioning acceptance of all the characters around her made her the ideal maternal figure just as her lack of bohemian values made her paradoxically a source of fascination in this world of artists devoted to willful eccentricity. As O'Hara wrote in his sonnet "Mrs. Bertha Burger":

> Her life is beautiful, and free from hate;
> to know her is to know how rarely one
> may love, as one again beholds the sun.

"She was a very saintly type, meaning sort of a little stupid and a little amazed by everything, and sort of the worst cook that ever lived," says Rivers. "Tennessee Williams came and used to spend nights with her so she must have had something I didn't understand." O'Hara, in his memoir of Rivers, was more happily mythological about Rivers's most constant model in those years:

She was called Berdie by everyone, a woman of infinite patience and sweetness, who held together a Bohemian household of such staggering complexity it would have driven a less great woman mad. . . . She appears in every period: an early Soutinesque painting with a cat; at an Impressionistic breakfast table; in the semi-abstract paintings of her seated in a wicker chair; as the double nude, very realistic, now in the collection of the Whitney Museum; in the later *The Athlete's Dream,* which she especially enjoyed because I posed with her and it made her less self-conscious if she was in a painting with a friend; she is also all the figures in the Museum of Modern Art's great painting *The Pool*. Her gentle interestedness extended beyond her own family to everyone who frequented the house in a completely incurious way. Surrounded by painters and poets suddenly in mid-life, she had an admirable directness with esthetic decisions: "it must be very good work, he's such a won-

derful person." Considering the polemics of the time, this was not only a relaxing attitude, it was an adorable one.

O'Hara was only too happy to find such a nurturing mother after his recent and painful experience with his own mother.

O'Hara and Rivers were both obsessed that season with the Russians. O'Hara's obsession was with Mayakovsky, who had so stridently declared that "The poet himself is the theme of his poetry" and "The city must take the place of nature," and from whom O'Hara had picked up what James Schuyler has described as "the intimate yell." (In a nasty swipe of a poem, "Answer to Voznesensky & Evtushenko," in 1963 O'Hara accused the Soviet poets of being "Mayakovsky's hat worn by a horse.") Rivers was busily reading *War and Peace,* about which John Myers grudgingly asked in a memoir: "And who got him to read *War and Peace?* Not Frank." Between Mayakovsky's "The Cloud in Trousers," O'Hara's "Second Avenue" and Tolstoy's *War and Peace,* the epic was in the air. So Rivers decided to make his own attempt at a large scale epic painting, *George Washington Crossing the Delaware,* which he has described as "like getting into the ring with Tolstoy." It was based on the original work by the nineteenth-century academic painter Emmanuel Leutze, a German-American sentimental realist known for the stage-set heroics in this tableau as well as in his mural decorations for the Capitol. O'Hara found the notion of updating this historic figure "hopelessly corny" until he saw the painting finished, his coming around later recorded in his 1955 poem "On Seeing Larry Rivers' *Washington Crossing the Delaware* at the Museum of Modern Art." Among the painters, however, the work—with its parodistic figure drawing— was a battle cry, thumbing its nose at Abstract Expressionism and pointing the way toward what would later become Pop Art. It was also quite revolutionary in dispensing with the lush brushwork of de Kooning in favor of thin, soaked washes. Rivers was sneered at in the Cedar, where Gandy Brodie, an abstract painter who had studied dance with Martha Graham, described him as a "phony" and one persnickety woman painter dubbed the new canvas *Pascin Crossing the Delaware.* The painting was a breakthrough for Rivers in finding his own breathing space in the increasingly claustrophobic crowd of young painters.

Meanwhile his relationship with O'Hara was becoming more difficult. O'Hara was making demands that Rivers felt were unreasonable. "He thought he wasn't putting pressure on me but he actually was," remembers Rivers of O'Hara's wanting to go home with him after a party. "Like we'd be somewhere and I'd be enjoying myself. And he

says, 'Well are we going?' Like meaning, 'Well is anything going to happen?' I wasn't in love in that sense." On July 27, Rivers mailed O'Hara a letter spelling out the obvious, which they had discussed many times recently:

I hammer home my same boring points and affectionate anxieties. You begin each session with belligerence based on some wrong that seems to disappear as soon as you are satisfied that you still maintain a certain place. You mean very much to me but probably not in the way you could wish. I feel alone and without any strong allies and your concern and glow fill me with strength and a power to go on against all the difficulties and jealousies of my contemporaries. I feel that wherever you are my light shines very powerfully and is protected. This makes me love you but something holds me from rushing up to you and fondling you I don't feel like kissing you anymore. I get so nervous that this is apparent to you that I am unhappy and I don't mean a lack of exuberances I mean oppressed by all that a minus of feelings inspire. . . . If Courbet knew Byron would he throw it away. Not after such joy and juice. Not Byron I mean Rimbaud.

As anticipated as the message of Rivers's letter had been, O'Hara took the news as a decisive upset. It was July, and O'Hara uncharacteristically wrote out with a pencil a responding poem on long yellow sheets of tablet paper. This was "Life on Earth," its concluding stanza wincing with the acceptance of a homosexual life, which O'Hara links ruefully with his romantic disappointment and more gleefully with the poisonous tang of an adolescently rebellious "evil":

Vile, ghastly, ignorant, I wander through the barriers,
I suck upon rue for my distinguished heart.
I roam through the city in a shirt and get very high.
I will not go away. I will never take a wife.
My heart is my own, the trapped hare belongs to the hour.
The loving earth bleeds out its laughing grunts which are green
and new and, above all! tender! yes, tender!
like the blue light seeping towards you under my closed eyelids,
so evil, and now closed at last in evil! evil! evil!

Yet O'Hara had already pinpointed Rivers's attitude and his own wry response more acerbically, flatly, and comically three months earlier in

"Round Robin." He anticipated the present temporary breakdown of intimacy between them when he described Rivers as

> *moved by my smile like a public accusation*
> *of homosexuality against the Great Wall of China;*
>
> *to him my affection's as pleasing as an insult*
> *to a nun.*

Meditations in an Emergency

On the rebound, O'Hara took up with Robert Fizdale, one half of the duo piano team of Gold and Fizdale. They had recently been introduced to each other by James Schuyler at Fairfield Porter's house in Southampton.

The setting for their brief romance, embarked on by both with somewhat mixed motives, was Sneden's Landing—a very private and small community along the Hudson just twelve miles north of the George Washington Bridge. Katharine Cornell, Noël Coward, Orson Welles, John Dos Passos, John Steinbeck, Aaron Copland, and Jerome Robbins had all lived there, and its few houses were either old, rambling white wood-frame structures or more compact homes built with red sandstone carved from a nearby river quarry, also responsible for many of Manhattan's "brownstones." The big, airy Victorian house Gold and Fizdale were renting was a direct result of their musical career since it belonged to Aaron Copland, the American composer whom they had called up in 1943 while still students at Juilliard to ask if he would write a four-hand sonata for them. Copland had pleaded busy but had referred

them to John Cage who wrote two prepared piano pieces titled "A Book of Music" and "Three Dances" for their debut at the New School for Social Research in 1944. Their Town Hall debut followed on February 15, 1946, a year during which they gave first performances of other works composed for them, included Bowles's and Haieff's sonatas for two pianos, and Milhaud's Concerto for Two Pianos. At a time when two-piano concerts connoted clatter and arrangements, Gold and Fizdale began to revamp the art. They eventually commissioned works from Rorem, Rieti, Barber, Thomson, and Howard Brubeck, and from the French composers Auric, Milhaud, Poulenc, Henri Sauguet, and Germaine Tailleferre. By the time O'Hara met Fizdale the team was already well known in concert halls throughout Europe.

Gold and Fizdale were not lovers but they were inseparable. As Robert Fizdale has described it, "It was almost like one person, different as we were. Everything that was in mine was in his. Almost like Siamese twins." This peculiar indivisibility could present problems for anyone who became involved with either one—the only solution was parallel romances. When O'Hara came on the scene, Arthur Gold was involved with O'Hara's roommate, James Schuyler, and Fizdale with an interior decorator. Fizdale, though, was jealous of the entrée Schuyler gave Gold to a tantalizing world of poets and artists. "It seemed to me much more romantic to be with a poet," admits Fizdale. "Jimmy and Arthur used to go see Auden a lot. I envied all that in a way and wanted to be part of whatever that was." When O'Hara came along Fizdale took the opportunity to send his current lover packing.

O'Hara was feeling available, but not completely so. Though he tried to escape his painful feelings for Rivers, he never allowed himself to escape entirely. When he and Fizdale first became involved during a summer's weekend in Southampton, O'Hara had protested, "But I'm in love with Larry." Even after O'Hara began to spend his free time at Sneden's Landing, often taking a bus to and fro with James Schuyler in an arrangement as perfectly balanced as a piece for piano four-hands, he could never quite give up on the idea of Rivers. "What was so odd was that when we were all at Sneden's Landing, Frank would have a few drinks and start talking about Larry Rivers," recalls Schuyler. "He'd go on and on about Larry. I blew up at him one night at dinner about it, started yelling at him, and went upstairs. There was some way you could call the operator, and she could call your number back, and you could talk from different ends of the house on the phone. Frank called up to say he was terribly sorry he made me mad. But what was weird

was that he would do this all the time. I don't think Bobby wanted to spend the rest of his life hearing about the other guy."

Still, O'Hara fulfilled many of the romantic expectations Fizdale had of his poet lover, and their time together in August and September was heightened by O'Hara's gestures and poems and Fizdale's piano-playing, so redolent for O'Hara of his childhood and early adulthood. "Frank would always take a long bath in my bathtub," recalls Fizdale. "He'd lie there reading Chekhov aloud and I'd sit on the toilet or on a chair. Looking down the river as it was getting dark with Frank in the tub reading Chekhov stories or Russian poems, I thought that was just wonderful."

O'Hara was sometimes inspired by the musical virtuosity around him to sit down at the keyboard again himself. "One of the most amazing things was one day I heard some Rachmaninoff or Liszt piece being dashed off at the piano and I thought Arthur must be playing," recalls Fizdale. "I went in and it was Frank playing this very difficult piano rhapsody, his hands flying over the keys. He really played particularly well. I didn't know he played at all so I was astonished."

Guests of the house were privy to glimpses of lives given over to art and love in a way that felt almost nineteenth century in its remove from the fast-paced life of Manhattan just down the river. "I went for a weekend at Sneden's Landing," recalls Grace Hartigan. "I was reading Jane Bowles, Frank was writing a poem, and Bobby and Arthur were working and we could hear this music of Poulenc going through the house. Sunday afternoon, before we went back to New York, they very formally invited Frank and me. So we went into this empty drawing room, empty except for two pianos and a Victorian love seat. Frank and I sat in the love seat and they threw us a blanket because we were both kind of cold, and we sat there for the first time listening to two professional pianists play Poulenc for us, the Poulenc thundering in this room with just me and Frank huddling together under a blanket."

Fizdale, though, soon learned that there was a price to pay for the pleasure of O'Hara's romantic excesses. He could be a disruptive influence, and his drinking was quite often out of hand. "One of the problems with Frank was that I'm not a drinker," says Fizdale. "We would often come into the city from Sneden's Landing to go to a party. I would drive us all back. When we'd get there I'd sort of have to drag him over the hills to get him into the house. I thought, 'What am I doing?' Also his hours were completely unlike mine. As a pianist I had to get up early and work all day."

Such difficulties were soon obscured by the great distance set up almost immediately in their relationship, a distance that helped to fan O'Hara's tendency toward unrequited longing. At the beginning of September Gold and Fizdale, with Schuyler accompanying Gold, set off for Europe on a concert tour that over the next four months took them to London, Paris, Brussels, Amsterdam, Rome, Palermo, and Milan. In Paris they had the thrill of telephoning Poulenc, who arrived at their hotel suite to listen to them play for the first time the sonata he had written for them. Fizdale showed O'Hara's poems along the way wherever he went. "Tonight Stephen Spender is coming to see us and we're going to be just like traveling salesmen displaying yours and Jimmy's wares," Fizdale wrote to him. "I'll let you know how the sales go." Fizdale also encouraged the composer Ned Rorem to write a piece for two voices and two pianos using the words of O'Hara, who then suggested by mail that the piece—which eventually premiered in Rome in March 1955 as "Four Dialogues"—be called "The Quarrel Sonata." (Rorem had already met O'Hara, having been steered in his direction by John Myers at a party at John LaTouche's the previous December when O'Hara had exclaimed to him, "You're from Paris and I think Boulez is gorgeous.")

During the latter half of 1953 O'Hara's poems, which always reflected the emotional tenor and subject matter of the particular relationships of the moment, were often poetic versions of musical forms. In "Sneden's Landing Variations" with its evocation of "the green river below" he uses five different kinds of rhymed stanzas. Both "Southern Villages" and "Green Words" are sestinas. The titles of many of the poems contain musical allusions such as "Appoggiaturas," "Chopiniana," and "Tchaikovskiania." "Romanze, or The Music Students" recalls

> *In Ann Arbor on Sunday afternoon*
> *at four-thirty they went to an organ*
> *recital: Messiaen, Hindemith, Czerny.*

The first poems he had written upon arrival at the house at Sneden's Landing in August—filled all day long with cascades of classical piano music—were "To My Dead Father" and "To My Mother," casting him back to his musical childhood.

O'Hara's many letters to Fizdale during the fall and early winter often included poems such as "To Bobby," its reference to Fizdale's lips

"which I so love to embarrass," a pun on the French *embrasser* as well as a reminder of an interlude in bed when O'Hara had tickled his upper thighs and Fizdale had playfully complained, "Don't do that it embarrasses me." The line between poetry and prose was difficult to determine in O'Hara's letters, which were filled with charming and seductive sentiments. Closing a letter of November 3, he wrote, "Now before I fall asleep, recall to your mind the immortal line of the sublime Pushkin 'far from your poet you are ranging' and accept the chaste (only because imaginary) kisses which will bring your famous 'shyness' to a white heat." Fizdale returned O'Hara's volleys faithfully. Writing from Palermo on December 6 he tenderly rhapsodized, "I love the way you get into a tub and stay in it and I love the way you rub the side of your hand very reflectively and I love the way you play the piano and the way you look while doing it, like a little boy with a serious expression—the kind that piano teachers fall in love with."

Within three weeks, however, Fizdale produced a surprise ending to their epistolary romance by mailing O'Hara a letter on December 23 that he described as "the most difficult letter I've ever had to write." In it he announced that "I adore you and I adore everything about you but I don't think I am in love with you." The prospect of returning to the demands of O'Hara's chaotic life had begun to wear on Fizdale. His thoughts were revolving again around the less unruly interior decorator whom he had left for O'Hara six months earlier. "It was very prudish of me, I suppose," explains Fizdale of this rapid turnabout, "but I couldn't cope with the fact that he was always drinking and always drunk and wanting to stay up until three in the morning."

O'Hara reacted to this sudden reversal with anger. He dashed off a letter claiming he felt "hideously depressed." Part of the disappointment felt by O'Hara, according to Fizdale, concerned the friendship he had been planning to enjoy by a sort of proxy with Fizdale's friend Jane Bowles, married to Paul Bowles. She was a writer cast in the idiosyncratic mold of Bunny Lang. Jane Bowles's play *In the Summerhouse* had just opened on December 29 at the Playhouse Theatre with a cast that included Judith Anderson, Mildred Dunnock, and Jean Stapleton, scenery by Oliver Smith, and incidental music by Paul Bowles. The tone of the poem titled "To the Meadow," which O'Hara wrote in response to feeling deceived by Fizdale, was as evenly vindictive and caustic as its last two lines: "my broken heart is in your debt / and it will mend—a few hours." Missing was the blue light of evil and loss that had infiltrated and strengthened "Life on Earth," written during his rupture

with Rivers. His liaison with Fizdale resulted in several minor poems and in a scratching sort of rancor, which lasted with no serious repercussions for a few more years. O'Hara's conflicted feelings for Rivers remained the stuff from which his richer poems continued to be inspired.

During the aftermath of the affair with Fizdale, O'Hara was far from paralyzed with grief. One of the banner events of a busy fall was the first issue of *Folder* magazine, edited by Daisy Aldan, a young teacher working on a dissertation about "The Influence of French Surrealism on American Literature" at Hunter College. O'Hara's "Blocks" and "Commercial Variations" were in the issue, as well as poems by Ashbery, Koch, Schuyler, and Merrill and three original silk screen prints for which Grace Hartigan was awarded a Graphic Arts prize from the Museum of Modern Art. Inspired by Caresse Crosby's unbound *Portfolio* magazine, which Aldan had discovered in the course of writing her thesis, she put together her own collection of loose-laid pages filed in a sort of slipcase; all five hundred copies were typeset by hand and sold for one dollar each. Most of the production work took place in a little studio downstairs from Grace Hartigan's, shared by Aldan's husband, Richard Miller, and his friend Floriano Vecchi. Aldan was aided in the production of this first edition of a magazine—almost Venetian in the lavishness of its paper and print—by O'Hara, Ashbery, and Hartigan who came by the studio where, according to Aldan, "we walked around a table putting the pages together like a smorgasbord." There were only about forty literary magazines in the country in 1953, mostly published by universities, so that *Folder* was published in a void that would eventually be more than filled by the mimeograph revolution in poetry magazines in the sixties.

That winter O'Hara attended *In the Summerhouse* with Larry Rivers and Grace Hartigan. "When it got to the line someone said 'Don't leave me, I love you,' all three of us burst into tears at the same time," recalls Hartigan. O'Hara's reaction to this play about a dominating mother and her caged bird of a daughter was extreme and passionate. Bowles, whom he did come to know slightly, became one of his heroes and he championed her play. Writing to Ned Rorem he exulted that *In the Summerhouse* was "one of the great things of the theatre and undoubtedly the best American play of our time. . . . But to cap all my praise, my dear, Nicholas Calas is doing a piece on it which relates it to *Electra* and I don't mean O'Neill's. That's hitting on all cylinders, don't you think?"

The lack of seriousness of O'Hara's liaison with Fizdale was proved

by the rapidity with which he became entangled again with Rivers. Susceptible to becoming more interested in someone who was unavailable, Rivers was a bit riled by O'Hara's involvement with Fizdale, although their affair was a development he could easily have prevented. Writing on September 11 soon after O'Hara had informed him that he'd "had it for awhile" and had taken up with Fizdale, Rivers wittily remonstrated, "You rat. I knew it was only my body you were after all the time. . . . I'll never trust another girl as long as I live." O'Hara apparently kept up his resolve to avoid Rivers during the period of his infatuation with Fizdale. At least so he claimed in a letter to Fizdale on November 3 in which he wrote, with seeming indifference, "Larry is here to do a sculpture commission of Lionel Abel's daughter but I've only seen him to say hello to, I've been so busy."

By the middle of January, however, O'Hara's feelings were hardly so nonchalant. Having resigned from his job at the front desk of the Museum of Modern Art, O'Hara was free to take off for two weeks in the middle of the month to stay with Rivers in Southampton. When the two came into town together they stayed at O'Hara's apartment on East Forty-ninth Street. This was a frequent enough occurrence as Rivers's show of plaster and cement sculpture was installed that month in Eleanor Ward's vast Stable Gallery, housed in a converted horse stable at Seventh Avenue and Fifty-eighth Street, which still smelled of manure on wet days. Rivers was supplementing his income during this period by teaching art classes for adults in Great Neck and moving furniture in a station wagon. O'Hara was beginning to earn some money by writing short reviews in *Art News,* which were published along with other initialed paragraph-length reviews in the "Reviews and Previews" section at the back of the magazine. The job meant that over the next year and a half O'Hara continued to visit galleries and artists' studios, giving him a further hands-on education in all the crannies of contemporary art.

Their circle of friends took a while to register these new developments. John Ashbery reported in a letter of January 14 to O'Hara in Southampton, of a party at John Myers's apartment, "I forgot to mention that at John's party he said to Jane how awful you were to have thrown over that poor Bobby Fizdale and that he also seemed furious that you were out at Larry's. Jane didn't bother to correct him on the first point." Joe LeSueur wrote from Tuxedo Park School on January 21, "My God, I was very surprised to learn of the turn of events— you're going back to Larry I mean." In a letter of his own to Freilicher on January 19, O'Hara, ignoring any feelings regarding Rivers's affair

with Freilicher the year before, confided, "We're getting along so well. . . . my heart couldn't be more of one piece! sometimes I think I'm so equilibrous as to be shallow! but perhaps this is just a temporary fever phase." Certain feelings had not been erased for Freilicher, though, who felt some oddness. "He really went out there and lived with Larry," explains Freilicher. "Frank was crazy about his two sons and he sort of became a member of the household. On the other hand he was writing me letters saying I hope I can come to New York, and let's do this and that." That such a pluralistic emotional outlook was possible for O'Hara is suggested by his felicitous poem for Freilicher written during this time—"To Jane, And in Imitation of Coleridge"—singled out for praise by Auden in 1955 from a manuscript O'Hara submitted for the Yale Younger Poets prize.

O'Hara went back to posing for Rivers—this time for a nude portrait modeled on a Géricault painting of a slave with rope, recently purchased by the Metropolitan Museum of Art and envied by Rivers. "In return for his keeping me warm and fed (he's very broke too)," O'Hara reported to Freilicher, "I am posing for Larry avec la nudité in great big boots for a canvas to be called *The Truth About Christine* and the drawings are going along with wonderful candor and verve." When the finished work was hung in the Tibor de Nagy Gallery, it caused quite a stir. During the installation, when Fondren introduced a wealthy collector to O'Hara, who was adjusting lights on a ladder, the woman, according to Fondren, "turned absolutely purple" because, as she explained to him later, "Well, you introduce me to this man whose portrait with an erection I'd just been looking at." The controversy was memorable enough for the *New York Times* to exhume the scandal of the painting in O'Hara's obituary in 1966. Rivers also worked that season on the sculpture of O'Hara mentioned in his third "On Rachmaninoff's Birthday":

> I am so glad that Larry Rivers made a
> statue of me
>
> and now I hear that my penis is on all
> the statues of all the young sculptors who've
> seen it
>
> instead of the Picasso no-penis shep-
> herd and its influence—for presence is
> better than absence, if you love excess.

Rivers, particularly fired by inspiration from Old Masters during this period, also executed a portrait after Delacroix of his ex-wife Augusta who visited Southampton for a few weeks during February. O'Hara expressed his approval of these activities in "To Larry Rivers": "You do what I can only name."

The sign from O'Hara that he had truly settled in Southampton was his writing in February of "Southampton Variations," an extended poem about a place in the tradition of his "Ann Arbor Variations" and "Sneden's Landing Variations." It was as if he needed to ground himself in particular locations in certain poems to be sure he belonged there and could go on writing, like an artist preparing his canvas with gesso. "Southampton Variations" is filled with William Carlos Williams vignettes in and about Rivers's house on Toylesome Lane, its front yard graced by one of Rivers's statues, which foreshadowed in its appearance George Segal's plaster molds of the sixties: "An African statue freezes in the snow." Analogous among Rivers's paintings in its intent to document is *The Studio*—after Courbet's *The Painter's Studio* (1855) seen by Rivers in the Louvre during his European trip—for which O'Hara posed along with Berdie and the boys in 1956.

The Rivers household provided a workable balance for O'Hara. Its family atmosphere was not at all suffocating or "bourgeois"—always a negative term for O'Hara—and his liaison with Rivers was romantic without being confining. As much as O'Hara imagined that he wished to possess Rivers, he was quite happy with his own independent adventures, usually at night and usually drunk. Rivers was flexible enough to find a tangential role for himself in these forays. A favorite destination was the Bluebird Inn, a bar in Riverhead frequented by blacks where Rivers played jazz while O'Hara tested his skills at picking up straight black males. Writing to O'Hara in 1956 Rivers asked nostalgically, "Do you remember those black evenings?" One of O'Hara's unrequited local flirtations was with an extremely macho-acting Indian worker, Mike Crippin, from the Shinnecock reservation in Southampton who did odd jobs around Rivers's house.

"I feel as if Frank probably eventually came on with everybody," surmises Rivers. "The world I saw of my friends that were gay, I think we called it 'queer' in the fifties, that was what it was about. It was like a painter is someone who paints pictures. To find a painter at an easel or at a wall painting is not very unusual. My idea of homosexuality was that it was about sex. You were sort of trying to make it every day, wherever you were, that was the point." While O'Hara was certainly dedicated to the sexual hunt, which he wrote of in March in "Homo-

sexuality," his notion of homosexuality was more nuanced. He once told Joe LeSueur that there were other reasons to be homosexual than the sexual one, that he loved the freedom.

Although O'Hara's love of freedom led him outside the perimeter of the traditional circle of marriage and family, he was equally agitated by some of the norms of homosexual society and discourse. The sharpest satire in his verse is reserved for effete homosexuals—in "Homosexuality," based on Ensor's *Portrait of the Artist Surrounded by Masks,* with its evocation of "the divine ones who drag themselves up / and down the lengthening shadow of an Abyssinian head / in the dust, trailing their long elegant heels of hot air" and in "The Bores," which begins "Detraction is their game." O'Hara complained in a letter to Grace Hartigan from Southampton in May about just such "homosexual detraction—that which is known as dishing to some of our acquaintants, that 'Oh my dear, I know she was heaven, but even Garbo can get *old,* can't she?' type of wit and wisdom, which is usually followed by something like 'Of course, I adore Cocteau's *movies,* but I had *him* in 1931 in Barcelona and it was nothing like what you'd expect.' Not that there aren't a lot of heterosexuals of similar persuasion, but they usually have to be drunk to talk that way (remember 'I had you last summer and you're a lousy lay'—J Pollock?), they don't seem to make quite so much of a professional attitude out of it." While O'Hara when drunk was certainly capable of pointed detraction, which would seem to blur the line between himself and the homosexuals he was criticizing, he was rarely given to vitriol based on the giving away of sexual secrets.

In March this halcyon period of writing poems, supporting himself by writing reviews, and generally gamboling while living mostly in the Rivers household was briefly disturbed. O'Hara was in town for the weekend to entertain his twenty-year-old brother, Phil, who was coming in from Fort Bragg where he was undergoing Army basic training. Although O'Hara refused to return to Grafton, he continued to see members of his family, including his mother, whenever they visited New York. Walking back to his apartment with bags full of groceries, O'Hara was accosted in the dark doorway of his building by at least one young hoodlum, who demanded his wallet and keys. O'Hara casually brushed off his assailant. "Go rob somebody else," he said. But as he started to go upstairs, he felt the impact on the first few steps of a sharp pain in his right buttock that he registered as a knife wound. He kept going. When his brother arrived on the scene within the hour, O'Hara's apartment was filled with police. "I looked in the door and Frank was sitting in a chair in the middle of the room and he had a

raincoat around him," recalls Philip O'Hara. "There were lots of lights in there. The paramedics were there, plus the police and the detective. I said 'What's happened?' They said 'Your brother's been stabbed.' I went over and we hugged. They were going to take him to Welfare Island so they asked him to stand up. When they did, I looked at the wound and I could see the puncture of a bullet hole. There was blackened blood around it. Then I looked at the coat and there were powder burns in the coat where the bullet went in. I talked to the detective and I said, 'He wasn't stabbed, he was shot.'"

The paramedics along with Philip took O'Hara in an ambulance over the Fifty-ninth Street Bridge to Metropolitan Hospital, which specialized in treating gunshot wounds. After his brother was checked in, Philip returned to stay the night in the apartment on East Forty-ninth Street. Both Jane Freilicher and Grace Hartigan arrived at the hospital soon after—Hartigan having received a call from O'Hara—and found him in a bed in the hall waiting to be admitted to a ward. "They couldn't remove the bullet, it was too close to a vital organ," recalls Hartigan of the bullet that was never finally extracted. "They were observing it. We went to see him every day. Jane brought him Mallarmé and I brought him movie magazines." Kenneth Koch and John Ashbery also visited. Although the incident was a shock, O'Hara's brushes with such danger never entirely surprised his friends, who always worried about his predilection for carelessly taking risks. The only mention of the incident in his poetry was in "Ode: Salute to the French Negro Poets" four years later: "as generations read the message / of our hearts in adolescent closets who once shot at us in doorways."

The simultaneous appearance of Freilicher and Hartigan at O'Hara's bedside reflected his equal affection for both these women in his life. But the balance was already beginning to shift toward Hartigan as Freilicher became more involved with her future husband. In April O'Hara wrote the last of his Jane poems—"To Jane, Some Air." That month he also reviewed her third show at the Tibor de Nagy Gallery and praised her highly: "She seems not to struggle with the pictures, but to identify with them in a gentle, unassuming way—the way Matisse does." As Freilicher's life settled down, though, and as she became more committed to marriage and family, O'Hara grew increasingly irritated by both her life and her art. While no fight ever took place, a gradual distancing did, leading to his comment to Joe LeSueur a few years later that "Jane's more interested in her refrigerator than she is in her paintings." O'Hara's current feelings about his friends, both positive and negative, could often be strong enough to affect his critical eye.

"What was difficult with Frank was that you sort of had to be completely at his disposal," says Freilicher. "He wanted to feel that there were no holds barred. It became difficult as we all got older and grew up. I sensed that Frank was no longer interested in me, my paintings, and that there was a slightly edgy note that got into our relationship. I think he felt that I was becoming bourgeois. On the other hand I somehow remained friends with John and Jimmy. Maybe he was just paying me back for years of repressed jealousy."

As Freilicher had replaced Bunny Lang as O'Hara's female muse three years earlier, Hartigan now replaced Freilicher. "I took Frank away from Jane, let's put it that way," says Hartigan. The evidence of Hartigan's growing place in O'Hara's heart—of which he claimed in "My Heart" that "the better part of it, my poetry, is open"—was his writing "For Grace, After a Party." This love poem to Hartigan is as tender and romantic as any written by him for any man:

> Last night in the warm spring air while I was
> blazing my tirade against someone who doesn't
> interest
> me, it was love for you that set me
> afire,
> and isn't it odd? for in rooms full of
> strangers my most tender feelings
> writhe and
> bear the fruit of screaming. Put out your hand,
> isn't there
> an ashtray, suddenly, there? beside
> the bed? And someone you love enters the room
> and says wouldn't
> you like the eggs a little
> different today?

As Hartigan became more involved with O'Hara that spring she necessarily became more involved with Rivers. All the bumps of their ups and downs registered in her own life. "Larry had a theory that you were supposed to go to bed with everybody you knew," claims Hartigan. "I used go to the City Ballet, the Balanchine, with Frank and Larry. Then they had a terrible fight and Larry asked if I'd go to the

ballet with him. He showed up at my studio with a gardenia and I thought 'Oh shit, it's my night.' He had this beat-up car. On the way he asked if I minded if he smoked a joint. I said, 'No, that's okay.' He parked the car, smoked some marijuana, and fell sound asleep. I tiptoed out of the car and took a cab home. I never got a gardenia again. The moment had passed." Rivers denies any such intention, however, claiming, "I never slept with Grace. She was too big, too wordy. Jane was about the most intellectual woman I ever had sex with. Mostly I picked on waifs, babysitters, people no one knows."

Whatever Rivers's plans may have been that evening, he was capable of spinning what Schuyler describes as "these endless spider webs." He even tried one night to go to bed with his mother-in-law in Southampton until intercepted by his estranged wife, Augusta. Such maneuvering only further complicated the basic incompatibility between himself and O'Hara. When the pain of not being able to possess Rivers absolutely was muted by the pleasure of his company, O'Hara was capable of writing beautifully melancholy poems. The most successful of that season was "To the Harbormaster," read by John Ashbery twelve years later in 1966 at O'Hara's funeral. Using one of his favorite literary metaphors, the lover as a boat tossed on tempestuous seas, O'Hara resignedly laments "the waves which have kept me from reaching you." He hints at the identity of Rivers—the son of Russian-Polish Jews—in the phallic line "I am hard alee with my Polish rudder / in my hand and the sun sinking." While the tempered masochism of "To / you I offer my hull and the tattered cordage / of my will" arose necessarily from a love in which pining was a constant ingredient, such a conceit also satisfied the classic taste for dissatisfaction in the literature of romantic love. O'Hara, in an unusual move, turned his private discomfort into a perfect anthology piece.

In June, however, the tension became unbearable again. Almost exactly a year after their first crisis, O'Hara and Rivers were again driven to a major fight and separation. This time the upset was even more disturbing for O'Hara, as he had to finally realize that his affection for Rivers would never find a satisfying romantic solution. Returning to New York that same month he wrote "Meditations in an Emergency"—its title changed from the less engagé "Meditations on an Emergency" at the suggestion of Kenneth Koch. Briefly self-exiled from the country, O'Hara wrote a paean to the city in this prose poem, one line of which was sculpted on a railing of Manhattan's Battery City Park in 1989: "I can't even enjoy a blade of grass unless I know there's a

subway handy, or a record store or some other sign that people do not totally *regret* life." The poem ends depicting the mix of despair, determination, confusion, and adventure felt by O'Hara at this terminus:

I've got to get out of here. I choose a piece of shawl and my dirtiest suntans. I'll be back, I'll re-emerge, defeated, from the valley; you don't want me to go where you go, so I go where you don't want me to. It's only afternoon, there's a lot ahead. There won't be any mail downstairs. Turning, I spit in the lock and the knob turns.

O'Hara was continuing to feel the effects of the rupture two weeks later on July 12 when he wrote what evolved into part 2 of "Mayakovsky." This four-part poem came about when Schuyler, helping O'Hara gather a manuscript of poems to submit for the Yale Younger Poets prize a few months later, found two poems that O'Hara had misplaced by folding them in a book. Schuyler suggested they splice these together with two other short poems in O'Hara's manuscript pile. O'Hara insisted, since it was *his* poem, that Schuyler think of a title, which he did, inspired by the well-thumbed copy of Mayakovsky's poems lying on O'Hara's desk. The second poem from O'Hara's pile, though—which begins "I love you. I love you, / but I'm turning to my verses / and my heart is closing / like a fist"—had originally been written as a short cry from the heart concerning his broken affair with Rivers and his tough resolve to salvage his pain poetically. The poem had been titled "To Someone Gone" and carried as its epigraph Greta Garbo's line in *Susan Lenox: Her Fall and Rise,* "Oh Rodney! dese wounds ve have inflicted on each odder are a bond!" On July 13, the day after writing this poem, O'Hara had mailed Rivers a letter in which he included the same Garbo line along with a little anthology of quotations about broken love from Rilke, Lord Byron, Saint-Beuve, and Shakespeare, for which he apologized in a brief note at the top: "I miss you so much that, at the risk of seeming fatuous I thought I'd let you know it. I suppose that's the literary curse, isn't it? making everything known?"

O'Hara took the summer to recover. He wrote to the painter Howard Kanovitz and his girlfriend Marilyn Meeker—with whom he stayed on his first weekend back in the Hamptons—of his staying clear of Rivers, "I feel very upset about the 'abyss' between us, and the only way for my wounded feelings not to be embarrassing is avoidance." In the middle of August he assured Kenneth Koch that "I am barely speaking to Larry still and wallowing in my DECISION. How many times

can you make the same one and call it by the same old name? I am determined to have my next affair with some pleasant (not *necessarily* cheerful) person who is attentive in life instead of art and physically affectionate-in-the-daytime; a tall order among those *we* get to meet, I mean I."

The quotation from Saint-Beuve's life of de Musset typed by O'Hara into his little anthology of lost love had contained the observation, "It is besides never a dishonour to have been loved and sung by a true poet, even if one afterwards appears to have been cursed by him. This malediction is a last tribute. A clear-sighted confidant might say: 'Take care, you will love her again.'" The insight of the "clear-sighted confidant" proved both true and not true in this case. O'Hara did manage to return to a full friendship with Rivers within a year, writing "On Seeing Larry Rivers' *Washington Crossing the Delaware* at the Museum of Modern Art" in November 1955. Because of his tendency to blur the lines between friendship and love, O'Hara had a capacity to cross this line of demarcation with apparent ease and flexibility.

However, after his tormented summer of 1954, O'Hara never let Rivers figure as strongly in his poems, which were mostly concerned, either candidly or secretly, with matters of emotional life and death.

O'Hara spent most of the next year, his twenty-eighth, casting about. He tried to find a way to make financial ends meet by working at different small jobs rather than committing to an absorbing profession that would interfere with his poetry. No longer fueled by his passion for Rivers, his poetry of that year was sparse and fitful. From July of 1954 until the following August he wrote only about a dozen poems; in the same period the year before, he had written over seventy.

O'Hara moved back to East Forty-ninth Street, where he lived alone, as Schuyler was traveling in Europe again with Gold and Fizdale until the following February. Schuyler wrote to O'Hara from England that he was pleased O'Hara had decided to face life on East Forty-ninth Street again. He brightly suggested they buy some white paint for the apartment so that it might look like one of those "smart light flannel suits worn with a fresh white shirt"—a bit of poetic interior decoration. But the transition to the city was difficult, and O'Hara could not shake his depression, which continued throughout the winter. Bill Weaver wrote from Rome on November 21 that "Perhaps the two of us were made to be happy, but not to love. Anyway, I'm sorry your poor little heart has been so busy readjusting." O'Hara was still feeling vulnerable

on New Year's Eve when he attended a party at the home of Gianni Bates, the photographer and set designer, upon the occasion of whose breaking up with LeSueur a year earlier O'Hara had written "To Joe," its title changed later to "Lines to a Depressed Friend." Feeling caught in a world of unhappy romances, his self-pity only increased by all the alcohol he was drinking, O'Hara was quite dramatic that night about his pain. "I had been to a black-tie dinner dance and then stopped by Gianni Bates's New Year's Eve party," recalls Hal Fondren. "The first person I saw was Frank, who was weeping wildly and threw his arms around me. I didn't know what it was all about. I dragged him home. He went to bed. He had a big breakfast, starting drinking the next morning. But he was fully recovered by then. I knew he was having a rocky period in his lovelife."

"I remember a terrible fight and I was in tears because Frank at dinner said, 'Oh you're jealous of Larry and his fame and talent,'" recalls Grace Hartigan. "Now that I've stopped drinking I don't just go bursting into tears. It's like late night in the bar with all the old Irish drunks. That's what crying in your beer is all about. Franz Kline used to cry, and I used to cry, and Frank would cry. That's what alcohol does to you."

No matter how rough the circumstances, or how exaggerated the reactions, O'Hara never stopped working. If O'Hara was a heavy drinker, he was the sort of heavy drinker whose sense of responsibility remained intact and who could continue to function quite successfully in the workaday world. He handed in short reviews each month to *Art News,* mostly unexceptional and official except for a few containing saving metaphoric conceits, such as his assertion that Hartigan's sitters in *Daisy and Olga,* in an October show of "Old and New" at the Tibor de Nagy Gallery, were "almost as Holbein might have done them now (and had he known Beckmann)" or that the "natural violence" in some of Frankenthaler's paintings in her December show at the same gallery evoked in some unexplained way "the compacted sordidness of one of those 'unspeakable' chapters in Henry James." At the intercession of John Bernard Myers, O'Hara also picked up a morning job during November and December working as a secretarial assistant to the fashionable English photographer Cecil Beaton in his duplex apartment in the Sherry Netherland Hotel on Fifth Avenue. Beaton's apartment had a living room and kitchenette on the first floor and a curving staircase up to the second floor where O'Hara worked on Beaton's papers and financial accounts. O'Hara found him to be a very pleasant boss. "It was wonderful of you to be so concise and businesslike about the accounts

as well as faithful and patient in so many other ways," Beaton wrote to
O'Hara from London at the end of December. "I often felt it was an
awful imposition to ask someone of your caliber to do such dreary
chores but I was grateful that you never seemed to mind my asking you
to do any of the ridiculous things. . . . I'm afraid we never got around
to arranging the Edith Sitwell meeting, but if you feel courageous
enough to give her a ring at the St. Regis tell her you are the one I spoke
to her about & arrange a meeting." All that O'Hara seemed to carry
away from his experience as Beaton's assistant was a story he liked to
tell of a party where Beaton rushed to thrust an armful of flowers at
Garbo leaving in an elevator to which Garbo replied, at least in
O'Hara's awfully good imitation: "Beaton, you fool."

In January 1955, O'Hara returned to the Museum of Modern Art,
where he was hired by Porter McCray in the International Program as
a special assistant on temporary assignment to help in preparing an ex-
hibition titled "From David to Toulouse-Lautrec: French Masterpieces
from American Collections," to be shown at the Musée de L'Orangerie
in Paris later that spring. O'Hara's job (at eighty-five dollars a week)
consisted mostly of paperwork—writing business letters to lenders and
paying attention to minute organizational details. Deceivingly organ-
ized, O'Hara's Harvardian side helped him sail through this first as-
signment and prove his administrative abilities. (His listing and dating
skills were reflected in notes for dates kept in increasingly busy agenda
books, as well as in the dating of most of his poems, a habit that ex-
tended to the slightly jokey specifying of times and dates in some of his
"I do this I do that" poems of the late fifties.) At the beginning of April,
after the show had been shipped overseas, O'Hara was promoted to a
more permanent position as Administrative Assistant in the Interna-
tional Program.

The International Program was to be O'Hara's home during much
of his time working at the Museum. Its offices were located on the
street side of the fifth floor of the International Style building housing
the Museum's permanent collection—after 1958 reached by way of a
grand staircase in an elegant old brownstone next door at 37 West Fifty-
third Street—and the International Program's separate location reflected
its somewhat anomalous position within the bureaucracy. Nelson Rock-
efeller, through Director Porter McCray, led the program—operated on
a five-year budget arranged in 1953 by the Rockefeller Brothers Fund—
which was charged with putting together traveling shows to help boost
America's cultural status abroad. McCray pursued this mandate by set-
ting an almost impossible pace for his staff in the first year, shipping

out twenty-five exhibitions, which included "Modern American Painters and Sculptors" and a show of postwar American architecture, "The Skyscraper." McCray's job required a true courtier's instinct for balancing the artistic with the political. Abstract Expressionism was becoming a somewhat unlikely tool of cold-war policy as the Museum backed by Rockefeller tried to prove to the rest of the world that America was not the cultural backwater presented in Russian propaganda. However, contrary pressure was constantly being exerted by the State Department and conservative senators whose notions of art were epitomized by Norman Rockwell's covers for the *Saturday Evening Post*. The government tried to stop the showing of Ben Shahn and Franz Kline abroad because of their alleged Communist sympathies, as well as Willem de Kooning because he was a foreigner. McCray often found himself caught between these conflicting political agendas. Such controversies were made even more difficult for him by jealousy and competitiveness within other branches of the Museum threatened by his program's autonomy, proliferation, and, most especially, its budget for European travel.

Still, the Museum was a much smaller place than it later became. And O'Hara's job was insignificant enough to keep him out of harm's way. He learned from McCray basic museum skills extending from the persuasive wording of letters of request to the physical handling of works of art, including framing, packing, shipping, and examining for damage. O'Hara particularly loved the close physical work, which allowed him to get to know certain paintings and sculpture more intimately. In the early days, O'Hara dressed in khaki pants and a frayed open shirt, rarely tailoring his flamboyant style to a more official one. "I still recall vividly my first real impression of him. . . . one afternoon when we had coffee in the museum's penthouse restaurant," wrote Waldo Rasmussen, who worked in a parallel position under McCray and continued advancing neck-and-neck with O'Hara over the years. "Perhaps I remember it so well because the memory is conflicted: he was in a rather campy, teasing mood, I think, and I felt a little embarrassed and fascinated at the same time." In such an unconventional atmosphere—Alfred Barr was given his doctorate from Harvard for publishing the Museum of Modern Art catalogue on Picasso; his right-hand person, Dorothy Miller, never got her doctorate—it was still possible for a clever, though academically untrained and curatorially uncredited young man such as O'Hara to make his way up through the ranks.

O'Hara's credentials were ambiguous and derived largely from his reviews and his position of respect with many of the painters the Museum was beginning to favor. Certainly the International Program was

dedicated from its inception to the ascendancy of Abstract Expressionism, a cause to which McCray, Rasmussen, and O'Hara were each devoted. O'Hara's position of authority at the Club made him a valuable source of current information on the painters' works. Yet his closer friendship with the younger, second-generation painters was more suspect and their position of favor in the Museum less secure. At a panel at the Club on January 21—less than three weeks after O'Hara began to work for McCray—O'Hara's essay "Nature and New Painting" (published with a drawing by Jane Freilicher in *Folder 3*) was discussed by a panel consisting of Alfred Barr, Jr., Clement Greenberg, and Hilton Kramer that was moderated by John Bernard Myers. Two more panels took up the essay over the next month—one of first-generation painters such as de Kooning and Kline and one of second-generation painters such as Hartigan and Mitchell. Although Barr's comments on O'Hara's essay were not recorded, he was already developing his bias against the second generation of New York artists, many of whom were praised in O'Hara's text. In a talk at the Club a few years later Barr made such doubts explicit by asking, "Is the younger generation rebellious or is it basking in the light of a half a dozen leaders? Are Tenth Street artists living on the energies of the painters of the forties or early fifties?" Such comments created a furor among many of O'Hara's friends. "I remember Barr speaking at the Club," says Hartigan. "I yelled at him but I don't remember what I was yelling at him about." O'Hara's precocious position as a Downtown leader made an impression on the brilliant but sometimes cranky Barr that helped O'Hara's star to rise at the Museum while simultaneously creating suspicion. "He'd always go back to the Eighth Street Club, the collaborations that had gone on between Frank and the others," recalls Porter McCray of Barr's later ambivalence about O'Hara. "He himself had been accused of this over many years in supporting Dorothy Miller's American shows. Then he indulged in this same kind of backbiting with Frank."

O'Hara continued writing for *Art News*, his reviews growing more personal and authoritative. He characterized Salvador Dalí in a review of a January show at Catstair's as "the Marshal Rommel of Surrealism." Also in January, he presciently approved of Robert Rauschenberg's show, at Egan, of collages of light bulbs, doors, and wheels, as well as two sex organs (male and female) made from old red silk umbrellas, writing, "in the big inventive pieces there is a big talent at play, creating its own occasions as a stage does." That same month he picked out for praise the work of Cy Twombly in his first one-man show at the Stable, an impulse he followed through on at the Museum by putting a painting

of Twombly's in the fourth International Art Exhibition in Japan in 1957. "That was very early," recalls Rasmussen. "It looked like a very shocking painting to me at the time. I thought it was a mess. But I saw it recently and it looked like a masterpiece." That O'Hara's critical responses were sometimes equally poetic is shown by his response to Joseph Cornell's show of box constructions at the Stable Gallery in September, for which he wrote a favorable review as well as a poem in two box-shaped stanzas—"Joseph Cornell":

> And in the open
> field a glass of absinthe is
> fluttering its song of India.

Such a blurring of lines between the various parts of his life eventually dogged O'Hara at the Museum. "He would do things that today wouldn't be acceptable for a Museum professional," claims Rasmussen. "He would write occasional essays for gallery catalogues. That would be frowned on today. And I didn't think it was such a hot idea at the time, frankly."

O'Hara was still paying attention to his poetry career and in the spring of 1955 applied for a Yale Series of Younger Poets prize. The editor of the series, W. H. Auden, was a distant and worshipped presence of an ambiguous sort among O'Hara's circle. All of the young poets had been so inspired by his early work that any friendship with him was always a bit strained. When Ashbery asked Koch, "What are you supposed to say to Auden?" Koch had replied that the only thing left to say was "I'm glad you're alive." Gradually, though, because of Schuyler's friendship with Auden's lover, Chester Kallman, he became an intermittent participant in their lives. One night at a party at the painter John Button's where Auden was present, O'Hara gave an impromptu piano recital playing works by Poulenc and Satie. "After Frank had played this French music, it seemed very beautifully, Wystan came up to him and said, 'A for effort, A for effort,'" recalls Kenneth Koch. "Meaning that's the best you can get for playing French composers, you should play German composers. Auden didn't like French music."

Auden's Francophobia surfaced during his judging of the prize that year, an award that included publication of a book of poetry by Yale University Press. Both O'Hara and Ashbery submitted manuscripts. O'Hara's was returned for arriving too late, and Ashbery's was weeded

out by a panel of readers. Auden was unhappy with the manuscripts he finally read and was prepared not to award the prize that year until he heard from Chester Kallman that O'Hara and Ashbery had submitted manuscripts he had never seen. At Auden's request the two poets mailed their manuscripts to the Italian island of Ischia west of Naples where he had been going since the late 1940s. Auden chose Ashbery's "Some Trees," writing an admonitory note of rejection to O'Hara on June 3 in which he criticized both of their works for a French taint: "I think you (and John, too, for that matter) must watch what is always the great danger with any 'surrealistic' style," he warned, "namely of confusing authentic non-logical relations which arouse wonder with accidental ones which arouse mere surprise and in the end fatigue." O'Hara did not seem to take this advice to heart, or at least not the bias behind the advice, as he wrote to Kenneth Koch, "I don't care what Wystan says, I'd rather be dead than not have France around me like a rhinestone dog-collar." He also seemed unconcerned by the loss of the prize to a close friend. His keenest feelings of competition were usually reserved for the actual writing of poems or the winning of love or friendship— matters closer to home. Prizes or publication concerned him as little as grades had at Harvard. "I certainly had no hard feelings about it since Auden chose my manuscript," says Ashbery. "But I don't think Frank did either. That wouldn't have been characteristic of him. He was much less jealous than I, I think." (In addition to the prize Ashbery, who had been writing flap copy and press releases for college textbooks at McGraw-Hill, was awarded a Fulbright fellowship to Montpellier for which he soon departed to write a dissertation on the works of the experimental French writer Raymond Roussel.)

That June Joe LeSueur moved in full-time with O'Hara after grad-uation exercises were completed at Tuxedo Park School. He had no plans of returning to his teaching post and soon found a job at the Holliday Bookshop on East Fifty-fourth Street, a position that had been filled before him by Schuyler. At the beginning of LeSueur's stay he shared a bed with O'Hara, and the pleasure for O'Hara of watching his blond friend asleep in his bed was captured in a sonnet "For Joe," written that month, which began,

> *The blueness of the hour*
> *when the spine stretches itself*
> *into a groan, then the golden cheek*
> *on the dirty pillow, wrinkled by linen.*

O'Hara began doting on LeSueur, praising his back as warmly and unceasingly as he had praised Freilicher's shoulder. The pleasure of this attention from such a charismatic young poet drew LeSueur into an ambivalent relationship—somewhere between friend, lover, and roommate—which continued on without any clearer definition or commitment over the next decade.

"Frank and I always had this undercurrent," explains LeSueur. "He was sort of in love with me I think. I was never in love with him. I was crazy about him. I remember the first time I went to bed with him I was surprised by his body. It was like a bird's. He was very small. At that time he was very sinewy, no excess. It was a very strange relationship. I could never figure it out. It was like having a brother I never had. I had two brothers but I wasn't close to them. Frank had his own brother but he wasn't close to him. Those first years he was wonderful to me. It worked itself out because Frank had other things going on. We even shared the same bed for a long time. I imagine it may have been hard on Frank in some way, I don't know. As I say, he always had some action going on." That is, O'Hara was continuing to carry on affairs with friends, or with strangers he picked up at bars or on the street.

In its earliest phase, O'Hara's relationship with LeSueur fit his usual romantic pattern, which could be summed up by the couplet from Auden's "The More Loving One": "If equal affection cannot be / let the more loving one be me." That his attraction was at least partly physical is evident in "Epigram for Joe" written about the beach the summer before:

> all the salt falling like
> a fountain across your mottled flesh,
> each curling hair unguently draped by
> the shivering sun.

The poem exploits a Greek god motif standard in male homosexual poetry. The ambiguities of their friendship were soon evened out by its practicality, however. LeSueur, like Fondren at Harvard, paid attention to certain domestic realities that O'Hara allowed to escape him. He made it his business to keep food in the refrigerator. He went to sleep regularly at night while O'Hara stayed up talking or drinking. He was a bright and steady companion who could accompany O'Hara through a complex social scene and even take care of him when an alcoholic bend

proved more precarious than usual. Their first summer living together was often punctuated with the sorts of evenings of camaraderie in humid gay bars evoked in "At the Old Place," written in July:

> *Down the dark stairs drifts the steaming cha-*
> *cha-cha. Through the urine and smoke we charge*
> *to the floor. Wrapped in Ashes' arms I glide.*
> *(It's heaven!) Button lindys with me. (It's*
> *heaven!) Joe's two-steps, too, are incredible,*
> *and then a fast rhumba with Alvin, like skipping*
> *on toothpicks.*

Unlike Fondren, whose tolerance for O'Hara's extreme disorderliness had come to an end by the time they both moved to New York, LeSueur was able to take a more humorous view of the attendant chaos. LeSueur has written in a memoir about the deteriorating conditions in "Squalid Manor": "Jane Freilicher agreed with us that we needed somebody to clean up the place, and she put us on to Mildred, a blasé cleaning woman who chain-smoked while she worked. So once a week for about two months—she simply didn't show up one Tuesday and we never heard from her again—Mildred would drop by and leave a trail of ashes through the apartment that testified to her thoroughness. On one of her visits, just as she was leaving, she looked over at the row of empty beer bottles that were accumulating in the kitchen and said, 'Boys, you'll never have to worry about getting up carfare so long as you've got those bottles.' But in those days we didn't worry about anything, not really." LeSueur, who was both domestic and hedonistic, was able to provide O'Hara with the sort of bohemian household he could tolerate, tidy homes being too reminiscent of Grafton.

On August 15 O'Hara took a two-week vacation from the Museum and his life in New York to visit Fairfield and Anne Porter, their daughter Katherine, and James Schuyler, all of whom were summering at the Porters' house on Great Spruce Head Island off the coast of Maine. Porter, a Harvard graduate who was older than most of the other poets and painters in the New York School and who had studied with Pollock under Thomas Hart Benton in 1930, provided an old-fashioned, genteel support. An art critic as well as a painter stubborn enough to continue to paint still lifes and portraits reminiscent of Vuillard during the hegemony of Abstract Expressionism, Porter had helped O'Hara secure his job at *Art News*. (O'Hara's first feature piece for the magazine, pub-

lished in January 1955, was "Porter Paints a Picture," detailing the making of an intimist portrait of the painter's four-and-a-half-year-old daughter.) Porter also lent Rivers the barn-studio behind his house in Southampton, where Rivers's *The Studio* was painted as well as numerous portraits of O'Hara. He was aided in his generosity by his wife, Anne, a poet and a convert to Catholicism who was well read in the medieval mystics. Porter liked O'Hara, although his own Yankee reserve and tendency to grind on philosophically about the destruction of Nature through technology put some distance between himself and the lighter-witted O'Hara. "Fairfield was more admiring of John and Jimmy than of Frank although he liked Frank, who stayed at his house a lot," says Freilicher. "Somehow Frank managed to make himself a member of the family. He could do things very nicely to help, and he had very beautiful manners and a way of easing things over and making things pleasant. But it seemed that Frank's article on Fairfield wasn't the most shimmering piece of appreciation. He didn't turn on the force, turn off the stops, let it flow. They seemed to be very friendly, but Fairfield was this kind of reserved person. He wasn't easily absorbed into the mainstream."

O'Hara, whose general anxiety was always high enough that he avoided taking naps for fear of dreaming, was plagued at first in Maine by nightmares. But he was soon revived by the joys of swimming, diving, hiking, and picnicking reminiscent of his childhood summers on Cape Cod. The fog that rolled in at dinnertime obscuring all but the tops of fir trees on neighboring islands reminded him of Japan seen from the U.S.S. *Nicholas*. During the evenings he and Schuyler and the Porters would sit in a group reading aloud to each other from Stendhal's *The Charterhouse of Parma* much as he and Schuyler had sat reading Chekhov with Gold and Fizdale at Sneden's Landing. O'Hara's eye was never still, and while he was on the island he wrote to Barbara Guest describing the sails of the local boys as "patched together inventively like a combination of Ryan, Cornell and Schwitters." Usually needing to claim a place—as he had claimed New York City—to write about it, O'Hara spent his time reading the works of Laura Riding rather than writing. "I had intended to write some here," he admitted to Guest, "but it's very hard to when you're new in a place so I guess I'll just coast."

To make up for the slack of not writing occasional poems daily, O'Hara had brought along *The Thirties*, a new play he had written for everyone to read. O'Hara had begun writing the play dedicated to John Ashbery at East Forty-ninth Street one Saturday morning and had fin-

ished by cocktail time that afternoon. It was partly inspired by Ernst Lubitsch's *Trouble in Paradise* (1932), which he had seen at the Museum during the week and described in a review in *Kulchur* magazine in the sixties as "the greatest drawing room comedy ever made." "It is called *The Thirties* and takes place in Paris at that time," O'Hara had written ahead to Porter, drumming up interest. "It has 3 acts but is as brief as anyone but the most severe could ask. It should really be called 'Homage à Ernst Lubitsch,' and if Marlene Dietrich, Kay Francis or Elisabeth Bergner took the role it would also have the advantage of lasting a full evening. Otherwise, a half hour! Like the early atonalist composers, I am 'reacting against the divine length' of more talented writers." The play's leading role, for which he was also imagining Lotte Lenya, to whom he had recently been introduced by Herbert Machiz, was an expatriate Russian countess who, according to O'Hara's description in a letter to George Montgomery, "is shot coming out of a ball by an anarchist who is distracted from assassinating the Ambassador by her blinding beauty and knocks her off instead." Unfortunately, on his return to Penn Station he lost his only copy of the play, as well as his suitcase and typewriter. He couldn't find the key to the storage box in which he had stored them when he headed directly downtown to meet Joe LeSueur at the San Remo. John Button and friends took up a collection to buy him a new Royal typewriter but he was never able to reconstruct the play, which had been written in his usual rush of inspiration. Its essence, however—a campy fascination with thirties Hollywood films and movie stars—did find an outlet that November when O'Hara wrote "To the Film Industry in Crisis."

O'Hara wrote two pastoral poems before he left Maine. One is titled "Goodbye to Great Spruce Head Island" and the other, originally titled "To Laura Riding," begins

> As the days go, and they go fast on this island
> where the fir grows blue and the golden seaweed
> clambers up the rocks, I think of you, and death comes
> not

During the fall, however, when O'Hara discovered his great theme and subject of that season he went back and switched the title of "To Laura Riding" to "To an Actor Who Died." (Despite his reputation for simple reporting, O'Hara was quite clever at occasionally fitting his poems into a more entertaining scenario: while Rachmaninoff's birthdate is April

1, the first and last of O'Hara's Rachmaninoff birthday poems were actually written in July; while he claimed that "Second Avenue" was written at Rivers's loft, many parts of the poem, including the typing in of the Haitian newspaper account of Bunny Lang's visit, were written on East Forty-ninth Street; while *Lunch Poems* bears a descriptive account on its back cover of the poet typing poems on his lunch hour on a sample Olivetti, some of the poems were written as far back as 1954 when O'Hara had no lunch hours.)

The subject O'Hara was fascinated with that fall was the death of James Dean, aged twenty-four, on September 30, 1955, in a crash in his Porsche Spyder near Paso Robles on his way to Salinas for a race. O'Hara responded by writing a number of elegies from October through the following April. "For James Dean," written the Wednesday after the crash, shows the influence of classical elegies, which the movie star's death had inspired O'Hara to read, including Milton's "Lycidas," Tennyson's "In Memoriam," and Shelley's "Mourn not for Adonais":

> *For a young actor I am begging*
> *peace, gods. Alone*
> *in the empty streets of New York*
> *I am its dirty feet and head*
> *and he is dead.*

The next day he wrote an elegy—later included as "Obit Dean, September 30, 1955" in "Four Little Elegies"—modeled on the format of Dean's newspaper obituary that simultaneously parodied a classical invocation to a goddess—in this case Carole Lombard: "This is / James Dean, Carole Lombard. I hope / you will be good to him up there."

The following weekend O'Hara accompanied Morris Golde, John Button, and Button's lover, the pianist Alvin Novak, to Golde's simple beach-washed angular wooden home atop a dunish hill on Water Island, a secluded community on Fire Island reachable only by motorboat or beach taxi. There O'Hara plunged more deeply into a poetry of grief and anxiety about death that he hung mostly on Dean's lyrically tragic demise. One afternoon he wrote a poem in the sand that he claimed to later remember and write down verbatim:

> *James Dean*
> *actor*
> *made in USA*

> *eager to be everything*
> *stopped short*
>
> *Do we know what*
> *excellence is? it's*
> *all in this world*
> *not to be executed*

On Tuesday before leaving he wrote a fuller poem in quatrains, "Thinking of James Dean," which alluded to the poem in the sand ("A leaving word in the sand, odor of tides: his name") as well as broadening out the more general awareness of temporality that seemed to be driving these poems:

> *To reach the depths and rise, only in the sea;*
> *the abysses of life, incessantly plunging not to rise to a face*
> *of heat and joy again;*

In the last of these elegies, written the following April, he turned into a stanza of poetry a bit of fanzine gossip gleaned from Joe LeSueur in Los Angeles—"There is an appalling story making the rounds on the West Coast now—Jimmy is not really dead but in the booby hatch, his face ruined beyond repair. Warner's, it seemed (à la Big Knife), thought it better to have him dead":

> *Your name is fading from all but a few marquees, the big red*
> *calling-card of your own death. And there's a rumor that you live*
> *hideously maimed and hidden by a conscientious studio.*

O'Hara's fixation on, and identification with, Dean had begun gaining momentum while Dean was still alive. After seeing *East of Eden* in July, in which Dean plays a character as rebellious as the tender hoodlum he played in *Rebel Without a Cause* released later that year, O'Hara argued with Ashbery over the film's excellence. In the course of their discussion O'Hara came to realize that Dean's Cain character struck chords with his identity within his own family. Writing to Fairfield Porter, O'Hara explained, "John didn't like it and in telling me about it, it was so strange, because the main character, a sort of naughty boy wondering why he's different, I felt very illuminating and even that eerie feeling that I was being exposed to an intimate, scarcely-remembered

level, whereas John identified with his brother, who is treated less fully though equally sympathetically, and didn't like the role he was put in. My own brother was not at all like John or Aaron in the movie, but the relationships and the things said were very close, especially in the father relationship. The movie takes place in California 1917 but the diction I remember in Massachusetts in 1938 was amazingly similar."

O'Hara took this analogy further in the same letter to Porter as he tried to find explanations for what he felt to be the difference between his poetry and Ashbery's, a question raised in part by the Yale Younger Poets prize. "I think one of the things about *East of Eden* is that I am very materialistic and John is very spiritual, in our work especially," O'Hara wrote, casting himself with reverse vanity as the James Dean of poetry. "John's work is full of dreams and a kind of moral excellence and kind sentiments. Mine is full of objects for their own sake, spleen and ironically intimate observation which may be truthfulness (in the lyrical sense) but is more likely to be egotistical cynicism masquerading as honesty. I'm sorry if you're bored by this, but sometimes I think that writing a poem is such a moral crisis I get completely sick of the whole situation. Where Kenneth and Jimmy produce art, for instance, I often feel I just produce the by-product of exhibitionism. Well, chacun à son mauvais goût!"

When "For James Dean" was published in *Poetry* with its title advertised on the front cover the following March, a small controversy ensued. Paul Goodman complained that James Dean wasn't a suitable subject for poetry. Bunny Lang agreed, calling the poem "too out" for publication. A letter printed in *Life* magazine pointed out that the appearance of the poem proved "The James Dean necrophilia has penetrated even the upper levels of culture." "I was as much against his being sentimental about me as I was about his being sentimental about other people," says Kenneth Koch of his feeling at the time about the James Dean poems. "Did the world really hate James Dean because he was good-looking and energetic? I don't know. It seems exaggerated." Even O'Hara confessed in a letter to the composer Ben Weber (whose setting of the second stanza of O'Hara's "Poem" [Here we are again] was published in *Folder* 4 in 1956) that he felt his James Dean poems were "awfully sentimental."

However, many others were thrilled by the poem and its feel of newness and contemporaneity. "Bravissimo for James Dean in *Poetry*," wrote Ned Rorem. Even more pleasing was LeSueur's postcard from California announcing that "James Dean on ouija says he likes poems." Despite the mixed reactions, the James Dean poems were an important

marker in the development of O'Hara's poetry. They introduced a Pop element into poetry that had so far only been hinted at in the artworld through the works of Rivers and Rauschenberg. More personally they allowed O'Hara, whose poetry was no longer inspired by Rivers, to express the sort of frustrated love that seemed to keep him particularly inspired. Dean became for him a screen actor version of the tragic lyric figure personified in literary history by Romantic poets who died young such as Keats and Shelley. The result was a deepening of O'Hara's poetic subject matter to take on the twin themes of love and death with a sentimental directness that set his work apart in style from that of Ashbery, Koch, and Schuyler.

"Some of his themes he removed himself from with irony and some of them he faced head-on," says Hartigan. "He went back and forth with taking it straight. I think that truly how one lives has to do with what you feel about death, whether you're conscious of it or not. The business of a poet is to be conscious of things like that. Frank took up emotional themes in a way that John and Kenneth and Jimmy never did. With the emotional investment that Frank made it was natural that he would. I think he was overly conscious of death. But it was as natural as it would be with Milton or Byron or any of those older poets. The poetic Byronic attitude had a lot to do with death."

In the fall, shortly after O'Hara had written the majority of his Dean poems, Bunny Lang came to stay briefly in his apartment on her way back to Boston. Over the past two years, she had been in and out of New York and in and out of O'Hara's life. LeSueur had never met her, however, and was surprised at her knack, much like O'Hara's, for instant intimacy. LeSueur arrived home one afternoon to the unusual sound of popular music on the radio (O'Hara listened only to classical), the sight of two suitcases and women's clothes strewn over the apartment, and heard Lang calling from the bathtub, "Joey, is that you? It's Bunny. I'm taking a bath, come on in." "Only later did I realize she was neither beautiful nor especially pretty, so disarmed was I by everything about this striking tableau, our grimy, grayish bathtub being a perfect foil for her fresh blond good looks," LeSueur later wrote. "Was she on the fleshy side, were her lips too full, did she seem a little jowly? No matter; who cared? Her compelling brown eyes bespoke such wit and intelligence that you knew without question that here was a blonde with a difference, someone to reckon with and adore. (Is she the only blonde in Frank's poems who's female?) 'Frank told me all about you,' she said with satisfaction, smiling up at me. 'Why don't you make us a drink? And sit there,' she added, lowering the lid on the toilet seat. I

don't remember ever being so quickly won over by anyone, before or since."

One of Lang's favorite comments around Cambridge about O'Hara was: "New York has brutalized Frank!" The judgment was partly a response to her feeling of having been edged out by his new friends and partly a response to her own unhappy experiences in the bigger city. Lang had made her first extended visit to Manhattan in January 1954 when Herbert Machiz, much to her annoyance, directed a production of her play, *Fire Exit*, at the Amato Opera Theatre at 159 Bleecker Street as an Artists' Theatre production. The full three-act verse play was a retreading of the Orpheus myth (particularly chic at the time because of Cocteau's movie) in which Eurydice's Hell is a burlesque house in Union City, New Jersey, where she works as a stripper—an echo of Lang's infamous gig at the Old Howard in Boston. The zither player for the production was John Gruen. "It was decided that the musical score would be played live, during every performance, so for three or four days I found myself the sole occupant of the Amato Opera's huge orchestra pit," Gruen later wrote. "Each night, I emerged from the theatre with bloody fingertips, proud to have been part of what we all thought was a deeply avant-garde production." The play was unfortunately marred for many by its length and pretension.

While she was in New York for this production, O'Hara introduced Lang at the San Remo to his friend the painter Michael Goldberg, and Goldberg and Lang launched into an affair that proved to be disastrous. Goldberg was a young Abstract Expressionist painter who had served as a paratrooper in Burma in World War II and was currently making money working for a paper box manufacturer in Greenwich Village. His heterosexuality and Jewishness and commitment to "the life" as a struggling young bohemian painter appealed to O'Hara, who encouraged him in his work, which was largely unrecognized. Larry Rivers has said that "Frank practically made Mike Goldberg into an artist in the sense that he talked Mike Goldberg into the fact that he was a good painter." Goldberg used to go up to O'Hara's apartment on Saturday afternoons to listen to the weekly radio opera broadcast. Once they even slept together, though with the familiarly undramatic results. "He and I once tried to fuck each other," says Goldberg. "But it was a fiasco. We both hadn't shaved for a couple of days. Both of us started to laugh at the same time. It just seemed funny. Admittedly we were pretty drunk. That was about as far as our sex life got."

O'Hara had persuaded John Myers to give Goldberg's de Kooning-esque paintings their first show in October 1953. It proved to be Gold-

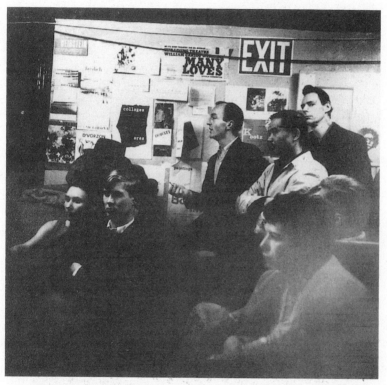

At The Club, with Lucia Dlugoszewski, Joe LeSueur, Mike Kanemitsu,
Ronald Bladen, and Golda Lewis, March 1959

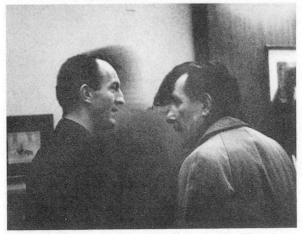

ABOVE: With Franz Kline at the Cedar Tavern, March 1959
BELOW: Benefit reading for *Yugen* with Ray Bremser, LeRoi
Jones, and Allen Ginsberg, The Living Theater, November 2, 1959
OPPOSITE: Regulars in front of the Cedar, 24 University Place,
October 1959

ABOVE: Frank O'Hara at the Museum of
Modern Art with (left) Roy Lichtenstein and
(right) Henry Geldzahler
BELOW: Mike Goldberg at work in his studio—
the inspiration for the O'Hara poem "Why I Am
Not A Painter"

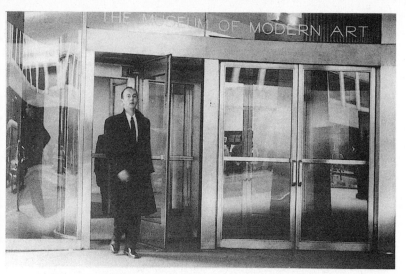

ABOVE: Leaving the Museum of Modern Art, January 1960
BELOW: Julia Gruen's third birthday party, Water Mill, New York, 1961. *Back row* (left to right): Lisa de Kooning, Frank Perry, Eleanor Perry, John Myers, Anne Porter, Fairfield Porter, Angelo Torricini, Arthur Gold, Jane Wilson, Kenward Elmslie, Paul Brach, Jerry Porter, Nancy Ward, Katherine Porter, unidentified woman. *Second row* (left to right): Joe Hazan, Clarise Rivers, Kenneth Koch, Larry Rivers, Miriam Shapiro, Robert Fizdale, Jane Freilicher, Joan Ward, John Kacere, Sylvia Maizell. Sitting and kneeling in front: Steven Rivers, Bill Berkson, O'Hara, Herbert Machiz, Jim Tommaney, Willem de Kooning, Alvin Novak.

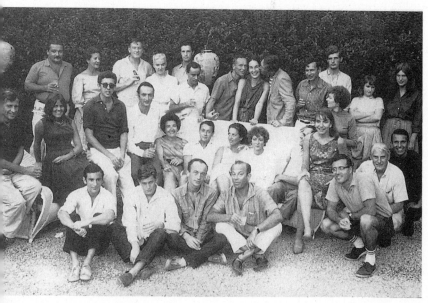

ABOVE: Wagner College Arts Festival—An Evening of Poetry; (left to right): Robert Lowell, Robert Harson, Willard Maas (moderator), O'Hara, and Gerard Malanga, Wagner College Auditorium, Staten Island, February 9, 1962
BELOW: Poet panel at the New York City Writers Conference, Wagner College; (left to right): Gerard Malanga, LeRoi Jones, David Shapiro, Bill Berkson, Frank Lima, and O'Hara, summer 1962

ABOVE: Acrylic on canvas (detail), Wynn Chamberlain, 1963. Seated (left to right): Joe Brainard, O'Hara, Joe LeSueur; standing: Frank Lima

BELOW: Acrylic on canvas (detail), Wynn Chamberlain, 1963.

O'Hara in the kitchen at 791 Broadway, 1963

RIGHT: With Allen Ginsberg at an Ungaretti party. In an elegy, Ginsberg later praised O'Hara's knack for "deep gossip."

BELOW: Reading in honor of Giuseppe Ungaretti (seated at right, in armchair) in a loft downstairs from O'Hara at 791 Broadway, May 2, 1964

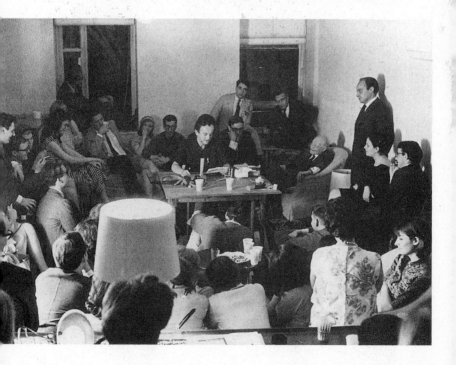

RIGHT: With David Smith at
Bolton Landing, 1965
BELOW: With Vincent Warren,
1965: "together we always will
be in this life come what may"

LEFT: With Robert Motherwell
and Bill Berkson (in background),
Provincetown, 1965
BELOW: Publicity photo taken by Italian
painter Mario Schifano while subletting
the loft with Anita Pallenberg one floor
down from O'Hara at 791 Broadway. The
photograph was meant to spearhead his
ultimately unrealized project of producing
poets' plays at a theater in Rome. (Left to
right): John Ashbery, Frank O'Hara, Patsy
Southgate, Bill Berkson, Kenneth Koch;
with lamp sculpture by Larry Rivers, 1964
BOTTOM: With Elaine de Kooning and
Reuben Nakian at Nakian opening,
Museum of Modern Art, 1966

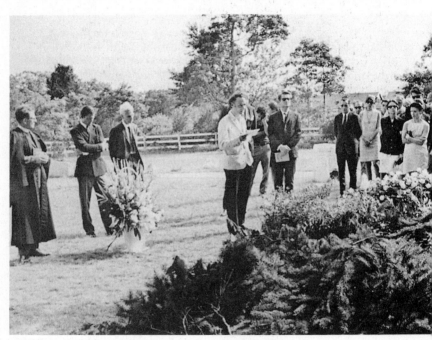

Larry Rivers delivering the eulogy, Springs Cemetery, July 27, 1966; other speakers (left to right): Rev. Renton, Bill Berkson, Edwin Denby, John Ashbery

berg's last show at the gallery, which he claims "at the time was THE interesting gallery." "I was then on two years probation from the courts," recalls Goldberg. "I had forged checks. My probation officer went to see the show. This man told me, 'You know I was looking at your pictures and this fat guy pranced in and said, "Hey, you don't want to look at these. Come in the back and I'll show you some good stuff." It was Johnny Myers. So I ran up to the gallery. I took all my paintings off the walls. I really threatened Myers. I said, 'Listen, when you see me, cross the street or I'll beat the shit out of you.'"

Goldberg's romance with Bunny Lang was marked by similar turbulence as neither of them was given to evenness of temper. (To exact revenge on a man in New York named Parker whom she felt had mistreated her, Lang had once gone to the trouble of pasting pink stickers with the printed message "My name is Parker and I am a pig" on his apartment house door, office windows, and in his local subway station.) Goldberg was serious enough about Lang at first to travel to Boston in April 1954 to ask her rigidly patrician father for her hand. His "beat" presence, however, was a shock to most of her friends, who were taken aback by this black-haired, pasty-skinned, sullen young man, his sneakers spotted with paint, who sat cross-legged on the floor and used hip phrases such as "It doesn't send me." "As they went out," recalled Alison Lurie of their appearance at one party, "he propelled her in front of him with his hand on her neck, as is seldom done in Cambridge, and she let him do it." Her father, however, was not so lenient. Rabidly anti-Semitic, he opposed the marriage. Such pressure and conflict were too much for Goldberg, who returned to New York feeling that he was in over his head. Adding to the complexity of the romance was Lang's health. She was beginning to undergo a series of X rays and blood tests at Phillips House, the private division of Massachusetts General Hospital, for a mysterious ailment that eventually turned out to be Hodgkin's disease.

While Goldberg tried to distance himself from Lang, he continued—to Lang's near hysteria—to see the painter Joan Mitchell. Like Edward Gorey a graduate of Chicago's progressive Francis Parker School, Mitchell had attended Smith College and the Chicago Art Institute. Her affair with Goldberg was grounded in their mutual passion for the paintings of Gorky, de Kooning, and Kline, and both their reputations had also been made early on by having been chosen to appear in the Ninth Street Exhibition of second-generation artists in 1951. Wiry, intense, angular, restless, and blunt, Mitchell invariably wore male attire rather than a dress. Like Hartigan and Frankenthaler, who were

featured with her in *Life*'s groundbreaking article on women painters in 1957, Mitchell obviously had special reserves of strength that she called on to maneuver her way through the definitively macho artworld of the fifties. "When I first hit the artworld in the late forties I was the only woman and I liked it," recalls Hartigan of Mitchell's appearance on the scene. "So the first blow was in comes Helen Frankenthaler with Clem Greenberg. I reluctantly made room for Helen and we actually became very good friends. Then in comes Joan Mitchell. Oi vay! Now we've got three women. So I reluctantly made room for Joan. She really impressed me with her ability to swear. I had never heard language like that coming out of a woman."

Bunny Lang's revenge on Goldberg and Mitchell was much more honed and creative than that against her maligned friend Parker. She wrote a pastoral verse play at their expense titled *I Too Have Lived in Arcadia*, which was awarded a Vachel Lindsay prize by *Poetry* magazine in October 1955. Its action concerns a bucolic life of goatherding led by Damon and Chloris—obviously Goldberg and Lang—until interrupted by Phoebe—obviously Mitchell—a painter and old girlfriend of Damon's from The City, who lures him back. The tip-off to Mitchell's barely concealed identity is a French poodle named Georges who speaks in trendy French. Mitchell did indeed have a poodle named George whom she painted abstractly in *George Swimming at Barnes Hole, but It Got Too Cold*—the painting a subject of "Mitchell Paints a Picture" in *Art News* in October 1957. Most of O'Hara's group felt that the French-speaking poodle was meant at least partly to be O'Hara, the gibe registering Lang's annoyance that he had not entered into the fray on her side.

By the time Lang showed up at O'Hara's apartment in the late fall, however, she had married and been on a honeymoon. Her new husband was a Harvard classmate of O'Hara's, Bradley Philips, the son of a Boston family wealthy enough to allow the newlyweds to take up residence in Oliver Wendell Holmes's library facing the Public Gardens. Characteristically, O'Hara didn't really become part of her married life. However, his sibling bond with Lang was too strong to break entirely. O'Hara's ties with Lang went back to such common references as the black dunce cap decorated with silver bells she once gave him at Harvard, instructing him to wear it whenever he wrote. "It will keep you relaxed," she had insisted, "free from distractions. It will keep away SPOOKS!" Lang suggested that fall that O'Hara apply to the Rockefeller Foundation for a playwright-in-residence fellowship at the Poets Theatre the following semester. Lyon Phelps, as chairman of the

Poets Theatre, was crucial in deciding who would be funded. Lang was applying as well, she cajoled, and perhaps they could have fun together again.

The offer came to O'Hara at the right time. He had written a letter of resignation to Betty Chamberlain, his editor at *Art News,* in October, passing his job on to James Schuyler. "My well has run dry, I'm afraid," he wrote by way of explanation to Fairfield Porter, "and anyway I had no time to write poems and I was getting to feel like a robot. Having time to myself had begun to seem like something that could only happen in Maine." While holding on to his job at the Museum, he had also applied to both Yaddo and the Iowa Writers Conference for a writer's residency in obvious hopes of having time to write. (He was turned down at Iowa by Robert Lowell in a letter that praised, with reservations, "Second Avenue.") A semester in Cambridge held the promise of free time to write poems and plays.

The problem for O'Hara was that his best writing seemed increasingly dependent on his life and friends in New York. For all his complaining, O'Hara had been able to be productive that fall and also enjoy the delicate balance of living with LeSueur on East Forty-ninth Street. Typical of the compatibility between his performance style of writing and his surroundings was his composition of "Sleeping on the Wing" on December 29. "One Saturday noon I was having coffee with Frank and Joe LeSueur, and Joe and I began to twit him about his ability to write a poem any time, any place," wrote Schuyler who was then temporarily living with Arthur Gold on Central Park West. "Frank gave us a look—both hot and cold—got up, went into his bedroom and wrote 'Sleeping on the Wing,' a beauty, in a matter of minutes." Hurried and topical, "Sleeping on the Wing" took off in its opening lines from O'Hara's current reading of a Modern Library edition of *Twelve Famous Plays of the Restoration and Eighteenth Century*:

> *Perhaps it is to avoid some great sadness,*
> *as in a Restoration tragedy the hero cries "Sleep!*
> *O for a long sound sleep and so forget it!"*

However, the poem soon dipped into the same questions and fears concerning the oscillation of life and death taken up in "For James Dean":

> *Dead,*
> *or sleeping? Is there speed enough? And, swooping,*

you relinquish all that you have made your own,
the kingdom of your self sailing, for you must awake
and breathe your warmth in this beloved image
whether it's dead or merely disappearing,
as space is disappearing and your singularity.

In December O'Hara was informed that he had indeed been awarded a fellowship to the Poets Theatre. His reaction to the news was mixed. "It would be lots of fun to be back in Cambridge for a while with you and Bunny both there," he wrote to George Montgomery, "though I do love the skyscrapers and gutters of New York."

Having quit his job on December 23, O'Hara arrived in Cambridge on January 4 for a six-month stay, which proved to be frustrating and disappointing.

On the train to Boston O'Hara already sensed that he had made a mistake. Although he had experienced similar doubts and anxieties on his way to Ann Arbor, he had then believed that he needed to escape from Harvard no matter how enticing his friendships were. Going back, however, was not in character. Feeling especially close to LeSueur and having experienced the excitement of social life among the most ambitious and colorful painters at the Cedar and the Club, O'Hara was not exhilarated to be leaving. Cambridge seemed more of a compromise than an adventure, and O'Hara was no more comfortable with compromise than he was with nostalgia.

"I practically died of lonesomeness for you on the train," he wrote to LeSueur the next day, "and still find life very odd without the prospect of seeing your beautiful self at any moment." His first round of meetings with old friends had done little to dispel his apprehension about the Poets Theatre or about the comparative provincialism of Cambridge: "They are all intense about the theatre and have little battles and factions going on, which I intend to stay out of, partly to save time, partly because it seems dull, partly because it would take a year to catch up on what's already happened." His only consolation on his first night had been a reunion with George Montgomery with whom he was, as he wrote, "getting back into our twin harness a little too fast for decency." Montgomery, however, had only fed his worst fears as they sat over beers at a newly popular bar, the Casablanca on Brattle Street. "He said he's been rather lonely and unhappy here and that he was just wait-

ing for me to arrive to start having some fun," O'Hara wrote to Le-
Sueur. "If Bunny knew about this she'd consider it a big set-back I think
since she's still trying to get me to live in Boston."

For the first three weeks, O'Hara stayed in a large room with eaves
on the third floor of Molly Howe's old house at 58 Highland Street.
Her credentials dated back to acting and writing for Yeats's Abbey
Theatre—and she once dismissed Yeats as "an appalling director."
Howe was the mainstay of the continuously shaky enterprise known
as the Poets Theatre, or more simply "the Poets," and in 1955 she
had ambitiously adapted *Finnegans Wake* for their stage. Her living
room was a prime spot for participants to gather to discuss money,
space, casting, to rehearse and read aloud, or simply to listen to
Howe's outspoken comments on all matters. Among her guests that
January was the journalist Leo Lerman, visiting Cambridge to write
an article on the Poets Theatre for *Mademoiselle,* who caught his first
glimpse of O'Hara through Howe's living room windows. "There
was a great snowfall, one of those extraordinarily glittering snows
we don't seem to have anymore," recalls Lerman. "It was probably
close to midnight. At a certain moment I looked out and under the
lamppost light there was a young man standing reading from an open
book. I said, 'Who's that?' One of the family said, 'He's Frank O'Hara.
He stays here.'" When O'Hara gave a poetry reading with Roger Shat-
tuck during his first week—reading "Invincibility," "To the Harbor-
master," and Kenneth Koch's satire on modern poetry "Fresh Air"—
Howe reacted with her usual edge. She commented to Bunny Lang
afterward, "Frank is the real thing, all right, but he has the terrible
affliction of the Irish—he doesn't trust his heart." Such subtle depreca-
tions from Howe and others seemed to plague O'Hara during his entire
tenure.

Nevertheless the Poets Theatre did exude an incalculably romantic
appeal. Located behind a blue door at 24 Palmer Street—an alleyway
behind the Harvard Coop—and up a rickety flight of stairs, with an
art gallery to the right where tickets were sold and coffee was served
during intermission, the theatre was a claptrap affair. It held only forty-
nine folding chairs, with room for one or two latecomers on the sink.
Its floors were coated with decades of noxious paint from the sign paint-
ers' concern previously housed there. Its spotlights were concocted from
pineapple juice cans. (O'Hara compared the space in size to Julian
Beck's at 100th Street and Broadway near Columbia University.) As no
dressing rooms could be constructed, the players usually buckled and
zipped in front of each other in an antique shop next door, then fidgeted

in their feathers or Puritan headdresses among the garbage cans at the base of a back stairway while they waited for their entrance cues. As Molly Howe recalls, "We had to run through snowdrifts dressed in our Shakespearean costumes." "They never stinted on anything, especially emotion," says Leo Lerman. "Their plays were genuinely poet experiences and had great validity to them. The performers were on the edge, like Judy Garland. You were always expecting disaster, and that lent a curious vitality and suspense."

Nine days after arriving, O'Hara was already back visiting New York, setting up the geographically schizophrenic pattern he followed for the duration. "When he could manage it he stormed back to New York, drank more than I ever saw him drink, and talked about how provincial and boring Cambridge was," recalled Joe LeSueur. Jules Cohn, a friend of LeSueur's who was renting O'Hara's room while writing a Ph.D. dissertation on political philosophy, was a victim of O'Hara's furious swings through town. Having led a relatively sheltered life in New Jersey, he was unprepared for the extreme emotions of O'Hara's life. "He would just come down from Cambridge and take possession again," complains Cohn. "He brought sailors back to the apartment. He cruised the streets. That was one of the things that was really grisly for me. Because it wasn't his apartment. I was renting half of that apartment from Joe. . . . This scene was heavier than I wanted it to be. This way of sex. It wasn't just that it was gay, although that was a big part of it for me, but also that it was so loose, so easy. I remember that there would be strangers there in bed with Frank and they'd be there in the morning. Or he'd arrive at three in the morning drunk. He was usually drunk at night."

Back in Cambridge by January 30, O'Hara vacated Molly Howe's to move into Lyon Phelps's apartment at 1306 Massachusetts Avenue for six months while Phelps worked in New York. The fifth-floor corner apartment was not far from Mower Hall where O'Hara had resided the first semester of his freshman year, the street scene at the entrance to his building a familiar jumble of markets, florist shops, drugstores, shoe stores, cafeterias, and old bookstores. The apartment was unfortunately filled with dreary personal touches left behind by the eccentric Phelps, such as a mahogany coffee table covered with a layer of sand two inches deep. O'Hara's desultory description in a letter to Joan Mitchell of lying in the room hung over "watching the slowly turning reflection of a record disc on the ceiling" gives some sense of the limbo he endured there, his lassitude made worse by writer's block. "Some times it seems to me that I'm operating myself by remote control from a broom closet

in the Empire State Building, but I guess I really am here," he wrote to Mike Goldberg at what he hoped was the end of an unproductive spell. "Before this there were a couple weeks of foul depression, gnashing teeth, pacing and boredom, when I felt that I would never, *NEVER* (like in those movies about concert pianists who've been in an accident) be able to play the typewriter again. But the presence of this Steinway you all gave me has finally asserted itself, and I now stagger from bed, stride to the desk, and begin my scales each morning, or almost each." O'Hara's sense of place was ameliorated by pasting to the wall a photograph of James Dean as well as by hanging a small de Kooning painting of a couch lent him by Fairfield Porter that had hung at East Forty-ninth Street. The painting appeared in "Radio," published in *Poetry* in March:

> *Well, I have my beautiful de Kooning*
> *to aspire to. I think it has an orange*
> *bed in it, more than the ear can hold.*

O'Hara did write a bit during his residency, characteristically finding his bearings by first writing the wintry "Cambridge":

> *The hot plate works,*
> *it is the sole heat on earth, and instant coffee. I*
> *put on my warm corduroy pants, a heavy maroon sweater,*
> *and wrap myself in my old maroon bathrobe. Just like Pasternak*
> *in Marburg*

Living on a grant intended primarily to generate new verse plays for the theatre, O'Hara worked as well in January on a twenty-page three-act comedy titled *The Moon Also Rises,* which Bunny Lang was lukewarm about producing. "I thought of calling it 'The Oriental Weekend,'" O'Hara wrote to Porter, "because all the characters get rather nutty over this Japanese translation that's read to them by their host." The play was lost, however, following into oblivion *The Thirties,* as well as another play of O'Hara's, *The House at Falling Hanging,* which Lang had briefly considered as a double bill with *The Moon Also Rises.* (Inspired by a cocktail party at the precipitous cliff-hanging dwelling of a wall-paper manufacturer in Sneden's Landing, this absurdist play was lost when O'Hara gave his only copy to Julian Beck to consider for a Living Theatre production.) O'Hara's most productive effort during his stay

was the revising, with suggestions from Schuyler and Koch, of his manuscript for the Yale Younger Poets prize, for publication the following year as *Meditations in an Emergency*. The publisher was Barney Rossett at Grove Press—O'Hara's connection being Rossett's brief marriage in the early fifties to Joan Mitchell. Plans had progressed far enough by June for O'Hara to notify Rossett of his decision to dedicate the upcoming book to Jane Freilicher, a gesture she appreciated, writing, "You know I'd love to accept anything from you but most of all the dedication of the book." (Freilicher might not have been so pleased had she realized that O'Hara's dedications were as much epitaphs as love notes—he dedicated *A City Winter* to Montgomery when the two were not speaking and *Lunch Poems* to Joe LeSueur in 1965 after they had stopped living together following an unhappy quarrel.)

Although O'Hara's fellowship never contributed an original play to the Poets Theatre repertoire, he shored up his side of the bargain from April 4 through April 26 by executive producing and appearing as "The Author of the Play" in John Ashbery's *The Compromise, or Queen of the Caribou*. On first reading the play a year earlier, O'Hara had described Ashbery's pastiche on Hollywood Westerns of the golden age as "a miraculous new 3 act play which takes place in the Canadian Northwest and is full of Mounties and Indians. It is more or less of an homage à Rin Tin Tin, with Pirandelloesque touches. It is full of something like fresh mountain air and has a simplicity like quicksand." A high point of the production was George Montgomery's dance onstage in the role of Blue Feather. A low point, according to John Simon then reviewing for a fly-by-night Cambridge drama magazine, *Audience,* was O'Hara's ruminating epilogue in which he "lounges around infinitely more vague and shadowy than any mental image." The writer Arnold Weinstein corroborates O'Hara's general discomfort onstage: "We went up to see him playing in John's mountie play, but he looked as if he didn't like it."

One of the pluses of this go-round at the Poets Theatre for O'Hara was meeting John Wieners, a twenty-two-year-old poet, who stage-managed the production as well as playing one of the feathered Braves. Working at the Lamont Library at Harvard while living in a roach-infested apartment on Hancock Street, Wieners had studied at the experimental Black Mountain College in North Carolina the previous summer—its faculty in the early fifties including poets Charles Olson, Robert Duncan, and Robert Creeley. Under Wieners's influence O'Hara was reading more of Olson's poems, and noticing the strong influence of Pound, he wrote to Koch that he found them "more attractive than

most, tho' ve / ry Ez, and quite sad-making it seems to me." O'Hara
and the young Wieners took a ferry to Provincetown to visit Edwin
Denby, ate wurst at an upstairs restaurant named Joe's, and drank beers
at Cronin's. O'Hara was struck by Wieners's unusual poetry, its vision-
ary exaggerations jiving with his darkly "beat" personal style. "I think
Wieners had a special appeal for Frank, especially his madness," says
Barbara Guest to whom O'Hara mailed a batch of Wieners's poems as
she was then an editor at *Partisan Review*. Wieners recorded the positive
responses of both O'Hara and San Francisco poet Jack Spicer in a mem-
oir: "We had met Jack Spicer previously at the Harvard Gardens and
while I read my poetry in the humid summer evening of Beacon Hill,
the both of them wept through the incipient rain and electric-charged
air." While Wieners's account is freighted with characteristic hyperbole,
O'Hara's poem "To John Wieners" does suggest a somewhat awed re-
action to hearing Wieners reading from his early poems at the Poets
Theatre:

> And one day weeks later the muffler grey and old
> for one so young unwraps its sheaf of poems
> heard already among the sets under the worklight
> a voice is heard though everyone was mumbling
> now so silent that the dark is all blown up

O'Hara mailed Wieners's poems to John Bernard Myers, who had re-
cently started a new magazine, *Semi-colon,* a four-page house organ de-
voted to short prose and poems mostly by New York School poets,
which sold for twenty cents a copy at the Tibor de Nagy Gallery, the
Cedar, and the Club. At O'Hara's behest, Myers accepted "With J. R.
Morton"—Wieners's first published poem.

Another bit player whom O'Hara came to know during *The Com-
promise* was Gregory Corso, a black sheep protégé of Bunny Lang's. In
"To Hell with It," written in 1957, O'Hara included a short glimpse of
a moment in the production: "memories of Bunny and Gregory and me
in costume / bowing to each other and the audience, like jinxes." A
self-taught poet who educated himself in the works of Shelley, Marlowe,
and Chatterton while serving a sentence for theft in Clinton Prison in
upstate New York, the twenty-six-year-old Corso was crashing in
Cambridge at the instigation of Lang who had uncovered him destitute
in New York. Lang insisted that the members of the company take up
a collection for his welfare in exchange for his sweeping the theatre. She

also arranged for him to stay in the room of Peter Sourian, a young Harvard novelist, who compliantly constructed a tent of dyed sheets on metal poles for the unlikely guest in his room in Eliot House. Corso hardly helped to conceal his fugitive presence. Invariably dressed in black and usually scowling, he confronted Archibald MacLeish in the Eliot House dining hall early on, informing him, "You're not a poet!" The previous year Corso had written a one-act play for the Poets Theatre, *In This Hung-Up Age,* its title and dialogue as hip as the language used by Damon in Lang's play, in which Beauty is presented as a pill-popping saxophone player juxtaposed to Poetman, a "little-magazine type with social complaints." In 1955 Corso published his first book of poetry, *The Vestal Lady on Brattle,* which included a poem "For Bunny Lang." O'Hara, for whom Corso cut a romantic figure, praised this book in an unpublished review for having "adopted successfully the rhythms and figures of speech of the jazz musician's world without embarrassment." This championing of Corso—as well as Wieners— continued over the next few years and helped establish O'Hara's link (exceptional among the New York School poets) with the so-called Beats. "Frank admired Gregory's poetry and Wieners's and I think that's what locked me into him," says Allen Ginsberg. "I was amazed he was so open and wasn't just caught in a narrow New York Manhattan Museum of Modern Art artworld cocktail ballet scene."

On one of O'Hara's parched visits to New York in late April he took Wieners along with him to see a performance of Samuel Beckett's *Waiting for Godot,* starring Bert Lahr and E. G. Marshall, at the Golden Theatre. Steeped perhaps for too long in the productions of the Poets Theatre, O'Hara, who had already discovered the relatively unknown writings of Beckett in his Harvard days, felt more moved by the stark tragicomedy than by any artistic event of the season. "I didn't have a chance to tell you how much I loved *Godot,*" O'Hara wrote to Joan Mitchell on May 4. "As a matter of fact it completely stopped me from working; whistling in the dark hardly ever gets to be music, alas, and who needs mine when they've got his. I guess it's good to know what you're up against, but it's not very painless. I came back and found my work sitting here waiting for me, all right, but it had turned into a pile of shit." O'Hara's swooning enthusiasm for the play set him at odds with Kenneth Koch who liked making comments such as "Why do you want to see all those sick people walking around onstage?"

O'Hara's last official task after returning to Cambridge was to help paint sets for a production of Cocteau's *Orpheus,* translated and directed by George Montgomery, that opened on May 14. By the time the play

closed—dismissed by John Simon as "a proem in pose"—O'Hara's experiment at leaving New York for Boston had come full circle and evidently failed. He had written of Cambridge to Grace Hartigan in early February, playing a variation on his own urban pastoral "Meditations in an Emergency," "it's not hot enough, it's not crowded enough, there's not enough asphalt, and you can see over buildings too easily." In May he was still bemoaning his paltry few poems. "Not that my virtuous return (?) has produced much either; it hasn't," he wrote to Joan Mitchell. "It just won't happen, whatever it is I want to happen, that is."

By June 15 O'Hara was recuperating at George Montgomery's farmhouse in Sandwich, New Hampshire, from the experience of being a writer-in-residence—something he would never do again. The rustic mood of the retreat with its meditative calm, as well as the enticing distraction for O'Hara of a motorcyclists' rally taking place in nearby Laconia, was summoned up in "A Raspberry Sweater," dedicated to Montgomery:

> And in the pale New Hampshire
> twilight a black bug sits in the blue,
> strumming its legs together. Mournful
> glass, and daisies closing. Hay
> swells in the nostrils. We shall go
> to the motorcycle races in Laconia
> and come back all calm and warm.

O'Hara, who woke up refreshed around five o'clock every morning, was mostly confined to the house, with its privy in the barn nibbled away by porcupines. He passed the time leafing through fifteen-year-old *Life* magazines and reading Proust's *Remembrance of Things Past*.

The influence of Proust's novel, built so much on the ironies of unequal love, pushed O'Hara to think about the matters of the heart that had so concerned him over the past few years. It was as if Cambridge had never happened. The stuff of his deepest concerns, and of his poetry, had taken place in New York, and no significant new friendships over the past six months had softened the craters left by those emotional crises. "I think Proust is ruining me, since when one is not actively reading him one seems to be unconsciously scrutinising one's own experiences and particularly one's motives (ugh!) and finding them unworthy," he wrote to James Schuyler from Sandwich. "For example it may be that where I acted like Marcel with Larry, I acted like Alber-

tine with Bobby and with Jane continue to act like the Prince de Guermantes to her Oriane, unconsciously heightening my own vulgarity to make clear to others my admiration and appreciation of her superior sensibility, sensitivity and wit (superior to my own, that is)."

O'Hara's dwellings on Proust's meditation on romantic longing and its relation to time and life led him to a sharply accurate perception of his own behavior—the sort of perception that could have provoked change if the sheer poisonous pleasure of the insight had not been nearly sufficient for him. "From all this, it is only too apparent what is occupying my mind these days while I make 'real life' into a fantasy which bears little resemblance to the actual and largely fortuitous events which inspired it in the first place," he continued in an unusually long letter to Schuyler. "All anyone has to do is smile and I'm off on an elaborate trip, accompanied solely by myself as usual. Crash! there goes the front tire. And here I am in the middle of the Arizona desert with no spare, out of gas, and hiking towards the nearest roadside lunch counter where I will find the cast of *Petrified Forest* waiting to begin the action when I ask for a cup of coffee."

The last week in June O'Hara returned with renewed zeal to New York City which he would describe six weeks later in "A Step Away from Them" (arguably his first "I do this I do that" poem) as a sort of surreal architectural folly in which girls' skirts flip up above their thighs like Marilyn Monroe's in the box-office poster for *The Seven-Year Itch*, Negroes pick their teeth beneath the fake waterfall of the Bond's sign on Times Square, and construction workers drink Coca-Cola while wearing yellow helmets, all at "12:40 of / a Thursday."

I Do This I Do That

On what was believed to be O'Hara's thirtieth birthday in 1956, Grace Hartigan threw a party for him at her studio. *Folder* editor Daisy Aldan discovered him crying and asked why.

"Because today I am thirty years old and have so little time left," he explained, sipping a drink while mourning his own death as intensely and romantically as he had mourned James Dean's a year earlier. "Chatterton died at eighteen. Keats at twenty-six."

The same day he began "In Memory of My Feelings"—a poem dedicated to Grace Hartigan that he wrote by leaving a page rolled in the typewriter to which he returned intermittently over the next four days. The poem alludes now and then to Hartigan, his female muse of the moment. The implicit pun in her first name is played on in the line used a decade later as the epitaph on his tombstone—"Grace / to be born and live as variously as possible."

O'Hara was not satisfied with the poetry he had been writing. He wrote "In Memory of My Feelings" as a new beginning, a departure. He broke through the sheer language, which Ciardi had described as a

"wall around him" at Harvard, to an abstract expression of his entire life, to serious autobiography. The poem, which sets up a tradition for his later long birthday odes to Michael Goldberg and Bill Berkson, has its roots in his early family life in Grafton, concentrating especially on its deaths:

> *The dead hunting*
> *and the alive, ahunted.*
>
> > > *My father, my uncle,*
> *my grand-uncle and the several aunts. My*
> *grand-aunt dying for me, like a talisman, in the war,*

But these family snapshots are quickly mingled with Expressionist dream material, O'Hara's casting himself especially as his favorite personal totem—a rattlesnake. The conflict in the poem is between the passing occasions of love in life (shed like the skins of a snake) and the more lasting dead statues and friezes of art:

> *I have forgotten my loves, and chiefly that one, the cancerous*
> *statue which my body could no longer contain,*
>
> > > > *against my will*
> > > > *against my love*
>
> *become art,*
> > *I could not change it into history*
> *and so remember it,*
> > > *and I have lost what is always and everywhere*
> *present, the scene of my selves, the occasion of these ruses,*
> *which I myself and singly must now kill*
> > > > *and save the serpent in their midst.*

O'Hara's running anxiety in this poem about being suddenly extinguished—"and animal death whips out its flashlight"—was only corroborated and deepened by events of the next six weeks. The first, and most upsetting, was the death of Bunny Lang at the age of thirty-two on July 29. While Lang's Hodgkin's disease had been gradually getting worse, she refused to admit to its seriousness, wishing to avoid being treated like a victim. Her tone remained that of her letter to Larry Osgood in which she complained of having contracted "a real dandy of a disease," which she could only fully discuss with a friend who was

dying of cancer. "He looks terrible but then so do I and we enjoy each other's company," she reported a bit flippantly to Osgood. "You see you do not change and it is not that we want to talk about death or the Things That Matter but simply that we now find immensely comical subject matter in things that make other people extremely uncomfortable." That her underlying feelings on the matter could be more gripping was obvious from *I Too Have Lived in Arcadia*, her pastoral play, described by O'Hara the following year on the occasion of its production at the YMHA Poetry Center as a "modern 'Shepheards Calendar'" in which "There on their island the City presses down upon them, initiating the failure of love, which is death." Seeing or reading the play once again, her friends could now realize that between the lines of satire on Goldberg and Mitchell Lang was speaking to them of her sense of her own impending death, flashing feelings of fear and resignation and resolve in a poetic Morse code that culminated in the play's last line: "And North North North, we'll point for home."

Like most of Lang's friends, O'Hara was taken by surprise at the news of her death. He had been tentatively planning a trip north that month to visit Lang and Philips in their summer home off the shore of Marblehead. But Lang slipped quietly into the hospital in early July and died three weeks later. "I learned about Bunny's death last week," LeSueur wrote condolingly from California. "I am glad Don Berry [a painter O'Hara befriended in Cambridge] was with you at the time, to make it less painful, and that Jimmy had come in the day you received the news. It's impossible to regard her death. . . . or Jimmy Dean's for that matter, with philosophical discipline." O'Hara flew up to Boston for the funeral in a small plane with Frederick English and Harold Brodkey, who recalls that O'Hara "cried and cried and cried." Services took place in Christ's Church, Cambridge, where Lang had been married a mere sixteen months before and where she had played Violet five years earlier in the Poets Theatre's first parish basement production of *Try! Try!* As organ music played, the Reverend Mr. Kellogg finished delivering his standardized eulogy over her purple-velvet-draped casket, and the mourners piled into cars and funeral sedans for the long drive up Brattle Street to Mount Auburn Cemetery where she was buried in a family plot.

O'Hara mourned Lang's death for the rest of his life. Ten years later he still kept a photograph of her next to his typewriter on his writing desk. The poet Bill Berkson recalls an evening in the early sixties when "Frank cried like crazy on his Ninth Street bed about Bunny Lang. . . . I was scared for him. I'd never seen anyone act like that." While O'Hara

had been less available than Lang had wished in the years following his departure from Harvard—and even during his residence earlier that year at the Poets Theatre—he was absolute in his expression of grief and affection for her after her death. She became his angel of death. In "The Unfinished," written in February 1959, he admits to "weeping over a 1956 datebook" and recalls looking for Gregory Corso in Paris "in the Deux Magots because I want to cry with him / about a dear dead friend." His attitude toward her death could veer from wisely philosophical to unrestrainedly sentimental. In "Ode to Michael Goldberg ('s Birth and Other Births)" he was savvy about his mourning: "you suspect that you are jealous of this death." In "To Violet Lang," however, written a month after "The Unfinished," in William Carlos Williams's triadic verse, O'Hara's grief was almost maudlin—stripped apparently of the consolation of his *Voice* memoir that "gradually that clear image of herself which is her work will be the sole image, a beautiful image, faithful to the original":

> *My darling*
> > *it would have been no sacrifice*
> > > *to give my life*
> *for yours*
> > *I wish, I am, waiting for you*
> > > *on the "other side"*
> *offering you a bath*
> > *and my new poems to read in it*
> > > *everything is gone*
> *except you, really you, you are always with me*

With Lang's death O'Hara came to grapple with the notion expressed in the title of his grieving poem dedicated to her, "The Unfinished." She was obviously someone with enormous talent who had not had time to make a coherent statement out of her many talents. When Bradley Phillips took on the job of editing a book of her poems and plays, O'Hara reacted against the idea of trying to finish what was authentically unfinished. Revealing something about his opinion of his own irregular poems, O'Hara counseled against tidying up. "Bunny and I often discussed the thing about 'finished' and 'unfinished' poems, to the effect that we both felt that the poem sometimes finished itself before we realized it or before we had wanted it to," he wrote in August

to Larry Osgood who was helping with the editing. "Sometimes the dissatisfaction which leads one to put something away for a few weeks and look at it later is not that the work is unfinished, but the inspiration is unfinished. You look at it later and realize that it is complete, and meanwhile the dissatisfaction has disappeared because it was part of the occasion rather than real critical response. It would be a shame if the poems that she had 'given up' on were excluded."

A week after Lang's death, O'Hara along with James Schuyler went to recuperate at Morris Golde's on Water Island. This tragedy had been doubled for all three earlier in the week by news of the death of thirty-eight-year-old John LaTouche from a reported heart attack at his summer home in Calais, Vermont. There turned out to be little time for healing and consolation, however. Schuyler was beginning to dip in and out of the schizophrenic episodes that plagued him during much of his life—and that later resulted in his "The Payne Whitney Poems" (1975) as well as in a few breaks during which he felt he saw visions of the dead Frank O'Hara. (One such incident was mentioned in Ron Padgett's "Poem" written in the summer of 1971: "the way Jimmy, stark / naked with rose petals / stuck to his body, / said, 'Have you seen / Frank? I heard / he's in town tonight.'") During this overcast and emotionally strained weekend, O'Hara guarded the fine details of Schuyler's condition from their somewhat puzzled host. "Frank took care of him like a twenty-four-hour nurse," recalls Golde. "He was absolutely devoted to him. He said, 'We need Miltowns. Do you have any Miltowns?' I said, 'We never use things like that.' He said, 'Well Morris, we need some.' The island was under one of the heaviest fogs I'd ever seen. But Frankie's power was such that I went out into the fog." Setting out in his Chriscraft to search for the tranquilizer, Golde luckily crossed the path of the captain of a larger pleasure boat who replied to his request: "Miltowns! We use it as ballast!"

That Sunday the already bedraggled group received news of forty-four-year-old Jackson Pollock's fatal crash the evening before on Fireplace Road, three miles north of East Hampton, while on his way to a concert at the house of painter Alfonso Ossorio. The event was reported on the front page of the *New York Times* as part of a more general article on two crashes that had caused eight deaths that night in the Hamptons. The somersaulting of Pollock's convertible caused injury to his girlfriend at the time, Ruth Kligman, who was hurled out into the woods while a friend of hers riding in the back seat, Edith Metzger, was killed instantly when the car, to which she was clinging, finally crushed her. (O'Hara in one of his nastier-tongued moments later nicknamed Klig-

man Death-Car Girl and the nickname stuck.) The triple tragedy of these premature deaths set O'Hara's circle into a period of mourning that continued for several weeks. As O'Hara wrote on August 22 to Howard Kanovitz, about whom he was trying with great difficulty to compose a one-paragraph essay for the catalogue of a September show at the Tibor de Nagy: "what with depression and everyone dying it has been hard to do." Strangely, the news of Pollock's accidental death had come to O'Hara at the same Water Island house where he had mourned the more distant car crash of James Dean a year earlier. Pollock's own crash similarly canonized him for the already admiring O'Hara.

If these deaths paralyzed O'Hara's critical hand, his poetic sense of inspiration was set in motion. In "In Memory of My Feelings" he wrote about the fragility of life, something felt at this point by all of O'Hara's close circle of friends. What was abstract had become more vividly real. And so O'Hara's response the following Thursday, August 16, was to write "A Step Away from Them," his most "figurative" poem to date. It was the first of the poems he would describe as his "I do this I do that" poems. (He used the phrase in 1959 in "Getting Up Ahead of Someone (Sun)": "I make / myself a bourbon and commence / to write one of my 'I do this I do that' / poems in a sketch pad.")

"A Step Away from Them" follows O'Hara in handheld camera fashion, wearing his trademark seersucker Brooks Brothers jacket with a volume of poems by Pierre Reverdy stuck in its pocket, as he heads on his lunch hour west and then downtown from the Museum, past construction sites on Sixth Avenue, through Times Square where he stops for a cheeseburger and a glass of papaya juice beneath the Chesterfield billboard with blowing smoke, and then back uptown to work. In the writing of the poem O'Hara left a record for history of the sensations of a sensitive and sophisticated man in the middle of the twentieth century walking through what was considered by some the capital of the globe. Using a deceptively flat pedestrian voice—"It's my lunch hour, so I go for a walk among the hum-colored / cabs"—O'Hara discovered a new kind of pleasure in writing a more public poetry. As Allen Ginsberg later told an interviewer, "He integrated purely personal life into the high art of composition, marking the return of all authority back to the person. His style is actually in line with the tradition that begins with Independence and runs through Thoreau and Whitman, here composed in a metropolitan spaceage architecture environment. He taught me to really see New York for the first time, by making of the giant style of Midtown his intimate cocktail environment. It's like having Catullus change your view of the Forum in Rome."

O'Hara was fired by the challenge of finding the good in the bad, the poetic in the mundane, the ancient and divine in modern New York. His tendency, like Whitman's, was to mythologize its daily life. In "A Step Away from Them" even construction workers—staples of the midtown terrain—are made to seem mysterious and glamorous and tropically sexual:

> First, down the sidewalk
> where laborers feed their dirty
> glistening torsos sandwiches
> and Coca-Cola, with yellow helmets
> on. They protect them from falling
> bricks, I guess.

Likewise the growing Puerto Rican population of the city was assimilated in the poem—this latest in a series of mass migrations of ethnic groups having just peaked in 1953: "There are several Puerto / Ricans on the avenue today, which / makes it beautiful and warm." O'Hara had first sounded this theme a month earlier when he and John Button sat on a fire escape composing a collaborative letter to Schuyler written in gay slang about the recent fire at Wanamaker's Department Store to which O'Hara contributed the line, "And the Porto Ricans seem to be having such a swell time in the street outside." Kenneth Koch grounds the line to a recent incident of heckling from a group of Puerto Rican boys. "We were walking up Sixth Avenue going to Larré's to lunch," recalls Koch. "It was a really hot day. There were these Puerto Rican guys on the street who made some remarks which made me angry. I said, 'Shit. Damn it.' Frank said, 'Listen. It means they think we're attractive.'" O'Hara's libidinal fantasies and poetic fancies were equal and intertwined enough that he could see what he wanted to see, or needed to see, on the lunch hour streets.

Part of the novelty of O'Hara's poem—published a year later in *Evergreen Review*—was that nothing seemed made up. Reporting his stop at a greasy spoon, Juliet's Corner, O'Hara follows with "Giulietta Masina, wife of / Federico Fellini, *è bell' attrice*." The association had surfaced because of his viewing *La Strada* a few weeks earlier. "John Button and I saw one of the all time great movies the other day, *La Strada* and man, was it ever!" he reported to John Wieners, then at Black Mountain College. "It has Anthony Quinn, Richard Basehart (what a nice last name) and someone named Giulietta Masina who is a genius,

she's the End. Also the director, Federico Fellini, seems to have a few insights into the soul not often granted by the Heavenly Hiders." O'Hara's adoration of Masina reached its peak a few years later when he met her at the home of the Italian countess Camilla McGrath, who translated as O'Hara—his hero worship always to the far side of theatrical—fell to his knees in front of the actress and gushed, "You are not simply a great artist, you are a fact of our lives!"

The true subject of the poem, though—like that of the equally ambulatory "The Day Lady Died" three years later—was revealed in its title. In "A Step Away from Them," written the day after Jackson Pollock's funeral in the Springs, O'Hara was feeling keenly the proximity of the line of death over which his three friends had so recently walked, or slid:

> *First,*
> *Bunny died, then John Latouche,*
> *then Jackson Pollock. But is the*
> *earth as full as life was full, of them?*

His reactions were not morose or baleful. Rather, the closeness of death, the personal awareness of decay and change, of "the Manhattan Storage Warehouse, / which they'll soon tear down," only made him feel more alert to his surroundings. He began to seize on moments, and street markers, and tiny objects such as wristwatches, with a new intensity in a poetry increasingly celebrating the dailiness of everyday. It was a poetry in which, as he put it in a later essay on Edwin Denby's dance criticism, "attention equals Life."

O'Hara had learned his lesson during his recent stay in Cambridge. New York was the place for his poetry and life. Settling with a newly energized commitment into his job at the Museum, where he would remain until his death, O'Hara also settled more deeply into his poetry. Writing "In Memory of My Feelings" and "A Step Away from Them" during the first six weeks of his return, he laid out the two productive directions of much of his work over the next three years. "In Memory of My Feelings" leads toward the abstract emotion and large scale of the *Odes* (published in 1960), and "A Step Away from Them" leads toward the smaller, more intimate "I do this I do that" poems, which most directly influenced the "second generation" of New York School poets who began showing up at O'Hara's door in the early sixties.

In January 1957, O'Hara finally moved Downtown with Joe LeSueur. The move was difficult, as the two roommates had found a comfortable balance on East Forty-ninth Street. "By that time we'd pretty well worked out things between us—which is to say, we went to bed together every so often," explains LeSueur. "It would happen casually and unexpectedly, and afterwards, like adolescents on a camping trip or buddies in the service, we did not acknowledge we'd been intimate. Yet for us, I believe, those seemingly chance encounters served a purpose, that of renewing and strengthening our ties while at the same time preventing Frank's and my boyfriends from coming between us. Maybe not an ideal situation, but we were reasonably comfortable with it—and extremely comfortable with each other, so much so that we sometimes wore each other's clothes; that was how close we'd become. And happy."

However, in the fall Schuyler moved back into the apartment after the breakup of his affair with Arthur Gold. Unfortunately he was still suffering from the severe personality disorder that had been apparent at Water Island, which cast an increasingly uncomfortable pall over their cramped quarters. LeSueur claimed to be the recipient of demonic "black looks" from Schuyler. As the tidiest of the three, he felt compelled to clean up Schuyler's crusted empty glasses of buttermilk and coffee mugs strewn throughout "Squalid Manor." Having had his bedroom reclaimed, he was now forced to sleep every night—not just on midsummer nights—in O'Hara's bed. Exhausted by these changes, LeSueur finally declared, "I think I'd better get a place of my own." O'Hara responded quickly: "Don't leave without me!" It was many years before Schuyler stopped blaming LeSueur for a maneuver he perceived as the stealing away of O'Hara.

"Jimmy seems to resent our moving somewhat, but I no longer see anything to do," O'Hara wrote to Koch, who was then in Rome. "His analysis seems to be going okay, but confidentially I have found it rather depressing myself, and have tended to go out too much, etc. . . . I guess I'm worried about leaving him alone (which isn't actually necessary either, since George Montgomery is looking for a place in New York and Cy Twombly wants to move uptown and share a place with someone), although I know he wants to be a great deal of the time and finds it difficult to work if we are around. And not working, he is alone enough—but when are Joe and I supposed to have a little solitude? I

think it's all for the best, anyhow, and am clinging to my self-interest like Ishmael to his spar."

O'Hara and LeSueur jumped at the opportunity when Mike Goldberg told them of an available coldwater two-room apartment on the third floor of a colorless brick building at 90 University Place, in what O'Hara coyly described to Koch as "the free, glamorous Village." The apartment was far from deluxe. The thin partitions between their rooms did not allow for much privacy, they shared a toilet in the hallway with a neighboring dancer, and the one gas heater did little to keep out the winter cold. But the location on Twelfth Street a few blocks up from the Cedar was ideal. And there was plenty of wall space for hanging pictures: "It also has a fireplace over which the de Kooning now lounges free from any fear of smoke or dust since the fireplace is sealed up." O'Hara felt satisfied enough by his new quarters to write the poem beginning "I live above a dyke bar and I'm happy." The rent was poetic, too, in its spareness, although even then the consistently broke O'Hara sometimes had to borrow from LeSueur, as documented in "Ode to Michael Goldberg": "and the rent / is due, in honor of which you have borrowed $34.96 from Joe."

O'Hara's move to University Place was accompanied by an inner move to handle his sexual appetite differently. The catalyst was an evening a few months earlier spent at the San Remo with Auden's lover, Chester Kallman, who was notorious at the time for picking up sailors or, less luckily, undercover police officers trying to entrap homosexuals. "He was always picking up detectives and taking them home and then they'd flash their badge on him," reports the poet Edward Field. "Auden had to buy off so many judges that he finally got him out of the country." On this particular evening Kallman was regaling everyone with a particularly graphic story about bringing a hustler back to the apartment on St. Mark's Place. When LeSueur and O'Hara finally exited the bar and climbed into a taxi, LeSueur annoyedly remarked, "Promise me something. If you ever catch me talking the way Chester did tonight, get a gun and shoot me. Don't ask me if I want to be shot, just shoot me."

A few months later, LeSueur noticed that O'Hara was no longer engaging in the sexual exploits he had so often dared when they were living on East Forty-ninth Street. "You're partly responsible," O'Hara explained. "I thought about it a lot, and about the way Chester talked, and I decided I didn't want to be like that." O'Hara's decision was not to renounce sexual encounters altogether but simply not to cruise the streets or sleep with strangers. Instead he embarked on a life just as

promiscuous, in which he went to bed with his friends. For all his complaining about his supposed lack of will, O'Hara followed through on this vow as rigorously as any member of a religious order. According to LeSueur, "This was in 1957, and to the end of his life, so far as I know, he never had sex with a stranger again."

O'Hara simultaneously increased the attention he paid to his friends in his poetry. Enclosing two recent poems, "Poem Read at Joan Mitchell's" and "John Button Birthday," in a letter to John Ashbery in March, he self-protectively wrote, "In order to show you what I've been up against (sand in the brain) I'll enclose my two latest efforts and perhaps you can tell me where I went off onto the dirt road. It may be that remark of Goodman-Goethe: 'Occasional poetry is the best kind.'" The first of these occasional poems—"Poem Read at Joan Mitchell's"— had been written and read at a party on February 16 in honor of Jane Freilicher's marriage to Joe Hazan. Patterning it after Apollinaire's "Poème lu au Mariage d'André Salmon" of July 13, 1909, O'Hara, too, chose friendship as his theme. But given the complications of his friendship with Freilicher over the past few years, his lines were tinged with loss as well as happiness:

> *This poem goes on too long because our friendship has been long, long,*
> *for this life and these times, long as art is long and un-*
> *interruptable,*
> *and I would make it as long as I hope our friendship lasts if I could*
> *make poems that long*

"The poem was very nice, but somehow I felt there was a certain resignation in the tone," says Freilicher of its double edge. This ambiguity was inevitable given the clutch of abandonment accompanied by snobbish disapproval usually felt by O'Hara when one of his close women friends finally married.

Less shadowed was O'Hara's straightforward poem of friendship written for John Button's birthday the following month. A figurative painter from San Francisco who showed at Tibor de Nagy and worked O'Hara's old post at the front desk of the Museum, Button was fast, irreverent, and witty. "He was very much in the style of Frank O'Hara," recalls John Gruen. "Wonderfully flip and naughty and hysterically funny. They were radiant in their queerness." Button, who was likely to start singing his favorite "Cleopatra had a jazz band," was definitely O'Hara's trustiest collaborator in the camping mentioned in

"John Button Birthday": "the tenting / tonight on the old camp grounds." O'Hara's innovation in this poem of gay friendship ("the laughing in bars till we cried, / and the crying in movies till we laughed") was to weave his "I do this I do that" style into an occasional poem by interrupting its flow every so often to comment on his own lapses into mundane life: "And now that I have finished dinner I can continue," or "Now I have taken down the underwear / I washed last night from the various light fixtures / and can proceed."

O'Hara's innovations in his poetry were matched by new tasks at work. His boss, Porter McCray, sensed that his return to the Museum marked a more serious availability for longer-term responsibilities. Believing O'Hara "too brilliant and too creative" for secretarial work, he immediately gave him some important assignments. The first was to select paintings to represent the United States in the Fourth Annual Art Exhibition of Japan, which opened in Tokyo in May 1957. For this exhibit of fifteen paintings by fifteen painters, O'Hara chose a mixture of second-generation Abstract Expressionist and figurative painters including Frankenthaler, Goldberg, Goodnough, Hartigan, Elaine de Kooning, Leslie, Mitchell, Pace, Parker, Resnick, and Rivers. Proving at once his considerable abilities as a talent scout, he also included a few "discoveries" who had only recently had their first New York one-man shows—Cy Twombly, Richard Diebenkorn, and Jan Muller. Sam Francis, who was living in Japan and quite well known, won a prize, but otherwise the exhibit went largely unnoticed. For O'Hara, though, the promotion from the job of typing identical copies of letters (in the days before photocopying), which had made up the bulk of his work on the "French Masterpieces in American Collections" show, was a relief and a stimulation.

O'Hara's next assignment was to curate the fourth Bienal in São Paulo opening in September 1957. This exhibition was more complex than the one in Tokyo and a more decisive test of O'Hara's curatorial skills. The show was in two parts: a retrospective of Jackson Pollock (which toured Europe afterward) and a group show consisting of four or five works each from painters Brooks, Guston, Hartigan, Kline, and Rivers and sculptors Hare, Lassaw, and Lipton. The choosing of the artists was handled by a committee made up of McCray, James Thrall Soby, Dorothy Miller, and Sam Hunter—O'Hara being a junior member. O'Hara mostly agreed with the choices of the board although he did complain in a letter to Ashbery that "I would have preferred another artist in one or two cases which you can readily guess."

With the selection of the Pollocks, however, O'Hara was given a

free hand. "The Pollock section of the show, 34 paintings and 29 draw-ings, was really thrilling to work on," O'Hara happily wrote to Ash-bery in late July. "How great he is! I got to select the exhibition myself but it was terribly nerve-wracking because Alfred Barr will be the com-missioner in São Paulo and I have the feeling that when he sees the show he may throw up his hands and say 'Ugh!'" In fact the Pollock exhi-bition was given a special commendation in São Paulo by an interna-tional jury on which Barr sat, overriding a restriction that only living artists could be so honored.

The São Paulo presentation of Pollock—O'Hara's first curatorial success—was actually an adaptation of an exhibition directed by Sam Hunter that had been shown at the Museum the previous winter. But O'Hara's selections were purposely more inclusive. While Hunter began his exhibition at 1943 with Pollock's *Guardians of the Street* and *The She-Wolf*, O'Hara included earlier works—*The Flame* (1937) and *Male and Female* (1942)—that he described to Ashbery as "ravishing," as well as a later work—*Painting* (1956)—and a larger number of drawings on pa-per. "Frank was a champion of Pollock's late works," says Rasmussen, "challenging the prevailing view that Pollock's gift had dried out and convinced that for all their undeniable unevenness the late works were pointing in new directions. An inveterate defender of the difficult, he had a special predilection for sensibilities which could be stubbornly independent." O'Hara was particularly inspired by being able to work on a show to which his response was poetic as well as personal. The previous December, at the time of the Hunter show, he had written "Digression on *Number 1, 1948*" after seeing Pollock's all-over drip can-vas at the Museum:

> *Stars are out and there is sea*
> *enough beneath the glistening earth*
> *to bear me toward the future*
> *which is not so dark. I see.*

The following summer he wrote "Ode on Causality," originally titled "Ode at the Grave of Jackson Pollock," followed a year later by a mono-graph on Pollock, published by Braziller.

These new responsibilities at the Museum changed the quality of O'Hara's life Downtown. Suddenly he had power over his friends' ca-reers. The first test case was Jane Freilicher—whom he did not select for either the Tokyo or São Paulo show and whose work was never

purchased by the Museum during his lifetime. "I remember him saying to me that Dorothy Miller clearly expected, and maybe James Thrall Soby and Alfred, too, expected him to push for Jane Freilicher being in the show because she was famously a friend of his," recalls Rasmussen. "He very carefully didn't push for Freilicher and wouldn't have because he was making a professional judgment aside from his friendship that this wasn't the kind of show, the time wasn't right, the locale was inappropriate. Yet he felt very clearly that they expected him to push friendship. So that was a kind of liability."

Uneasiness was felt from the other side as well, as O'Hara came under pressure from friends. Happy as a careless enthusiast, he was being subtly forced toward greater caution, if only because the voicing of his enthusiasms could now hold a false note of promise. So he began to carry himself slightly differently. "He had this thing of being the official representative of the Museum of Modern Art," says Freilicher. "He started going very high up in that sort of bureaucracy. That made me feel somehow that there was a wall between us." Hartigan corroborates that "I think it started to fall apart when Frank became a curator of the Museum of Modern Art. It became impure because people wanted the world thing, not just his enthusiasm and eye. There was that sense around of using him."

"I used to complain to Edwin Denby about his working for the Museum," says the composer Virgil Thomson with whom O'Hara was becoming distantly friendly through Denby. "It was just like those French poets. They all wrote blurbs about modern painters and got paid off in pictures. The Picasso gang were all plugged by poets. I don't say incorrectly, but they were. Poets write the best advertising copy in the world. Now the Museum of Modern Art was very busy keeping up the price of the pictures in its trustees' collections. They were back and forth to Paris all the time. As a matter of fact they used to get Paris writers to do catalogues for them for awhile. And then they found Frank, this flexible Irishman who could push the opinions they wanted pushed."

That summer O'Hara gravitated toward Rivers and Hartigan—his painter friends who were the most established at the Museum. (Hartigan's *Persian Jacket* was even hung temporarily that year in the International Program's offices.) His friendship with Hartigan at its peak, O'Hara was often present for displays of her toughness that rivaled any of the male action painters'. One evening she reacted quite strongly to a painter who was tagging along drunkenly while she and O'Hara and LeSueur made their way from a party on Eighth Street to the Cedar.

"He was an abstract painter," recalls LeSueur, "with a pathetically small red mustache and dim little eyes, and like a number of Cedar Bar artists and would-be artists, he never had a one-man show—in short, he was a loser. . . . trailing slightly behind us as we headed for the Cedar, he was unsteady on his feet, slobbering slightly, and slurring his speech from having drunk more than he could hold. Do you think Grace felt sorry for him? Not at all. Without warning, she hauled off and hit him so hard on the side of his head that he landed in the gutter. Frank stopped to help him to his feet as Grace, eyes straight ahead, continued walking." Asked by LeSueur who had hurried to catch up with her what had possessed her, Hartigan replied staunchly, "I can't stand a man who doesn't act like a man!"

While O'Hara's friendship with Hartigan sometimes appeared odd to onlookers, he responded to a full-blooded gutsiness and sentimentality in her that he found lacking in some of his wittier friends. Like O'Hara when she was drinking, Hartigan was a bawler who could follow emotions through to their full-blown conclusion. O'Hara's passion for her blossomed surprisingly one night that summer when he visited while she was staying in the Creeks Gate House of the painter Alfonso Ossorio's estate in Wainscott. (That year Hartigan painted *Interior, the Creeks,* which was shown in the "New American Painting" show in 1958, on which O'Hara worked.) Only slightly drunk, O'Hara proposed that they spend the night together. He was ready to try to push past the strictures of his homosexuality to live as variously as possible. "I was in the bedroom and he was in the front room," recalls Hartigan. "Before we went to bed he said we should sleep together. And I said, 'And ruin this? No way!' But everyone teased him about it afterwards." A witness to the overture and Hartigan's rebuttal that sex might complicate their friendship, LeSueur claims that "Frank took Grace's rebuff in his stride, seemed not to be hurt or fazed by it. It would take more than that to end their friendship."

When not visiting Hartigan, O'Hara was visiting Rivers. Their rapprochement as friends was thorough enough that he stayed the entire month of August at Rivers's house on Toylesome Lane. This scene of their earlier collaborations was again the scene of their commencing work together, on a series of lithographs called *Stones*. The project came about one day that summer when Tatanya Grossman, whose Universal Art Editions printmaking workshop was located in West Islip, Long Island, visited Rivers in Southampton to ask him to work on a series of lithographs in collaboration with a poet. (Later works from her workshop included over a hundred lithographs by Jasper Johns, and

Robert Rauschenberg's series of lithographs on Plexiglas, *Shades*.) O'Hara
had been suggested to her as the best poet to work with Rivers by
Barney Rossett, who was busily preparing *Meditations in an Emergency*
for fall publication. Not knowing that O'Hara was Rivers's house guest,
Grossman made her request to Rivers, who responded by calling out
"Hey Frank!" whereupon O'Hara appeared in blue jeans. Always sizing
themselves up against the poets and painters of Paris in the earlier part
of the century, when Apollinaire had pasted his poem "Les Fenêtres"
on the back of Delaunay's painting of the same title to establish an
equivalence, they immediately agreed to Grossman's request. "We were
grown up," Rivers has written, "but we wanted to taste that special
lollipop Picasso, Matisse, Miró, Apollinaire, Éluard and Aragon had
tasted and find out what it was like." The process turned out to be
more involved than expected, especially for O'Hara, unused to writing
poems backward using a mirror with a wet crayon on stone. As the
collaboration was mutual—not simply an illustration of a poem—
O'Hara was given the chance to participate more fully in the hands-on
work of the artist. This was a crossover for which he had been temper-
amentally primed by his last five years in New York. "I remember them
working together on *Stones*," says Kenneth Koch. "Frank sitting there,
puffing and thinking, and looking up." The resulting twelve litho-
graphs accomplished over the following two years were eventually
printed in a series of twenty-five portfolios called "Tabloscripts" (the
name suggested by Rossett) published by Grossman in 1960.

Rivers's celebrity that summer grew beyond the boundaries of the
Downtown artworld. His name became currency in the larger world of
television and popular magazines—an early inkling of the commercial-
ization of the artists of the sixties. O'Hara responded to Rivers's ap-
pearance in *Life* magazine in April with characteristic fanzine camp:
"Your ineffable charm must have been felt by all who could afford the
20 cents for a copy, or is it because I already knew what you look like?
Has M-G-M been in touch yet? That's me, always the adolescent with
hopeless dreams of easy glory." In a further jolt of media attention,
Rivers appeared as a contestant on the television quiz show "The
$64,000 Question," answering questions in his chosen category of
"Contemporary Art." (He crammed for this appearance in the Museum
of Modern Art library.) This was the year when such shows were the
center of national interest and controversy as Columbia professor
Charles Van Doren won $129,000 on a rigged segment of the quiz show
"Twenty-One." Winning the second place prize of $32,000 on June 16,
Rivers showed up with his check at the Cedar where he bought drinks

for the entire bar. "It was like a movie scene," remembered Rivers, "and the check was grabbed from my hand and passed around the entire bar so that everybody could take a look at what I had won."

The successful glow of productivity that summer was darkened for O'Hara and Rivers, though, by the illness of Berdie. Her condition was serious enough by late August for O'Hara to write to Goldberg of visiting her in the hospital, "The other day when Joe and I were there she told us a lot of troubles and broke off suddenly with: 'Did you boys have lunch? Go down and take whatever you need. I can't picture where the kitchen is, but you can find it can't you?' *Oi!*" Rivers's mother-in-law finally died in September of a brain tumor. Her funeral was held in a synagogue on Second Avenue, and the actress Irma Hurley remembers O'Hara delivering the eulogy "with that big Irish face that he had and a little yarmulke sitting on the back of it."

O'Hara found himself devastated by any death, but he took the passing of this benevolent maternal figure particularly hard. He wrote "Song of Ending," plaintively opening, "Berdie, Berdie / where are you, and why?" He followed this simple elegy shortly after the anniversary of her death a year later with "Berdie," the title as well of one of his and Rivers's *Stones* lithographs of 1959. That Berdie had been the silent, or at least less agitated, center about which the Rivers household had revolved was proved by the artist's return along with his two sons that fall to Manhattan. O'Hara claimed in his memoir of Rivers that "For many of us her death was as much the personal end of a period as Pollock's death was that of a public one."

Another marker of beginning and ending was the appearance in September of *Meditations in an Emergency* as an Evergreen Book of Poetry from Grove Press—following fourteen letters to Rossett over two years debating which poems to include. Although fifteen deluxe editions were printed with a frontispiece by Grace Hartigan and one hundred special edition copies were hardbound, the bulk of the printing was nine hundred paperback copies. Having been unnaturally indecisive and procrastinating in choosing the poems, O'Hara could not bring himself to publish another paperback book until *Lunch Poems* appeared from City Light Books in 1964. *Meditations,* out of print by 1960, was the volume by which he was primarily known during most of his lifetime. The quality of immediacy that marked his best work making him at the same time often a poor judge of which of his poems could communicate most strongly on the page or at a public reading, O'Hara's selection in *Meditations* was at least more astute than in *A City Winter.* Included were such poems unmistakably in O'Hara's voice as "To the Harbor-

master," "To the Film Industry in Crisis," "Chez Jane," "Meditations in an Emergency," "For James Dean," "Sleeping on the Wing" and "Mayakovsky."

The few critics who reviewed the book were friendly but puzzled. They had a hard time placing the voice in any context. Kenneth Rexroth in the *New York Times Book Review* on October 6 complained that "Frank O'Hara is a friend and interpreter of many of the leading abstract expressionist painters. I believe he fancies himself as doing much the same sort of thing in poetry. If so, he is mistaken. This is the poetry of flat, dead-pan colloquialism." W. T. Scott in the *Saturday Review* chose a Surrealist rather than Abstract Expressionist hook: "His is a talking, rapid poetry, nervous, alert and, as I imply, sometimes surrealist. If now and then it is forced and smart, it is only seldom so." For Robin Magowan in *Voices* the key was jazz: "A jazz idiom suits O'Hara's style, because jazz, being improvised, is itself provisional, self-contained." Mostly, though, critical response was simply not forthcoming. "It was not surprising that his work should have initially proved so puzzling to readers—it ignored the rules for modern American poetry that had been gradually drawn up from Pound and Eliot down to the academic establishment of the 1940s," Ashbery has written of the tentative reaction of the literary establishment. "To ignore the rules is always a provocation, and since the poetry itself was crammed with provocative sentiments, it was met with the friendly silence reserved for the thoroughly unacceptable guest."

O'Hara was largely as indifferent to the reviews as to the publication of the book itself. Filling his incessant letters to friends with gossip about people and parties as well as worries over his last few poems, he forgot to comment on the appearance of *Meditations*—an event that would have consumed the attention of many other writers. He was more beguiled by the place of poetry in his daily life. In September the appearance of the increasingly hip John Wieners, always quietly mysterious, seemed more absorbing to O'Hara. At age twenty-three, Wieners, whose favorite childhood writer was Edgar Allan Poe, had a shy and darkly retiring manner, which registered on many as the appropriately cool and aloof stance of a hipster. He had just been summarily fired from his job at the Lamont Library at Harvard on the day *Measure,* a new poetry magazine he was publishing—containing section 9 of "Second Avenue"—appeared on the racks. (He had held down that job since graduating from Boston College with a B.A. in English in 1954.) So he looked up his Poets Theatre mentor O'Hara, asking to crash on his couch for a weekend before heading to San Francisco—a route glam-

orized that month by the publication of Jack Kerouac's best-selling *On the Road*. "Saturday afternoon John went to do some sort of research at the Forty-Second Street public library while we went to see *The Curse of Frankenstein* at Loew's Sheridan," recalled LeSueur of Wieners's visit. "That evening John, high on benzedrine, came home and told us about the horrifying, hallucinatory experience he'd had at the library. Later I said to Frank, 'Isn't it funny, we go to a horror movie and don't feel a thing and John just goes to the library and is scared out of his wits.'" O'Hara referred to the incident briefly—"While we are seeing *The Curse of Frankenstein* he / sits in / the 42nd Street Library, reading about Sumerians"—in his poem "To a Young Poet," written that month about Wieners, in which O'Hara takes realistic pleasure in the smallness of poetry, a response as fitting to his own book publication as to Wieners's poems:

A YOUNG POET
full of passion and giggles
 brashly erects his first poems
and they are ecstatic
 followed by a clap of praise
 from a very few hands
belonging to other poets.
 He is sent! and they are moved to believe, once
more, freshly
 in the divine trap.

That O'Hara scattered his lines freely across the page in this poem to Wieners was part of his homage to their friendship. For Wieners was O'Hara's sympathetic link to Charles Olson, a poet teaching at Black Mountain, whose essay "Projective Verse" in 1950 had led many of his followers to open up the field of their verse by paying attention to their own breath patterns rather than to counting syllables or relying on rhymes to make a poem. "ONE PERCEPTION MUST LEAD IMMEDIATELY AND DIRECTLY TO ANOTHER PERCEPTION," Olson had insisted in capital letters in his manifesto. Wieners had been a disciple ever since he walked by the Charles Street Meeting House in Boston "on the night of Hurricane Hazel, Sept. 11, 1954" and "accidentally" heard Olson reading. O'Hara, though, was a bit put off by Olson's priest-prophet stance. His own manifesto, "Personism," was

partly a parody of Olson's "Projective Verse" and its discussion of met-
rics more sassy than serious: "As for measure and other technical ap-
paratus, that's just common sense: if you're going to buy a pair of pants
you want them to be tight enough so everyone will want to go to bed
with you. There's nothing metaphysical about it." Yet following his
exposure to Wieners's emulation of Olson, and his own mimicry of
"projective verse" in "To a Young Poet," O'Hara began to use an open
field more consistently as the formless form for the odes on which he
concentrated much of his poetic attention over the coming year.

While O'Hara's odes were hardly classical in form, dispensing with
any hint of strophes, antistrophes, or epodes, they did maintain a clas-
sical spirit in dealing ostensibly with subjects worthy of praise in a pub-
lic voice. Rather than singling out political leaders for praise, such as
Marvell's "Ode upon Cromwell's Return from Ireland," O'Hara chose
painters as his heroes—Willem de Kooning, Jackson Pollock, Michael
Goldberg. Like Pope who wrote on Solitude, or Collins on Fear, he also
wrote odes titled after abstract emotions—"Ode on Lust," "Ode to
Joy," "Ode on Necrophilia." He even borrowed a title from Dryden for
"Ode on Saint Cecilia's Day." Introducing "Ode on Lust" at a reading
hosted by Charles Olson (when he held an endowed chair of poetics at
the State University of New York at Buffalo), O'Hara off-handedly de-
livered an unenlightening explanation of his choice of the genre, or at
least of the name of the genre: "I wrote it because the ode is so formi-
dable to write. I thought if I call it an ode it will work out." His attitude
basically simmered down to a conviction that an ode was any poem he
chose to call an ode.

In "Ode (to Joseph LeSueur) on the Arrow That Flieth by Day"
O'Hara used the large poetic canvas of the open field for what was
essentially an "I do this I do that" poem written on Mother's Day, 1958.
"Frank was struck by the title of a *Times* book review, 'The Arrow That
Flieth by Day,' and said he'd like to appropriate it for a poem," recalled
LeSueur of the genesis of the ode dedicated to him. "I agreed that the
phrase had a nice ring, and asked him for the second time what I should
do about Mother's Day, which I'd forgotten all about. 'Oh, send your
mother a telegram,' he said. But I couldn't hit upon a combination of
words that didn't revolt me and Western Union's prepared messages
sounded too maudlin even for my mother. 'You think of a message for
my mother and I'll think of one for yours,' I suggested. We then pro-
ceeded to try to top each other with apposite messages that would have
made Philip Wylie applaud. Then it was time to go hear a performance
of Aaron Copland's Piano Fantasy by Noel Lee. 'It's raining, I don't

want to go,' Frank said. So he stayed home and wrote 'Ode on the Arrow That Flieth by Day,' which refers to the Fantasy, Western Union, the rain, and Mother's Day."

Mother's Day was a reminder for O'Hara of a relationship that had been strained nearly to the breaking point for several years. His anxiety and nagging remorse were expressed quietly among all the other topics crowding the surface of the poem:

> *the unrecapturable nostalgia for nostalgia*
> *for a life I might have hated, thus mourned*
>
> *but do we really need anything more to be sorry about*
> *wouldn't it be extra, as all pain is extra*

Curiously, O'Hara slipped in a remark of Joan Mitchell's that takes on an almost mythological resonance in the context of Mother's Day: "if Joan says I'm wounded, then I'm wounded." O'Hara's wound remained undefined but was related by him in the context of the poem to his mother. LeSueur at the time felt that Mitchell's comment was directed at O'Hara's sexual performance, which rarely matched the intensity of his seduction and foreplay—an impotence for which alcohol was at times responsible. "I obviously read that as if she knew he had been hurt in some way that crippled him sexually," says LeSueur. "The impotence had nothing to do with heterosexuality. It was pervasive. It also had to do with homosexuality. He had a difficult time with an erection." For O'Hara, who was somewhat addicted to the notion of the tragic, romantic artist, the image of a wound was also bound up more grandly in the story of Sophocles's Philoctetes—seized on later by André Gide, Edmund Wilson, and even Tom Hess in *Abstract Painting*—whose noxious snake bite made him eligible to be a recipient of the bow of Hercules, his disability and genius being inextricably entwined.

Whatever the deeper tugs of nostalgia and pain, O'Hara chose not to play into his mother's hands. Unmoved by sentimental demands of family and genealogy, he allowed his fury against his mother to surface as easily as his fury against any friend with whom he was fighting. Phone calls from her often turned into shouting matches as O'Hara grew more and more infuriated by the telltale *accents graves* in her voice when she drank. Once O'Hara walked in on the tail end of a phone conversation between his mother and LeSueur. "I was talking pleasantly," recalls LeSueur, "and I said, 'Nice talking to you too,' and he

just sort of sensed who it was, and I hung up. I didn't let her know he had just walked in. He said, 'It was my mother, wasn't it?' I said, 'Yes.' He said, 'What do you mean by talking so pleasantly to her?'"

One of the dreaded phone calls from his mother came during a subway strike. She was very drunk and had a distorted idea that the city was extremely dangerous because of the interruption of the trains. She called wondering if her son was all right. O'Hara reacted to her supposed concern by speaking to her rather abusively about bothering him at such a late hour—an ironic complaint from O'Hara, who was famous for the four-o'clock-in-the-morning phone call. Her response, typically trying to use guilt as her dagger, was "Is that any way for a Harvard graduate to talk to his mother?"

More lighthearted was one of their telegrams that found its way into the poem:

(hello, Western Union? send a Mother's Day message to Russia: SORRY NOT TO BE WITH YOU ON YOUR DAY LOVE AND
 KISSES TELL THE CZAR LA GRANDE
JATTE WASNT DAMAGED IN THE MUSEUM OF MODERN
 ART FIRE /S/ FRANK)

The reference was to a catastrophe that had been absorbing most of O'Hara's energies over the past several weeks at work. Shortly after noon on April 15 a serious fire had broken out at the Museum of Modern Art, causing the death of an electrician and the injury of thirty firemen. The fire started on the second floor, which was undergoing renovation, but had quickly spread smoke all through the building from the second floor to the members' penthouse on the sixth. Generally blamed on a cigarette dropped by a workman on a painters' drop cloth, the fire was quelled within an hour. But there was cliff-hanging suspense about the fate of many of the pictures, especially those in a major Seurat exhibition, which included *La Grande Jatte* on loan from the Art Institute of Chicago, where O'Hara had first seen the pointillist masterpiece with Jane Freilicher while on break from school in Ann Arbor. O'Hara was among those wading through water to carry pictures out of the Museum. Indeed, a bucket line of the Museum's staff—including curators, guards, secretaries, librarians, and maintenance crew—helped to pass paintings down the stairs and into the Whitney Museum next door. *La Grande Jatte,* however, its frame weighing 500 pounds and hav-

ing been mounted on a platform behind protective glass, presented a special problem, which was handled by the more expert carpenters and workmen. "It was remarkable seeing how they worked, slowly undoing things in exactly the reverse order in which they'd been done, very carefully, very deliberately," recalled Museum librarian Bernard Karpel. "They could have been doing it on a moonlit night in their own backyard. It was carefully handled like a tender babe, wrapped and sealed in paper, covered with a tarpaulin, and wheeled into the Whitney." Unfortunately, some other paintings were not so fortunate. Monet's big *Water Lilies*—just purchased in 1955—was a total loss. More poignantly to O'Hara, Rivers's *George Washington Crossing the Delaware* was burned in its lower right corner and its entirely unvarnished (and so uncleanable) surface discolored by the heat and smoke. Pollock's *Number 1, 1948*—the inspiration for another of O'Hara's poems—was smoke-damaged. The current exhibit "U.S.A.: 1958—5,000 Works" was moved to the Madison Square Garden basement, and much of the rest of the spring and summer was spent preparing the Museum for a grand reopening on October 8.

During the summer of 1958 O'Hara shifted his center of interest in the Hamptons to the house Mike Goldberg was sharing with the painter Norman Bluhm. (Goldberg's *Summer House* of 1958 was included by O'Hara in his "Documenta II '59" show in Kassel, Germany.) With both Bunny Lang and Joan Mitchell in his past, Goldberg was still a source of infatuation for O'Hara. His sexual appeal—to which many of O'Hara's friends were oblivious—was later revealed to be part of the energy generated by a sociopathic personality. But O'Hara was drawn in with no qualms; Kenneth Koch was not. With his elitist desire to keep out whomever he considered to be artistic riffraff, he opposed O'Hara's friendship with Goldberg. "It was easy to be annoyed at Frank for thinking certain people were so great," says Koch. "It was wonderful when you were getting it. But not when he was going around saying how great Mike Goldberg was. It was impossible not to like the 'Ode to Michael Goldberg('s Birth)' though the fact that it was to Mike Goldberg made it impossible for me to like it at first." (The poem's title was actually arbitrary, as it was written between January and March 1958, while Goldberg's birthday fell on Christmas Eve.) Equally impossible for Koch to dislike had been "Why I Am Not a Painter," O'Hara's poem, beginning with his usual deferential salute to painters, that tells the story of Goldberg writing the word *Sardines* in charcoal across the bottom of a canvas:

I am not a painter, I am a poet.
Why? I think I would rather be
a painter, but I am not. Well,

for instance, Mike Goldberg
is starting a painting. I drop in.
"Sit down and have a drink" he
says. I drink; we drink. I look
up. "You have SARDINES in it."
"Yes, it needed something there."

Read in 1963 by Ossie Davis on a segment of "Creative America," "Why I Am Not a Painter" remained one of the self-doubting poet's favorites. Writing to Goldberg once to complain of writer's block, O'Hara added, "In the midst of the shit a little flame glows and it spells *SARDINES*."

O'Hara was merciless and indefatigable in his needling of Koch about his heterosexuality. But the humor and sarcasm behind that game were missing in their fights about Goldberg, one of which occurred in an old sawdust bar on Irving Place. "When he'd go on talking to Mike I'd be kind of mad," admits Koch. "I remember that one night I was very drunk and I got mad at him. Of course he thought that was inappropriate. Which it was. I didn't have any claim on Frank."

O'Hara reported the incident in a letter to Schuyler in which he reveals how lacerating he could be when he decided to dissect the character of a friend. "I had a stupid fight with Kenneth which he started over my liking Mike Goldberg more than him—he was so dumb and insulting and snobbish that I couldn't even get angry with him, I just asked him to leave or I would," fumed O'Hara. "How did he ever become so convinced that he is 'interesting'? I felt depressed and ashamed of the ideas he expressed about people's 'worth,' because I felt responsible for him as a friend and Elaine and Bill looked so shocked. How can anything be so simple as that I like Mike 'because he's a *MAN*' . . . According to his own ideas of me I think that he would seriously have to question his own 'manliness.' It's too bad that knowing so many homosexuals hasn't disburdened him of any of his middle-class clichés."

Goldberg's life took a turn during the summer of 1958 that opened up a new arrangement for O'Hara, who was certainly undaunted by complicated solutions to the problem of intimacy. "I had quit working two weeks before and I was too drunk to go sign for unemployment

insurance so that summer I rented a house out in the Springs," recalls Goldberg of the simple beginning of the season. Patsy Southgate, a neighbor down the road whom Goldberg had met at Lee Krasner's, invited Goldberg to a Bloody Mary party on Memorial Day, to which he brought along O'Hara and LeSueur. Having a knack for recording important moments and meetings in his life, O'Hara fit the party into "June 2, 1958":

> *Meanwhile,*
> *back at Patsy Southgate's, two grown men*
> *are falling off a swing into a vat of Bloody Marys.*

Patsy Southgate was one of the great beauties of the Hamptons with her sun-bleached blond hair, cornflower blue eyes, wonderful smile, and femme fatale manner. O'Hara described her in his poem "Macaroni" as "the Grace Kelly . . . of the New York School." Such comparisons to movie actresses were constantly on her friends' and admirers' lips. The daughter of a socialite and a diplomat, Southgate was recovering at the time from a divorce from the novelist Peter Matthiessen with whom she had two children, Luke and Carey. As a founder of the *Paris Review,* Matthiessen had involved Southgate, who was also a writer of plays and stories, in a life among the *Paris Review* crowd, which included William Styron, George Plimpton, James Baldwin, Terry Southern, and Irwin Shaw. According to Gay Talese, their apartment in the early 1950s was "as much a meeting place for young American literati as was Gertrude Stein's apartment in the Twenties." Goldberg—for Southgate, as for Bunny Lang—cut a more bohemian figure and held out the promise of a different life. That he came along with O'Hara, whom she describes as "bottomlessly interesting," made him all the more appealing. So she and Goldberg and O'Hara entered into a sort of three-way fascination along the lines of O'Hara's earlier relationship with Rivers and Frei-licher. That LeSueur was O'Hara's constant companion that summer evened out the bridge game to two teams.

"It was like everyone just sort of stayed in my life from that moment on," says Southgate of her Bloody Mary party. "I really kind of can-celed the rest of my life and started up this one with Frank and Joe and Mike and the whole works. My life with Peter Matthiessen had been sort of Uptown, and I considered this a move to Downtown."

By the end of the year Southgate and Goldberg had married—their courtship a rapid blur—and moved into Arnold Weinstein's apartment

on Second Avenue. Southgate's mother was no more pleased with her marriage to the young painter than Bunny Lang's father had been about her proposed one. "The only time my mother ever did this, she called up my shrink," recalls Southgate. "She said, 'My daughter married a Jew and she wants me to call her Mrs. Goldberg. Can you please stop this?' My shrink said, 'Didn't you know, Mrs. Southgate, that he was recently featured in *Time* magazine?' That made her feel a little more amenable." (Goldberg was featured in *Time* in January 1959, in an article on Abstract Expressionism titled "Question Marks in Color.")

For O'Hara, however, the situation seemed ideal. He managed to establish a place for himself in a bohemian household similar in style and tenor to Rivers's house on Toylesome Lane in which he had settled during the early fifties. Goldberg satisfied O'Hara's need for a straight male painter with whom he could be affectionate without being overly committed. Southgate was as glamorous an artistic woman as any of those with whom he had been involved, and she was also able to serve as "den mother" for the group with her motherly skills of cooking and supporting. Again there were two children with whom O'Hara—to the marvel of most of the other sophisticated adults on the beach in the Hamptons—could spend hours carelessly riding waves or playing in the sand. Adept at trimming wisteria and other gardening chores because of his early training in Grafton, O'Hara happily included himself as a member of the household that became his center of operations in the Hamptons for the rest of the fifties and throughout the sixties.

"Frank was in many ways a kind of surrogate father to me," says Luke Matthiessen. "Although it was never communicated directly, I think that was also very important to him. We used to have great pear fights all the time in the country. I remember several times being thrown back and forth in the ocean between Joe and Frank. I remember making Bloody Marys for him in the morning, and I would bring them to him in bed when I was six or seven. Also Frank loved the dogs. We had these two German shepherds. The dogs meant a lot to him. We meant a lot to him. The whole family meant a lot to him. I have this very real sense of Frank being a part of the family."

To some, however, the situation reeked of complex and incomplete transactions. Hartigan, who was so much more careful about the lines between friendship, love, and marriage, was boggled, annoyed, and probably jealous as well of this latest development in O'Hara's life. "Frank was crazy about Mike," says Hartigan, who was soon to be replaced by Southgate as the woman in O'Hara's life. "And then he

went on being crazy about Mike when he married Patsy Southgate. That's really why Frank was so close to Patsy I think."

To Jane Freilicher the situation seemed a version of her earlier triangle with him carried into the arena of marriage and family: "He spent a lot of time with Patsy and Mike Goldberg when they were married. But he was like the center of their universe. They were both in love with him. And they all drank a lot, which I never did, so they had that common bond, which I think is very strong."

For O'Hara, the communal experience was largely marked by the edgy enthusiasm of "On Rachmaninoff's Birthday & About Arshile Gorky":

> Soon I will fall drunken off the train into
> the arms of Patsy and Mike and the greenish pain.

Toward the end of the summer of 1958, O'Hara made his first of several trips to Europe. Visiting Europe in the 1950s was still a rare enough event among Americans to carry a desirable cachet. The recent installation of Calder's *125. 1957* in New York's Idlewild Airport reflected the glamour and modernity with which air travel was imbued. There was competition among workers in various branches of the Museum for plum European travel assignments. The pages of literary magazines were beginning to be dotted with what were known as "Fulbright poems"—poems about the cobblestones or pigeons of Rome or Provence written by an elite of subsidized young Americans abroad. Among O'Hara's circle, Ashbery and Koch had benefited from such largesse. O'Hara had planned to make the trip himself in 1954 with an inheritance left him by his Aunt Grace, but his Uncle Leonard had written a letter persuading him to give the money instead to his sister, Maureen, to pay her tuition at Walnut Hill boarding school. O'Hara agreed, feeling the big-brotherly need to make sure that his little sister was safely out of the domain of his unpredictable mother. Consoling him for his disappointment, Rivers had written, "I was sorry to learn you were done out of $2,000. Well Europe can wait." While O'Hara never dwelled on his desire, he did express some longing, at least literary longing, in "Ode: Salute to the French Negro Poets": "From near the sea, like Whitman my great predecessor, I call / to the spirits of other lands to make fecund my existence." Ashbery, with whom O'Hara was able to enjoy a reunion on his European visit in 1958, felt that O'Hara's trip produced a subtle realignment in his friend's character. "His first

trip to Europe changed him and made him much easier to get along with," says Ashbery. "I think that people who have never been to Europe have a certain chip on their shoulder."

Though O'Hara loved traveling to the capitals of Europe for an exposure to contemporary activity, he was not particularly interested in ruins or landmarks. As he wrote to Grove editor Don Allen from Rome on August 20: "Not much going on here except *LIFE* and I just haven't been able to persuade myself that *Aida* in the Caracalla is what I need though I'm sure I should have. But I hate to just *see* things because they're there."

Madrid on August 10 was O'Hara's first stop on this first trip out of the country since the end of World War II. His job was to help in the dismantling of "The New American Painting" show of Abstract Expressionism, which was to be shipped to Berlin. He was also given a chance to see the work of younger Spanish painters—an exposure that led to his putting together the "New Spanish Paintings and Sculptures" show two years later. Given direction in his search by Luis González Robles, the director of the Museo Nacional de Arte Contemporáneo, O'Hara was immediately impressed by "some very snappy paintings" by young painters of what he referred to as "the Bluhm-Goldberg generation and under." Writing to Grace Hartigan on August 19 from Rome he claimed that the Spanish painters "have a certain stern or bitter quality to the best of them that keeps any of their innovations from being decorative." He also found the late hours of Madrid conducive to living his own insomniac life in a familiar fashion. "Madrid was heavenly and I thought very cheap," he wrote to Hartigan, whose own departure for Europe was imminent. "It's such fun to eat lunch at 2:30, and sleep, and dine at 10:30, and theatre or walk in the gorgeous parks till 2:00. I stayed in a very cheap hotel there (Hotel Mora, Paseo del Prado) right near the Prado—but so is the Ritz Hotel near the Prado and you can't stay in a Ritz anywhere else for $7 a day so I made a terrible mistake. It is simply gorgeous and in a charming Madrid square. You can also have drinks in the downtown section in the evening on the roof of the Hotel Plaza on the Avenida José Antonio overlooking the Plaza de España with its monument to Cervantes, the road to Portugal and god only knows what other night-lit splendors."

O'Hara had the good fortune, or good sense, to fall in love with his translator—a young "boy" named Oscar Salvador. From the first day he disembarked from his plane O'Hara's datebook was filled with extracurricular lunches, dinners, and theatre dates with Salvador, who helped him along in his estimation of the Prado as "astounding" and

his wish to live in Madrid for a year simply to watch the seasons change. "I sent you a postcard from Madrid my last night but forgot to mail it for the utter tragedy of my departure," he wrote to Hartigan from Rome of his Spanish romance of five days. "I was absolutely crazy about someone there and still think it is one of the major tragedies of space travel that I had to leave. You know how long it's been since I've *cared* about anyone. I mean, really." In Rome a week later he joyfully received a letter from Salvador, to whom he had just written "Places for Oscar Salvador":

> *in the Greco martyrdom we occupy so little space*
> *that no one notices a sad chance of immanence come true*
> *except a crazy artist gentler than a dog is blind*
> *hears a guitar string snap it is our space he hears*

Serendipitous love rather than architecture or language helped glorify Madrid for O'Hara.

In Rome he was crankier. Because of the rhythm of traveling, O'Hara's normal romantic curve of longing followed by depression was speeded up and intensified. So his attitude toward the splendor of Rome—where he had gone on August 15 to meet Porter McCray to accompany him to the Venice Biennale—was slightly more jaded. "Rome is gorgeous of course and everything is extraordinary especially if you're a humanitarian, which I'm not," he wrote double-handedly to Hartigan. "The newish monumental building to Vittorio Emmanuele in the Piazza di Venezia, which is unavoidable, shows how lucky we are not to be living when this city was new, but then time will do it every time except to people. It is lovely, and heedless and enjoyable, like the Catskills." Describing a walk outside the Coliseum he made the accurate qualification: "if you can *be* outside it." Most pleasing to O'Hara was his Hotel Inghilterra, which boasted Byron as one of its former guests and was small and elegant and located in the heart of Rome near the Spanish Steps. Referring to *Three Coins in the Fountain,* the box-office hit filmed in Rome five years earlier, he pictured the Spanish Steps for Hartigan as "a lot prettier than that disgusting Trevi Fountain those 3 starlets threw their coins in." For a scrim through which to experience Rome, O'Hara preferred Tennessee Williams's novel *The Roman Spring of Mrs. Stone,* about the drift into lassitude and moral decline of a widowed American actress in Rome: "As far as Italy is concerned I think I'm turning into Mrs. Stone. Everyone is so attractive it makes you

wonder if you're not demented." When in Rome, though, O'Hara tended mostly to dwell on Madrid.

O'Hara arrived in Venice on August 22 with Porter McCray, and he took care of business on a seemingly round-the-clock schedule for two days straight. The occasion of their visit was the mounting of an American exhibition of paintings at the twenty-ninth Venice Biennale. A glaring example of the isolationism still prevalent in American politics even after World War II, the American pavilion at the Venice Biennale had been taken on as the private responsibility of the International Program, with Rockefeller Brothers' funding. The American government refused to sponsor showplaces for their artists in such prestigious international exhibitions. (In 1953 the American ambassador to Italy, the ever politically savvy Mrs. Clare Boothe Luce, was so annoyed at having to attend an opening exhibition she suspected of publicizing American artists with Communist sympathies that she wore blue sunglasses throughout.) O'Hara's unlikely responsibility in the exhibition of 1958 was the selection of small one-man shows by Seymour Lipton and Mark Tobey, while Sam Hunter was assigned Mark Rothko and David Smith—artists whose work O'Hara felt to be more major. Nevertheless O'Hara's Tobey selection won for the Pacific Northwest abstract painter an International Prize for Painting—making him the first American so awarded since Whistler.

Next O'Hara flew to West Berlin where he arrived on the evening of August 24—staying at Hotel Am Zoo on the Kurfürstendamm—to work on the installation and gala opening of "The New American Painting" and Pollock traveling shows simultaneously. O'Hara had written expectantly to Don Allen while still in Italy, "Those ugly Germans will straighten me out, if indeed they're ugly which I doubt." Unfortunately O'Hara was too busy to take in much about Germany. He did buy several volumes of poems by Gottfried Benn—his college German apparently being supple enough for him to write a reply to Benn's poetry in "To Gottfried Benn": "Poetry is not instruments / that work at times / then walk out on you." He also dashed off a postcard of a poem—"Poem" (Today the mail didn't come)—on August 26 in which "a student with a mustache was repairing the façade of the Hotel Kempinski / with glass that was falling apart / and it suddenly started raining." However, O'Hara spent most of his time in the long white tunnel-like halls of the Hochschule für Bildende Kunst hanging the two shows, which to the surprise of the International Program staff were creating headlines of seismic shock, disbelief, ridicule, and simple anti-Americanism

all across Europe. The reactions were reminiscent of those in America to the 1913 New York Armory Show, which exhibited all of the avant-garde to stunned visitors. A Roman newspaper headline described Pollock as "Il Presley della pittura." In London the response of one rankled newspaper psychiatrist was titled: "'Save Me from the Great String Spider Webs': This Is Not Art—It's a Joke in Bad Taste."

While the Pollock show was O'Hara's sole responsibility, he had worked more subordinately on the vastly important "The New American Painting" show as an assistant to its director, Dorothy Miller, whom McCray characterizes as having been "the absolute slave of Alfred Barr." Because of the overbooked schedules of the museum curators, "The New American Painting" show almost never transpired, or at least was about to be postponed, until O'Hara and Rasmussen zealously stepped in. "For Frank and me it seemed the great opportunity to do something important about American painting, and timing seemed critical," Rasmussen has written of their missionary sense about the project. "Together we drafted a schedule of preparation for the show which made it seem a feasible proposition (which it only barely was—less than five months was an incredibly short amount of time in which to prepare so major an exhibition and its catalog). Porter used our memo to push his case for the show and Frank volunteered to help Dorothy Miller with the selection and all the paper work concerned." Miller and O'Hara found themselves in general agreement on the artists except, according to McCray, "when Alfred would raise an objection and then Dorothy's loyalty would rear its ugly head." One of these disputes was over Hans Hofmann, whose historical importance O'Hara felt needed to be recognized. (While O'Hara's interest in Hofmann was more respectful than passionate, he had briefly hung one of his gouaches in his office.) The artists finally agreed upon to represent the achievements of Abstract Expressionism were: Baziotes, Brooks, Francis, Gorky, Gottlieb, Guston, Hartigan, Kline, de Kooning, Motherwell, Newman, Pollock, Rothko, Stamos, Still, Tomlin, and Tworkov. The show—a curator's nightmare of crates and color plates to catalogues, and sheaves of official documents—then traveled to eight European countries and, upon its return to New York, was hung as the first International Program exhibition in the main wing and the first Museum show devoted entirely to Abstract Expressionism. (Barr had tended to dwell on the Mount Olympus of twentieth-century French painting.) "The New American Painting" continually crossed the path of the complementary Pollock show, with both exhibitions appearing simulta-

neously in Basel, Berlin, and Paris. By the time the tour was completed in Paris in February 1959, Abstract Expressionism had triumphed and was rivaling jazz as America's most influential cultural export.

To prepare for the appearance of "The New American Painting" and the Pollock shows in Paris in January, O'Hara flew to Orly on the evening of September 7. He ended up spending far more time, however, at the cafés Flore and Deux Magots on Boulevard Saint-Germain than at the Musée National d'Art Moderne. Both John Ashbery and Joan Mitchell were now expatriates living in Paris. Sam Francis was in town for the show. Barbara Guest was visiting her family. Grace Hartigan also arrived with Robert Keene, a Southampton bookstore owner who was briefly her third husband, to bask in the publicity of "The New American Painting." (She was singled out in *Le Monde* when the show opened in Paris for "producing street scenes of brilliant and clashing patches of color that recall the Fauves.") That Hartigan—a favorite of Dorothy Miller's—was the only member of O'Hara's inner circle chosen to be in the show gave her a momentary top-dog ascendancy in the increasingly biting competition Downtown. O'Hara's mood in Paris was a bit less ebullient than hers, as he was caught in the middle of the competitiveness among his friends as well as being exhausted by the international bureaucratic snags. "I had a dinner alone with Frank because Bob Keene got a gut thing," recalls Hartigan. "We walked by Nôtre Dame. That was 1958 and there was already a sadness about Frank because of the responsibilities of the Museum."

At a lunch later in the week with Hartigan, Keene, and Barbara Guest, O'Hara showed an impatient attitude toward Blue Guide tourism. "We all congratulated ourselves on being in Paris," Guest has recalled, "and moreover being in Paris at the same time—a continuation of the Cedar Bar, where we had formerly and consistently gathered." After lunch Guest suggested that the group cross the street to explore the "bateau lavoir" where, she explained, Picasso and Max Jacob had first lived and where they had thrown studio parties for Apollinaire and Marie Laurencin. O'Hara, surprisingly, balked at the suggestion. He crossed the street but did not bother to go into the building. "Barbara," he remonstrated, flushed with wine, "that was their history and it doesn't interest me. What does interest me is ours, and we're making it now." The incident, and attitude, show up in O'Hara's Paris poem of September 12, "With Barbara Guest in Paris":

> *Oh Barbara! Do you think we'll ever*
> *have anything named after us like*

rue Henri-Barbusse *or*
canard à l'Ouragan?

On September 17, the day of his departure from Paris, O'Hara wrote a poem dedicated to Joan Mitchell, "Far from the Porte des Lilas and the Rue Pergolèse," in which he expresses his appreciation for the sentiment of travel balanced by his peculiar disregard—as someone focused on personalities—for any simple change of scenery:

> *a dream of immense sadness peers through me*
> *as if I were an action poem that couldn't write*
> *and I am leaving for another continent which is the*
> *same as this one*
> *goodby*

O'Hara returned to America charged with a stronger sense of internationalism—both in painting and literature. Setting a fast pace as a cultural Mercury with wings on his heels, he responded to events abroad with all the urgency of events Downtown. He began to talk up the Spanish painters to their American counterparts. "He was able to deal with all these messages from people and take them from place to place," says Jasper Johns, whose large white American flag painting from his first show at Castelli in January O'Hara had seen and recommended for purchase to Alfred Barr. "Maybe these days there are more assaults or attempts to impress you with information from other areas than there was then. He would go to Europe and come back and talk about things in Europe. He would make it interesting and make the point that there were these people doing things. Whether you wanted to hear it or not you had to hear it and you learned something."

In literature, of course, O'Hara had been championing French and Russian poets since his days at Harvard, and this passion was reignited in October by the award of the Nobel Prize in Literature to Pasternak, who subsequently refused the prize under pressure from the Soviet government. One night at the Cedar, O'Hara became more and more incensed at the injustice. Finally he said to Kenneth Koch, "Kenneth, we've got to do something. He's a great poet and the Russians aren't going to let him accept the prize. I think we should send him a cable." "Won't he get in trouble getting cables from the United States?" Koch replied dubiously. But O'Hara set to work on the wording of the cable. Later, at three in the morning, he called to check the final text with

Koch whose phone was answered by his indulgent wife. "Frank felt it was very important that we not only applaud his getting the prize but that we let him know that there were poets in America who loved his early work, not just *Doctor Zhivago*," recalls Koch. "We sent it off and I felt like an angel or like an airplane. I felt that life was much bigger. Frank did that all the time for everybody. By taking everything so seriously it became a part of him and a part of us. Every little injustice in the world, usually in the artistic world, Frank was really aware of and wanted to do something about and write this, do this, do that. It was before any poet we knew except Allen Ginsberg was interested in real politics."

O'Hara also began working on a review of *Doctor Zhivago* (a best-selling novel that year in America), which appeared in the Winter 1959 issue of *Evergreen Review* as "About Zhivago and His Poems." Suggested by Don Allen to Grove's Barney Rossett as an outlet for trying out new work, such as Kerouac's *The Subterraneans*, to see if there was a public, *Evergreen* was on a roll at the time as a showcase for unusual or overlooked talent. It was an alternative to the more academic literary magazines and seemed to have tapped a larger audience than expected. "I had done quite a bit of work with the *Partisan Review* and its anthologies," says Allen. "I thought there was room for a real magazine that did publish contemporary writers and less academic stuff. Barney seemed to feel the same way." O'Hara's essay on Pasternak was the first of his truly impassioned critical essays—leading to his monograph on Pollock the following year. It was a form in which he was much more comfortable than in the constricting reviews for *Art News*. Even he, though, worried about how far he could stretch his critical prose. "Several people said they liked the *Zhivago* review which was a relief," he wrote to Allen the following March. He had been worried about its last sentence in which he unabashedly sounded a soaring note borrowed from the grand tradition of European humanism: "And if love lives at all in the cheap tempestuousness of our time, I think it can only be in the unrelenting honesty with which we face animate nature and inanimate things and the cruelty of our kind, and perceive and articulate and, like Zhivago, choose love above all else."

Don Allen not only printed O'Hara's poems and essays but relied excessively on his talents as scout, messenger, and guide. "He thought that Frank was the person who was the pass-key," says the poet Richard Howard, who served as the house translator for *Evergreen*. "He really thought he was the center and that from the outside he could learn about it all through Frank." O'Hara was a bit suspicious of Allen before his

first meeting. "I am having dinner with Don Allen next week to discuss 'poetry' with him but I don't know how it will turn out as I am not such a good manager of poetic discussions with people I don't know, though I guess Allen Ginsberg has broken him in," O'Hara wrote to Kenneth Koch with some condescension. "He also said his favorite poem of John Wieners was a ballad about Alice O'Brien who is a Boston Queen who hung herself in prison by her shoe-strings and it is a marvelous poem but quite far from the best apart from the subject matter which makes it pseudo-understandable. What won't people do for a point of view! They'll like anything. I like the poem, too, mind you, but if one liked it one would have to like others more." O'Hara overcame his reservations, however, upon meeting Allen, a shy, middle-aged man with a silent chuckle, "like one of those figures in Shakespeare always referred to as a 'ghostly father,'" according to Howard. "He lusted after people in those days. He didn't lust after Frank but he lusted after the aura around Frank. He found that very sexual and exciting." O'Hara in turn fed Allen constantly with new ideas for the magazine.

An unlikely poet friend of O'Hara's—at least from the viewpoint of some of his more Uptown friends—was Allen Ginsberg. While O'Hara could often be found at a cocktail party dressed in a tie and jacket, Ginsberg was at the vanguard of the more unshaven "beat" movement thriving at that moment in San Francisco, in which the style of the poets was toward long hair and beards and lumber jackets. Ginsberg's poetry was visionary, incantatory, and Blakeian, his language more hip and oracular than queer, his drug of choice marijuana rather than vodka and vermouth. Attracting a frenzy of media attention from all directions after the seizure in 1957 of his long poem *Howl* for obscenity, Ginsberg—accused by Diana Trilling in the pages of the *Partisan Review* of having a "talent for self-promotion,"—was frequently chosen by glossier *Time* and *Newsweek* magazines as spokesman for a generation Paul Goodman would sympathetically claim were reacting against "growing up absurd." "Beat" was enough of a household word—and annoyance—in America by the end of the decade for a TV show, "The Many Loves of Dobie Gillis," to debut in 1959 with a character named Maynard G. Krebbs whose goatee, black turtleneck, bongo playing, and elliptical remarks were meant as a send-up of this jazz-and-poetry movement.

Both O'Hara and Ginsberg, however, were serious poets with a shared distaste for the neat academic stanzas being promulgated as poetry by many staid literary magazines. And they were both great communicators whose zest for talk and action inspired them to see past

superficial differences that might have stopped others short. "From 1955 on there was somewhat of a breakthrough in American poetry known variously as San Francisco Renaissance or New York School or Beat Generation or Open Form or whatever, but antiacademic, antiformalist style," says Ginsberg. "I don't think people nowadays realize what a strong hold the notion of stress and accent and stanza had on poetry in what were considered the serious literary magazines—*Partisan Review, Hudson Review, Sewanee Review, Poetry*. At that point there seemed to be some sort of alliance between the San Francisco Open Form people such as Snyder, Whalen, McClure, Olson, Creeley, Duncan and the New York group of O'Hara, Schuyler, Ashbery. The common ground seemed to be admiration building on William Carlos Williams's American vernacular idiomatic diction and rhythm and the spontaneous writing of Gertrude Stein. So this was quite a phalanx of new poets who liked each other to some extent."

O'Hara's friendship with Ginsberg developed at the Cedar, although they had first been introduced by the poets Jack Spicer and Robin Blaser in Cambridge in 1956. Ginsberg was impressed by O'Hara's early discovery of both Wieners and Corso—two poets who later became mostly identified with the San Francisco Renaissance. In 1956 O'Hara lent him his copy of Herbert Marshall's translation of Mayakovsky, which included a good translation of "At the Top of My Voice." "I had never read any Mayakovsky, but Frank turned me on to him and I'm always indebted to him because that opened my interest in Russian poetry," says Ginsberg. "He turned me on to the open public voice, especially the suicidal desperation of 'At the top of my voice.' It's a great classic. You see Mayakovsky wasn't printed in America, as Neruda was not printed in those days, for being commies. It was a blackout." On his way through New York to Europe in January 1957, Ginsberg gave O'Hara a copy of his own stridently public-voiced *Howl*, which O'Hara claimed in a letter to Kenneth Koch that he "like[d] enormously. Beat that. I think he's gotten *very good*. . . . I feel very enthusiastic about him." Enjoying the unlikeliness of their literary alliance, O'Hara wrote again to Koch two weeks later, "Allen Ginsberg is still here, I had coffee with him yesterday. I thought he had already left. He is certainly pulling all the publicity into shape in a way which even you, Kenneth Koch, did not, because of your essentially lyrical, shy nature. He is seeing lots of editors, and has been interviewed by Harvey Breit [*New York Times Book Review* editor] (I should have sent *that*) and is even moved to mention Ashbery-Koch-O'Hara in his promotion as being part of the 'new' poetry. It's hands-across-the-Rockies for perhaps the first time in Amer-

ican history since the Chisholm Trail was opened and then closed
abruptly by the railroads." By 1958 Ginsberg had dedicated the poem
"My Sad Self" to O'Hara, their glue strengthened by a bungled
ménage-à-quatre one evening between O'Hara, LeSueur, Ginsberg, and
Ginsberg's boyfriend, the poet Peter Orlovsky. "I think around that
time we had a double date with Joe LeSueur and Frank O'Hara that
was somewhat of an aborted orgy," says Ginsberg. "I think Joe and
Peter and Frank and I were supposed to make out but I got cold feet.
We wound up naked in bed at first, necking."

Ginsberg was more seduced by O'Hara's taste for poems so unlike
his own and by his championing of poets within Ginsberg's camp.
"Frank liked Corso and Wieners who at this point were not outlaw
poets but out of the world of poetry, or associated with the beat people,
but certainly not part of the New York art scene money scene sophis-
tication," explains Ginsberg. "I remember then Richard Howard was a
young critic, or poet, I had known since Columbia. As far as poetics in
those days he and John Hollander were more or less academic so-called
rightniks. I said, 'Well Frank O'Hara thinks Wieners is great.' He said,
'Well anything Frank O'Hara says is true.' Apparently Richard, who
differs a great deal in taste from me, really admired Frank and took
him very seriously as a deep literary taste rather than saying, 'Oh that's
him, he's a beatnik.' So O'Hara seemed to me like a pillar of probity,
honesty, or virtue." (Howard's admiration for O'Hara extended to hav-
ing claimed to have gone to bed with him a summer before in the
Hamptons, both hung over after an all-night party at Larry Rivers's.
According to Howard, "I just wanted to be one more of the people who
had been to bed with Frank.")

O'Hara's following his feelings also led to some instances of divi-
siveness. His generosity and kindness were almost sexual in their pas-
sion, not matters of conscience or consistency, so he could sometimes
turn abruptly. One of the poets who felt his cutting side was Robert
Duncan, a leader of the San Francisco Renaissance, who was living then
with Jess Collins, a painter who worked with trompe l'oeil, collage,
magic, and hermetic mysteries. Duncan took poetic inspiration chiefly
from Whitman and the "projective verse" of Charles Olson. When
Wieners emigrated to San Francisco he first contacted Duncan as the
leader and center of the emerging poetry scene on the West Coast. Al-
though initially put off by O'Hara's poetry, Duncan was moved to a
reevaluation when "In Memory of My Feelings" (the birthday poem of
O'Hara's thirtieth year) was published in *Evergreen* in Autumn 1958.
Publication of the long poem was an important plot point in O'Hara's

growing reputation. Richard Howard claimed, "In my circle of poets that had a kind of stamp of a certain kind of authority which I recognized immediately and read everything he wrote from then on." Duncan responded by writing a letter to O'Hara on November 20, delivered by Don Allen, with this compliment: "Your poem in the current (#6) Evergreen Review which I came at warily enuf has won me over—to re-search and see the section in MEASURE anew. . . . I write to tell you that you have another concerned reader: as I in turn have new instances of joy." Duncan's version of "Yours truly" was "With that love that we have for the secret writer of the poem who has reached into and touched a center that waited, Robert Duncan."

O'Hara's reaction was not pleasure but annoyance. Ever since parochial school he had been agitated by authority figures with priestly tones, and Duncan seemed too close to adopting such a stance. O'Hara preferred living in a world of his own discoveries and enthusiasms and not being forced to see himself in the mirror of an older West Coast poet. As he had written almost in anticipation of this moment in his collaborative camp letter with John Button to James Schuyler in 1956, "As those West Coast poets are always saying 'Hell hath no fury like an Eastern Queen.'" There was an element of homosexual politics to O'Hara's disdain for Duncan, as many of his own recent young poet friends to whom he was attracted—Wieners, Blaser, Corso, Ginsberg, Orlovsky—went back and forth between them as between two magnetic poles. O'Hara liked to include large numbers of artists in his widening circle, but he could be jealous and odd if he felt their allegiances were truly elsewhere, or that they were tourists in his salon. O'Hara sent the letter back to Don Allen with a simple note written across the top: "Don—please return this as I haven't answered it."

"I remember when I got back from Europe that Robert Duncan had written him a letter saying that, as Frank described it, Duncan was the Queen of the West and Frank the reigning King and Queen of the East," says Ginsberg. "Duncan admired his work and wanted to initiate some kind of community between them, or mutual admiration society, or Duncan was giving Frank his stamp of approval. Frank was offended, saying, 'I don't need his stamp of approval. Who does he think he is? I don't even like his poetry that much. He's much too formal.' I don't remember exactly Frank's precise words, but he sort of shrugged his shoulder, flouncing, saying how dare he make such a thing out of it. . . . I was a little shocked because I did respect Duncan and thought of him as among the elders of the West Coast." Duncan clearly got the message. "My relationship with the New York School has been very

difficult—O'Hara was absolutely intolerant of my existence," Duncan complained to Ginsberg at a discussion on "Early Poetic Community" at Kent State in 1971. "My correspondence with O'Hara was only one long letter to him when I read a marvelous love poem of his and said, 'What a pouring-out of soul this is!' But for O'Hara it was wrong to have read his poem as a pouring out of soul, I guess, really."

On January 2 O'Hara returned to Paris for three weeks to supervise the hanging of "The New American Painting" and Pollock exhibitions. His assistant, overseeing the unpacking of the crates at the Musée National d'Art Moderne and in translating whenever necessary, was John Ashbery, who was otherwise at work on his never-to-be-completed dissertation on Raymond Roussel. Refusing ever to take his work too seriously, or to appear to take it too seriously, O'Hara was pleased to have Ashbery as his accomplice during this working visit. "Whether or not you are interested in doing any work," O'Hara had written ahead, "I do hope you'll make yourself at home in the Musée while I'm there at least, so I won't die of boredom." Ashbery more than fulfilled his mission of diversion. "Thursday afternoon there was a press cocktail at which John and I did not fail to get fairly fried," O'Hara wrote to LeSueur on January 17. Of a later cocktail party following an official public opening at three in the afternoon, O'Hara reported to LeSueur, "John and I ran out on this to go to *Les Dialogues des Carmelites* which I loved and wish you had been with me at—especially since John succumbed after the 2nd act to drink and fatigue and had to go home." Porter McCray put the two poets in charge of the invitation list for the artists' party at the Closerie des Lilas to which they fancifully invited Cocteau, Man Ray, Pierre Boulez, René Char, Robert Bresson, Yves Montand, Simone Signoret, Alain Robbe-Grillet, Raymond Queneau, and Henri Michaux, among other favorite French names. "I tried to get Porter to invite Brigitte Bardot but he just couldn't be led that far out," O'Hara complained to LeSueur. "A lot of people seem to have accepted which John and I find quite amusing for some reason or other." Among those who came to the champagne and foie gras party were the novelists Nathalie Sarraute and Michel Butor—an inventor of the *nouveau roman* whom Ashbery had been trying to interview about Raymond Roussel. Before O'Hara's departure on the twenty-first he even managed to squeeze in an imaginary romance, this time with "a German James Dean who haunts my thoughts—it was too legendary since he was leaving for Munich in another hour, and just like my life usually is."

Back in New York the golden moment of rapprochement between "beat" and "New York School" poetry over which O'Hara had presided began to show signs of coming apart, caused as much by sexual politics as by aesthetic differences. The deciding schism took place at a poetry reading given by O'Hara and Gregory Corso at the Living Theatre at Fourteenth Street and Sixth Avenue on the evening of March 2. Corso, fresh from a benefit reading in Chicago for a suppressed issue of the *Chicago Review* that had published six pages of Burroughs's *Naked Lunch,* asked O'Hara, who disliked public readings, to appear with him. Only about sixty people were present in the sparse audience, which included de Kooning sitting in a row by himself, Franz Kline, Allen Ginsberg and Peter Orlovsky, Morton Feldman, Joe LeSueur, Willard Maas, Julian Beck. Most of the trouble was caused by a drunken Jack Kerouac who within a year would have written *Big Sur,* an account along the lines of F. Scott Fitzgerald's *Crack-Up* of an alcoholic breakdown and DTs in Big Sur, California.

Corso read poems from *Gasoline,* his new book, published by Lawrence Ferlinghetti's City Lights Press in San Francisco—also the publishers of Ginsberg's pocket-sized *Howl* and, in 1964, of O'Hara's *Lunch Poems.* During his set, a drunken Corso shouted out to de Kooning, "Now wasn't that beautiful, de Kooning? Aren't you going to give me a painting? Goldberg and Rivers did." De Kooning shouted back wittily, "I'll give you a reproduction." After reading his last poem, "Marriage," Corso turned to O'Hara and said, "You see, you have it so easy because you're a faggot. Why don't you get married? You'd make a much better father than I would." Ginsberg then shouted from the audience, "Shut up and let him read." Corso replied, "And you're a fucking faggot too, Allen Ginsberg." Willard Maas, an underground filmmaker, then joined in, "Why don't you marry Frank, if you want to so much, Gregory?" Kerouac then yelled, "Let me read. I want to read from *Doctor Sax.*" Playing up to Kerouac as a fellow beat and a fellow straight male, Corso slyly prefaced O'Hara's set, saying, "He's sort of chichi sometimes but when he *feels* something it's terrific." O'Hara, simmering but still controlled, read a few poems and concluded with "Ode to Michael Goldberg," after which Corso sighed, "That's beautiful." Kerouac broke the spell of the interested audience, shouting, "You're ruining American poetry, O'Hara." Quick on his feet, O'Hara snapped back, "That's more than you ever did for it."

Intermission was heated. Corso engaged O'Hara in a long emotional scene of apology. When Kerouac appeared backstage Corso wailed at him, "You're taking my Frank from me. You put me in a

bad light. You shouldn't put down Frank's work. 'Ode to Mike Gold-berg' is beautiful." Kerouac, brooding, replied, "I don't like it." "Jack, I've known you for several years," O'Hara cut in, "and I don't care whether you like me or it or anything else." To which Kerouac replied: "I'm sick and tired of your 6,000 pricks." Stage manager Julian Beck then broke up the fight and pleaded for the poets to return to the stage. Unfortunately Kerouac also chose to join them, sitting onstage on a chair with his back to the audience. Corso read "Bomb" beautifully. O'Hara then tried to read "The Unfinished" but became exasperated enough by Kerouac's heckling simply to make a hasty exit from the stage through the rear door with Joe LeSueur trailing behind him. "I just don't feel like reading," he explained to the audience on his way out. "This may seem uninteresting but it's no more uninteresting than Jack Kerouac's wanting to read."

"What was rather disgusting was the way Gregory prefaced his poems with explanations such as, 'You know I came from the Lower East Side and it really is remarkable that I'm up here doing this instead of being in jail or something,'" O'Hara reported of the catastrophic reading to John Ashbery. "Or 'This is about a dear friend of mine, Bunny Lang, who was also a dear friend of Frank's and she first took me to Cambridge where I started getting educated and everything, so when she died I wrote . . .' Now how do you like that? His fans adored this tranche de vie approach. Granted that I do love Gregory's poems it suddenly seemed as if he felt about them the way Jane Freilicher does, that they're just Clifford Odets narrations on what everyone already knows. I think they're better than that, but does Gregory?"

Ginsberg was perhaps the most horrified as he felt caught in the middle and saw his vision of a harmonious antiestablishment poetic community crumbling as the evening wore on. "As O'Hara left the stage in disdain and irritated, Willem de Kooning, who knew about drunks, tried to restrain Kerouac," remembers Ginsberg. "I was shri-veled in my seat, embarrassed for my friend Kerouac and at the same time sympathetic with O'Hara, wondering if O'Hara understood how great Kerouac was and what grief and fear and paranoia he was talking out of. Peter didn't know what to do, everything being very disgrace-ful. . . . Kerouac had a lot of scope in the sense of rough trade. O'Hara appreciated rough trade. But I think the problem was alcohol, alas."

An attempt was made at reconciliation when Ginsberg, Orlovsky, and Kerouac visited O'Hara's apartment in his absence later that year. They left behind haikus typed on O'Hara's machine along with a for-mal apology from Kerouac—"Dear Frank: the reason I was extraordi-

nary that nite I was jealous of Gregory liking your poetry.—J.K."
Kerouac told LeSueur on his way out of the apartment that he thought
O'Hara was the best American poet after Ginsberg and Corso, a com-
pliment O'Hara dismissed in a letter to Ashbery as "news of a rather
obvious kind—I wonder how long he thinks this little honeymoon is
going to last? Probably until we see each other again and then *BOOM*."

At the end of March O'Hara moved into his third apartment in
New York. The shabbiest and most precariously located so far, this new
apartment on the second floor of 441 East Ninth Street just off Avenue
A and Tompkins Square Park proved to be the most conducive to po-
etry. Or O'Hara was inspired enough during his time there to write in
spite of the noise of the street, the cockroaches, the alcoholic super, and,
according to LeSueur, "a black rat the size of a well-fed cat that ap-
peared one morning." O'Hara had resisted moving to the apartment,
which they had heard about from Larry Rivers and Howard Kanovitz.
"Notice our new address which we are moving into this weekend to
celebrate Easter on the 'lower' Eastside," he wrote Don Allen on March
25 as the painter Al Held was preparing to help in the moving. "It is
that place we almost got before and now finally have for less money,
more rooms and kitchen and bath—though I really don't particularly
like living on Avenue A, Tompkins Park or no." The park was no
particular draw as LeSueur described it: "in those pre-hippie days it was
a bleak and forbidding place frequented by disgruntled old people." Yet
LeSueur was attracted by the cheap rent—an advantage soon offset by
paying extra in cabs to travel to such an inaccessible location. LeSueur
was also lured by the two bedrooms on opposite ends of the apartment
that he felt would insure his deep sleep which O'Hara so disparaged.
They did their best—moving in the butterfly chairs, painting the refrig-
erator orange, lining up the kitchen table (which doubled as O'Hara's
desk) against a row of windows, and covering the tub in the kitchen
with a plank of plywood. Their view of Ninth Street included Garfin-
kel's Surgical Supply Company, a candy store, and in the distance the
steeple of St. Bridget's, which is "leaning a little to the left" in "Steps."
On the wall O'Hara hung his ever-increasing collection of paintings,
which now included works by Rivers, Cavallon (his "Cavallon Paints a
Picture" having appeared in *Art News* the previous December), Harti-
gan, Goldberg, and Mitchell, as well as a de Kooning *Woman* in pencil
and the "orange bed" painting of "Radio." Whenever LeSueur com-
plained about the mistake they had made by moving, O'Hara never
failed to remind him, "Well it was your idea to move here."

But O'Hara had a more compelling reason for avoiding that move

than the practical drawbacks of cab fare and roaches. At the age of thirty-two, having a roommate seemed an idea of the past. O'Hara had given up cruising the streets and was thinking more and more of taking a lover. While his relationship with LeSueur was comfortable, he wondered vaguely if he and LeSueur were also complicitously keeping each other from ever finding a more committed partner. O'Hara confronted him with the question soon after their move to East Ninth Street, saying, "Joe, neither one of us is ever going to get a lover or have anything. I think we should separate." LeSueur, however, was extravagant in his rejection of the notion, saying, "I'd rather go on living with you than ever have a lover." "All right," O'Hara concluded. "Then we'll never talk about it again." There was no going back from O'Hara's remark, however, and something began to change in their relationship over the next five years.

At work O'Hara's energies that spring were mostly wrapped up with preparing the "Documenta II" show, which was exhibited in Kassel, Germany, from July until October 1959. The show was selected by Porter McCray and O'Hara and was in many ways a more comprehensive and revealing panorama of contemporary American art than "The New American Painting," including 144 works by forty-four American artists—not only painters but also sculptors such as Calder, Ferber, Gabo, Lassaw, Lipton, Noguchi, Roszak, and Smith.

Rauschenberg's *The Bed* was included—having been banned at the Festival of Two Worlds in Spoleto just the year before because it looked to the judges as if a murder or rape had taken place in the paint-splashed piece. O'Hara got back at Dorothy Miller by including Hans Hoffmann this time as well as other painters left out of "The New American Painting," such as Cavallon, Marca Relli, Pousette-Dart, and Tobey. "Barnett Newman emerged in particular as a greater 'star' than he was generally then considered to be," Rasmussen wrote, "represented by two of his greatest works: *Tundra* 1950, a brilliant orange field with red stripes, and *Cathedra* 1951, nearly eighteen feet long and eight feet high of blue field with white stripes, one of the masterpieces of American art." In this less glaringly publicized show, O'Hara was able to be more personal in his choices and included many of his friends who had been left out of "The New American Painting"—Norman Bluhm, Helen Frankenthaler, Michael Goldberg, Joan Mitchell. He allowed himself personal satisfaction when choosing the works by including the de Kooning from 1945 that hung on his apartment wall as well as Joan Mitchell's *To the Harbormaster*—homage to his poem of the same name.

In the breathing space that followed when "Documenta II" had

been shipped off to Kassel, O'Hara wrote more and better poems than ever. As the heat and humidity of summer reasserted themselves, he wrote in July such consummate poems about the city as "Rhapsody," which opens with mention of a building at Fifty-third Street and Madison Avenue that he passed on his way to work when he saved money by taking the Lexington Avenue subway uptown rather than a cab:

> 515 Madison Avenue
> door to heaven? portal
> stopped realities and eternal licentiousness
> or at least the jungle of impossible eagerness
> your marble is bronze and your lianas elevator cables

The poem's title was borrowed from a 1954 film starring Elizabeth Taylor about a woman in love with two different musicians. A day later he wrote "Song":

> Is it dirty
> does it look dirty
> that's what you think of in the city.
>
> does it just seem dirty
> that's what you think of in the city
> you don't refuse to breathe do you
>
> someone comes along with a very bad character
> he seems attractive. is he really. yes. very
> he's attractive as his character is bad. is it, yes

Although he was in a heat of poems that had begun three years earlier and would continue unabated over the next two years, O'Hara still could not shake his doubts about his poetry. Often he would walk over to Joan Mitchell's empty studio on St. Mark's Place where either he or LeSueur would take turns living away from each other while she was in Paris. There on July 31 O'Hara wrote his doubts into an unusually solitary poem called "At Joan's":

> the breeze is cool
> barely a sound filters up
> through my confused eyes

I am lonely for myself
I can't find a real poem

if it won't happen to me
what shall I do

O'Hara would indeed have to confront such an impasse and the question posed by the impasse. But not for a few years.

Evidence that O'Hara's talent for "I do this I do that" poems was still intact was "The Day Lady Died," which he had written just two weeks earlier on July 17. The poem was composed on the day of Billie Holiday's death, a Friday, which O'Hara introduced with the accuracy of a wristwatch in his elegy:

It is 12:20 in New York a Friday
three days after Bastille day, yes
it is 1959 and I go get a shoeshine
because I will get off the 4:19 in Easthampton
at 7:15 and then go straight to dinner
and I don't know the people who will feed me

The news of Holiday's death led O'Hara to think back to the last time he had heard her sing. His fullest exposure to her had been two years earlier at Loew's Sheridan on Seventh Avenue and Twelfth Street in the summer of 1957 when she had appeared a few hours late for her midnight show. She was forced to perform in the cavernous old movie theatre because she was not permitted—due to an arrest for heroin use—to sing in a bar that served drinks. "We didn't leave," recalls Irma Hurley, who accompanied O'Hara along with Mike Goldberg, Joan Mitchell, and Norman Bluhm. "Frank said, 'I will wait.' I think she was coming from Philadelphia. She finally arrived pretty zonked out. But she did sing." O'Hara's reaction to her performance was as exhilarated as his reaction to Judy Garland's show at the Palace Theatre, after which he had commented to John Button, "Well, I guess she's *better* than Picasso." But the last time O'Hara had heard Holiday sing was at the Five Spot, a jazz bar on Fifth Street and Third Avenue at Cooper Square, which was beginning to replace the Cedar as the gathering spot of the artists. Like the San Remo a few years earlier, the Cedar had been picked up by the media and was now overcrowded with tourists on the lookout for Pollock-like painters, and young guys cruising for loose "art

girls." At the Five Spot the painters could mellow out listening to the jazz of John Coltrane, Ornette Coleman, Thelonious Monk, or Charlie Mingus. Kenneth Koch and Larry Rivers had begun staging jazz-and-poetry evenings there in response to similar events in San Francisco initiated by Allen Ginsberg and Kenneth Rexroth. One night Koch had read his poems with the accompaniment of Mal Waldron, a black pianist who usually accompanied Holiday. She showed up to visit with Waldron and later in the night was persuaded to break the law by singing. "It was very close to the end of her life, with her voice almost gone, just like a whisper, just like the taste of very old wine, but full of spirit," recalls Koch. "Everybody wanted her to sing. Everybody was crazy about her. She sang some songs in this very whispery beautiful voice. The place was quite crowded. Frank was standing near the toilet door so he had a side view. And Mal Waldron was at the piano. She sang these songs and it was very moving."

O'Hara had written his poem on his lunch hour. Later he caught the train with LeSueur to East Hampton where they were met by Mike Goldberg in the olive-drab Bugatti he had bought the year before when he and Southgate were in Italy on their honeymoon. Ready with a thermos of martinis and plastic cups, both a welcoming gesture and a self-protective ploy so that he could drink while waiting for the inevitably delayed train, Goldberg explained in the parking lot, "We're eating in, the dinner was called off." On the drive to the house Goldberg was renting that summer on Georgica Pond, the only topic of discussion was the tragedy of Billie Holiday's death at the young age of forty-four. "I've been playing her records all afternoon," said Goldberg. Arriving back at the house, Goldberg put a Billie Holiday record on the hi-fi while Patsy Southgate, having finished putting the two kids to bed, brought out a tray of hors d'oeuvres. O'Hara, who had been silent about the matter throughout the trip, pulled a poem out of his pocket that he announced he had just written that afternoon and read it straight down to its concluding stanza:

> *and I am sweating a lot by now and thinking of*
> *leaning on the john door in the 5 SPOT*
> *while she whispered a song along the keyboard*
> *to Mal Waldron and everyone and I stopped breathing*

Love

On August 10, 1959, O'Hara wrote in "Joe's Jacket" of returning to New York after a weekend in Southampton:

> *returning by car the forceful histories of myself and Vincent loom*
> *like the city hour after hour closer and closer to the future*

The Vincent who was his fellow passenger was a 20-year-old dancer whom O'Hara had met only four nights earlier. That he was already projecting a destiny for the two of them as grand as the approaching skyline of Manhattan was an indication of the eagerness and poetic inspiration that he brought to bear almost instantly on this much-longed-for romance.

Actually O'Hara had been aware of the handsome young dancer for some time. Vincent Warren had performed for two years in the company of the Metropolitan Opera and worked as well with the respected underground modern dance choreographer James Waring at the Henry Street Playhouse, Living Theatre, and Judson Church. Warren knew

Edwin Denby and was sometimes invited to evenings at Gold and Fiz-
dale's. His youth and all-American demeanor as well as his accomplish-
ments as a dancer made him a desirable addition to their world. He had
some close brushes with O'Hara, too. Both joking and bragging, Joe
LeSueur had written to O'Hara in Paris the previous January, "The
Berg-Schoenberg-Stravinsky program was lovely. . . . I took Vincent
Warren and went to bed with him later since I didn't let him pay me
for the ticket." Warren recalls borrowing cab fare from O'Hara once
after a party. But not until Thursday, August 6, had the recognition
occurred that O'Hara later remembered in a letter to Warren as the
night "we 'met' on the floor at John Button's." (As the first in their
circle to own a television set, Button often had parties that revolved
around watching old movies or specials.)

Warren swiftly became O'Hara's new muse. Over the next twenty-
one months O'Hara wrote a cycle of about fifty poems assiduously tak-
ing the pulse of their affair, poems that were often surprising even to
him in their openness and clarity. As he wrote, taking stock, in "Avenue
A" in January 1960:

> *everything is too comprehensible*
> *these are my delicate and caressing poems*
> *I suppose there will be more of those others to come, as in the past*
> *so many!*
> *but for now the moon is revealing itself like a pearl*
> *to my equally naked heart*

Writing to John Ashbery, who was at work on some new experimental
"poèmes concrètes," O'Hara archly complained, "I might have known
as I sink into the mush of love you would be foraging ahead into the
21st century." Writing "Statement for Paterson Society" in March 1961,
he commented on the change as well: "it used to be that I could only
write when I was miserable; now I can only write when I'm happy.
Where will it all end?" Unlike Larry Rivers who inspired poems of
expressionist pain and dazzling surface, or Jane Freilicher and Grace
Hartigan who inspired poems of almost weightless fondness and
affection, Vincent Warren was the first muse to inspire O'Hara to
openly gay love poems. This put his poetry in the line of Whitman,
Cavafy, and Genet and led to his being cast after his death in the role
of an early poet of liberation by the gay political movement of the
1970s.

Vincent Warren was not exactly O'Hara's type. Their involvement was as much a departure personally as poetically. Indeed he was young and attractive. That he had light chestnut brown hair was overlooked by O'Hara who willfully described him in "Personism" as "a blond," a reference based partly on Warren's having bleached his hair that summer. But Warren certainly did not fit within the genre of straight male painters to whom O'Hara had been addicted. Nor was he black or Jewish or particularly macho. "Vincent was beautiful-looking," says Rivers. "He was really gorgeous. I've always been attracted to men who look like women. Vincent was like that. He had terrific features." He also had a high-pitched voice, and, as O'Hara once complained, "he talks so fast." O'Hara, however, romanticized Warren the dancer. "To me tights weren't glamorous," says Warren, "but to Frank they might have been." The two shared a rabid interest in old movies and ballet and they would sit up for hours at the kitchen table loquaciously debating the ins and outs of various performers past and present. O'Hara's big-brotherly nature responded to Warren's sweet, open temperament. He found the relationship in many ways healing. Its fatal flaw was that O'Hara was thirty-three and Warren was twenty and unable to respond fully to O'Hara's overtures. The gap in age, as well as Warren's need to travel continuously with various dance companies, set up a new version of the intractable distance that had produced the combination of romance and frustration in so many of O'Hara's previous affairs.

"The whole tragedy about Frank and me, and it's obvious in the poems, is that he loved me and I didn't know how to love at that age," says Warren. "It scared me how he loved me. He gave the poems to me and I could never know what to say. They were obviously very beautiful. Even then you could see how beautiful they were to read. But it scared me because I knew I didn't love him as much as that."

The weekend that launched their affair began the day after they met. O'Hara had scheduled a bon voyage lunch with the painter Norman Bluhm, who was flying to Paris that night. LeSueur was coming to the lunch, too, and he and O'Hara were later to board a train to Kenneth Koch's for a weekend in the Hamptons. LeSueur called at noon to suggest that O'Hara write one of his off-the-cuff occasional poems for Bluhm. O'Hara complained, "Are you crazy? We're meeting him in less than an hour and I've got piles of work to do." During the phone call LeSueur begged off their weekend plans. As O'Hara gossiped in the occasional poem he did write ten minutes later and presented to Bluhm at lunch, titled "Adieu to Norman, Bon Jour to Joan and Jean-Paul":

and Joe has a cold and is not coming to Kenneth's
although he is coming to lunch with Norman
I suspect he is making a distinction
well, who isn't

O'Hara telephoned Warren at the last minute to invite him to Koch's in LeSueur's place, and Warren happily accepted.

O'Hara recorded the details and undercurrents of the weekend in "Joe's Jacket," beginning with their train trip on the Cannonball with Jasper Johns: "Entraining to Southampton in the parlor car with Jap and Vincent." This Friday afternoon train trip to the Hamptons in the late fifties was as social as any gallery opening. Johns and his friend Robert Rauschenberg were often among the familiar artworld faces on the waiting platform—having established themselves the year before as rising stars of the Leo Castelli Gallery. Steven Rivers recalls one of the weekends during the season when Johns and Rauschenberg had stopped by the Rivers house in Southampton while O'Hara was visiting to bury their pet monkey: "Jasper had this marmoset and it died and was buried under a tree in Larry's backyard. I'll never forget Bob and Jasper crying. I was very upset. I think Frank thought that was very funny. He had a very sick sense of humor sometimes." Johns's and Rauschenberg's models for their bonding were similar friendships from the previous generation, especially that of Merce Cunningham and John Cage—pairings as responsible for cross-germination in the arts as any aesthetic philosophy.

On this particular weekend, however, Rauschenberg was absent. As O'Hara and Johns settled into talking, while scenery perceived by the poet as "a penetrable landscape lit from above" raced past, Warren had his first taste of the high-flying jokes and pronouncements to which he would be a quiet bystander during much of his time with the catalytic poet. When they got together, O'Hara characteristically tended to draw Johns out about his painting, to flatter and delve. Johns was going beyond his flag and target paintings to make canvases playing with colors and their stenciled names for his show the following February. "There was this weird thing of Frank's interest in and understanding of other artists that seemed to put no obligation on his own work, neither threatened, nor helped, but was in a sense disassociated from his work," recalls Johns. "I doubt that it was. But there was that sense, perhaps sadly. I had no sense that he needed anything from me about his work but that his interest in me was about my work. In the very way he

behaved you wouldn't have had much time to have thought that he felt anything else. The focus was always someplace else."

At the station O'Hara and Warren were met by Kenneth Koch, who drove them back to Southampton:

> *at the station a crowd of drunken fishermen on a picnic Kenneth*
> *is hard to find but we find, through all the singing, Kenneth smiling*
> *it is off to Janice's bluefish and the incessant talk of affection*

The bluefish found its way as well into O'Hara's polite thank-you note written the following Tuesday: "Vincent and I had a terrific time from the opening bluefish to the closing bourbon."

On Saturday night "an enormous party mesmerizing comers in the disgathering light" was given at the Porters' sprawling white Southampton home, the invitation to which listed the names of fellow hosts Joe Hazan, Jane Freilicher, Jane Wilson, and John Gruen. "Now does it really take that many people to have a party?" O'Hara asked wryly in a letter to Joan Mitchell. "It sounds rather like the entrance to Fairlawn Cemetery which our glorious Jean Harlow is buried in." As Kenneth Koch recalls, "That weekend Frank told me why he drank so much. He said he drank so he wouldn't be nervous." When he included his response in "Joe's Jacket," the variations on the theme were multiplied:

> *I drink to smother my sensitivity for a while so I won't stare away*
> *I drink to kill the fear of boredom, the mounting panic of it*
> *I drink to reduce my seriousness so a certain spurious charm*
> *can appear and win its flickering little victory over noise*
> *I drink to die a little and increase the contrast of this questionable moment*
> *and then I am going home, purged of everything except anxiety and*
> *self-distrust.*

O'Hara's answer was echoed by Patsy Southgate who claims, "I've always agreed with Joe that the reason he drank so much was out of boredom. I think that his mind and body worked at a far faster rate than most people's. Part of the effect of the alcohol was to slow him down to a more normal metabolism." Missing in these accounts, of course, was a more mundane recognition of the persistence of alcoholism in the O'Hara family and of the sort of deadly game of Russian roulette being played long distance by him and his mother.

When Patsy Southgate came across O'Hara with Vincent Warren

at the party she was furious. "That really pissed me off," recalls South-gate. "Frank was dumping Joe and I was furious. Frank explained to me that he wasn't dumping Joe. But that he was madly in love." O'Hara's friendship with LeSueur was so ambiguous that even their closest friends were never entirely sure of its true nature. Since they lived together and were usually in tandem at parties, most people simply assumed they were lovers. Even though they were not, LeSueur might well have begun to feel some tentative fear of being pushed aside. War-ren's entrance certainly threw his reliable weekend plans with O'Hara into jeopardy. "Another little trouble in paradise may be brewing, since from a very sweet poem he wrote for me last weekend and subsequent developments it seems he wasn't only pleased by Patsy's remark at that party, he agreed with her!" O'Hara wrote the next Wednesday to Schuyler, who was sharing the Hamptons house with Koch. "Not hav-ing caught onto this subtle manifestation, I said, 'Well, maybe you should go to Patsy and Mike's and I should go to Kenneth and Jimmy's.' His reply: 'All right, go there and take Vincent with you.'"

A victim of insomnia, O'Hara was fascinated and touched by War-ren's ability to sleep, many of his poems to him containing restful im-ages of an oblivious Vincent, as in "Poem" (That's not a cross look it's a sign of life): "my insatiable thinking towards you / as you lie asleep completely plotzed and / gracious as a hillock." "Joe's Jacket" gives a sense of O'Hara's sleepless Saturday night as a guest in the country deprived of the usual diversion of bars and all-night parties. (The Koch summer house was not as dipsomaniacal as that of Goldberg or Rivers.)

my bed has an ugly calm
I reach to the D. H. Lawrence on the floor and read "The Ship Of Death"
I lie back again and begin slowly to drift and then to sink
a somnolent envy of inertia makes me rise naked and go to the window

The following afternoon Koch read to O'Hara and Warren from a li-bretto he was working on:

and we are soon in the Paris of Kenneth's libretto, I did not drift
away I did not die.

As Koch recalls, "The nicest thing about this house was there was a peach orchard. We sat out there and I read him and Vincent my opera *Angelica,* which Frank liked very much. He very much approved of peo-

ple doing long and ambitious works. He would take it very seriously."
Always trying to stir up affection and interest between his friends—
especially between his boyfriends and his friends—O'Hara tended to
describe their feelings for each other in distorted, or at least magnified,
ways. Thanking Koch for the weekend, O'Hara mentioned Warren's
great interest in the libretto—the reading of which Warren claims to
have completely forgotten. Again, "I saw Vincent last night," wrote
O'Hara two days later, "and he liked the libretto so much I wouldn't
be surprised if he took up singing along with the other things he ap-
parently is taking up. What energy!" O'Hara included LeSueur as well
in the supposed excitement: "Joe is wistful about not hearing you read
the 'Angelicus Redivivus' and hopes that you will have gathered
strength by the time he sees you since he wants to hear it in your voice."

"Joe's Jacket," as its title confusingly implies, was not simply an
account of a honeymoon weekend with a new boyfriend. O'Hara
needed to figure out how this new romance was going to fit into the
puzzle of his life. LeSueur and Southgate were already expressing the
anger and upset often generated by the entrance of a new player onto an
established social scene, and O'Hara did not wish to threaten the valu-
able comfort and support he enjoyed from LeSueur. These were the
qualities with which he imbued LeSueur's seersucker jacket, borrowed
to wear to work on the Monday morning of his return:

I borrow Joe's seersucker jacket though he is still asleep I start out
when I last borrowed it I was leaving there it was on my Spanish plaza
 back
and hid my shoulders from San Marco's pigeons was jostled on the
 Kurfürstendamm
and sat opposite Ashes in an enormous leather chair in the Continental
it is all enormity and life it has protected me and kept me here on
many occasions as a symbol does when the heart is full and risks no speech

Whether LeSueur or O'Hara could be satisfied with an arrangement that
tried to balance—and divide—romantic fervor and domestic comfort re-
mained to be tested.

O'Hara wrote "Joe's Jacket" on Monday, and by Tuesday evening
he had written "You Are Gorgeous and I'm Coming." The poem is an
acrostic in which the first letter of each line spells out Vincent Warren's
name, the *V* resulting in its first line, "Vaguely I hear the purple roar
of the torn-down Third Avenue El." ("I never saw the Third Avenue

El," says Warren. "By the time I got to New York it was a public memory.") Warren expressed a worry almost immediately that O'Hara's poems would somehow be read by his mother in Florida and expose to her the secret of his homosexuality. His somewhat far-fetched paranoia only goaded O'Hara to further tricks and poetic camouflages. Because of what he described in "Saint" as Warren's "familial anxieties," O'Hara used his middle name, Paul, in titles such as "Those Who Are Dreaming, A Play About St. Paul" or "St. Paul and All That." His impulse in deleting the *P* in "V (F) W," claimed O'Hara in a letter to Warren, was "so it won't embarrass your mother." As Warren was born in Jacksonville, Florida, O'Hara made a flurry of references to the state: he used the title "Leafing Through Florida"; he recalled impossibly the time "when my grandmother came back from Florida" in "Poem" (O sole mio, hot diggety, nix 'I wather think I can'); he included the "Jacksonville / Chamber of Commerce" in "September 14, 1959 (Moon)." Teasing Warren about his discretion became that season's poetic challenge for O'Hara. It was a game only slightly tinged by his anxiety that by not carving their names in poetry, an impermanence that he already feared would be given greater sway. As he wrote to Ned Rorem in October, "When I am unhappy I am terribly anxious to get happy and when I am happy I am terribly anxious that I don't lose it."

Within weeks of their meeting, Warren became privy to some of O'Hara's intenser confrontations. He found them a bit over his head. "Frank could be acerbic," recalls Warren. "I remember once in a taxi cab that Frank made Joe cry. Frank said some hard, direct things that made Joe face himself and Joe needed that. Frank could cut to the heart of the matter with people. But it was scary sometimes too. I think I was probably the only one who could get away with being Pollyanna in the middle of all that. I wouldn't fight. We never had any fights, never had any confrontations. He was very permissive to me. He was in love with me, obviously." To try to quell Warren's shock at witnessing some of these *in vino veritas* dramas in the first two weeks of their relationship, O'Hara wrote for him "Poem" (Hate is only one of many responses) on August 24:

> *Hate is only one of many responses*
> *true, hurt and hate go hand in hand*
> *but why be afraid of hate, it is only there*
> *think of filth, is it really awesome*
> *neither is hate*

> *don't be shy of unkindness, either*
> *it's cleansing and allows you to be direct*
> *like an arrow that feels something*

Originally titled "For Another's Fear," the poem was not about a fight with Warren but rather about his upset, similar to a child's at witnessing a fight between parents. "I remember Frank talking once about the kinds of sexual relations one has just out of vanity and the kind one has because someone really cares for somebody," says Kenneth Koch. "I was very naive. I was very interested to hear somebody as young as I was talking about these things. I was very surprised by how wise he could be. It was the kind of smartness you can see in a poem like 'Hate is one of many responses.'"

Three days later, on August 27, in the middle of what the poet Bill Berkson has described as the *"annus mirabilis* of his poetry," O'Hara had lunch with the young black poet LeRoi Jones (who changed his name in the late sixties to the more radical Amiri Baraka). O'Hara's relationship with Jones was always a matter of conjecture to those around them and O'Hara did little to allay the confusion. "I remember it was very funny when Frank told me he met LeRoi," says Kenneth Koch. "He said he'd met this marvelous young poet who was black and good-looking and very interesting. 'And not only that,' he said, 'he's gay.' Like I was supposed to be jealous of this. Like Frank would get more of him than I would. I don't know whether LeRoi yielded to Frank's almost irresistible charms or not. Nor do I care. So I assumed that LeRoi was gay for a while, but that's before I got to know him. I don't know whether Frank was serious or not. Maybe he was just optimistic."

At the time of their lunch, Jones had been married for a year to Hettie Roberta Cohen, a young white Jewish woman who was advertising and business manager of the *Partisan Review.* She had been instrumental in having Jones's fierce rebuttal of Norman Podhoretz's "The Know-Nothing Bohemians" published in *Partisan Review* the summer before. Together they were now publishing *Yugen,* which ran for eight issues before ceasing publication in December 1962. As one of the first journals in the city to devote itself to "new" poetry—soon followed by *Floating Bear, Kulchur, Fuck You: A Magazine of the Arts,* and *C—Yugen* published a mix of Beat, Black Mountain, and New York School poets. (It had published O'Hara's "To Hell with It," "Music," and "Ode on Causality" earlier that year.) Jones had also started his own Totem Press, which published Charles Olson's *Projective Verse,* and he teamed

up in 1960 with the owner of the Eighth Street Bookshop, Ted Wilentz, to publish a pamphlet version of O'Hara's *Second Avenue* with a cover by Larry Rivers, as well as Ginsberg's *Empty Mirror,* Gary Snyder's *Myths and Texts,* and Jones's own *Preface to a Twenty Volume Suicide Note.* No phenomenon separated the sixties more distinctly from the fifties among poets than the appearance seemingly overnight of this paper river of magazines, broadsides, mimeos, and poetry chapbooks.

"Looking at Frank O'Hara was like looking at James Baldwin," remembers Baraka. "If you don't know they're gay, you can't see. That's not a little parasol to be tossed away. That's them. Frank would come in a place and toss his coat on the floor like Greta Garbo. I think Frank would get campier the more he got drunk. Same thing with Jimmy. He'd get extremely photogenic. What most people feared about both of them was their tongue. When they caught hold of people they would catch hold of them good. But I think Frank and I had an unspoken agreement not to jump on each other. We tended to be allies. It was a political jungle Downtown. Even as an artsy world, it was still very political, and very much he-said and she-said, and rumors of this and rumors of that, and a coup in the East and a coup in the West. But we were very supportive of each other."

Their lunch that afternoon took place at Moriarty's, a glorified workingman's bar and grill on Sixth Avenue famous for its corned beef and cold beer. Their conversation, which turned on various literary topics, was set down paratactically by O'Hara in "Personal Poem," written when he returned to his desk that afternoon:

> we don't like Lionel Trilling
> we decide, we like Don Allen we don't like
> Henry James so much we like Herman Melville
> we don't want to be in the poets' walk in
> San Francisco

They also toyed with thinking up a movement. "We went to lunch and said, 'Let's think of a movement,'" says Baraka. "'What movement?' 'Personism.' It was Frank's movement. He thought it up. What was good for me was that it meant that you could say exactly what was on your mind and you could say it in a kind of conversational tone rather than some haughty public tone for public consumption." As O'Hara recalled the genesis of Personism in his mock-manifesto, "It was founded by me after lunch with LeRoi Jones on August 27, 1959, a day

in which I was in love with someone (not Roi, by the way, a blond). I went back to work and wrote a poem for this person. While I was writing it I was realizing that if I wanted to I could use the telephone instead of writing the poem, and so Personism was born." The poem, written of course to Warren, "between two persons instead of two pages," was "Personal Poem," which ends in a major key:

> *I wonder if one person out of 8,000,000 is*
> *thinking of me as I shake hands with LeRoi*
> *and buy a strap for my wristwatch and go*
> *back to work happy at the thought possibly so*

O'Hara didn't write the manifesto that went with the movement until the following Thursday, September 3. The instigation was Don Allen, who was putting together his *New American Poetry* anthology for Grove. O'Hara had been his primary unofficial consultant, advising on trends as well as lobbying for the inclusion of personal favorites such as Edward Field and Barbara Guest. Allen had asked for a statement on poetics from all of his contributors, and O'Hara as usual was being dilatory. With Allen on his way across town that evening to pick up the statement, though, O'Hara poured himself a bourbon and water and decided to type out the manifesto, which he had been thinking about ever since lunch with Jones. LeSueur, noticing him preparing finally to get down to work, asked if he wanted him to turn down the radio. "No, turn it up," O'Hara replied. "They're playing Rachmaninoff's Third next." "But you might end up writing another poem to Rachmaninoff," LeSueur joked. "If only I could be so lucky," O'Hara shot back. When the concerto was finished in less than an hour O'Hara showed what he had written to LeSueur. "Do you think it's too silly?" he asked. LeSueur's only complaint was the title: "Personalism: A Manifesto." "Personalism is the name of a dopey philosophy in Southern California," he explained. "Oh, then I'll call it 'Personism,'" O'Hara quickly replied. "That's better anyway." Allen, however, felt that the aesthetics of "Personism" applied to O'Hara's love poems but not to the odes. He asked him to try again. So LeRoi Jones published both the manifesto and "Personal Poem"—works in which he had been so intimately involved—in *Yugen*. For Allen, O'Hara wrote a less anecdotal, though equally insouciant, statement: "I am mainly preoccupied with the world as I experience it, and at times when I would rather be dead the thought that I could never write another poem has so far stopped

me. I think this is an ignoble attitude. I would rather die for love, but I haven't."

With his attention taken up by love, O'Hara seemed to have more energy than ever for the realpolitik of poetry and painting. His job was becoming busier every day. He now had a devoted assistant from a Roman family, Renée Neu, sitting crowded with him in his office every day helping to ease the work load and protect him from overly intrusive or jealous colleagues. Their tiny office, with its two large desks, one window facing an airshaft, shelves lined with books and museum catalogues, and an ornate mirror, showed up in O'Hara's "L'Amour avait passé par la," written there on August 19:

> Yes
> like the still center of a book on Joan Miró
> blue red green and white
> a slightly over-gold edition of Hart Crane
> and the huge mirror behind me blinking, paint-flecked
> they have painted the ceiling of my heart
> and put in a new light fixture

One of O'Hara's current projects—assisting James Thrall Soby in putting together a show for Rome and Milan, "Twentieth-Century Italian Art in American Collections"—slipped into the poem as well:

> it is the great period of Italian art when everyone imitates Picasso
> afraid to mean anything.

In and out of this office all day long, O'Hara stirred up a frenzy of activity, both personal and professional, indecipherable to onlookers. Only Renée Neu was fully apprised of all the goings-on. "He would come in quite late in the mornings," recalls Neu. "He would call me for a moment from home around ten o'clock and tell me what happened the evening before. When he finally came in it was a madhouse. We never had a moment's peace. Philip Johnson would call asking what was that bit of poetry he had written. The Registrar would check if there was any young poet or artist who needed an available job. Larry Rivers or Norman Bluhm would drop in and start chatting for hours. When he was working he concentrated very much. But at the same time he didn't give the impression of working hard. Anything could be taken very casually. It was almost like a pose." O'Hara spent so much time

on his phone at the Museum that he complained of what he called "black ear" in "Macaroni." "I once called him at the museum and the operator said, 'Good God!,'" recalled James Schuyler, "but she put me through."

In September O'Hara's monograph *Jackson Pollock* appeared as one of six books published by George Braziller in its Great American Artists Series. (A book on de Kooning by Thomas Hess was also included in the series.) Emboldened by the response to his essay on *Doctor Zhivago,* O'Hara opened his essay on Pollock with an epigram from Pasternak's autobiography, *I Remember,* in which Pasternak grandly described Scriabin as "not only a composer, but an occasion for perpetual congratulations, a personified festival and triumph of Russian culture." Pulling out all stops, O'Hara launched into his own essay—"And so is Jackson Pollock such an occasion for American culture." His essay was both a poetic paean to Pollock's work and an iconoclastic, though classically scholarly treatment of the mythological content of such early 1940s paintings as *Guardians of the Secret* and *The She-Wolf.* According to Sanford Friedman, a friend of Pollock's wife, Lee Krasner, "Lee loved his book. She felt that his was the book of a poet rather than an art critic. He said things in there about *The Deep* that she felt absolutely hit the mark." This winning over of Pollock's widow helped greatly seven years later when O'Hara began to work on a major retrospective of Pollock. The tenor of the remarks on the later works that she so appreciated was most pronounced in his seductive appraisal of *The Deep* as "a scornful, technical masterpiece, like the *Olympia* of Manet. And it is one of the most provocative images of our time, an abyss of glamor encroached upon by a flood of innocence."

The critics hardly agreed with Lee Krasner. Typical of the roasting O'Hara's poetic prose received from the press was Aline Saarinen's review in the *New York Times Book Review* on September 27: "Frank O'Hara is adulating, emphatic and unrestrained, perhaps as is inevitable with a poet! . . . His praise is so extravagant it loses its effectiveness. But, somehow, something of the fervor, the dedication, the lyricism, the serious purpose and the undeniable quality of Pollock's art come through this purple, poetic prose." George Heard Hamilton in *Art Journal* found O'Hara's prose "just a bit intense." Hilton Kramer in *Arts* called O'Hara a "pseudo-Apollinaire" and accused him of "phony poetics." Like Virgil Thomson, Kramer was suspicious of the axis linking O'Hara the "poetaster" with the power of the Museum of Modern Art: "I think future historians will find it significant that the 'poetic' school of criticism, particularly as it concerns Abstract Expressionist painting,

came forward at precisely the same moment that collectors and museums began buying the pictures." The attack was inevitable, as many saw a conflict of interest in O'Hara's many positions.

With Helen Frankenthaler, married the year before to the painter Robert Motherwell after the break-up of her relationship with Clement Greenberg, O'Hara used the reviews as an excuse for his lateness in finishing a catalogue essay for her upcoming exhibition in January at the Jewish Museum. "I feel ashamed that it took so long," he wrote to her on December 16, "but the criticism of the Pollock thing (which didn't bother me when it occurred—even Lincoln Kirstein puts it down / I will introduce him and Hilton), and which was mitigated by your, Bob's and Grace's kindness, suddenly left me very self-conscious and with absolutely no brio about my ideas about your work since I thought my admiration might just bring about the same situation." Mostly, though, O'Hara's response was tinged with the shrugging humor and contempt he displayed as armor against criticism directed either at him or his friends. He had relayed the news to Ashbery at the end of November that his book was panned as "'hopeless' or something by Hilton Kramer which is nice since he is so loathsome in every way that I would hate to suffer under his approval. The text is pretty feverish and I don't know why it came out the way it did, but it did so what could I do about it having no character and even less of a sense of responsibility?"

This wrist-slapping from the critical establishment certainly did not slow down O'Hara's involvement with artists. The winter of 1960 was a busy time for his circle of second-generation New York School painters, many of whose careers were now in full force. Shows were hung and dismantled of Freilicher, Goldberg, Bluhm, Frankenthaler, and Katz. The Tibor de Nagy Gallery mounted what *Art News* described as "a kind of homage" to O'Hara, showing Hartigan's *Oranges* and Rivers's and O'Hara's *Stones* plus portraits of O'Hara by both. "Do you think I should show every year or every other year?" he wrote humorously of the event to Joan Mitchell. There was also a benefit sale of paintings for Nell Blaine who had been struck by polio recently on Mykonos. Among the fifty artists contributing to the show at the Poindexter Gallery where Hal Fondren was working as a dealer were Elaine de Kooning, Mitchell, Hofmann, Reinhardt, Guston, Motherwell, Hartigan, Rivers, Frankenthaler, de Niro, and Pollock.

O'Hara showed up at as many of these events as possible with Vincent Warren. A lot of their time was spent as well on other sorts of dates. That fall and winter they saw many movies (*Riptide, Les Enfants*

du Paradis, Desire with Marlene Dietrich, the Marx Brothers' *Duck Soup*), operas (*Turandot, Così fan tutte,* Kurt Weill's *Street Scene*), musical performances (Orff's *Carmina Burana,* Stravinsky's *Oedipus Rex*), and plays (*The Three Sisters, Krapp's Last Tape*). They often watched movies together at the Museum of Modern Art, Warren stopping by to meet O'Hara in the lobby after work, or at the Huff Society, a club for old-movie buffs that rented out office buildings and lofts for private screenings, or on John Button's black-and-white television screen. (A showing of a 1923 Rin Tin Tin movie titled *Where the North Begins* at the Huff Society had inspired John Ashbery's 1955 play *The Compromise*—a retelling of the plot with the dog eliminated.) O'Hara's and Warren's conversation could be consumed with rehashing the plots of old movies they had seen together or making references to current, if slightly obscure, B-movie actors. For instance, O'Hara liked to compare his boyfriend to Jeffrey Hunter, a rugged, boyishly handsome actor in action movies such as *A Kiss Before Dying* and *Count Five and Die* who surprised everyone by playing a beatific Jesus in Nicholas Ray's *King of Kings* in 1961. "He and Vincent used to sit every night and watch old films on television in the sixties," recalls the dancer and choreographer Dan Wagoner. "Frank would go on and on for hours about whether someone was good in a movie or why they weren't. They would argue over who played a certain part and who didn't." Typical of this over-the-top enthusiasm was O'Hara's note to Warren, "I hate to tell you that *Queen Christina* is on TV this thurs—how can I bear it without you? xxx F."

Their favorite activity together, though, was attending the New York City Ballet, which they did two or three nights a week. During the 1960 season they attended the company premieres of *Night Shadow, Theme and Variations, Tchaikovsky Pas de deux,* and *The Figure in the Carpet.* At that time the New York City Ballet wasn't selling out every night. As a student dancer, Warren sneaked in at intermission and invariably found a seat. But O'Hara was usually able to spring for tickets—orchestra seats costing about five dollars. Or Edwin Denby, who shared O'Hara's fondness for Warren, would treat them both. If they weren't with Denby, they tended to go with John Button whose rapid-fire takes on the ballets were honed by years of practice. Much of the jabbering took place at intermission on the way to or from the hotel bar across the street. Of *Agon,* premiered in 1957 and amplifying the growing Balanchine-Stravinsky repertoire to which the fall's *Momentum Pro Gesualdo* would be the next addition, Button had announced, "It's as great as *Guernica!*" "The subject of *Agon* is pride," O'Hara had rejoined of the abstract ballet set to twelve-tone music. Marcel Duchamp remarked to Edwin

Denby on its opening night that he felt the way he had after the opening of *Le Sacre*. Denby recorded his own opinion in a review in *Evergreen*: "The 'basic gesture' of *Agon* has a frank, fast thrust like the action of Olympic athletes, and it also has a loose-fingered goofy reach like the grace of our local teenagers."

Luckily, in such heady discussions of dance—he and O'Hara saw *Agon* performed by Diana Adams and Allegra Kent—Warren was not out of his depth. Perhaps no element was more solid in his relationship with O'Hara than their late-night debates on the ballet, since Warren had the advantage of insider's knowledge. They certainly did not always agree. Warren tended to be more dubious than O'Hara about the technical skill of certain of the dancers. "The corps de ballet was not as strong or as together as in later years," recalls Warren of his opinion of the company in 1960. "I remember applauding while consciously saying in my mind that this was for Balanchine, not for the corps de ballet; this is for the conception not the execution. But Patricia Wilde was a fantastically brilliant fast dancer. Frank loved Maria Tallchief though I never understood why. It's important to remember too that dancers' bodies changed in this period. Tanaquil LeClercq was extremely long and thin at a time when dancers were short and compact. She was exaggerated in her thinness. She was ahead of her time in the sense that she had an elongated line and a sharpness to her that was different than the dancers of her period. Seeing that Balanchine liked her, other dancers started to look like her." O'Hara evoked LeClercq's elongated line in his "Ode to Tanaquil LeClercq" written that June, in which he called her "narrow like a lost forest of childhood stolen from gypsies" and "the superb arc of a question." A week earlier he had written "Glazunoviana, or Memorial Day" in which the lines "Maria Tallchief returns to the City Center / in a full-length *The Seasons*" alluded to the libretto he told Warren he had written at the request of Lincoln Kirstein, the General Director of the New York City Ballet. "He chose *The Seasons*," Warren remembered, "and wrote a wildly romantic story about a nymph (to be danced by LeClercq) and faun (Nicholas Magallanes) to be done in modern dress—it doesn't sound very Balanchinesque. It was refused not because of the story, but because 'Mr. B.' didn't like *The Seasons*—though years later he did a marvelous Glazunov ballet, so maybe it *was* the story."

Warren was as ambitious, busy, and unavailable as most of his student dancer friends. As Larry Rivers recalls, "Vincent was a dancer, and dancers always seem to me to not be there. He would be in a room, but he was only going to be there for a few minutes because he had to

go dance, or practice, or exercise, or sleep. He was like an athlete. It was always like, 'Oh, I'll see you.' He'd walk in one second and very rarely spend the whole evening." This rhythm generally worked, though, for O'Hara. More exposure might have been difficult for someone as complicated in his needs for so many different people as O'Hara. As he wrote of his general satisfaction to Ashbery on December 30, "I am still madly in love and we are both very happy and wildly unhappy now and then when we fight and it is all *SO MOVING,* probably more than anything else ever in either of our lives (this makes me feel like Hart Crane writing to Waldo Frank, if you don't mind the position I'm putting you in) and is full of the concomitant uneasiness about What May Suddenly Happen, etc., though Vincent is less neurotic than I am in that respect until I communicate some uneasiness at which he becomes even more upset than I am and we make up (knock on wood). He really is the greatest, as you may have gathered from my poems. One sweet and odd thing about our relationship is that I get jealous of some dancer or actor I think he may be attracted to physically whereas he gets jealous of some poet or painter he thinks I might find more fascinating than him. Which is unlikely to say the least." An example of the smoothing of ruffled feathers common in their first few months of intimacy was O'Hara's "Poem" of January 7 beginning

> *That's not a cross look it's a sign of life*
> *but I'm glad you care how I look at you*
> *this morning*

The first interruption in their romance, which had been so workably smooth for seven months, was the trip O'Hara took to Spain on Museum business in March 1960. He was excited to return to Madrid—the site of his first European stop two years earlier. As John Ashbery was meeting him there to travel to various cities in Spain, he was especially eager. "More of seeing you than Spain," he charmingly wrote him. But lurking was the fear of upsetting the love he was convinced he had but was uncertain he would be able to maintain. "Oh I do hope nothing happens while I'm gone to change certain affections," he wrote skittishly to Ashbery on March 8.

On the morning of March 23 O'Hara was the recipient of a good-bye kiss from Warren behind a panel near the Calder mobile at Idlewild before he boarded his Iberia Air Lines plane. "That's what it always needed, a little history!" O'Hara wrote Warren of the mobile in longhand from the airplane.

Arriving in Madrid at 4:30 a.m., he made his way to the Hotel Wellington where he received a wake-up call at 9:00 from Oscar Salvador, the translator with whom he had had an affair on his last trip. O'Hara had much business to accomplish in Madrid in ten days. His assignment was to put together a show, "New Spanish Painting and Sculpture," scheduled to open at the Museum of Modern Art in four months and circulate afterward throughout the United States. Among the painters in Madrid whose studios he needed to visit, or whom he met for coffee, drinks, lunch, dinner, or thimbles full of red wine with sausages or skewered lamb at stand-up workers' bars were Canogar, Rivera, Farreras, Millares, and the sculptor Chirino, all of whom worked in a style of abstraction that was seemingly becoming universal. At the time, the thirty-four-year-old Millares was the only painter in Madrid to have won a following outside Spain, for his works of burlap dipped into white paint that he then bunched and tore up, smeared and daubed with black and called "homunculi." Compared to their American counterparts, the Spanish painters tended to more somber palettes, of tawny and rusty tones, grays, and blacks. Different cities, though, had different painters, even different dialects of style, so that O'Hara needed to make a tour. The supposed rift between a School of Madrid and a School of Barcelona was addressed dismissively by him in his introduction to the show's catalogue: "Whether or not there is a factional hiatus in actuality, reminiscent as it is of the rumored divergence between our own New York School and l'École du Pacifique (a hiatus which, like the Spanish one, was formulated in Parisian critical circles), is a question which seems irrelevant here." His itinerary after Madrid was that laid out in "Having a Coke With You," written to Warren on April 21, four days after O'Hara's return to New York:

HAVING A COKE WITH YOU
is even more fun than going to San Sebastian, Irún, Hendaye, Biarritz, Bayonne
or being sick to my stomach on the Travesera de Gracia in Barcelona

O'Hara needed to take care of personal business in Madrid as well. His wish to be reunited with his translator, Oscar Salvador, had come true. Unfortunately O'Hara's situation had changed. He now had Vincent Warren in his life and was at pains not to jeopardize their romance, though he did report the nature of his rendezvous with Salvador in his

letters home. The first night, O'Hara was at pains to explain, they parted "1/2 way between Oscar's house and my hotel." The next night, though, they had their "inevitable talk," which left Salvador bereft and O'Hara queasy until he discovered that Salvador, too, had a boyfriend as well as a "trail of broken hearts around Madrid"—many of whom eyed O'Hara hostilely in various gay bars they visited together. "Now that is very odd because I haven't seen him since 1958, though we have written letters from time to time," a conveniently level-headed O'Hara wrote to Warren. "I can be faithful or whatever you want to call it (I don't necessarily mean sexually, except that you continue to prefer the one you love, not that I can't be sexually faithful), but it would have to be based on something more than 10 days 2 years ago." (The affair had actually lasted five days.)

The fun in O'Hara's Spanish trip this time was mostly provided by John Ashbery who arrived in Madrid on the evening of March 25. In his letters O'Hara put all the romantic expectancy that had animated his letters from Europe on his last trip into the figure of Ashbery. Perhaps in reality, but certainly in his letters to Warren, Ashbery became the very type of what O'Hara called "a highly excitable vacationist. I wonder if he really spends as much time in the Prado while I'm working as he says he does." One evening he and Ashbery clattered down the steps of the cavelike El Tres, a "queer bar" in Madrid, as familiarly as if it were the Old Place in New York, O'Hara making out in the near dark the "usual slightly sinister male couples you see at 'polite' gay bars." O'Hara distanced himself from his fellow homosexuals now and then with digs. "The funny thing that occurred to me is probably why I like Madrid so much as a city," O'Hara wrote to Warren later on the hotel typewriter. "It is just like New York in that one has the same kind of relationships here. (Unlike Paris or Rome.) That is, the queens always hate me and the heterosexual painters seem to like me. So naturally I prefer them socially."

O'Hara enjoyed a side trip to Toledo, a city he compared to "a great cubist painting—it's completely wrapped in the Tagus River and there's a drive you can take on the surrounding mountains so you can see the whole city from every vantage point." He overcame his anger against Catholicism enough to be amazed by the Cathedral, with its El Greco paintings of Christ and the Twelve Apostles, "all of whom look somewhat like his own self-portrait." However, in the love poem he wrote to Warren after his return to Madrid, "Now That I Am in Madrid and Can Think," he reverted to his feeling that love vanquishes all religious art:

and in Toledo the olive groves' soft blue look at the hills with silver
 like glasses like an old lady's hair
it's well known that God and I don't get along together
it's just a view of the brass works to me, I don't care about the Moors
seen through you the great works of death, you are greater

On Sunday, April 3, O'Hara and Ashbery took a train to Barcelona where a letter from Warren was waiting at the Hotel Colón. "The first thing that greeted my eyes was an enormous fountain all lit up (it was 11 pm) and the next was the Catedral which is also lit up and looks fabulous at night since it's lit from within too so you can see the stained glass windows," he wrote back immediately. "But I wasn't really buying any of this (as I hope they said in *The Best of Everything*), it was really your letter that seemed wonderful." He and Ashbery were treated the following afternoon to a three-hour tour by the painter Tharrats—described by O'Hara in his catalogue essay as "a headlong expressionist, astral, destructive of order"—of Gaudí's Parque Güell, which O'Hara found "the ultimate triumph of gingerbread." He kept appointments, too, with Tapies and Cuixart: Cuixart, who made Gaudíesque shapes on his canvases from thick metal paint, was with him when he threw up in the gutter in front of his house. Thirty-six-year-old Anton Tapies, perhaps the most internationally known of the Spanish painters, had abandoned the University of Barcelona law school to take up painting in 1946, heaping his canvases with paint that he then gouged, cut, and scraped. For the show, O'Hara chose his *Three Stains on Grey Space*—three swirls of thick paint anchored at the bottom of a gray canvas.

On April 10 he and Ashbery boarded a "Shanghai-Express Type train," which arrived the next day in San Sebastián, where O'Hara met with the sculptor Chillida whose iron-and-steel works resembled David Smith's recent *Raven* series of 1955–57. They then traveled to Biarritz, which Ashbery wanted to research because Raymond Roussel's family had owned a summer house there and the scenery occurred in some of his work. This last leg of the Spanish tour was recorded by O'Hara in "A Little Travel Diary" written in Paris on April 14:

 storms break over
 San Sebastian, 40 foot waves drench us pleasantly and we see
 a dead dog bloated as a fraise lolling beside the quai
 and slowly pulling out to sea

to Irún and Biarritz
we go, sapped of anxiety, and there for the first time
since arriving in Barcelona I can freely shit

At the end of the poem, written on the day of their arrival by plane in Paris, O'Hara introduced for the first time into his poetry, and so into the maze of his inner life, the young poet Bill Berkson:

see the back
of the head of Bill Berkson, aux Deux Magots, (awk!) it gleams
like the moon through the smoke

It was a pivotal entrance.

O'Hara had already met Berkson in New York, where the young poet had been introduced to him by Kenneth Koch. Berkson was twenty years old and strikingly handsome in a Kennedy way that made him seem even more handsome in the early sixties. The son of Seymour Berkson, a famous Hearst newspaperman and publisher of the *Journal-American,* who had recently died, and Eleanor Lambert, a fashion publicist whose provenance was Manhattan's uptown café society, Berkson communicated an unusual mixture of patrician reserve, bohemian curiosity, intelligence, politeness, and brash rudeness. Having left Brown University in early January 1959, he considered registering for John Cage's composition course at the New School but instead chose Koch's spring term poetry workshop, where he was seized by his instructor's enthusiasm for modern poets from Whitman, Stevens, Apollinaire, Stein, Auden, and Williams straight through to O'Hara and Ashbery, whom Koch adventurously taught in the same breath. As Koch recalls of his first impressions of Berkson, "He had an aristocratic bearing, perfect manners, very cultivated, acting as if he knew and had read everything, which of course wasn't true. . . . He seemed to be at least as mature as I was and I was in my mid-thirties. He used to have coffee with me after class every day. I liked him a lot. I liked the way he wrote also. He wrote poems that had an effortless, funny, unself-conscious depiction of upper-class life which I liked since I didn't have that in my life. Everything was very rich and smooth and fragrant."

Koch, who had a talent for teaching an alternative tradition of modern poetry that consisted mostly of his and O'Hara's and Ashbery's favorites, soon became a "funnel for young poets" through his workshops at the New School, Wagner College, and Columbia. He was still

young enough to welcome these neophytes quite readily and hospitably into the living room of his and Janice's Perry Street apartment in the Village. In 1959 the appearance of someone as fresh and interested in the "new" poetry as Bill Berkson was still a novelty. So Koch gave him entrée into a literary world. One night Koch invited him to supper along with Paul Carroll and Norman Mailer. Berkson brought along a poem he had written called "A Poem for Frank O'Hara," which he had actually written before he met the poet. Carroll asked him on the spot if he cared to publish the poem in his new small magazine, *Big Table*— an off-campus, and so uncensored, offspring of the beleaguered *Chicago Review*. A sidelight of the evening was Mailer's trying, at least from Berkson's point of view, to goad him into a fight. Berkson recalls that Mailer insisted that by his looks he must be a big-time college athlete. The next night Mailer made headlines by stabbing his wife.

A more fruitful introduction on Koch's part had been O'Hara. Koch had invited Berkson in the spring of 1959 to a party at Joe Hazan and Jane Freilicher's, apprising him beforehand that O'Hara would be there. Berkson claims that Koch then warned him, "He'll become a germ in your life." Berkson and O'Hara did meet and spent most of the evening leaning on the mantel of a fireplace. "Frank and Bill didn't like each other," remembers Koch. "They were both very opinionated. Just because Bill was nineteen years old didn't mean that he didn't have very strong opinions about everything. I don't know what it was about, whether it was about Countee Cullen or Elsa Maxwell or Shakespeare. Probably, though, it was something literary. They really didn't get along. Frank could be very strict about his opinions when he was drinking." By the fall, however, Berkson and O'Hara were on friendly enough footing for Berkson to be invited to stop by the apartment on East Ninth Street where they sat in the butterfly chairs and O'Hara showed him some of his new poems to Vincent Warren. "I don't think being in love is very good for your poetry," Berkson responded snottily. It was the sort of response that irritated O'Hara's friends but that he registered as "cute."

Berkson and O'Hara ran into each other occasionally but their friendship did not really take off until their meeting in Paris that spring. Conditions were almost ideal in the capital of European art. Cars honked up and down the Boulevard Saint-Germain where Berkson sat alone dressed in jeans and a fatigue jacket in the Deux Magots, one of many customers spilling out onto the slightly chilly sidewalks lined with chestnut trees, which, in April, still had not yet budded. O'Hara and Ashbery showed up en route to the Hôtel de

l'Université a few blocks away. As Berkson was avowedly straight, O'Hara felt free to flirt with him in a friendly way without endangering his prior engagement with Warren. So when Berkson explained that he was staying in a small hotel with no bath, O'Hara invited him to take a bath in his room. That was the occasion of "Embarrassing Bill," the first of O'Hara's many poems to be written to, with, or about Berkson:

how pleasant it is to think of Bill in there, half-submerged, listening
and when he comes to the door to get some more cologne he is just like a
 pane of glass
in a modernistic church, sort of elevated and lofty and substantial
well, if that isn't your idea of god, what is?

The poem ended with the sarcastically motherly admonition, "now, Bill, use your own towel." O'Hara was already falling into the admiring, spoiling, obliquely flirting, and blatantly flattering mode that would constitute much of their complicated friendship. It was the attitude that caused friends to accuse him of puffing up Berkson.

O'Hara did not fall under Berkson's sway immediately. It was not in his interests to do so, as he was absorbed personally and poetically with Warren. Yet even before their chance meeting in Paris Warren was feeling some jealousy and irritation at the presence of Berkson. As he had written to O'Hara on April 7, "I saw B.B. at the Concert. . . . He isn't in Paris yet—it's funny to think that he'll be with you before I will. Take care of yourself and don't fool around too much (not at all!)." O'Hara had written to Warren on March 29, "when I get back on Easter Sunday evening I would far rather see you than a lot of people. . . . the thought of other people watching me when I see you again for the first time makes me nervous even now." By the time he actually returned, though, complications had arisen on both sides. Maxine Groffsky, who had become Larry Rivers's girlfriend two summers before when she was a waitress at the Five Spot in the Hamptons, had planned a party with Warren in honor of O'Hara's return. O'Hara had decided to return on Pan Am flight 115 with Bill Berkson. At the airport Kenneth Koch coincidentally arrived from an Easter vacation in Haiti. As O'Hara wrote of the crowded reunion to Ashbery, "When we were going through customs at Idlewild there was Vincent waving down at us and beside him Kenneth and Janice and Katherine who had just gotten back from their Easter in Haiti. It was very strange. I was

very tired." "After the trip we saw a lot of him," says Warren, who was crestfallen to see Berkson get off the plane with O'Hara.

At first O'Hara experienced a resurgence of the innocent, adoring sort of love for Warren he had enjoyed before he left. He seemed finally to have found something even higher on his scale of value than painting. Upon his return O'Hara was mostly concerned with the "Twentieth-Century Italian Art in American Collections" show opening on April 30 in Milan. It was a vast undertaking that included a significant collection of Futurist paintings as well as Marino Marini's large equestrian statues of 1947 and 1949, but O'Hara was able to put his work in the proper perspective with life, as is evident in "Having a Coke with You":

and the fact that you move so beautifully more or less takes care of Futurism
just as at home I never think of the Nude Descending a Staircase or
at a rehearsal a single drawing of Leonardo or Michelangelo that used to
 wow me
and what good does all the research of the Impressionists do them
when they never got the right person to stand near the tree when the sun sank
or for that matter Marino Marini when he didn't pick the rider as carefully
as the horse
 it seems they were all cheated of some marvellous experience
which is not going to go wasted on me which is why I'm telling you about it

The excitement of being back in New York with Warren wore off within the week as O'Hara began to feel quite unwell. Though he had been plagued by diarrhea, nausea, and fatigue in Spain, he had viewed his symptoms as the classic side-effects of tourism and change of diet. When he continued to feel run down in New York, he decided to see David Protech, a society doctor on Fifth Avenue, who diagnosed him as having syphilis. Warren then went to the same doctor and was similarly diagnosed. Together they underwent a treatment of massive doses of penicillin. Most of the rest of their relationship was clouded by returns to Dr. Protech for shots or follow-up blood tests at intervals of a few months. While no blame was ever voiced, O'Hara began to have doubts about this great passion. For him, this was the first snake in the garden. "I'm sure that I'm the one who got the syphilis and gave it to Frank," says Warren. "At the beginning of the relationship especially, even though he was passionately in love with me, I was carrying on a little bit. When the syphilis came up, neither of us took responsibility.

It was just there. But I think that made some distrust happen on Frank's part."

In a cab on Wednesday afternoon, April 27, after being informed of his condition, O'Hara wrote "Song"—a disappointed response to the news. He was more disappointed by the possible failure of love than by having contracted a venereal disease:

> *mud clambers up the trellis of my nerves*
> *must lovers of Eros end up with Venus*
> *muss es sein? es muss nicht sein, I tell you*
>
> *how I hate disease, it's like worrying*
> *that comes true*
> *and it simply must not be able to happen*
>
> *in a world where you are possible*
> *my love*
> *nothing can go wrong for us, tell me*

A week later, on May 5, he wrote "An Airplane Whistle (After Heine)"—its title a reference to an airplane whistle given him by Vincent Warren from a Cracker Jack box. The poem was another response to the ominousness of the depression he was feeling:

> *The rose, the lily and the dove got withered*
> *in your sunlight or in the soot, maybe, of New York*
> *and ceased to be lovable as odd sounds are lovable*
> *say blowing on a little airplane's slot*
> *which is the color of the back of your knee*
> *a particular sound, fine, light and slightly hoarse*

O'Hara took a break from writing love poems to Warren for a few months and became absorbed in what was to become a busy period in his dual careers. An important boost to his poetry was the appearance in April of Donald Allen's *The New American Poetry: 1945–1960* from Evergreen Books. Described by Allen Ginsberg as "a great blow for poetic liberty," the anthology brought before a much larger public the post–World War II antiacademic poets whose work until then was mostly available only in little magazines, broadsheets, pamphlets, limited editions, circulating manuscripts, or poetry readings in coffee

shops, bars, or church basements, where it was heard by growing audiences. Donald Allen made the strong—and controversial—decision to classify the forty-four poets by groups: New York School, Beat Generation, San Francisco Renaissance, and Black Mountain. "Through their work many are closely allied to modern jazz and abstract expressionist painting, today recognized throughout the world to be America's greatest achievements in contemporary culture," wrote Allen in his introduction to the volume, whose title echoed that of "The New American Painting" show on which O'Hara had worked. "This anthology makes the same claim for the new American poetry, now becoming the dominant movement in the second phase of our twentieth-century literature and already exerting strong influence abroad."

Allen made O'Hara a star of the volume, giving him what Ginsberg describes as a "large dominance within it." Allen was one of the few editors who knew how many poems O'Hara was actually writing and filing away without trying to publish. So he chose to include fifteen poems of O'Hara's—more than any other poet's—including the large-scale "Ode to Michael Goldberg ('s Birth and Other Births)." When Allen wavered on including the lengthy ode, O'Hara complained, "But it's my *greatest* poem!" Because of the Allen anthology, teenage poets all around the country, who would eventually gravitate to New York and to O'Hara, were given their first tantalizing, if sometimes baffling, exposure. Typical was David Shapiro, who at the Greenwood Swimming Pool in New Jersey hid the volume from a thirteen-year-old girl because of the lines from "Ode to Michael Goldberg" "YIPPEE! I'm glad I'm alive / 'I'm glad you're alive / too, baby, because I want to fuck you.'" According to Ron Padgett, who read O'Hara's poetry as a teenager in Tulsa, Oklahoma, "There was a certain high pitch in some of those poems that scared me, a certain kind of diction and intensity that I hadn't seen before."

Whatever pleasure O'Hara might have felt from the publication of his poetry was lost in the hectic schedule of the Museum, which was particularly demanding and Byzantine that season. Laboring to mount his "New Spanish Painting and Sculpture" show by the beginning of July—its novelty already dulled by the Guggenheim's Spanish show, which had opened on June 6—O'Hara had to deal as well with the stress of political intrigue. The fate of the International Program, and of his boss Porter McCray, had come into question a year before at a special meeting at the summer estate of William Burden, the president of the Museum, in Bar Harbor, Maine. Burden had invited Blanchette and David Rockefeller, the members of the Coordinating Committee,

and the group that came to be known as the "Young Turks," to spend
a long weekend. The Young Turks were led by Arthur Drexler and
included Elizabeth Shaw, head of Public Information, Richard Griffith
of the Film Library, and Emily Woodruff Stone, in charge of Member-
ship and "special events." At that meeting Drexler, the head of the De-
partment of Architecture, accused McCray of "empire building"—that
McCray's field of study at Yale had been architecture as well had always
created tension between them. In what became known in the oral his-
tory of the Museum as "The Revolt of the Young Turks," McCray
threatened to resign—a move he did not follow through on for two
years, which left his office in a state of perpetual anxiety. Drexler's re-
sentment of McCray was shared by many curators throughout the Mu-
seum. "I think they were awfully jealous," Eliza Parkinson, who
became president of the Museum's Board of Trustees, has said of the
attacks on McCray, "because the International Council had become very
important and it entailed a lot of travel and they all wanted to travel. He
represented the Museum and there were all these parties that they'd hear
about. But the fact was that he was setting up a little museum within
the Museum."

As McCray was O'Hara's champion, the jockeying for power af-
fected his own equilibrium. To make sure that O'Hara was not swept
out as well because of his own resignation, McCray worked to have
him promoted. This politicking was successful enough that O'Hara's
title was changed as of July 5, 1960, to Assistant Curator in the Inter-
national Program for Painting and Sculpture Exhibitions. "Alfred on
two occasions asked that Frank be removed," claims McCray. "I
pleaded his case in both instances and had Frank sustained against in-
sinuations that he was bad for the institution. When I left the Museum
I made a particular point that his position had been sufficiently en-
trenched. He had his position and title before I left. That was to try to
fix him in a staff position. It was also intended as a sort of velvet glove
restraint on Alfred. Beyond a certain point your position is more or less
entrenched unless something violent happens."

Such infighting dogged O'Hara every step of the way in the Mu-
seum. In his higher position he now had a new set of enemies, some of
whom were simply viscerally uncomfortable with his homosexuality or
his seemingly flip style or his intimate ties with Downtown artists. Ru-
mors spread about the risqué poems that were being printed and the
nude portraits of him being shown at the Tibor. Peter Selz, the German-
born Curator of the Department of Painting and Sculpture, became a
particularly serious enemy. "There was a lot of hostility on the part of

Selz," recalls Waldo Rasmussen, who took over McCray's job after his
departure finally in July 1961. "He would have liked Frank to go. I
remember one time he voiced his concern about him in a meeting I was
in. The Director, René d'Harnoncourt, was present. Selz was complain-
ing about Frank's lack of qualifications. I made a crack about Frank
being the Apollinaire of our times, which he didn't think was very
funny."

While maintaining a seemingly oblivious demeanor O'Hara was ac-
tually quite adept at the ins and outs of these power games. He was
Machiavellian enough to have survived and risen quickly up the ladder.
"He became quite engagé in the cogs and all the maneuvering and ma-
nipulation and excitement of Museum matters," says Helen Franken-
thaler, who often heard about his struggles at lunch at Del Pezzo's, a
midtown restaurant that offered steak au pommes frites with red wine
and a green salad for ninety-nine cents. To some extent, she said, "He
was as involved with the Museum as he was with his friendships." He
and his colleague Waldo Rasmussen were competitive and had engaged
in a few fights over the exhibition of certain artists. "Frank was ambi-
tious, and he could be a tough customer in an argument," Rasmussen
has written. "His tongue could be sharp and, after a few drinks, more
than that. He loved a fight, he loved drama, he enjoyed being a star,
and all of these traits could be a trial minutes after they had been an
entertainment. He wasn't exactly the model museum employee nor the
trustees' dream."

With the artworld becoming a hot spot for both the media and
savvy investors, everyone's projects in the Museum were becoming an
occasion for debate and controversy. Luckily O'Hara enjoyed storms.
Even his Spanish show, which opened for the press on July 20, proved
to be difficult terrain. Fascist Generalissimo Franco was in power in
Spain, and many critics distrusted any work that could be exported
from that country. As Natalie Edgar wrote in *Art News*: "All in all, the
new Spanish movement is a local propaganda asset because it seems to
demonstrate the liberality of the regime. As a result it has the benevolent
support of the government." (When "The New American Painting"
show had traveled to Spain, Motherwell had threatened to pull out until
persuaded otherwise by McCray.) The Spanish paintings did lack some
of the confrontational danger of the American Abstract Expressionist
canvases. "At the time the work looked fresh and vigorous," Rasmussen
has written, "if perhaps a little 'handsome' by comparison with its
American counterparts." For the first time O'Hara was faced with the
dilemma of writing enthusiastically about art toward which he was ac-

tually ambivalent. Learning to write with a forked tongue was not a happy experience for him. "Frank said something to me that was very untypical of him about the Spanish artists," says Grace Hartigan. "He said, 'It's very hard for me to deal with sensibilities that are lesser than my own.'"

The weekend after the opening of the Spanish show—and a week after enthusiastically watching Eleanor Roosevelt second the nomination of Adlai Stevenson at the 1960 Democratic National Convention on Button's TV—an extremely exhausted O'Hara took off for a long weekend to visit Vincent Warren, who was appearing in summer stock in Cohasset on Cape Cod. ("I never watched one before and had no idea that some of those senators were as Al Capp as they really are," he had written to Warren, disappointed at Stevenson's defeat.) The play was *The Pajama Game,* in which Warren excelled in the "Steam Heat" number. After a month of separation, they rekindled their romance in a secluded cove where they sunned on large rocks rising up out of the cold clear water. "And the rocks place is really great," he wrote to Warren on his return to the city on July 26. "I think it must be sort of like Greece, if one knew what Greece is like, and we spent the afternoon like Greek lovers who had been sent to different battles and had just gotten back together." Two days later he remembered the rocks in "Cohasset":

> *the huge rocks*
> *are like twin beds*
> *and the cove tide*
> *is a rug slipping*
> *out from under us*

The trip satisfied O'Hara somewhat for a few weeks. But the uncertainty of Warren's comings and goings occasionally tormented him; he could not help but question the fractured nature of his love life, though he seemed unable to change the pattern. As he wrote on August 10 in "Ballad," one of his more depressed poems about Warren: "why is it that I am always separated from the one I love it is because of / some final thing." O'Hara wrote the poem a few days after he had written to Warren, "I have been very depressed this week because I have found everyone so boring compared to you, and there's nothing I can do about that, but it makes me feel guilty towards them." The situation was relieved near the end of August when O'Hara returned to

Cohasset for a few days, the two of them traveled on to New London for the last performance of the Connecticut College Dance Festival, featuring Merce Cunningham's new ballet *Crises*. Warren then returned with O'Hara to New York where he spent the fall supering for the Royal Ballet production of *Swan Lake* and the New York City Ballet production of *Firebird*, in which he carried a banner. In "Flag Day," written for Warren's twenty-second birthday on August 31, O'Hara pleasantly welcomed him back by realizing "you shared the first year of your manhood with me."

O'Hara was relieved to have Warren back. But somehow the perfect circle of body and soul he had described the previous November in "Poem 'À la recherche d' Gertrude Stein'" (originally 'À la recherche d' Gertrude Stein et d' Vincent Warren') no longer seemed capable of circumscribing them:

> *when I am in your presence I feel life is strong*
> *and will defeat all its enemies and all of mine*
> *and all of yours and yours in you and mine in me*
> *sick logic and feeble reasoning are cured*
> *by the perfect symmetry of your arms and legs*
> *spread out making an eternal circle together*

Whether Warren was in the city or away, he obviously was intent on keeping an independent distance. When the subject of living together arose, he insisted that he wanted to keep his own apartment. Mostly, though, such subjects were not discussed. Warren was too young. O'Hara tended to store his private thoughts in his poems and so flash them to Warren indirectly. "The poems always said much more than he said," claims Warren. "He never talked that way to me, but he said it in the poetry. That was moving, but frightening. I didn't withdraw completely, but in the end it really did scare me. I could never match the emotion in his poetry. I think you'd have to be a thirty-five-year-old man in love with a twenty-year-old person to do it. I wasn't ready for that." Warren would express his doubts and reservations by shying away during certain weeks from sleeping with O'Hara—a maneuver O'Hara reacted to with grief. That one such period of unavailability occurred almost immediately upon Warren's return to New York in September was a rude message to O'Hara. "I suppose I should have realized it, but for the last few weeks my pillow has been rather a sodden mass," he wrote to Ashbery on September 30. "It really gave me

a shock, and has even caused me to work quite hard; anything not to think. I would like to move to another city. It is very funny to be around somebody who is terribly fond of one, but doesn't want to romp. It makes me feel like Edwin Denby."

At the same time that O'Hara's affair with Warren was unraveling, his intense friendship with Grace Hartigan was ending. Hartigan had never been easy. She had become even more difficult recently as she disapproved of his moves toward Patsy Southgate and Mike Goldberg as friends and toward Vincent Warren as a lover. Perhaps she sensed O'Hara beginning to drift away from her as he had once drifted toward her from Freilicher. At a party she gave to which O'Hara brought Warren, Hartigan had drawn Joe LeSueur aside and complained, "I like the idea of Frank having sex and everything, but does he have to bring his boyfriends around?" Freilicher, too, had apparently been annoyed when Vincent Warren, dressed as Marlene Dietrich in wig, makeup, and trench coat, appeared at her Halloween party to join O'Hara after leaving a friend's costume party. "Frank was relaxed," remembers Warren. "I think I did shock Jane Freilicher and Joe Hazan. They weren't having a costume party. Frank wanted me to come, though. I think Frank was like pushing me down their throats. I had to try to brazen it out. But John Button was like 'Wow.' He was looking at the makeup. I thought that was good that somebody appreciated good work." According to Hartigan, her complaint about Warren was simply his unavailability to O'Hara. "Frank always gave his heart," says Hartigan. "The men he fell in love with were always cooler than he was. We couldn't understand, because Frank was so adorable and lovable and wonderful."

Hartigan did not break up with O'Hara because of Warren. She had met Dr. Winston Price, a medical scientist at Johns Hopkins. As Larry Rivers described him in *Drawings and Digressions,* he was "a scientist who was going to discover a cure for the common cold." Hartigan decided to move to Baltimore to marry him. In the context of her psychoanalysis, she also decided that she would never have a fulfilling marriage unless she also broke off all relations with O'Hara and John Bernard Myers. "I was going to a shrink," recalls Hartigan. "What I had is known as 'neurotic.' I had lovers and I was in love with homosexual men. Two. John Myers and Frank. They were the ones I talked to every day, they were the ones who knew me better than anyone in the world. They were the ones I told everything to, who understood me. My lovers I slept with. I met Winston Price, who existed for me on all levels. He was a brilliant man, a collector, a scientist, witty, a great man, and I wanted to have a total marriage. My shrink said, 'You

cannot have a total marriage and be in love with a homosexual man.'
So I cut it." Hartigan's method was to write a "Dear John" letter to
O'Hara informing him of her decision.

O'Hara was furious. From that day forward he made only mean,
catty remarks about Hartigan. He liked to regale friends with stories
about how she supposedly used to pick up men on the streets for sex
while she was painting to get rid of excess emotion and then return
immediately to work. He reviewed her 1963 show in *Kulchur* magazine
badly, accusing her of "repetitiousness of feeling" and "vulgarity of
spirit." "She wrote those letters in a very dramatic fashion," says Frei-
licher of Hartigan's letters to O'Hara and Myers. "It was a big ego trip.
She broke with them formally." According to Schuyler, "Frank would
never ever forgive that." A few years later Hartigan called up saying
that she was in New York and badly wanted to stop by. As he sat
waiting for her, O'Hara was fuming. Then he noticed a small painting
she had once given him. "Oh no she doesn't," he said. He took the
picture off the wall and stuck it in a closet. Nothing was resolved at
their awkward meeting that afternoon.

While Hartigan was exaggerated and radical in her split, she was
merely acting out in broad strokes the gradual drift of many of O'Hara's
friends from his early days in New York. As old friends married, raised
families, or settled into jobs and careers, they tended to be less available
for the bohemian life. O'Hara was turning to new, younger friends.
"Anyone who got married sort of left," says Hartigan. "Kenneth Koch
married Janice and they had their kind of life going. The people who
hung around were people who had loose marriages like Phil Guston
and Musa where he could stay and close the Cedar bar or go to a coffee
shop or on to his studio and talk until dawn. But once someone had a
family life, then they weren't part of it."

The next departure followed on January 15 when Vincent Warren
left New York for two months to dance with Les Grands Ballets Ca-
nadiens in Montreal. At the time of his December audition for the stint
O'Hara had wishfully written in "Variations on Saturday," "I'm staying
with you / fuck Canada." A barometer of O'Hara's mood toward War-
ren was the palm tree in Warren's fifth-floor walk-up around the corner
on Avenue A, which O'Hara would water while Warren was away. Dur-
ing a rough spot while Warren was in Cohasset O'Hara had written in
"Ballad":

you will hate certain intimacies which to me were just getting to know

you

> *and at the same time*
> *you know that I don't want to know you*
> *because the palm stands in the window disgusted*
> *by being transplanted, she feels that she's been outraged and she has*
> *by well-wisher me, she well wishes that I leave her alone and my self alone*
> *but tampering*
> *where does it come from? childhood?*

O'Hara took this last farewell in stride, his temporary acceptance evident in his humor about the emblematic palm tree in a letter to Warren two days after his departure: "You'll be relieved to know that I not only watered your favorite palm, but I also washed off its fronds under the faucet and it now looks very healthy and 'in period' beside the lamp. If I keep at it I could make that room into a set for *Salammbô* with this start."

On January 20, 1960, John F. Kennedy was inaugurated in stylish top hat and morning coat as thirty-fifth president of the United States. Reading a commemorative poem for the Harvard graduate from a podium on the East Front of the Capitol, Cambridge poet Robert Frost, his white hair blowing in the wind, proclaimed in stately lines of iambic pentameter—the rhythm so exploded in Allen's recent anthology—"A golden age of poetry and power / Of which this noonday's the beginning hour." (Kenneth Koch's parody of Frost, "Mending Sump," was one of the more critically commented-upon poems in the anthology.)

Kennedy's inauguration on that cold, clear January day marked the beginning of an awakening political interest in O'Hara and his group that had been largely dormant in them during the fifties. Kennedy was an Irish-Catholic Navy veteran Harvard graduate from Massachusetts, and his ascendancy to power meant greater access to the White House by a constituency to which O'Hara had ties. "Frank was a very political animal," says his brother, Philip, who in 1959 began visiting the city to have lunch with him. "He campaigned for John Lindsay. He was devastated when Jack Kennedy died. We used to talk politics a lot in New York." Throughout the sixties O'Hara was very opinionated about current issues such as civil rights, the Congo, Vietnam.

The politics of his group, though, was more often that of parody and bemused humor. Typical was Kenneth Koch's play *The Election*, which was put on at the Living Theatre each night of election week, following Jack Gelber's hugely successful underground play *The Con-*

nection, about drug addicts waiting for dope. In Koch's parody of *The Connection*, the candidates Nixon and Kennedy, acting stoned as if on heroin, wait around for the vote. Larry Rivers played Lyndon Johnson, Bill Berkson John F. Kennedy, Arnold Weinstein Richard Nixon. O'Hara, impatient with rehearsals and acting, did not participate in either *The Election* or Koch's later art play *The Tinguely Machine Mystery* at the Jewish Museum in 1965. (His disinterest in acting was as strong as his disinterest in playing games. At a party at the poet Kenward Elmslie's a game of charades was played with Gian Carlo Menotti and Leonard Bernstein as team captains, but O'Hara preferred to sit out on the sidelines drinking and talking.) A particular fascination in the new politics, though, for O'Hara and his friends—as for most of America—was the thirty-one-year-old first lady, Jacqueline Kennedy. She appeared just a few weeks after the inauguration in his poem "Who Is William Walton?" inspired by news of the first lady's visit to the Tibor de Nagy Gallery:

> *he isn't the English composer*
> *and I'm quite aware that everybody*
> *doesn't have to know who everybody*
> *else is*
> *but why did he take Mrs Kennedy*
> *to the Tibor de Nagy Gallery worthy*
> *as it is of her attention*

Walton was actually an artist and close friend of the Kennedys who worked as an adviser to Mrs. Kennedy on the redecoration of the White House.

If Kennedy's inauguration marked the commencement of the public sixties in America, the ascendancy of Bill Berkson—the John F. Kennedy of the stage of the Living Theatre—marked the onset of O'Hara's personal sixties. For the rest of the year, Vincent Warren's comings and goings could be charted in O'Hara's poetry by the shift between the "open style" of his love poems to Warren and the "closed style" of his experimental poems of parody, reportage, dialogue, and ventriloquism to, or in collaboration with, Bill Berkson. For a while O'Hara had vacillated on Berkson. "Is it true . . . that you don't like Golden Bill—if so, you'd better rush over here because Joe hates him and Vincent tolerates him out of a spirit of one-upmanship," he wrote to Ashbery on February 1. "You could have such fun with them. I on the other hand still like him very much." At other times, though, his assessment of

"Golden Bill" was less positive, especially when he was appeasing Warren. "It's a shame you're not here to enjoy the decline of my affection for Bill Berkson, with whom I had lunch today and who acted very stuffy and boring," O'Hara wrote to Warren during the same period. "As a matter of fact he was acting quite a bit like Kenneth when he's in a bad mood, though a little less pointed." Eventually, though, as Warren's place in his life became less and less dependable, O'Hara began to depend on Berkson as a companion.

This development, as O'Hara indicated to Ashbery, was extremely irritating to Warren and LeSueur. "I think all of us thought that Bill was latching onto a poetic star, and we were all upset when they started writing collaborations," claims Warren. "It was like Bill was using Frank's reputation." At the time Berkson, who had done translations of Cendrars and Aretino and won the Dylan Thomas Memorial Poetry Award at the New School in 1959, had not yet moved into his apartment on East Fifty-seventh Street. Warren, while only a year older than Berkson—his birthday on August 31 only a day after Berkson's—developed a resentment against Berkson as "still a kid" early on. "I remember visiting his apartment where his mother lived and being impressed because she had a costume designed by Adrienne for Greta Garbo on the wall," says Warren. "Then I realized that Bill was still like a teenager in a funny way. He showed us his bathroom where he used to go and steam himself. He'd close the door and turn the bathroom into a steamroom. All the paint was flaking. Here we were on Fifth Avenue and this kid was ruining his mother's bathroom to make a steambath. . . . Frank and Bill necked in the back of a car, according to Edwin Denby. Edwin loved telling me that story. There was an attraction there. Here was another typical American boy, more upper-class than me, but another of Frank's images I guess." Berkson has no memory of the backseat incident.

For LeSueur, who had soon grown fond of having Warren around the apartment, Berkson was an interruption of a different caliber. As Mike Goldberg put it, "One had the feeling with Vincent that he was just another pretty face. He was in the background. You didn't feel that with Bill. He was a presence. It was hard to find out who the hell Bill was, though, for the simple reason that he was concentrating on Frank so much." It was this single-minded concentration that drove LeSueur to distraction. "Frank was nuts about Bill Berkson," says LeSueur. "I remember him telling me about him before I even met him. Then I met him, and he was indeed attractive but he was insufferable. He would come to visit. They would be having a conversation and Bill Berkson would never look at me. If I ever said anything Frank would

maybe look at me. But mainly they just looked at each other. They cut me out completely. Bill wasn't nice to me at all."

If others felt excluded by their friendship, O'Hara benefited from the companionship. Their pleasure in each other's company was mutual. Their sexual attraction was not. It was the deciding imbalance. "It seems to me in retrospect like being best friends in the eighth grade," says Berkson. "You know how intense that can be? Complicated by a lot of rhetoric and expression, person-to-person it was like being in love." To outsiders they displayed many of the telltale signs of being in love. "I once saw Frank and Bill Berkson together on a Sunday noon as if they'd been sleeping together and had just woken up," recalls Ned Rorem. "They were walking down Greenwich Avenue. One would race ahead to point out something in a shop window. The other would catch up and they would gesture excitedly. Then the other would get ahead for a while. I didn't cross over to say 'hello' to them. I didn't want to disturb the moment. They were like Daphnis and Chloë together." According to Larry Rivers, "Bill liked him better than any woman he knew. Maybe not that way. But he really liked him." Many were the afternoons when friends on the beach in the Hamptons would watch O'Hara and Berkson walking arm in arm or frolicking nude in the waves. (Once when O'Hara had forgotten to bring his swimsuit he appeared on the beach in a colorful pair of women's panties.)

O'Hara was Berkson's mentor as well. This was a role into which he stepped quite comfortably as he entered his late thirties—not only with Berkson but with most of the young poets and painters who began to seek him out. He was as perceptive a lay psychoanalyst as he was a guide to all the arts. "He really came into his own as a sort of confidant-confessor," LeSueur has written. "Except Frank, unlike an analyst or priest, did most of the talking. He was a born talker to begin with, and he especially liked giving advice, which often came down to nothing more than encouragement: 'you can do it, all you have to do is make up your mind; you've got lots of talent, so what's stopping you?' etc. etc. But it wasn't what he said that counted; it was his authority and passion, along with his marvelous understanding of a friend's needs, that made the difference." He gave Berkson plenty of advice. "I was involved with somebody in the early sixties and I used to talk with him about this tragic love affair that I had," says Berkson. "It wasn't tragic, it was sort of pathetic. And he was very against it because he said, 'This person's going to draw you into café society and that could be ruinous.'" Berkson's casual affairs with Uptown society girls and beauties were numerous enough for Truman Capote to describe him to an in-

terviewer as having "cut a wide swathe" in sixties New York. (He was thinking particularly of Bianca Jagger, whom Berkson met in Acapulco in 1967, a year after O'Hara died.) So O'Hara had plenty of good material to work with. Typical of his sizing up of Berkson was his mention in a letter to Warren that Berkson had "told me some anecdotes about the girls he goes out with and he doesn't really seem interested in them except for the obvious reasons, and even then sort of amused rather than charmed." "Bill Berkson once told me that Frank and he became such good friends, and he was sort of swamped by Frank's charm, and it was sort of like being wooed," says Schuyler of O'Hara's ability—and tendency—to dissect character. "Then one night walking across Tompkins Square Park Frank started to take him apart one piece at a time, telling him everything that was wrong with him. It wasn't always alcohol. Something had happened that had piqued him. Then POW!"

As stimulating for both of them was O'Hara's rather coy and unofficial slipping on of the mantle of the older poet. He was a born teacher who preferred to do his teaching informally. Extremely anti-authoritarian, he offered his tips and observations in the guise of a friend or lover. Unlike Kenneth Koch, O'Hara was uncomfortable in the formal role of teacher. He shone less brilliantly during his one semester teaching a poetry workshop at the New School in 1963 to such future second-generation New School poets as Tony Towle, Gerard Malanga, Joe Ceravolo, and Jim Brodey, than he did talking casually with young poets at the Cedar Bar or at his apartment. Berkson was stamped by the education he received daily from O'Hara. "*Silly*, as Auden once reminded an audience, has a root sense in *soulfulness*," says Berkson. "We talked very seriously, soulfully, about many things. I'm sure my part was often ponderous, inchoate, but I listened hard to what he said about poetry, about all the arts, about people, about living." O'Hara always seemed to have James Joyce's *Collected Poems* lying around his apartment ready to be opened. He owned D. H. Lawrence's poetry in the three-volume set and referred to "Ship of Death" constantly, as well as to another old favorite, Auden's *The Orators*. His bookshelves were crammed with diverse volumes, which Berkson liked to take down and look at, especially the two volumes of *Anatomy of Melancholy*, Sinclair's *Divine Comedy* with facing original and prose translations, *Fantomas* by Pierre Souvestre, and the poetry of John Wheelwright.

As Berkson telegraphed the experience in his biographical note in *An Anthology of New York Poets*, published in 1970 and dedicated to O'Hara: "General 'cultural' education through friendship with Frank O'Hara: the Stravinski-Balanchine *Agon* (and Edwin Denby's essay on it), Satie (we

created four-hand annoyances at various apartments, once played for Henze in Rome). Feldman, *Turandot,* a certain Prokofiev toccata. Virgil Thomson (I had heard a recording of *Four Saints* at Harry Smith's, Providence, 1957), movies . . . we read Wyatt together, recited Racine, skipped through galleries."

The first poem written after Warren's departure from New York was "For the Chinese New Year & for Bill Berkson" with an epigraph from D. H. Lawrence, a favorite poet of both O'Hara and Berkson. A month's silence had been a sign of O'Hara's confusion about direction in his tightly entwined art and love. The writing of the poem on February 14, Valentine's Day, was a stab at a solution. O'Hara had begun— and would continue through the sixties—to look for another Vincent Warren to give breath and life to his poetry. Berkson gave him energy, and an immediate audience, but not the warmth of plausibly returned romantic affection. The coy trick of titling the poem for the holiday of Chinese New Year's rather than Valentine's Day was symptomatic. The poem, which begins "Behind New York there's a face," was filled with lines about hiding and peeking such as "so / what if I did look up your trunks and see it." Its tone was sharp and sophisticated rather than tender. "There are signals to me in poems that I didn't read as signals until later," says Berkson, for whom much of the drama of O'Hara's emotional life was as unfathomable as it had been for Warren. "There's incredible rage in 'For the Chinese New Year & for Bill Berkson.' How much of it is directed at me or how much the 'you' in there is me I'm not sure. But some of it is I'm sure."

Working a new job as an editorial associate on *Art News Annual,* Berkson was a steady escort of O'Hara's at many art openings of burning interest to both of them that winter. A high point was Michael Goldberg's show at the Martha Jackson Gallery, where the painter seemed finally to deliver on the promise O'Hara had been touting for several years. Reviewing his "black paintings," a critic in *Art News* claimed, "Goldberg is one of the most talented and knowledgeable young artists on the New York scene. These pictures are his most monumental and distinctive to date." For O'Hara the show was "absolutely major." Writing to Ashbery he ascribed to the paintings "the context of a grandeur, authority and seriousness which gave me that impressive and pleasurable sensation of wondering if I really knew Mike at all. I don't think anyone else saw this emerging during the summer either, except in one called *Anthology of Greek Tragedy,* so he must have been keeping a lot hidden in his deeps. They were somber, harsh and damning in a beautiful way, like the thickness of *Hamlet,* which otherwise seems so

lyrically formal. What *am* I talking about? It's a good thing I don't work for the *Tribune*." (Following O'Hara's lead, Ashbery had begun writing art criticism and had eventually become an art critic for the European edition of the *New York Herald Tribune*.)

O'Hara was becoming more involved as well with the work of Alex Katz, whose show opened at the Stable in February. As with Rivers, O'Hara involved himself multiply with Katz as critic, model, and artistic director. Boyish, with a tall forehead, thick black hair and a broad, stammering New York accent, Katz was an admirer of Pollock who worked representationally, eventually becoming famous for his cool portraits and flat standing sculptures. Reviewing his first show of Cézanne-inspired landscapes at RoKo Gallery in 1954, O'Hara had accused him of "an almost Oriental calm." In 1958, though, after marrying Ada del Moro, Katz became more involved in portraiture, his works taking on the racier quality of heightened gossip, similar to O'Hara's poems. (While Katz's work seemed to some like early Popism, his choice of friends such as Edwin Denby rather than mass culture icons such as movie stars for subjects kept him within the New York School party.) In 1959 Katz developed a new technique of cutting a figure from the canvas and pasting it to plywood, leading to his directly painted cutouts. One of the first of these was a five-foot-high *Frank O'Hara*. In 1961 he did a painting of O'Hara and Berkson together in uniforms as *Sailor and Marine*. O'Hara bought *Blackie,* a mad scene of a few images of a successively smaller figure climbing into a wall, from Katz's 1958 show. Katz also lent O'Hara *Ada on the Beach* and gave him a sunset painting—all of which hung on O'Hara's wall. Such gifts began to be seen as bribes by some detractors, of course, but O'Hara's enthusiasm was hardly contrived. He pushed Katz from the early quiet of interiors and landscape to more extroverted figures. "The great thing this year I think is Alex Katz," he wrote to Ashbery on February 1. "His show last year was outstanding but included some rather atypical or perhaps I should say typical interiors relating to the Matisse of the *Goldfish,* but with figure things that were startling and original."

"I think he was mostly involved with me as an artist, not as a person really," says Katz of O'Hara's strong pushing of his point of view with him in the early sixties. "I remember one night it was really late and he started telling me what I should be doing and what I shouldn't be doing. I really got kind of pissed off and was about to throw him out of the house. He went right up to the edge, and stayed on that edge, and never went over it. I realized Frank figured out what he was going to say very carefully and got enough nerve to do it when he was

drunk. . . . He thought I was going to turn into a Morandi-type painter with those pretty little paintings, and that's what he really objected to. I figured what he said was right. . . . Frank told everyone what to do in his work and in everything else. He was really an out, aggressive guy. Allen Ginsberg is a little like Frank. But Allen is in a very small area. He's just in poetry. Frank was in painting, dancing, everything he could get his hands on. He affected artists in other fields." O'Hara prodded Katz toward the large scale of *The Smile,* his 1963 cinematic close-up painting in the permanent collection of the Whitney.

After Berkson, the next young poet with whom O'Hara was involved that season was Diane di Prima, who had started, with LeRoi Jones, *The Floating Bear* magazine, its name taken from a passage in *Winnie the Pooh*. Di Prima had entered O'Hara's life through Freddy Herko, a dancer who was Vincent Warren's roommate. Warren and Herko had both appeared in James Waring's *Dances Before the Wall,* which O'Hara had seen in 1958 at the Henry Street Playhouse and memorialized in 1959, after he met Warren, in a poem by the same name, spoofing the dance world:

> suddenly everybody gets excited and starts
> running around the Henry St. Playhouse which is
> odd I don't care whose foot it is and Midi
> Garth goes tearing down the aisle towards Fred
> Herko while Sybil Shearer swoons in the balcony
> which is like a box when she's in it and Paul
> Taylor tells Bob Rauschenberg it's on fire
> and Bob Rauschenberg says what's on fire and
> by that time it is all over but the plangent
> memory of a rainy evening in lower Manhattan

A red-haired Beat poet in her mid-twenties hailing from a family of first-generation Italians in Brooklyn, di Prima became one of O'Hara's early protégées. As she wrote in "For Frank O'Hara, An Elegy":

> you my big brother brought me up
> brought me to openings, admired my dumpy style
> bought me so many lunches! how often I vowed
> to buy you lunch when I got a little richer

mornings I'd bring onion bread to 9th St. for Sunday brunch
our walks in Tompkins Square, St. Brigit's looming aside

Di Prima's first extended exposure to O'Hara had been in August 1960, when she worked as stage manager for the production of his *Awake in Spain* at the Living Theatre's Monday Night Series. "He was backstage a lot and was kind of babysitter for my daughter, who was two," recalls di Prima, "while I was the stage manager for this play, which had about forty or fifty characters in it and a million props." Faced with such extravagance, its director, James Waring (the choreographer with whom Warren had been briefly involved), decided to use seven actors sitting at a table reading from the script while changing hats for different parts. "I hope Jimmy doesn't make it too serious," O'Hara had written to Warren. "There are only three serious speeches, one by Marilyn Monroe, one by the Crown Prince Frank and one by Thomas Hardy which is the closing line." (Hardy's supposedly serious closing line was "O dynasties, incessantly tumbling.") Included in the play as well was a line that de Kooning told O'Hara Arshile Gorky had said to him once as they were leaving a Kay Francis movie: "It's terrible under Kay Francis's armpits." (O'Hara liked Gorky's weird *aperçu* enough to include it also in "On Rachmaninoff's Birthday & About Arshile Gorky.") "I love the way Frank used rhyme in *Awake in Spain*," says Koch. "He did it in a very original way. He used obvious forced rhymes. He made a beautiful thing out of that. There are speeches in which the rhymes are as awkward and forced as they could be." O'Hara was no less conventional in his suggestions for a background music tape, on which he wanted to include *Nights in the Gardens of Spain, Capriccio Ensemble,* Rachmaninoff's *Rhapsody on a Theme by Paganini,* and Debussy's *Iberia.*

Di Prima became closer to O'Hara as her involvement with LeRoi Jones intensified. She had worked with Jones and his wife pasting up and editing *Yugen,* Jones's magazine, which had appeared erratically since 1958, publishing Ginsberg, Corso, Kerouac, Creeley, and Olson, as well as introducing such poets as Peter Orlovsky (his first published poem appeared in *Yugen* 3) and Rochelle Owens. Di Prima then began *The Floating Bear* when she and Jones became romantically involved—which led to di Prima's bearing Jones's child, Dominique, in 1962. *The Floating Bear,* which published O'Hara's "Now That I Am in Madrid and Can Think," "Song" (Did you see me walking by the Buick Repairs?), "Cohasset," and "Beer for Breakfast" in the second issue in February 1961, and "For the Chinese New Year & Bill Berkson" in the

fifteenth issue in November, was more of a newsletter than a magazine, as it was run off by Jones and di Prima quickly on a mimeograph machine with di Prima doing all the stenciling. "It was like writing a letter to a bunch of friends," she has said of the experimental newsletter, which was never sold but was supported by contributions and frequently ran work by Olson, Creeley, Burroughs, Jones, and O'Hara. Because of her intimate involvement with Jones, di Prima was also privy to signs of the light flirting that went on at the time. According to di Prima, "When Roi and I were in the thick of our affair I said to him, 'Let's run away together to Mexico.' He said, 'You're the second person who asked me to do that this week.' I said, 'Who was the other one?' He said, 'Frank.'"

Di Prima adjusted easily to the casualness and disorder of the publication process with O'Hara. It was as if this personal poet, who used poems as physical anchors to the world and his friends, was not entirely easy about giving them up. His critical ambivalence about his work did not help either. Writing to Ashbery in February in praise of his "acoherent" poem "Europe," which collaged found passages from such unlikely sources as *Esquire* magazine and a British children's book titled *Beryl of the Biplane,* and which had recently been published in *Big Table,* O'Hara claimed, "I've only been doing very few poems and they are pretty much blabbing along chicly while sitting on WC Williams' cracker barrel with my legs crossed." This attitude could be balanced, or contradicted, by an equally blaring self-confidence. One evening in 1961 he remarked to LeSueur of the work of a poet who was winning lots of academic prizes, "It'll slip into oblivion without my help." He then immediately began praising several poets whom he had recently read and admired. "But what about *your* work?" LeSueur asked. "What about it?" O'Hara replied blankly, as if he had not understood the question. "I mean," LeSueur said, "how do you think it stacks up against their stuff?" O'Hara declared simply, "There's nobody writing better poetry than I am."

"When I tried to get manuscripts for *The Floating Bear* from him I would go up to his place and he'd let me look through everything including the dirty laundry," says di Prima. "He'd finish poems and put them anyplace. His typewriter was always on his kitchen table. He was always in the middle of a piece. But as pieces got done they just wandered anywhere. The towel drawer was a very good place because I guess towels were flat. I would just take whatever I wanted. Often he didn't have another copy. That didn't seem to be an issue or a point. When John Wieners lived on his couch for a long time, John wound up

leaving a whole manuscript behind, which Frank gave to me and I later gave to an editor of a magazine who professed that he was going to publish it as a book but never did." O'Hara applied Personism by abandoning big literary magazines and publishing poems only in small magazines by editors who solicited them face-to-face.

On March 10 Vincent Warren finally returned to New York for what would be his last extended stay. Writing to him in Montreal on the Monday before his arrival, O'Hara concluded—after railing against a mutual friend who was getting on his nerves—"You are the closest person to me in the world so I tend to rant on to you about all my insecurities. I hope it's not too boring and despicable. The only thing I've ever done that shows my virtue or sensibility is loving you only and completely." Off to such an enthusiastic start, O'Hara dedicated himself to making life with Warren as good as he hoped it could be, beginning with meeting him at 11:30 on a Friday night at Idlewild. Three days later O'Hara slipped happily back into his "I do this I do that" mode by writing "Vincent and I Inaugurate a Movie Theatre" about a trip to the Charles Movie Theatre on Avenue B a block east of Warren's apartment to see *Alice Adams*—a black-and-white 1930s film with Katharine Hepburn and Fred MacMurray, about a social-climbing small-town girl who falls in love. In the smoke-filled balcony O'Hara spotted Ginsberg and Orlovsky who were preparing to depart soon for India:

> Now that the Charles Theatre has opened
> it looks like we're going to have some wonderful times
> Allen and Peter, why are you going away
> our country's black and white past spread out
> before us is no time to spread over India

O'Hara mailed the poem to Paris to Ginsberg and Orlovsky, who had stopped by and left a good-bye note for him and Warren before leaving. He called it "a little souvenir of a night when I saw you but you didn't see me—I was too hungry to wait for you to get out of the movie."

A bit of a didactic jab, however, was in evidence throughout the poem, despite its light and friendly tone; O'Hara was impatient with Ginsberg's flirtation with Oriental cultures and especially religion. To O'Hara, it smacked of posturing and violated his own sense of New York as Mecca. As he had written to Barbara Guest in December 1959, "Allen is getting to look so Christ-like with his beard growing and his hair in back very long and his black silk suit. . . . He is as sweet as ever

and as worldly, but it seems a little ominous of any Fun and Frolic to be found in that quarter (a remark which bears out Paul Goodman's estimation of me as shallow and superficial, sans doute)." Ginsberg was aware of O'Hara's attitude and of the issues that divided them. "In that way I think there was a slight limitation of his scope," says Ginsberg of O'Hara's slyness about his Hindic interest, "because his canon still was American-European. He did accept a slight extension of that in the French Surrealist poets and a great extension in Mayakovsky." Certainly Ginsberg's travels were outstripping O'Hara's, as was his reaching out for non-Western poetic inspiration. Ginsberg spent the period from March 1961 to July 1963 traveling to France, Morocco, Greece, Israel, India, Vietnam, and India.

From March through May O'Hara wrote the last of the poems in the cycle of poems to Warren—sixteen of which were collected in *Love Poems (Tentative Title)*, published by Tibor de Nagy Press in 1965. The basic feeling of the poems of that spring was sadness and regret, forecasting the inevitable collapse of the affair. As O'Hara wrote in "Vincent, (2)" on April 17:

> *this morning a blimp is blocking 53rd Street*
> *as inexplicable and final as a sigh*
> *when you are about to say why you did sigh*
> *but it is already done and we will never*
> *be happy together again never sure*

Such melancholy occasionally lifted. For a few months in the spring, Warren worked building bookcases for O'Hara, to earn some extra cash. O'Hara loved having him around. He wrote him poems with dance themes such as "Mary Desti's Ass" on April 15, referring to the author of a catty book about Isadora Duncan. (Introducing the poem at his S.U.N.Y., Buffalo, Reading in 1964 O'Hara said, "I thought that was very funny to say *The True Life of Isadora Duncan* and talk about yourself all the time.") On April 18 he wrote "At Kamin's Dance Bookshop," referring to a bookshop frequented by Warren on Fifty-third Street near the Museum. On May 6 he wrote the erotic hymn to fellatio, "Poem" (Twin spheres full of fur and noise):

> *Twin spheres full of fur and noise*
> *rolling up my belly beddening on my chest*
> *and then my mouth is full of suns*

> *that softness seems so anterior to that hardness*
> *that mouth that is used to talking too much*
> *speaks at last of the tenderness of Ancient China*

In many of O'Hara's poems of that period, though, Warren was miss-
ing. "Early on Sunday," written on May 1, gives a picture of O'Hara
alone in bed in his apartment on a morning that might normally have
been shared:

> *how sad the lower East side is on Sunday morning in May*
> *eating yellow eggs*
> *eating St. Bridget's benediction*
> *washing the world down with rye and Coca-Cola and the news*
> *Joe stumbles home*
> *pots and pans crash to the floor*
> *everyone's happy again*

LeSueur remained as the dependable, even taken-for-granted, figure of
"Joe's Jacket," written at the beginning of O'Hara's romance with War-
ren a year and a half earlier.

The final break-up poem was written by O'Hara on May 20, a few
months before it was totally clear that circumstances would keep them
from hardly ever being in the same city at the same time again. In "St.
Paul and All That" O'Hara uses his alias for Warren for the last time.
(The use of a saint's name was partly O'Hara's dig at Roman Catholi-
cism, which he considered synonymous with the repression of homo-
sexuality.) The poem begins:

> *Totally abashed and smiling*
>> *I walk in*
>> *sit down and*
>> *face the frigidaire*

"When Vincent left him he wrote this poem about staring at a refrig-
erator door," says Hartigan. "That was the coldness of Vincent." Har-
tigan's interpretation, however, was skewed by her own mixed feelings
about O'Hara's boyfriends. Most simply the appliance was O'Hara's

vanishing point when he sat down at the kitchen table to type. Emotionally, its coldness was an objective correlative for the devastation O'Hara felt as the man he believed embodied his possibility for love and happiness slipped away. The coldness was not Vincent's, but Vincent's absence. Warren, for him, like poetry itself, had always been associated with the sun. So the poem was crepuscular:

the sun doesn't necessarily set, sometimes it just disappears
 when you're not here someone walks in and says
 "hey,

there's no dancer in that bed"
 O the Polish summers! those drafts!
 those black and white teeth!
you never come when you say you'll come but on the other hand you do come

O'Hara did not know when Warren departed on May 27 for three months of summer stock in Santa Fe that "St. Paul and All That" would be so final. It was the first time, however, that he had not seen Warren off.

Both O'Hara and Berkson tried to shift gears while Warren was in town. They saw less of each other. "Early on, before the deluge, I was probably the first bone of contention," says Berkson of his uneasy presence in their relationship toward the end. "Frank sometimes said, 'Vincent is very upset that we're spending so much time together.' I said, 'I don't want to mess this up.'" After Warren's departure, however, O'Hara, who abhorred a vacuum, drew Berkson back in. He began, in the poetry, with "Drifts of a Thing That Bill Berkson Noticed," written on June 19. They then began to collaborate. "In 1961 Frank and I were walking along First Avenue and noticed the funny steeples of St. Bridget's Church on Tompkins Square Park in the distance—one steeple curved limply. We were delighted by the sight, and later that day I went home and wrote a poem in outright imitation of Frank called 'Hymn to Saint Bridget,' which became the first St. Bridget poem. . . . Most were written at Frank's place, some at Larry's in Southampton, taking turns at the typewriter." They then started a series of exchanges of poems disguised as office memos called "F.Y.I." poems after the title of the in-house organ of *Newsweek*, where Berkson had worked as a summer intern in 1956 and 1957, and the "Fobb correspondence," poems written between two imaginary Fobb brothers named Fidelio

(Berkson) and Angelicus (O'Hara). "They're really like the two of us talking," says Berkson of the poems.

O'Hara mailed some of the collaborations to Ashbery, who had begun a magazine in Paris with the writer Harry Matthews titled *Locus Solus* after the novel of that title by Raymond Roussel. "Bill and I have become pretty inseparable," he wrote to Ashbery on July 10. "We are almost finished with a book together, which we plan to send for your perusal. Kenneth has seen some of the collaborations already (1 or 2) and didn't like them—but since his criticism of them was that we seem to like each other too much in them, I don't think you will necessarily have the same reaction. Then too of course perhaps they are terrible. We are going to call it something like *THE MEMORANDA OF ANGELICUS FOBB, INCLUDING SUNDRY HYMNS TO ST. BRIDGET AND MISCELLANEOUS POEMS*. Do you think this is a nice idea? The St. Bridget's poems and a few others are actual collaborations line for line or passage for passage, but the Fobb (our initials) poems are mostly a bunch of 'answer' poems (like 'Collected Poems' and 'Collected Proses'). It's been loads of fun doing them, and I hadn't written anything for so long it was quite a relief when we accidentally started and they turned into a whole series. I suppose they really began in the Hôtel de l'Université that time." In a letter to Warren that same week a mentally intoxicated O'Hara wrote, "Bill and I are almost finished with a book of poetry and prose which we modestly figure will be the mid-20th-century equivalent of Coleridge and Wordsworth's *Lyrical Ballads*. We did a lot out at Larry's the weekend of the 4th of July." Of the batch, Ashbery chose to print only O'Hara's "F.M.I." and Berkson's "F.Y.I. 6/25/61 (The Picnic Hour)" in the Winter 1962 *Locus Solus*.

Having written O'Hara only two letters in twelve weeks, Warren finally called from Santa Fe on August 25 to say that he would be back in New York on August 31 but that he would then be leaving for Montreal for several more months of dancing, perhaps permanently. Inevitable as the news was, O'Hara was shaken. Like the syphilis he wrote about in "Song" (I am stuck in traffic in a taxicab), Warren's decision to move to Canada was a fear that had become a reality. O'Hara conveyed the information from this phone call in a letter to Warren's friend Peter Boneham, who had danced with him in Cohasset. O'Hara was obviously upset about having revealed his insecurities to Warren: "C'est la vie, and being a writer I tell everyone everything. It's the Norman Mailer in me, UUUUUUUUUUGH. But how do you avoid it? I sometimes think that all writers were children who vomited when they got nervous. I guess there are certain feelings that only occur in music,

you can't say them. It's probably very bad for a poet to feel that way. I mean it makes him a bad poet. Well, who's living for that anyway? Don't ask me what one is living for, on the other hand. . . . I think I'm probably very unhappy but I'd rather be the last to know, how do you like that?"

The two waning lovers made the best of their few weeks together. With Edwin Denby they attended the Kirov Ballet's *Giselle* danced by Kholpakova. With Joe LeSueur they went to see Samuel Beckett's new play, *Happy Days*, which caused O'Hara to cry in the second act and to which he returned two more times, thinking of it as "an Irish Götter-dämmerung." But mostly the confusion of Warren's comings and goings had become too much for O'Hara to face directly, either on the page or off. They had both already moved on, so that their time together until O'Hara shared a farewell breakfast with Warren at the bus terminal on the morning of September 25—could only be described as vaguely uncomfortable.

"Vincent has been here for several weeks, but Saturday he leaves for Montreal and another several months of dancing there," O'Hara wrote to Ashbery on September 20 of the predicament he had laid out in "St. Paul and All That" four months earlier. "It is very confusing, this sort of life, but what can one do?"

Bill's School of New York

It is simply a property of Bonnard's mature work," O'Hara wrote in a 1962 review of a show at the new Guggenheim Museum, "to look slightly washed-out, to look what every sophisticated person let alone artist wants to look: a little 'down,' a little effortless and helpless."

The statement could have been a description of O'Hara himself: over the last five years of his life he became more "down," more "effortless," and even more "sophisticated." He also became, as Kenneth Koch puts it, "overinvested in life." A clue is in the poetry, which he had once claimed (in the poem "My Heart") was "the better part." During his two years with Vincent Warren, he had written nearly a hundred poems. During the two years from 1961 to 1963 he wrote about fifty—most of them his share of poetic volleys with Bill Berkson. In 1964 he wrote fourteen poems. In 1965, two. In 1966, one. His Muse had deserted him and he was looking for another.

At the same time, drinking seemed to be playing a bigger role. By 1962 O'Hara might get himself started in the morning with a filterless

cigarette and a glass of bourbon and orange juice. Arriving at the office in the late morning, he worked and talked on the phone for an hour or so before heading off for lunch, which often began with a martini or a negroni at Larré's French restaurant on West Fifty-sixth Street. At night O'Hara was invariably invited to several cocktail parties and dinners; as an influential curator, critic, and conversationalist, he was always in great demand, especially by all the artists. According to Helen Frankenthaler, invitations at the time often bore the written promise "Frank will be there!" In the evening O'Hara could drink several vodkas or bourbons without falling down or losing control. If he had too much, however, he might lash out—his painstaking politeness giving way to what Mike Goldberg describes as "playing truth." Luckily, he was able to get by on only six hours of sleep. Luckily, too, he was smart and organized enough so that when he concentrated on his work in the afternoons at the Museum he was able to be very productive. Eventually, though, the signs of drinking began to show. "I hadn't seen him for a number of years," says Schuyler of a visit after 1963. "I was sitting down and somebody was standing right there and I suddenly realized it was Frank. I was shocked at the physical change. His complexion was bad. His eyes were very red. It was just all that alcohol. He was a terrific alcoholic."

The O'Hara of the sixties could also be found more often Uptown. Life at the Museum drew him into a more fashionable circle. Parties at the Motherwells' on East Ninety-fourth Street had a different character from those of the fifties at Larry Rivers's loft on Second Avenue. They were more elegant, less bohemian, more obviously intellectual. The usual guest list included Mark Rothko, Frank Stella, Harold and May Rosenberg, Barnett and Analee Newman, Clement Greenberg, Hannah Arendt, David Smith, Philip Rahv. Actually O'Hara was simply following a move being made generally by the artworld of the time, toward money and glamour. "I think one thing that was so nice in the fifties was that these painters weren't selling their work much," says Kenneth Koch. "All their excitement was about making their work and what they were discovering and what they were finding out. There was a noticeable change in that scene. There was a certain point where you'd go to an artist's house for dinner and you'd be surrounded by people you didn't think you'd be having dinner with, and they were collectors. There weren't any collectors at the Cedar Bar. I'm not saying collectors are not as attractive as artists, but some of them aren't." Many of O'Hara's Downtown friends reacted to his extending of his social life

above Fourteenth Street with a kind of suspicion similar in its uneasy timbre to the reaction of his Cambridge friends when he moved from Boston to New York. They found the scene "meretricious" or "corrupting."

O'Hara's colleague at the Museum Waldo Rasmussen pinned some of the blame for his becoming "glamorized" on Bill Berkson. "His friendship with Bill Berkson brought him into contact with Bill's mother and her whole circle of friends in the fashion industry," says Rasmussen. "The fashion world is the most superficial, silliest branch of New York society. It wasn't that he had any illusions about it. I would go to some of those parties with him and they were fun. But he seemed sort of glamorized by it in a way I guess I disapproved of. Barnett Newman became a great friend. And Barnett Newman had enormous style. But very close friends of Barnett Newman were Alexander Liberman and his wife, and there you're talking about *Vogue* magazine and that whole scene. Then there was the rise of the new collectors. The whole social game about contemporary art was beginning, with the Sculls and Ben Heller. He gravitated more toward them. I don't think he was taken in by it. But I thought at the time that it was bad for him."

In fact, O'Hara had ties with café society long before Berkson arrived on the scene. Indeed, O'Hara's friend at the University of Michigan, Kenneth Jay Lane, now a jewelry designer and enthusiastic participant in Uptown life, had only recently become a friend of Berkson's. They became close in 1959 when Berkson, after hitchhiking around France and Spain, visited a house in the south of France where both his mother and Lane happened to be staying. He caught Lane's attention because he was lying by the pool reading *Meditations in an Emergency*. "So we had quite a lot in common," says Lane. "Billy soon was in the same position with Frank as I had been in 1950 when I was a freshman. I had seen him every day, as Billy did." Berkson did introduce O'Hara to D. D. Ryan, a socialite who liked to collect artists and "beautiful people," among others. Ryan had once worked for Diana Vreeland as a *Harper's Bazaar* editor, tended to make the "best-dressed" list, and was currently married to John Barry Ryan III—a Wall Street banker whose grandfather was Otto Kahn. O'Hara's motive in occasionally joining Ryan's circle was to be close to Berkson. But he had always intercut his Communist with Royalist sympathies, as in "In Memory of My Feelings": "one of me has a sentimental longing for number, / as has another for the ball gowns of the Directoire." As Allen

Ginsberg wrote in "City Midnight Junk Strains," his elegy for O'Hara, "you mixed with money / because you knew enough language to be rich."

Berkson, who occasionally showed up at Downtown parties in one of his classic pinstripe suits from the fashionable London tailor Donaldson, Williams and Ward—also Kenny Lane's tailor—was a convenient symbol to certain friends of O'Hara's supposed upward mobility. But actually the heating up of their friendship simply paralleled the cooling down of O'Hara's affair with Warren. In October 1961—a month after Warren departed for Canada—O'Hara and Berkson took a pleasure trip to Rome and Paris. It was a sort of platonic honeymoon. O'Hara had completed his selection of works by Motherwell and sculpture and drawings by Nakian for the São Paulo Bienal, which opened on September 10, as well as putting together "René Magritte and Yves Tanguy," which began to circulate nationally in November. (One of O'Hara's typical headaches during the Magritte exhibition was the damage done to the collector John De Menil's *Le Mond Invisible* while en route to New Hampshire. The matter concluded with a letter from De Menil, to whose house O'Hara was invited for cocktails during the sixties, conceding, "If Mr. O'Hara is satisfied that it was a good repair job, I am not going to make a fuss.") "The exhibitions he worked on were assignments and not all were really central to him," Rasmussen has written. "He was a professional, however, and could become absorbed in such assignments and produce creditable results." O'Hara took advantage of a lull before beginning work on a national circulating exhibition of sculpture and drawings by Gaston Lachaise to make his only trip to Europe not involved with business. As he wrote to the poet Lawrence Ferlinghetti from Amsterdam on a business trip in 1963, "One of the ironies of my life is that the only time I'm not broke is when they send me somewhere and I have a per diem."

On October 28 Berkson and O'Hara boarded Pan Am flight 114 at Idlewild Airport, arriving at Orly at 8:00 Sunday morning. The flight became its own happening. Before their departure, Norman Bluhm finished a three-panel painting titled *Flight 114* in celebration of the trip, which O'Hara deemed "terrific." (A year before O'Hara and Bluhm had completed a series of twenty-six "poem-paintings.") Berkson wrote a response to the painting, titled "Flight 114" and dedicated to Bluhm. On Pan Am flight 115 a month later, returning from Rome via Paris to New York, O'Hara and Berkson wrote the collaborative play *Flight 115: a play, or Pas de Fumer sur la Piste* on a small portable Hermès Rocket they passed back and forth, balancing the typewriter on their

knees. Their neighbor on the aisle, who described himself as "in government work," asked "Are you *sure* you really are Americans?" because all the lines in the play pretended to be in a foreign language.

"The second trip occurred during what was probably the peak of our friendship," writes Berkson of their second visit together in Paris.

The painter Paul Jenkins had gone to New York and left us keys to his studio on the rue Vercingetorix. There we stayed and collaborated on two pieces: "Notes from Row L" (for NYC ballet program, commissioned by Edwin Denby who edited a collection of poets' appreciations of the company & its repertoire) and "Reverdy" (because John Ashbery suggested we contribute to the Mercure de France homage to Reverdy who had just died.) During the Paris stay, we both met Marcelin Pleynet and Julien Alvard, and otherwise saw Joan Mitchell & Riopelle, David Budd, Ilse Getz & Manouche Yektai, Shirley Goldfarb, Kimber & Gaby Smith, Harry Matthews, Jean Tinguely & Niki de Ste. Phalle, Yves Klein, and two friends of Joan's named Mario & Marc. Two salient details: 1) walking with John and Frank one night by the Luxembourg Gardens, we passed a short figure of a man in leather jacket, and afterwards John said "Genet"; 2) during lunch at Joan's, Frank referred to John (not present) as "the foremost poet in English today"—Joan had in her studio the page proofs of *The Tennis Court Oath,* which I immediately snapped up, sat down in a corner to study. Joan said, apropos "Europe": "God, how I worked over that poem!"

Joan Mitchell was probably the liveliest of their hosts in Paris that trip. But much of her liveliness was the outcropping of her difficulty. As Vincent Warren describes her, "She looked haunted. She used to wear a trench coat and her hair would be hanging very lank. She looked beaten down, haggard, furtive, scared, a little desperate, highly nervous, highly strung. Her eyes were intense. She needed an emotional response." Mitchell gave Berkson and O'Hara a hard time when she discovered they were sharing a double bed in Jenkins's studio and tried to be provocative to discover the truth about their relationship. "Joan was interested in people's psychologies," explains Berkson. Her unintentional boon was a stray remark made at lunch one day, which found its way as an epigraph into the play they later wrote at thirty thousand feet. "I think the happiest days of my life were when I was going to a chiropractor," said Mitchell. "Isn't that the most depressing thing you've ever heard?" O'Hara particularly enjoyed Jean-Paul Riopelle, Mitchell's lover at the time, a French-Canadian Abstract Expressionist painter who was given to driving fast cars and racing sailboats. One

night, Riopelle, about whom O'Hara would write a piece titled "International Speedscapes" in *Art News* two years later, charmed them all by holding forth until early morning about Picabia at the Closerie des Lilas—the Montparnasse gathering spot of poets and artists from the Symbolists on that had been the scene of many lyrical outpourings from Apollinaire at the turn of the century. The scene was enough for O'Hara to feel justified in pronouncing the entire Paris leg of their trip "HEAVEN" in a letter written to Ashbery on their return.

On November 10 O'Hara and Berkson flew to Rome. They stayed at the Hotel Inghilterra, near the Spanish Steps, where O'Hara had stayed on his first trip in 1958. Their host in Rome was Bill Weaver, who gave a party for them that was attended by, among others, the German composer Hans Werner Henze. With Weaver they went to see the Caravaggios in Santa Maria del Popolo and Santa Maria dei Franchesi, and on their own went to the Vatican and the Accatolico cemetery and had tea with the curators of the Keats-Shelley Memorial House. O'Hara also spent time with Cy Twombly and visited the galleries on the Via Marguta one afternoon while Berkson visited his tailor. O'Hara was distracted, however, by the presence nearby of Richard Burton and Elizabeth Taylor, who were making international headlines by carrying on their romance during the filming of *Cleopatra*. "Bill's mother has shown up here too (she was also in Paris for a couple of days)," O'Hara wrote to Rivers. "We hope this means she will bend her will to getting us permission to visit the set of *Cleopatra* some day when Elizabeth Taylor does feel like working." As a friend of Roddy McDowall, who was playing Octavian, Eleanor Lambert gained the two poets access to the Forum set although filming was over and the set was empty. Of his mother's take on his unorthodox friendship with O'Hara, to which she had been more fully exposed during this trip, Berkson says, "I think that she just sort of put the best shine on it."

The two returned to New York on November 19, and O'Hara's ebullient mood is perhaps best evoked in the pastoral opening of "Flight 115": "How pleasant it is to be above the tundra of clouds with you." Back in the city O'Hara managed to draw out his feelings for Berkson by returning to work on "Biotherm," a long poem he had begun on August 26 to present to Berkson for his birthday but kept in the typewriter until January 23 when he finally finished it. Explaining the title of the ode-length poem, O'Hara wrote to Don Allen, "Biotherm is a marvelous sunburn preparation full of attar of roses, lanolin and plankton ($12 the tube) which Bill's mother fortunately left around and it hurts terribly when gotten into one's eyes. Plankton it says on it is prac-

tically the most health-giving substance ever rubbed into one's skin."
Biotherm appears in the poem as a sort of elixir, in a parody of a pas-
sage from William Carlos Williams's *Paterson* V:

> *"measure shmeasure know shknew*
> *unless the material rattle us around*
> *pretty rose preserved in biotherm*
> *and yet the y bothers us when we dance*
>
> > *the pussy pout"*

Parody, mimicry, and the interpolation of a crowd of voices marked
a shift in O'Hara's work from the lyric to the more dramatic. If "Sec-
ond Avenue" had aspired to the abstraction of de Kooning, "Biotherm"
in its use of found language was closer to the assemblages of Rauschen-
berg, as well as to Ashbery's "Europe." Another snippet parodied the
"Flower Song" from *Carmen*:

> *"the flow'r you once threw at me*
> *socked me with hit me over the head avec*
> *has been a real blessing let me think*
> *while lying here with the lice*
>
> > *you're a dream"*

O'Hara also included a passage from Wyatt, from which he was con-
sidering lifting the phrase "wherebye shall seace" to be the poem's title:

> *"This dedelie stroke, wherebye shall seace*
> > *The harborid sighis within my herte"*

"Biotherm" was filled with quotations from Marlene Dietrich in *A For-
eign Affair*, as well as other movie remarks such as "Talk / to me Harry
Winston," which was an interjection made by Marilyn Monroe while
she and Jane Russell sang "Diamonds Are a Girl's Best Friend" in
Gentlemen Prefer Blondes. Included, too, were such impossibly private
lines as "where I am going is to / Quo Vadis for lunch"—a reference to
his lunch at that chic restaurant on January 4 with Gian Carlo Menotti.
Eleanor Lambert's lotion recurred at the conclusion of the poem, its
mood reminiscent of the "wings of an extraordinary liberty" passage
at the equally oceanic finale of "Ode to Michael Goldberg ('s Birth and
Other Births)":

> *you the quicksand and sand and grass*
> *as I wave toward you freely*
> *the ego-ridden sea*
> *there is a light there that neither*
> *of us will obscure*
> *rubbing it all white*
> *saving ships from fucking up on the rocks*
> *on the infinite waves of skin smelly and crushed and light and absorbed*

The similarities to the Goldberg ode were not lost on O'Hara, who described the poem to Rivers—at whose house in Southampton much of the poem was written, most of the rest being written at his Museum office—as "a longy about the size of the Mike Goldberg ode." To Don Allen he had written, "I've been going on with a thing I started to be a little birthday poem for BB and then it went along a little and then I remembered that was how Mike's Ode got done so I kept on." That he considered the Goldberg ode his best poem shows that his poetic ambitions were still intact for "Biotherm." Unfortunately, after this final long poem his output did not keep pace with his ambition.

"Biotherm" was filled with winks and digs meant for Berkson alone. It was a work of complex courtship. But between many of its lines were complaints of frustration—a frustration on which O'Hara perversely fed. He wrote by the eighth line of "a year and a half of trying to make him." He wrote, too, of the "claustrophobia" Berkson used to complain of experiencing if O'Hara became too demanding or intimate:

> *we have our usual contest about claustrophobia*
> *it doesn't matter much*
> *doing without each other is much more insane*

These tug-of-love matches often led to Berkson's leaving O'Hara's apartment or to O'Hara's feeling the need to leave Berkson's (Berkson lived in a one-room apartment with a roof on East Fifty-seventh Street between Lexington and Park). The Beckett-like indecision of some of their exchanges was recorded in "Metaphysical Poem," written in January 1962:

> *I can just go home*
> *I don't really mind going there*

but I don't want to force you to go there
you won't be forcing me I'd just as soon
I wouldn't be able to stay long anyway

The unbudging fact at the bottom of their many-sided relationship was
Berkson's saying "No" to O'Hara's advances on the few occasions
when they were directly made. The "NO" in "Biotherm," though, ac-
cording to Berkson, refers to O'Hara's famous morning call after a
drunken evening, asking if he had said anything too awful:

and when yesterday arrives and troubles us you always say NO
I don't believe you at first but you say no no no no
and pretty soon I am smiling and doing just what I want
again

"There were times when Frank came on to me in a way," says
Berkson. "We'd maybe been out to the movies or the bar. I'd stop back
at his place for a drink and maybe it was time to go. I got up to go and
he sort of hugged me and kissed me. We were both a little drunk. I
would get this claustrophobic feeling like 'Hey, wait a minute, this is
heading in this direction which is not where I'm going.' Why? I don't
know. When I think of everything that was going on between us and
how attached I really was to him and in some ways dependent, feeding
on, thriving on this affection between us, I think 'Why not just go make
it?' But it just wasn't in me. It just wasn't where my body was going.
The more I think about it the weirder it seems. In a way it casts a
perverse light on the relationship. Like why not? But it was a not."

O'Hara smoked joints occasionally with Berkson, but drugs only
seemed to accent the more obstreperous side of their friendship. "John
[Button] and Bill and I have been getting high on hashish lately which
leaves me funky and nervous," O'Hara had written to Warren in July
1961. "I don't really like it even as much as pot, but I find myself doing
it and it's fun for part of the time and then everything gets terribly
stormy, usually between me and Bill. How interesting. Ugh." O'Hara
never entered fully into the drug culture, which was becoming so pop-
ular during the sixties. (Ginsberg was already experimenting with the
hallucinogen yage in South America in 1960 and was introduced shortly
afterward to Timothy Leary with whom he tried LSD.) In "On Rach-
maninoff's Birthday #161," written in 1961, O'Hara wrote "I have a
hash hangover." And he took mescaline at Larry Rivers's place in 1963

before going to the movies to see *Silk Stockings*—a musical remake of *Ninotchka*—during which Rivers commented to O'Hara's great amusement that Fred Astaire looked "half dead." Mostly, though, he disapproved of Rivers's drug use, asking him facetiously after one of his drug experiences, "And what else do you imagine happened to you?"

Luckily, he and Berkson had the New York City Ballet, Busby Berkeley movies at the New Yorker Theatre, art gallery openings, and poetry readings to ventilate Berkson's claustrophobia. During the 1961–62 season, which included the premieres of Balanchine's *Raymonda Variations* and *A Midsummer Night's Dream,* O'Hara's and Berkson's collaborative "Notes from Row L" ran in the New York City Ballet program. Berkson often accompanied O'Hara to after-performance parties at Lincoln Kirstein's house near Gramercy Park. The dancers weren't invited to Kirstein's soirees, however, and Balanchine did not attend either. O'Hara preferred parties for the dancers, such as the reception given at the ballroom next to the theatre on the evening of January 17 after the premiere of *A Midsummer Night's Dream,* at which O'Hara played the role of the drunken fan to the hilt. One of his favorites was the black dancer Arthur Mitchell who danced Puck, and O'Hara told Kirstein that the rising young star should be given a solo call at the curtain. Mitchell protested, "Oh Frank, stop! You know I can't blush." Half an hour later O'Hara had moved on to regale Patricia Wilde with his opinion of her greatness. "Frank's love of the company wasn't so unique but maybe his response was," says Berkson. "He was so emotionally rapt by the performances; he would gasp, get teary-eyed, reach out and grasp his companion by the forearm, and otherwise sit very erect in his seat, not missing a turn."

On February 9, Berkson accompanied O'Hara to a poetry reading he was giving with Robert Lowell at Wagner College on Staten Island. This pairing of readers, however, turned out to be a miscalculation on the part of Willard Maas who organized the event. It was a snowy night on the Staten Island ferry as O'Hara traveled in the wintry dark to the reading. He fought his discomfort by writing "Poem" (Lana Turner has collapsed!), inspired by a story in the tabloids that day about the actress's collapse at a party. His reading of the occasional poem a few hours later was a predictable hit with his amused audience:

> *I was in such a hurry*
> *to meet you but the traffic*
> *was acting exactly like the sky*

and suddenly I see a headline
LANA TURNER HAS COLLAPSED!
there is no snow in Hollywood
there is no rain in California
I have been to lots of parties
and acted perfectly disgraceful
but I never actually collapsed
oh Lana Turner we love you get up

When Lowell began his set he prefaced his poems by apologizing some-what disingenuously for not having written a poem on the spot. His implication was that writing poems was not such a casual affair for him.

According to Gerard Malanga, who participated in the reading as a protégé of Willard Maas, O'Hara had invited the snub from Lowell, about whose work he had been cantankerous ever since Harvard. "Wil-lard got really pissed off at Frank at the reading," remembers Malanga, who read first along with another student poet. "Frank read for almost an hour. The idea was that these two poets were only going to read for maybe twenty minutes apiece. Willard felt that Frank was being disre-spectful toward Robert Lowell. When Lowell began his reading, he said, 'I'm only going to be reading for a few minutes,' as if to give the needle to Frank. . . . Frank was stewed or something. But he had it in for Robert Lowell for some reason. To him he was some kind of stuffy poet. This was his way of showing him up."

In the spring, both Berkson and O'Hara began writing for a new small prose magazine, *Kulchur* (its title homage to Ezra Pound's *Guide to Kulchur*), that was funded by a wealthy Park Avenue collector named Lita Hornick. Married to Morton Hornick, the owner of a lucrative cur-tain business, Lita used to be referred to as Lita Curtainstar by Andy Warhol, who painted her portrait in 1966. In the early 1960s, though, before she moved full force into the artworld, most of Hornick's friends were Downtown poets. As most of its writers already had an outlet for their poetry in *The Floating Bear* or *Yugen*, *Kulchur* was able to fill its self-defined niche as "the only vanguard magazine devoted principally to Criticism and Commentary—essays on literature, art, jazz, politics and pop culture by leading poets." Its board in 1962 was largely a co-opting of O'Hara's inside group. He served as Art Editor, LeRoi Jones as Music Editor, Bill Berkson as Film Editor, and Joe LeSueur as Theatre Editor. During the sixties the magazine published essays on many topics of popular culture: pornography, drugs, Wilhelm Reich,

the Kama Sutra, Freud, civil rights, blues singers, Hollywood's ten best social protest movies, and the dangers of hipness. Literary essays included Robert Duncan on the meaning of form, Jerome Rothenberg and Robert Creeley on "deep images," and Louis Zukofsky's "5 Statements for Poetry." Many of the reviews were as cutting in tone as LeRoi Jones's criticism of Robert Bly's and William Duffy's magazine *The Sixties*: "I suspect Mr. Bly and Mr. Duffy are ignorant fools." O'Hara's attitude toward Hornick was sarcastic, and he found board meetings a bit trying, especially when she ignored his advice. She was equally rankled by his inability to meet the deadlines for which she was paying him. (Berkson had to write one of O'Hara's "Art Chronicles" to fill in.) "She would be running these Board of Director things for this little magazine and Frank thought it was just a riot," recalls the poet Jim Brodey of meetings in her dining room, where she summoned the maid using a buzzer under the table. "He would make remarks, then LeRoi would make a remark, and they'd kick each other under the table."

But the magazine gave O'Hara a place to think on paper about current art exhibitions without feeling constricted by the editorial voice of *Art News* or the internal politics of the Museum. His art writing was never livelier than in these "Art Chronicles" as he mapped his personal trail through a season's openings. In the Spring 1962 issue he reviewed the "Abstract Expressionists and Imagists" show at the Guggenheim, pausing to vent his feelings about the controversial building, opened in 1959: "in general my idea is that this may not be (as what is) the ideal museum, but in this instance Frank Lloyd Wright was right in the lovable way that Sophie Tucker was to get her gold tea set, which she described as, 'It's way out on the nut for service, but it was my dream.'" His highest praise in the group show went to a painting of Motherwell's he somewhat bafflingly described as possessing "an opulence and a majesty which is completely uncharacteristic of the American sensibility unless you think your mother went to bed with an Indian." (A retrospective of Motherwell's works based on O'Hara's selection for the São Paulo Bienal had just opened on February 18 at the Pasadena Art Museum.) He commented as well on Claes Oldenburg's *THE STORE on East 2nd Street,* calling it "the best thing since L.L. Bean"; mentioned Rauschenberg's December show at Castelli, comparing his *Dante Illustrations* of the previous year favorably to those of Doré; and wrote that his friend Norman Bluhm's March show at David Anderson showed "a spirit similar to that of Pollock, which is to say that he is *out.*" (In the same issue of the magazine LeRoi Jones published his essay "Tokenism: 300 Years for Five Cents," which introduced the word *tokenism* into the

language. Picking up on the term a few weeks later on the radio, Martin Luther King, Jr., credited both *Kulchur* and Jones.)

O'Hara continued to track his own peregrinations in the New York artworld in his second "Art Chronicle," which appeared that summer in *Kulchur,* along with "Liner Notes" by the avant-garde composer Morton Feldman, whose work was championed by O'Hara, an essay on current English poetry by Denise Levertov, a polemic on the theatre by Julian Beck; and Louis Zukofsky's play *Arise, Arise.* O'Hara was especially enthusiastic about the sculptor Reuben Nakian's May show at the new Egan Gallery on East Seventy-ninth Street. But then O'Hara's enthusiasm was well known. The steel-plate piece he singled out for a long aria of praise—*The Rape of Lucrece*—had been included in his selection of Nakian for the São Paulo Bienal after its extended display in the stairwell of the Museum of Modern Art. Its two abstract figures "delineated by great scooping sheets of black" vivisected by black rods had been evoked by him in his love poem "Vincent":

> I saw
> a very surprising thing this
> morning before you were up
> a sea of sexual sheets
>
> draped
> on black steel rods and behind
> them the glistening white
> hair of Nakian on this strange
> warm morning

Commenting on the Nakian sculpture of shaped steel and aluminum forms floating like huge leaves that was commissioned for the façade of the Loeb Study Center facing Washington Square Park, O'Hara decided, "His career has been somewhat parallel to that of William Carlos Williams: decades of ardent appreciation by 'the happy few' and then BOOM!" O'Hara had also been taken with Alex Katz's show of flat sculptures at Tanager in March. Comparing them to the Dummy-Board Figures that stood by English firesides in the late seventeenth and early eighteenth centuries, he quoted a remark made by Bill Berkson at the opening: "He's a dumb-watchman—you know, like a dumb-waiter or a dumb-valet." Writing to Vincent Warren of the show, which included a cut-out of himself (purchased after the show by Elaine de

Kooning) and Rivers's ex-girlfriend Maxine Groffsky, he reported, "Edwin went into the office to make a phone call and when he hung up he addressed a remark to my cut-out, which was right near the door with its back to him, and then wondered why I hadn't answered. And everyone went around behind Maxine's to see if she had a bathing suit on in the rear, and were rewarded by her not." Equally exciting to him that season—if less gigglingly so—were shows of Arshile Gorky's paintings and drawings, as well as "a brilliant monograph" on the pioneer abstract artist by Harold Rosenberg in the same series as his own *Jackson Pollock*. For the May issue of *Art News*—whose cover featured Guston's *The Clock*—O'Hara also wrote a piece titled "Growth and Guston" on Guston's first major retrospective at the Guggenheim. After the reception of *Jackson Pollock* and his "Art Chronicles," O'Hara felt he could let some lyrical language find its way into the predictable style of *Art News*, claiming of Guston's recently darkened palette of rusty oranges, dark reds, and shades of gray that "The surface of the painting may now take on the feel in your hand of the Indian clubs, of the hide of the horse, of the pain of another physical presence which has hurt you or is driving you mad."

Guston wrote in a letter to Bill Berkson of the power of O'Hara's studio visits at the time: "One memory in particular involves the three of us—of a night he brought you by my loft to have us meet and see new paintings. The loft was over an old Hook and Ladder Co. in Chelsea—the oiled wooden floors a giant ashtray, black-tarred skylights, oceans of dried paint on my palette, brushes stuck. . . . I was starting those black and grey paintings. You were silent. Frank was in his most non-stop way of talking, saying that the pictures put him in mind of Tiepolo. Certain cupola frescoes. Suddenly I was working in an ancient building now a warehouse facing the Giudecca. The loft over the Firehouse was transformed. It was filled with light reflected from the canal. I was a painter in Venice."

As Larry Rivers was spending the summer of 1962 having shows in London and Paris, he lent O'Hara his house in Southampton for three months. O'Hara had received a poetry grant from the Merrill Foundation and was excited at the prospect of being able to extend his summer weekends into weeks. So on June 8 he opened Rivers's house for the summer with the help of Bill Berkson, Jasper Johns, and Joe LeSueur. "When Bill was finding your tennis racquets, we also found the little bronze of Berdie which I have placed next to the telephone on the white table so we could enjoy glaring at it," he wrote to Rivers. On

Saturday night they all kicked off the season by giving a "chic dinner party" for the Goldbergs. As his Rockefeller grant to Poets Theatre had backfired, the Merrill grant funded a nonproductive summer. (In June he managed to write "First Dances," "Political Poem on a Last Line of Pasternak's," and "Rogers in Italy.") The switch from guest to host, though, barely affected his social life, which continued to be mostly wrapped up with Mike Goldberg and Patsy Southgate—especially Patsy Southgate.

His feelings for Southgate at the beginning of their friendship had been involved with his feelings for Goldberg. Now, though, the triangular attraction was beginning to shift. Described by Terry Southern (in London that year working on the screenplay for Stanley Kubrick's *Dr. Strangelove*) as a "breath-taking Miss America plus type beauty," Southgate was the latest of O'Hara's few heterosexual flirtations. Luckily, her marriage was loose enough to allow for adolescent-style experimenting. As Berkson recalls of one weekend when he stayed as a guest in a double bed with O'Hara upstairs at the Goldbergs' in the Hamptons, "Through the doorway I got the sense that Frank had gotten up in the middle of the night and that Frank and Patsy were making out in the hall. I didn't see it. But my hearing told me something. That kind of thing happened."

One humid August night O'Hara and Southgate attempted to give themselves over to the feelings they'd had about each other. O'Hara had been at a party at the Goldbergs' in the Springs after which all the guests had suddenly disappeared into New York City, leaving Southgate with the responsibility of driving him back to Southampton. At 5 a.m.— just as dawn was breaking—they set out in an old Chevy wagon, O'Hara in his white striped seersucker jacket, Southgate in her yellow dress with big white polka dots. About a hundred yards down the road Southgate swerved over to let O'Hara take the wheel. "Frank was probably in no better shape to take the wheel than I," she has written, "but he was better at assuming responsibility, and as we rolled along at a stately twenty m.p.h. through the 'Lawrence of Arabia' daybreak I remember marvelling at his responsibility-assuming leadership qualities and complimenting him lavishly on these as well as on his driving skills." Arriving at Rivers's Gothic American house, O'Hara fixed a couple of Screwdrivers as they sank into the white sofa in the bay window to listen to an Erik Satie record. When Satie's *musique d'ameublement* eventually faded, they quoted poetry to one another, culminating in a mangled rendition in unison of Shakespeare's sonnet beginning "When

in disgrace with fortune and men's eyes." They then decided to brave going to bed together, O'Hara freshening up their drinks along the way for this "first."

After stumbling into bed and fondling each other lightly for a while O'Hara came out with what seemed to Southgate like a line from a soap opera. "I just can't go through with this," he apologized. "Mike's too good a friend of mine." "Rats!" she thought, not knowing whether to laugh or cry. Then she began to talk herself down, reminding herself, "The reason fags are fags is that they don't like to screw women, *can't* screw women. It's nothing personal, you dope, it's just Frank's way of begging off." She couldn't help wondering whether things would have worked out differently if her husband had been there instead of her. As Goldberg was hardly monogamous, though, she refused to feel guilty.

"Listen, Frank," said Southgate, disentangling herself and lying back staring up at the ceiling, "I really don't give a flying fuck whether we make it together or not. Just lying here in bed with you is enough. In fact, it's pure heaven."

"I know," he said.

October 1962 was a month of crisis in America. President Kennedy engaged in nuclear brinksmanship by announcing an air and sea quarantine of Cuba until Russia agreed to dismantle its missile sites. As O'Hara wrote of the incident to Rivers on October 29, "Well, it's too bad Cuba didn't give us that wonderful opportunity to be tragic, but perhaps something even more exasperating will come up soon." Domestic politics was likewise tense as Ross Barnett, the governor of Mississippi, barred a black student, James Meredith, from registering at the University of Mississippi until federal troops were dispatched to enforce integration.

Events in the New York artworld that month seemed just as critical within the heated circle of painters, critics, curators, collectors, and dealers. After a powerful decade of international recognition and the spawning of a second generation of followers, Abstract Expressionism had finally and fatally been challenged. The decisive shot was the "New Realists" show, which opened at the Sidney Janis Gallery on the evening of October 31. It marked the entrance into the limelight of the sort of irreverent revolt Alfred Barr had been agitating for in his talk a few years earlier at the Club. John Canaday had been equally keen on an overthrow of Abstract Expressionism, a feeling he had rushed into print in an article titled "In the Gloaming: Twilight Seems to Be Settling

Rapidly for Abstract Expressionism" in the *New York Times* in September 1960. Included in the Janis show were Jim Dine, George Segal, Claes Oldenburg, Roy Lichtenstein, Andy Warhol, James Rosenquist, and Jean Tinguely. Drawing their inspiration largely from graphics, store window displays, newspaper ads, comic strips, billboards, and industrial design, these controversial painters became known in the press as "sign painters" (as opposed to such "house painters" as de Kooning), "commonists," "New Realists," and eventually "Pop artists."

The opening, on Halloween, was a bash. As Tom Hess reported with justified paranoia in his review in *Art News,* "The New Realists were eyeing the old abstractionists like Khrushchev used to eye Disneyland—'We will bury you' was their motto." That the show took place at Sidney Janis added adrenaline to the event. A group of older abstract painters affiliated with the gallery had already resigned in protest—Philip Guston, Robert Motherwell, Adolph Gottlieb, Mark Rothko. Another Janis artist, Willem de Kooning, came to the opening and paced up and down in front of Warhol's *200 Campbell's Soup Cans* and Jim Dine's *Bathroom* with its mirror, toothbrushes, and medicine cabinet all painted "sick flesh" pink for two hours before leaving without uttering a word. "After the opening, Burton and Emily Tremaine invited me to their house on Park Avenue," Rosenquist has recalled of a party at the collectors' apartment. "I was surprised to find Andy Warhol, Bob Indiana, Roy Lichtenstein, and Tom Wesslmann there. Maids with little white caps were serving drinks, and my painting 'Hey! Let's Go For A Ride!' and Warhol's Marilyn diptych were hanging on the wall next to fantastic Picassos and de Koonings. Right in the middle of our party de Kooning came through the door with Larry Rivers. Burton Tremaine stopped them in their tracks and said, 'Oh, so nice to see you. But please, at any other time.' I was very surprised and so was de Kooning. He and the others with him soon left. It was a shock to see de Kooning turned away. At that moment I thought, something in the art world has definitely changed." Raw feelings erupted at a party at Larry Rivers's in the Hamptons in the late sixties when de Kooning screamed at Warhol, "You're a killer of art, you're a killer of beauty, and you're even a killer of laughter. I can't bear your work!"

O'Hara was not impressed with the Janis show, his allegiances being decidedly in the de Kooning camp. As he wrote diffidently to Joan Mitchell on November 11, "The New Realism show (2 shows actually, 1 at Janis and 1 in a glass store front, ground floor, West Fifty-seventh Street, which catches the man in the street with a big Oldenburg) has opened but no discernible wave of particular excitement seems to have

been generated in hearts other than those already excited by previous manifestations at Martha Jackson et al. Except of course for the *New York Times* which treated it with unprecedented kindness, along with their policy of anything-but-abstract-expressionism. A few things are nice, especially the Tinguelys and the Jim Dines are interesting and Oldenburg is fun—most of it is boring and crappy though." To Joe LeSueur he remarked wishfully and quite incorrectly of Pop Art, "It's going to last about six months." To John Ashbery he complained on November 20, "Around here, the Abstract-Expressionism New-Realism situation is pretty 'Thou art either for me or agin me' as the good book say."

O'Hara took advantage of his "Art Chronicle III" in the Spring 1963 issue of *Kulchur* to bitch at John Canaday at the *New York Times* as well as his least favorite New Realists—Andy Warhol and Robert Indiana—at the expense of his favorite "contemporary High Art" painters. "Mr. Canaday's specialty along this line has been the wise-suspicion-esthetic-hoax strategy," he wrote of his whipping boy, "a strategy aimed exclusively at the abstract-expressionists with the equally simplistic belief, apparently, that no figurative artist has ever wanted to sell a painting." O'Hara's tack was that the New Realists were only tilling ground already laid open: "The best works were those in which the connections between the originator of the idea, the off-shooter and the new-realizer were most clear. . . . Oldenburg (Gaudí and Miró through Pollock), Dine (Barnett Newman through Jasper Johns and Bob Rauschenberg), Segal (Giacometti through Larry Rivers' sculptures of the late 50s), Rosenquist (Magritte through Motherwell)." He then brushed aside the New Realist show altogether in the face of the January shows of Motherwell at Janis and Rivers at Tibor de Nagy. "Motherwell's series of Spanish Elegies continues to expand and move," he wrote of the exhibition of the new *Elegies No.70* and *No.77*. "Some preconceptions in imagery stand still at their freshest (soup cans, newspaper pages, road signs), like a high school performance of *The Petrified Forest*. But the Elegies mean something, and you can't beat that." Of Rivers's show in which he showed franc notes, Camel packs, and nudes with vocabulary lessons stenciled next to them that seemed extravagantly "Pop" in everything but brushwork, O'Hara claimed, "Rivers is after a more complicated and mysterious visual experience, more related to Johns and Rauschenberg than to Indiana and Warhol. For Rivers the stencil is simply another element available to expression, to several other painters recently it has been *the* expression. The latter idea is perfectly agreeable in theory, but the resultant works have seldom gone further than the me-

chanics of their construction." He found Warhol's paintings "chi-chi" and "wall-eyed."

O'Hara was vexed by Warhol's rise. They had both arrived in New York at about the same time. But Warhol's acceptance by the artworld in which O'Hara was so celebrated was peripheral at best. Of Warhol's first show at the Hugo Gallery in 1952, an unimpressed *Art News* reviewer had written that his drawings of young boys' heads and women dressed in the style of the twenties were "airily" reminiscent of the novels of Truman Capote. As a curator, O'Hara had visited Warhol's studio in 1959. "He was very unkind to Andy," says the poet John Giorno. "This was when Andy was still drawing shoe ads and making all that money. Frank O'Hara and two other people came to visit Andy in that house on Eighty-ninth Street and Lexington Avenue. It was very chicly decorated at the time—black vinyl walls, a horse from a carousel. I remember Andy saying that Frank walked into that front room and just started laughing and putting him down for being chi-chi. That's not what they wanted to see or what they thought was important. He told me, 'Frank was so meeeean.' That carried through when he became a famous artist. But then at some point Frank made a change and thought that what Andy was doing was valid."

Warhol had begun doing drawings of feet long before the shoe ads—an expression of his fetish. Introduced to O'Hara by Willard Maas at Charles Henri Ford's, Warhol asked O'Hara if he could draw his feet. Well aware of the eroticism in the suggestion, O'Hara refused. "But you let Larry Rivers draw your feet," complained Warhol, who had early on bought a Rivers drawing from John Bernard Myers on an installment plan of five dollars a month for five months. "Well that's Larry Rivers!" O'Hara exclaimed. O'Hara was not nearly so difficult with Jasper Johns, who made a sculpture of wood, lead, metal, brass, and sand in 1961 titled *Memory Piece (Frank O'Hara),* in which a rubber cast of a foot in the sand was taken from a plaster mold of O'Hara's foot. "I remember casting his foot on Front Street in my studio," says Johns. "I cast his foot and did a drawing for the piece, which included a cabinet with the drawers full of sand. At that time I had a house in South Carolina. I needed a carpenter but could never find anyone to do it. I think it was done after his death. But I gave Frank the drawing for it." This was the piece referred to in O'Hara's letter-poem to Johns, written in 1963: "Dear Jap, when I think of you in South Carolina I think of my foot in the sand."

Masterful at the art of manipulation and careerism, Warhol had targeted O'Hara at first as someone who could open doors for him. "Andy

wanted Frank's respect, I think," says Gerard Malanga. "But Andy was not getting it, so he was kind of two-faced about the situation. He actually was not that impressed by Frank. But he would get hurt by these negative reactions from people he thought he could look up to." Soon enough, of course, doors opened without O'Hara. Warhol's one-man show in November at the Stable Gallery, which included his Marilyn diptych, *100 Soup Cans, 100 Coke Bottles,* and *100 Dollar Bills,* set him at the head of the pack, which O'Hara would rather have seen him trailing. Bill Seitz, the chief curator of the Museum's Department of Painting and Sculpture, bought a Marilyn for himself for $250. Philip Johnson bought the *Gold Marilyn* for $800. Yet when Warhol gave him one of the Marilyns, O'Hara instantly put it in his closet. Jim Brodey, a poet from O'Hara's New School class, recalls a cocktail party at O'Hara's at which Warhol gave O'Hara an imaginary drawing of the poet's penis, which he crumpled up and threw away in annoyance.

O'Hara's antagonism toward Warhol was mixed with art politics and sexual politics. Warhol was relegating the Abstract Expressionists to the past. By threatening O'Hara's allies, he was threatening O'Hara's own vanguard status, a position he had enjoyed since he was a teenager. He offended O'Hara as well by rejecting the brushstroke, with its touching, personal, humanistic implications, in favor of silkscreening and mechanical reproduction. Larry Rivers's commissioned billboard for the first New York Film Festival in 1963 included a camera, strips of celluloid, a Rudolph Valentino cameo, a leopard, a figure of Jane Russell in her briefest costume from *Gentlemen Prefer Blondes,* and stenciled letters. When it was mounted at the corner of Broadway and Sixty-fifth Street, O'Hara wrote to Joan Mitchell, "You can make out what the message is through a few well-placed letters here and there, but mostly it is pure Rivers—no Andy Warhol he. It's quite funny that they do all those paintings that look like billboards, and when a billboard is finally commissioned it looks like a painting, or rather is one."

"In his love of objects in his poetry and in his association with Larry Rivers he certainly wasn't antirealist," says the painter Wynn Chamberlain. "On the other hand he was very much anti-Death, which is what Warhol signified to him I think. And to all of us at that point. He was the prophet of doom. There was a complete division between the Warhol-Geldzahler camp and the O'Hara-Rivers-de Kooning camp. Frank was at the Museum of Modern Art, and that Museum was the thing to be overcome by the younger Pop painters." Among his fellow curators at the Museum, O'Hara was actually relatively open to some

of the "New Realists," if not always to Warhol. "Like a lot of people who were involved with Abstract Expressionism I was very resistant to Pop," says Waldo Rasmussen. "It really seemed trivializing to me. And in some aspects of it he was too. But he was much more open to it than I. He became very quickly a good friend of Claes Oldenburg. He liked Lichtenstein's work." (The painter Al Leslie recalls a panel discussion at the Skowhegan School of Painting and Sculpture in Maine at which O'Hara savagely "devastated" an art historian who criticized Lichtenstein, beginning his tirade with his trademark insult, "You big sack of shit!")

Some of O'Hara's peeves with Warhol were personal. Paramount was a friendship of Warhol's with Freddy Herko—the young dancer who had roomed with Vincent Warren after rooming with Diane DiPrima. Warhol had filmed the struggling dancer roller-skating all over New York on one bleeding foot in a sixteen-millimeter film titled *Dance Movie* in September 1963. In October 1964, Herko killed himself tripping on LSD by dancing out the fifth-floor window of a friend's Greenwich Village apartment while Mozart's *Coronation Mass* played on the record player. When he heard the news, Warhol reportedly said, "Why didn't he tell me he was going to do it? We could have gone down there and filmed it!" O'Hara, who attended the memorial service organized by Diane DiPrima at Judson Church, reacted to Herko's death with his usual overblown mourning and sorrow. Warhol's response cinched O'Hara's opinion of him as cold-blooded. As he wrote to Mike Goldberg, "How did you know incidentally about my being so depressed about Freddie? I was, very, but when this girl told me that Andy Warhol and Alan Marlowe had found it 'beautiful' and I said that I hoped they would both be locked into a Ben Hecht movie and left to starve, I felt greatly relieved."

O'Hara was first brought to Warhol's "Factory," which was then located in a warehouse and factory building at 231 East Forty-seventh Street, by Joe LeSueur in 1964. (LeSueur had appeared eating a banana that year in *Couch,* a lightly pornographic movie filmed in July on an old red couch in the middle of the Forty-seventh Street Factory with cameo appearances by Malanga, Ginsberg, Corso, Orlovsky, Kerouac, Mark Lancaster, and Baby Jane Holzer.) O'Hara half-heartedly agreed to write, with LeSueur, a segment for a plotted movie (conspicuously missing until then in the Warhol canon) to be called *Messy Lives,* but he never did it. His only contribution was an episode written with Frank Lima called "Love on the Hook." "Frank left the Factory that day not

very impressed with what Andy was doing," says Malanga of O'Hara's only visit. "But there was a weird homosexual climate there at that point. Maybe he felt Andy was too sissified for his tastes."

Instead O'Hara preferred to collaborate with the painter, filmmaker, and ex-bodybuilder Al Leslie, who had filmed *Pull My Daisy* based on a Jack Kerouac story in 1959 and to whom O'Hara announced in the mid-sixties, "Now you'll be my filmmaker." O'Hara subtitled an experimental film of Leslie's, *The Last Clean Shirt,* which consisted of identical footage shown three times in a row, of a couple driving down a New York street speaking in East Europeanese—a film that had the distinction of being mercilessly booed at the Lincoln Center Film Festival in the fall of 1964.

Warhol's style of homosexuality was counter to O'Hara's, who preferred the artist cowboys of the Cedar. Warhol felt alienated by such aesthetic roughhousing. As he later wrote of the Cedar, "I tried to imagine myself in a bar striding over to, say, Roy Lichtenstein and asking him to 'step outside' because I'd heard he'd insulted my soup cans. I mean, how corny. I was glad those slug-it-out routines had been retired—they weren't my style, let alone my capability." The Factory was Warhol's attempt at a party he could control, and the scene's infiltration of Max's Kansas City in 1966 changed the life of artists at least as much as the Janis show. Max's—with its red velvet booths and black vinyl walls covered with works by Frank Stella, Donald Judd, Dan Flavin, and Richard Bernstein—became the new Cedar. The dividing line O'Hara had described as so "New York" in his letter to Warren from Madrid, between the heterosexual painters who liked him and the effete homosexuals who didn't, had been erased.

Eventually O'Hara, like the rest of the artworld, made room for Warhol. As the painter Joe Brainard wrote, "I remember Frank O'Hara putting down Andy Warhol and then a week or so later defending him with his life." In 1964 Warhol, using his Bolex, shot movie footage of O'Hara giving a poetry reading at Café Le Metro—a subbasement coffee shop and antique furniture store on Second Avenue between Ninth and Tenth streets that was the hangout of the East Village poets until the founding of the Poetry Project at St. Mark's Church in-the-Bowery in 1966. In an interview with a British journalist in October 1965, O'Hara found kind words to say about Warhol: "I went to Boston recently and saw the full mounting of the picture of Mrs. Kennedy. . . . It was never shown in New York full scale. And it's absolutely moving and beautiful. Not sarcastic, and it's not some sort of stunt. It really is compelling work when shown in the way he wanted it to be shown.

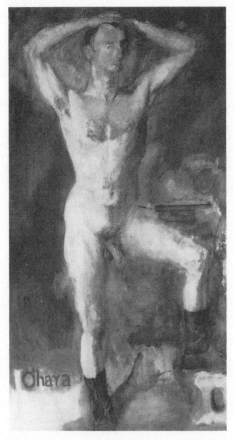

O'Hara, oil on canvas, Larry Rivers, 1954

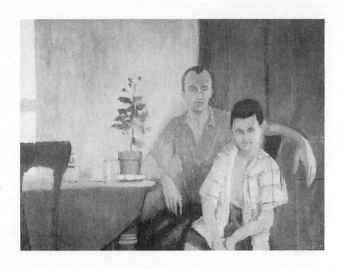

ABOVE: *Frank O'Hara and Steven Rivers*, oil on canvas, John Button, 1956
RIGHT: *Portrait of Frank O'Hara*, oil on canvas, Fairfield Porter, 1957

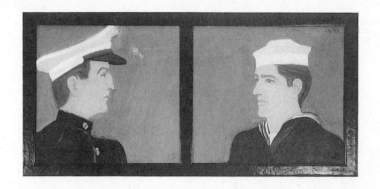

ABOVE: *Marine and Sailor*
(Frank O'Hara and Bill
Berkson), diptych, oil on
board, Alex Katz, 1961
RIGHT: *Frank O'Hara*,
cutout, oil on wood, Alex
Katz, 1959-60

LEFT: *Frank O'Hara*, oil on wood, Elaine de Kooning, 1956. "When I painted Frank O'Hara, Frank was standing there. First I painted the whole structure of his face; then I wiped out the face, and when the face was gone, it was more Frank than when the face was there" (Elaine de Kooning, *Art in America*, 1975).
BELOW: *Frank O'Hara*, pencil-and-ink wash on paper, Don Bachardy, 1965

The Killing Cycle: #4, The Telephone Call, oil on canvas, Alfred Leslie, 1971 –72

Collage comic with Joe Brainard, 1964

One of the twenty-six poem-paintings handwritten by O'Hara in
black-and-white gouaches on paper by Norman Bluhm, 1960

Etching by Franz Kline with poem handwritten by O'Hara
from the portfolio *21 Etchings and Poems*, 1960

When it's as big as it's supposed to be and there are that many images of her and the color somehow works from image to image. And I think that he—you know, just as one knows that Duchamp's serious—I think Andy is a terribly serious artist rather than an agent to make everything lively, which he sometimes is taken for in the United States. The European evaluation of him is much more exact." In a memo written shortly before his death, on a Pollock retrospective he was organizing, he proposed a panel of five critics and artists he thought would be "pentagonally opposed"—Harold Rosenberg, Clement Greenberg, Barnett Newman, Alfonso Ossorio, and Andy Warhol.

The rise of the Pop artists did mark, as O'Hara and others foresaw, the decline of the Abstract Expressionists and with them the second-generation New York School. In a sense O'Hara was one of those second-generation artists. His poetry, especially works such as "Second Avenue," came out of Abstract Expressionist aesthetics. And yet he was in the first wave of the New American Poetry, along with Ashbery, Koch, Schuyler, Ginsberg, Kerouac, Corso, Olson, Creeley, Wieners, Duncan, Levertov, and so many others involved in nonacademic poetics. A surprise of the sixties for O'Hara was the recognition of his work by a second generation of poets from across the country, drawn mostly by Allen's anthology. Following the lead of Bill Berkson, a line of young poets began to show up at his figurative—and sometimes actual—doorstep. Ted Berrigan, a young poet from Tulsa, Oklahoma, who sent O'Hara his first fan letter in the fall of 1961, used to stand on Avenue A staring up patiently at O'Hara's apartment before they ever met. (Ashbery gave the nickname "Tulsa School of Poetry" to Berrigan and his three teenage friends—Ron Padgett, Dick Gallup, and Joe Brainard—who were overwhelmed by the new poetry in high school and moved to the East Village after graduation.) Brainard recalls walking with Berrigan down Second Avenue on a cool early spring evening when they recognized O'Hara from photographs and ran up to tell him they were fans of his work. "I remember that he seemed very sissy to me," Brainard has written. "Very theatrical." Writer and musician Jim Carroll used to wait outside the Museum to trail O'Hara down Fifty-third Street as he left work.

Mostly O'Hara met young poets in more traditional settings—in classrooms or at poetry readings. One meeting spot for young poets was the summer conference held annually at Wagner College on Staten Island, where O'Hara had read so disastrously with Robert Lowell. During the summer of 1962, Poetry was being taught by Kenneth Koch, Playwriting by Edward Albee, and Fiction by Kay Boyle. In July

O'Hara took part on a poetry panel organized by Koch with LeRoi Jones, Bill Berkson, and Gerard Malanga. Afterward he met two young poets attending the conference—David Shapiro, a fifteen-year-old prodigy of a poet and violinist from Deal, New Jersey, and Frank Lima, a twenty-three-year-old Mexican-American who had begun writing poems in prison as wild as "Mom I'm All Screwed Up" about having sex with his mother. Lima cut a romantic figure to O'Hara. As he wrote to Ashbery in September, exaggerating down the age of his new find, "He's 19 or 20, an ex-junkie, the most attractive person in New York, and a boxer (hence I got invited to the Golden Gloves tournament this fall)—I told him to send you some stuff, but maybe Kenny already has. He's coming out in *Evergreen* next issue." When Lima became involved with heroin and other drugs, O'Hara let him stay on his couch on East Ninth Street for a few months until he could pull his life back together.

During the 1962–63 academic year O'Hara taught a poetry workshop at the New School. (Koch, who was teaching there, brought in both O'Hara and LeRoi Jones.) The class met every Wednesday afternoon at four at the New School on West Twelfth Street, the modern building that in 1933 had become a "university in exile" for the intelligentsia fleeing Nazi Germany and France, including Jacques Maritain and Claude Lévi-Strauss, and whose teachers included W. H. Auden, Aaron Copland, and John Cage. Unlike Koch, whose brilliant teaching style included impromptu speeches given in iambic pentameter as well as clever assignments involving imitations of Williams or Stein or of elaborate verse forms such as sestinas, pantoums, or canzones, O'Hara's teaching style was rather low-key. One afternoon he would bring in the *Selected Poems* of Williams, read a few favorites, and ask students their opinion. Another afternoon he would read from W. H. Auden's *The Orators* or "New York Letter." He never gave assignments but wrote comments on any poems students chose to hand him. Among those taking the course were the poets Tony Towle, Gerard Malanga, Joseph Ceravolo, James Brodey, Ruth Kraus, Jean Boudin, Anne Fessenden, Frank Lima, and Allan Kaplan. The teaching picked up at the end of the two hours when O'Hara went off to the Cedar, allowing any students who hung around after class to tag along. "He was the mentor and we were the student friends who followed him around," says Lima.

"He was the opposite of Kenneth as a teacher," says Tony Towle. "He was very generous in allowing the students to speak, perhaps too much so. What he would have had to say would have been a lot more interesting than what some of the students had to say. He was that way to a fault. He was self-effacing. Whereas Kenneth was very didactic.

Theirs were both afternoon classes. After class Kenneth would run off somewhere and was unapproachable but he was a brilliant teacher and very inspiring. Whereas with Frank anyone who wanted to could go along to the Cedar Bar and have a couple of beers. He was at his best in an informal social situation."

"He followed up his enthusiasms in a physical way," says Koch. "I had all these wonderful students at the New School. But you didn't see them at my house. You didn't see me in bars with them. They became *friends* of Frank O'Hara." At times, of course, Koch felt a bit jealous of O'Hara's charisma—a charisma based in part, of course, on availability. When David Shapiro, who along with Ron Padgett was studying with Koch at Columbia College, began visiting O'Hara's apartment, Koch complained, "Now I've lost you like Bill Berkson. Now you're going to be one of Frank's." (On one of Shapiro's visits, O'Hara and LeRoi Jones were watching the TV news concerning the Mississippi riots. O'Hara remarked in favor of black power, "It's good that the right side finally got the guns." On another visit to O'Hara's, Allen Ginsberg read Shapiro's poems, after which he remarked a bit cuttingly, "Why don't you write about your big green sweater?" Shapiro thought to himself, "Well Blake didn't write about *his* big green sweater.")

O'Hara liked saving people as much as he liked teaching them. His stance in his tenement apartment was not unlike that of the Xaverian Brothers who used to be available for help day or night. Frank Lima was such a case. While Lima was staying with him O'Hara persuaded Larry Rivers and others to sell paintings through John Myers to pay for Lima's analyst. He would give Lima advice such as that in a note in February 1963, "Be selfish for a change, and stop punishing yourself for your family's faults, and your neighborhood's faults and the city's faults. You're not going to atone for their sins by knocking yourself out. All that will do is make it so there is one less good poet in the world." He even gave Lima assignments. The first was to read Milton's "Lycidas" and look up the classical references in Bulfinch's *Mythology*. He also told him to read a page of the dictionary every day. The pedagogy was somewhat diluted, though, by their bond as drinking buddies. "We got loaded every night," says Lima. "At that point in his life I think the alcohol was beginning to debilitate him. He would get up at eight in the morning and have a bourbon and soda."

Sudden, unannounced visits by a dozen new young poets laid an extra burden on Joe LeSueur. Not only was there more traffic but there were accidents—such as the window Lima broke when he was drunk one night. "I never fought them off, but I sure didn't want those young

poets coming around as often as they did," says LeSueur. "They would come sometimes before Frank got home from work. I remember Tony downstairs yelling up, 'Frank! Joe! Are you up there? I know you're up there. Let me in.' He wanted to come up and drink our liquor and wait for Frank so they could sit and talk and talk and talk and talk. Then Bill Berkson would call and Frank would get on the phone and talk to him for thirty minutes to an hour while someone else was cooling his heels right there. I was in the other room doing my own thing."

After 1962 Bill Berkson's visits began to subside. Although he had been the first of O'Hara's poetic disciples, he had also become embroiled in one of his ambiguous loving friendships. O'Hara's "flamethrower affection" scared him off a bit. Their intimacy was becoming as much a barrier as a bridge between himself and his peers Downtown. "I had a sense sometimes that I was sitting there and other young poets weren't because those other young poets knew enough or instinctively kept a certain judicious or appropriate distance from Frank," says Berkson. "Frank was Frank. It was very interesting to know him, he was a very great person, and a very great poet from whom they could learn but from whose heat they necessarily should keep their distance. Tony Towle did. Ted Berrigan, who in some ways quite rightly could declare himself to be the world's foremost Frank O'Hara authority and was steering himself in that direction as early as 1962, never really became pals with Frank. He watched him very carefully and read the poems very closely. That's more like standard operational procedure for a poet of the next generation. Or Ron Padgett. In some ways, strategically, it was a mistake for me or anyone else to get that intimate with Frank." Whenever Berkson was around, though, he was given priority. Many of O'Hara's other young friends would be told not to call or not to come by until midnight because Berkson was visiting. Ironically, though, as O'Hara began to travel in the sixties with a facsimile of an entourage, he was becoming more alone.

The winter of 1963 was marked by particular neediness on the part of O'Hara's mother. Matters had hardly changed over the years as mother and son—both shadowed in different ways by alcoholism—had kept an uneasy truce. Her weapon was guilt and cloying innuendo, his a nasty tongue. The phone line was the only way to keep a hold on her son, who had not been to visit her since 1952. O'Hara had laid out his feelings about her methods in "Essay on Style" in 1961:

> *wouldn't you know my mother would call*
> *up*

> *and complain?*
>
> > *my sister's pregnant and*
> *went to the country for the weekend without*
> *telling her*
> > *in point of fact why don't I*
> *go out to have dinner with her or "let her"*
> *come in? well if Mayor Wagner won't allow private*
> *cars on Manhattan because of the snow, I*
> *will probably never see her again*
> > > *considering*
> *my growingly more perpetual state*

He ended the poem:

> > *no I am not going*
> *to have you "in" for dinner nor am I going "out"*
> *I am going to eat alone for the rest of my life*

All the young poets who came by were treated sooner or later to O'Hara's screaming at his mother on the phone—usually she called when she was in her cups asking for money. According to Lima, "After his mother called him, Frank would become very unpleasant." The boy who had written home from the Navy good-naturedly comparing his family life to a "Blondie" comic strip had become the man who could write to Joan Mitchell, "Tell JA not to miss Bette Davis and Joan Crawford in *Whatever Happened to Baby Jane?* It reminds me of my family."

One afternoon Mrs. O'Hara came into town to have lunch with her son and her daughter, who was now married to Walter Granville-Smith and living in New York City. O'Hara roped LeSueur into coming along. LeSueur, who sat next to Mrs. O'Hara, found her to be "an extremely attractive woman, very kind of seductive." O'Hara sat across the table from them practically gritting his teeth throughout the entire meal, driven mad by his mother's pleasantries and his interpretation of what lay behind them. She kept calling him Francis, which he hated. As they finally left, she said, "You must come and see me, Francis. And bring your Joey with you." O'Hara's only comment to LeSueur as he pushed his way through the front doors of the smart restaurant was, "That fucking bitch. How dare you be so nice to her?"

In January 1962, Katherine O'Hara was in dire need of money. She

had sold the family house in Grafton and moved to Rye, New York, to be nearer her sister Rose. She needed to be hospitalized for a hysterectomy. Philip O'Hara suggested a family pledge of a yearly sum of money to keep her afloat. Philip had been opposed when O'Hara tried to involve his mother in therapy for her alcoholism a decade before. "He didn't want my mother to go to a psychiatrist," says Maureen O'Hara. "He would beg Frank to not try to do this." Now, O'Hara agreed to contribute some money but not without reminding his brother, "You may recall that when I did have an opportunity to try to rectify some of her obvious maladies, you made it impossible for me, not out of sensitivity, but out of a sense of social disgrace, and that the situation has not really taken such a great upswing or you wouldn't have had to write your letter. So who, finally, was right? Don't mistake me, I'm terribly sorry I was not wrong. But also get this straight: I have about as much interest and compassion for her, as she had for Maureen when I had to force her to let me get her out of that house and into a boarding school. . . . Your sentimental indulgence of your overdue feelings may make you feel fine but they make me feel furious."

O'Hara did not hesitate to use the same tone with his mother when she called on April 20. As he wrote to Rivers, from whom he had just borrowed money:

You are much nicer to me than I am to my mother who called me up yesterday for some money and to whom I gave a long pent-up character analysis free for her pains. She has always done that whenever I earned any money ahead or got a grant or something and now she is getting so fucking clairvoyant in her old age that she can even sense when I borrow some! I want you to know that I kept everything clear and understandable; ignoring the deeper meanings of her actions over the past 15 years I simply told her in straightforward English, no psycho jargon, that she was mean bitchy selfish stupid hysterical self-pitying ungrateful ignorant etc. Of course I did have to send her a little, but she really got a message that would have cost anyone else at least a year at $30 the session. And I was very professional about it: no advice, just the straight dope.

O'Hara tended to talk about his brother in much the same tone with his friends. While he still doted on his little sister, all tender feelings for the rest of his family had been largely scourged. O'Hara had drinks or dinner with his brother when he came to town, but only grudgingly. Philip had moved to Chicago, where he kept all the furniture and stored books from the closed house in Grafton. Although O'Hara had made

no effort to rescue his own books, he would often complain when scanning his bookshelves for a particular volume, "Oh shit, it's in one of those boxes in storage in Chicago—which my brother has probably thrown out!"

O'Hara resented Philip's "sentimentality" in the case of their mother, and his attitude toward his brother was mostly that of the irritated last lines of "Dear Jap": "(just an apprehensive thought before I go to sleep) / my brother has been bothering me a lot lately."

In May 1963, O'Hara moved to the last of his four apartments in New York—a floor-through loft on the third floor of a building at 791 Broadway near Tenth Street, across the street from Grace Church. (Unlike the less elegant St. Bridget's on Avenue B, this 1846 Gothic revival church, where both Tom Thumb and Edith Wharton had been married, never showed up in O'Hara's poetry.) At $150 a month the loft was upscale for O'Hara and LeSueur. "It was quite grand and kind of Uptown," says Patsy Southgate of the clean and roach-free space divided into two good-sized bedrooms at opposite ends of a large living room with two fireplaces and a shower. The only drawback was the necessary purchase of a stove and refrigerator, which O'Hara told Rivers was like "pricing the Kohinoor diamond (or is it emerald)?"

Most attractive were the spacious walls, perfect for hanging O'Hara's burgeoning art collection. A big painting by Mike Goldberg filled one entire wall. Alongside was Alex Katz's *Ada on the Beach*. A funny Larry Rivers multibulb sculpture rested like a lamp on the floor. On the coffee table were sculptures by the Italian Arnoldo Pomodoro and George Spaventa. One of Hartigan's *Oranges* gouaches remained over his bed. Also on the walls were a little drawing by de Kooning, the *Summer Couch* of 1943 that he disappointedly had to return to Fairfield Porter to help pay for Schuyler's psychiatric hospitalization, a large Helen Frankenthaler, a large Hartigan oil painting also from the *Oranges* series, small works by Cavallon, Riopelle, and Goldberg, an early *Bathers* by Rivers on cardboard, a small version of Elaine de Kooning's 1962 faceless portrait of O'Hara, and a tearsheet from Pollock's black-and-white show from the early fifties. A drawing by Dubuffet hung in the bathroom. Dubuffet had sent it in a battered mailing tube after reading in *Big Table* O'Hara's poem "Naphtha," about the French artist he had never met but whose 1959 show was then hanging at the Museum (the show's catalogue was the source for the line "with a likeness burst in the memory"):

> *Ah Jean Dubuffet*
> *when you think of him*
> *doing his military service in the Eiffel Tower*
> *as a meteorologist*
> *in 1922*
> *you know how wonderful the 20th Century*
> *can be*

Dubuffet had drawn the head of a man in India ink on stationery, around which was written, "Salut Frank O'Hara . . . de Paris . . . le jour de Noël 1960 . . . à vous . . . un bon jour . . . d'un ami . . . j'ai lu le poème . . . dans *Big Table* . . . bonne année . . . Jean Dubuffet." Upon receiving the gift O'Hara had reported to Vincent Warren, "Renée said I should write one about Picasso immediately."

The four-story building on lower Broadway with its endless flights of stairs quickly became a sort of dormitory, anticipating in a sophisticated fashion the communal life-style of the later sixties as well as the artists' conversion of industrial buildings in SoHo in the seventies. Elaine de Kooning had pioneered 791 Broadway when she took over a studio from Mercedes Matter on its second floor above an orthopedic appliances store. O'Hara's contact for moving in was Donald Droll, an art and antiques dealer, who had taken over de Kooning's vacant studio with his friend Roy Leaf, a painter working at City Center. When a sculptor on the top floor was evicted for using acetylene, O'Hara's old Harvard friend George Montgomery, and his lover, the dancer Dan Wagoner, moved in. Sandwiched between the two couples, O'Hara enjoyed even more traffic as his neighbors' informal visits meshed with those of the already ensconced young poets. "Some nights two or three people were staying over," says Frank Lima of O'Hara's new headquarters. "It was a big elegant crash pad."

His new loft gave O'Hara a chance to throw big parties—a natural impulse reined in until now only by the small scale of his apartments. He threw his first big cocktail party on August 21 in honor of John Ashbery who, following his reading at the Living Theatre at which Kenneth Koch introduced Ashbery, was given a sort of triumphal-return treatment by the young poets who knew his work but had never had the opportunity to meet him. O'Hara, of course, had been trumpeting his poems stridently. The only poet to consistently devote large portions of his own readings to his friends' poems, O'Hara had read Ashbery's "Idaho" at Yale, "The Ascetic Sensualists" in Toronto, and

"The Lozenges" in New York—all from *The Tennis Court Oath*. O'Hara's readings helped the distant Ashbery become a bit of a cult figure. "Because Ashbery lived in France he was mysterious," says Ron Padgett. "Nobody ever saw him. Ted Berrigan and I had endless discussions about how *The Tennis Court Oath* was secretly derived from *The Golden Bough* of Sir James Frazier and from seasonal rituals. We had all these theories, which were completely punctured as soon as we saw John read and met him. That was not how the guy operated at all."

No one was more surprised by their curiosity than Ashbery himself. "When I came back to New York for the first time in five years Frank gave a party for me," says Ashbery. "At this party all sorts of young poets that Frank had gotten to know, like Tony Towle and Jim Brodey, came up to me and acted as if I was some kind of celebrity. I was completely dumbfounded. No word of this had trickled over to France. At least nothing I had given any credence to." At the time Ashbery's work was barely being reviewed. Typical of the few reviews was a pan of *The Tennis Court Oath* from his old Harvard classmate John Simon in *Hudson Review*: "Mr. Ashbery has perfected his verse to the point where it never deviates into—nothing so square as sense!—sensibility, sensuality, or sentences." As the critic Richard Kostelanetz has written of the period, "His American eminence grew in his absence (and perhaps because of it), as Ashbery's work became a controversial issue—a litmus test that seemed to separate advanced tastes from retrograde."

Often a guest in O'Hara's loft, Ashbery gradually became aware of the aura of unhappiness about him that was largely hidden by the constant frenzy and verbal confetti of the cocktail parties. He noticed signs of heavy drinking. "I remember having breakfast with him," says Ashbery. "He was getting up late to go to his job at the Museum and poured himself some vodka and grapefruit juice. He had a couple of those before going off to work. I thought, 'I don't remember that he drank during the day like this.' He seemed kind of sad also." But those moments remained anomalous. For Ashbery, O'Hara mostly continued to exude the gentleness and constructive purposefulness that had always constituted the light and air of their friendship.

At work that fall O'Hara was plunged into putting together a retrospective for Europe of the paintings of his old friend Franz Kline. Having paid his dues by assembling traveling exhibitions of artists such as Magritte and Tanguy, about whom his feelings were positive but lukewarm, O'Hara was more mentally and emotionally absorbed in the Kline exhibition. He was entering into the last phase of his work at the

Museum, in which he would mount rather rhapsodic, curatorially draining homages to artists whom he considered to be modern American masters—the drawing exhibitions of Arshile Gorky and David Smith and the full retrospectives of Kline, Motherwell, Nakian, and Smith. As Rasmussen wrote of O'Hara's selection of Kline, who had died suddenly of a heart condition the year before, "I saw how difficult it was for Frank to cope with selecting the work of an artist to whom he had felt so close and whose loss he still grieved." Yet O'Hara's exhibitions had been shadowed by death ever since his first Pollock show a year after the artist died and would continue to be so. Nevertheless, he was particularly set on championing the work of Kline, to whom he had given the treatment of a Pollock or a Pasternak in his introduction to an informal interview—included in the exhibition's catalogue—done over three visits at Kline's University Place apartment in 1958, "Franz Kline Talking": "These personages which are at the same time noble structures ('Cardinal,' 'Elizabeth,' 'Siegfried'), these structures which are at once tragic personages ('Wanamaker Block,' 'Bridge,' 'C&O'), seem both to express and to live by virtue of the American dream of power, that power which shuns domination and subjection and exists purely to inspire love." O'Hara felt that Kline had been undervalued at the Museum, and he always enjoyed righting a perceived wrong.

On September 15 O'Hara traveled to Amsterdam to prepare for the opening of the Kline exhibition at the Stedelijk Museum five days later. He needed to arrive early in part to supervise the reframing of four Klines lent by a collector in Milan. As the entire show consisted of sixty-seven oil paintings, gouaches, and collages, which would then be traveling over the next year to Turin, Brussels, Basel, Vienna, London, and Paris, O'Hara immediately found himself deep in paperwork as he shuttled between warehouse and museum. Over the next ten weeks he visited Amsterdam, Turin, Antwerp, Paris, Milan, Rome, Copenhagen, Stockholm, Vienna, Zagreb, Belgrade, and Prague. He made last-minute preparations for the Kline show, discussed possible future exhibitions with Eastern European museum staffs, and visited artists' studios. In his passport O'Hara had entered his occupation for his own amusement as "Exhibition Specialist."

The night before O'Hara left on his trip, Southgate went over to his loft to help him pack. Like Ashbery, in the quiet of his somewhat vast new apartment she felt the presence of an encroaching sadness usually kept hidden by O'Hara. "The one time I got some sense of Frank being in some kind of pain or uncertainty was the time he was packing to go to Europe and Czechoslovakia," says Southgate. "There was

something very tragic about him. He was all alone in this huge apart-
ment with this tiny suitcase, sort of not knowing what to bring, not
wanting to leave. His loneliness suddenly came across very strongly. He
was packing these formal clothes. In formal circumstances he always
dressed very well. But when he was in a tuxedo he had a fake smile
that broke my heart. It indicated to me that he was extremely strained.
Here he was going to a place where there would be all strangers in
formal situations. It didn't come easily to him. I realized how really
alone he was."

O'Hara soon filled in his datebook in Europe as fully as in New
York. At first, though, most of these were business appointments. His
way of fighting loneliness was to fall back on Vincent Warren, to whom
he wrote a letter three days after his arrival. "I certainly wish you were
with me since I have a feeling it is all more remarkable than I am seeing
it, marvelous though that is," he wrote, as he had on his other trips,
on an Olivetti borrowed from the Museum. "I thought of you partic-
ularly this afternoon in the Rijksmuseum when I was thinking of send-
ing Donald a postcard saying 'I think I have underrated majolica' and
realized that you probably never did." More generally he claimed to find
the city "very beautiful, the canals marvelous and filthy and calm, and
there are people everywhere but it doesn't seem crowded—probably be-
cause most of them are on bicycles."

Soon, however, his social life picked up. He didn't write to Warren
again. Harry Matthews arrived from Paris and they attended an open-
ing of *Die Walküre* at the opera. But the lifesaver of his trip was Jan
Cremer—a twenty-four-year-old Dutch writer and artist who had re-
cently published a beat novel titled *I Jan Cremer.* Cremer met O'Hara to
interview him for a Dutch paper and mentioned in the unsigned arti-
cle—to O'Hara's delight and the irritation of many others—that he had
been complimented in the dedication to "Second Avenue" as "the terror
of Holland." Of Cremer, whose photograph he was eager to pass
around on his return, O'Hara wrote to LeSueur, "He's married and is
about to have a second child (at 24!) so it's not what you think exactly,
I mean not like Oscar, though in a way more—well, no sense going
into that, it requires too much theosophising." That Cremer filled a
necessary slot in O'Hara's life—whether traveling or stationary—was
obvious from O'Hara's comparing him in the same letter to Berkson
(now living in Paris): "Bill never arrived in Amsterdam because of get-
ting an apartment which was just as well because Jan and he would have
hated each other and I was wondering which way my temperament
would force me involuntarily to swing if he did. (Just a plaything of the

gods, and all that.)" The playthings, of course, were just as much the young men, who tended to be leery of each other while vying for O'Hara's "puffing-up" sort of attention. O'Hara and Cremer spent time sampling fish markets along the wharves. On O'Hara's final day, the canals looking "lovely and dappled," Cremer came to see him off in the rain.

Like Berkson, Cremer gave O'Hara an impetus to write. It was a way to keep things stirred up in a romantic friendship with no sex. O'Hara suggested that he would send him poems, which he could set with drawings. While the book never materialized, O'Hara was interested enough to write ten new poems during one week while on sick leave from the Museum, which he mailed to Cremer in May: "At the Bottom of the Dump There's Some Sort of Bugle," "Chicago," "Enemy Planes Approaching," "Here in New York We Are Having a Lot of Trouble with the World's Fair," "I Love the Way It Goes," "Should We Legalize Abortion?" "The Bird Cage Theatre," "The Green Hornet," "The Jade Madonna," and "The Shoe Shine Boy." Neither lyrical and personal like the Vincent Warren poems, nor filled with in-group chatter like the Berkson poems, the poems to Cremer are predominantly Pop, although O'Hara would never admit the term. "We can call them poems by me drawings by you," he suggested in the letter to Cremer. "I also thought of a couple of other titles, such as 'The End of the Far West' or 'The New York Amsterdam Set' ('set' as in jazz set). What do you think? As you will see, for some reason a lot of the poems refer to cowboys, Western outlaw heroes (Wyatt Earp), etc." The poems were filled with cowboys because O'Hara, now owning a small black-and-white television set, was writing these days while watching his favorite TV shows. "We were watching a western on T.V.," Joe Brainard has remembered of the composition of one of the Cremer poems, "and he got up as tho to answer the telephone or to get a drink but instead he went over to the typewriter, leaned over it a bit, and typed for four or five minutes standing up. Then he pulled the piece of paper out of the typewriter and handed it to me to read. Then he lay back down to watch more T.V. I don't remember the poem except that it had some cowboy dialect in it."

O'Hara behaved with Cremer as he did with Berkson. He seemed to enjoy being a human mirror for narcissistic young men. It was a tendency at once saintly, erotic, manipulative, distant, and lightly masochistic. He liked coddling difficult personalities. Jack Larson, a friend of O'Hara's who had played Jimmy Olsen on the television program "Superman," recalls one evening in particular with O'Hara and Berk-

son: "Jim Bridges and I," he says, referring to the TV, stage, and film actor and writer who later became a director, "were living at that time at Montgomery Clift's on East Sixty-first Street. Bill Berkson had an apartment in the East Fifties, so Jim and I met him and Frank there for dinner. They wanted to go to a Chinese restaurant in the East Seventies. We started to walk and we were on Seventieth Street or something when Bill suddenly said, 'I forgot my cigarette lighter.' It was a fancy jade green lighter he liked. Frank said, 'You can't live without it.' He insisted we walk all the way back to Bill's to get it. He was indulging him like a spoiled child. Frank was being ironic, a bit sardonic and loving at the same time." When Cremer arrived in New York on a visit in 1965, O'Hara was similarly tolerant and bemused. He encouraged him to flash. At a Museum of Modern Art opening Cremer showed up in a skintight fire engine red outfit with the exotically beautiful Venezuelan sculptor Marisol on the back of his Harley. "Frank thought it was a riot," says Jim Brodey of the highjinks of Cremer, who made a big splash with Pop society that trip and began going around with Nico of the Velvet Underground. (At the same opening Brodey claims that O'Hara introduced him to Nelson Rockefeller to whom Brodey spoke in thick street slang, to O'Hara's extreme discomfort.)

On September 30 O'Hara had left Cremer in Amsterdam to travel to Copenhagen, which he found "pleasant and rather average" until calling upon the self-reliant initiative he had exercised so often in the Navy. He discovered a listing in *This Week in Copenhagen* for a chamber music concert by Isaac Stern, Eugene Istomin, and Leonard Rose, playing Brahms, Ravel, and Schubert at the Odd Fellows Pelaeat. "They played it sublimely!" as he wrote afterward to LeSueur of the Ravel. "It made chills course up and down my back, it is so musical (virile, not impressionistic) and profound (which most people avoid in Ravel). . . . There was a big ovation after the Ravel, and after the Schubert (end of concert) there was a 20 minutes standing ovation with clapping rhythm and stamping in unison. It made me like the whole country." While Paris and Rome were now much like New York for O'Hara—in Paris he went everywhere with Bill Berkson or John Ashbery, in Rome, with Bill Weaver—Eastern Europe fascinated him by its oddness. He loved Zagreb, where he arrived on November 15. "I admit that it's rather like loving Pittsburgh, but I did," he wrote to LeSueur. In Belgrade, where he arrived on November 18, he was inevitably haunted by Kafkaesque perceptions. "In the daytime it's very nice and pleasant and even rather pretty in a wrongheaded sort of way (the parks don't fit right somehow, and the squares appear to be in the wrong places, and there is all of a

sudden a hill or an abutment where there shouldn't be—as if the building of the city had stubbornly resisted taking cognizance of the site), but as soon as dusk falls, about 5:30 it is really quite dark, these peculiar ghostly iridescent lightings come on here and there making very bright places and leaving very dark ominous ones, and a dry smoky mist appears, like in the back of a pool hall."

O'Hara was in Vienna when he heard the news of President Kennedy's assassination on November 22. He had not been as affected by any international news event since hearing of President Roosevelt's death while stationed in the South Pacific. "I intended to write you last night, but was completely plotzed by a waiter telling me about our president and simply couldn't think," he wrote to Donald Allen. "I still don't know much about it as my German is so spotty and the French papers which would have the news haven't arrived yet. I hope to get them at the station tomorrow morning before I leave as they don't have any foreign papers in Czechoslovakia I am told. I think it's an event, apart from the personal aspects, of the direst significance for 'our country' and creates a complete political abyss, as well as re-establishing the old cultural one, that is too appalling to go into." Before departing for his last stop, Prague, on November 24, he wrote a letter of condolence to Mrs. Kennedy.

On the whole, however, O'Hara's trip had turned out to be a happier affair than he had anticipated while packing with Southgate in his underfurnished loft. These trips abroad for the Museum were among the most enriching in his life. But he was always eager to return home. As he wrote to Don Allen before flying to New York on November 28, "I'm tired of it all and feel like Horace McCoy just finishing a novel, except that I've never finished one, which is even more depressing. In a way, I like traveling because it's a way of being alone for a while, but I don't like it for too long and am dying to get back to me flat."

After a crammed holiday season marked by endless swinging between hangovers and flu, O'Hara confessed in a letter to Ashbery on January 21, "I have been very interested (and unfortunately equally interested) in about five people, and don't know whether I'm coming or going, not that it isn't fun trying to find out. But Joe is getting rather tired of not knowing who he's going to be having coffee with in the morning."

Indeed O'Hara's love life was becoming more and more splintered and less and less satisfying. The only common denominators among his boyfriends were youth and an interest in poetry. LeSueur's agitation,

though, was due in part to sensing O'Hara's interest in his own boy-friend at the time—J. J. Mitchell. "He was nuts about J. J. from the beginning when I first came around with him," says LeSueur. Dubbed "the Siren of Second Avenue" by the painter Wynn Chamberlain, John Joseph Mitchell was the son of a Navy admiral, a sandy-haired twenty-six-year-old Harvard graduate who was working as a fact-checker at Grolier. Smart, lively, good-looking, and seemingly steeped in sexual mystique, Mitchell was relatively new to New York, having served time in the Navy following college and a short stint on the *Washington Post*. According to Virgil Thomson, "J. J. was pretty busy sleeping with everybody. He was real genuine promiscuous. A nice fellow. I liked him very much." Like O'Hara, Mitchell loved to drink. While Mitchell and LeSueur were carrying on their affair, he and O'Hara were fast becom-ing drinking buddies. "I think with Joe and J. J. it was just two pretty blondes getting together," says Paul Schmidt, a friend of Mitchell's from Harvard, who had acted in George Montgomery's *Orpheus* the year O'Hara was at the Poets Theatre. "But with J. J. and Frank there was that blood bond. They were like two Irish drunks. When they got to-gether they talked and laughed and carried on." The dynamic in January still involved jealousies and intermittent squabbles, reported by O'Hara in a letter to Rivers, "I ended up in the 5 Spot with JJ drinking stingers. The next morning Joe was so jealous that he made up their current fight, so all ends well that drinks well."

O'Hara had his own late-night assignations with several friends whom LeSueur claimed to be able to identify the next morning by their clothes piled outside the door of O'Hara's bedroom in the front of the loft. A regular visitor was Jim Brodey, the blond poet from O'Hara's New School class. "When I first met Jimmy he was rather hard to take," says Frank Lima. "He was arrogant and difficult. But Frank acted as a buffer and liaison. He felt that Jimmy was very talented." Crossed out of "[Dear Jap,]" was the line "today I read a beautiful poem out loud by James Brodey." Brodey wisely waited to go to bed with O'Hara until after his twenty-first birthday, as his parents, who lived on lower Fifth Avenue, had warned him that O'Hara was "a woman in a man's body" and he didn't want to risk their taking legal action. He finally went on a date with O'Hara to a concert of John Cage and Morton Feldman at Lincoln Center followed by a party at which Brodey met Aaron Copland. "We went back to Frank's place and one thing led to another and we ended up in bed which was fabulous," recalls Brodey. "There was a sense of a chameleon about Frank because he could become whatever you wanted him to become but still stay in

control of the situation. I always felt that he wanted me to take the dominant role in our sexual thing but I also felt that he was manipulating me. That was fine with me because I wasn't sure what I was supposed to do." As much as sex, O'Hara enjoyed the ritual of simply lying in bed talking. One night while they watched a Marlene Dietrich movie on TV he entertained Brodey by getting up from bed and pantomiming Dietrich—an old charade of his from college.

O'Hara kept his sexual activities carefully compartmentalized. Most of his liaisons took place outside the party scene. "One time he called me when he got home at about 2:30 after a party at the Whitney," says Brodey. "So I went over there and rang the bell. There was no answer. The lights were all on. I went across the street and yelled up but there was no answer. It was very cold. I was very disappointed. I went home. The next day he called me up from work. He said, 'I've got a hangover.' He generally never said that. He said, 'I got really plotzed last night. Did we talk? I passed out.' He had woken up in the morning fully clothed on the sofa."

O'Hara warned Brodey to be discreet about the late-night side of their friendship. "For about six or seven months he insisted we didn't kiss or hold hands or have any physical show of affection," says Brodey. "He said, 'You're going to find out that my being this friendly with you is going to be a problem for you. You aren't going to want them to know.' He was talking about Tony Towle, Frank Lima, and Ted Berrigan. Their assumption was that I was heterosexual and I was their friend. Their sexuality would be endangered somehow if they knew. He also said that it would hurt Kynaston. He named Kynaston several times." Kynaston McShine was a Trinidad-born curator who had been hired by Porter McCray in the International Program and who worked with O'Hara. "I once called out 'Frank, Jim, are you ready for coffee?'" says LeSueur. "Kynaston McShine sort of stuck his head out the door and said, 'Bitch!' I said, 'Oh Kynaston, I didn't know it was you. I thought it was Jim Brodey.' Frank said, 'Would you shut up?' Because he was having these things going on at the same time."

A young writer brought into O'Hara's orbit by J. J. Mitchell was Stephen Holden, who had graduated as Yale's class poet in 1963 and was working as a fact-checker with Mitchell at Grolier's. (Holden went on to become a culture critic for the *New York Times*.) Holden met O'Hara when he was recruited as a fourth in a game of bridge. "It was more of a party," says Holden. "It wasn't a serious bridge tournament." (As Joe Brainard wrote, "I remember that playing bridge with Frank was mostly talk.") O'Hara and Holden then kept up a sporadic friend-

ship for a few years. "He called me up once at three o'clock in the morning when I was living on East Seventy-fourth Street," recalls Holden. "He was obviously extremely drunk and woke me up and started railing about Bob Dylan, about how much he hated his music, how horrible he was. He was trying to pick a fight. At the same time there was something sexual about it. He wanted me to come over and have a sexual thing go on too. The provocation wasn't entirely angry." Allen Ginsberg claims that he was thinking of Holden in his lines addressed to O'Hara in "City Midnight Junk Strains":

> *Darling date*
> *for the charming solitary young poet with a big cock*
> *who could fuck you all night long*
> *till you never came,*
> *trying your torture on his obliging fond body*
> *eager to satisfy god's whim that made you*
> *Innocent as you are.*
> *I tried your boys and found them ready*
> *sweet and amiable*
> *collected gentlemen*
> *with large sofa apartments*
> *lonesome to please for pure language;*

Holden was present the night O'Hara heard about the murder of the American composer Marc Blitzstein in Martinique in January 1963. As always in the case of a young or accidental death, O'Hara's mourning was intense, carrying some of the self-pitying overtones of having been abandoned or left. Although he had not known Blitzstein well, O'Hara became increasingly maudlin as his personal wake wore on. "When Marc Blitzstein died he stayed up wailing, crying, and weeping with Joe LeSueur until the wee small hours of the night, just going on and on and on about death," remembers Holden. "It deeply upset him. It was this amazing, horrible, lurking thing that just got to him if anyone he knew or respected died. He never got over the deaths of certain people. I didn't understand it myself. But then Frank was frantic. There were many times when he seemed not to want to go to bed at all. He drove himself, he drank heavily, and late at night he became more emotional, much more emotional than during the day."

O'Hara had the capacity to become blind drunk at night and still lead a high-pressure life as a curator and social animator successfully. "For a creative, ambitious alcoholic he was a perfect role model," says Paul Schmidt. "He made it look possible. You looked at Frank and you said, 'Aha, you can have your cake and eat it too.'" Along the way, though, he had to give up certain activities. He was conflicted about not writing poems. He was less conflicted about giving up writing art reviews for *Kulchur*. When LeSueur had written to him in Rome telling him of Lita Hornick's annoyance that he had not yet sent in his next "Art Chronicle," O'Hara wrote back to him, "Obviously if I come back at the end of November I can hardly have anything ready for the 1st of December. (When have I ever?)" On February 17 he simply wrote a letter of resignation to Hornick, its sarcastic angry tone becoming more frequently a characteristic response if he felt his back up against a wall: "It's quite obvious, to me at least, that despite your study of Zukovsky you don't have too much patience, let alone understanding, of how difficult it is to write anything you mean, which is to say what you want to see in print (as apart from party conversation), or that it takes a certain number of hours to think and some more to write (as apart from the hours you work), so I for my part think that your arbitrary deadlines had better be met by someone else."

With his poetry writing on the wane, his creativity was mostly being expressed in art that was collaborative or involved with actual events—play productions, poetry readings, parties. On March 23, *The General Returns from One Place to Another* was produced by Present Stages at Writers Stage Theatre on East Fourth Street, on a double bill with LeRoi Jones's *Baptism*. A satire on the return of a General MacArthur type to the scene of his battles during World War II in the South Pacific, *General*, which ran only four performances over two weekends, starred Taylor Mead, who went on to become an Andy Warhol "superstar" in *Lonesome Cowboys*. Robert Hatch in *The Nation* favorably reviewed Jones's companion play *Baptism*—in which Mead played a homosexual Satan—while dismissing *General* as a "series of loosely integrated skits." But then Jones was suddenly a hot property because of the success at the Cherry Lane Theatre in January of *Dutchman*—a bold political allegory about a bourgeois white woman sexually teasing and then murdering a black man on the subway. (After a preview of *Dutchman*, O'Hara, Brodey, Towle, and Norman Bluhm had stopped by the Cedar, where Brodey recalls Bluhm's remarking somewhat unconvincingly, "You know the great thing about that play is it doesn't have to do with LeRoi's white friends.") That summer, as Harlem and Brook-

lyn erupted into race riots in which 141 people were injured, Jones's play was seen as prophetic, and he was rapidly seized on as a public spokesman for blacks.

"We had a chance to move the plays to a really good off-Broadway theatre," complains Taylor Mead. "Both LeRoi and Frank had to sign up at this new theatre. But LeRoi would never sign up. He had written *Dutchman* at the time, and *Dutchman* was black against white. I think his agent was pushing him to keep to the black against white stuff. *Baptism* was integrated. I said to Frank, 'LeRoi is just lying to us.' Frank said, 'What can I do?' He was too cool. He went on that plane of people working in museums." In spite of Mead's bitterness, O'Hara loved the actor's campy delivery of such broad lines as the General's order to his aides, upon arriving in Manila, to have "every square inch of marble in this palace shining like snow in the Arctic." So he amended his dedication of the play "to Vincent Warren and to Warner Brothers and Taylor Mead."

O'Hara had a certain laissez-faire attitude toward the production of his own plays. This flexibility was perhaps more appreciated by directors than actors. When *Love's Labour's Lost* had been presented the month before as a production of the New York Poets Theatre at the New Bowery Theatre on St. Mark's Place, Diane di Prima had been exhilarated by the carte blanche she felt given her by O'Hara. (The New York Poets Theatre had been founded in 1961 by di Prima, LeRoi Jones, Allen Marlowe, Freddy Herko, and James Waring, its location constantly shifting like that of small art theatres in Paris.) In the first production of this nonsensical pastoral eclogue for a cast of versifying shepherds and goddesses at the Living Theatre in December 1959, Vincent Warren had played Cub Reporter, Freddy Herko Paris, and the Merce Cunningham dancer Valda Setterfield, Venus. The set was by Norman Bluhm. Di Prima's production in 1964 was more outrageous. Minerva played a brand-new folk song on guitar. A drag queen named Francis Francine vamped as Venus. "He was so dumb that the only way he could ever remember his lines was if they were all written on his fan," says di Prima. "He'd have to look down at his fan for each line and then look up and announce it." The actor who played a shepherd in a tiger-skin loincloth went on to become a member of the first drag ballet troupe, Trocadero. "Even people like Jimmy Waring and the whole gang around him who worked all the time in off-Broadway theatre held their heads," says di Prima. "But Frank loved it. He wasn't one of those people in the theatre sitting on the edge of their seat worrying, 'Oh my God, are they going to change a line in my play?'" Even

O'Hara, though, had his limits. When the director of a planned third
production of *Try! Try!* in February 1962, at the Maidman Theatre on
Forty-second Street, was keen on adding a few topical crowd-pleasers,
O'Hara balked. "I have to talk the director out of opening it with
the lover taking a few moments before his first lines *TWISTING* for the
love of god!!! when everybody in the world is sick of hearing about
the fucking thing!" he had written to Vincent Warren. "I mean it's fun
to do but not to watch." (The play was to have been on the bill of "4 ×
4" with three other plays by Elaine May, Kenneth Koch, and Arnold
Weinstein, but when Elaine May complained that O'Hara's contribu-
tion—which O'Hara had already read at a preview with the actress
Gaby Rodgers—was lessening their chances at the box office he with-
drew and the consequent flop was retitled "3 × 3.")

Plays were a dominant art form in the sixties. Collaboration was
not just a personal penchant of O'Hara's. It fit in with the desire of the
age of Happenings for making connections between different media.
O'Hara also happened to have more friendships with different kinds of
artists than anyone else. "What interested me first about Frank," says
Edward Albee, the proceeds of whose *Who's Afraid of Virginia Woolf?*
had helped pay for the first showcase of *Dutchman,* "was that he rep-
resented as much as anybody the involvement in more than one of the
arts." But then everyone seemed to be trying to blur lines of distinction
between playwriting and painting, art and life. Kennneth Koch's con-
tribution to "3 × 3" had been "George Washington Crossing the Del-
aware" (inspired first by Larry Rivers's painting) with sets by Alex
Katz—cutouts of three British soldiers, a cherry tree, a British flag
caught by the wind in three folded sections, and a big white horse. (The
cutouts were then sold by Martha Jackson at a show in June 1962.) Larry
Rivers designed the urinals for LeRoi Jones's *The Toilet,* set in a high-
school latrine where a group of black youths beats up a white homo-
sexual boy for sending a love letter to their gang leader. "Larry designed
wooden urinals," says Baraka. "That was funny to us because it looked
like a real urinal. It was actually a piece of sculpture. It was early Pop
Art." (*The Toilet* was first printed in *Kulchur* 9.) Happenings blurred
the lines between canvas and stage even more completely. In Allen Kap-
row's *The Apple Shrine,* the audience threaded its way through a maze
of tar paper and chicken wire to a tranquil space where apples were
suspended from the ceiling along with signs reading "Apples apples
apples etc" and then wound their way out of the gallery. Other key
Happenings of the early sixties were Jim Dine's *Car Crash* (with Dine
drawing a car crash on a blackboard in an old shop with shelves of

remnants), Allan Kaprow's *Spring Happening* (in which a rotary lawn mower raced down at the audience as the side walls fell with a crash), and Robert Whitman's *The American Moon* (the finale of which featured Whitman's swinging over the heads of his audience squashed into a narrow space by a plastic bubble being progressively blown up).

If Happenings were three-dimensional action paintings, then parties were simply more spontaneous Happenings. Favored cultural leaders Downtown in the sixties tended to be those with enough friends—and living space—to throw good parties. O'Hara after 1963 was one of them. He succeeded in reproducing the achingly arty Grafton parties of his youth on the more critically demanding stage of Downtown New York. On March 15, 1963, he threw a party celebrating Edwin Denby's sixtieth birthday for which the invitation was his 1955 acrostic poem "Edwin's Hand," beginning

> *Easy to love, but*
> *difficult to please, he*
> *walks densely as a child*
> *in the midst of spectacular*
> *needs to understand.*

Frank Lima cooked vats of beef bourguignonne for the event. Virgil Thomson read a cabled poem from the English ballet critic Dickie Buckle, which, according to O'Hara, "featured Edwin as some sort of Fantomas figure who came out only at night and cruised 8th Street making poets leave their typewriters and dancers leave their school." Red Grooms entertained with a puppet show after dinner. Among those contributing $100 for tickets to the party to be used as a purse for Denby were Willem de Kooning and Lincoln Kirstein.

On May 2, 1964, O'Hara hosted a cocktail party downstairs at Donald Droll's apartment—being sublet at the time by Italian artist Mario Schifano and Anita Pallenberg—for the visiting white-haired Italian poet Guiseppe Ungaretti. "That was the first time I met Ungaretti, with whom I later had a lot of relations," says Allen Ginsberg. Present at the party was Ed Sanders, who wished to raise money for his fresh *Fuck You: A Magazine of the Arts* by gathering pubic hairs from the poets to be sold as Pop relics. Ginsberg and O'Hara gladly contributed. When they asked Ungaretti, he beamingly plucked a hair, exclaiming, "C'est blanche. C'est blanche. It's white." The collection of pubic hairs labeled in glassine envelopes was later offered for sale to literary

collectors through Sanders's Peace Eye Bookstore. Toward the end of the party, sitting at a flat wooden table pushed into the main room in front of windows through which a May breeze was blowing, various poets read from their work, including Schuyler, Koch, Ginsberg, Jones, and finally, in thunderous Italian, Ungaretti. O'Hara read a poem he had just written, "Enemy Planes Approaching," dedicated to Terry Southern, who published his best-selling *Candy* that year:

> *Terry Southern*
> *is my favorite writer*
> *always going down on*
> *the Twentieth Century like Jonathan Swift gas.*

"I was shocked when he read it," says David Shapiro who was present that evening along with a score of young poets. "I thought it was very brittle, empty, and a little more Pop-Artish than usual."

On the evening of September 7, 1964, O'Hara held a small party to watch the arrival of the Beatles at Kennedy Airport where they were met by a screaming crowd of ten thousand. "I remember a whole bunch of people lying on the bed watching the TV," says Brodey. (Brodey saw *A Hard Day's Night* with O'Hara, who found the film "a riot.")

The New York party scene was just as divided and political as all the undertakings of the artworld. O'Hara, as usual, was unique in his gift for obliviously overstepping boundaries. "He had a big loft and gave parties and was social and we had a big house and gave parties and we were central too in that way," says Hettie Jones. But the crowd at the Joneses' apartment on West Twentieth Street between Ninth and Tenth avenues (a few doors down from which Kerouac had written much of *On the Road*) and later on East Fourteenth Street near First Avenue usually included jazz musicians such as Ornette Coleman, Don Cherry, and Cecil Taylor and black poets Langston Hughes and A. B. Spellmann. "Frank favored the cocktail party, which would start about six o'clock," says Baraka. "The parties I gave were more on the nature of big bashes. Whoever came, came. Let's pile in and let's do it, do it to death. At his parties there would be a lot of painters and a lot of people we would talk about as the 'Upper East Side types.' I knew and hung around with the Ginsberg crowd and the Olson Creeley Black Mountain crowd. Because of their principles they would pretend not to know people who lived above Forteenth Street." There was inevitable mixing, though, as long as O'Hara was involved—often to the strain of both camps. "I

remember Kenneth Koch walking out of Frank's place one night when LeRoi Jones had all these people together about to play blues," says David Shapiro. "Kenneth said something like, 'I'm not going to take this cliché.'"

Less troubled and fraught than either O'Hara's or Jones's cocktail parties were those thrown in the more well-to-do homes of his old friends from the fifties. Some of the best parties were at Joe Hazan and Jane Freilicher's house on Eleventh Street between Fifth and Sixth avenues or around the block at Kenward Elmslie's. There was talk in groups of two, three, or five; dancing to jazz records; impromptu theatrics by Kenneth Koch who performed spontaneous blues parodies while backed up at the piano. O'Hara was usually guilty of padding the guest lists. "If you invited him over he would come with six or seven people and so you would have a houseful of people every time you wanted to see Frank," complains Freilicher. "It wasn't that fascinating after awhile. You didn't have a visit with Frank. You had Frank and his crew." But O'Hara liked to be the one putting the spin on the ball. Writing to Ashbery of Freilicher's 1963 New Year's Eve party he claimed that because of his recruits Tony Towle, Frank Lima, and Jim Brodey, "a new note of 'let's make out' was added which perked the rest of us up quite a bit and led to several sexual re-evaluations but no unpleasant confrontations that I know. Larry and I also 'entertained' at the piano with popular songs and everyone was too busy to bob for apples, though there seemed to be a lot of other bobbing going on, and the bathroom was very popular." O'Hara was inspired enough by such bashes to write "Bathroom" in June 1963 in Ruth Kligman's bathroom after a "stunning dinner party"—he sent the poem afterward to Jasper Johns for a possible lithograph. Another scene came together at Larry Rivers's parties in his house on West Fourth Street, where more jazz musicians and women were mixed in. According to Bill Berkson, "Larry's parties were more frantic, frontal, beat, but no less nuanced." Norman and Carey Bluhm and Mike and Patsy Goldberg had smaller places so they gave smaller parties. Morris Golde had "salon" events at his house a block west of Freilicher's on West Eleventh Street where he invited theatre and music people as well—Edward Albee, Richard Barr, Aaron Copland, Ned Rorem, Leonard Bernstein, Marc Blitzstein, Bill Flanagan. Summers in the Hamptons the party-givers were the Gruens, the Hazans, Larry Rivers, Wilfred Zogbaum, Marca Relli, and, one time, Willem de Kooning. A famous photograph of the group with O'Hara sitting cross-legged on the sand in their midst, taken at Julia Gruen's third birthday party in Water Mill in 1961, served as their Por-

trait of a Scene in the tradition of George Platt Lynes's photograph of André Breton's "circle" taken at Peggy Guggenheim's in 1943.

O'Hara had long ago mastered the art of the one-line remark—quick, cutting, and apt. One evening Kynaston McShine ended one of his turns with a kind of grand plié causing his trousers to rip all the way around to the back. Looking down at the rip O'Hara quipped, "That will interest no one but your tailor." At a party given by Gold and Fizdale O'Hara became irritated with a *New York Times* art critic, Stuart Preston, turning on his heel to announce within everyone's earshot, "Now, listen, Stuart, go bother someone else. There are 8,000,000 people in New York City, and I only like about ten, and you're not one of them." Unfairly, Arthur Gold then ushered Preston to the door, explaining, "Frank can do what he wants in my house and if somebody's bothering him they've got to go." "Frank would be stimulated by alcohol and he would say these things under the influence and they were usually negative," recalls Richard Howard. "They were hard to bear. You usually cowered because you didn't want to have these arrows directed at you. But you wanted to hear them because they were very funny and memorable and the next morning someone would say on the phone, 'Did you hear what he said last night?' He was good at one-liners on the moment."

"I remember going to a party at Ned Rorem's where he became the center of attention by becoming drunk and delivering a lecture on how horrible Monet was," says Stephen Holden. "He said that Monet was the most overrated artist in the world. That he was too Establishment. He went on and on and on. That was typical of Frank. Something hallowed in the middle-class art world was something to be torn down. But it was very vehement and very angry."

He carried on at favorite hangouts, each of which had a purpose. Sing Wu was the Chinese restaurant on Second Avenue everyone went to after art openings. John's on East Twelfth Street near First Avenue was a favorite for its good food and cheap prices. "Once Donald Droll and I were looking for a place to eat," says Alex Katz. "We walked in this restaurant and there were Frank, Joan Mitchell, Riopelle, and Patsy Southgate. We sat at the end of the table. I think Donald was just shivering hoping that Frank wouldn't direct anything at him. I didn't say anything for the whole meal. Frank called someone 'a bag of shit.' Joan said, 'Yes and tomorrow you'll call up and say 'Did I say anything bad?' It was like a Strindberg play. It was very theatrical. They all had great rhetorical styles. Frank, I think, was taken with Elizabethan rhetoric. I think that's a part of his poetry. He had that kind of Shakespearean

energy and flamboyance. He would have loved to get on stage and say these awful things to people and they'd say awful things back. It's as if Shakespeare went through a depressive Irish playwright like O'Neill and came out with this frothing English style. That's what Frank was like."

"At the time he was going out with Kynaston McShine I was having dinner at John's restaurant with my wife," says Frank Lima. "He came in there with Kynaston. I made some off-hand remark. Frank hit me in front of everybody. He called me the next morning to apologize. He had just had a tremendous argument with Kynaston. I happened to be there at the end of it. Frank was an incredible arguer. He was a very endearing man, but after a couple of drinks he could be difficult and unpleasant."

"I remember one night at dinner at John's Restaurant with Frank, Mike, my mother, Joe, and Joan Ward," says Patsy Southgate's son Luke Matthiessen, who was then twelve years old. "Joan Ward was de Kooning's mistress with whom they had a daughter. Well Frank lit into her in a very savage way. I don't even remember what it was about, but he tore her apart and everyone was kind of taken aback. He tore the skin off her bones at dinner."

During the spring of 1964, the incestuous fevered party of the artworld was forced to contend, if only in passing, with the more institutionalized global festival of the World's Fair. O'Hara reacted to the event with a mixture of bemusement and anger. His irritation was partly due to the public glorification of the art of the Pop artists rather than the Abstract Expressionists. As the architect of the New York Pavilion at the fair, Philip Johnson had commissioned murals for the outside wall of its concrete theatre almost exclusively from the New Realists contingent—Lichtenstein, Rosenquist, Indiana, Chamberlain, Rauschenberg, Warhol. Allan D'Arcangelo executed a Pop Art mural for the outside of the Transportation and Travel Building.

But O'Hara's true rancor was political. In preparation for its visitors—twenty-seven million finally attended, less than anticipated—there had been months of crackdowns, cleanups, and security measures anticipating political demonstrations. A campaign to control gay bars had already begun in January when the Fawn in Greenwich Village was closed by the police. Reacting to this closing by police department undercover agents, known as "actors," the *New York Times* on January 17 ran a front-page story headed "Growth of Overt Homosexuality in City Provokes Wide Concern," which addressed "the city's most sensitive open secret—the presence of what is probably the greatest homosexual population in the world and its increasing openness."

O'Hara was quick to report to Ashbery in Paris on the article—

debate about which was keeping dinner parties in Manhattan animated that winter: "You may be interested to know that the *New York Times* had a front page (and a full page continuation inside) story on how New York is the world center of homosexuality, with somewhere between 100,000 and 600,000 of *THEM* prowling the areaways of fair Gotham. Kind of exciting, isn't it? It also explains how they identify one another by a fraction of a second longer look than normal people give. I'll keep you informed. I think it was all triggered by the closing of The Fawn, a charming little dancing boite on Christopher Street near the Hudson River which the police used to like to visit even more than the fags (three times a night, and with blinders on) until obviously someone wouldn't pay them off anymore. Adieu, petit faune!"

By mid-April repressive measures were stepped up. O'Hara wrote irately to Rivers, who was in London as an informal artist-in-residence at the Slade School of Fine Arts:

In preparation for the Worlds Fair New York has been undergoing a horrible cleanup (I wonder what they think people are *really* coming to NYC for, anyway?). All the queer bars except one are already closed, four movie theatres have been closed (small ones) for showing unlicensed films like Jack Smith's *Flaming Creatures* and Genet's *Chant d'amour* (Jonas Mekas has been arrested twice, once for each). . . . Lots of committees are springing up to protest all this, everything from a lawyers committee, a free speech committee to protest the closing of coffee houses which have non-profit poetry readings (Allen and I read for this one), and one Diane has started to protest all this plus the new zoning laws which are driving artists out of their lofts. . . . The fair itself, or its preparations are too ridiculous and boring to go into, except for the amusing fact that [Robert] Moses flies over it in a *helicopter* every day to inspect progress. And CORE has promised to totally stop traffic the first day by lying down on the highway. I hope they do.

O'Hara expressed some of his annoyance in "Here in New York We Are Having a Lot of Trouble with the World's Fair":

> If every Negro in New York
> > cruised over the Fair
> in his fan-jet plane
> > and ran out of fuel
> > > the World

would really learn something about the affluent

society.

The poem's somewhat fantastic radical rhetoric was softened by "We are happy / here / facing the multiscreens of the IBM Pavilion." As critical as the issue of racism was the issue among art historians of transporting Michelangelo's fragile sculpture, *Pietà,* which arrived at the Vatican Pavilion on loan from St. Peter's in a special waterproof, floatable crate designed to free itself from a sinking ship. *Art News* published an editorial protesting the transport in February 1964. O'Hara, always slightly more amused than hysterical on most public issues, wrote in "Poem" (I to you and you to me the endless oceans of): "and when the cartoon / of a pietà / begins to resemble Ava Gardner / in Mexico / you know you're here."

O'Hara's appearance with Ginsberg that spring in a reading protesting the freedom of speech issue lurking behind trying to tax Le Metro for a cabaret license was typical of the political impetus of many of his public readings in the sixties. He was more naturally and temperamentally engaged than most of the other New York School poets. "Frank at least had a political sense," says Baraka. "Kenneth Koch and Kenward Elmslie and all those people were always highly antipolitical, which is why I couldn't get along with them longer than two minutes. Frank was not haughty about it. He had a real feeling for the human element in it." Politics was a hot vent for O'Hara's spleenish anger. "I remember on a street near Grace Church having a big argument with him about Vietnam because he was seeing it correctly and I wasn't," says Berkson of the issue that was heating up in 1964 with Lyndon Johnson's bombing of North Vietnam. "I was sort of buying the line that China was intruding as much in Vietnam as the United States. I said, 'You're just being a sentimental Communist.' We used to have terrific political arguments."

Most of the bandwagon readings in which O'Hara was involved were instigated by LeRoi Jones or Diane di Prima. The first of these occurred on June 23, 1961, as a benefit for *Floating Bear.* O'Hara, who never enjoyed reading, because he felt that his style was "terribly peculiar and really something odd," gave in because, as he wrote to Warren, "Diane is so sweet in that I-love-poetry-way that it's almost impossible to refuse her." Four months later, issues of *Floating Bear* were seized on grounds of obscenity for printing excerpts from William Burroughs's *Naked Lunch* and Jones's *The System of Dante's Hell.* "The postal cops came," says Baraka who was arrested. "At three in the morning there's

this guy standing over my head with a gun." Jones defended himself
successfully by reading Judge Woolsey's decision on *Ulysses* in court. On
June 24, 1963, O'Hara participated in a reading at the Living Theatre
to raise money for LeRoi and Hettie Jones who had both contracted
infectious hepatitis. On March 11, 1964, O'Hara agreed to go down to
Princeton to give a reading to benefit Lewis MacAdams's little maga-
zine *eggs,* to which he brought along Jones, Koch, Brainard, Towle, and
Berrigan, although only eight people showed up as an audience. In
April 1964, after reading with Jones at the Loeb Student Center at
N.Y.U., O'Hara wrote to Rivers, "We've been giving a lot of readings
together which is getting to be like the Bobsy Twins so we're stopping
out of exhaustion." O'Hara did have his limits. As he wrote to Ashbery
in November 1962, "Julian and Judith Beck organized a poetry reading
for peace at dawn on Armistice Day in Fort Clinton in the Battery, but
so far as I know nobody went but Kenward. As Kenneth put it: 'Judith
and Julian are like one's parents: they've done wonderful things but you
just can't help them.'"

O'Hara's support for Jones did not stop with readings. Jones's in-
volvement with the politics of race in America was thrilling to O'Hara.
As Kenneth Koch once remarked to David Shapiro, "Frank is a revo-
lutionary poet without a revolution." The issue of racism had been par-
ticularly powerful for him ever since his days in the Navy when he was
riled by segregation in the barracks and had composed his "Tribute to
Afro-Americans." He expressed his annoyance at anyone's trying to dis-
qualify him from participating in racial politics because of being white
in "Answer to Voznesensky & Evtushenko"—the recipients of his open
letter of a poem being two Russian poets he felt had drawn overly sim-
plistic political cartoons of the American race situation in their poetry:

> We are tired of your tiresome imitations of Mayakovsky
> we are tired
> of your dreary tourist ideas of our Negro selves
> our selves are in far worse condition than the obviousness
> of your color sense

In a tone that he described as "snotty," he went on in the poem: "you
shall not take my friends away from me / because they live in Harlem"
and "I consider myself to be black and you not even part." An amusing
ingredient in O'Hara's attraction to black causes and to "the strange
black cock which has become ours despite your envy" was his rooting

for the poet-boxer Cassius Clay (later Muhammad Ali). Clay had become famous before his match with Archie Moore in 1962 for his rhymed taunts: "I'll say it again, I've said it before / Archie Moore will fall in four." As O'Hara described Clay to Ashbery, he was "as beautiful as dawn over the Gaboon" and "a wonderful argument for integration, as if one had ever needed one." To Vincent Warren he heralded Clay as "the Alvin Ailey of the ring!"

Motivated by his usual mix of sexual attraction, politics, and friendship, O'Hara pushed hard for LeRoi Jones's work. When Philip Roth in the *Times* wrote a piece praising Edward Albee's *Zoo Story* at the expense of Jones's *Dutchman,* O'Hara fired off a letter: "*The Zoo Story* is a virtuoso rhetorical performance in the writing which reaches a ridiculous denouement and puts in question all that went before; *Dutchman* grows in power, concentration and meaning through every word and gesture." O'Hara's point of view in the letter to the editors was basically that of the comment made to him at a cocktail party during that time by Virgil Thomson, "Edward Albee killed Tennessee Williams dead as a doornail, and now LeRoi Jones has Edward on the run." (This reversal pleased O'Hara, who tended to tangle at parties with Albee, whom he found to be "a gloomy bossy number.") Sadly, though, O'Hara's political point in the letter was based on an old-fashioned leftist bent that would only leave him disappointed as Jones became more involved in an increasingly separatist and militant black power movement: "The action of Mr. Jones' play cannot be confined to the conflict between two races; it is a larger, and more final, vision of American life which relates as closely to thirty-eight mute witnesses to murder in New York City as it does to brutalities in Florida and Mississippi." (The reference was to the neighbors who watched Kitty Genovese being beaten to death in 1964 without phoning the police.) The radicalizing of the conflict toward black separatism had already been picked up on by Frank Lima and his girlfriend Sheila. As O'Hara, who never allowed his political sympathies to interfere too excessively with the rhythm of his life, reported the incident to Rivers in June 1963: "Frank Lima went by 125th St after watching the Palisades Park fireworks with his girl the other night and they stopped to hear a Black Muslim speech which ended up with the phrase 'The only good white man is a dead white man,' so they beat a hasty retreat downtown. There are supposed to be a lot of riots coming up over the 4th, but fortunately we will be in East Hampton with the Goldbergs."

"Frank introduced me to Lincoln Kirstein, Leonard Bernstein, and Lauren Bacall," says Baraka of O'Hara's efforts at the time on his be-

half. "Bernstein came up with this idea that he wanted to do music for *The Toilet*. He comes to my house in this limousine with Lauren Bacall and he's got his tuxedo and he's got his dinner jacket and shit on. I was feeling particularly grumpy. I said, 'What makes you think that I want you to do music for my play?' I told him I would get somebody elegant like Duke Ellington. I told him he didn't even dress as good as Duke Ellington. I drove him out of my house being real haughty. It was funny at the time. We all laughed."

The more O'Hara became "overinvested" in other people's lives and in the art and politics of an increasingly frenetic and confusing era of experimenting and building and destroying, the more his own life became the sum of other people's chaos. As one Museum employee who observed O'Hara fielding an enormous number of phone calls at work recalls: "He had millions of calls on the telephone every day for solace and comfort from his friends. There was something about him that made everyone call him for that. He made the anxious ones feel better. But it was a real problem and made it impossible for him to write. He had to do much of the writing of the catalogues at home. It was like a madhouse."

One twist of fate particularly devastating to O'Hara during the fall of 1964 was the admission of Mike Goldberg to the Psychiatric Institute at the Columbia-Presbyterian Medical Center in upper Manhattan—especially as his confinement was the result of a negotiated compromise to prevent incarceration for forgery. "Bill de Kooning stayed with Patsy and me for about a week," recalls Goldberg of the series of events that put him in jeopardy of criminal charges. "He was drunk and wanted to dry out. We were then in East Hampton. He gave me the keys to his place and said, 'Go there and take two drawings for yourself.' He told me where they were. So instead of taking two I took ten. I sold eight of them for next to nothing. I signed his name to them. It took about two months for it to come out that I had done this. . . . Everybody decided that I was crazy. Through a lot of luck and a lot of using people they got me into the Psychiatric Institute. I stayed there for eighteen months, which was a thrilling eighteen months as a matter of fact. I was given about twenty-two hours of therapy a week. Patsy and I eventually got divorced while I was in the hospital. I left Martha Jackson's gallery. I felt I'd best retreat from that world if I could."

"It finally all came out," says Southgate. "I managed to get de Kooning to agree not to prosecute, which wasn't easy because he had a very tough lawyer, Lee Eastman. He promised not to prosecute if I returned the paintings and Mike went to a psychiatric institute, which

I managed to get him into. I had to sell a Pollock and a Kline I owned to get them back. Mike was a psychopathic personality. They said their aim was to graft a conscience onto him. He didn't have a conscience. He didn't even get sweaty palms. And he was living at such high speed that they gave him tranquilizers to get him to slow down enough to experience the anxiety. They succeeded in making him into a fairly reputable person. But I could not be married to him after that."

O'Hara was oddly enough one of the last people to notice any shortcomings in Goldberg's character. Whether or not he had a blind spot in evaluating his friends' paintings, he certainly did not see faults he did not wish to see. O'Hara simply refused to allow anyone to criticize Goldberg until he was finally forced to face the evidence. "Frank couldn't see it," says Berkson. "And then he had to see it. And then he was shocked at himself that he wouldn't allow himself to see that this friend of his was actually doing something wrong, or was off base, or had lost touch with reality. I remember that as being a particular trauma for him. He was traumatized that he had refused to recognize what was going on." Friends recall seeing O'Hara tearing into Goldberg "like a buzzsaw" when the news broke. But when Goldberg was finally hospitalized, O'Hara rallied at least half-convincingly. They began a collaborative "travelogue" by mail of twelve poems and seven paintings titled "A Trip by Michael Goldberg or Signs & Portents; as told to Frank O'Hara (War stories suppressed) (evacuated) (expurgated edition)." Their friendship, though, had actually become as strained for O'Hara as Southgate's marriage for her.

Publicly there was little sense that O'Hara was feeling as generally agitated as he was. Or that he had stopped writing poetry. In fact, more and more of his poems were beginning to appear in print. That fall, *Audit,* a student literary magazine from S.U.N.Y., Buffalo, devoted a special issue to O'Hara's poetry, including an essay by Kenneth Koch, "A Note on Frank O'Hara in the Early Fifties," as well as Albert Cook's "Frank O'Hara We Are Listening." When its editor, Michael Anania, had visited O'Hara at 791 Broadway the previous winter to try to put his hands on the poems, he had been given the usual scattered treatment. "After some getting-to-know-you conversation, he showed me to an alcove off the front of the loft," Anania has recalled. "There were manuscripts in stacks on the floor, and he said that he couldn't imagine how we would make a selection. Some of the stuff was quite old, some quite recent. He took out a great quantity of stuff . . . and I began to look at poems, great quantities of them. He would pass a sheaf to me, occasionally adding a few comments . . . Out of what I was

handed I took a large stack of things, well over a hundred and fifty ms. pages. . . . As I recall 'Biotherm' was not in that group. Frank sent that along later. I think it had come up in our conversation as a result of my enthusiasm for longer poems, but he couldn't find it that night." With *Meditations* having been out of print since 1960, the fifteen hundred copies of *Audit* quickly sold out. O'Hara was particularly pleased by what he described as "the world premier" of "Biotherm."

After O'Hara's reading on April 7 at the Loeb Student Center with Jones as well as Ginsberg, Orlovsky, Levertov, Towle, Brodey, and Berkson, he vowed in a letter to Rivers on April 18, "I will not read for at least a year, if ever again." He did not keep his promise, however. On July 8 he read at Wagner College; on July 15 he recorded poems at WBAI radio station; on September 25 he read at S.U.N.Y., Buffalo, with Charles Olson, who remembered "quietly walking around the dead streets of Buffalo" with him afterward; on November 15 he read again at N.Y.U.'s Loeb Student Center. With so much practice he had gradually grown out of his earlier dry, arch Anglo reading style toward a chattier, more conversational tone. Though never exactly formidable at the podium—another formal situation like teaching—his appearances were increasingly attended by the public. He was becoming a celebrity. When he appeared at one reading in a remodeled carriage house on the East Side, his secretary, Renée Neu, recalls a "frisson" running through the audience as people turned around to watch him enter, whispering "Frank is here. . . . There is Frank O'Hara." All smiles and full of friendliness as he entered, O'Hara nevertheless was feeling a bit fraudulent reading only old poems. He needed the instantaneous on-the-edge performance drama of a "Lana Turner Has Collapsed" to feel valid.

Taking up the baton from *Yugen, Floating Bear,* and *Locus Solus,* Ted Berrigan kept O'Hara in print in New York that year by constantly pressing him for poetry for his new legal-sized mimeographed magazine called *C,* which was launched in May 1963. (Berrigan shared mimeograph privileges with Ed Sanders's *Fuck You: A Magazine of the Arts* at the Phoenix Bookstore on Cornelia Street, whose owner, Robert Wilson, remarked rightly one night after Berrigan left, "I don't know why he prints that magazine on legal-sized paper. Bookstores will never carry them. No one will ever buy them.") O'Hara not only published poems there but also comic-strip collaborations he did with Joe Brainard for the two popular comic-strip issues of *C.* As O'Hara introduced his new collaborator with raves in a letter to Larry Rivers: "Now I am making some cartoons with Joe Brainard, a 21-year-old assemblagist genius you will like a lot, as he looks remarkably like Joe Riv though

not so handsome and far more shy. (Kenneth is doing some too, and Tony Towle and Bill Berkson.) It is a cartoon revival, because Joe Brainard is so astonishingly right in the drawing etc."

Brainard also filled a spot for a while in the life of Joe LeSueur following the gradual defection of J. J. Mitchell. "I started going with Joe courtesy of Frank," says Brainard. "I was too shy to make a pass. And Joe didn't really know if I was gay or not. I was over there one night and Frank said to Joe, 'Why don't you move the TV into your bedroom?' So I got seduced for the first time in my life. I found out later it was all a set-up. Frank had gotten tired of Joe talking, I guess. But then I went over there a couple of times when Joe wasn't there, and Frank came over a couple times to his old apartment on East Ninth Street where I was living with Tony Towle. A dozen times at the most probably. I think if Joe had known I was seeing Frank on the side he would have been jealous."

O'Hara had other motives in trying to matchmake for LeSueur. His own friendship with J. J. Mitchell was heating up as LeSueur's was cooling off. He hoped to take some of the heat off the strained transition by distracting him a bit. In the meantime he was not at all reserved about throwing himself with his usual passion—and at least initial success—into wooing Mitchell. As Mitchell later recalled in rather effusive language in a memoir: "At our first meeting, Frank's legendary capacity for friendship was extended (over bourbon and orange juice one morning with Joan Mitchell) in a way which I doubt will ever be duplicated again (by anyone) in my lifetime. That friendship grew truly marvelous (in the lost sense of the word) over the five years that I knew him. Frank orchestrated it—as only he could—from awe to ease to delight to love. It was reinforced by daily lunches at Larrés French restaurant on West 56th Street (*Lunch Poems* never precluded lunch!), the ballet (Balanchine!), gallery openings, parties, weekends at Patsy and Mike Goldberg's or at Larry Rivers (the Hamptons!). . . . Late, late shows, endless talk, the mad fix, fueled probably by a mutual Irish passion for life, laughter, liquor—and the dread of ever going to sleep!"

Unfortunately O'Hara's use of Brainard as a decoy did not placate LeSueur, who was becoming increasingly upset over this latest development. So he entered into a power struggle with O'Hara. Confiding something of his complicated love life, O'Hara wrote to Goldberg in the psychiatric hospital on November 28, "I seem to be having a kind of double one, which means probably that I will soon be totally alone and able to write you even longer and more frequent letters. It seems right now to be equally divided between JJ and Kynaston, both of

whom I am crazy about, though not necessarily happy because of. However, that is not a complaint, since I have long since given up the idea of being happy for the idea of being active, or engagé, or whatever it is the French tell us we ought to be and Walt Whitman seems to back up. . . . I have also been having some interesting fights with Joe because he is pompous, hypocritical, egotistic, jealous and doesn't deliver phone messages unless they are from Kynaston, a little trick that may cost him plenty since Kenward has moved into his scene in no uncertain terms." The reference was to Kenward Elmslie, who was growing romantically involved with Joe Brainard—a double-whammy that did little for LeSueur's self-esteem during this rocky period.

Many friends did not understand the significance attached to the issue by LeSueur. They felt he was overreacting. J. J. Mitchell, after all, was a bit fly-by-night in his attachments, at least romantically and sexually. And certainly the two roommates had been living in a communal situation only slightly ahead of its time for some years. "I was always fascinated by their relationship," says Kenward Elmslie. "They had these little cubicle bedrooms like at the Baths but in their own apartment. And they could hear everything that went on in the middle of the night in the other's room. I think this auditory sharing was an important bond in their relationship. So I wondered why Joe became so upset when J. J. switched over to Frank's bed since by that point the line of morals was already so broken." But LeSueur felt there was an arguable line in the sand. "I'm sorry, but he had been my lover just three months before," complains LeSueur. "Maybe if more time had elapsed. Maybe six months. Imagine me taking up with Vincent Warren and bringing him around if they'd broken up. I couldn't do it. He would have killed me."

LeSueur was amazed by being presented with his ex-boyfriend's coming to coffee in the mornings with O'Hara. Bad feeling between the two roommates led to scenes drawn almost too cleverly from their extensive knowledge of the repartee of Hollywood actresses in unintentionally funny melodramas. When Mitchell appeared after his first night with O'Hara to take a shower, LeSueur delivered an uncomfortable, though stagey, "Well hi, J. J." When O'Hara later asked Mitchell how many sugars he wanted in his coffee, LeSueur couldn't help but reply *for* him: "One sugar." "Frank and I were like Bette Davis and Miriam Hopkins," says LeSueur, referring to the two Hollywood actresses thrown into a publicity-inspired feud by Warners in the 1930s. At times their B drama escalated beyond humorous self-dramatizing. One night at dinner when Mitchell complained that the rice wasn't properly sep-

arated, LeSueur, the cook, threw the remains of the unseparated rice from the pot into his face with a campy flourish that faltered.

O'Hara was impatient with these threats to his freedom, his entire adult life having been an escape from his mother's domain where he felt fenced in by demands of guilt or propriety. The more outspoken Le-Sueur became about his feelings of anger and rejection, the more O'Hara dug in his heels. As he was beginning to write a few poems in which Mitchell was a hinting presence, he felt there was some hope there for resuscitation. A poem of two years earlier introduced Mitchell jauntily enough:

> *Dee Dum, dee dum, dum dum, dee da*
> *here it is March 9th, 1962*
> *and JJ is shooting off to work*
> *I loll in bed reading* Poets of Russia
> *feeling perfectly awful and smoking*

"The Green Hornet," a poem inspired by the TV show *Wyatt Earp,* was dedicated to Mitchell in the spring. O'Hara was addicted to love and friendship for the sake of his art. He knew that he worked best as a love poet and so needed love, or its illusion. "I do think his Muse was gone," says Stephen Holden. "I think one of the reasons he latched onto J. J. was that he was looking for another Vincent. I remember J. J. told me proudly sometime after they were sleeping together that Frank had written his first poem to him."

J. J. Mitchell was a perfect party escort for O'Hara, too. He was one of the few drinkers who could match him stinger for stinger. And he looked attractive—O'Hara's eye coming into play in romance as much as in art. "You have to understand that J. J. was like the Number One Thing in New York," explains Alex Katz. "Frank was like a movie mogul with all these guys. The dancer, Vincent, was pretty. But J. J. was a real number."

"J. J. was very beautiful and Frank adored him," says Holden. "Frank worshiped physical beauty the way he worshiped beautiful music. But when it went over the line from being friendship into being something sexual it was very upsetting to Joe. I saw it as a kind of competition that Frank decided to win. Maybe it was a way for Frank to ease the bond between him and Joe, and sort of end that, or at least to take it to a much lower level. It was cruel basically. But then Frank, just like J. J., could be very cruel about things that were emotional,

intense things. They both behaved as if you just went after what you wanted."

Feeling the conflict between the comfort of LeSueur who had evolved more blatantly into a "caretaker" figure, and the appealing tugs of romantic love and freedom—a more bitter version of the conflict in "Joe's Jacket" almost five years earlier—O'Hara turned for advice to Jack Larson. O'Hara always referred to the actor who played Jimmy Olsen in the "Superman" television series and who went on to write the libretto for Virgil Thomson's opera *Lord Byron* as Joe's "friend from Hollywood." O'Hara was titillated that Larson had known James Dean but became exasperated when he would criticize as "a neurotic act" the teen idol's penchant for sitting in a corner at Hollywood parties playing bongo drums with his back turned. O'Hara would brook no negative comments about the "tar-haired" tragic idol of his "A Ceremony for One of My Dead." Through Larson, O'Hara had met Montgomery Clift. Larson and Clift even stayed briefly in the loft beneath O'Hara's. (When the two came upstairs one time to a dinner that LeSueur was cooking, Clift decided to reduce his wardrobe by passing out a handful of his neckties to the young poets Brodey, Towle, and Brainard.) O'Hara felt that Larson was equally a friend of his and LeSueur's and that he would be able to balance for him the scales of emotional justice.

So one afternoon O'Hara called Larson to ask him to go for a long walk. Larson immediately knew what the subject must be. O'Hara explained as they walked through the Village that he had always loved J. J. Mitchell but that he had not thought anything was possible as he was LeSueur's lover. Now Mitchell was free and claimed to be in love with O'Hara. "He's my chance for happiness," O'Hara said extravagantly. He then revealed that LeSueur was acting terribly, making sharp remarks to Mitchell, stirring up trouble. He was afraid that LeSueur would interfere with this opportunity. As he wrapped up his request for advice, which was actually more of a monologue, a screwing up of his own resolve, he insisted to Larson, "If Joe ruins this for me I'll never forgive him!" Matters could only disintegrate further. And they did. When O'Hara was talking about LeSueur shortly afterward at a party, Kenward Elmslie heard him hiss the word "hate" as he had never heard it hissed before.

At Christmastime O'Hara decided that he and LeSueur could no longer live together. "So it got really unpleasant," recalls LeSueur. "Donald Droll, who lived beneath us and got us to move into the place, just hated this. He sat us down at this big table we had and he was like the counselor, trying to save this relationship, this marriage, whatever

you want to call it. Frank was giving his side. I was giving my side. Frank was complaining about me as being wonderful-looking and sexy and having people always wanting to go to bed with me. I said, 'What are you talking about? You're this wonderful poet. You've got all these people after you. I never complained about that.' It was back and forth. Frank would never attack me for not being so smart or so well read. I would never attack him for a receding hairline or anything physical. But I would attack his intelligence. It was all right to do that. It was like brothers." But the issue of J. J. Mitchell, however trumped up, turned sibling camaraderie into sibling rivalry. "You're the most petty person I've ever known!" O'Hara concluded. As he had paid the initial down payment for the apartment, he now claimed the right to stay.

So in January 1965, after nine and a half years, LeSueur moved to his own apartment, on Second Avenue at First Street.

O'Hara had nerve. It was both a plus and a minus. Implying both spontaneity and outrageousness, "nerve" was O'Hara's campy version of Keats's prescription of "negative capability" or "wise passivity" for the young lyric Romantic poet. In his poetry, "nerve" was his aesthetic motor, his program. As he had written in "Personism"—"You just go on your nerve." Most simply, the method of composition was that prescribed in the first line of one of his last poems, "I Love the Way It Goes": "You just start writing." "Nerve" was certainly a favorite word in his poetic lexicon. It showed up as if lit in neon. In "Early Mondrian," he had written of Mondrian's early paintings first exhibited in New York in the early 1950s, as "the clear architecture / of the nerves." Consuming a "liver sausage sandwich in the Mayflower Shoppe" on Fifth Avenue in "Music," he was "naked as a table cloth, my nerves humming." In "Ode to Willem De Kooning" he regretted "the last lapse of nerve which I am already sorry for." It was the poet of "nerve" who could write "Second Avenue" as a sort of tournament race with Kenneth Koch, also at work on an epic poem; "Sleeping on the Wing" on a dare from James Schuyler over coffee one morning; "Lana Turner Has Collapsed" on the Staten Island ferry on his way to a reading in a snowstorm.

But "nerve" as practiced in O'Hara's life had more dubious results. Sequestered in his Quonset hut in the Admiralties in March 1945, the young O'Hara had worried about his father's lecture on the split between his intellect and his emotions. Russell felt his son was too easily carried away. O'Hara bought into his father's Polonius-style prediction that his "sentimentality" would be "cured by age and experience." At Harvard, though, after his father's death, the only change was in

O'Hara's attitude. He now romanticized his supposed lack of judgment. He happily noted in his journal Kassner's remark that in Rilke "the conflict between judgment and feeling which is so masculine, so peculiar to men, did not exist." His homosexuality, his poetry, and his lack of a cool reasonableness were mixed up for him. As he wrote later in "Meditations in an Emergency": "I will my will, though I may become famous for a mysterious vacancy in that department, that greenhouse." Or in "To the Harbormaster": "To / you I offer my hull and the tattered cordage / of my will." The nerve in which he so stubbornly believed was will without the caution lights of intellect or judgment. Unfortunately, that nerve often had a reckless edge, especially when mixed with alcohol. Under its influence he could fall asleep in construction sites, play "chicken" with buses on Second Avenue, run naked into the ocean at night during a lightning storm. This was the Frank O'Hara who pretended to throw himself in front of a train in Daisy Aldan's 1955 film *Once Upon an El*. He liked taking chances more than making hard choices.

"By the early sixties I think a lot of those people who were old friends of his were feeling that Frank hadn't matured," says Bill Berkson. "I'm talking about his friends who had gotten married or undergone psychoanalysis. Frank didn't want to slow down. He didn't want to grow up in those terms. Psychoanalysis was in the air. Joe LeSueur had a Jungian therapist. I remember him reading a book on individuation. There were people going to Reichian therapists. Kenneth Koch was in intensive analysis for nine years beginning about the time that I met him. People in either direction could say that the other was simply not real. They could think 'Grow up' or 'Get rid of those neuroses' or 'Adapt to society' or 'Stabilize' or whatever. But Frank was volatile."

"I think he was drinking more and more and in a real quandary about his life and poetry," says Stephen Holden of O'Hara at the time LeSueur moved out. "The Museum was taking a tremendous toll on his time. I don't know if he was really ambitious, but he was such a bright light that he was going to go far. All these things were making various claims on him. He was getting older. He was not choosing anything, just going with it."

Romantic love was O'Hara's favorite chance to take. He continued to be affected by its lure. "Frank had a penchant for getting very happy when he was getting involved with someone," says Frank Lima. "The other side of that was getting very unhappy because the affair was breaking up. There was no in-between. Frank was in and out of things all the time. He was very visible about the whole thing too." When

faced with the choice in 1964, O'Hara gave up the comfort of LeSueur's symbolic seersucker jacket hanging in the closet, which had "protected me and kept me here," for the thrill and importance of love. As he had written shortly before meeting Vincent Warren in 1959 in his essay on *Doctor Zhivago*, "And if love lives at all in the cheap tempestuousness of our times. . . . choose love above all else."

In the case of J. J. Mitchell, however, the choice proved to be a miscalculation. If O'Hara was looking for an excuse to give the shove to LeSueur he succeeded. But as a "chance for happiness" Mitchell, no matter how intimate a friend he became over the next year and a half, fell short. As O'Hara remarked only half-jokingly to LeSueur about the effect of his departure on their affair, which until then had been kept tickled by the excitement of the triangular conflict, "I could kill you for moving out. As soon as you moved out it ruined everything." In the wake of LeSueur's departure, the loft at 791 Broadway seemed even draftier and more cavernous. The refrigerator was certainly empty most of the time, its contents having been winnowed down to a bottle of vodka, a bottle of vermouth, and some olives for martinis.

Visitors over the next year and a half often chanced on an unusually "down" O'Hara—sometimes sick, sometimes still in bed, often hung over.

Death

Early in 1966 Bill Berkson asked O'Hara why he was writing so few poems. "I just don't have any ideas," he replied.

The lusterless moment he had feared so much in "At Joan's" in 1959 had definitely arrived:

> I am lonely for myself
> I can't find a real poem
>
> if it won't happen to me
> what shall I do

Depending as he did so entirely on the inspiration of the moment, O'Hara's stopping writing for a few years was not necessarily a disastrous sign for his poetry. Rilke had once stopped writing for twelve years. But it was disastrous for his sense of happiness. O'Hara was invariably unhappy about not writing. As he complained to Larry Rivers when he was becoming aware of the seriousness of the slippage in

February 1964: "I've done so little work lately (new), it's revolting. I guess my head must be completely empty and I'm trying to keep busy so I won't have to acknowledge it to myself. But that will change soon I trust, as I'm getting bored with running around." Such a change, however, did not come about. O'Hara simply became busier and busier.

Indeed he became so busy that he allowed no one enough time or access to notice the problem. Berkson's confrontational question was rare. As O'Hara's public life became more complex and colorful, he kept the worries about his inner life and poetry even more tightly wrapped. During the last year and a half of his life, his closest friends were dropping away. Grace Hartigan was married and living in Baltimore. She and O'Hara had one strained dinner together with Phil and Musa Guston in February 1964 that an intractable O'Hara described to Rivers as carrying "a bit of the oddness of Jackie Kennedy's dinner with Marlon Brando." Of his uneasy relations with Jane Freilicher he had written to Joan Mitchell, "I am quite tired of people whose lives, and mine, have taken divergent ways, and who bitch me for some obscure disloyalty in not calling them when they have phones of their own and don't give a fuck for me anyway." Larry Rivers, married again and with a young daughter, was dividing his time between London, California, and New York. Joe LeSueur, his anchor for so many years, was beginning to come into his own in his apartment on lower Second Avenue. When O'Hara started teasing him one night at John Button's, LeSueur snapped, "Frank, we don't live together now. You have to treat me decently. Someone sitting in a change booth in the subway treats me better than you do." Bill Berkson was spending more time Uptown. "From 1962 I just wanted to distance myself from that scene," says Berkson. "It was partly because I recognized that I was hanging out with these people who were all older than I was." In retrospect, to his friends, the last phase of O'Hara's life was an enigmatic mixture of distance and hectic activity. The enigma was increased since O'Hara stopped writing not only poems but also letters. He was leaving very few traces, though no one had yet noticed. Certainly no one intervened.

Typical of the stance of his old friends was that taken by John Ashbery, who returned to New York in 1965 to work as executive editor of *Art News*. "When I moved back I thought, 'Well now, at least I'll be able to spend a lot of time with Frank,'" says Ashbery. "But you never could, because so many people wanted to see him and there was just so much of him to go around. You'd make a dinner date and find the curator from Stockholm at the same table. So I got rather pissed off at him. As did his other friends. I think that we were all very jealous of

each other and Frank's attentions. This wasn't what I had imagined, because we used to spend so much time alone together. When I did see him it seemed to me there was a sort of melancholy I didn't remember from before, and a kind of tiredness. I remember going over to see him on a Sunday. I brought him the *Times* and he was alone in bed. He was sick with something or other. I remember being surprised to see him feeling so down, physically and mentally."

Yet O'Hara had a very high profile in 1965 and 1966. Ironically, the less he wrote the more he became published. Practically overlapping in spring 1965 were the publications of *Lunch Poems* from City Lights and *Love Poems (Tentative Title)* from Tibor de Nagy. *Lunch Poems* had been in the works for six years, O'Hara's dilatoriness and ambivalence almost solely responsible for its unusually long gestation. "I met O'Hara with Allen Ginsberg when we went up to Larry Rivers's studio one night," recalls his publisher Lawrence Ferlinghetti. "He was writing poems on his lunch hour and I was interested in that. So I said, 'Why don't you do a book of lunch poems?'" Responding to his request in December 1959, O'Hara wrote Ferlinghetti, "Yes suh, lunch is on the stove and lordy, I surely hope you don't think I forgot to put the fire under the greens, I am even flavoring same with cholesterol and hormones so we will all live for ever." That letter was followed by nine more to Ferlinghetti over the years, as well as several to Donald Allen who was helping him select poems. O'Hara was constantly apologetic in his letters to Ferlinghetti for his "various doubt-seasons." Typical of his habit of dedicating books to friends and lovers on the wane, he dedicated *Lunch Poems* "to Joe LeSueur." During one panic that the title was too close to Ginsberg's *Reality Sandwiches* or McClure's *Meat Science Essays*—both published by the San Francisco press—he even toyed with calling the book *To Joseph LeSueur* until convinced otherwise by Kenneth Koch. When asked by Ferlinghetti to write its jacket copy, he dreamed up an unconventional paragraph in one quick typewritten draft on his second or third drink before dinner one night in September 1964: "Often this poet, strolling through the noisy splintered glare of a Manhattan noon, has paused at a sample Olivetti to type up thirty or forty lines of ruminations, or pondering more deeply has withdrawn to a darkened ware- or fire-house to limn his computed misunderstandings of the eternal questions of life, co-existence and depth, while never forgetting to eat Lunch his favorite meal. . . ." He also suggested—and received—his favorite colors, orange and blue, for the jacket. *Lunch Poems* was printed in a first run of three thousand copies and consistently panned by those few critics who did not ignore the volume entirely. Francis Hope in the

New Statesman, trying to link O'Hara with Ginsberg, claimed "there's not much reality in these sandwiches"; Gilbert Sorrentino in *Bookweek* felt these were "messages to a personal cosmopolitan elite, which apparently consists of O'Hara and his immediate friends"; even Raymond Roseliep in the New York School house organ of the fifties, *Poetry,* stuck to picking out examples of "defecation" and to deriding "Ave Maria" as "offensive" morally.

That same March the pamphlet *Love Poems (Tentative Title)* appeared from Tibor de Nagy Press, which had published his first pamphlet, *A City Winter,* fourteen years earlier. This collection of sixteen love poems to Vincent Warren was edited by John Bernard Myers after years of "constant urging." When O'Hara finally mailed twenty-eight poems to Myers for consideration in October 1964, he attached a note: "Now don't forget, if you don't think these can make some sort of decent thing by elimination, *LET'S NOT HUMILIATE OURSELVES,* there's enough of that around already!" As Myers has written of the attenuated process, "I waited for these poems for three or four years. Frank could never get himself to type them up. When he did give them to me I couldn't induce him to arrange them in their proper sequence nor give me a title. I wrote 'Love Poems (Tentative Title)' on the first page, then arranged them so that the sequence would show the beginning of a new love, its middle period of floundering, the collapse of the affair with its attendant sadness and regret. Frank liked the arrangement and my 'tentative' title. And that was that." In spite of O'Hara's usual exaggerated misgivings about surrendering his floating poems to the finality of the printed page, the five hundred copies of the edition sold out within the year. Going with the sense of O'Hara as a lightweight poet, Marius Bewley in the *New York Review of Books* grudgingly described O'Hara's verse lines in *Love Poems (Tentative Title)* as "amiable and gay, like streamers of crepe paper fluttering before an electric fan."

The Tibor de Nagy Gallery that published O'Hara's last chapbook was a very different place from the fledgling gallery that had printed his first. In 1951 Tibor de Nagy was launching itself as *the* gallery for a second generation of New York School painters. By 1965 the lure of money from newer dealers and disgust with certain unprofessional antics of Myers had caused many of the painters from his original stable to defect. Each of these defections had been a major trauma for the hypersensitive Myers. First had been Helen Frankenthaler, who left Myers in 1958 soon after her marriage to Robert Motherwell to join the André Emmerich Gallery. "John's attitude on favorites and intimates got to be rather wrapped up in, and often in conflict with, seeing the art

itself, and that bothered me somewhat," says Frankenthaler. "It seemed there was a whole range of first-class citizens and then the others." As O'Hara reported the break to Ashbery in Paris in October 1958, "John didn't sleep for four nights but on the afternoon before the 5th he found out where she went and immediately slept. These are his words. He also cried a lot. The lot of a New York dealer is quite a lot." Grace Hartigan's marriage also led to her break with Myers in 1960, after which he would not speak to her for twenty years. The cruelest blow, of course, was Rivers's move to Marlborough Gallery in 1963. As O'Hara reported some of the fallout of Myers's hysteria to Rivers in April 1964, "He also predicts that Marlborough is folding & that you will be coming back sooner than you think and in more trouble than you think. He has made up a very cute recipe for your reconciliation dinner with him when Marl closes, which consists partly from what I can remember of crow in aspic and humble pie. . . . He is also terribly pleased that Mrs. McGinnis is auctioning all her Hartigans off next because she is 'bored with them.' I wonder how that tallies up with having sold them to her in the first place. Apparently art has less durable qualities than we, once in our far-off youth, supposed." Whatever its politics, the disintegration of the de Nagy Gallery was a sign of the passing of the youth of the New York School. The de Nagy aura of the midfifties had been passed on to and magnified by the Castelli Gallery, now representing Warhol, Lichtenstein, Johns, and Rauschenberg. There was little room for the likes of a Surrealist-puppeteer-turned-art-dealer. In 1970, after disagreements with his partner, Myers split to start over again in his own ultimately unsuccessful John Bernard Myers Gallery.

As a sign of the shift of the de Nagy Gallery from the center of things to the sidelines, O'Hara's next involvement in a public nudity-in-art scandal took place at the Fischbach Gallery on Madison Avenue. The occasion was the opening of Wynn Chamberlain's show of "Nakeds" on February 1, 1965. Working from photographs taken at his studio, Chamberlain had painted nude photo-realist canvases of personalities from the world of art and poetry, including Ruth Kligman, John Giorno, Bill Berkson, Tony Towle, and Allen Ginsberg. O'Hara appeared in the middle of two group shots—one clothed, one nude—with Brainard, LeSueur, and Lima. The show's flyer, featuring nudes of Kligman, Giorno, and Chamberlain striding forward, was banned by the postal authorities. As Kligman had been married to a South American painter between the time of the painting and the showing, she insisted in a panic that she would sue, so Chamberlain agreed to change her face in the painting to be less recognizable, though O'Hara said of the

final result, "But now she's *more* recognizable." Allen Ginsberg wrote an introduction, meditating on his feelings on seeing his own naked body. With the press getting wind of the scandal, the gallery was forced to post a security guard at the door to keep out minors. "For a young curator in those days this ado was not exactly logical," says Renée Neu. "Mr. Barr was nice but rather puritanical. I would say that Frank could have tried to not have it shown or not let it happen. If he ever wanted to have a career at the Museum, that is."

As a curator, though, O'Hara insisted on making his own rules. His rationale was basically European existentialist. He could only understand by doing. If he had a sure value for the institution, it would be for his connections as much as his evaluations. When asked by a British interviewer in 1965 whether such a double life as a poet moonlighting posing for male nudes was not "something rather unusual in a museum official," he answered confidently, "In America it's very hard to codify the art as it emerges anyway, so that your participation is really your interest in a sort of emotional way which leads you perhaps to understand a little bit better than the general public at the time the work is appearing. And then you're either right or wrong later."

At the Museum, in spite of the passions stirred by such publicity among his fellow curators, O'Hara was gaining enough power to be able to fuse his emotional interests with his curatorial gig more and more fully. In January 1965 he was promoted to Assistant Curator in the International Program, and in July 1966 his title was changed to Associate Curator in the Department of Painting and Sculpture Exhibitions. The last title change marked his move at the beginning of 1966 into the main building of the Museum. This was a time of turmoil during which the meaning of such switches was unclear. Alfred Barr was fading as a force. His decline changed that world of which O'Hara had declared him in the fifties "a god." As John Canaday had written in the *New York Times* as recently as 1960, "There is not a dealer in town, nor a collector, nor yet a painter hoping to hang in the Museum of Modern Art who doesn't study each of Mr. Barr's syllables in an effort to deduce what he should offer for sale, what he should buy, or what he should paint." Along with the weakening of Barr went the loss of the "pioneer spirit" that had sparked the Museum's early days. The institution was evolving into a more traditional museum, as galleries and dealers took on more of the job of scouting talent—with all the blatant commercial bias such a shift implied. At the time the Department of Painting and the Department of Exhibitions were split, Dorothy Miller was in charge of Painting. There was a sense that O'Hara was being

groomed to take over the Department of Exhibitions. Devising shows was certainly his forte. As Rasmussen later wrote in a eulogizing fashion: "Frank's exhibitions were ephemeral but I remember them as I do great performances, as brilliant jabs of imagination, daring exercises of power and lyricism."

The first show O'Hara worked on after his promotion of 1965 was "Modern Sculpture U.S.A." O'Hara liked working on this traveling exhibition because of his increasing conviction that sculpture was at the cutting edge. As he said in an interview at the time, "Oddly enough, it seems to me that the most original work is being done right now—except for people who are already acknowledged as original creators—in sculpture." This turn toward sculpture was a maneuver by which he was able to move forward without turning toward Pop Art. The exhibition also gave O'Hara an opportunity to work with the Director of the Museum, René d'Harnoncourt, on a gargantuan show of seventy sculptures, which traveled, as the largest show of American sculpture ever presented in Europe, to Paris, Berlin, and Baden-Baden from June 1965 to April 1966. "René d'Harnoncourt was a father figure to me and to Frank too to some degree," says Waldo Rasmussen. "He stood up for Frank. He appreciated his talents. He didn't always agree with his decisions. But the experience of working with him on the sculpture show sort of clinched it. He learned to respect his eye and his judgment." Among the sculptors chosen were Bourgeois, Chamberlain, Cornell, Lachaise, Marisol, Nakian, Newman, Oldenburg, Segal, and David Smith. O'Hara went up against d'Harnoncourt to fight for the inclusion of Tony Smith, as he had lobbied Dorothy Miller in 1958 to include Hans Hofmann in "The New American Painting" exhibition. He lost this round, too. In trying to push the fifty-year-old minimalist sculptor, who had not yet shown publicly, O'Hara even went out to New Jersey at Barnett Newman's suggestion to see a large cube piece of Smith's titled *Die,* which he came back to draw excitedly for d'Harnoncourt. Nevertheless, his alliance with the popular and charming six-foot-six Vienna-born Director was helpful to O'Hara in the next year as he succeeded in extricating himself from the International Department, where his colleague Rasmussen had become his boss by default after McCray's departure. "We were not as close at the very end of his life as we had been before," admits Rasmussen. "We never had a rupture, but we had a couple of fights. I think it was competition masked as professional issues. I think his alcoholism was also part of it. Photographs of him show the change. The face changes. It begins to look bloated."

Simultaneous with the opening of "Modern Sculpture U.S.A." was the opening of "Recent Landscapes by Nine Americans" at the Two Worlds Festival in Spoleto, Italy, in which O'Hara felt comfortable finally including some of his closer friends—John Button, Robert Dash, Jane Freilicher, Alex Katz, and Jane Wilson. That same month O'Hara flew to Los Angeles to be the key speaker at the opening of a "New York School, First Generation" show at the new Los Angeles County Museum. He stayed at the apartment of curator Jim Elliot overlooking the Santa Monica pier. When Jack Larson went to visit him on his first morning O'Hara opened the door with a wince and the exclamation "Quel head!" Nursing a tomato juice and fingering the slides for his talk, which he had not yet quite organized, O'Hara murmured campily while glancing at himself in a mirror, "I'm not as sylphlike as I was wont to be." His short trip was crowded, as O'Hara was given the celebrity treatment. He visited Dennis Hopper and Brooke Hayward at their Spanish-style house in the foothills just above Hollywood Boulevard, Jack Larson and screenwriter-director Jim Bridges at their home, and collector Frederic Weissman's Trousdale estate where to O'Hara's dismay he found hanging his old de Kooning *Summer Couch*. He also visited Christopher Isherwood in Santa Monica Canyon where he met Julie Harris (whom he had admired as Sally Bowles in *I Am a Camera*) as well as Isherwood's companion, Don Bachardy, who had sketched O'Hara's portrait in February. O'Hara's performance at the large museum theatre never quite gelled, though. When he took to the podium his slides were still disordered and his grasp on them as shaky as it had been sipping tomato juice for his hangover a few days earlier. "The slides went on relentlessly with Frank having something to say about each one, presumably with the idea in mind that each might have been of a painting on loan from a local collector and therefore wanting comment," recalls Larson. "After two hours, when it became apparent that Frank was going to speak about every painting in the huge exhibit, the audience began to thin out quite seriously. In fact, an exodus took place. . . . Everyone, including Frank, recovered at a delightful Museum reception afterwards where it appeared that most of the audience had only been hiding and had come out again to meet Frank over dinner and congratulate him." When O'Hara wrote a thank-you note to Larson and Bridges on his return to New York, he made no comment on his gaffe of a lecture, musing entertainingly instead on the humid heat of New York: "It goes to show that 8,000,000 people can be wrong, especially in August."

More successful was his huge Robert Motherwell retrospective,

which opened at the Museum on October 1. The show was made up of eighty-seven paintings, drawings, and collages done over twenty-five years by the most elegant of the Abstract Expressionists. Motherwell was committed to stressing the influence of European thought and poetry in his abstract canvases as well as in his pursuit of a cultivated life with his wife, Helen Frankenthaler, as they shuttled between their townhouse on the Upper East Side and an eighteenth-century house in Provincetown. Though committedly abstract in form, his paintings were literary and political as well. One of his early collages as well as a later lithograph were titled *The Poet*. Motherwell discovered the *Elegy to the Spanish Republic* motif while making a drawing for a poem by Harold Rosenberg, and the first major painting of the series, *At Five in the Afternoon* (1949), was titled after the repeated refrain of García Lorca's elegy for the bullfighter Ignacio Sánchez Mejías. His titles *Mallarmé's Swan* and *Throw of the Dice* evoked Mallarmé; *The Voyage* and *Joy of Living*, Baudelaire; and *Jour la Maison, Nuit la Rue*, and *Automatisms*, the Surrealist poets of France. In an article in *Vogue* the month of the exhibition, titled "The Grand Manner of Motherwell," O'Hara argued that Wallace Stevens was "the American poet probably most similar in sensibility to Motherwell." The coupling of the two, though, hinted at O'Hara's slight misgiving about both their works. As he had written in "Biotherm": "but I don't get any love from Wallace Stevens no I don't."

O'Hara had first met Motherwell in East Hampton in 1952. Whenever they talked, the talk was intellectual—O'Hara having described Motherwell as "an engaging, wily conversationalist." "When we did talk later, it was almost always about poetry," he wrote in *Vogue*. "Apollinaire, Baudelaire, Jacob, Reverdy, Rilke (not so much), and Lorca (lots), and we also got to Wallace Stevens and William Carlos Williams. I had been tremendously impressed by the Documents of Modern Art Series which Motherwell had edited (indeed, it was The Gospels for myself and many other poets). At the time we never discussed painting, so far as I remember."

O'Hara came under lots of fire from his disgruntled Downtown friends for mounting the show. The move was seen as part of his shift Uptown. Motherwell's paintings were felt at the time by some detractors to lack the violence and roughness of Pollock or de Kooning, to be too finished, too School of Paris. "Motherwell wasn't considered to be that great by us," says Hartigan. According to Rivers, "Frank started to have two sets of feelings. He gave other people exhibitions only because they were sort of abstract and known in the field, but he didn't feel that their work was that great. Robert Motherwell, for instance. He

admitted to me that he didn't like Motherwell's work at all. And he thought that he was an idiot on top of it." "That's one thing in Frank's career as a curator that's not to his credit," says LeSueur. "The other painters didn't like it at all. The catalogue was all this pretentious stuff." O'Hara was also criticized at the Museum for bringing in Berkson to help edit the writings of Motherwell, whom they had visited together in Provincetown earlier in the year. "I felt there wasn't enough room for another person on that exhibition," says Renée Neu of the catalogue, for which a chronology was already being prepared by Kynaston McShine. Despite the flak, O'Hara did feel positively about Motherwell's work—though without the added exultation, perhaps, that so many had come to expect. He wrote in *Vogue* that beside Motherwell's work, Op Art, the subject of a huge show at MOMA by William Seitz the year before, "becomes merely trompe l'oeil." His finale to the piece was a suggestion in his tragic mode that Motherwell's work was a wall against Death, always a compliment and concern for O'Hara: "Like the rest of us, but more as an exemplar than a companion, he has his arrogant insistence on joy and his fateful cognition of the deaths around us. . . . With each line, mass, and torn edge, he is, like Apelles, erecting for us the noble wall of his aspiration against the darkness without." The tone was that of "Little Elegy for Antonio Machado"—O'Hara's last poem, written the following March for a show at Tibor de Nagy to benefit refugees of the Spanish Civil War:

> *no domesticated cemeteries can enshroud your flight*
> *of linear solarities and quiescent tumbrils*
> *vision of the carrion*
> > *past made glassy and golden*
> *to reveal the dark, the dark in all its ancestral clarity*

The death on his mind when he was writing the *Vogue* piece, though, was not Machado's but that of the sculptor David Smith—Motherwell's closest friend and the subject of O'Hara's next show. A Midwesterner with a tough-guy demeanor similar to Pollock's, Smith died in May 1965 when his truck swerved off a highway near Bennington, Vermont, reminiscent of Pollock's accident nine years earlier. The news devastated O'Hara who, for several years, had been working with Smith quite closely on a retrospective. It had certainly not been his intention to put together yet another homage along the lines of his postmortem shows for Pollock and Kline. Having first become friendly with

Smith in 1961 when he visited his Terminal Iron Works in Bolton Land-
ing, New York, O'Hara had written a piece about Smith's new sculp-
tures in painted steel, stainless steel, and bronze titled "David Smith:
The Color of Steel" for *Art News* that December. Soon afterward he
wrote "Mozart Chemisier" for Smith, whose favorite composer was
Mozart. Smith's series of *Zig*s, which he had begun in 1960 inspired
by Sumerian art, appeared in "Biotherm":

<div align="center">

extended vibrations

ziggurats ZIG I to IV *stars of the Tigris-Euphrates basin*

</div>

O'Hara also interviewed Smith in November 1964 for the educational
TV series *Art: New York* whose executive producer was Bill Berkson.
A wan and sophisticated O'Hara in a cloud of cigarette smoke made a
humorous juxtaposition with the gruff cigar-smoking cowboy-artist.
Smith corrected O'Hara's poetic flight about his sculptures arranged
outside on the hills of Bolton Landing seeming like men and women at
a cocktail party: "Well, they're all girl sculptures. . . . I don't make boy
sculptures." (O'Hara preferred his interview with Smith to the one he
did with the more philosophically weighty Barnett Newman for the
same program in December 1964. As he wrote to Mike Goldberg, "Bill
has gotten me involved in a TV appearance with Barney Newman on
Channel 13 which has me more confused than Athens just before the
fall. You should really be on it in my place since you know all about
metaphysics, he said bitchily.") Visiting Smith at Bolton Landing,
O'Hara was always pleasantly surprised by the sumptuous meals this
"great, hulking, plain-spoken art-worker out of Whitman or Dreiser"
prepared as he spoke of his love of Renaissance music, or the writings
of James Joyce, or the musical ideas of John Cage, or the choreography
of Merce Cunningham, or the poetry of Dylan Thomas and William
Carlos Williams, or the work of the younger sculptors John Chamber-
lain, Mark di Suvero, Anthony Caro, and the painter Kenneth Noland
who had influenced his own *Circle* series. As Motherwell had once said
to Smith, "Oh David! You are as delicate as Vivaldi, and as strong as
a Mack truck."

Hans Hofmann's response to David Smith's violent car death was
"How American!" O'Hara felt much less flip about the matter. Those
around him were drawn repeatedly through the wringer of O'Hara's
mourning for Smith that year. Erje Ayden, a young Turkish writer who
had published a novel, *The Crazy Green of Second Avenue,* for which
O'Hara had written a blurb, passed a rocky evening with him drinking

one Martel after another with café espressos mixed in at the El Quijote bar of the Chelsea Hotel. Abruptly O'Hara cut short whatever Ayden was saying and started talking expansively about David Smith. "And when Frank cried at the death of David Smith, self-consciously letting his tears drop into the cognac, I did much the same thing," Ayden recalled. "That was the first and last time I saw Frank unable to walk from too much liquor. It was snowing out. I carried him to a taxi. I wanted to go with him and help him with the stairs of his building. 'Oh, those, those are nothing, Erje. I climb down them every morning. Besides our favorite young novelist should rest.'"

On May 8, 1966, O'Hara traveled to Holland for the opening of the Smith show at the Rijksmuseum Kröller-Müller in Otterlo, the Netherlands. The weeks before the trip had been a strain. Near the end of April he had woken up one morning with an extreme pain in his left leg. Although Joe LeSueur spread the romantic rumor that the bullet from his shooting in 1954 had shifted and he was paralyzed in one leg, he was actually suffering from a viral infection. "I have had an x-ray by now and it's not the bullet," he wrote to Vincent Warren, "but on the other hand it's not my performance in the *Bluebird* pas de deux either so I wish it would just go away." After ten days in bed, hardly to the hyperactive O'Hara's liking, the pain still had not passed entirely. So he was forced during final preparations for the show, as well as during his trip to Holland, to use a cane at the end of the day. The preparations he limped through were particularly demanding, as he was overseeing the crating and shipping of forty-eight colossal steel and cast-iron sculptures, often weighing over a ton. On the Holland side O'Hara carefully and melancholically touched up those *Zigs* that had been chipped en route, writing to Warren that he had painted them "with the very paint he prepared for such an exigency (sob) and which I brought with me."

O'Hara's trip to Holland was quick and businesslike. He did not even have time for a detour to Paris. He did enjoy the Hotel Groot Warnsborn in Arnhem, which he described to Vincent Warren, to whom he was writing faithfully as was his habit on business trips, as making "East Hampton seem like Times Square and surrounded by what seems like the Vienna Woods though in the wrong country as usual." He got a tan working on the chipped sculptures in a clearing among the trees; met the American ambassador to help him with his speech for the opening; traveled to Amsterdam to see an "adynamical" film by a young director-photographer and to meet the newest young Dutch sculptor, Wim Schippers. On May 16 after a week, he returned to New York.

On his return, O'Hara was forced to plunge while still jet-lagged into preparations for his show of the sculptor Reuben Nakian opening at the Museum on June 20. Although admitting to Vincent Warren that "Smith is still the greater artist," O'Hara found many of Nakian's works "glorious," especially those in which classical themes and mythological eroticism were dealt with as subtly as in the Pollock paintings of the forties that O'Hara had so admired in his monograph. Some of the huge new works by the sixty-eight-year-old Abstract Expressionist sculptor were *Judgement of Paris* (with four separate figures in a group), *Birth of Venus,* and *Goddess with the Golden Thighs* (which weighed 6,000 pounds). "I'm having a bit of trouble with how far to go with his having various of his heroines, particularly Leda, Europa and some nymphs, corn-holed by various swans, bulls, goats and satyrs and not in a very abstract way either," he wrote to Warren. "I'm trying to cover our traces publicly, or pubicly?, by a lot of blab about good clean classical eroticism in the catalog introduction, but I wonder if Alfred Barr won't lower the boom." According to Alex Katz, the catalogue copy covered over some artistic problems too: "It was brilliant the way he covered all Nakian's defects. He did a very nice job. He really liked the stuff viscerally. So he got around the problems very gracefully." The show—deemed by *Arts* the "apotheosis" of Nakian's career—was a critical success. Writing to him after the opening, a gracious and courtly O'Hara thanked him for the "joy" and "privilege" of working on the show, adding, "The only untoward thing that's happened so far is that last Sunday an over-ardent young lady got too intense about the small *Voyage to Crete* in the garden near the Goddess and it fell backwards into the ivy, surely the most comfortable rest a Europa ever had."

The other gala event for O'Hara that summer was the opening of Stravinsky's *Oedipus Rex,* with sets and costumes by Larry Rivers, at Philharmonic Hall on July 20. O'Hara liked Rivers's conception of Oedipus Rex as a prizefighter in a silk bathrobe and approved of his wrapping Jocasta in a tubular dress made of aluminum foil but lectured him severely when he stopped by 791 Broadway to show the somewhat flip statement he had written for the program. "You're doing sets for one of the greatest composers of the twentieth century, if not the greatest," O'Hara told him. "This is Stravinsky. This isn't Mortie Feldman or John Cage. You've got to write something better than this." (Stravinsky was definitely in O'Hara's pantheon. One night in front of the Chelsea Hotel, when he had met Kenward Elmslie on the way to a party Stravinsky would be attending, O'Hara insisted he greet the composer with a grand and deep Russian bow, which he illustrated by swooping down

on one knee in the snow.) LeSueur, who had been over to O'Hara's for dinner the night Rivers brought by his statement, left the two of them to rework it. Walking home at three in the morning after cruising the streets, he chanced across a tired-looking Rivers just leaving. "He wouldn't let me leave until we fixed it," Rivers complained. The night of the performance, though, O'Hara had no reservations. "We were sitting together at *Oedipus Rex,*" recalls the writer Arnold Weinstein, with whom O'Hara began but never finished collaborating on the libretto for a musical, *The Undercover Lover.* "Larry did certain very beautiful things with lights at the end. I just felt so good that it had all worked out that tears came to my eyes. I turned and happened to catch sight of Frank who was also totally in tears." Their reaction was unfortunately not shared by those audience members who booed Rivers when he came onstage at the end, nor by the *Times* critic, who accused him of "low camp."

O'Hara's last month was filled with shows of tears interrupted, like sun storms, by small happinesses and reckless leaps of hubris. The tears were mostly brought on by meditations on either love or death over too many glasses of liquor. The first of these small tragedies, of course, had been the almost instantaneous fizzling of his romance with J. J. Mitchell after LeSueur's departure. "Suddenly J. J. had fallen in love with somebody else by the name of Peter," recalls Jack Larson. "He was a big tall guy who was a kind of a hippie. The next time I was in town Joe gave a little party in his apartment. Edwin Denby was there. Frank came and was actually happy. We were standing talking against a Joan Mitchell painting on the wall. Suddenly J. J. came in with Peter. Frank was gracious and charming to Peter. I felt something negative, though. I felt this was capricious of J. J. to come between Frank and Joe and then go off with someone else." Mitchell remained reliable, though, as O'Hara's favorite drinking buddy and party date.

His relations with Berkson had cooled to an easier temperature for his young protégé. But things could still heat up in the right (or wrong) circumstance. One of their uncomfortable confrontations took place at Wynn and Sally Chamberlain's country house on the Hudson near Rhinebeck where O'Hara was visiting with Berkson for the weekend. After dinner the guests played a game of Twenty Questions. The question was, "What are you most afraid of?" O'Hara's answer: "Living beyond forty. I don't ever want to grow old. I want to be like Shelley and Keats and die while I'm still young and beautiful." Later that night,

according to Sally Chamberlain, O'Hara kept them all awake by pounding on Berkson's door, calling out, "Let me in, let me in." (According to Grace Hartigan, O'Hara once said to her similarly that he didn't want to live longer than Apollinaire, who died when he was thirty-eight during an influenza epidemic.)

"I remember going over one time and finding Frank a wreck," says Elmslie. "He was just getting up. He complained that he was just an old homosexual. This shocked me. Especially the casting aside of the importance of being a poet. It didn't seem to impinge at all. But Andy Warhol said much the same thing to me one day walking hand in hand down Park Avenue. He said that he was going to end up like a madam in a homosexual whorehouse watching over the boys." Arnold Weinstein concurs on O'Hara's mood by 1966: "Frank was winding down. Not because he was feeling things more. He always felt things more or less. But each affair, each breakup, each disappointment was like a heart attack. Even though he understood it."

The sun on the horizon again for O'Hara that summer oddly enough was Vincent Warren. On April 18 Warren had visited O'Hara in New York. They made love together at 791 Broadway and talked openly about their feelings for each other. O'Hara wrote to Warren on May 10 that he had decided "your mere presence in the world wherever you might be was a system of values in itself." Warren claims that he was seriously thinking about returning to New York, giving up his career as a soloist for a step down to a position in the corps de ballet of the New York City Ballet in order to be closer to O'Hara, to save him. "I was going to give up my dance career because I was so upset about Frank doing so much work at the Museum and not being interested in writing anymore," says Warren. "I thought that my destiny, my fulfillment would be in doing that."

They spent their last weekend together at Patsy Southgate's house in the Springs at the end of June. On Friday afternoon, they took the 4:19 to East Hampton—the same train they had taken to Southampton on their first weekend together over seven years before. Warren stayed through Monday, June 27, which was celebrated as O'Hara's fortieth birthday though the event was not marked by any gigantic party. The weekend was a perfect one for O'Hara. Willem de Kooning and Joan Ward came to dinner on Saturday evening. Calling O'Hara later, de Kooning said of Warren, whom O'Hara was proud he had remembered, "Yeah, I have a hard time remembering people unless they're kinda mahvulous." O'Hara reported the comment to Warren in a letter, calling it "Praise from Caesar." De Kooning also bicycled by, while

O'Hara was trimming wisteria on a high ladder, to announce that he would finally agree to a retrospective at the Museum. "If *you* do it, OK!" he said. The agreement was a coup, as de Kooning had refused such a show for years. He had dismissed retrospectives as obituaries. O'Hara and Warren also visited Lee Krasner, who threw her support behind a Pollock retrospective O'Hara wanted to curate. As he wrote to Warren, "The museum is of course quite astounded by that and Bill too." O'Hara was most immediately pleased, though, by the rekindling of his romance with Warren. So pleased, and distracted, that when Joe LeSueur called to wish him happy birthday he did not bother to come to the phone. "We felt just as badly as you did when the train pulled out of the station," he wrote to Warren of his own stay until Wednesday. "As a matter of fact we drove back to the Springs with both Patsy and me having tears rolling down our cheeks, which fortunately the children didn't notice as they were already fighting about something in the back seat."

"I remember taking a longish walk with Frank on a boardwalk over the dunes talking about getting back together," says Warren. "I remember there were two guys coming and I didn't want to turn around, I wanted to check them out. That made me feel terrible when I realized I was still cruising. Here we were making plans and I was already looking at other people. I probably would have gone to New York and taken care of Frank and slept around. Would I have really helped him?" Such plans at the time, though, were hardly so clear-cut. Writing to O'Hara on July 7, Warren sent a message much more in keeping with their understanding of their situation at the time: "What a beautiful time in East Hampton with you . . . and Frank, what about us—maybe it's *more* beautiful this way—because I know that you'll always love me, even if I don't see you more than twice a year—because my life is really in Montreal now—or rather my art is—and finally that has become my life—something that could never happen in New York. Anyway, I'll always love you, I know now—thank you."

The summer was marked by other real or imagined reconciliations. "I remember just before he died he was out here for a weekend," recalls Larry Rivers. "He was going to sleep in his own room. He opened the door and said in a whisper, 'Want a blow job?' Here we were in our forties. So I said, 'Okay.' All these years he would sometimes try but it wouldn't work. Here we were alone in the house. It was a scene. I just thought, 'Oh why not? What am I building?' So he came in." (According to LeSueur, O'Hara told him the story afterward but claimed that Rivers had turned down his overture.)

Grace Hartigan remembers a weekend in the Hamptons that was far more conciliatory than their 1964 dinner, at which O'Hara told Rivers he had found her "insufferably opinionated" and "much louder even than before." "Just before Frank died I invited him to come for a drink at a place Win and I had for a month at Gardiners Bay," says Hartigan. "He said he had these friends with him and I said, 'Well I have plenty to drink.' He said, 'I wasn't talking about the supply you have. I was wondering if you minded if I brought some friends.' So he did have four or five lovely lads who came along who were good-looking and charming and nice. Increasingly it was impossible to have Frank to yourself, I think. We had a long talk and he said, 'I would never have forgiven you if you'd done it any other way.' In other words, I broke with him with the seriousness which the relationship deserved."

On a weeknight in the middle of July, O'Hara went out to Brooklyn Heights to have a dinner of soft-shell crabs with his sister, Maureen, her husband, and two sons. He was very lively that evening. "I remember when he came to dinner that evening, wearing his moccasins, he was so high-spirited," recalls his sister. "He was wonderful with the kids." One of the topics with which he was obsessed was the Vietnam War, that spring having been marked by demonstrations in seven American and seven foreign cities against the growing war. Midway through the meal he popped up from the table and said, "It's just clear that President Johnson should stand up before the entire world and apologize and get this over with!" He stayed until one or two in the morning and then insisted on walking to the subway rather than taking a cab. In a rare moment of complaining, though, he admitted to his sister, "I wish other people cared about my work as much as I care about theirs."

Dark comments threaded through the month's lunches and dinners. At Larré's O'Hara remarked to Stephen Holden, "Death doesn't bother me but pain in life does." In a phone call one Friday afternoon to Tony Towle from Penn Station he remarked apropos of nothing in particular, "You know, when I was doing rough trade in the subways years ago nothing ever happened to me. Well, it's always when you least expect it." Memories of such comments have been recognized, of course, by hindsight.

Bill Berkson saw O'Hara almost daily in July as he was beginning to work on the Pollock retrospective scheduled for March 1967. At lunch on July 7, he and Helen Frankenthaler were startled to watch O'Hara, visibly nervous, shaking as he tried unsuccessfully to lift his first negroni to his lips. Frankenthaler shot Berkson a look that seemed to say, "What?! DTs perhaps?" O'Hara explained, however, that he was merely nervous because he had just promised that he would direct the

entire Pollock show. He wasn't sure he could meet the deadlines. He was trying as well to get a Guggenheim to escape the Museum grind for a year to write a biography of Pollock for Coward-McCann publishers. Berkson noted in his diary for July 13 a similar lunch: "Frank still seems distracted. Noticed a slight tremble in one hand at lunch, at which notice he gave me a little, bemused side glance."

One night after attending an event at Lincoln Center, O'Hara and Berkson went to a coffee shop around the corner. Like O'Hara's sister, Berkson was surprised to hear him bewail his own lot. It was so out of character. "I can't handle things," O'Hara said suddenly without being prompted or asked. "There are all these people in my life, all of whom want all of me. What do I do?"

On Friday, July 22, O'Hara showed up at work wearing a maroon shirt and Top-Siders—an outfit casual enough for his new secretary, Elizabeth Tweedy, to notice. He was planning to leave early that muggy Friday afternoon for a weekend at Morris Golde's house on Fire Island with Virgil Thomson and J. J. Mitchell. O'Hara seemed cheerful, but then he was always a bit "enigmatic" and "difficult to read" to his new secretary, who claimed to be in awe of him, "like a deer blinded by headlights." "I had never been around a cult figure before," says Tweedy, who had just graduated from college.

Fire Island was not O'Hara's first choice for the weekend. He had called Larry Rivers to try to wangle an invitation to the Hamptons for himself and J. J. But Clarice Rivers had protested. "The girl I was married to made me feel that she didn't like J. J. and that she would prefer them not to come," says Rivers. Next O'Hara called Golde, who had already invited Virgil Thomson. "You know, I really have never gotten to know Virgil," O'Hara said of the sixty-nine-year-old composer and former music critic for the *Herald Tribune*. "Can I join you? Can I bring J. J.?" Golde, used to mixing guests at his painting-filled garden apartment on West Eleventh Street, gladly agreed. The house party made sense, as Thomson was fond of Mitchell. As O'Hara had written to Ashbery of Thomson's first meeting with Mitchell in 1961, "He turned to him abruptly and said, 'How do you feel about older men, baby.' JJ: 'I think I prefer younger ones.' VT: 'Very good, so long as we get things straight at the start. You're a good boy.'"

O'Hara and Thomson had certainly been well acquainted for years though their friendship was cautious. O'Hara complained to Kenward Elmslie that Thomson got on his nerves by pontificating too much.

Thomson complained to Edwin Denby repeatedly that O'Hara had sold out by working at the Museum. They were at their best together at busy campy parties. "Joe and JJ and I and Kenward went to dinner at Chuck's which featured Virgil and Ned and a negro hustler named Joe who called himself Miss Dietrich from Hollywood," O'Hara had written to Rivers of one such gathering in 1963. "It was just like John Rechy's novel. He was of course 6'2", gorgeous. He liked my chest the best, but money more. V at first tried to talk him out of any fee by saying, 'Well baby, it's a noble thing to be a negro, but it's an ignoble thing to be a whore, right?' To which this Harry Belafonte substitute smiled gently and replied, 'Ah don't know as ah understand quite what yuh mean.' Ned was quite huffy to him since he thinks *he's* Miss Dietrich. After we were kissing in the kitchen the hustler opined that it was a pity I was a 'poor poet,' a piece of information he picked up from that sand-bagging Joe L. Anyhow, I thought you'd be interested to know how we cultural leaders who remain in New York during the summer amuse ourselves (and each other)." The makeup of the group at Golde's that July weekend promised more of the same.

Golde drove out on Friday afternoon in his Mustang. "Virgil loved riding around in little cars," Golde says. They all then climbed into his small Whaler for the trip across the Great South Bay to Water Island, one of the more inaccessible communities on the thirty-two-mile-long barrier beach of Fire Island. O'Hara, of course, was quite familiar with the cedar house on stilts, where he had written his first James Dean poem and had heard the news of the death of Jackson Pollock. Arriving late in the day, the four had a leisurely dinner before retiring early.

Saturday was a brilliant beach day—sunny and breezy with temperatures in the eighties. The only damper was Thomson, whose exuberant plunges into the surf were making everyone nervous. Though hefty in appearance, the composer actually had the bone structure of a thin man. When Thomson was eventually knocked over by one of the Atlantic rollers, O'Hara, thoroughly acclimated to this "dolorous surf / and the brilliant sunlight declaring all the qualities of the world," dove in to fetch him. Emerging a bit shaken by the experience, Thomson simply said, "I think I've had it with the ocean." That night they dined sumptuously on a meal for which Thomson drafted J. J. Mitchell as sous-chef. The menu was prepared à la Alice B. Toklas, whose complicated cooking style Thomson had been privy to in Paris in the 1920s when he was writing the music for Gertrude Stein's opera *Four Saints in Three Acts*. There was a gigot, corn sheared from the cob, and a

generous accompaniment of Moulin à Vent. "The Belgian rule," Thomson insisted. "Seven bottles for six people." As Water Island was a dark town with no electricity, the glassed-in house with surrounding deck over the dunes was lit with kerosene lamps and flickering candles. O'Hara was unusually quiet that night. "Virgil expounding, Frank deferring," recalled Mitchell. After dinner, Thomson justified his dominating the stage of the dinner table by expounding about Love and Manliness in a way that left them all stunned. "It was a grand, incredible speech," recalls Golde. "Frankie just loved it. Virgil was saying that being gay was not a modification of manliness but rather a call for more manliness. Because that's what it took to have a real love. It was positively Homeric. It was as if somebody were just pulling a final curtain down on Frankie." To cut the awed silence afterward, Thomson said, "Thank you for letting me be brilliant. Now let's go look at the animals!"

Thomson was referring to the partyers at Fire Island Pines, a few miles down the beach—a far more hopping community than Water Island although only a vague premonition of the roaring disco orgy that evolved there during the 1970s. Its manmade harbor, later host to world-class yachts by the score, was still largely black and quiet at midnight with only the sound of the bay waves slapping. Nightlife was confined to the restaurant of the Botel—a hotel on the harbor—that converted into a dance bar on weekends. The Pines, though, already had a reputation for being "piss-elegant" in comparison to Cherry Grove, the next resort up the beach. Cherry Grove was an older community made up of down-to-earth beach cottages with back-porch showers and campy names such as "Shirley's Temple." "Cherry Grove was much more hard-core," says an art critic who rented a house there, as did W. H. Auden, Janet Flanner, and curator William Lieberman. "The Pines was newer, flashier, with more luxurious houses and more Madison Avenue types." Both communities were mixed, although their tone was decidedly gay. Among the residents of the more chic, less populated, higher rent Pines in the summer of 1966 were Montgomery Clift, a group of Paul Taylor dancers, and collector and painter Heidi Kleinmann and her husband. The previous summer Warhol had filmed *My Hustler* starring Paul America on its beach and in one of its spare angular wooden houses built along narrow boardwalks over dense growths of pines, cedar, holly, and wild cherry. With the Pines dance bar as their destination, Golde's party called for a beach taxi—one of the various licensed covered jeeps driven on the wet sand along the ocean's edge by local guys from Long Island. Until restricted after 1966 because of erosion

and a series of accidents, these beach buggies were the only vehicles allowed to ply the island, which had no roads and was otherwise inaccessible to traffic of any kind.

While the scene at Fire Island Pines might have been quiet in comparison to what transpired a decade later, the Fire Island Pines bar discotheque could spiral far upward and outward as a Saturday night wore on, its hit song that year being "These Boots Are Made for Walking" by Nancy Sinatra, its most popular drink Blue Whales. "At that time the Pines was like no other place on the Eastern seaboard, or Europe, or anyplace in the world," recalls Golde. "It was very chic and smart and well dressed. It had its loonies and it had its eccentrics. There was tons of dancing." Even the driving beat, though, could not stop Thomson from taking his customary after-dinner snooze at their table. An hour later he wanted to go home. However, O'Hara and Mitchell, true to form, wanted to linger to have yet another stinger. So they were left by Golde and Thomson to follow later. O'Hara was wound up by now, his attitude the one he had expressed to Mitchell only two weeks earlier after a similar night of drinking. Mitchell had asked, "Don't you ever get tired and want to sleep?" O'Hara replied winsomely, "If I had my way, I'd go on and on and on and never go to sleep."

Finally they grew tired of the scene and made their way down to the beach to hail a taxi. White Cap Taxi Company, owned by a Patchogue resident, operated a fleet of a dozen red-and-white covered jeeps with oversized wheels that ran twenty-four hours a day—its drivers being required to wear white caps, although they usually didn't bother. O'Hara and Mitchell squeezed into one of the taxis, already overcrowded with seven or eight "groupers"—young men and women who pooled their resources to rent a cottage for the summer. They were on their way to the singles community of Davis Park with its own nude beach less than a mile up from Water Island. O'Hara and Mitchell were the only two passengers on their way to the more reclusive Water Island. Within minutes of setting off, however, the taxi threw its left rear tire, leaving its passengers stranded on the darkened beach near Crown Walk, still within the limits of Fire Island Pines. The driver radioed for another taxi while keeping his headlights shining up in the air to warn any oncoming traffic. There was no other illumination from the roadway or the sky, as the first-quarter moon had set a few hours earlier, and little if any light from the houses on the beachfront about 150 feet away. The passengers milled about while the driver tried to fix the tire. J. J. Mitchell loitered on the land side of the broken-down taxi. O'Hara, who had

been standing by Mitchell, wandered off momentarily toward the rear to look up out at the water. The rest was a bleary nightmare.

Driving down the beach with a girlfriend in the direction of the stalled water taxi was twenty-three-year-old Kenneth Ruzicka from Patchogue. His vehicle was an old red four-cylinder jeep built in 1944 with a square, sharp hood and a steel beam across its front serving as a bumper. Living in Davis Park that summer while working driving taxis or doing odd jobs for the summer visitors on the island just a brief ferry ride across the bay from Patchogue, Ruzicka was a popular local boy. With square jaw and dark wavy hair, the handsome young man had been a football star on the Patchogue Raiders as well as a member of the school's soccer and track teams. His legend in the 1961 yearbook: "Maneuvers smoothly on the football field where he prefers to be." That night, according to Ruzicka, he and his girlfriend were on their way to a discotheque at Cherry Grove. It was reportedly common practice for Suffolk County police and rangers, as well as local workers, to go for such joy rides in their jeeps.

The time was approximately 2:40 a.m. Claiming to have been blinded by its headlights, Ruzicka attempted to avoid the water taxi upon which he was suddenly bearing down. "There was a light," says Ruzicka. "I had driven taxi cabs so I knew what the conditions were. If the lights were in my eyes then there must be a flat tire on one side, so you give a wide upsweep so that you wouldn't be involved with anybody who might be around a taxi." The maneuver, however, was too little too late. Mitchell yelled "Frank!" as the rest of the passengers jumped back. O'Hara had just stepped out from the darkness and was standing in the path of the oncoming machine. In Ruzicka's testimony at a hearing of the New York Department of Motor Vehicles in February 1967, he emphasized that he was going slowly, "anywheres from fifteen to twenty. I was up in the soft sand in second gear." He emphasized O'Hara's culpability as well. "He was coming towards me, that's all I could see," testified Ruzicka. "He didn't even try to move, he just kept on walking." That O'Hara was smashed by the right front fender instead of the left implies that he was taking a wide arc as he stepped out to face the oncoming headlights. Ruzicka claimed that the wheels did not run over O'Hara. "He kind of fell over the right fender," he said. "I think just the hood had a little indentation in it, not a permanent dent, just like a buckle, like you hit a refrigerator."

J. J. Mitchell remembered the accident as unfolding at a higher and much more threatening speed. "After waiting about three or four min-

utes a beach buggy came from the direction we had been heading from, the east," he testified in a deposition filed in January 1968 as evidence in an unsuccessful attempt to bring "negligent homicide" charges against Ruzicka. "The driver approached and we could see his head-lights quite a distance away. As he neared us he appeared to be coming quite close to our cab and was not slowing down. So all of us jumped out of his path and shouted 'Frank!' Frank turned around to face the oncoming beach buggy but did not have time to get out of his way. The beach buggy struck him and continued on about ten or fifteen feet be-fore stopping. Frank was on the beach about ten feet from the rear of the taxi and about twenty feet from the rear of the beach buggy. The beach buggy appeared to have run over him." He added, "The driver appeared to be going as fast as the beach buggy could go on the sand, which is close to the water and probably was relatively packed."

Whatever the conflicts of emphasis, the truth was that the body of Frank O'Hara was now lying battered in the sand as vehicular head-lights pointed off at different angles into the dark sky. Everyone rushed toward him, propelled by a numbing confusion. "Frank was suddenly lying in the sand, obviously hit by the beach buggy, which had now stopped ahead in the darkness," Mitchell has written in a memoir. "We all run to his aid. The taxi radios for the Police and the Pines doctor. We examine him. He is unconscious, but beginning to stir, moan. It doesn't look disastrous. (Frantic inner denial of the worst, hope for the best.) The young summer resident doctor arrives, miraculously fast. He takes his pulse, probes with his fingers. Frank's leg is definitely broken; contusions, abrasions, but no immediate evidence of internal damage." As Mitchell told the painter Al Leslie, "He lay on the sand—on his back—one hand on his chest—he looked like he was asleep." Ruzicka concurs: "I took my blanket that I had in the cab and covered him up and he just lay there snoring."

Police Patrolman Warren Chamberlain, Jr., arrived on the scene at 3:05 a.m. Also a resident of Patchogue working on the island for the summer, Chamberlain had various ties with Ruzicka. Chamberlain's father, Warren Chamberlain, Sr., had been an art teacher and class ad-visor at Patchogue High School when Ruzicka was a student. Cham-berlain's brother, Dean, was a classmate of Ruzicka's and a comember of the Pep Club senior year.

In his Traffic Accident Report, Patrolman Chamberlain wrote that Ruzicka and his passenger were in "apparently normal" condition and had not been drinking. He described the accident from Ruzicka's point-of-view: "Comp stated he was proceeding west, when he was blinded

by lights from veh—At this time Ped walked from behind veh and into his path." He failed to write down the names of either the driver of the water taxi, Ruzicka's female passenger, or any of the stranded passengers who had witnessed the accident. When asked about this oversight at the Motor Vehicles hearing, Patrolman Chamberlain explained that "we were more concerned with the victim than we were with the vehicle at the time." Of the young lady in the car, he said that she had no statement to make. Ruzicka testified that his passenger was named "Bette Smith" and that she may or may not have seen O'Hara hit. The judge was satisfied with his explanation and did not call the woman to testify. "I think she was talking to me or something," said Ruzicka. "It just happened, it's hard to describe it, it just . . ." On the night of the accident, as the local paper, the *Long Island Advance,* reported, "No summons was issued to Ruzicka." Such casualness and leniency led to a later unsubstantiated feeling among O'Hara's friends that the accident was covered up because of loyalty among local workers, who perhaps were less than sympathetic with "summer people," or homosexuals from the city. Patrolman Chamberlain completed his investigation at 3:38 a.m., a half hour after arriving on the scene.

O'Hara's agony, though, was just beginning and would continue for the next forty hours. The police transferred him to a jeep to transport him to the bay side of the island to await a police launch for the ride to the mainland where he would be met by an ambulance. The original plan was to rush him to Brookhaven Memorial Hospital in Patchogue, the largest hospital in the area, with about 150 beds. "Everything proceeds with remarkable expediency," J. J. Mitchell wrote. "I accompany Frank across the bay, holding him down as he begins to come to. Complains of terrible pain—leg, ribs. Terribly uncomfortable. Won't stay still. I try to comfort him: 'Easy, don't move, your leg is broken . . . we'll be at the hospital soon . . . bear up . . . everything will be O.K.' Not much comfort." Ashore a private ambulance was waiting. They were told that the emergency rooms at Brookhaven and elsewhere were full because of Saturday night highway accidents. So the ambulance instead drove O'Hara—by now thrashing about deliriously—to Bayview General Hospital, a privately owned hospital in Mastic Beach.

Bayview General Hospital was a disappointment, looking, as J. J. Mitchell wrote, "like it was built with a Girl Scout cookie fund." It was a modest two-story red brick building with about thirty-five beds, an operating suite, and laboratories. There was hardly any staff. The only doctor present was a one-night emergency doctor who set to work immediately on O'Hara, Mitchell having been told to wait in the re-

ception area. After a short examination the doctor informed Mitchell
that he had done all he could do. There was still no evidence of serious
internal injury. The next step would be to wait until the arrival of the
daily staff and an orthopedic doctor to set the leg. Meanwhile O'Hara's
external abrasions were bandaged and he was wheeled into an empty
private room to await the dawn. At around five in the morning, Mitch-
ell called Morris Golde. "Keep us posted," said Golde. Lulled into false
optimism Mitchell then fell asleep on the waiting room sofa.

With the light of morning the daily hospital staff finally arrived.
They insisted that J. J. Mitchell keep out of the ward, wait outside. He
pushed, made inquiries, feeling frustrated by "a long conspiracy of si-
lence." Finally he was informed that O'Hara's blood pressure had be-
gun to drop—a sign of serious internal injury. At around eight that
morning Mitchell called Joe LeSueur. "It's serious, Joe," he said. He put
through another call to Golde and Thomson, who then made plans to
make the trip across. Next he called Patsy Southgate.

The hospital's procedure was to call a list of local Long Island doc-
tors to find out who would be available for surgery that afternoon. A
team of four doctors and an anesthetist were eventually lined up. A call
was put out as well for Type A blood, which was delivered throughout
the morning at intervals by dozens of state troopers. By late morning
Golde and Thomson arrived to discover an exhausted Mitchell and a
hospital that did little to inspire their confidence.

"It was a dreary little hospital," recalls Golde. "They didn't know
who they had there." He was informed that no one would be allowed
in to see O'Hara as he was in intensive care. There was talk of calling
D. D. Ryan and other rich friends in New York to have him moved to
a better hospital, but they were told that he could not be moved. Soon
Patsy Southgate and Norman Bluhm arrived from East Hampton. They
were equally discouraged by the situation. "They were extremely rude,"
says Bluhm. "The information was minute. We requested and asked.
We were curious. We asked if we could just walk in and out. They
wouldn't let us. They were really raw. It was a bad scene. It left a bad
taste in everybody's mouth." O'Hara's friends waited uneasily through-
out what seemed an interminable operation, trying their best to chit-
chat beneath a tree outside the hospital. At the end of the afternoon, a
fatherly looking surgeon finally emerged to confer with them. Thomson
reported the surgeon's prognosis in a letter to the painter Maurice Gros-
man the next day: "A broken leg and facial plus other lacerations are not
important, but a liver injury which caused the loss of a quarter of it
(most of the left lobe) give him, it seems, less than a 50–50 chance to

live." O'Hara also had serious kidney contusions and there was danger of internal hemorrhaging. "Everything possible has been done," wrote Mitchell of the feeling at the end of the day. "The night will tell. Nothing more to do. A numb return to New York."

By the next day—a Monday, July 25—the alarm had been sounded among O'Hara's friends in New York and the Hamptons. His brother had boarded a noon flight from Chicago. His sister and her husband had finally been located on vacation in New Hampshire and were driving down. Various friends were converging on the tiny hospital, few as yet completely comprehending the seriousness of the situation. Larry Rivers drove Joe LeSueur, Kenneth Koch, and J. J. Mitchell to the hospital from New York. Willem and Elaine de Kooning came from East Hampton. (At a party in East Hampton the day before, Marta Zogbaum had rushed in and said excitedly, as though it were a juicy bit of gossip, "Frank O'Hara's been seriously injured." Elaine de Kooning later told Joe LeSueur she felt as if she wanted to slap Zogbaum for being so flippant. She immediately left to tell Willem de Kooning.) Wynn and Sally Chamberlain stopped by on their way from Bridgehampton to Rhinebeck. Tony Towle drove Tatyana and Maurice Grosman from Universal Limited Art Editions in West Islip. René d'Harnoncourt arrived from the Museum and arranged to pay for a round-the-clock private nurse. A specialist in internal surgery at Columbia-Presbyterian was called to consult on the possibility of airlifting O'Hara to New York. The consensus, though, seemed to be that nothing more could be done.

The head surgeon decided that a few close friends could see O'Hara one at a time, for a minute or two. De Kooning, who had arrived with a big checkbook offering to pay for everything, discovered O'Hara in great pain. "When I spoke his name he opened his eyes and he said, in that way of his, 'Oh Bill, how nice!'" de Kooning later recalled. "He had so much grace, that man, even through all the delirium and agony." On his way out of the room he was faced with Wynn and Sally Chamberlain holding flowers. "Bill de Kooning came out crying," recalls Wynn Chamberlain. "I've never seen him like that, just weeping. When we went in we realized Frank wasn't going to live. He looked like a Francis Bacon."

"Frank was there looking bruised but with that same damnably lovable indomitable head of his," recalls Kenneth Koch of his brief visit. "He was just being polite, wanting to spare everybody pain, saying he was fine. He wasn't fine. He wanted everybody to feel just what everybody would like to feel, that it would just all go away. I wanted so much

to feel that it would just all go away that I believed him. Then when we got out of the room I said to the doctor, 'Is there anything we can do?' He said, 'Pray for your friend.' That's when I really thought he was going to die."

"I remember talking to him on the telephone from Provincetown when he was in the hospital," says Helen Frankenthaler, who made one of the few successful calls in. "I said, 'Do you want or need anything?' He said yeeessss! Just that way: small *y*, bigger *e*, huge *s*. I could hear he was in trouble."

Larry Rivers, with his figure-drawing eye for unsettling details, took in with shock the condition of his best friend. His eyes traveled in horror over O'Hara's body as he lay without a pillow in the hospital crib, his skin purple where it peeked through the white hospital gown, eyes black and blue, stitches three or four inches long, a splintered leg. "He breathed with quick gasps," as Rivers recalled at O'Hara's funeral. "His whole body quivered. There was a tube in one of his nostrils down to his stomach." Rivers claims that O'Hara recognized him intermittently although he would then lapse into speed talking. "He was raving," says Rivers. "He would say, 'I think that Norman Bluhm should give a cocktail party and we'll invite Joan but we'll tell her to wear . . .' It was like that."

J. J. Mitchell and Joe LeSueur decided to go in together. O'Hara at first said "Oh Steve," mixing J. J. up with Stephen Holden, who also had long hair at the time. "We see him enmeshed in all the paraphernalia of post-surgery, but alert and trying to be cheery," J. J. Mitchell has written. "I say: 'The doctor says you can't drink for a year.' He says: 'It hurts to laugh. Isn't it nice of Bill (de K) to come?' Brave and gracious to the end. Joe chats a moment, we leave: 'Don't worry. We're here. See you tomorrow.' On leaving the room we burst simultaneously into tears." As LeSueur recalls, "We sort of barely touched him. He didn't really know us. There wasn't much connection there."

Outside on the lawn they talked for a bit with the anaesthetist, a charming woman born in France. "Who is he?" she asked, taking in the growing crowd of visitors. "It's extraordinary that he is alive. His will to live is in his favor. He detected my French accent and joked with me in French." According to LeSueur, "She wanted to know how much drinking he did. She said he would very likely have survived this thing if his liver hadn't been in such terrible shape. In other words he had drunk so much that he couldn't withstand the horrible thing that happened to him that night. In a sense he died of alcoholism."

The doctor then cut off the flow of visitors. Tony Towle, arriving

late, wrote a note to be sent upstairs parodying O'Hara's Lana Turner poem: "Frank. We love you. Get up." The friends all then converged on a nearby clam bar for a late lunch. "Again, a numb return to New York," wrote J. J. Mitchell of their dispersal by late afternoon. "Cheerless drinks at Max's with Larry et al. 'What would life be like—New York be like—without Frank?' False hope persists, but foreboding has set in."

By early evening the family finally arrived. The stories of O'Hara's brother and sister diverge on what actually transpired in the last hour of O'Hara's life. Reflecting the sort of family schisms that had developed after the death of their father as they tried to cope with their mother's alcoholism, Maureen O'Hara, like Frank O'Hara, was often at odds with her brother Philip. Philip O'Hara remembers arriving at the hospital after stopping in town at the office of one of the clinic's doctors, who told him that his brother's injuries were "terminal." Reminded of his trip to Metropolitan Hospital after his brother's bullet injury in 1954, Philip O'Hara hopped back in the car he had rented at La Guardia Airport to drive to Mastic Beach. "I went in the lobby and it was empty," says Philip. "There was nobody there but a nurse. I identified myself, asked how Frank was, and I went upstairs to the room. His right hip and lower leg were in a cast, he was all bandaged up, his head was double its size, he was unconscious but breathing. I kissed him and then he woke up and said, 'Phil, you don't have to be here. Go down in the lobby with Ariel and the kids. I'll be right down.'" The reference was to Philip O'Hara's wife and children. "They were in Chicago," explains Philip O'Hara. "It was all hallucination. I was there alone. And then he was gone."

According to Maureen O'Hara she arrived at the hospital with her husband before her brother's death. "It was just myself, my brother, and Walter," she says. "No one else was there. Then I called Patsy Southgate. Frank was talking. I don't know whether you'd call it a coma. He was just talking so fast. It was just amazing. I didn't think he would die. I just saw all that energy. There were lots of things going on in his mind. He was hallucinating or something like that. George Montgomery called and said, 'Be sure and give him a hug.' I talked with Bill Berkson. I talked to the doctor at Columbia-Presbyterian." Patsy Southgate remembers talking with Maureen O'Hara at the hospital.

"Maureen was there after he was dead, absolutely," counters Philip O'Hara. "She got there about fifteen minutes after he died. They asked me to leave after he died, and the nurse put a sheet over his head. They put me in an anteroom, and Walt and Maureen came sometime after

that into the dark room where I was. They hadn't moved Frank. Maureen wanted to know why I hadn't had him lifted to Columbia-Presbyterian. Then she asked to see him. She looked at him and then went off and got very upset about Columbia-Presbyterian. She kept talking about helicopters and all that stuff."

What is certain is that at 8:50 p.m. on July 25, 1966, Frank O'Hara passed away at the age of forty.

Within the hour everyone seemed to know of O'Hara's death. Helen Frankenthaler called Bill Berkson at D. D. Ryan's in Newport. Patsy Southgate called Joe LeSueur. Joe LeSueur called Larry Rivers. Kynaston McShine called Tony Towle. Tony Towle called Jasper Johns. Roy Leaf called Vincent Warren in Montreal. Janice Koch sent a telegram to Fairfield and Anne Porter and James Schuyler on Great Spruce Head Island in Maine. Waldo Rasmussen called J. J. Mitchell. J. J. Mitchell called Joe LeSueur, who already knew. "Come over," LeSueur said.

LeSueur hosted a spontaneous wake that evening in his tiny apartment on Second Avenue. There were lots of tears. Emotions were distorted, raw. The weirdness of the limbo between a death and a funeral was accentuated by the suddenness of the event. Many of O'Hara's friends were crowded in: Frank Lima, Ned Rorem, Camilla McGrath, J. J. Mitchell, Larry Rivers, Alvin Novak, Mike Goldberg, Karen Edwards. The actress Barbara Harris called to talk to Arnold Weinstein. "They were all the people you saw at parties," recalls Rorem. "They were high-powered, spirited intimates of Frank. Here were all these people, who should normally be laughing and screaming behaving as if the world had come to an end." When Rorem politely asked Mike Goldberg, "How have you been?" the artist turned on him. "That's a hell of a question at a time like this," he snapped, filled with the inchoate anger of the moment. "I remember Larry asking J. J. how much money Frank had in his wallet," says LeSueur. "He said, 'Well I won't make a claim against the estate. Just give me what's left. Because he borrowed $600 from me." Then Kenneth Koch arrived at the door carrying two suitcases. "Have you come for the weekend?" LeSueur slightly joked. "No," said Koch. "These are for Frank's papers. I want to get the keys to the apartment. I'm going to get the poems to make sure nothing happens to them."

Koch may have been put up to the mission by Larry Rivers. "I remember that Larry and I were talking on the phone feeling that we had to do something," says Koch. "I guess our instinctive criminality

led us." They were also receiving distressing messages from East
Hampton, feeding their paranoia. Frank O'Hara's brother and sister
were both staying at Patsy Southgate's house at her invitation. South-
gate remembered that O'Hara had once told her that he would like to
be buried in Green River Cemetery. This was the burial plan favored by
Maureen O'Hara and Bill Berkson, who was in a small plane on his
way from Newport to the Hamptons. However, the schism between
Maureen and Philip, friends and family, was deepening and growing
more jagged by the hour. "There was a lot of alcohol consumed and a
lot of emotion," recalls Philip O'Hara. "The two main issues were
where he was going to be buried and if my mother would indeed be
there. Initially I wanted him to be buried in Grafton and I was a ma-
jority of one. But I was also a majority of one on my mother coming.
So there was a trade-off." Norman Bluhm describes Philip O'Hara at
the time as "a real lace-curtain Irish drinker." Sometime during the
confusing week Philip O'Hara managed to retrieve from 791 Broadway
some "personal stuff" rumored to have been angry letters written by
Joe LeSueur to Frank O'Hara during their falling out. "There was talk
at Patsy Southgate's of going into Frank's apartment, unauthorized, and
saving everything," says Philip O'Hara. "I took steps to make sure that
didn't happen." As O'Hara had died intestate, Koch and other poets
were worried that night about the confiscation of the poetry. "We were
afraid that his family, especially his brother, would throw away his
poems like happened to Blake," says Frank Lima. "William Blake's
executor burned a lot of his poems because he thought they were
irreligious."

So Kenneth Koch, Larry Rivers, and Frank Lima raided 791 Broad-
way. "I was in a fog," recalls Lima, who, according to LeSueur, took
O'Hara's passport as a memento. Larry Rivers picked up some of his
own paintings, which he had lent O'Hara and felt were endangered.
Koch focused most clearly on the task at hand. "In the closet we found
all of these manuscripts," says Koch. "Jesus, he'd written a lot that no
one had ever seen. They were all dated. They were very organized,
some of them revised. I went over those poems, crying all the time."

Talk was already beginning that night among O'Hara's friends
about the nature of the death. A romantic notion of suicide was even
given play. "I always felt that Frank's death was at least part suicide,"
concurs Grace Hartigan, who had not been intimate with O'Hara dur-
ing his last years. Yet an answer to that view had already been given
by O'Hara in a line that began to haunt those of his friends who re-
membered Al Leslie's *The Last Clean Shirt,* a line about accidents: "I

have the other idea about guilt. It's not in us, it's in the situation. You don't say that the victim is responsible for a concentration camp or a Mack truck." The ingredient of suicide was part of the general destructiveness of alcohol. That the liver was the organ responsible for O'Hara's death seemed apt. That he had been drinking was hardly surprising to those who had known him well during the fallout of the sixties. "I think Frank died because things got out of hand and because of the strain on his attention," says Berkson. "He died in a moment of extraordinary, for him, inattention. He didn't see that car coming. Or if he did, his reflexes ordinarily were faster. I think that everything had become too much for him." "At the end he fought for his life: I'm convinced of that," counters LeSueur. "This was someone who wanted to live, who had a great deal to live for—though, admittedly, he was headed for trouble when he was struck down."

Reading a cautionary tale into O'Hara's awful death was a temptation at such a moment. Certainly the last year of his life had hardly been his happiest, or his most coherent. And he had undeniably been flirting over the years in his writing with a kind of easy romanticizing of James Dean and Jackson Pollock as archetypal, tragic, suicidal, American geniuses. In "For James Dean" he had deified Dean as a victim of "hubris" who was punished by a society that supposedly resented the "prodigy and invention of his nerves." But O'Hara in that poem was in part updating the worshipful praise of religious poets of centuries past by bringing in an element of fanzine hyperbole. That he became caught up in a similar destiny to Dean's and Pollock's—though significantly not by driving a vehicle but by being run over by one—was perhaps misleading.

O'Hara had actually been refreshingly modern. He often wore a jacket and tie—the tie that is "blowing up the street" in "Poem" (Khrushchev is coming on the right day!). He held down an enormously demanding day job. Impatient with self-indulgent romanticist binges he sensed were truly dangerous or terminal, he tended to give depressed friends pep talks. In 1963, when Frank Lima was threatening to fall back into heavy drug use, O'Hara leveled him boldly: "All that will do is make it so there is one less good poet in the world." When he had seen a newspaper headline about Lana Turner's collapse he responded almost immediately with the poem ending with his exasperated demand, "oh Lana Turner we love you get up."

No one will ever know all that happened during the early hours of July 24, 1966, on the beach at Fire Island. Its blur of headlights, alcohol,

and police flashlights remains obscure. O'Hara was forty years old. Had he survived, it is quite likely that he might in due course have found a new Vincent Warren to serve as his muse and produced more volumes of poetry, maybe even liberating himself from the Museum of Modern Art in the process. He might even have curbed his drinking as time wore on. He had talked about starting an art gallery. In his last year he expressed interest in writing a commissioned critical biography of Jackson Pollock. These were the practical steps of a man who was capable, as he wrote in "Getting Up Ahead Of Someone (Sun)," of being

> *truly awake letting it all*
> *start slowly as I watch instead of*
> *grabbing on late as usual.*

O'Hara's growing fame as a poet might have helped shake his "ideas" loose as well. The cult that developed during the late 1960s and 1970s was already active before his death. Most of Ted Berrigan's early poems were bald imitations of O'Hara's "I Do This, I Do That" poems. This style, more than any other, was fast becoming the preferred style copied by most of the second-generation New York School poets already gathering at the St. Mark's Poetry Project, started in 1966 as the official home of unofficial poetry.

Eventually that night such talk died down. Everyone dispersed reluctantly to their own homes. Or to bed. J. J. Mitchell left LeSueur's to return to his own fifth-floor walk-up apartment in a tenement on East Ninth Street. Morris Golde had handed him O'Hara's weekend beach bag. When he unzipped the bag with curiosity, he found inside the usual tumble of beachwear—sneakers, swim suit, shorts, and toilet kit. He found as well two exceptional items. One was a manila envelope containing a carbon copy of a scientific paper prepared by Jackson Pollock's psychoanalyst exploring the role of the analyst vis-à-vis the artist genius. The second was a small journal with an embossed cover designed with a leafy pattern of red ink on a cream background. A small sticker inside the back cover noted that it came from "Roma"—probably bought by O'Hara on a Museum trip. The journal's pages were all blank except for a single entry on the first page, dated 4/7/66. It was a poem in O'Hara's own handsomely vertical writing titled "Oedipus Rex"—evidently inspired by Stravinsky's opera, for which Larry Rivers was designing sets at the time. The poem was O'Hara's last:

> *He falls; but even in falling*
> *he is higher than those who*
> *fly into the ordinary sun.*

A few weeks later Maureen O'Hara arranged for Kenneth Koch and Bill Berkson to use the photocopying machines at her husband's office in the Young & Rubicam advertising firm in midtown Manhattan. They spent a few nights there after the firm was closed discovering new poems. "Look at this!" one or the other would say excitedly as he found an unpublished or half-forgotten poem. They then took copies home to collate and classify by date.

Reading through the stack of poems later in his apartment on West Fourth Street, Koch came across for the first time "A True Account of Talking to the Sun at Fire Island," a poem that was to become a favorite anthology piece, which O'Hara hadn't shown to anyone while he was alive. A variation on Mayakovsky's "An Extraordinary Adventure Which Befell Vladimir Mayakovsky in a Summer Cottage," the poem had been written by O'Hara on July 10, 1958, when he was visiting Hal Fondren at his rented house at Fire Island Pines, not far from the spot where he would be hit almost exactly eight years later. The poem consists of a conversation between the Sun, who wakes O'Hara and complains petulantly, "When I woke up Mayakovsky he was / a lot more prompt," and the apologetic poet's comment, "Sorry, Sun, I stayed / up late last night talking to Hal."

"I almost fell off my chair," remembers Koch. "It was Frank talking about his own death." In the following months, Koch often read the poem at poetry readings to audiences who were invariably moved by its almost too neatly prophetic parting stanza:

> *"Sun, don't go!" I was awake*
> *at last. "No, go I must, they're calling*
> *me."*
> *"Who are they?"*
> *Rising he said "Some*
> *day you'll know. They're calling to you*
> *too." Darkly he rose, and then I slept.*

Notes

page 4 "It seems": Letter from FOH to Kenneth Koch, 6/16/58.

"Frank's head": interview with Robert Dash, 9/5/91.

"two hundred mourners": An incomplete list of those attending the funeral includes: William Agee, John Ashbery, William Berkson, Ted and Sandy Berrigan, Sheyla Beykal, Norman and Carey Bluhm, James Brodey, Harold Brodkey, Robert Cato, Joseph Ceravolo, Jerry Cohen, Robert Dash, Edwin Denby, Willem and Elaine de Kooning, René d'Harnoncourt, Karen Edwards, Frederick English, Morton Feldman, Helen Franc, Helen Frankenthaler, Jane Freilicher, B. H. and Abbie Friedman, Sanford Friedman, Henry Geldzahler, Allen Ginsberg, Mike Goldberg, Robert Goldwater, Tatyana Grosman, John Gruen, Barbara Guest, Philip Guston, Stephen Holden, Richard Howard, Sam Hunter, Irma Hurley, Howard and Mary Kanowitz, Alex and Ada Katz, Kenneth and Janice Koch, Lee Krasner, Ibram and Ernestine Lassaw, Frank Lima, Joseph LeSueur, Alfred Leslie, Joseph Lieber, Luke Matthiessen, Camilla McGrath, Kynaston McShine, J. J. Mitchell, Robert Motherwell, John Bernard Myers, Reuben Nakian, Barnett and Annalee Newman, Ellen

(Adler) and David Oppenheim, Lafcadio Orlovsky, Peter Orlovsky, Larry Osgood, Robert Perrell, Waldo and Gary Rasmussen, Larry and Clarice Rivers, Gaby Rodgers, Harold and May Rosenberg, Sheila Rosenstein, Irving Sandler, Peter and Linda Schjeldahl, David Shapiro, Jack Smith, Patsy Southgate, James Thrall, Tony Towle, Chuck Turner, Mindy Wager, Arnold Weinstein, Monroe Wheeler, Jane Wilson, and Marta Zogbaum.

5 "I always felt": interview with Edward Gorey, 12/14/89.

"Why does it seem": letter from Joe LeSueur to the author, 2/21/92.

"many bearded": Peter Schjeldahl, "Frank O'Hara: 'He Made Things & People Sacred,'" *Village Voice*, 8/11/66, reprinted in *Homage to Frank O'Hara*, ed. Bill Berkson and Joe LeSueur (Bolinas, Calif.: Big Sky, 1978), 139.

6 "at the funeral": Lewis MacAdams, "Red River," in *Homage*, 147.

"I felt": interview with Joe LeSueur, 5/9–10/88.

"After his": interview with Virgil Thomson, 2/2/89.

"it's well known": "Now That I Am in Madrid and Can Think," *The Collected Poems of Frank O'Hara*, ed. Donald Allen (New York: Alfred A. Knopf, 1979), 356.

7 "I never knew": interview with Bill Berkson, 10/2/88.

"That minister": interview with LeSueur, 5/9–10/88.

"Frank O'Hara": René d'Harnoncourt, Letter to the Editor, *New York Times*, 7/31/66, 16.

"a god": FOH, "Larry Rivers: A Memoir," *Collected Poems*, 512.

"standing": Berkson, "Afterword," in *In Memory of My Feelings* (New York: Museum of Modern Art, 1967).

"America's": Schjeldahl, "Frank O'Hara," 139.

"germ": interview with Berkson, 10/2/88.

8 like voodoo: interview with James Brodey, 11/11/88.

"As a poet": Schjeldahl, "Frank O'Hara," 139–40.

"full of dreams": letter from FOH to Fairfield Porter, 7/7/55.

"Larry's": interview with Waldo Rasmussen, 4/25/88.

"rather like": FOH, "Larry Rivers," 512.

"the question": "Frank O'Hara, 40, Museum Curator," *New York Times*, 7/26/66, 35.

9 "yoyo-cartwheel-violences": "Invincibility."

"Larry's eulogy": interview with Henry Geldzahler, 9/5/91.

"Frank was my": Larry Rivers, "Speech Read at Frank O'Hara's Funeral," in *Homage*, 138.

"People had acted": interview with Marjorie Luyckx, 9/5/91.

10 "What happened?": interview with Tom Broderick, 3/10/90.

"Frank O'Hara was": Rivers, "Speech," in *Homage*, 138.

11 "He was": interview with LeSueur, 5/9–10/88.

Birth

12 "a sort of W. C. Fields": interview with Joe LeSueur, 4/10/90.

"He did give the feeling": interview with Jane Freilicher, 1/9/90.

13 "I didn't want him": interview with Grace Hartigan, 9/13/89.

"I'm leaving": interview with Maureen O'Hara, 1/18/88.

"As you know": letter to Philip O'Hara, 1/11/63.

"Blondie will always be": letter from FOH to family, 12/10/44.

16 "shyster": interview with Grafton resident, 4/13/90.

17 "My mother said": interview with Maureen O'Hara, 11/14/88.

"huge brilliants-encrusted": FOH, "Autobiographical Fragments," in *Standing Still and Walking in New York,* ed. Don Allen (San Francisco: Grey Fox Press, 1983), 3.

19 "I am amused": interview with Maureen O'Hara, 11/14/88.

"calm and cool-headed": letter from FOH to family, 10/13/44.

"one of the best-known men in town": obituary in local Grafton newspaper, 1/25/47.

20 "My father drove": interview with Philip O'Hara, 10/19/89.

"an astounding capacity": letter from FOH to family, 3/19/45.

"with hands as big as clubs": interview with Philip O'Hara, 10/19/89.

21 "His father sold": interview with Tom Broderick, 3/10/90.

22 "wild": interview with Grafton resident, 4/13/90.

"I remember Aunt Margaret": interview with Maureen O'Hara, 3/14/90.

"My mother never": interview with Philip O'Hara, 10/19/89.

"She had these euphemisms": interview with Phil Charron, 9/8/90.

23 "I've often thought": interview with Philip O'Hara, 10/19/89.

"They were part": interview with Burton Robie, 10/11/89.

"You get the feeling": letter from FOH to family, 5/21/45.

"The other night": letter from FOH to family, 10/21/44.

26 "sissy": Bill Berkson, "Afterword," in *In Memory of My Feelings* (New York: Museum of Modern Art, 1967).

"cover myself": FOH, "A Journal," in *Early Writing* (Bolinas, Calif.: Grey Fox Press, 1977), 108.

"the coffee lake": "Kitville."

27 "If you couldn't get along": interview with Broderick, 3/10/90.

"toughened up": letter from FOH to family, 3/16/45.

28 "Russell could play": interview with Broderick, 3/10/90.

"My earliest political": FOH, "Autobiographical Fragments," 29.

"the only truth is face to face": "Ode: Salute to the French Negro Poets."

"heated 'discussions'": letter from FOH to family, 11/3/44.

29 "I think my father": interview with Philip O'Hara, 10/19/89.

29 "Our differences lie": letter from FOH to family, 3/29/45.
 "if it is true": FOH, "A Journal, 1/28/49," 109.

30 "Don't get in trouble now": letter from FOH to family, 11/30/44.
 "Then again": letter from FOH to family, 11/30/44.
 "as if each piece of chicken": letter from FOH to family, 3/9/45.
 "It's a Bergdorf-Goodman": letter from FOH to family, 12/15/44.
 "He was in love": interview with Hartigan, 2/14/88.

31 "She was a very hands-on": interview with Philip O'Hara,
10/19/89.
 "Francis was definitely": interview with Grafton resident, 4/13/90.
 "nigger": letter from FOH to family, 3/29/45.
 "She was a goner": interview with Philip O'Hara, 10/19/89.

32 "Francis just didn't": interview with Mary O'Hara, 11/15/89.

33 "I had no truck": interview with Philip O'Hara, 10/19/89.
 "Margaret and Francis": interview with Broderick, 3/10/90.
 "To this day": letter from FOH to family, 11/10/44.

34 *"I went to my first movie"*: "Ode to Michael Goldberg ('s Birth
and Other Births)."
 "He loved movies": FOH, *The 4th of July,* unpublished manu-
script, 2.

35 "I hope": letter from FOH to family, 3/9/45.

36 "And after all": FOH, "Personism: A Manifesto," in *The Col-
lected Poems of Frank O'Hara* (New York: Alfred A. Knopf, 1979), 498.
 "Lizzie had three times": interview with Philip O'Hara, 10/19/89.
 "I was sent": FOH, "Autobiographical Fragments," 30.

37 "My next political memory": FOH, "Autobiographical Frag-
ments," 31.

38 "A lot of my aversions": FOH, "Autobiographical Fragments," 30.
 "the orderly scuffing": *The Red and White,* vol. 4, 12/23/42, 3.

39 "These students have": *Golden Conquest,* ed. Brother Elias,
C.F.X. (Worcester, Mass.: Century Press, 1944), 124.
 "the bully who broke": "[It seems far away and gentle now]."
 "spikey": interview with Richard Dorr, 3/2/90.
 "Frannie wasn't gregarious": interview with William Cronin,
3/6/90.

40 "well-read": letter from FOH to family, 7/14/45.

41 "Now (10:26)": letter from FOH to family, 12/10/44.
 "The first time": interview with Charron, 9/8/90.
 "with all the fire": letter from FOH to family, 10/21/44.
 "One of the fondest": interview with Philip O'Hara, 10/19/89.

42 "Whenever he had friends over": interview with Maureen
O'Hara, 11/14/88.
 "Sweaters and shirts": letter from FOH to family, 12/27/44.
 "I have decided that Smith": letter from FOH to family, 4/1/45.

"And always remember": letter from FOH to family, 1/17/45.

43 "Fran loved to swim": letter from Birchard DeWitt to author, 2/15/90.

44 "Fran's mother really enjoyed": interview with Charron, 9/8/90.
"Everybody's a genius": interview with Charron, 9/8/90.

45 "the Bloomsbury Circle": letter from Robie to author, 6/6/89.
"the Left Bank crowd": interview with Genevieve (Kennedy) O'Connor, 8/9/90.

46 "Frank never had a best": interview with Robie, 3/11/90.
"He had pictures": interview with Philip O'Hara, 10/19/89.

47 "Fran idealized": interview with Charron, 9/8/90.
"Beethoven improved": letter from FOH to family, 8/21/44.
"my favorite": letter from FOH to family, 1/27/45.

48 "all the tripe": letter from FOH to family, 1/20/45.
"along the road to riches": letter from FOH to family, 5/25/45.
"too pompous": letter from FOH to family, 8/8/45.
"For when can we separate": letter from FOH to family, 5/25/45.
"Stephen is out": letter from FOH to family, 2/11/45.

50 "straining struts": "Poem" (To be idiomatic in a vacuum)
"strange sense of isolation": Michael True, source unknown, O'Hara family archives.

51 "We talked": interview with Charron, 9/8/90.
"Frank told me": interview with Larry Rivers, 3/2/89.

55 "my mess": "My Heart."
"His sexuality": interview with Dorr, 9/7/90.
"He did stay": interview with Robie, 10/1/89.

56 "So you think": FOH, "Autobiographical Fragments," 31.

57 "She walked past": FOH, *The 4th of July*, unpublished manuscript, 43.

58 "Only the good": letter from FOH to family, 7/18/45.
"Phil is doing": letter from FOH to family, 1/17/45.

59 *"So I left"*: "Ode to Michael Goldberg ('s Birth and Other Births)."

Navy

60 "Daddy will be": letter from FOH to family, 8/8/44.
"Today has really": letter from FOH to family, 8/18/44.

61 "the usual stuff": letter from FOH to family, 8/21/44.
"my rococo self": "To a Poet."
"My father crying":FOH, *The 4th of July*, unpublished manuscript, 106.
"And after all": FOH, "Lament and Chastisement," *Early Writing* (Bolinas, Calif.: Grey Fox Press, 1977), 117.

62 "Coming away": *The 4th of July*, 106.

62 "And I alone": ibid, 108.

"No one": "Lament and Chastisement," 112.

63 "more or less": letter from FOH to family, 7/19/44.

"The records here": letter from FOH to family, 8/2/44.

"You may be sure": letter from FOH to family, 6/30/44.

"Be sure & notice": letter from FOH to family, 9/13/44.

"the height of gentility": letter from FOH to family, 4/2/45.

"the nearest thing": letter from FOH to family, 7/3/44.

"periwinkle eyes": "Lament and Chastisement," 113.

"This boy is": letter from FOH to family, 8/21/44.

64 "He was soft-spoken": interview with Jim O'Connor, 7/3/90.

"I was waiting": letter from FOH to family, 8/15/44.

"very nervous": letter from FOH to family, 8/24/44.

"And from up North": "Lament and Chastisement," 113.

"from the one": *The 4th of July,* 108.

"Without exaggerating": letter from FOH to family, 8/24/44.

65 "lieutenant in one": letter from FOH to family, 8/18/44.

"My father": interview with Philip O'Hara, 10/19/89.

"who are so darn": letter from FOH to family, 8/2/44.

"the lonely Jewish boy": *The 4th of July,* 108.

"wouldn't march": letter from FOH to family, 8/2/44.

"The 6 yrs": letter from FOH to family, 7/7/44.

66 "The training should": letter from FOH to family, 9/25/44.

"Don't think": letter from FOH to family, 7/3/44.

"It feels": letter from FOH to family, 7/25/44.

"it's the only": letter from FOH to family, 6/25/44.

"not too far": letter from FOH to family, 9/25/44.

"roz biff": letter from FOH to family, 9/30/44.

67 "palm trees": "Lament and Chastisement," 115.

"It was nice to think": ibid., 116.

"I've gone": letter from FOH to family, 10/4/44.

"The City of Key West": Christopher Cox, *A Key West Companion* (New York: St. Martin's Press, 1983), 159.

"There are also": "Lament and Chastisement," 115.

"I can understand": letter from FOH to family, 7/19/44.

68 "At Key West": "Lament and Chastisement," 115.

"When you see": ibid., 114.

"the sea was": letter from FOH to family, 10/24/44.

"They seem": letter from FOH to family, 11/13/44.

69 "Why yes": "Lament and Chastisement," 115.

"For an eighteen-year-old": interview with Thomas Benedek, 6/11/90.

"Wherever I'm sent": letter from FOH to family, 11/10/44.

70 "depressing": letter from FOH to family, 10/6/44.

"I've been in the navy": "Lament and Chastisement," 114.

"Except for the sky": ibid., 116.

"periodic spells": letter from FOH to family, 12/2/44.

"For Norfolk": "Lament and Chastisement," 116.

"pink beading": letter from FOH to family, 12/11/44.

71 "I'm glad to be": letter from FOH to family, 12/25/44.

"perfect stranger": letter from FOH to family, 12/26/44.

"I waited": "Lament and Chastisement," 117.

"I hated to have": letter from FOH to family, 7/3/45.

"My mind": letter from FOH to family, 1/1/45.

"In some places": letter from FOH to family, 12/23/44.

72 "Lately I've been": letter from FOH to family, 12/24/44.

"There was the": "Lament and Chastisement," 121.

"practically without": ibid., 118.

73 "my kids": letter from FOH to family, 11/12/45.

"I think Market Street": "Lament and Chastisement," 118.

the Navy's Shore Patrol . . . crackdown: For information on the life of gay soldiers in World War II, I am indebted to Allen Berube, *Coming Out Under Fire* (New York: Free Press, 1990).

"devil-may-care spirit": *Variety*, 11/4/42, 1.

"The more I am on SP": letter from FOH to family, 1/27/45.

74 "Pretty soon": letter from FOH to family, 1/14/45.

"a gloomy efficient": "Lament and Chastisement," 119.

"He was doing": letter from FOH to family, 2/5/44.

"squint his eyes": letter from FOH to family, 1/14/45.

75 "as Sally Warren's": letter from FOH to family, 1/26/45.

"From now on your son": letter from FOH to family, 2/3/45.

"I never liked": letter from FOH to family, 1/27/45.

"sculptured orotund": "Lament and Chastisement," 119.

"I don't like": letter from FOH to family, 1/27/45.

"Wish I'd meet": letter from FOH to family, 1/12/45.

"She moves like": letter from FOH to family, 1/18/45.

"bohemians": letter from FOH to family, 2/3/45.

"similar to pagodas": letter from FOH to family, 1/22/45.

76 "a young lady": "Lament and Chastisement," 119.

"Mrs. Brown": letter from FOH to family, 1/26/45.

"a beautiful art": "Lament and Chastisement," 121.

"a very attractive": letter from FOH to family, 2/7/45.

"I shall never": letter from FOH to family, 2/3/45.

77 "nice-looking": letter from FOH to family, 2/7/45.

"We're going": letter from FOH to family, 2/9/45.

"turgid": "Lament and Chastisement," 118.

"on the whole more": letter from FOH to family, 1/26/45.

78 "I'll remain": letter from FOH to family, 2/10/45.

78 "It isn't as if": letter from FOH to family, 3/13/45.
 "like cattle": interview with Gordon Rosenlund, 7/11/90.
 "I'm a chemist": "Lament and Chastisement," 122.
 "The other night": letter from FOH to family, 2/21/45.

79 "a work of ignorance": "Lament and Chastisement," 122.
 "Emerson says": letter from FOH to family, 2/21/45.
 "great gray tarpaulin": "Lament and Chastisement," 121.
 "a second birth": ibid., 122.

80 "taxi off": letter from FOH to family, 2/21/45.
 "noisy as heck": letter from FOH to family, 2/22/45.
 "When we were": interview with Rosenlund, 7/11/90.
 "very oriental": letter from FOH to family, 3/14/45.
 "watch; chow": letter from FOH to family, 4/13/45.
 "situated in clearings": "Lament and Chastisement," 123.

81 "where the beaches flower": "Ode to Michael Goldberg."
 "wheeling in the air": letter from FOH to family, 3/1/45.
 "bats swooped": "Lament and Chastisement," 123.
 "He was composing": interview with Rosenlund, 7/11/90.
 "a chapel made": "Lament and Chastisement," 124.

82 "One of the cooks": interview with Rosenlund, 7/11/90.
 "situations arise": letter from FOH to family, 5/5/45.
 "Our religion": letter from FOH to family, 3/12/45.

83 Whitman's *Leaves of Grass*: O'Hara included a reading list of his
favorite Whitman poems for his parents in a letter dated 3/22/45: "From
'Inscriptions': One's-Self I Sing, In Cabin'd Ships at Sea, The Ship
Starting. From 'Calamus': To a Stranger, This Moment Yearning and
Thoughtful, Here the Frailest Leaves of Me. From 'Song of the Open
Road': All of Sea Drift. From 'By the Roadside': A Boston Ballad, Gods,
When I Heard the Learn'd Astronomer, O Me! O Life!, Roaming in
Thought, A Child's Amaze, All of 'Memories of Pres. Lincoln'. All of
'So Long!' My particular favorites of these are Sea Drift, Gods, O Me!
O Life! and So Long!"
 "It's most appropriate": letter from FOH to family, 4/5/45.
 "I hope you don't": letter from FOH to family, 6/14/45.
 "You seem to think": letter from FOH to family, 3/16/45.
 "taste in liquor": letter from FOH to family, 3/19/45.

84 "cycle of moods": letter from FOH to family, 3/29/45.
 "horseplay, jokes": letter from FOH to family, 4/13/45.
 pin-ups of Vargas girls: Alberto Vargas (1896–1982) was the Pe-
ruvian creator of *Esquire*'s pin-up girls during World War II.
 "more realistic": letter from FOH to family, 3/19/45.
 "I know every one": letter from FOH to family, 4/4/45.
 "I can no more": letter from FOH to family, 4/5/45.

85 "Borneo loomed": "Lament and Chastisement," 126.

"we killed the great": ibid., 128.

86 "I probably won't": letter from FOH to family, 5/8/45.
"sleeping on the open": "Lament and Chastisement," 126.
"Butch": interview with Larry Rivers, 3/2/89.
"Dear Butch": letter from shipmate on U.S.S. *Nicholas* to FOH, 2/14/50.
"Frank had": interview with George Montgomery, 1/12/88.

87 "he and another": interview with Larry Osgood, 6/18/90.
"He said he went": interview with Joe LeSueur, 4/10/90.
"Frank talked": interview with Hal Fondren, 6/18/90.

88 "huge and ungainly": letter from FOH to parents, 7/14/45.
"Does it stink!": letter from FOH to parents, 4/30/45.
"It really": letter from FOH to parents, 7/14/45.
"When we pulled": interview with Pete Bouthiette, 7/7/90.

89 "emotion-filled": letter from FOH to parents, 9/21/45.
"gold-braided": letter from FOH to parents, 9/2/45.
"a segment of landscape": letter from FOH to parents, 8/29/45.
"(ripe too!)": letter from FOH to parents, 1/10/46.

90 *"to the orange covered"*: "Ode to Michael Golberg ('s Birth and Other Births)."
"One night Frank": interview with LeSueur, 4/18/89.
"What could be": letter from FOH to family, 3/8/45.

91 "It was a great": interview with Philip O'Hara, 3/11/90.
"It's independence": letter from FOH to family, 1/10/46.
"This finality": letter to Larry Osgood, 6/23/50.

Harvard

92 "educational hobo": letter from FOH to family, 5/31/45.
"It's not the education": interview with Douglas Starr, 9/18/90.

93 "For now I like": letter from FOH to family, 7/18/45.
"Naturally": letter from FOH to family, 4/13/46.
"If so, it looks": letter from FOH to family, 5/4/46.
"his authority": interview with Phil Charron, 9/8/90.
"I think my father": interview with Philip O'Hara, 10/19/89.

94 "Not much hope": letter from FOH to family, 4/4/46.
"Their policies": letter from FOH to family, 4/20/46.
"mentally": letter from FOH to family, 9/3/45.
"a very likeable fellow": Counsellor for Veterans' Interview Sheet, 7/8/46.

95 "I must specialize": letter from FOH to parents, 7/18/45.
"It is very well": letter from FOH to parents, 9/3/45.

96 "Annapolis on the Charles": *Crimson*, Freshman issue, 1946.

97 "conveyor-belt diploma-mill": Anton Myrer, "Our Harvard," in *Our Harvard*, ed. Jeffrey L. Lant (New York: Taplinger, 1982), 173.

97 "a great exuberance": interview with Hal Fondren, 12/9/89.
"Earnest, Issue-sly": *Crimson*, 10/19/46.

98 "Nobody ever seems": *Crimson*, 5/14/47.
"all work": interview with Spiros Paras, 10/23/90.
"as if merely": letter from FOH to family, 5/31/45.

99 "Oh I'm going": interview with Charron, 9/8/90.
"one of the most interesting": letter from FOH to family,
12/11/46.
"practically died": interview with Edward Gorey, 12/14/89.
"my son": *Crimson*, 4/13/49.
"No more late nights": letter from FOH to family, 7/18/45.

100 "I was a little": letter from FOH to family, 12/11/46.
"refined": interview with Thomas Benedek, 6/11/90.
"This was the age": Alison Lurie, "Their Harvard," in *My Harvard, My Yale*, 39.

101 "Sat. nite": letter from FOH to family, 12/16/46.

102 "Tell Mary": interview with Mary Guerin, 10/13/90.

103 "I don't think": interview with Philip O'Hara, 10/19/89.
"It's odd how soon": letter from FOH to family, 5/29/45.
"Frank went": interview with Philip O'Hara, 10/19/89.

104 "His father": interview with Genevieve Kennedy, 8/9/90.
"Dear Dad": letter from FOH to Russell O'Hara, 4/13/46.
"I sensed": letter from FOH to Russell O'Hara, 4/13/46.

105 "You're not going to": letter from FOH to family, 8/15/44.
"Kay looked": Phil Charron diary entry, 1/25/47.

106 "It always amuses": letter from FOH to family, 7/30/45.

107 "keen sense": Harold Furth, "Loaded Dice," in *My Harvard, My Yale*, 64.
"I asked him": interview with Philip O'Hara, 10/19/89.

108 "I believe *Ulysses*": letter from FOH to Benedek, 1/2/47.
"I've studied": letter from FOH to family, 7/18/45.
"Remember to make": letter from FOH to Philip O'Hara,
1/23/45.

109 "I was never sure": interview with Edward Gorey, 12/14/89.
"You just tell me": interview with Jerome Rubenstein, 8/28/90.

110 "sewing machine music": interview with Gorey, 12/14/89.

111 "She sure did try": interview with Maureen O'Hara, 11/14/88.
"Frank was sticking": interview with Maureen O'Hara, 12/12/89.
"Fran became heroic": interview with Charron, 9/8/90.

112 "I really got": interview with Philip O'Hara, 10/19/89.
"I should not find": letter from FOH to family, 7/30/45.

113 "the whole room": *The 4th of July*, unpublished manuscript, 15.
"It was beer": interview with Kennedy, 8/9/90.
"All the girls": interview with Kennedy, 8/9/90.

114 "It's too bad": interview with Charron, 9/8/90.
 "entertain-each-other": letter from FOH to Benedeck, 1/2/47.
115 "all the flapping": interview with Hal Fondren, 12/9/89.
 "I remember": interview with George Montgomery, 1/12/88.
116 "I was reading": interview with Gorey, 12/14/89.
 "I remember thinking": interview with Gorey, 11/12/90.
 "He either called": interview with Gorey, 12/14/89.
 "It was all very": interview with Fondren, 12/9/89.
117 "Frank talked": interview with Donald Hall, 9/3/90.
 "That was where": interview with Kennedy, 8/9/90.
 "in a tacky": interview with Gorey, 12/14/89.
 "Mon ange": letter from FOH to Gorey, 9/1/49.
118 "We had a very": interview with Gorey, 12/14/89.
119 "One of the younger": *Crimson*, 3/10/47.
 "The purpose": *Crimson*, 4/29/48.
 "He was kind of scary": interview with Hall, 9/3/90.
 "a lovely sardonic": letter from John Ciardi to Donald Allen, 5/27/75, in *Homage to Frank O'Hara*, ed. Bill Berkson and Joe LeSueur (Bolinas, Calif.: Big Sky, 1978), 19.
 "It was always": interview with George Rinehart, 10/5/90.
120 "He really did just toss": interview with Gorey, 12/14/89.
 "You've got to be":
 "like a young Mozart": interview with Larry Osgood, 7/6/88.
 "He showed his brilliance": letter from Ciardi to Allen, 5/27/75.
121 "They were thin": interview with Gorey, 12/14/89.
 "always felt a bit": interview with Gorey, 11/12/90.
122 "We used to stay": interview with Hall, 9/3/90.
 "This actually almost": interview with Ashbery, 2/24/88.
123 "It's quite possible": interview with Ashbery, 2/24/88.
 "It is good": *Crimson*, 5/1/48.
 "My writing": *Firbankiana* (New York: Hanuman Books, 1989).
 "We were giddy": interview with Gorey, 12/14/89.
124 "all sorts of invidious": interview with Fondren, 12/9/89.
125 "What is English 130?": letter from FOH to Osgood, 9/27/50.
126 "Frank wasn't doing": interview with Rubenstein, 8/28/90.
 "one of the best": Lurie, "Their Harvard," 41.
 "Guerard was very": interview with Gorey, 12/14/89.
 "With three weeks": interview with Rubenstein, 8/28/90.
127 "psychoanalysis by bourbon": Ciardi, "Vale," *The New Yorker*, 6/25/49, 26.
 "His was a biting": interview with Hall, 9/3/90.
 "Mirror mirror": interview with Osgood, 7/6/88.
 "Koch and Ashbery": interview with Hall, 9/3/90.

127 "a confessional": Edward Lucie-Smith. "An Interview with Frank O'Hara," *Standing Still and Walking in New York,* ed. Donald Allen (San Francisco: Grey Fox Press, 1983), 13.

128 "I suspected": interview with Rubenstein, 8/28/90.

"In a journal": "A Journal," in *Early Writing,* ed. Donald Allen (Bolinas, Calif.: Grey Fox Press, 1977), 104.

"utter depression": ibid., 98.

"I often wish": ibid., 100.

"Holidays coming": ibid., 101.

"Back at school": ibid., 108.

129 "lit by store windows": ibid., 98.

"good and cold and raw": ibid., 101.

"short stories which clack": ibid., 102.

"dense and comforting": ibid., 108.

"people who are": ibid.

"I voted": ibid., 106.

Eliot House straw poll: *Crimson,* 11/1/48.

"Your letter": letter from F. O. Matthiessen to FOH, 4/29/48.

130 "dupes": "Dupes and Fellow Travelers Dress Up Communist Fronts," *Life,* 4/4/49, 42–43.

"How much the state": *Crimson,* 4/10/50.

"Who killed": "A Journal," 101.

"The fragility": ibid., 109.

"I am reading": ibid., 98.

"against death": ibid., 106.

"I am romantic": ibid., 105.

131 "Frank was ferocious": interview with Harold Brodkey, 12/7/89.

"elegant machinery": "A Journal," 102.

"the most harrowing": ibid., 109.

"I feel steadily": ibid., 110.

132 "moving onward and upward": interview with Gorey, 11/30/90.

133 "Some people don't": FOH, Notebook, unpublished manuscript, 129.

"I'm so": ibid., 131.

"Tony and Ted": interview with Fondren, 12/9/89.

"I have to admit": interview with Gorey, 11/30/90.

"I felt that": interview with Gorey, 11/12/90.

"It all happened": interview with Fondren, 12/9/89.

134 "Frank made a lot": interview with Fondren, 10/29/89.

"He was quiet": interview with Arthur Gartaganis, 10/25/90.

"I wasn't aware": interview with Rubenstein, 8/25/90.

135 "Two very good": interview with Frederick English, 1/8/88.

"It became a salon": interview with Fondren, 12/9/89.

"The Mandrake": interview with Hall, 9/3/90.

136 "I knew instinctively": Ashbery, "A Reminiscence," in *Homage*, 20.

137 "I seem to remember": interview with Ashbery, 2/24/88.

"There was a sort": interview with Ashbery, 1/31/90.

"He didn't look": interview with Ashbery, 2/24/88.

"Frank had an air": letter from Robert Bly to author, 1/17/88.

"I had known": interview with Ashbery, 2/24/88.

138 "One day I": interview with Brodkey, 12/9/88.

"It sounds like": interview with Ashbery, 2/24/88.

140 "As for the mill": letter from Lyon Phelps to FOH, 7/7/49.

"Some people": letter from FOH to Gorey, 9/1/49.

"I can see": letter from FOH to Osgood, 8/31/50.

141 "Of what use": FOH, Notebook, 124.

"perhaps the most": letter from FOH to Osgood, 8/31/50.

142 "I dimly remember": interview with Ashbery, 2/24/88.

"Whatever you do": description of visit taken from interviews with Fondren, 10/29/87, 12/9/89.

144 "Anyone passing by": interview with Fondren, 12/9/89.

145 "I swear that everyone": interview with Fondren, 10/29/87.

146 "Parisian artiness": Ashbery, "Introduction," in *The Collected Poems of Frank O'Hara*, ed. Donald Allen (New York: Alfred A. Knopf, 1979), x.

"I never thought": interview with Ashbery, 2/24/88.

"pure psychic automatism": Paul Auster, "Introduction," in *The Random House Book of Twentieth-Century French Poetry* (New York: Random House, 1982), xxxviii.

"Much of the poetry": Ashbery, "A Reminiscence," in *Homage*, 21.

"I first saw": FOH, "V. R. Lang: A Memoir," in *Standing Still*, 86.

147 "She had a mournful": interview with Ashbery, 2/24/88.

148 "You meet": Lurie, "V. R. Lang: A Memoir," in *V. R. Lang: Poems & Plays* (New York: Random House, 1975), 27.

"Bunny was definitely": interview with Gorey, 12/14/89.

"Bunny Lang was a fag hag": interview with John Simon, 9/27/90.

"It's so black": FOH, "V. R. Lang: A Memoir," 86.

149 "an astonishing": letter from Bly to author, 1/17/88.

"a glamour boy": interview with Ashbery, 1/31/90.

"I once saw Frank": interview with Brodkey, 12/9/88.

"The NERVE": letter from Bunny Lang to FOH, 11/22/50.

150 "Eet's a seem-bol": interview with Osgood, 7/6/88.

151 the writings of Freud: O'Hara had written of Freud in a letter
to his parents on 5/29/46: "Freud practically started psychoanalysis and
psychiatry single handed. Boy is it interesting."

"As soon as I started": interview with Osgood, 7/6/88.

152 "Frank was always": Brad Gooch, "Cruising the San Remo,"
The Advocate, 5/16/84.

"There were times": interview with Osgood, 7/6/88.

"one of his most": John Ashbery, "Introduction," vii.

153 "How'd you get": interview with Osgood, 7/6/88.

154 "I waved the bottle": interview with Fondren, 12/9/89.

155 "I was telling": letter from FOH to Osgood, 6/23/50.

"One must live": FOH, "A Journal," 101.

Ann Arbor Variations

157 "Beacon Hill was": FOH, *The 4th of July,* unpublished manu-
script, 33.

159 "disappointing": *Crimson,* 5/5/49.

"I am looking": letter from FOH to Osgood, 8/2/50.

160 "You go out": letter from Donald Hall to author, 1/28/88.

"He is inquiring": letter from FOH to Larry Osgood, 8/2/50.

"hotsy-totsy": letter from John Ashbery to FOH, 8/25/50.

"Of course we both can't": letter from Ashbery to FOH, 8/9/50.

"mad madrigal": letter from Ashbery to FOH, 9/5/50.

161 "the biggest": Ashbery, "Frank O'Hara's Question," *Book
Week,* 9/25/66, 6.

"We weren't": interview with George Montgomery, 1/21/89.

162 "And you think": letter from FOH to Osgood, 6/23/50.

"my constant": letter from FOH to Osgood, 8/31/50.

"You and I are much": letter from Ashbery to FOH, 8/9/50.

"neatness": letter from FOH to Osgood, 8/31/50.

"Oh Frank": letter from FOH to Osgood, 9/27/50.

"knowing that you": letter from FOH to Osgood, 8/31/50.

163 "standing with their backs": FOH, *The 4th of July,* 33.

"ankle deep": ibid., 39.

"thick with boats": ibid., 80.

"huge copper": ibid., 72.

"flashing gold dome": ibid., 73.

"Everyone looked": ibid., 85–86.

164 "artificer": ibid., 27.

"Billy!": ibid., 117.

"the ash trays": ibid., 152.

"like a hillside": ibid., 55.

"going to walk": interview with Maureen O'Hara, 11/14/88.

"Shaking her head": FOH, *The 4th of July,* 24.

165 "my father works": ibid., 6.

"His flesh smelled": ibid., 104.

"He always seemed": interview with Ashbery, 1/31/90.

"little bagatelle": letter from FOH to Osgood, 8/2/50.

"fresh and odd": FOH, *The 4th of July*, 81.

"Poor dear": ibid., 144.

166 "My god": ibid., 140.

"I looked": ibid., 49.

"hung with pale": ibid., 3.

"bare head looked": ibid., 5.

"sprinkled and looped": ibid., 17.

"You are not": letter from Bunny Lang to FOH, 9/27/50.

"Surely Ann Arbor": letter from FOH to Osgood, 9/27/50.

168 "At Michigan": interview with Hall, 9/3/90.

"He was very warm": interview with Susan Wexler, 1/24/91.

"Homage to Rrose Selavy": The title of (a pun on "Eros c'est la vie") refers to a signature used by Duchamp.

"He struck me": interview with Jascha Kessler, 1/27/91.

169 "Remember you're doing": interview with Osgood, 7/6/88.

"Professor Cowden is": letter from FOH to Osgood, 9/27/50.

"I must say": letter from FOH to Osgood, 10/19/50.

"SUPERB": letter from FOH to Osgood, 10/19/50.

"Do you think": letter from FOH to Freilicher, 6/6/51.

"just like that": letter from FOH to Freilicher, 6/6/51.

"some kind of feeling": interview with Osgood, 7/6/88.

170 "I had never read": letter from FOH to Osgood, 9/27/50.

"I thought about": *The 4th of July*, 125.

"I'm the city": ibid., 184.

"Frank changed": interview with Kenneth Lane, 2/3/88.

172 "it makes me think": letter from Ashbery to FOH, 11/6/50.

"so incomparably lucid": letter from FOH to Freilicher, 6/6/51.

173 "In conversations": letter from Donald Allen to Marjorie Perloff, 7/13/75, in *Frank O'Hara: To Be True to a City*, edited by Jim Elledge (Ann Arbor: University of Michigan Press, 1990), 184.

"I'm glad W. C. Williams": letter from Ashbery to FOH, 8/25/50.

"the most beautiful": FOH, "Rare Moderns," *Poetry* 89 (February 1957), 307–16, or reprinted in *Standing Still and Walking in New York*, 77–8.

"Though we grew": Ashbery, "A Reminiscence," in *Homage to Frank O'Hara*, ed. Bill Berkson and Joe LeSueur (Bolinas, Calif.: Big Sky, 1978), 20.

174 "You always disagree": letter from Ashbery to FOH, 12/7/50.

175 "demented telephone": FOH, "Larry Rivers: A Memoir," in

The Collected Poems of Frank O'Hara, ed. Donald Allen (New York: Alfred A. Knopf, 1979), 512.

175 "a better composer": Clement Greenberg, "Art," *The Nation,* 4/16/49, 454.

"I probably was": Larry Rivers and Carol Brightman. *Drawings and Digressions* (New York: Clarkson N. Potter, 1979), 36.

176 "Frank said": Kenneth Koch, "Fate," in *Homage,* 173–75.

"I thought he was crazy": FOH, "Larry Rivers: A Memoir," 169.

"queerdom": John Gruen, *The Party's Over Now* (New York: Viking, 1967), 133.

"I as usual": Gruen, *Party,* 141.

"As the party was": interview with Ashbery, 2/24/88.

"Let's see": Gruen, *Party,* 141.

177 "I'm going to": interview with Ashbery, 1/31/90.

"It seems against": letter from Ashbery to FOH, 10/14/50.

"He became": interview with Freilicher, 1/9/90.

178 "All my friends": interview with Ashbery, 2/24/88.

179 "Today I was": letter from FOH to Freilicher, 3/8/51.

180 "This Poets Theater": *Crimson.*

"My name is": letter from Lang to FOH, 3/1/51.

181 "The play earned": Daniel Ellsberg, "The Playgoer," *Crimson,* 3/1/51.

"bad performance": *Crimson,* 3/1/51, 2.

"Thornton Wilder": interview with Molly Howe, 1/28/91.

"Archie MacLeish": letter from Richard Wilbur to author, 9/16/90.

"Frank's play": letter from Lang to FOH, 3/1/51.

"Please write more plays": *Change Your Bedding* by FOH was presented by the Poets Theatre on May 14, 1951, with George Montgomery, V. R. Lang, and Jack Rogers. This second "Noh play" was dedicated "To John and Judith Ciardi."

"Cocteau was": interview with Freilicher, 1/9/90.

182 "like a forest": message written on poster mailed by FOH to Freilicher, spring 1951.

"In addition to": letter from FOH to Freilicher, 3/8/51.

"The serious poems": letter from FOH to Freilicher, 3/8/51.

"lyrical talent": letter from Peter Viereck to Roy Cowden, 5/11/51.

"intensely interesting": letter from Louis Untermeyer to Cowden, 1951.

183 "The collection": letter from Karl Shapiro to Cowden, 5/9/51.

"trying on": Ashbery, "Introduction," in *Collected Poems,* vii.

"broken the dominance": John Xirox Cooper, "William Carlos Williams," *Dictionary of Literary Biography 54*, 1987, 564.

"of the baleful influence": Kenneth Koch, "Fresh Air," in *Selected Poems* (New York: Vintage, 1985), 38.

184 "Weinstock is looking": *Michigan Daily*, 5/26/90.

"No publication": letter from FOH to Freilicher, 6/6/51.

"I am writing": letter from FOH to Freilicher, 5/1/51.

"What's so Hollywood," "She doesn't live," and "It would be": letter from FOH to Freilicher, 6/6/51.

185 "a little like": interview with Freilicher, 1/9/90.

"Rubens-like": postcard from FOH to Rivers, 7/51.

"He was the beloved": interview with Freilicher, 2/1/88.

186 "I have been": letter from FOH to Freilicher, 8/1/51.

"Here 'tis": letter from FOH to Freilicher, 6/6/51.

"New York has": interview with James Schuyler, 1/27/88.

187 "the fact that": letter from Ashbery to FOH, 4/26/51.

"shell-shocked": Paul Goodman, "Advance-Guard Writing, 1900–1950," *The Kenyon Review* 13 (Summer 1951): 357–80.

"The only pleasant": letter from FOH to Freilicher, 8/1/51.

188 "*A POEM!*": letter from FOH to Freilicher, 1951.

"feverish": letter from FOH to Freilicher, summer 1951.

"I do think": letter from Freilicher to FOH, undated.

"I will surely be": letter from Fondren to FOH, 8/8/51.

"only a hop-skip": letter from Fondren to FOH, 6/7/51.

"The one thing": Ashbery, "Jane Freilicher," in *Reported Sightings: Art Chronicles 1957–1987*, ed. David Bergman (New York: Alfred A. Knopf, 1989), 241.

Second Avenue

189 "a Baths": interview with Hal Fondren, 2/27/91.

190 "ozone stalagmites": "Poem" (Khrushchev is coming on the right day!)

"Hal was sort of": interview with Larry Osgood, /88.

"We did a lot": interview with Jane Freilicher, 1/1/88.

"I couldn't write": interview with John Ashbery, 2/4/88.

191 "If fame ever comes": interview with Joe LeSueur, 5/9–10/88.

"Everyone felt": interview with Freilicher, 1/1/90.

"living": FOH, "Notes on 'Second Avenue,'" in *The Collected Poems of Frank O'Hara*, ed. Donald Allen (New York: Alfred A. Knopf, 1979), 497.

192 "A scent": Ashbery, "Introduction," in FOH, *Collected Poems*, x.

"This was not": interview with Fondren, 10/29/87.

193 "The cockroach": LeSueur, "Four Apartments," in *Homage to*

Frank O'Hara, ed. Bill Berkson and Joe LeSueur (Bolinas, Calif.: Big Sky, 1978), 47.

194 "Whichever restaurant": interview with William Weaver, 6/15/89.

"The cops are making": letter from Larry Rivers to FOH, 8/14/51.

"A Harvard friend": interview with Fondren, 10/29/87.

195 "Mary's was very": interview with James Schuyler, 1/27/88.

"Mary's Bar": Ned Rorem, *Paris and New York Diaries* (San Francisco: North Point Press, 1983), 362.

"Main Street": interview with Edward Albee, 5/14/89.

196 "I used to get": Kenward Elmslie, *Gay Sunshine Interviews,* vol. 1–2, ed. Winston Leyland (San Francisco: Gay Sunshine Press, 1982), 103.

"piss-elegant": interview with Frederick English, 3/15/91.

197 "Hellfire must be fun": interview with Harold Brodkey, 4/18/89.

198 "John Myers was": interview with James Merrill, 3/27/89.

199 "heroic": *Art News,* October 1951.

"His early painting": FOH, "Larry Rivers: A Memoir," in *Collected Poems,* 515.

"his dark": Freilicher, in *Homage,* 23.

"The long neck": John Bernard Myers, "Frank O'Hara: A Memoir," in *Homage,* 34.

For a discussion of American Business Consultants, a free-lance blacklister, see Victor S. Navasky, *Naming Names* (New York: Viking Press, 1980).

"hanky-panky": John Gruen, *The Party's Over Now* (New York: Viking, 1967), 134.

"John M. has been": letter from Rivers to FOH, 8/14/51.

200 "John Myers": interview with Rivers, 3/2/89.

"Why my dear": interview with Schuyler, 1/27/88.

"This was rich": Schuyler, "Frank O'Hara: Poet Among Painters," in *Homage,* 82.

201 "Paul Goodman": interview with Kenneth Koch, 7/7/88.

"Even then there": interview with Merrill, 3/27/89.

202 "In the San Remo": FOH, "Larry Rivers: A Memoir," 512.

"verbal news shop": Rivers with Carol Brightman, *Drawings and Digressions* (New York: Clarkson N. Potter, 1979), 71.

203 "ich-schmerz": Irving Sandler, *The New York School* (New York: Harper & Row, 1978), 49.

"The drinking": interview with Helen Frankenthaler, 4/7/90.

"At the Cedar": Terry Miller, *Greenwich Village and How It Got That Way* (New York: Crown, 1990), 118.

"The attitude": interview with Koch, 7/7/88.

204 "Most of those": interview with Al Leslie, 9/8/88.

"How do you like": Andy Warhol and Pat Hackett, *Popism: The Warhol 60's* (New York: Harcourt, Brace & Jovanovich, 1980), 14.

"You may be": Steven Naifeh and Gregory White Smith, *Jackson Pollock* (New York: Clarkson N. Potter, 1989), 749.

"Sucked any": ibid., 749.

"fag": John Button, "Frank's Grace," in *Homage,* 43.

"If Jackson Pollock": FOH, "Larry Rivers: A Memoir," 512.

"like pressing": ibid., 513.

205 "I liked him": Peter Schjeldahl, "Frank O'Hara: He Made Things & People Sacred," *Village Voice,* 8/11/66, 12; and in *Homage,* 141.

"Oh look": Ronald Sukenrok, *Down and In: Life in the Underground* (New York: Collier Books, Macmillan, 1987), 53.

"It is interesting": FOH, "Larry Rivers: A Memoir," 513.

206 "He used to just love": interview with Freilicher, 2/1/88.

"Abstract Expressionism": Ashbery, *Reported Sightings: Art Chronicles 1957–1987* (New York: Alfred A. Knopf, 1989), 241.

"When he posed": interview with Rivers, 3/2/89.

207 "Meyer Schapiro": FOH, "Larry Rivers: A Memoir," 512.

"a dictionary of art": interview with Freilicher, 1/9/90.

"It seems now": Ashbery, "Foreword," in *Drawings and Digressions,* 8–9.

"Frank had idols": Schuyler, "Frank O'Hara," 82.

208 "He had this sort": interview with Freilicher, 1/9/90.

"There's a poet": LeSueur, "Four Apartments," 46.

"a blond beauty": interview with Rivers, 3/2/89.

209 "an intellectual climber": LeSueur, "Footnotes," unpublished manuscript, 7.

"He was a different type": interview with Rivers, 3/2/89.

"When John Cage": FOH, "Frank O'Hara: Second Edition," in *Homage,* 218.

"It had very little": Gruen, *Party,* 158.

210 "had to be almost carried": interview with Ashbery, 2/24/88.

"those drunks": interview with Maureen O'Hara, 11/14/88.

"Frank said he owed": interview with Grace Hartigan, 9/13/89.

211 "I'm leaving": interview with Maureen O'Hara, 11/14/88.

"I never met": interview with Hartigan, 9/13/89.

"They're all shit": interview with Hartigan, 2/14/88.

"Hefty, big-boned": LeSueur, "Footnotes," 104.

"Grace always seemed": interview with Weaver, 6/15/89.

212 "When I first met": interview with Hartigan, 9/13/89.

"directly and boldly": *Art News,* April 1952, 44.

"I told you": interview with Hartigan, 9/13/89.

212 "We fell in love": interview with Hartigan, 2/14/88.
213 "Grace brought": interview with Koch, 11/30/88.
 "like Hamlet": interview with Hartigan, 2/14/88.
 "It is to be": Myers, "Frank O'Hara: A Memoir," in *Homage*, 37.
214 "like seeing": interview with Koch, 11/30/88.
 "Let's have discussion": Gruen, *Party*, 177.
215 "the important book": FOH, "Larry Rivers: A Memoir," 512.
 "It's a rotten": Naifeh and Smith, *Jackson Pollock*, 658.
216 "When anybody": Gruen, *Party*, 270.
 "the White Goddess": FOH, "Larry Rivers: A Memoir," 512.
 "father of modern poets": FOH, "Notes for a talk on 'The Image in Poetry and Painting,'" unpublished manuscript, 467.
217 "It was a poetry": interview with Schuyler, 3/14/91.
 "clown": FOH, "Notes for 'New Poets,'" unpublished manuscript, 156.
 "I couldn't stand": interview with Fondren, 10/29/87.
 "If you were out": interview with Rivers, 3/2/89.
218 "giddy mixture": Schjeldahl, "At the Mad Fringes of Art," *New York Times Book Review*, 11/18/79, 39.
 "For Frank": interview with Weaver, 6/15/89.
 "The City Ballet": interview with Howard Kanovitz, 3/28/89.
219 "It is the greatest": letter from Freilicher to FOH, 3/7/51.
 "At the ballet": interview with Morris Golde, 6/30/88.
 "Notes from Row L": New York City Ballet Program, 1961–62 season.
220 "I hope the poem": FOH, "Notes on *Second Avenue*," in *Collected Poems*, 497.
 "Frank O'Hara was a catalyst": Gruen, *Party*, 166.
 "One night we took": interview with Weaver, 6/15/89.
222 "a hot house": Patsy Southgate, "My Night With Frank O'Hara," in *Homage*, 119.
223 "swell-elegant": interview with Elmslie, 3/22/91.
 "I don't want to give": letter from FOH to Freilicher, 6/6/51.
 "I was goggle-eyed": interview with Elmslie, 3/22/91.
 "I read them": interview with Koch, 7/7/88.
224 "Alack aday": letter from FOH to Freilicher, 6/6/51.
 "I don't know why": interview with Ashbery, 2/24/88.
 "When Frank first" and "H.D.": interview with LeSueur, 5/9–10/88.
225 "Something about": Koch, "A Note on Frank O'Hara in the Early Fifties," in *Homage*, 26.
 "burst on us all": ibid., 27.
 "action painters": Harold Rosenberg, "The American Action Painters." *Art News*, December, 1952, 22.

226 "Easter": For Perloff's discussion, see *Frank O'Hara: Poet Among Painters* (Austin: University of Texas Press, 1977), 65–68.

"Camp": See Christopher Isherwood, *The World in the Evening,* (New York: Random House, 1952), 110–11.

"camping all over": Eric Bentley, review of *The Matchmaker. New Republic,* 1/2/56, 21.

Susan Sontag, "Notes on 'Camp,'" *Partisan Review,* 31 (Fall 1964): x. For a tracing of the term *camp* to Australian police slang for "Criminal, Adult, Male, Prostitute" see John Adkins Richardson, "Dada, Camp and the Mode Called Pop," *Journal of Aesthetics and Art Criticism* (Summer 1966): 549–58.

227 "I hated it": Elmslie, *Gay Sunshine Interviews,* 101.

"Afterward Betty": interview with Schuyler, 1/27/88.

"Working at my": interview with Freilicher, 1/9/90.

"Most people": interview with Rivers, 3/2/89.

"He tended": interview with Ashbery, 1/31/90.

"I think she": interview with Rivers, 3/2/89.

"Larry had this": interview with Freilicher, 1/9/90.

228 "I probably": interview with Rivers, 3/2/89.

"My wound": letter from Rivers to FOH, 11/18/52.

"Frank said that": interview with Freilicher, 1/9/90.

"For a guy": interview with Rivers, 3/2/89.

229 "It seemed doomed": interview with Weaver, 6/15/89.

"I think Frank": interview with Rivers, 3/2/89.

"He usually picks": Rivers and Brightman, *Drawings and Digressions,* 79.

"Let me in": interview with Rivers, 3/2/89.

230 "depressed": Helen Harrison, *Larry Rivers* (New York: Harper & Row, 1984), 21.

"There they are": Myers, "Frank O'Hara: A Memoir," 37.

"Luckily": ibid., 35.

"John Myers was like": interview with Elmslie, 3/5/91.

"Herbert Machiz is": letter from Bunny Lang to Alison Lurie, 2/5/54.

"Larry and Frank": interview with Jane Wilson, 3/23/89.

"They talked endlessly": interview with Koch, 11/30/88.

231 "One aspect": interview with Kanovitz, 3/28/89.

"Larry alone": interview with Goldberg, 9/14/88.

"He talked": interview with Rivers, 3/2/89.

"Larry has never": interview with Hartigan, 2/14/88.

"A lot of those": interview with Koch, 7/7/88.

232 "strange, large-eyed": Myers, "Frank O'Hara: A Memoir," 35.

"At the first": FOH, "Larry Rivers: A Memoir," 35.

"Up until rehearsal": interview with Hartigan, 2/14/88.

232 "John": FOH, "Frank O'Hara: Second Edition," 217.

233 "John's chief": letter from FOH to Rivers, 6/27/53.

"One day I told": Koch, "A Note on Frank O'Hara in the Early Fifties," 27.

"Frank called": interview with Weaver, 6/15/89.

234 "Three fat cops": Rivers, "Life Among the Stones," *Location* (Spring 1963), 92.

"They were lovers": interview with Hartigan, 2/14/88.

"I had no clear": Koch, "A Note on Frank O'Hara in the Early Fifties," 27.

"To speak historically": Koch, "Poetry Chronicles," *Partisan Review* 28 (January–February 1961), 130–32.

"Frank's greatest poem": Perloff, *Frank O'Hara: Poet Among Painters,* 70.

235 "difficult pleasure": Ashbery, "Introduction," ix.

"Where Mayakovsky": "Notes on *Second Avenue,*" 497.

236 "The Women": interview with Koch, 11/30/88.

"Rivers' drawing": "Notes on the Poems," *Collected Poems,* 525.

"How about": interview with Hartigan, 2/14/88.

"It coincided with": interview with Hartigan, 2/14/88.

"I often": letter from FOH to Hartigan, 2/10/56.

237 "I'm Larry": interview with Jack Larson, 8/10/90.

"bugged": interview with Steven Rivers, 6/1/89.

"She was a": interview with Rivers, 3/2/89.

"She was called": FOH, "Larry Rivers: A Memoir," 513.

238 "intimate yell": Ashbery, "Introduction," vii.

"And who": Myers, "Frank O'Hara: A Memoir," 35.

"like getting": Rivers and Brightman, *Drawings and Digressions,* 59.

"hopelessly corny": FOH, "Larry Rivers: A Memoir," 514.

"phony": FOH, "Why I Paint as I Do," *Horizon,* September 1959. Reprinted in FOH, *Art Chronicles 1956–1966* (New York: Braziller, 1975), 113.

"He thought": interview with Rivers, 3/2/89.

239 "I hammer home": letter from Rivers to FOH, 7/27/53.

Meditations in an Emergency

242 "It was almost": interview with Robert Fizdale, 2/16/91.

"What was so odd": interview with James Schuyler, 1/27/88.

243 "Frank would": interview with Fizdale, 2/16/91.

"I went for": interview with Grace Hartigan, 2/14/88.

"One of the problems": interview with Fizdale, 2/16/91.

244 "Tonight Stephen": letter from Fizdale to FOH, 10/30/53.

"You're from Paris": Ned Rorem, "From *The Final Diary,*" in

Homage to Frank O'Hara, ed. Bill Berkson and Joe LeSueur (Bolinas, Calif.: Big Sky, 1978), 39.

245 "Don't do that": interview with Fizdale, 2/16/91.
"Now before": letter from FOH to Fizdale, 11/3/53.
"I love the way": letter from Fizdale to FOH, 12/6/53.
"The most difficult": letter from Fizdale to FOH, 12/23/53.
"It was very prudish": interview with Fizdale, 2/16/91.
"hideously depressed": letter from FOH to Fizdale, 1/4/54.

246 "we walked around": Dennis Barone, "Daisy Aldan: An Interview on *Folder,*" *Triquarterly* 43 (Fall 1978): 274.
"When it got": interview with Hartigan, 2/14/88.
"one of the great": letter from FOH to Rorem, 4/20/54.

247 "had it for awhile": letter from LR to FOH, 9/3/53.
"You rat": letter from Rivers to FOH, 9/3/53.
"Larry is here": letter from FOH to Fizdale, 11/3/53.
"I forgot": letter from John Ashbery to FOH, 1/14/54.
"My God": letter from Joe LeSueur to FOH, 1/21/54.

248 "We're getting": letter from FOH to Jane Freilicher, 1/19/54.
"He really went": interview with Freilicher, 2/1/88.
"In return": letter from FOH to Freilicher, 1/19/54.
"turned absolutely": interview with Hal Fondren, 10/29/87.

249 "Do you remember": letter from Rivers to FOH, 5/10/56.
"I feel as if Frank": interview with Rivers, 3/2/89.

250 "homosexual detraction": letter from FOH to Hartigan, 5/21/54.
"Go rob someone": interview with LeSueur, 5/9–10/88.
"I looked in": interview with Philip O'Hara, 10/19/89.

251 Metropolitan Hospital: Then on Welfare Island. The name was changed to Roosevelt Island in 1969 when it became a housing development on the recommendation of a mayoral commission. The hospital is now in Manhattan.
"They couldn't remove": interview with Hartigan, 2/14/88.
"She seems": FOH, *Art News,* April 1954, 45.
"Jane's more": interview with LeSueur, 5/9–10/88.

252 "What was difficult": interview with Freilicher, 2/1/88.
"I took Frank": interview with Hartigan, 2/14/88.

253 "I never slept": interview with Rivers, 3/2/89.
"these endless": interview with Schuyler, 1/27/88.

254 "I miss you": letter from FOH to Rivers, 7/13/91.
"I feel very upset": letter from FOH to Howard Kanovitz, 7/17/54.
"I am barely": FOH to Kenneth Koch, 8/14/54.

255 "smart light flannel": letter from Schuyler to FOH, 9/27/54.
"Perhaps the two": letter from William Weaver to FOH, 11/21/54.

256 "I had been": interview with Fondren, 10/29/87.

"I remember": interview with Hartigan, 9/13/89.

"almost as Holbein": FOH, *Art News,* October 1954, 53.

"natural violence": FOH, *Art News,* December 1954, 53.

"It was wonderful": letter from Cecil Beaton to FOH, 12/29/54.

257 "Beaton, you fool": Waldo Rasmussen, "Frank O'Hara in the Museum," in *Homage,* 85.

258 "I still recall": Rasmussen, "Frank O'Hara," 85.

259 "Is the younger": Alfred H. Barr, Jr., *Defining Modern Art* (New York: Harry N. Abrams, 1986), 41.

"I remember Barr": interview with Hartigan, 2/14/88.

"He'd always go back": interview with Porter McCray, 6/14/88.

"the Marshal": FOH, *Art News,* January 1955, 49.

"in the big": ibid., 47.

260 "That was very": interview with Rasmussen, 4/25/88.

"What are you": "John Ashbery," *Poets at Work: The Paris Review Interviews,* ed. George Plimpton (New York: Viking, 1989), 394.

"After Frank had played": interview with Koch, 7/7/88.

261 "I think you": letter from W. H. Auden to FOH, 6/3/55.

"I don't care": letter from FOH to Koch, 4/56.

"I certainly": interview with Ashbery, 2/24/88.

262 "Frank and I": interview with LeSueur, 4/14/89.

263 "Jane Freilicher agreed": LeSueur, "Four Apartments," in *Homage,* 47.

264 "Fairfield": interview with Freilicher, 11/1/88.

"patched together": letter from FOH to Barbara Guest, 8/21/55.

265 "the greatest drawing": FOH, "Comedy of Manners (American)," *Kulchur* 2 (Spring 1962): 5.

"It is called": letter from FOH to Fairfield Porter, 7/28/55.

"is shot coming": letter from FOH to George Montgomery, 11/9/55.

267 "There is an appalling": letter from LeSueur to FOH, 3/56.

"John didn't like": letter from FOH to Porter, 7/7/55.

268 "too out": letter from FOH to Michael Goldberg, 2/16/56.

"The James Dean": *Life,* October 1956, 15.

"I was as much": interview with Koch, 7/7/88.

"awfully sentimental": letter from FOH to Ben Weber, 6/18/56.

"Bravissimo": letter from Rorem to FOH, 4/14/56.

269 "Some of his themes": interview with Hartigan, 9/13/89.

"Joey is that": LeSueur, "Footnotes," unpublished manuscript, 5.

270 "New York has": interview with Osgood, 7/6/88.

"It was decided": John Gruen, *The Party's Over Now* (New York: Viking, 1967), 87.

"Frank practically": interview with Rivers, 3/2/89.

"He and I once": interview with Mike Goldberg, 9/14/88.

271 "As they went": Alison Lurie, "A Memoir," *V. R. Lang: Poems and Plays* (New York: Random House, 1975, 47.

272 "When I first": interview with Hartigan, 2/14/88.

"It will keep": FOH, "A Personal Preface," *Standing Still and Walking in New York*, ed. Don Allen (San Francisco: Grey Fox Press, 1983), 88.

273 "My well has run": letter from FOH to Porter, 10/3/55.

"One Saturday noon": Schuyler, "Frank O'Hara: Poet among Painters," in *Homage*, 82.

274 "It would be lots": letter from FOH to Montgomery, 11/9/55.

"I practically died": letter from FOH to LeSueur, 1/5/56.

275 "an appalling director": Nora Sayre, unpublished manuscript, 281.

"There was a great": interview with Leo Lerman, 1/22/91.

"Frank is the real": letter from FOH to Porter, 1/26/56.

276 "We had to run": interview with Howe, 1/28/91.

"They never stinted": interview with Lerman, 1/22/91.

"When he could manage": LeSueur, "Four Apartments," 50.

"He would just come": interview with Jules Cohen, 6/14/88.

"watching the slowly": letter from FOH to Joan Mitchell, 5/4/56.

"Some times it seems": letter from FOH to Goldberg, 2/16/56.

277 "I thought of calling": letter from FOH to Porter, 1/26/56.

278 "You know I'd love": letter from Freilicher to FOH, 5/15/56.

"a miraculous": letter from FOH to Koch, 5/9/55.

"lounges around": John Simon, "Towards the Extramural or Next Week: Theda Bara," *Audience*, 4/18/56, 4.

"We went up": interview with Arnold Weinstein, 4/19/89.

"more attractive than most": letter from FOH to Koch, 4/56.

279 "I think Wieners": interview with Guest, 5/5/88.

"We had met": John Wieners, "Chop-House Memories," in *Homage*, 65.

280 "You're not a poet!": Nora Sayre, manuscript, 294.

"adopted successfully": FOH, "Gregory Corso," *Standing Still*, 83.

"Frank admired": interview with Allen Ginsberg, 3/19/89.

"I didn't have": letter from FOH to Mitchell, 5/4/56.

281 "a proem in pose": John Simon, "Facilis Descensus Averno: A Facile Descent into Hell," *Audience*, 5/24/56, 5.

"it's not hot": letter from FOH to Hartigan, 2/11/56.

"Not that my virtuous": letter from FOH to Mitchell, 5/4/56.

"I think Proust": letter from FOH to Schuyler, 6/15/56.

I Do This I Do That

283 "Because today": Dennis Barone, "Daisy Aldan: An Interview on *Folder,*" *Triquarterly* 43 (Fall 1978): 277.

284 "a real dandy": letter from Bunny Lang to Larry Osgood, 9/17/53.

"'modern'": FOH, "V. R. Lang: A Memoir," *Village Voice,* 10/23/57.

"I learned about": letter from Joe LeSueur to FOH, 8/15/56.

"cried and cried": interview with Harold Brodkey, 12/9/88.

"Frank cried": Bill Berkson, "Quotes and Inscriptions." unpublished manuscript, 7.

286 "gradually that clear": FOH, "V. R. Lang," 10/23/57.

"Bunny and I often": letter from FOH to Osgood, 8/20/56.

287 "Frank took care": interview with Morris Golde, 6/30/88.

288 "Death-Car Girl": interview with Ruth Kligman, 11/29/88.

"what with depression": letter from FOH to Howard Kanovitz, 8/22/56.

"He integrated": Petr Schjeldahl, "Frank O'Hara: He Made Things & People Sacred," *Village Voice,* 8/11/66; reprinted in *Homage to Frank O'Hara,* eds. Bill Berkson and Joe LeSueur (Bolinas, Calif.: Big Sky, 1978), 143.

289 "And the Porto": letter from FOH and John Button to James Schuyler, 7/17/56.

"We were walking": interview with Kenneth Koch, 7/7/88.

"John Button and I": letter from FOH to John Wieners, 7/21/56.

290 "You are not simply": LeSueur, "Footnotes," unpublished manuscript, 3.

"attention equals Life": FOH, "Introduction," in Edwin Denby, *Dancers, Buildings and People in the Street,* (New York: Horizon Press, 1965), 9.

291 "By that time": LeSueur, "Footnotes," 78.

"Jimmy seems to resent": letter from FOH to Koch, 1/10/57.

292 "He was always": interview with Edward Field, 4/7/89.

"Promise me something": LeSueur, "Footnotes," 83.

293 "In order to show": letter from FOH to John Ashbery, 3/27/57.

"The poem was": interview with Jane Freilicher, 2/1/88.

"He was very": interview with John Gruen, 3/2/89.

294 "too brilliant": interview with Porter McCray, 6/14/88.

"I would have" and "The Pollock section": letter from FOH to Ashbery, 7/24/57.

295 "Frank was": Waldo Rasmussen, "Frank O'Hara in the Museum," in *Homage,* 88.

296 "I remember": interview with Rasmussen, 4/25/88.

"He had this thing": interview with Freilicher, 2/1/88.

"I think it started": interview with Grace Hartigan, 2/14/88.

"I used to": interview with Virgil Thomson, 2/2/89.

297 "He was an abstract": LeSueur, "Footnotes," 105.

"I was in": interview with Hartigan, 2/14/88.

"Frank took Grace's": LeSueur, "Footnotes," 107.

298 "Hey Frank!": Marjorie Perloff, *Frank O'Hara: Poet Among Painters* (Austin: University of Texas Press, 1977), 100.

"We were grown up": Rivers, "Life Among the Stones," *Location* (Spring 1963): 92.

"I remember them": interview with Koch, 11/30/88.

"Your ineffable charm": letter from FOH to Rivers, 4/8/57.

299 "It was like": Rivers and Carol Brightman, *Drawings and Digressions* (New York: Clarkson N. Potter, 1979), 71.

"The other day": letter from FOH to Mike Goldberg, 8/26/57.

"with that big": interview with Irma Hurley, 4/8/89.

"For many of us": FOH, "Larry Rivers: A Memoir," in *The Collected Poems of Frank O'Hara*, ed. Donald Allen (New York: Alfred A. Knopf, 1979), 514.

300 "Frank O'Hara is": Kenneth Rexroth, "Two Voices Against the Chorus." *New York Times Book Review*, 10/6/57, 43.

"His is a": W. T. Scott, "The Everyday and the Fanciful," *Saturday Review*, 4/12/58, 72.

"A jazz idiom suits": Robin Magowan, "It's You I Love," *Voices* 166 (May/August 1958): 41–44.

"It was not": Ashbery, "Introduction" in *Collected Poems*, vii.

301 "Saturday afternoon": LeSueur, "Four Apartments," in *Homage*, 52.

"on the night of": Raymond Foye, "John Wieners," *DLB* 16, 572.

302 "I wrote it": FOH, poetry reading, taped by Donald Allen, Buffalo, New York, 9/25/64.

"Frank was struck": LeSueur, "Four Apartments," 52.

303 "I obviously": interview with LeSueur, 5/8–9/88.

305 "It was remarkable": Russell Lynes, *Good Old Modern* (New York: Atheneum, 1973), 364.

"It was easy": interview with Koch, 7/7/88.

306 "In the midst": letter from FOH to Michael Goldberg, 8/26/57.

"When he'd go on": interview with Koch, 7/7/88.

"I had a stupid": letter from FOH to Schuyler, 4/54.

"I had quit": interview with Goldberg, 9/14/88.

307 "as much a meeting": John L. Cobbs, "Peter Matthiessen," *DLB*, 219.

"bottomlessly": interview with Patsy Southgate, 4/14/89.

308 "Frank was": interview with Luke Matthiessen, 5/17/89.
 "Frank was crazy": interview with Hartigan, 2/14/88.
309 "He spent a lot": interview with Freilicher, 2/1/88.
 "I was sorry": letter from Rivers to FOH, 6/10/54.
 "His first trip": interview with Ashbery, 2/24/88.
310 "Not much going on": letter from FOH to Don Allen, 8/20/58.
 "some very snappy": letter from FOH to Allen, 8/20/58.
 "have a certain": letter from FOH to Hartigan, 8/19/58.
 "astounding": letter from FOH to Hartigan, 8/20/58.
311 "I sent you": letter from FOH to Hartigan, 8/19/58.
 "if you can": letter from FOH to Allen, 8/20/58.
 "a lot prettier": letter from FOH to Hartigan, 8/19/58.
 "As far as Italy": letter from FOH to Allen, 8/20/58.
312 "Those ugly Germans": letter from FOH to Allen, 8/20/58.
313 "Il Presley" and "Save Me From": Kenneth Rexroth, "2 Americans Seen Abroad," *Art News,* Summer 1959, 30.
 "the absolute": interview with McCray, 6/14/88.
 "For Frank and me": Waldo Rasmussen, "Frank O'Hara in the Museum," 88.
314 "producing street scenes": André Chastel, *Le Monde,* Paris, 1/17/59.
 "I had a dinner": interview with Hartigan, 2/14/88.
 "We all": Barbara Guest, "Frank and I happened to be in Paris," in *Homage,* 77.
315 "He was able": interview with Jasper Johns, 2/26/90.
 "Kenneth, we've got": interview with Koch, 7/7/88.
316 "I had done": interview with Allen, 10/1/88.
 "Several people": letter from FOH to Allen, 3/25/59.
 "He thought": interview with Richard Howard, 5/31/91.
317 "I am having": letter from FOH to Koch, 4/3/57.
 "like one": interview with Howard, 5/31/91.
 "talent for": Diana Trilling, "The Other Night at Columbia: A Report from the Academy," *Partisan Review,* Spring 1959, 216.
318 "From 1955 on": interview with Allen Ginsberg, 3/19/89.
 "like[d] enormously": letter from FOH to Koch, 1/10/57.
 "Allen Ginsberg": letter from FOH to Koch, 1/29/57.
319 "I think around": interview with Ginsberg, 3/19/89.
 "I just wanted": interview with Howard, 5/31/91.
320 "Your poem": letter from Robert Duncan to FOH, 11/20/58.
 "As those West": letter from FOH and Button to Schuyler, 7/17/56.
 "I remember when": interview with Ginsberg, 3/19/89.
321 "Whether or not": letter from FOH to Ashbery, 12/22/58.
 "Thursday afternoon": letter from FOH to LeSueur, 1/17/59.

322 "Now wasn't that": letter from FOH to Ashbery, 3/16/59.

323 "As O'Hara left": interview with Ginsberg, 3/19/89.

"Dear Frank": letter from FOH to Allen, 1/13/60.

324 "news of a rather": letter from FOH to Ashbery, 10/29/59.

"a black rat": LeSueur, "Four Apartments," 53.

"Notice our new": letter from FOH to Allen, 3/25/59.

"in those pre-hippie days": LeSueur, "Footnotes," 3/2/91.

"Well it was": LeSueur, "Four Apartments," 53.

325 "Joe, neither one": interview with LeSueur, 5/8–9/88.

"Barnett Newman": Rasmussen, "Frank O'Hara in the Museum," 89.

327 "We didn't leave": interview with Hurley, 4/8/89.

"Well, I guess": Button, "Frank's Grace," in *Homage,* 42.

328 "It was very close": interview with Koch, 7/7/88.

"We're eating in": the account is drawn from LeSueur, "Footnotes," 1–6.

Love

330 "The Berg": letter from Joe LeSueur to FOH, 1/9/59.

"we 'met'": letter from FOH to Vincent Warren, 8/2/60.

"I might have": letter from FOH to John Ashbery, 11/27/59.

331 "Vincent was": interview with Larry Rivers, 3/2/89.

"he talks": letter from FOH to Peter Boneham, 8/25/61.

"To me tights": interview with Warren, 3/4–5/89.

"Are you": LeSueur, "Four Apartments," in *Homage to Frank O'Hara,* ed. Bill Berkson and Joe LeSueur (Bolinas, Calif.: Big Sky, 1978), 54.

332 "Jasper had": interview with Steven Rivers, 6/1/89.

"There was": interview with Jasper Johns, 2/26/90.

333 "Vincent and I": letter from FOH to Kenneth Koch, 8/4/59.

"Now does it really": letter from FOH to Joan Mitchell, 8/7/59.

"That weekend": interview with Koch, 7/7/88.

"I've always": interview with Patsy Southgate, 5/10/88.

334 "Another little": letter from FOH to James Schuyler, 8/12/59.

"The nicest": interview with Koch, 7/7/88.

335 "I saw": letter from FOH to Koch, 8/4/59.

"I never saw": interview with Warren, 3/4–5/89.

336 "so it won't": letter from FOH to Warren, 11/18/60.

"When I am unhappy": letter from FOH to Ned Rorem, 10/16/59.

"Frank could be": interview with Warren, 3/4–5/89.

337 "I remember": interview with Koch, 7/7/88.

"*annus mirabilis*": interview with Bill Berkson, 10/2/88.

"I remember": interview with Koch, 7/7/88.

338 "Looking at": interview with Amiri Baraka, 3/8/90.

339 "No, turn": LeSueur, "Four Apartments," 54.

340 "He would": interview with Renée Neu, 5/6/88.

341 "I once": interview with Schuyler, 1/27/88.

"Lee loved": interview with Sanford Friedman, 6/19/91.

"Frank O'Hara": Aline B. Saarinen, "Chosen from the American Collection," *New York Times Book Review,* 9/27/59, 7.

"just a bit": George Heard Hamilton, "The Great American Artists Series," *Art Journal* 20 (Fall 1960).

"pseudo-Apollinaire": Hilton Kramer, "Critics of American Painting," *Arts,* October 1959, 26.

342 "I feel": letter from FOH to Helen Frankenthaler, 12/16/59.

"'hopeless'": letter from FOH to Ashbery, 11/27/59.

"a kind of": *Art News,* December 1959.

"Do you think": letter from FOH to Mitchell, 12/7/59.

343 "He and Vincent": interview with Dan Waggoner, 1/12/89.

"I hate to tell": letter from FOH to Warren, 6/27/60.

"It's as great": interview with Warren, 3/4–5/89.

"The subject": Edwin Denby, "Three Sides of *Agon,*" *Dance Writings* (New York: Alfred A. Knopf, 1986), 463.

344 "The corps": interview with Warren, 3/4–5/89.

"He chose": Vincent Warren, "Frank . . ." in *Homage,* 75.

"Vincent": interview with Rivers, 3/2/89.

345 "I am still": letter from FOH to Ashbery, 12/30/59.

"More of seeing": letter from FOH to Ashbery, 3/17/60.

"Oh I do": letter from FOH to Ashbery, 3/8/60.

"That's what": letter from FOH to Ashbery, 3/17/60.

346 "Whether": FOH, "New Spanish Painting and Sculpture" (New York: Museum of Modern Art, 1960), 7.

347 "1/2 way": letter from FOH to Warren, 3/26/60.

"trail of": letter from FOH to Warren, 4/4/60.

"a highly excitable": letter from FOH to Warren, 3/26/60.

"The funny thing": letter from FOH to Warren, 3/29/60.

"a great cubist": letter from FOH to Warren, 4/1/60.

348 "The first thing": letter from FOH to Warren, 4/4/60.

"Shanghai": postcard from FOH to Warren, 4/10/60.

349 "He had": interview with Koch, 7/7/88.

350 "He'll become": interview with Berkson, 10/2/88.

"Frank and Bill": interview with Koch, 7/7/88.

"I don't think": interview with Berkson, 10/2/88.

351 "I saw B.B": letter from Warren to FOH, 4/7/60.

"when I get back": letter from FOH to Warren, 3/29/60.

"When we were": letter from FOH to Ashbery, 4/25/60.

352 "After the trip": interview with Warren, 3/4–5/89.

353 "a great blow": interview with Allen Ginsberg, 3/19/89.

354 "Through their work": Donald M. Allen, "Preface," in *The New American Poetry,* (New York: Grove Press, 1960), xi.

"large dominance": interview with Ginsberg, 3/19/89.

"But it's": interview with Allen, 10/1/88.

"There was a certain": interview with Ron Padgett, 11/21/88.

355 "empire building" and "I think": Russell Lynes, *Good Old Modern* (New York: Atheneum, 1973), 389–90.

"Alfred": interview with Porter McCray, 6/14/88.

"There was a lot": interview with Rasmussen, 4/25/88.

356 "He became quite": interview with Frankenthaler, 4/7/90.

"Frank was": Rasmussen, "Frank O'Hara in the Museum," in *Homage,* 87.

"All in all": Natalie Edgar, "Is There a New Spanish School?" *Art News,* September 1960, 45.

"At the time": Rasmussen, "Frank O'Hara in the Museum," 89.

357 "Frank said something": interview with Hartigan, 2/14/88.

"I never watched": letter from FOH to Warren, 7/14/60.

"And the rocks": letter from FOH to Warren, 7/26/60.

"I have been": letter from FOH to Warren, 8/5/60.

358 "The poems always": interview with Warren, 3/4–5/89.

"I suppose": letter from FOH to Ashbery, 9/30/60.

359 "I like": Brad Gooch, "Cruising the San Remo," *Advocate,* 3/16/84, 29.

"Frank was relaxed": interview with Warren, 3/4–5/89.

"Frank always": interview with Hartigan, 2/14/88.

"a scientist": Rivers and Carol Brightman, *Drawings and Digressions* (New York: Clarkson N. Potter, 1979), 88.

"I was going": interview with Hartigan, 2/14/88.

360 "repetitiousness": FOH, "Art Chronicle III," *Standing Still,* 143.

"She wrote": interview with Freilicher, 2/1/88.

"Frank" and "Oh no": interview with Schuyler, 1/17/88.

"Anyone who": interview with Hartigan, 2/14/88.

361 "You'll be": letter from FOH to Warren, 1/17/61.

"Frank was": interview with Philip O'Hara, 10/19/89.

362 "Is it true": letter from FOH to Ashbery, 2/1/61.

363 "It's a shame": letter from FOH to Warren, 1/18/61.

"I think": interview with Warren, 3/4–5/89.

"One had": interview with Mike Goldberg, 9/14/88.

"Frank was nuts": interview with LeSueur, 5/9–10/88.

364 "It seems to me": interview with Berkson, 10/2/88.

"I once": interview with Rorem, 3/26/90.

"Bill liked": interview with Rivers, 3/2/89.

364 "He really": LeSueur, "Four Apartments," 51.
"I was involved": interview with Berkson, 10/21/88.

365 "cut a wide swath": letter from Berkson to author, 10/4/88.
"told me some": letter from FOH to Warren, 1/18/61.
"Bill Berkson": interview with Schuyler, 11/27/88.
"*Silly*": letter from Berkson to author, 10/4/88.
"General 'cultural'": Rod Padgett and David Shapiro, eds., *An Anthology of New York Poetry* (New York: Vintage Books, 1970), 546.

366 "There are signals": interview with Berkson, 10/21/88.
"absolutely": letter from FOH to Ashbery, 2/1/61.

367 "an almost": FOH, Review, *Art News,* November 1954, 53.
"The great thing": letter from FOH to Ashbery, 2/1/61.
"I think he was": interview with Alex Katz, 1/29/89.

368 *"Dances Before the Wall"*: The references in the poem are to figures in the audience or on stage or both in the incestuous avant-garde dance world at the time. The poem was actually written on October 27, 1959, over a year after the performance of *Dances Before the Wall* at the Henry Street Playhouse on March 30, 1959, choreographed by James Waring, with a set by Julian Beck, and dancers including David Gordon, Fred Herko, Valda Setterfield, and Vincent Warren. Those mentioned in the poem were not necessarily present but *could* have been. The Henry Street Playhouse, where Alwin Nikolais had a company and Martha Graham taught, was located on the Lower East Side; Midi Garth was a modern dancer, shy and tentative in her style; Sybil Shearer was a modern dancer with Martha Graham; Paul Taylor had danced with Graham but was well known for his own choreography; Robert Rauschenberg had made sets for Waring.
"you my big brother": Diane DiPrima, "For Frank O'Hara, An Elegy," in *Homage,* 156.

369 "He was backstage": interview with Diane DiPrima, 7/24/89.
"I hope Jimmy": letter from FOH to Warren, 7/26/60.
"I love the way": interview with Koch, 7/7/88.

370 "It was like" and "When Roi and I": interview with DiPrima, 7/24/89.
"acoherent": adjective used by Richard Kostalanetz in "How to Be a Difficult Poet," *New York Times Magazine,* 5/23/76, 22.
"I've only been": letter from FOH to Ashbery, 2/1/61.
"It'll slip": LeSueur, "Four Apartments," 55.
"When I tried": interview with DiPrima, 7/24/89.

371 "You are the closest": letter from FOH to Warren, 3/16/61.
"a little souvenir": letter from FOH to Peter Orlovsky, 3/23/61.
"Allen is getting": letter from FOH to Barbara Guest, 12/4/59.

372 "In that way": interview with Ginsberg, 3/19/89.

373 "When Vincent": interview with Hartigan, 2/14/88.

374 "Early on": interview with Berkson, 10/21/88.

"In 1961": letter from Berkson to author, 9/9/88.

375 "They're really": interview with Berkson, 10/21/88.

"Bill and I": letter from FOH to Ashbery, 7/10/61.

"Bill and I": letter from FOH to Warren, 7/17/61.

"C'est la vie": letter from FOH to Boneham, 8/25/61.

376 "an Irish": letter from FOH to Ashbery, 9/20/61.

"Vincent has been": letter from FOH to Ashbery, 9/20/61.

Bill's School of New York

377 "It is simply": FOH, "Art Chronicle I" in Donald Allen, ed., *Standing Still and Walking in New York* (San Francisco: Grey Fox Press, 1974), 126.

"overinvested": interview with Kenneth Koch, 11/30/88.

378 "Frank will be": Peter Schjeldahl, "He Made Things & People Sacred," *Village Voice*, 8/1/66, in *Homage to Frank O'Hara,* ed. Bill Berkson and Joe LeSueur (Bolinas, Calif.: Big Sky, 1978), 141.

"playing truth": interview with Mike Goldberg, 9/14/88.

"I hadn't seen": interview with James Schuyler, 1/27/88.

"I think one": interview with Koch, 7/7/88.

379 "meretricious": interview with Joe LeSueur, 5/9–10/88.

"His friendship": interview with Waldo Rasmussen, 4/25/88.

"So we had": interview with Kenneth Jay Lane, 2/3/88.

380 "If Mr. O'Hara": letter from John De Menil to FOH, n.d.

"The exhibitions": Rasmussen, "Frank O'Hara in the Museum," in *Homage,* 88.

"One of the": letter from FOH to Lawrence Ferlinghetti, 9/25/63.

"terrific": letter from FOH to Ashbery, 10/16/61.

"poem-paintings": These twenty-eight "poem-paintings" were made by O'Hara and Norman Bluhm in October/November 1960. The poems were handwritten by O'Hara on black-and-white gouaches being done simultaneously by Bluhm on white paper or large sheets of brown butcher paper in his studio on top of the old Tiffany Glass Building on Park Avenue South—the first batch finished while they listened to a recording of Toti del Monte, the famous 300-pound soprano, singing *Madame Butterfly.*

381 "in government": Bill Berkson, "About *Flight 115* a play, or Pas de fumer sur la piste," unpublished manuscript.

"The second trip": letter from Berkson to author, 9/9/88.

"She looked haunted": interview with Vincent Warren, 3/4–5/89.

"Joan was interested": interview with Berkson, 10/2/88.

382 "HEAVEN": letter from FOH to Ashbery, 12/7/61.

"Bill's mother": letter from FOH to Larry Rivers, 11/11/61.

382 "I think that": interview with Berkson, 10/2/88.

"'Biotherm' is": letter from FOH to Don Allen, 9/20/61.

384 "a longy": letter from FOH to Rivers, 7/31/61.

"I've been going": letter from FOH to Allen, 9/20/61.

385 "There were times": interview with Berkson, 10/2/88.

"John and Bill": letter from FOH to Warren, 7/17/61.

386 "half dead": interview with LeSueur, 5/9–10/88.

"And what else": interview with Koch, 7/7/88.

"Oh Frank": letter from FOH to Warren, 1/19/62.

"Frank's love": letter from Berkson to author, 9/9/88.

387 "Willard got": interview with Gerard Malanga, 11/20/88.

"The only" and "I suspect": Elliott Anderson, ed., "The Little Magazine in America," *Tri Quarterly* 43 (Fall 1978), 710.

388 "She would be": interview with Jim Brodey, 4/11/88.

389 "delineated" and "His career": FOH, "Art Chronicle II," in *Standing Still,* 133.

"He's a dumb-watchman": FOH, "Art Chronicle II," 136.

390 "Edwin went": letter from FOH to Warren, 2/2/62.

"a brilliant": FOH, "Art Chronicle II," 138.

"One memory": letter from Philip Guston to Berkson, 3/77.

"When Bill was": letter from FOH to Rivers, 6/11/62.

391 "breath-taking": Terry Southern, "Frank's Humor," in *Homage,* 115.

"Through the doorway": interview with Berkson, 10/2/88.

"Frank was probably": Patsy Southgate, "My Night With Frank O'Hara," in *Homage,* 119–21.

392 "Well, it's too": letter from FOH to Rivers, 10/29/62.

393 "The New Realists": T.B.H. (Thomas B. Hess), *Art News,* 12/63.

"After the opening": Victor Bockris, *The Life and Death of Andy Warhol* (New York: Bantam: 1989), 115.

"You're a killer": Bockris, *Andy Warhol,* 244.

"The New Realism": letter from FOH to Joan Mitchell, 11/11/62.

394 "It's going to last": interview with LeSueur, 5/9–10/88.

"Around here": letter from FOH to Ashbery, 11/20/63.

395 "He was very": interview with John Giorno, 11/21/88.

"But you let": interview with LeSueur, 5/9–10/88.

"I remember": interview with Jasper Johns, 2/26/90.

"Andy wanted": interview with Malanga, 11/20/88.

396 "You can make": letter from FOH to Mitchell, 8/28/63.

"In his love": interview with Wynn Chamberlain, 3/28/89.

397 "Like a lot": interview with Rasmussen, 4/25/88.

"Why didn't he": Bockris, *Andy Warhol,* 157.

"How did you": letter from FOH to Goldberg, 11/28/64.

"Frank left": interview with Malanga, 11/20/88.

398 "Now you'll be": Judith Stein, "Telling History: A Chronological Account of Alfred Leslie's Killing Cycle," in *Alfred Leslie: The Killing Cycle* (St. Louis: St. Louis Art Museum, 1991), 18.

The Last Clean Shirt: O'Hara also created subtitles for *Philosophy in the Bedroom*, an animated 35-millimeter film by Alfred Leslie made after March 1966. At the time of his death he was working on subtitles for a film of Leslie's titled *Act and Portrait*.

"I tried": Andy Warhol and Pat Hackett, *Popism: The Warhol 60s* (New York: Harcourt Brace Jovanovich, 1980), 15.

"I remember": Joe Brainard, "Frank O'Hara," in *Homage*, 167.

"I went to": Edward Lucie-Smith, "An Interview with Frank O'Hara," in *Standing Still*, 19–20.

399 "pentagonally opposed": FOH, Proposal to MOMA, 5/7/66.

"I remember": Brainard, "Frank O'Hara," 167.

400 "He's 19": letter from FOH to Ashbery, 9/11/62.

"He was the mentor": interview with Frank Lima, 6/21/91.

"He was the opposite": interview with Tony Towle, 11/15/88.

401 "He followed": interview with Koch, 7/7/88.

"Now I've lost": interview with David Shapiro, 11/6/87.

"Be selfish": letter from FOH to Lima, 2/6/63.

"We got loaded": interview with Lima, 6/21/91.

"I never fought": interview with LeSueur, 5/9–10/88.

402 "flamethrower affection": interview with Berkson, 10/2/88.

403 "After his mother": interview with Lima, 6/21/91.

"Tell JA": letter from FOH to Mitchell, 11/11/62.

"an extremely": interview with LeSueur, 5/9–10/88.

404 "He didn't": interview with Maureen O'Hara, 3/14/90.

"You may recall": letter from FOH to Philip O'Hara, 1/11/63.

"You are much": letter from FOH to Rivers, 4/21/63.

405 "Oh shit": Berkson, "Memory Notes," unpublished manuscript, 4.

"It was quite grand": interview with Southgate, 5/10/88.

"pricing the Kohinoor": letter from FOH to Rivers, 4/7/63.

406 "Renée said": letter from FOH to Warren, 1/23/61.

"Some nights": interview with Lima, 6/21/91.

407 "Because Ashbery": interview with Ron Padgett, 11/21/88.

"When I came": interview with Ashbery, 2/24/88.

"Mr. Ashbery": Richard Kostelanetz, "How to Be a Difficult Poet," *New York Times Magazine*, 5/23/76, 22.

"His American": Kostelanetz, "Difficult Poet," 24.

"I remember": interview with Ashbery, 2/24/88.

408 "I saw how difficult": Rasmussen, "Frank O'Hara in the Museum," 89.

408 "These personages": FOH, "Franz Kline Talking," in *Standing Still*, 89.

"The one time": interview with Southgate, 4/14/89.

409 "I certainly wish": letter from FOH to Warren, 9/18/63.

"the terror": letter from FOH to LeSueur, 9/30/63.

410 "We can call": letter from FOH to Jan Cremer, 5/8/64.

"We were watching": Brainard, "Frank O'Hara," 167.

411 "Jim Bridges": interview with Jack Larson, 8/10/90.

"Frank thought": interview with Brodey, 11/11/88.

"pleasant": letter from FOH to LeSueur, 9/30/63.

"I admit": letter from FOH to LeSueur, 11/19/63.

412 "I intended": letter from FOH to Allen, 11/23/63.

"I have been": letter from FOH to Ashbery, 1/21/64.

413 "He was nuts": interview with LeSueur, 5/9–10/88.

"the Siren": interview with Chamberlain, 3/28/89.

"J. J. was pretty": interview with Virgil Thomson, 2/2/89.

"I think with Joe": interview with Paul Schmidt, 11/15/88.

"I ended up": letter from FOH to Rivers, 1/23/64.

"When I first": interview with Lima, 6/21/91.

"a woman": interview with Brodey, 11/11/88.

414 "I once called": interview with LeSueur, 5/9–10/88.

"It was more": interview with Stephen Holden, 8/1/89.

"I remember": Brainard, "Frank O'Hara," 167.

415 "He called": interview with Holden, 8/1/89.

416 "For a creative": interview with Schmidt, 11/15/88.

"Obviously": letter from FOH to LeSueur, 11/19/63.

"It's quite": letter from FOH to Lita Hornick, 2/17/64.

"series of loosely": Robert Hatch, "The Baptism," *The Nation*, 4/13/64.

"You know": interview with Brodey, 11/11/88.

417 "We had": interview with Taylor Mead, 5/18/89.

"He was so": interview with DiPrima, 7/24/89.

418 "I have to": letter from FOH to Warren, 2/2/62.

"What interested": interview with Edward Albee, 5/14/89.

"Larry designed": interview with Amiri Baraka, 3/8/90.

419 "featured Edwin": letter from FOH to Maxine Groffsky, 3/18/63.

"That was the first": interview with Allen Ginsberg, 3/19/89.

420 "I was shocked": interview with Shapiro, 11/4/87.

"I remember": interview with Brodey, 11/11/88.

"He had a big": interview with Hettie Jones, 8/29/89.

"Frank favored": interview with Baraka, 3/8/90.

421 "I remember Kenneth": interview with Shapiro, 11/4/87.

"If you invited": interview with Jane Freilicher, 2/1/88.

"a new note": letter from FOH to Ashbery, 1/21/64.

"stunning dinner party": letter from FOH to Johns, 6/20/63.

"Larry's parties": Berkson, "Memory Notes," 4.

422 "That will interest": interview with Richard Howard, 5/31/91.

"Now, listen": letter from FOH to Ashbery, 4/20/62.

"Frank can do": LeSueur, "Four Apartments," 51.

"Frank would": interview with Howard, 5/31/91.

"I remember going": interview with Holden, 8/1/89.

"Once Donald": interview with Alex Katz, 1/29/89.

423 "At the time": interview with Lima, 6/21/91.

"I remember": interview with Luke Matthiessen, 5/17/89.

"actors": "Growth of Overt Homosexuality in City Provokes Wide Concern," New York Times, 12/17/63, 1.

424 "You may be": letter from FOH to Ashbery, 1/21/64.

"In preparation": letter from FOH to Rivers, 4/18/64.

425 "Poem" (I to you and you to me the endless oceans of) was first printed in Galleria Odyssia's catalogue for the Italian artist Mario Schifano's show in 1964.

"Frank at least": interview with Baraka, 3/8/92.

"I remember": interview with Berkson, 10/2/88.

"terribly peculiar": letter from FOH to Warren, 6/17/61.

"the postal cops": interview with Baraka, 3/8/90.

426 "We've been": letter from FOH to Rivers, 4/18/64.

"Julian and Judith": letter from FOH to Ashbery, 11/21/62.

"Frank is": interview with Shapiro, 11/4/87.

"snotty": letter from FOH to Rivers, 4/18/64.

427 "as beautiful": letter from FOH to Ashbery, 11/21/62.

"the Alvin Ailey": letter from FOH to Warren, 12/3/62.

"The Zoo Story": FOH, Letter to the Editor, New York Times, 6/30/64.

"Edward Albee": letter from FOH to Rivers, 4/18/64.

"a gloomy": letter from FOH to Warren, 3/13/62.

"The action": FOH, letter, New York Times, 6/30/64.

"Frank Lima went": letter from FOH to Rivers, 6/30/63.

"Frank introduced": interview with Baraka, 3/8/90.

428 "He had millions": interview with Elizabeth Streibert, 7/19/91.

"Bill de Kooning": interview with Goldberg, 9/14/88.

"It finally all came out": interview with Southgate, 4/14/89.

429 "Frank couldn't": interview with Berkson, 10/2/88.

"like a buzzsaw": interview with Larry Osgood, 7/6/88.

"After some": letter from Michael Anania to Alexander Smith, Jr. in Frank O'Hara: A Comprehensive Bibliography, ed. Alexander Smith, Jr. (New York: Garland Publishing, 1980), 132.

430 "the world premier": letter from FOH to Rivers, 4/18/64.

430 "I will not": letter from FOH to Rivers, 4/11/64.

"quietly walking": letter from Charles Olson to George But-
terick, 4/26/69, in *Homage,* 144.

"frisson": Renée Neu, "With Frank at MOMA," in *Homage,* 91.

"I don't know": Lewis MacAdams, "Big Ted," in *Nice to See
You: Homage to Ted Berrigan,* ed. Anne Waldman (Minneapolis: Coffee
House Press, 1991), 211.

"Now I am making": letter from FOH to Rivers, 4/18/64.

431 "I started": interview with Brainard, 4/13/88.

"At our first": J. J. Mitchell, "The Death of Frank O'Hara,"
in *Homage,* 144.

"I seem to be": letter from FOH to Goldberg, 11/28/64.

432 "I was always": interview with Kenward Elmslie, 1/6/89.

"I'm sorry, but": interview with LeSueur, 5/9–10/88.

433 "I do think": interview with Holden, 8/1/89.

"You have to": interview with Katz, 1/29/89.

"J.J. was very": interview with Holden, 8/1/89.

434 "caretaker": interview with Chamberlain, 3/25/89.

"friend from Hollywood": interview with Jack Larson, 8/10/90.

"hate": interview with Elmslie, 1/6/89.

"So it got": interview with LeSueur, 5/9–10/88.

435 "sentimentality": letter from FOH to Russell O'Hara, 3/29/45.

436 "the conflict": FOH, "A Journal," in *Early Writing,* ed. Donald
Allen (Bolinas, Calif.: Grey Fox Press, 1977), 109.

"By the early sixties": interview with Berkson, 10/2/88.

"I think he was": interview with Holden, 8/1/89.

"Frank had a": interview with Lima, 6/21/91.

437 "I could kill": interview with LeSueur, 5/9–10/88.

Death

438 "I just don't": interview with Bill Berkson, 10/2/88.

439 "I've done so": letter from FOH to Larry Rivers, 2/13/64.

"a bit of": letter from FOH to Rivers, 2/13/64.

"I am quite": letter from FOH to Joan Mitchell, 11/11/62.

"Frank, we don't": interview with Joe LeSueur, 5/9–10/88.

"From 1962": interview with Berkson, 10/2/88.

"When I moved": interview with John Ashbery, 2/24/88.

440 "I met O'Hara": interview with Lawrence Ferlinghetti, 4/5/89.

"Yes suh": letter from FOH to Ferlinghetti, 12/18/59.

441 "there's not": Francis Hope, "Suffer and Observe," *New States-
man,* 4/30/65, 688.

"messages to": Gilbert Sorrentino, "The New Note," *Book-
week,* 5/1/66, 19.

"defecation": Raymond Roseliep, "From Woodcarver to Wordcarver," *Poetry* 107 (February 1966): 326.

"constant urging": John Bernard Myers, "Frank O'Hara: A Memoir." in *Homage to Frank O'Hara,* ed. Bill Berkson and Joe LeSueur (Bolinas, Calif.: Big Sky, 1978), 36.

"Now don't": letter from FOH to Myers, 10/2/64.

"I waited": letter from Myers to Alexander Smith, Jr., 8/24/76.

"amiable": Marius Bewley, "Lines," *New York Review of Books,* 3/31/66, 20.

"John's attitude": interview with Helen Frankenthaler, 4/7/90.

442 "John didn't sleep": letter from FOH to Ashbery, 10/15/58.

"He also predicts": letter from FOH to Rivers, 4/18/64.

443 "But now": letter from Berkson to Ashbery, 1/27/65.

"For a young": interview with Renée Neu, 5/6/88.

"something rather": Edward Lucie-Smith, "An Interview with Frank O'Hara," in *Standing Still,* 4.

"a god": FOH, "Larry Rivers: A Memoir," in *The Collected Poems of Frank O'Hara,* ed. Donald Allen (New York: Alfred A. Knopf, 1979), 512.

"There is not": John Canaday, "In the Gloaming," *New York Times,* 9/11/60.

"pioneer spirit": interview with Elizabeth Streibert, 7/19/91.

444 "Frank's exhibitions": Waldo Rasmussen, "Frank O'Hara in the Museum," in *Homage,* 90.

"Oddly enough": Lucie-Smith, "An Interview," *Standing Still,* 20.

"René d'Harnoncourt": interview with Rasmussen, 4/25/88.

445 "Quel head!": Jack Larson, "Frank O'Hara in Hollywood," in *Homage,* 102–105.

446 "the American": FOH, "The Grand Manner of Motherwell," *Vogue,* October 1965. Reprinted in *Standing Still,* 174–79.

"Motherwell wasn't": interview with Grace Hartigan, 2/14/88.

"Frank started": interview with Rivers, 3/2/89.

"That's one": interview with LeSueur, 5/9–10/88.

447 "I felt there": interview with Neu, 5/6/88.

"Like the rest": FOH, "The Grand Manner," in *Standing Still,* 129.

448 "Bill has gotten": letter from FOH to Mike Goldberg, 11/28/64.

"great, hulking": FOH, "Introduction," in *David Smith* (New York: Museum of Modern Art, 1966). In FOH, *Art Chronicles 1954–1966* (New York: George Braziller, 1975), 55.

449 "And when": Erje Ayden, "From *Seven Years of Winter,*" in *Homage,* 172.

"I have had": letter from FOH to Vincent Warren, 5/10/66.

450 "Smith is still": letter from FOH to Warren, 3/24/66.
"glorious": letter from FOH to Warren, 3/24/66.
"I'm having": letter from FOH to Warren, 3/24/66.
"It was": interview with Alex Katz, 1/29/89.
"apotheosis": *Arts,* September 1966, 51.
"joy": letter from FOH to Reuben Nakian, 7/19/66.
"You're doing": interview with LeSueur, 5/9–10/88.

451 "We were sitting": interview with Arnold Weinstein, 4/19/89.
"low camp": Harold C. Schonberg, "Music: 'Oedipus Rex' by Philharmonic," *New York Times,* 7/21/66.
"Suddenly": interview with Larson, 8/10/90.
"What are you": interview with Wynn and Sally Chamberlain, 3/28/89.

452 "I remember": interview with Kenward Elmslie, 1/6/89.
"Frank was": interview with Weinstein, 4/19/89.
"your mere": letter from FOH to Warren, 5/10/66.
"I was going": interview with Warren, 3/4–5/89.
"Yeah, I have": letter from FOH to Warren, 7/16/66.

453 "I remember": interview with Warren, 3/4–5/89.
"What a beautiful": letter from Warren to FOH, 7/7/66.
"I remember": interview with Rivers, 3/2/89.

454 "insufferably opinionated": letter from FOH to Rivers, 2/13/64.
"Just before": interview with Hartigan, 2/14/88.
"I remember when": interview with Maureen O'Hara, 11/18/88.
"It's just clear": interview with Maureen O'Hara, 11/14/88.
"Death doesn't": interview with Stephen Holden, 8/1/89.
"You know when": interview with Tony Towle, 11/15/88.
"What?": Berkson, "From a Journal, 1966," unpublished manuscript, 2.

455 "I can't handle": interview with Berkson, 10/2/88.
"enigmatic": interview with Streibert, 7/19/91.
"The girl": interview with Rivers, 3/2/89.
"You know": interview with Morris Golde, 6/30/88.
"He turned": letter from FOH to Ashbery, 6/30/63.

456 "Joe and J.J.": letter from FOH to Rivers, 6/30/63.
"Virgil loved": interview with Golde, 6/30/88.
"dolorous surf": "Thinking of James Dean."
"I think": interview with Golde, 6/30/88.
"The Belgian": J. J. Mitchell, "The Death of Frank O'Hara," in *Homage,* 144.

457 "It was": interview with Golde, 6/30/88.
"Thank you": Mitchell, "Death," 144.

458 "At that time": interview with Golde, 6/30/88.
"Don't you": LeSueur, "Four Apartments," in *Homage,* 47.

no other illumination: Moonset occurred on July 23, 1966, at
11:55 p.m.

459 "There was": interview with Kenneth Ruzicka, 11/14/89.

"Frank!": Mitchell, deposition, filed with attorney Saul Lef-
kowitz, 1/15/68.

"anywheres from": Kenneth Ruzicka, testimony for the State of
New York Department of Motor Vehicles, Suffolk County Center, Riv-
erhead, New York, Roger Whelan, referee, 2/15/67.

"After waiting": Mitchell, deposition.

460 "Frank was suddenly": Mitchell, "Death," 145.

"He lay": Judith Stein, "Telling History: A Chronological Ac-
count of Alfred Leslie's Killing Cycle," in *Alfred Leslie: The Killing Cycle*
(St. Louis: St. Louis Art Museum, 1991), 34.

"I took my": interview with Ruzicka, 11/14/89.

"Apparently normal": Police Department Traffic Accident Re-
port, filed by Patrolman Warren Chamberlain, Jr., Shield No. 541, Fifth
Precinct, County of Suffolk, New York, 7/24/66.

461 "No summons": "Man Struck by FI Buggy Dies Monday,"
Long Island Advance, 7/28/66, 14.

"Everything proceeds": Mitchell, "Death," 145.

462 "Keep us posted": interview with Golde, 6/30/88.

"a long conspiracy": Mitchell, "Death," 145.

"It was a": interview with Golde, 6/20/88.

"They were extremely": interview with Norman Bluhm, 8/14/91.

Selected Letters of Virgil Thomson, eds. Tim Page and Vanessa
Weeks (New York: Summit Books, 1988), 324.

"A broken leg": letter from Virgil Thomson to Maurice
Grosser, 7/25/66.

463 "Everything possible": Mitchell, "Death," 145.

"When I spoke": Peter Schjeldahl, "Frank O'Hara: He Made
Things & People Sacred,'" *Village Voice,* 8/11/66. Reprinted in *Homage,*
139.

"Bill de Kooning": interview with Chamberlains, 3/28/89.

"Frank was there": interview with Koch, 7/7/88.

464 "I remember": interview with Frankenthaler, 4/7/90.

"He breathed": Rivers, "Speech Read at Frank O'Hara's Fu-
neral," in *Homage,* 138.

"He was raving": interview with Rivers, 3/2/89.

"Oh Steve": interview with LeSueur, 5/9–10/88.

"We see": Mitchell, "Death," 145.

"We sort of": interview with LeSueur, 5/9–10/88.

"Who is he": Mitchell, "Death," 145.

"She wanted": interview with LeSueur, 5/9–10/88.

465 "Frank": interview with Towle, 11/15/88.

465 "Again": Mitchell, "Death," 146.
"terminal": interview with Philip O'Hara, 10/19/89.
"It was just": interview with Maureen O'Hara, 11/18/88.
"Maureen": interview with Philip O'Hara, 10/19/89.
466 "Come over": J. J. Mitchell, "Death," 146.
"They were": interview with Ned Rorem, 9/13/88.
"I remember": interview with LeSueur, 5/9–10/88.
"I remember": interview with Koch, 7/7/88.
467 "There was": interview with Philip O'Hara, 10/19/89.
"a real lace-curtain": interview with Norman Bluhm, 8/11/91.
"personal stuff": interview with Philip O'Hara, 10/19/89.
"We were afraid": interview with Lima, 6/21/91.
"In the closet": interview with Koch, 7/7/88.
"I always": interview with Hartigan, 2/14/88.
468 "I think Frank": interview with Berkson, 10/2/88.
"At the end": letter from Joe LeSueur to author, 2/21/92.
"All that will do": letter from FOH to Frank Lima, 2/6/63.
470 "Look at this!": interview with Berkson, 10/2/88.
"I almost fell": interview with Koch, 11/12/92.

Index

Permissions Acknowledgments

Illustration Credits

Insert following page 144: page 1 of insert, Courtesy of Philip O'Hara; page 2 (all) Courtesy of Philip O'Hara; page 3 (all) Courtesy of Maureen O'Hara Granville-Smith; page 4 (top and bottom) Courtesy of Douglas P. Starr, (center) Courtesy of Maureen O'Hara Granville-Smith; page 5, the Estate of George Montgomery; page 6, the Estate of George Montgomery, Courtesy of Lawrence Osgood; page 7 (bottom) the Estate of George Montgomery; page 8 (top) Walt Silver, Courtesy of the Estate of Grace Hartigan, (bottom) Courtesy of The Wylie Agency, LLC. For the Estate of Joe LeSueur; pages 9, 10, 11, Walt Silver, Courtesy of the Estate of Grace Hartigan; page 12 (top and center) John Button, Courtesy of Georges Borchardt, Inc., on behalf of John Ashbery.

Insert following page 272: page 1 of insert, the Estate of Fred W. McDarrah; page 2 (top and bottom) the Estate of Fred W. McDarrah; page 3, the Estate of Fred W. McDarrah; page 4 (top and bottom) the Estate of Fred W. McDarrah; page 5 (top) the Estate of Fred W. McDarrah, (bottom) John Gruen; page 6 (top and bottom) © Archives Malanga; page 7, Anthony F. Holmes; page 8, Mario Schifano, Courtesy Joe LeSueur; page 9 (bottom) Camilla McGrath; page 10 (top) Colin Clark, (bottom) the Estate of George Montgomery; page 11 (top) Helen Frankenthaler, (center) Mario Schifano, (bottom) George Cserna; page 12, Camila McGrath

Insert following page 400: page 1 of insert, © Estate of Larry Rivers/ Licensed by VAGA, New York, NY; page 2 (top) Courtesy Alvin Novak and Collection of Nell Blaine, (bottom) Courtesy Hirschl & Adler Modern, New York; page 3 (top and bottom) Courtesy Robert Miller Gallery, New York; page 4 (top) Elaine de Kooning, (bottom) Don Bachardy; page 5 Alfred Leslie, "The Killing Cycle: #4, The Telephone Call," 1971-1972, oil on canvas, Collections of Mr. and Mrs. Robert Orchard, St. Louis Museum, Acc #284-1989; page 6, Collection of the Estate of Patsy Southgate; page 7, John D. Schiff, Courtesy of Bill Berkson and the Estate of Norman Bluhm; page 8, Digital Image © The Museum of Modern Art/Licensed by SCALA / Art Resource, NY